~ ~ ~ Modigliani

Also by Pierre Sichel

~ SUCH AS WE
~ THE JERSEY LILY
~ THE SAPBUCKET GENIUS

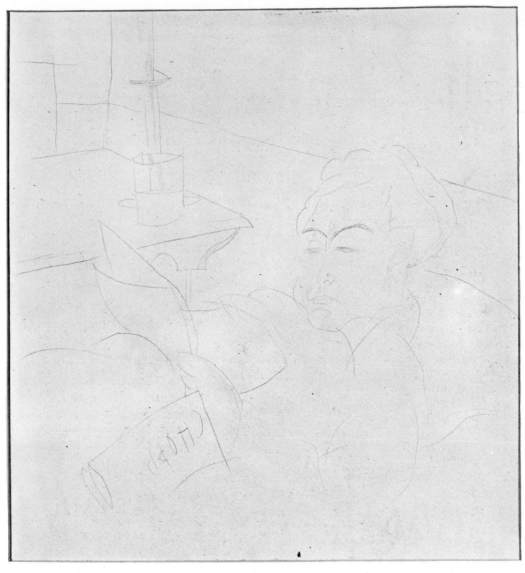

Self-portrait in bed. Even sick and exhausted as he appears to be here, Modigliani was busy sketching. *(From the collection of Mr. and Mrs. James W. Alsdorf, Winnetka, Illinois, U.S.A.)*

Pierre Sichel

A Biography of
Amedeo Modigliani ∽∽∽

E. P. DUTTON & CO., INC. NEW YORK 1967

MODIGLIANI

Grateful acknowledgment is made to the following for permission to quote from copyright material:

Antony Alpers: *Katherine Mansfield*. Published by Alfred A. Knopf, Inc., and reprinted with their permission.
Frank Arnau: *Three Thousand Years of Deception in Art*. Published by Jonathan Cape Limited, London, and reprinted with their permission.
Anthony Blunt and Phoebe Pool: *Picasso, The Formative Years*. Published by New York Graphic Society Publishers, Ltd., 1962, Greenwich, Conn.
John Malcolm Brinnin: *Dylan Thomas in America* and *The Third Rose*. Published by Atlantic-Little, Brown and Company, and reprinted with their permission.
Umberto Brunelleschi: "Rosalie, l'ostessa di Modigliani." Reprinted from *L'Illustrazione Italiana*, September 11, 1932.
Anselmo Bucci: "Modigliani dal vero." Reprinted from *Panorama dell'Arte Italiana* by Marco Valsecchi and Umbro Apollonio. Published by S. Lattes & C. Editori, Turin.
C. J. Bulliet: *Apples and Madonnas*. Copyright by Crown Publishers, Inc., 1958. Reprinted by permission of the publishers.
John Canaday: *Mainstreams of Modern Art*. Published by Simon and Schuster, Inc., and reprinted with their permission.
Francis Carco: *L'Ami des Peintres*. Copyright, ©, 1953, by Editions Gallimard. Published by Editions Gallimard, Paris, and reprinted with their permission. Also *Ombres Vivantes*. Published by Editions Ferenczi, Paris, and reprinted with their permission. And *Bohème d'Artiste* and *Montmartre à Vingt Ans*. Published by Editions Albin Michel, and reprinted with their permission.
Ambrogio Ceroni: *Amedeo Modigliani Peintre* and *Amedeo Modigliani, Dessins et Sculptures*. Published by Edizione Il Milione, Milan, and reprinted with their permission.
Jean Cocteau: *Bibliothèque Aldine des Arts* and *Modigliani*. Published by Fernand Hazan Editeur, Paris, and reprinted with their permission.

Gertrude Coor: *Neroccio De'Landi 1447–1500*. Published by Princeton University Press, and reprinted with their permission.

Pierre Courthion: *Montmartre* and *Paris in Our Time*. Published by Skira International Corp., and reprinted with their permission.

Fleur Cowles: *The Case of Salvador Dali*. Published by Little, Brown and Company, and reprinted with their permission.

Thomas Craven: *Modern Art*. Published by Simon and Schuster, and reprinted with their permission.

Jean-Paul Crespelle: *Montparnasse Vivant*. Copyright, ©, 1962, by Librairie Hachette. Published by Librairie Hachette, Paris. *Montmartre Vivant*. Copyright, ©, 1964, by Librairie Hachette. Published by Librairie Hachette, Paris.

Maud Dale: *Modigliani*. Published by Alfred A. Knopf, Inc. Reprinted with permission of publisher.

Charles Douglas: *Artist Quarter*. Published by Faber and Faber, Ltd., London. Reprinted with permission of Mrs. Malin Goldring.

Ilya Ehrenburg: "Modigliani: How Many Vertebrae to a Neck?" Reprinted from *Show*, the Magazine of the Arts, July, 1962. Originally published by Alfred A. Knopf, Inc.

Frank Elgar and Robert Maillard: *Picasso*. Published by Frederick A. Praeger, Inc., and reprinted with their permission.

Jacob Epstein: *An Autobiography*. Published by Studio Vista Limited, London, E. P. Dutton & Co., Inc., New York.

Evarts Erickson: "Amedeo Modigliani, Son of the Stars." Reprinted from *School Arts*, Vol. 58, No. 8, with their permission.

Harold Ettlinger: *Fair Fantastic Paris*. Copyright, 1944, by The Bobbs-Merrill Company, Inc. Reprinted by permission of the publishers.

Bergen Evans: Introduction to *I Promessi Sposi* by Alessandro Manzoni. A Premier Book published by Fawcett Publications, Inc. Copyright, ©, 1962.

Florent Fels: *L'Art Vivant de 1900 a Nos Jours*. Published by Pierre Cailler Editeur, Suisse, Switzerland. Reprinted with permission of publisher.

Gustave Fuss-Amoré and Maurice des Ombiaux: *Montparnasse*. Published by Editions Albin Michel, Paris, and reprinted with their permission.

Helen Gardner: *Art Through the Ages*, Fourth Edition. Published by Harcourt, Brace & World, Inc., and reprinted with their permission.

Carola Giedion-Welcker: *Constantin Brancusi*. Published by George Braziller, Inc. Reprinted with the permission of the publisher.

Michel Georges-Michel: *From Renoir to Picasso*. Published by Houghton Mifflin Company, and reprinted with their permission.

André Gide: *The Journals of André Gide*, Vol. I, 1889–1913. Published by Alfred A. Knopf, Inc., and reprinted with their permission.

Arnold Haskell: *The Sculptor Speaks, Jacob Epstein to Arnold L. Haskell*. Published by William Heinemann Ltd., London. Reprinted with permission of the author.

Fernand Hazan with Carlton Lake and Robert Maillard (eds.): *Dictionary of Modern Painting*. Published by Tudor Publishing Company, and reprinted with their permission.

Ernest Hemingway: *A Moveable Feast*. Copyright, ©, Ernest Hemingway Ltd. Published by Charles Scribner's Sons, and reprinted with their permission.

Barbara W. Holender: "Portrait by Modigliani." Reprinted from *The New York Times*. © 1960 by The New York Times Company. Reprinted by permission.

Max Jacob: "Connaissez-vous Maître Eckart?" Reprinted from *Derniers Poèmes*, published by Editions Gallimard. Copyright, ©, Editions Gallimard.

Augustus John: *Chiaroscuro: Fragments in Autobiography*. Reprinted with permission of the Executors of the Estate of Augustus John. Published by Jonathan Cape, London.

Kiki: *The Education of a French Model*. Published by Belmont Productions, Inc. Copyright, ©, Samuel Roth. Reprinted by permission of Samuel Roth.

Katherine Kuh: "Italy's 'New' Renaissance: An Inquiry." Reprinted from the *Saturday Review*, Vol. XLIV, No. 6, February 11, 1961.

Jacques Lassaigne, Raymond Cogniat, and Marcel Zahar: *Panorama des Arts*. Published by Editions Aimery Somogy, Paris, and reprinted with their permission.

Edgar Levy: "Modigliani and the Art of Painting." Reprinted from *The American Scholar*, Summer, 1964, with their permission.

A. J. Liebling: *Normandy Revisited*. Published by Simon and Schuster, Inc., and reprinted with their permission.

Jacques Lipchitz: *Amedeo Modigliani*. Published by Harry N. Abrams, Inc., and reprinted with their permission. "I Remember Modigliani." Reprinted from *Art News*, Vol. XLIX, No. 10, February, 1951, with their permission.

Philip Mairet: *A. R. Orage, A Memoir*. Published by J. M. Dent & Sons Ltd., London, and reprinted with their permission.

André Malraux: *The Voices of Silence*. Published by Doubleday & Company, Inc., and reprinted with their permission.

Katherine Mansfield: *The Letters of Katherine Mansfield to John Middleton Murry*, edited by John Middleton Murry. Also *Journal*. Published by Alfred A. Knopf, Inc. and Constable Publishers, London. Reprinted with permission of Alfred A. Knopf, Inc. and The Society of Authors as the literary representative of the late Katherine Mansfield. "Je Ne Parle Pas Francais." Reprinted from *The Short Stories of Katherine Mansfield*. Published by Alfred A. Knopf, Inc., and reprinted with their permission.

Ludwig Meidner: "The Young Modigliani—Some Memories." Reprinted from *Burlington Magazine*, April, 1943, Vol. 82, pp. 87–91, with their permission.

Jeanne Modigliani: *Modigliani: Man and Myth*. Published by Grossman Publishers, and reprinted with their permission.

Bernard S. Myers: *The German Expressionists*. Published by Frederick A. Praeger, Inc., and reprinted with their permission.

Eric Newton: *Arts of Man*. Published by New York Graphic Society Publishers, Ltd., 1960, Greenwich, Conn.

Fernande Olivier: *Picasso et Ses Amis*. Published by Editions Stock, Paris, and reprinted with their permission.

Giovanni Papini, *Laborers in the Vineyard*. Published by David McKay Company, Inc., and reprinted with their permission.

Irene Patai: *Encounters*. Published by Funk & Wagnalls Company, Inc., and reprinted with their permission.

Roland Penrose: *Picasso: His Life and Work*. Copyright, ©, 1958, 1962 by Roland Penrose. Published by Schocken Books, Inc., and reprinted with their permission. *Portrait of Picasso*. Published by The Museum of Modern Art, New York, and reprinted with their permission.

The Penguin Book of French Verse. Published by Penguin Books Ltd., Middlesex, England, and used with their permission.

The Penguin Book of Italian Verse. Published by Penguin Books Ltd., Middlesex, England, and used with their permission.

Henri Perruchot: *Cézanne*. Published by The World Publishing Co., and reprinted with their permission.

Arthur Pfannstiel: *Modigliani, et Son Œuvre, Critique et Catalogue Raisonné*. Published by La Bibliothèque Des Arts, Paris, and reprinted with their permission. Also *Dessins de Modigliani*. Published by Editions Mermod, and reprinted with their permission.

Maurice Raynal: *Modern Painting*. Published by Skira International Corp., and reprinted with their permission.

Jean Renoir: *Renoir, My Father*. Published by Atlantic-Little, Brown and Company, and reprinted with their permission.

Maurice Rheims: *The Strange Life of Objects*. Copyright, ©, 1959, by Librairie Plon, Paris. English translation copyright, ©, 1961, by George Weidenfeld and Nicholson Ltd., London. Published by Atheneum Publishers, and reprinted with their permission.

Seldon Rodman: *Conversation with Artists*. Published by G. P. Putnam's Sons, and reprinted with their permission.

Robert S. de Ropp: *Drugs and the Mind*. Copyright, ©, Robert S. de Ropp, 1957. Reprinted with permission of St. Martin's Press.

Claude Roy: *Modigliani*. Published by Skira International Corp., and reprinted with their permission.

John Russell: Introduction to the Modigliani Exhibition Catalogue. Published by The Arts Council of Great Britain, 1963. Reprinted by permission of John Russell and the publisher.

Franco Russoli: *Modigliani*. Published by Harry N. Abrams, Inc., and reprinted with their permission.

André Salmon: *Modigliani: A Memoir,* translated by Randolph and Dorothy Weaver. Published by G. P. Putnam's Sons, and reprinted with their permission. *La Vie Passionneé de Modigliani*. Published by Editions Seghers, Paris, and reprinted with their permission.

William Schack: *Art and Argyrol, The Life and Career of Dr. Albert C. Barnes*. Published by A. S. Barnes & Company, Inc., and reprinted with their permission.

Paul Selver: *Orage and the New Age Circle*. Published by George Allen & Unwin Ltd., London, and reprinted with their permission.

Sir Osbert Sitwell: *Laughter in the Next Room* and *Noble Essences*. Reprinted by permission of Sir Osbert Sitwell and Macmillan & Co., Ltd., London.

James Thrall Soby: *Modigliani*. Published by The Museum of Modern Art, New York, and reprinted with their permission

Ardengo Soffici: *Ricordi Di Vita Artistica e Letteraria*. Copyright 1942 by Vallecchi Editore, Florence, Italy.

Elizabeth Sprigg: *Gertrude Stein, Her Life and Work*. Published by Harper & Row. Reprinted with permission of the author.

Francis Steegmuller: *Apollinaire, Poet Among Painters*. Published by Farrar, Straus & Giroux, Inc. Reprinted with permission of the publisher.

Gertrude Stein: *The Autobiography of Alice B. Toklas*. Published by Random House, Inc., and reprinted with their permission. *Picasso*. Published by E. P. Dutton & Co., Inc. Reprinted by permission of the Estate of Gertrude Stein.

John Storm: *The Valadon Drama*. Published by E. P. Dutton & Co., Inc. By kind permission of Mrs. John Storm.

Alice B. Toklas: *What Is Remembered*. Published by Holt, Rinehart and Winston, Inc., and reprinted with their permission.

Maurice de Vlaminck: *Tournant Dangereux*. Published by Editions Stock, Paris, and reprinted with their permission.

Marevna Vorobëv: *Life in Two Worlds*. Reprinted by permission of Abelard-Schuman Ltd. All rights reserved. Copyright year, 1962.

Patrick Waldberg: *Mains et Merveilles*. Published by Mercure de France, Paris, and reprinted with their permission.

André Warnod: *Fils de Montmartre*. Published by Librairie Arthème Fayard, Paris, and reprinted with their permission.

Herman J. Wechsler: *Lives of Famous French Painters*. Copyright, 1952, by Herman J. Wechsler. Published by Washington Square Press, Inc., and reprinted with their permission.

Alfred Werner: "The Life and Art of Amedeo Modigliani." Quoted from *Commentary*, May, 1953. Copyright, ©, 1953, by the American Jewish Committee. *Modigliani, the Sculptor*. Published by Arts Inc., Publishers. Reprinted with permission of the author and the publisher.

Monroe Wheeler: *Soutine*. Published by The Museum of Modern Art, New York, and reprinted with their permission.

Frederick S. Wight: "Recollections of Modigliani by Those Who Knew Him." Reprinted from *Italian Quarterly*, Vol. 21, No. 1, Spring, 1958, with their permission.

Wilenski, R. H.: *Modern French Painters, 1863–1903* and *Modern French Painters, 1904–1938*. Published by Harcourt, Brace & World, Inc., and reprinted with their permission.

Bertram Wolfe: *The Fabulous Life of Diego Rivera*. Published by Stein and Day Publishers, and reprinted with their permission.

For my brother and sister—
Lucien Jouvaud Sichel and
Yvonne-Eugénie Passmore

Life is a Gift: from the few to the
many; from Those who Know and have
to Those who do not Know and have
not.

AMEDEO MODIGLIANI

⌒ ⌒ ⌒ Contents

⌒ 13

~ ~ ~ *List of Illustrations*

Self-portrait (frontispiece).

Insert pages 1–4, following page 192

Birthplace of Modigliani.
Commemorative plaque on birthplace.
Modigliani's mother, Eugenia Garsin Modigliani.
Modigliani as a baby.
Year-end theatricals at Eugenia Modigliani's school.
A Sunday afternoon session at Gino Romiti's studio.
Modigliani in 1904.
Modigliani in his early twenties.
The Bateau-Lavoir, 13 Rue Ravignan.
Père Frédé at the Lapin Agile.
Rosalie Tobia in her little restaurant.

Insert pages 5–8, following page 224

Modigliani in his familiar corduroy suit.
Modigliani during the early years in Paris.
Modigliani with one of his sculptures.
Modigliani, Picasso, and André Salmon in 1915.
Modigliani, Jacques Lipchitz, and Durct.
Maurice Utrillo, Suzanne Valadon, and André Utter.
Chaim Soutine.
Jacob Epstein.
Moïse Kisling.

∾ ∾ ∾ Foreword

Much of what is known about Amedeo Modigliani is sketchy, contradictory. He has been the subject of apocryphal stories, wild surmise, and still wilder anecdotes. Although certain facts of his life have been substantiated, there remain great gaps that invite speculation, especially since Modigliani left behind very little correspondence and almost none of the documents necessary for complete biography.

He lived an extraordinarily chaotic life—transient and disorderly. When he met this person; when he painted and lived with that lovely model; when he had a studio at some of his known addresses in Montmartre and Montparnasse; when he made his two—or was it three? —visits home to Leghorn, more often than not the exact dates are in dispute or beyond absolute proof. The same is true of his work, for which a definitive chronology is lacking because so much of it is undated. At precisely what time of his life he did much of his painting and sculpture remains uncertain, a matter of guesswork. Often, paintings, sketches, and sculpture have been arbitrarily assigned to what is assumed to be a significant year or period in his development.

A legend in his brief, tempestuous lifetime, Modigliani has become more of a legend year by year until now it overshadows the man and his art. For close-ups of Modigliani one has to depend on the memories of those who knew him. Jeanne Modigliani, who has written a revealing biography of her father, is wary of these sources, and classifies them mordantly:

> There are the indulgent sentimentalists who melt as they tell of the handsome and elegant young man, so lordly, so cultivated, and so ex-

quisitely kind-hearted. There are the intolerant for whom the artist does not excuse the unbearable buffoon, who could neither stand alcohol nor keep away from it, the weak author of his own downfall, the boring, drunken spoil-sport. Finally, there are the self-centered, for whom Modigliani is only an excuse to recall their own youth.

To these one might add the embittered, such as André Hébuterne, the brother of Modigliani's last and greatest love, Jeanne Hébuterne, who adamantly refuses to give any testimony whatsoever.

Miss Modigliani's is a valid judgment, if perhaps a little too harsh, sweeping, and intolerant. Yet it is as suspicious and protective as one might expect of Modigliani's daughter. Why should she choose to disbelieve her father's friends when she never knew him herself? Besides, where else can one turn than to the people who knew him? Apocryphal incidents and distorted accounts of those who have battened on the fame of Modigliani notwithstanding, most of the stories and anecdotes about him can be regarded as smoke from a fire: they contain sparks of truth.

Who can say how reliable, how truthful these yellowed recollections are? And where the passionately flamboyant legend is ignored, what does it matter after all these years? Witnesses are witnesses, some true, some false.

The jealous amazement of some of his contemporaries is understandable. To them it seemed impossible that this noisy, combative drunk, this lecherous, doped-up loner should have achieved stunning fame; that his paintings, which he couldn't even give away, are now worth hundreds of thousands of dollars. It must be acknowledged that Modigliani was indeed a difficult, even impossible, man—arrogant, proud, wholly dedicated to his art. But along with Van Gogh, Gauguin, Toulouse-Lautrec, Pascin, Soutine, Utrillo, and a few others who were labeled *peintres maudits,* his legend continues to grow. It has been assisted by sensational novels, hoked-up or fictionalized biographies, and films that of course accent drink, drugs, degradation, sex, sin, and madness, and give no time to the exploration of his towering artistic achievement.

Great artists are more fortunate than great kings, statesmen, generals, and dictators in that they reverse Shakespeare's lines about the evil men do living after them and the good being oft interred with their bones. They leave neither new countries nor divided ones, neither civilizations in bondage nor hopes and opportunities denied, nor a people crushed or murdered. They leave in their paintings, sculptures, symphonies, and books an imperishable legacy. More than most, artists truly "make good the honor of being men."

I have taken pains not to alter, blur, or distort the essential spirit of Modigliani in this account of his troubled life set against his untroubled

art. While pointing out what is admittedly unverifiable, I have tried to show that Modigliani was much more than the monstrous masquerade character romantic legend makes him; much more than a grotesque bohemian, a stereotype cheapened, warped, and ridiculed in print as a poseur, a swaggerer, and a seducer of women, as a man who was always drunk, crazy-drugged or both; much more than the irresistibly handsome god always penniless, starving, and in rags as he wandered the streets of Montmartre or Montparnasse either truculent or, in a stupor, mumbling Dante.

Modigliani was perhaps all these things, but not *constantly*, not *always*. Most of us are, now and then or every so often—and so it was with Modigliani. Besides, when could so debauched a man have found time to paint, carve statues, and make so many thousands of drawings? As Jacob Epstein, Modigliani's good friend and fellow sculptor, said, "The legend of the debauched artist is just a legend." What legend gives us is an implausible caricature of a man, a painter who could have left behind only a body of legends. Amedeo Modigliani left behind a life's work in art.

PIERRE SICHEL

SHERMAN, CONNECTICUT
March, 1966

〜 〜 〜 Modigliani

〜〜〜 Chapter One

"A little spoiled, a little moody, but joli comme un
cœur."

The greatness of Amedeo Modigliani's art was perhaps more difficult
for his native Italy to acknowledge than for the rest of the world.
Bad enough that he turned his back on his own country, lived in
Paris for fourteen hectic years, and there achieved fame. To have *foreign-
ers* hail him as possibly the greatest Italian painter since the Renaissance
was condescension, arrogant insult, sure proof of French artistic ig-
norance.

He was truly famous and appreciated only after his death in January,
1920, when Modigliani the artist began to overtake Modigliani the leg-
end. Then his work was exhibited with great success in Paris: the prices
of his portraits doubled, trebled, and quadrupled, and greedy art dealers
realized thousands of francs by speculating in him. In 1922 the Museum
of Grenoble added a touch of respectability to him by buying one of his
pictures. It was the first European museum to do so.

In that same year Modigliani was exhibited for the first time in Italy.
Twelve of his pictures were hung in the Twelfth Venice Biennial, includ-
ing paintings of young women, housemaids, little girls, the Baroness Oet-
tingen, a gypsy, a self-portrait of the artist (known to have been a drunk-
ard, dope addict, and lecher) and one of Jeanne Hébuterne. Italian crit-
ics were apparently eager to prove French judgment wrong. The strange,
distorted, blank-eyed, slab-nosed, long-necked, tilt-headed portraits with
sad, dreamy expressions made it easy, if that was all one saw. Surely the
foremost Italian critic of the time spoke for all his compatriots when he
blasted the portraits as "twelve ugly unformed heads that a child of five
might have drawn." [1] It was a charge to be leveled often at Modigliani's
work before it was understood and valued as great art.

A more sympathetic critic who knew him in Paris finds the resemblance of Modigliani's models to one another to be extraordinary, attributing this not to an assumed style or a superficial trick of painting, but to the artist's view of the world, a view at once childlike and wise. Whether they are clothed or nude, young or old, blond, gray-haired, or bearded, Ilya Ehrenburg feels that they are all like hurt children. He believes that to Modigliani the world seemed like an enormous kindergarten run by harsh adults. The same adults, led by such critics as those of the Twelfth Venice Biennial, continued to be harsh to his memory.

The French insisted that Modigliani's art owed everything to Parisian influences; the Italians, that Paris had blunted everything that had once been good in his art; but later, convinced the current was running against them, agreed that he was a great artist only *because* of his Italian heritage. Meanwhile his prestige increased. The price of his paintings went up and up and up, until one of his portraits sold for as much as a $272,000 at a recent auction (a portrait of Germaine Lable, the daughter of Max Jacob's concierge, entitled *La Fille du Peuple,* bought by the Hammer Galleries, New York, in December, 1965) and in some instances began to bring more than Picassos, a bit of poetic justice that would have delighted Modigliani.

The greatest Modigliani exhibition in the United States was shown first in the Museum of Fine Arts, Boston, in January, 1961, and from March 29 to April 30 of that same year at the Los Angeles County Museum. The forty-four paintings and forty-four drawings were valued at more than $4,000,000.

Modigliani has been canonized among modern artists, and at last recognized by his own country. He was a Jew, and he had first been recognized in Paris; but he was an Italian born in Italy. He had died longing for his homeland, and supposedly murmuring, *"Cara, cara Italia."* Now a plaque on the house where he was born signifies that Italy has recognized him historically as well as artistically. Once a luxurious home in the elegant residential section of Leghorn (Livorno), Number 33 Via Roma is a run-down three-story building in the poor part of town. (See photograph, facing page 192.) Shops flank the central entrance, with six shuttered windows above it. Between the two right-hand windows on the second floor is the plaque, which reads:

HERE WAS GIVEN THE GIFT OF LIFE, TALENT, VIRTUE TO THE PAINTER AMEDEO MODIGLIANI. THE CITY HALL OF LIVORNO ON THE 75TH ANNIVERSARY OF HIS BIRTH, JULY 12, 1959.

Modigliani liked to write aphorisms on the margins of some of his thousands of drawings. The best-known, and certainly the most pointed,

is: "Life is a Gift: from the few to the many; from Those who Know and have to Those who do not Know and have not."

He would have admitted grudgingly that he had received the gift of life in Leghorn. Certainly he repaid it many times over. As for talent, who knew where that came from? But surely its cultivation was all his own doing. And virtue—well, that was a tricky word. But whatever virtue he possessed was also his own.

In any case, here in the house on Via Roma, Leghorn, his story begins.

Amedeo Clemente Modigliani was born July 12, 1884, the fourth child of Eugenia Garsin and Flaminio Modigliani. The eldest, born in 1872, was Giuseppe Emanuele, who became a politician and a militant Socialist and was to climax his career by being elected to the Chamber of Deputies from Budrio in 1913. Next came Margherita Olimpia, born in 1874, an irritable intemperate spinster who was never close to her youngest brother (though she was to bring up his orphaned daughter); and then, in 1878, Umberto Isacco, possibly the most reserved of the family, who became an electrical engineer.

The Modiglianis lived in affluence before financial disaster overtook them the year Amedeo was born. His mother recalled, "The house on the Via Roma, huge and full of servants, the meals fit for a Pantagruel, with the table always set for an endless number of relatives and friends, great receptions in a series of vast drawing rooms on the second floor or in the ground-floor hall which opened onto the big and still well-tended garden."[2]

The Modiglianis were strict orthodox Jews with a strong sense of family. Flaminio's father was king of the household, held court daily, and dealt royally and brusquely with his subjects, who paid him formal homage by kissing his hand and addressing him in the third person. Important and formidable, he had once lived in Rome and dealt with Church authorities. In comparison with the members of her own family, who, though patriarchal, were lighthearted and affectionate, Eugenia thought the Modiglianis "uncultivated, overbearing and authoritarian."

The Modiglianis' dealings with Church authorities in Rome may have accounted for their residence in Leghorn. While to foreigners their name sounds authentically Italian, to Italians it is unmistakably Jewish. The Modiglianis were Sephardic (Spanish-Portuguese) Jews and of an old Italian Jewish family. Like other Jews, they were forced to choose a family name from a list, or else to assume a place name, and their name, not an uncommon one in Italy,[3] probably derived from the town of Modigliana, near Forli and about two hundred miles south of Venice. While the Ashkenazim (German, Polish, and Russian) Jews who settled in the north of Europe were persecuted, confined to ghettos, and reduced to

miserable poverty, the Sephardim in Italy were more readily accepted by Gentiles, and could become quite prosperous.

Amedeo Modigliani never encountered any anti-Semitism until he went to Paris. Even in Paris he was thought typically Italian (which is one reason he took pains to identify himself as a Jew), while such artist friends as Chagall, Soutine, Michel Kikoine, Pincus Kremegne, Jacques Lipchitz, and Moïse Kisling were always considered Jews and never Russians, Lithuanians, or Poles.

So the Modiglianis flourished in Italy and became rich. However, in the papal state of Rome in the nineteenth century there were still restrictions on Jews. One restriction forbade them to own land. According to a somewhat vague legend in the family, who, after their wealth was gone, liked to recall their better days, a Modigliani who lived in Rome— perhaps a banker—found himself in a position to lend money to a cardinal in the Vatican. This emboldened him to defy the long-standing papal edict and invest in a vineyard. When the Church authorities heard of it, they ordered the brash Modigliani to dispose of the vineyard at once. He seems to have complied, and then, furious, decamped for the greater freedom of Leghorn.

Something like this may well have happened, but there could have been other reasons for the flight to Leghorn. In 1848, when Italian patriots of the Risorgimento led by Mazzini and Garibaldi established a democratic republic in Rome, the Modiglianis, along with other Jews, strongly supported them. The republic was quickly overthrown by the Zouaves sent by Napoleon to help Pope Pius IX, and the majority of Jewish republicans followed Garibaldi's troops in retreat to the northeast.

The Modiglianis arrived in Leghorn late in 1849. Ever since Ferdinand I, Duke of Tuscany, had declared Leghorn a free port in 1590 and invited religious and political refugees to settle there, Leghorn had been a promised land. The Jewish community prospered; in time they made up one quarter of Leghorn's population and built a beautiful baroque synagogue, second in size only to Amsterdam's. Cynics liked to say that it was safer to knock down the grand duke himself than to strike a Jew.

Just what the business holdings of the Modiglianis were remains unknown. They may have owned silver or zinc mines in Sardinia, or held shares in them, as well as forests in northern Italy used for making charcoal; and they seem to have operated a coal and wood business in Leghorn. The fact that Flaminio spent more time in Sardinia than in Leghorn suggests they owned the mines. In any case, the loss of their fortune was not sudden; it had been diminishing slowly until, around 1884, it failed completely, owing to the depletion of forests and mines, the world market, or to bad management by the family.

Because his mother's family, the Garsins, had once been international

bankers and the Modiglianis had boasted of being "bankers to the Pope," Amedeo, when he lived in Paris, enjoyed speaking grandly of his background. And so the legend grew that he had a rich banker father who was outraged when Amedeo became a painter. Another reason for this distorted legend is the confusion between the Italian words *banca*, bank, and *banco*, agency.[4] But Amedeo never deceived himself. In applying for admission to the Institute of Fine Arts in Venice in 1903, he listed his father's occupation as *commerciante*, a merchant or dealer. Flaminio, after the failure of 1884, seems to have run a small agency and been a commission agent for coal, wool, or hides.

Flaminio Modigliani met his future bride, Eugenia Garsin, in 1870, when she was fifteen years old, in her family's home in Marseille, where they ran a business that had branches in London and Tunis. The Garsins had once lived in Leghorn, but had moved on before the Modiglianis arrived. Eugenia saw Italy for the first time when she went to Leghorn to be married, probably early in 1872. The marriage was no doubt arranged by the two old and honorable Jewish families, who knew each other through a business relationship.

Whatever Eugenia's thoughts of Flaminio, she was expected, like any other well-bred girl of her class and time, to follow her family's wishes. Fifteen was a proper age for marriage, and Flaminio's thirty years were no barrier: he was of suitable family, with a similar Italian-Jewish background. A two-year engagement was in line with custom.

Eugenia traced the Garsin family back to Tunisia where, in the eighteenth century, a Garsin was renowned for his school of Talmudic studies. Their name, according to the family, came from the Hebrew "gars," an abbreviation of "gerai Sinai," dweller of Sinai, though it was more likely derived from the common name Gershom.[5] Some Garsins emigrated to Leghorn, where Amedeo's great-grandfather, Giuseppe, was born to Solomon and Regina Spinoza Garsin on February 6, 1793. On the basis of the Spinoza in her name, Amedeo later liked to boast of his direct relationship to Baruch Spinoza, the great Dutch philosopher who was excommunicated from the Jewish community in 1656. Spinoza had no children, though Regina was possibly a collateral descendant; but the relationship was tenuous, except to Amedeo.

Regina Spinoza Garsin, who seems to have been a philosophical woman, was left a widow with seven children whom she educated to support themselves. Obviously a capable, no-nonsense mother, she "allowed herself the luxury of kissing her children only after they were asleep." [6] Regina's moral discipline was felt through several generations until, perhaps fortunately, it was relaxed with the spoiled and precocious Amedeo. Giuseppe profited from his mother's training, moving to Marseille in 1835 to operate a successful business and establish his family in a four-

story house at 21 Rue Bonaparte, where four generations of Garsins were to live. Eugenia remembered that her grandfather Giuseppe dominated family life. He was a cultivated man, "devoted to philosophical discussion," who guided his little community to a "liberal and unaffected Judaism." Eugenia, daughter of Isaac and another Regina Garsin, had an English Protestant governess, then went to a French Catholic school. From eight in the morning till six in the evening, she was a student in a worldly Catholic, French institution. Back home she was Italian, Jewish, serious-minded, the daughter of a patriarchal household. It is hardly remarkable that she felt a stranger in both worlds.

The cultivated and adventurous Garsins had financial ups and downs. They did not care for money as such, although they showed, Eugenia said, "an amused admiration for financial transactions," and looked on dealings on the stock exchange "as an intellectual game like chess or philosophical speculations." Eugenia recalled that the family was shame-faced about mentioning money. She was never forbidden a dress or a hat because it cost too much, but only for vague and unanswerable reasons: she was too young; her father did not want her to become used to luxury; it was too showy. In another generation, the Modiglianis too, like Thomas Mann's Buddenbrooks family, gained in aesthetic sensibility and morbidness as they lost their skill in business.[7]

By the time Giuseppe Garsin died in 1883, aged ninety and blind for thirty years, the Garsins were penniless again.

As a young bride and matron in Leghorn, Eugenia Garsin Modigliani was impressionable enough to be overwhelmed by the Modigliani wealth, perhaps especially so since her own family's fortunes were declining. But she had an independent spirit, and came to resent the domination of her husband's family. If she found them "uncultivated, overbearing and authoritarian," she must also have been overawed by these "Jews of the strictest observance." The Garsins were liberal and unorthodox, remembering perhaps that their forebear Spinoza had been excommunicated by his own people. The religious differences must have seemed trivial to her at first. Although the Modiglianis obeyed all the rites and laws of their faith, they did not have a regular pew in Leghorn's Tempio Israelitico (a mixture of orthodoxy and modernism, where women sat separate from men in an upper gallery, yet organ music was played) and they attended the synagogue only on holy days. The young husband must have loved his wife. Although he believed, as he had been taught, in the Modigliani code of "social conformity . . . obligatory calls at fixed hours and the complete submission of the women of the family to their husbands, their parents-in-law and the prescribed rules of etiquette," he was confirmed in his ". . . passionate exaltation of the Garsin family virtues."

Eugenia was expected to conform; she was never to raise her voice against authority, and she was supposed to spend sparingly. Since the Modiglianis checked all her accounts, she spent less and less. She also kept her thoughts to herself. Her husband, Flaminio, who always remained an obscure and ineffectual figure, seems to have accepted this state of affairs. Most of the time he was away from Leghorn on business trips, in any case.

With her own family, Eugenia maintained close ties. When Emanuele was born on October 21, 1872, her mother made the long trip to Leghorn to look at her grandson. The old woman was suffering from tuberculosis —as her grandson Amedeo was to suffer later—and went home to Marseille to die shortly afterward. In 1874, the year Margherita was born, Eugenia's father, Isaac, came to live with her; and her unmarried sisters, Laura and Gabriella, who were often to come and go between Leghorn and Marseille, soon joined him.

Isaac Garsin was a brilliant man, well read particularly in history and philosophy. He spoke Italian, French, Spanish, and Greek fluently, and had some English and Arabic. Fond of chess, conversation, and debate, he left business affairs to his father and his clerks, spent a few hours at the stock exchange each morning, then carried on at his club, the Phocéen. But when the London and Tunis branches of the Garsin firm failed in 1873, Isaac suffered a severe nervous breakdown. Unable to get along with his family or business associates, he became such a problem that he had to be sent away, and the family sent him to Eugenia, though she was pregnant with Margherita. Now she was saddled with a bitter, angry old man unhinged by a persecution complex. Later her sister Laura had the same affliction, and in time so did Margherita. Years later in Paris, Amedeo also was tormented by it. His friends have told of his aggressive outbursts, violent and bitter displays of emotion that even his addiction to drink and drugs does not explain.[8] But he then had tuberculosis, and victims of that disease also display mental symptoms of paranoia. They can be morose, bitter, argumentative, and spiteful by turns.

Isaac spent several months with Eugenia and her daughter in the country, where he imagined "that even the gardeners were persecuting him." But he improved enough to resume some business activities and soon went back to Marseille and then on to Tripoli as director of a bank, taking his young daughter Clementine with him. But in 1886, after Clementine's death, he was to return to Leghorn to spend the rest of his life with the Modiglianis and to become the companion of his youngest grandson, Amedeo.

The state of the Modigliani family could hardly have been worse when Amedeo was born, July 12, 1884. The business crash that

struck Italy that year had wiped out their diminishing fortune completely. The family was bankrupt and was being dispossessed of their home. The bailiff had given the usual notice and was taking over. Furniture, pots and pans, clothes, jewelry—everything had to be relinquished to the authorities. It is easy to imagine the distress of the proud head of the family and his relatives, the numb shock of Flaminio, ruined just at the birth of his fourth child, and the bewilderment of twelve-year-old Emanuele, ten-year-old Margherita, and six-year-old Umberto.

Suffering amid the tears, outcries, and confusion, Eugenia could do little. But the family did make the most of an old and unusual provision in Italian law which stipulated that, while officers could impound whatever they chose, they could not touch a bed in which a woman had given or was about to give birth. The family thwarted the bailiff as much as they could by heaping all their most precious possessions on her bed.

And so began one of those sturdy family stories, to be repeated with embellishments over the years. As Eugenia was later to tell it to her granddaughter Jeanne, the money was gone, the furniture was being taken over, and at the moment the bailiff stepped into the house, her labor pains began. To Eugenia the incident was always a bad omen. Little Amedeo, whose name meant "beloved of God," had certainly begun life at a disadvantage. If he was sickly and not too strong later on, it was no surprise to Eugenia.

Amedeo was to be the object of much of his mother's and his family's solicitude. The first mention of him in the family record appears in 1886 when Eugenia began to keep a diary. She wrote that "Dedo" (pronounced Day-dough) was "a little spoiled, a little moody, but *joli comme un cœur*," a good description of Amedeo as a baby and for many years to come.

Shortly after his bankruptcy, Flaminio moved his family from the big house on the Via Roma to a smaller one on the quiet Via delle Ville. The Modiglianis always hoped to recoup their fortunes, but they never did. Flaminio was to be away from home constantly, perhaps on useless trips to the silver or zinc mines of Sardinia or the forests of northern Italy, or more probably on travels related to his occupation as a small business agent. Forty-four years old when he lost his money, and no doubt stunned by the turn of events that had reduced the wealthy Modiglianis to the status of poor struggling Jews, he seems to have lacked the temperament or fortitude to begin again. He was a weak, confused, well-meaning man, inept in business, an absent father without influence in the family, and an unsatisfactory husband. Flaminio refuses to emerge from the record. He remains a mysterious and undefined figure. His considerable family, including his formidable father and other relatives, also

vanish from the story at this point. Although they remained in Leghorn and certainly ran into Eugenia from time to time, there is no further mention of them either in the published extracts from family history or in the diary, nor does Modigliani himself ever seem to have referred to his father's family. The break, while tacit, appears to have been complete.

But the strong-minded Eugenia, whose rebelliousness and independence had already been presaged by the near contempt she felt for the Modiglianis, did not give up. In 1886 she found herself with a household of ten people to look after. Grandfather Isaac had returned to stay; Eugenia was still living with her husband, although he was usually away on business; there were her four children, her maternal grandmother, known as Signora "Nonnina," and her two sisters Gabriella and Laura.

Money was short, and Flaminio was not bringing in enough to run such a large household and feed, clothe and educate four children. Eugenia would have to earn money herself—something unheard of in Leghorn society. It meant flouting the Modigliani family and humiliating her ineffectual husband, but there was no other course. She was encouraged in her plans by several Leghorn friends, including Father Bettini, a priest whom she had met on holiday in the country.[9] Eugenia's self-assertion and her independence must have been rankling to the Modiglianis; that she was encouraged by a Roman Catholic priest must have been bitter indeed. Flaminio no doubt protested, but gave in to concentrate on his own business in the hope of putting a stop to Eugenia's nonsense. But Eugenia had tasted freedom, and Flaminio was never to earn enough to support the family. So began the widening division between husband and wife.

Eugenia, with the help of her sister Laura, started a school in the house on the Via delle Ville. At first they probably gave English and French lessons to the young ladies of Leghorn; it may have been a sort of finishing school. But it seems to have grown. There is an old family snapshot showing a group of fifteen youngsters from five to sixteen years of age taking part in theatricals marking "the end of the 1897 school year in the Modigliani school"—which indicates that Eugenia's project had become a fairly large private day school and that subjects other than French and English were taught. (See photograph, following page 192.)

With the three older children in school, Eugenia could give most of her time to teaching. Gabriella's job was to keep house. She "spoiled the grandchildren," and little Dedo, so heartbreakingly beautiful, was supposedly her favorite. But it was Grandfather Isaac who spent all his time with Dedo. Hand in hand, they strolled the streets of Leghorn and along the waterfront. Their intimate relationship was to continue until the old man's death. And Dedo, so much younger than his brothers and not

drawn to his sister, seems to have spent the time when other boys of his age were roughhousing and playing games walking and talking with his grandfather.

Isaac discussed art and philosophy with his grandson, giving him all the benefit of his knowledge and experience. Emanuele and Umberto, restless and boyish, were bored and disgusted with such talk. They liked ships and sailors, guns and soldiers, all the vital things of a boy's world; but Dedo, Emanuele recalled,[10] "was furiously bored by anything to do with action, which he considered silly and a waste of time." Instead, he was exposed to the ideas and the ideals of the Garsin family heroes: Spinoza, of course, with emphasis on the cultural tradition of the Spanish Jews rather than on religious pride; Uriel da Costa (1590–1647), the Jewish rationalist, born a Catholic, converted to Judaism, three times excommunicated for criticizing the faith, publicly humiliated and, finally, a suicide for his beliefs; Moses Mendelssohn (1729–1786), German Jewish philosopher and grandfather of the composer, and a leader of the movement for cultural assimilation. To the Garsins, Amsterdam was the headquarters of freedom of thought, and they spoke of it with great emotion.

The Leghorn that Amedeo knew in his childhood was not an artistic desert. There was a handsome *duomo*, or cathedral, as well as many churches and monuments, and a local museum and privately owned gallery in which old Isaac and his grandson could see paintings by Ghirlandaio, Titian, Caravaggio, and Murillo, and works of Dürer, as well as of two famous nineteenth century artists, Giovanni Fattori and Vittorio Corco, who were natives of Leghorn. Fattori was considered the city's greatest artist, and later was honored by having his work displayed in a special museum there. Modigliani was to know and work with him for a short time.

Modigliani loved the city, knew it well, and in his last years spoke longingly of returning to his beloved Livorno to live. He even wrote a poem that began:

> titter and chitter of swallows
> over the Mediterranean
> O Leghorn!

It was a large city that, although it had long been the refuge of the destitute of all nations and had an international flavor, was unspoiled by tourists. Baedeker stated flatly that "Leghorn contains little to detain the traveler," but an Englishman who visited and wrote of it in 1899 [11] found it a quaint, picturesque city of the "real" Italy, the only modern influence being confined to obscure quarters of the town where merchant seamen drank bad rum, disgraced their flag, and otherwise outraged the

native Tuscan courtesy. The Livornesi were cheerful and polite, and loved to make foreigners welcome to their *"Cara Livorno."* Of course no city had less *sang pur* than Leghorn: the city directory listed German, English, Scotch, Swiss, Greek, Arabic, and Armenian names; and in addition to its huge synagogue and many Catholic churches there were an English church, a Scottish free kirk, an Italian Ebenezer, and a Dutch church.

In the woefully neglected English cemetery, surrounded by stately cypresses and overgrown with myrtle, yew, roses, and ivy, there were headstones bearing such good English and Scottish names as Lockhart, Murray, Ross, Lubbock, Kempthorne—and Tobias George Smollett, who had written *Humphry Clinker* in nearby Antignano. In the Villa Valsovano, Shelley had written most of *The Cenci* in 1819 in a picturesque arbor formed by the trained branches of a stout elm.

Among the throngs of people in the narrow, cobbled, arcaded streets one could see *carabinieri* in old-fashioned Napoleonic hats, cloaks worn loosely over their shoulders, high-necked tunics with bright buttons, swords swinging at their sides; Capuchin lay brothers with skullcaps, great beards, and voluminous habits; Sisters of Mercy in big broad-brimmed hats and white wimples; blind beggars in tattered clothes.

On the waterfront was Giuseppe Bandini's famous statue of Ferdinand I, father of the city, a splendid figure in white marble gazing moodily over the sea from which he had once swept the Barbary pirates. At his feet were four huge Moors in chains, cast in green bronze, superbly alive, magnificent. The Moors were the masterpiece of Pier Jacopo Tacca, who was said to have used actual Moorish galley slaves as his models.

The port of Tuscany, linked to Pisa by the placid Canale dei Navecelli plied by small boats carrying coal, marble, and farm produce, Leghorn had a vast harbor formed by a fine new mole that protected the entrance to the old port. Along the curved mole a few men slumped with fishlines in the water; from its end one could see the islands of Elba, Capraia, Gorgona, Montecristo, immortalized by Alexandre Dumas, and Giglia; and far out, Corsica lay like a huge polished amethyst.

Along the waterfront old sailing ships stood at anchor, a naval cruiser belched smoke, derricks loaded steamships, small fishing craft put in or out to sea. The salt air was brisk and clean, the promenade inviting. Neat flower beds flanked the sea wall, shimmering explosions of colors framed by masses of evergreen shrubs. In the background stood tamarisks thirty feet high, their white and pink flowers nodding on wandlike branches; stone pines, slender oleanders bearing red flowers and dark green leaves, undulating spiny-leaved sloes with big splashy spikes of blossoms, orange, white, and green.

Winter afternoons were warm, spring days cool, and during the sea-

bathing season from June 24 to August 31, prosperous Florentine families came to enjoy the tonic of the sea air and the cool *maestrale*. The drive along the shore to the suburb of Ardenza swarmed with the carriages of aristocratic visitors and rich residents.

Leghorn, lying on the sea among its hills—the villa-studded Monte Nero to the south, the Pisan hills to the east, and to the north the marble mountains of Carrara and the snowcapped peaks of the Pistoiese Apennines—had much to detain the traveler. Here Eugenia Modigliani struggled against poverty to support her stormy, capricious family and young Dedo, so prone to sickness, so bright and intelligent, so angelically beautiful, and already so irresistible to women.

~~~ Chapter Two

*"The child's character is still so unformed that I
cannot say what I think of it. He behaves like
a spoiled child, but he does not lack intelligence.
. . . Perhaps an artist?"*

The death of his old grandfather, who had been mentor and com-
panion to Dedo, was undoubtedly a saddening experience and
helped turn the boy in on himself more than he already was. This
seems to have occurred in 1894 when Dedo was ten. Eugenia was just get-
ting by with her school, making sacrifices to educate Emanuele and Um-
berto, both at the University of Pisa and rarely at home. The break with
her husband's family was apparently complete and permanent, though
whether Flaminio and Eugenia still lived together or were separated, as
they surely were a few years later, is not known. What is known is that
Flaminio had little influence on his family and that Dedo found it in-
creasingly difficult to give him even the minimum respect due an Italian
father. At the age of twelve, ". . . Dedo already showed a precocious im-
agination and an impatience at family restrictions, above all of his fa-
ther's authority, to such a point indeed that Rodolfo Mondolfi once had
to take him to task for it." [1]
Now the household knew long gloomy periods, broken and brightened
periodically by visits from Amedeo Garsin, Eugenia's best-loved brother,
after whom Dedo had been named. Small, slim, bearded, and mustached,
a cheerful, lively man, the good uncle would arrive unexpectedly, full of
fun, surprises, and gifts. His arrival would cast a glow over the house, for
he was, from all the evidence, a man who brought a special warmth to
each member of the family. Even his departure "left behind a breeze of
fantasy, generosity, and warm enthusiasm." [2] He had a mysterious side,
too, with a reputation as a plunger, a gambler who loved to take wild
chances in business and who had made and lost thousands and thousands
in his time.

He encouraged, indulged, and entertained Eugenia's children. He took them on unforgettable outings. He approved of Eugenia's school and told her to keep on resisting her husband's family if that was what she had to do. And if she needed money or help with the children, she could count on him.

He was an antidote to discouragement and the genteel drab life, made even more unbearable by Margherita, now twenty-one, who seemed never to have been young at all. She was a difficult, argumentative young woman. She helped her mother at home and with her little school, but she badgered Dedo, of whom she seems to have been morbidly jealous. Probably no one ever said so, but, no more than Aunt Gabriella or Aunt Laura, it was assumed that Margherita would never marry.

Another antidote to the inevitable quarrels and bitter arguments so frequent in a house full of strong-willed women, three of whom were spinsters, was Rodolfo Mondolfi, a teacher at the *ginnasio* where Dedo was a student. He was a warm and understanding friend of Eugenia, and often visited the house evenings and helped Dedo with his Latin. One of his sons, Uberto, although seven years older, was Dedo's first good friend. The two families were always close, and Eugenia affectionately called Uberto her "extra" child. Uberto's friendship must have been good for Dedo, who was shy and withdrawn and without male companionship in his female-dominated home. And he was ever more Garsin than Modigliani.

But Dedo and quarrels and the daily worries were suddenly forgotten. The worst of the many crises Eugenia Modigliani had yet faced was in the making. For a while there was no time for Dedo or his pleadings to be allowed to study art.

Emanuele, who was a very mature twenty-three when Dedo was ten, had finished his military service in the construction corps, had taken his degree in law at the University of Pisa, and had been elected a *consigliere*, a councilman, of Leghorn. The family was proud of him but not surprised, for he had always been a brilliant and serious student. He had been a strong monarchist when he entered the university, but he became a Socialist and was deep in the politics of the movement.

On May 4, 1898, he was arrested and jailed for his political activities.

Though Umberto, Eugenia's second son, was dependable, and working hard for his degree in engineering at the University of Pisa, Emanuele was the man of the family and had a high standing in the community as a member of the forty-member town council that elected the *assessori*, the board of aldermen.

Eugenia knew that Emanuele had been attending secret meetings of the Socialist Party that had been founded on May 10, 1894, in Leghorn. She knew, too, that the situation had been tense since the government had raised the price of bread. Riots had followed. A state of siege, compa-

rable to our martial law, had been declared, and the police had begun to arrest everyone suspected of having anything to do with the demonstrations.

Because Tuscany was under martial law and because Emanuele was charged with political crimes, his case came under the jurisdiction of the military tribunal. Three charges were presented against him before it in Florence,[3] and the tribunal found him guilty. On the first two counts, offenses against the public security laws, he was sentenced to six months in jail and ordered to pay a 600-lire fine, besides 150 lire in costs. On the third and most serious charge—instigating rebellion—he was sentenced to another two years in jail.

Emanuele's imprisonment marked the parting of the ways between the Modigliani and the Garsin families. Although there is slight evidence to go on, there is no doubt that at this point Flaminio fades out of the picture. One has the impression that thereafter he lived alone, saw his wife and family only occasionally, and was granted the respect due him out of custom.

No further mention of Flaminio can be found until Amedeo, at the end of a post card to his mother from Paris, dated November 9, 1915, wrote: ". . . Give my love to my father when you write to him. . . ."

The last mention of him is in a short biography of Amedeo written by Margherita and given to the painter's good friend Dr. Paul Alexandre. Margherita says that the Modiglianis came from long-lived, robust stock, and adds, "Father was eighty-four in 1924 and in good health." [4] This was four years after Modigliani's death in Paris.

Emanuele's arrest and indictment were a setback to the new Socialist movement and a warning to subversives. To Emanuele and his family his jail sentence was long and demeaning. But it could be endured. The 750-lire fine, about $150, was another thing: it was a stiff penalty, and difficult for Eugenia to raise. Her husband's family could not be counted on for even a token sum, not with the disgrace of having a Modigliani a jailed criminal. Her own savings were meager, and she worried about the effect of the scandal on her school. Would parents withdraw their sons and daughters? It seemed likely.

There is no proof that Eugenia turned to her brother, but the heavy fine seems to have been paid, and it is logical to assume that Amedeo Garsin paid most of it. His help with money is also evident in the entry in Eugenia's diary for July 17, only three days after Emanuele's conviction. She wrote that Dedo had not done well in his examinations, but she was not much surprised because he hadn't studied hard all year. Then:

At the beginning of August he starts drawing lessons, which he has wanted to do for some time. He already sees himself as a painter; I do

not want to give him too much encouragement for fear that he will neglect his studies to pursue a shadow. All the same I wanted to do what he asked, to get him out of this state of apathy and sadness in which we all, more or less, are drifting at the moment.

Here again it seems unlikely that Dedo, under the circumstances, would be given the lessons he craved unless there was money at hand. And who else but Amedeo Garsin would cheer the dispirited family and advise his sister to let Dedo have his art lessons?

The shock and scandal surrounding Emanuele's arrest, trial, and imprisonment hit his immediate family hard. But Dedo was proud of his brother, thrilled at his exploits, and regarded him as a martyr to the cause. Emanuele's experience was bound to appeal to Dedo's "precocious imagination," his romantic and poetic nature. The Socialist struggle for more freedom for the people, the vindictive tyranny of the government, his brother's secret meetings, the riots and shooting, the arrest and trial —it was an exciting business, straight out of Gabriele D'Annunzio or Alessandro Manzoni's stirring novel *I Promessi Sposi, The Betrothed,* which Italians esteemed "as second only to the *Divine Comedy* as an expression of their national character." [5]

Mamma Modigliani was brave as always. Margherita was good only for tears and hysteria and shame. Let her hide if she was too ashamed to venture out on the street! Dedo wasn't ashamed. Let people stare at him. Let the boys at school crowd around and ask questions. Who else had a brother languishing in jail for the noble cause of freedom? Who else had a hero for a brother?

But on the nonromantic side, Dedo shared his brother's socialistic ideas and later wrote sociological articles with his Aunt Laura. He always "inclined towards a tragic view of both the social and emotional condition of humanity." [6] Very early, as an art-school student in Leghorn and as later on in Paris, Dedo sketched or painted beggars, longshoremen, prostitutes, and the down-and-out, by choice. Jeanne Modigliani says that Renato Natali, one of his fellow students at Micheli's, remembers that "Dedo's favorite haunts were the dubious alleys and the canals of the old part of Leghorn known as "Little Venice. . . ." There can be no doubt that, born and brought up in difficult circumstances, Modigliani's sympathies were always with the poor and unfortunate. Emanuele's arrest could only have been a great and confirming shock.

In what a tumult of excitement the fourteen-year-old Dedo must have been as he walked into Guglielmo Micheli's big ground-floor studio in the Villa Baciocchi on a side street of Leghorn. It is altogether likely that Mamma Modigliani accompanied her son and that while she talked to

the teacher, who undoubtedly made the usual allowances for a mother's proud exaggerations, he had a chance to study the sturdy dark-haired boy with the extraordinarily handsome face. And Dedo must have been oblivious of everyone as he looked around the room cluttered with easels, three-legged stools, rows of tables covered with a litter of paint tubes, brushes, pencils, bits of chalk and charcoal, bottles and jars, rags and scraps of paper.

Then Dedo saw the model's stand, set on a small dais at the front of the room, facing the easels. On it was a table with a still life of three apples, two oranges, a peach, a candlestick, and an empty Chianti bottle in a neat geometrical arrangement.

This was what he had longed for; this was what he wanted to do; above all, this was where he wanted to be.

Dedo did not attend art school long. In that same August of 1898, Aunt Laura returned to Leghorn from Marseille. Three days after her arrival Dedo was taken seriously ill. Perhaps he was run down, perhaps he had a summer cold, perhaps he threw himself too intensely into his art studies, or perhaps he was just susceptible. An infectious disease, typhoid was also a deadly one in 1898. The signs were unmistakable: nosebleed, aching, fever, prostration, then the rose spots. The hospital, probably one run by Sisters of Mercy, was the only place for such a sick boy. And now there occurred that famous miracle of family tradition, which was later to be magnified, distorted, and romanticized by biographers. Raving with fever and delirium, the young boy, who had never thought seriously of being an artist, began to speak of paintings in the Pitti and Uffizi galleries in Florence. Dedo, who had never been to Florence, identified the paintings in both museums by subject and master. Incredible!

He mumbled of annunciations, Angel Gabriels, crucifixions, and Madonnas. He begged that he be taken to Florence on the train before it was too late. Or so went the stories that told of this "miracle." For so they had to be when he identified the pictures and the painters without ever having visited the Pitti or Uffizi.

Dedo hovered ". . . between life and death for weeks, and was delirious for a month. During his delirium Dedo expressed a desire to be a painter. He had never spoken before of what must have been only a dream. He could not have thought such a career possible for him. But his character was very formed and strong . . ." Margherita wrote later.[7]

The explanation could easily be a simple one. Like other little boys Dedo did not go home directly after school was out. Lingering in the street, he found a little art-supply shop off the Piazza Vittorio Emanuele. He admired some reproductions of old masters on the counter. They fascinated him. Dedo took to stopping by the art shop on the way home from school. He pored over the reproductions, absorbed their details,

noted who had painted them and the fact that they were now hanging in the Pitti or Uffizi. Later on, he was to pin reproductions of his favorite old masters on the walls of the studios he occupied one after the other. Very probably his first glimpse of classical and Renaissance art occurred in this little art shop in Leghorn. He saw the reproductions every day; he may even have bought some without Mamma Modigliani being aware of it. And when the miracle occurred, when the nuns, the doctors, or his mother heard him mumbling of paintings he had never seen, who can say that he wasn't merely recalling the series of paintings that had become indelibly stamped in his memory by studying the art-store reproductions?

As it was, he barely escaped death. The miracle of picture identification supposedly occurred at the crisis in his illness. After that, he was out of danger.

It was a long illness, and his recuperation took even longer. As further proof that he began his art studies *before* his illness, Jeanne Modigliani cites a remark of Gina Micheli, Professor Micheli's daughter, "Modigliani had had typhoid and, as he came into the sitting room, Mamma Micheli, the master's wife, went forward to greet him and stroked his cropped hair saying, 'How well your head turned out, Amedeo!' " [8]

Meanwhile various changes had taken place within the family. After having been in jail eight months, Emanuele was released. An uneasy government had generously granted amnesty to political prisoners, but there was no doubt that all Socialists would be kept under surveillance. Still a member of the town council, Emanuele became a local celebrity, and had considerable backing. A ponderous man, he now wore glasses, a bushy beard and mustache, as he did for the rest of his active political life.

He came home, was welcomed by his family, and his release was no doubt celebrated by neighbors and friends. He was a changed man, more than ever devoted to the Socialist Party. Dedo must have admired him greatly. But to Emanuele, a practical man who knew how much he owed to the sacrifices of his mother, Dedo's art lessons must have seemed a foolish waste of time and money. Much better that the boy follow his brothers' example and take up a remunerative career, such as the law or engineering, in which he could support himself and his family. But Dedo was still young and hard to take seriously. Besides, Emanuele himself was in a rather vulnerable position to give advice.

Eugenia had long broken with the old-fashioned ways of the Modiglianis, and Emanuele's experience had only strengthened her liberal outlook. Her school was apparently still operating but on a reduced scale: she and Margherita gave French and English lessons. Laura now taught only sporadically, spending most of her time writing articles on philoso-

phy and sociology. Eugenia had had some success with writing herself. She had sold a short story to a publisher and done some translations of D'Annunzio's poetry. She had considered writing a novel to amuse herself, but had put it aside for something more practical. It was probably a publisher in Florence who introduced her to the American who used her as a ghost writer and "for whom over the years she composed a series of studies on Italian literature." [9]

On the basis of the indefatigable Eugenia's essays, this American was able to achieve a respectable university career in the United States. Jeanne Modigliani knew him as a child and remembers his devoted admiration for her grandmother. Her grandmother considered her association with Mr. K. as one of the most comic experiences of her life. On one occasion Eugenia served the man artichokes, a vegetable he knew nothing about. Watching him eat them, sharp leaves and all, Eugenia considered herself suitably avenged for all the nonsense she had taken from him, and thereafter allowed herself to be exploited good-naturedly.

Her diary entry of April 10, 1899, contained her only mention of the typhoid, saying just that Dedo's illness and recovery had left too strong a mark on the family's memory for her to go into details. Under the same date she went on to give an account of her son's progress in art school. Dedo's dedication to art was so marked and so real that, in the beginning where he had probably spent several hours a day or even a week with Professor Micheli, his mother was now permitting him to attend art classes every day instead of continuing with his regular high school course. It was an unusual indulgence on the part of a cultured woman eager to see her sons well educated, but then Dedo was an unusual boy— dogged, insistent, and persistent, particularly when he liked what he was doing. And how devoted he was to art!

> Dedo has completely given up his studies and does nothing but paint, but he does it all day and every day with an unflagging ardor that amazes and enchants me. If he does not succeed in this way, there is nothing more to be done. His teacher is very pleased with him, and although I know nothing about it, it seems that for someone who has studied for only three or four months he does not paint too badly and draws very well indeed.

While there would seem to be some inconsistency in Eugenia's writing that he had only been studying art for three or four months, it simply means that either Dedo's convalescence was a long one or that he had been attending Micheli's school full time only for the last three or four months. But the extraordinary thing is the way Emanuele's ordeal had changed Mamma Modigliani's way of thinking. She was letting matters arrange themselves. Emanuele was in politics, Umberto was studying en-

gineering at the University of Liège in Belgium, and now she was letting Dedo have his head as well. As for her school, it did not bother Eugenia that her sister Laura was pursuing her scholarly interests, yet contributing nothing to the family support by teaching.

This each-his-own-way approach eliminated the bickering that had rent the family in the past. Eugenia had taken over the reins of the family completely, and the liberal Garsin philosophy had routed what remained of the conservative and conforming Modigliani influences.

Though Dedo had given up high school for art, he was an omnivorous reader; and because his mother was too busy to discuss books with him, he turned to his Aunt Laura, who, though unstable, had a brilliant mind. She was very close to her nephew, and together they read D'Annunzio, Friedrich Nietzsche, and Henri Bergson. In addition, Aunt Laura introduced him to the work of Peter Kropotkin, the Russian anarchist—his *Memoirs of a Revolutionary* and his treatises *Bread* and *The Unwed Mother*.

Dedo steeped himself in poetry. Often alone, he spent his free hours reading and dreaming when he wasn't drawing and painting; he had no friends at the house except for the much older Uberto Mondolfi. Toys never seemed to have appealed to him, nor did he have the usual brattish, bouncy childhood. Living among adults, full of the ideas he had learned from his Grandfather Isaac as a toddler, he preferred books, talk, and adult pursuits. Dedo seemed so naturally inclined in this direction that his mother and his aunts could not help being impressed. It probably never occurred to any of them that he had missed having a childhood. It was this very difference from boys of his own age that Eugenia prized in him. It convinced her that he ought to devote himself to art, as he yearned to do, rather than complete his classical education as had her other two sons.

Further, his long period of illness and convalescence encouraged Dedo to read and to dream. There were Shelley, who had lived in Leghorn; the passionate and disturbing D'Annunzio; and Dante, his favorite and the favorite of all Italians—Dante and his love and passion for the incomparable Beatrice in *La Vita Nuova*. There were also Petrarch singing of his inspiration and devotion to the divine Laura; Giacomo Leopardi, who had lived such an unhappy, cloistered life; and Giosuè Carducci, still Italy's greatest living poet, evoking his ethereal Maria *bionda*, the sweetheart of his young days. He read and reread Ariosto, who wrote so movingly of love and chased the amazing Angelica through his *Orlando Furioso*. Love of poetry also led Dedo to read such relative unknowns as Emanuele Romano,[10] a friend of Dante's, whose satiric verse was perhaps especially appealing to Dedo because Romano was also an Italian Jew.

Apparently at fifteen he memorized passage after passage. Effortlessly, he read, he absorbed, and the haunting verses imprinted themselves on his receptive brain. He loved the sonorous words, the delicate imagery, the fire and the passion. Their patriotism stirred him; their romantic yearnings gripped him. To have a Beatrice, a Laura, a Maria, an Angelica of his own . . .

Precocious in so many things, Dedo was also to be precocious in love. An unusually handsome boy, he would have been insensitive not to notice the effect of his good looks on the young ladies of Mamma Modigliani's school. When he met and mingled with them, when his proud Mamma showed him off or made him recite for them, he noticed how the girls blushed and became uneasy in his presence, how their eyes lingered on him and grew bright in response to his flashing smile.

Strange individuals throng the Garsin history written by Eugenia. The Garsins were not limited to merely intellectual amusements, and the history contains "certain spicy episodes," which Eugenia recorded "with an open-mindedness that is almost French."

The family history reveals nothing of Dedo's amorous exploits in Leghorn. They may have been deleted, or perhaps Eugenia, looking at them open-mindedly, thought them too unimportant to record. Legend embroiders and exaggerates, but a romantic and susceptible youth full of dreams of finding his Beatrice, so handsome that he made heads turn and was the pursued rather than the pursuer, had to be successful in love.

Dedo was a diligent pupil at the *ginnasio* in Leghorn, where he had the regular courses in classic studies, advanced for his age, probably because of all he had learned from his Grandfather Isaac. But, according to his brother Emanuele, Dedo was precocious in other ways. He continued to be *joli comme un cœur,* and "From his boyhood the girls were crazy about him." This was just the beginning.

Certain scandals concerning the young Lothario and girls of the district caused some trouble and much gossip, and there was an *affaire* with the little maid of all work who was all the family could afford in the way of a domestic.

"Such manifestations of precocious virility" were hardly regarded as scandalous in Italy as they would have been in England at the time.[11] As it was, Dedo's "peccadilloes only occasioned indulgent smiles in the family" behind his back. To his face, Mamma and Margherita must have scolded and shaken their fingers. Emanuele seems to have thought little of it. "However, talking seriously," he was ". . . inclined to think that Amedeo's amatory adventures were perhaps carried to excess in his early boyhood and may even have contributed to the consumptive trouble that

overtook him before he was out of his teens." Medically, this is an unsound diagnosis.

Dedo's early history foreshadows what he was to be for the rest of his comparatively short life: artist and lover. He had immense talent for both.

## ᦜᦜᦜ Chapter Three

*". . . Your real duty is to save your dream. . . ."*

So far as is known, Guglielmo Micheli was the only art teacher in Leghorn, and probably not only the best available locally but perhaps the best in Italy at the time. He belonged to what was known as the Macchiaioli movement, a name its founders purposely chose after critics had castigated them for depending on *macchie,* or patches of color, in the composition of their paintings. The Macchiaioli met at the Café Michelangelo in Florence during the heyday of Garibaldi and the Risorgimento. Among the best known were Fattori, Giovanni Boldini, who was to become famous as an elegant portrait painter in Paris, and Vincenzo Cabianca. They had organized in protest against the insistence of the Florentine Academy that artists turn out slick, standardized studio paintings that dealt with no contemporary subjects. They affronted academicians by painting soldiers on maneuvers, peasants in the fields, and street women. Then they turned to the favorite subjects of the French Impressionists—bucolic landscapes, scenes of farm life, and seascapes— but their approach was so muted, their colors were so subdued, and their composition was so essentially traditional that they never made so strong an impression on art as the Impressionists. But they did have the historical importance of rebelling against the romantic academicians.

A pupil of the great Fattori, Micheli was thirty-three, bearded, friendly, an excellent teacher, a competent artist, but probably no better than third-rate. He did his best for his students, introducing them to all phases of art and, outside school hours, painting indefatigably, as if sheer volume might compensate for his lack of talent. He was patient, easygoing, and had no illusions about his art, but he concealed a bitterness

against Fattori, who often visited Micheli's art school whenever he re-
turned to Leghorn.

The other art students attending Professor Micheli's school at the same
time as Modigliani in 1899 were Benvenuto Benvenuti, eighteen; Gino
Romiti, eighteen; Llewelyn Lloyd, twenty; Renato Natali, sixteen; Man-
lio Martinelli, fifteen; Oscar Ghiglia, twenty-three; Lando Bartoli, and
Aristide Sommati, the only members of the class not to follow an art ca-
reer, who were probably a few years older than Modigliani. The best tes-
timonial to Micheli is the fact that of his nine pupils at the time (includ-
ing Modigliani), seven are listed in the three-volume, 1962 edition of the
*Illustrated Dictionary of Modern and Contemporary Italian Painters,
Draftsmen, and Engravers* published in Milan. They all became compe-
tent, third-rate painters with Macchiaioli and Impressionist traits, prov-
ing they had learned their lesson from Micheli well. The only exception
is Oscar Ghiglia, who became Modigliani's best friend for a short time.
Along with Modigliani, he was the only one in the school to grow beyond
Micheli to a forceful style of his own.

Micheli took his pupils through all the fundamentals of painting, be-
ginning with charcoal drawing, simple still lifes, watercolors, painting in
all phases, the study of the figure, and drawing the model. He also
taught special techniques. Dedo executed a *carta intelaiata,* according to
Silvano Filipelli, which was "a still life with drapery behind it, using the
charred areas of partly burned paper as half-tints." [1] Perhaps Micheli
tacked this drawing on the wall as an example to the other students, be-
cause Fattori, grizzled, bent, and looking a little like Mark Twain with
his handle-bar mustaches, saw the drawing and praised it. Mamma must
have heard about this from her son. Imagine! The great Fattori praising
Dedo's work. Perhaps he *was* on the right track.

One of the students, Gino Romiti, had a studio where his friends met.
With his beard, mustache, and smock, he looks very much the artist in a
snapshot showing Benvenuti, Sommati, Bartoli, and a haughty, dignified,
and well-dressed Dedo sitting and standing around his easel. (See photo-
graph, following page 192.)

As they progressed and there was little more they could learn from
Micheli, the class walked to the country to paint landscapes and farm
scenes. Once a peasant woman took them for peddlers and wanted to buy
the combs she was certain they had in their paintboxes. Another time
they were set up to paint a bridge over the Ardenza, then had to run for
cover as a little boy attacked them, shying stones at them like an aveng-
ing David.

Good-looking, self-possessed, well mannered, gentle, and impeccably
dressed, Dedo was a little too wise for his age, something of a showoff and
braggart, but he easily held his own among his friends, almost all of

whom were older than himself. He had a reputation as a lady-killer and probably a certain glamour because of his big brother Emanuele. He praised the Pre-Raphaelites, was mad about Baudelaire, whom he had read in the original French (learned from his mother), and he quoted so enthusiastically from Nietzsche, whom he had studied with his Aunt Laura, that Professor Micheli jokingly referred to him in class as "the superman."

Dedo drew constantly. Even in this period, he preferred to roam the waterfront and the rundown, colorful sections of Leghorn in his search for subjects. That was the down-to-earth, provincial way of Macchiaioli. But his drawing was no more exceptional than his painting. Only in his nudes, according to a friend, did he show "a certain independence, giving free expression to his interest in line." [2]

At heart Dedo and his student friends were bourgeois, living respectable lives of limited decorum. For the most part they were members of families of high social standing, decent, honorable young men devoted to their country and to art. Or so they considered themselves, according to Jeanne Modigliani, who describes how all of Modigliani's Leghorn friends were convinced that Paris had ruined Dedo and that he "had been a nice young man with a future," until he made the unforgivable mistake of turning his back on Italy. It was Paris that wrecked the man, they always felt, Paris that destroyed his young artistic promise.

As long as he was in Leghorn, Dedo was of them and with them. When they painted in Romiti's studio, Fattori dropped by just as he used to at Micheli's school. They learned and they listened, and Romiti always insisted that Modigliani's clear, limpid line came from Fattori, "either indirectly through Micheli or directly from Fattori."

Dedo was friendly with his fellow art students. They visited his home, had tea there, and Eugenia came to know all of them. He was closest from the beginning to Oscar Ghiglia, who was a good eight years older but who apparently shared the same sophisticated ideas on art, Nietzsche, poetry, and women. Both had dedicated their lives to art, an art beyond Micheli and the Macchiaioli, and they felt imprisoned in Leghorn.

By this time Dedo seems to have visited Florence with his mother when she saw her publisher. Eugenia made good her promise at the time of his illness to take him to the Pitti and the Uffizi. He must have visited the museums and the galleries, going from room to room, admiring the paintings with a feeling of déja vu. They were even more beautiful than in the prized reproductions of the art shop. Now he wanted to see more —in Rome and in Venice.

Oscar Ghiglia was amused by his young, impetuous friend. Ghiglia smoked, drank, and went with women. Dedo was easily led. It wasn't right that he should go around with a friend so much older than himself.

Margherita said what she thought of the friendship. Mamma Modigliani hushed her, but she worried. In her brief biography of her brother, Margherita spoke of the bad influences on him at this time, one of them a moral one: ". . . There was an older comrade who led Modigliani into a vulgar fantasy, the practice of spiritualism." ³ A confusing, possibly misleading remark, but Margherita could have been referring to Oscar Ghiglia.

Margherita knew very well that this high-spirited, convivial group of youngsters did more than paint. She wrote that there were excursions to the country, ". . . but there were also other excursions, and *flânerie*. There were too many cigarettes; and too early an initiation from chambermaids. His brothers saw him drifting into laziness."

Dedo and Oscar discussed literature in a superior way; they were supermen, different from the others. They went out together, came back late, and Margherita no doubt swore that she smelled liquor as well as tobacco on Dedo's breath. Maybe the pair picked up a couple of dressmakers or other complaisant young women and had their fun. Or did they go to the Café Bardi or to a cheap waterfront tavern to drink Leghorn punch, that potent half-and-half mixture of coffee and rum, boiled together, and served steaming hot?

Whether Oscar Ghiglia was the bad moral influence on him, whether he and Dedo raised hell together or not, Modigliani painted and drew, read, memorized poetry, and dreamed. He also thought about his art, about his future, and about leaving Leghorn, where there was nothing further for him to study. It was no place to live—*really live*.

Now once again Modigliani was taken ill. The last two years had marked a tranquil period in his life in which, more and more, he was painting and learning on his own. But he did feel lost and uncertain. He had absorbed all that Micheli could give him, and began, as pupils will, to think little of his teacher. This was natural, if unfair, to the hardworking Micheli, who gave "the boy much more in the way of technical training that the latter was ever to acknowledge." ⁴ Dissatisfied, confused about his future, looking up to the older Ghiglia, who knew where he was going and what he wanted to do, Dedo neglected his health, kept late hours, and struggled to keep up with his friend.

Now he came down with pleurisy again, perhaps double and acute this time, and also signs, which doctors could no longer mistake, of something chronic and infinitely more serious. The accounts vary, but Margherita's seems valid enough. She wrote that in September, 1900, her brother had a violent hemorrhage followed by fever.⁵ No doubt now that Dedo had tuberculosis. Whether he was told at the time is doubtful, but he was very sick.

The doctors pronounced his case hopeless, and told Mamma Modi-

gliani to resign herself to the inevitable. But Eugenia, who had seen her favorite child through the nearly fatal typhoid attack two years earlier, "did nothing of the sort." She sent a telegram to her brother, Amedeo, who was then in Marseille and involved in the type of speculative venture he most enjoyed. Taking time off from his efforts to raise capital for founding a company to develop Madagascar, he wired back to the distracted Eugenia, "Consider your son as mine and I shall take care of your necessary expenses."

So Eugenia took her son to the south of Italy against the advice of the doctors because she feared the winds of Leghorn would be harmful to him and because "she also wanted to take him under wing so that she could supervise his conduct." She would not allow him to go by himself. He was only sixteen, had never been away from home, was still sick and weak, and in no condition to manage his affairs. Mamma didn't trust him. He was too impressionable, nor would she have let him go off by himself with Amedeo Garsin's money. The doctors probably protested that the sea air and the damp climate were the worst thing for a tubercular. If she did have the money to spend, the boy should go to the mountains where the air was thin, crisp, and dry—preferably a sanitarium in the Swiss Alps.

But Eugenia had little faith in doctors. They had predicted her son would die of typhoid, and she had proved them triumphantly wrong. She would do so again because she was an optimist. And further, although there had been cases of tuberculosis in the family before, Dedo was young. Surely rest, good nourishing food, and vigilant nursing would make him well again. It was the bad influence of his friend that was really to blame for Dedo's being sick and rundown. Away from bad company and closely supervised, he would mend quickly.

Dedo's friends called on him to say good-bye. Oscar Ghiglia was leaving Leghorn. He hoped to exhibit in competition in Venice and to study there or in Florence. He talked with Dedo about the painting he planned to submit. He wondered about painting a self-portrait. They agreed to keep in close touch, to write often, to confide in each other absolutely.

Dedo chafed to get started on his own career, to be his own master as Oscar was. Mamma reminded him that he was much younger, had been terribly sick, and that the doctors insisted that he rest and get well or he might never paint again. She hinted that there was more behind the doctor's warnings than she cared to admit, but Dedo was plainly too excited to take notice. He would play along with his mother, be a good boy, regain his health, and then he would join Oscar in Florence and get on with his own work.

Naples was their first stop. Here Modigliani showed his first active interest in sculpture. He haunted the National Museum with its big

collections of Greek and Roman sculpture; "and spent long hours contemplating the bronzes, particularly, *Silenus,* and the *Boy Taking the Thorn From His Foot,* and a Hermes, or perhaps an Isis with numerous breasts, held his attention." [6] Dedo had never seen so much sculpture displayed at once, and the medium fascinated him. Eugenia liked to visit museums and see the sights, too. She accompanied her son, marveled at the hours he spent before the exhibits, and then directed him to the city's notable churches—Santa Chiara, Santa Maria Donna Regina, San Domenico, and San Lorenzo.

From Naples, where Eugenia never left him alone for a moment, they went to Torre del Greco. It was the off-season, the big hotel was almost empty, and they had reduced rates. They were here by the sea for two months. The long, quiet, restful days were beneficial to Dedo. "He was far from evil influences—he slept in his mother's room—and he had a studio and every facility," Margherita wrote. "An old beggar often posed for him, and he painted him for his mother, but later on he destroyed the painting."

Dedo was pleasing his mamma with every action, even painting. He was a kept man, a prisoner in his mother's bedroom, always under her watchful eye. Perhaps he complained, and there was bitter argument. And now his mother probably had to tell him the truth. He had had tuberculosis; he was recovering and would soon be sound again *if he did as he was told,* but he would have to take precautions the rest of his life. Dedo listened and the lesson sank in—to a point. He felt too well, it was too beautiful, and all his friends were fulfilling themselves. He was wasting time, rotting, doing nothing when there was so much to be done.

He dressed and looked and behaved much older than his years. He grew a slight, wispy curly beard, and Margherita described him as having a rather condescending air, a cool manner, a way of talking on every subject with intelligence, and of giving the impression of a grown man. He sketched and he painted around the hotel. Margherita told of a brief exchange that he had with an English guest. Mamma must have carried the story back to Leghorn, thinking perhaps that the Englishman's smug, stuffy advice had inspired Dedo, that her son's reply was polite and grateful rather than sarcastic.

"You should paint with intuition, imagination, and concentration," said the Englishman.

And Dedo gave a nice-boy's reply.

"That is quite a program. I shall apply myself to it."

Mother and son left Torre del Greco in March for Capri. Margherita wrote: "Here he found more people and the sea air restored his health. The fever lifted and the nights were easy." Mamma Modigliani followed the doctor's regimen and kept daily check on her son's temperature. She

may have had him examined by doctors in Capri to see how he was progressing. Dedo's frustration increased and was evident in the letters [7] he wrote to Oscar Ghiglia, who had broken his word and proved a poor correspondent:

MY DEAR GHIGLIA:

. . . And this time answer me, unless your laurels are too heavy for your pen. I have just read in the *Tribune* of your being accepted in Venice: Oscar Ghiglia, Self-Portrait. I suppose that's the portrait which you discussed with me and were already thinking about in Leghorn. I congratulate you most sincerely. You can imagine how this news moved me.

I am here at Capri (delightful place in parentheses) and I'm taking a cure. . . . It's four months now since I've accomplished anything, but I am accumulating material. I'm going to Rome soon, then to Venice for the Exhibition . . . I'm doing just like the English. But the time will come when I'll undoubtedly set myself up in Florence to work, but in the full meaning of the word: that is, to dedicate myself faithfully (body and soul) to the *organization* and *development* of every impression, of every germ of an idea that I have collected in this place as if in a mystic garden.

But let's come to you: we left each other in the most critical moment of our intellectual and artistic development, and we have taken different paths. I wish I could see you now and talk with you. Don't take this letter for the usual one of congratulations, but as testimony of the sincere interest in you which I hold as your friend,

MODIGLIANI

Hotel Pagano, Capri

Dedo was bored with the island and had no desire to paint. Capri was full of tourists, especially silly amateur artists squatting all over the rocks with their equipment, grimly painting pretty pictures of the pretty scenery. He seems to have pleaded with his mother to leave for Rome, but she put him off, and they moved to the Villa Bitter, Anacapri, Isola di Capri, which was the heading on his next letter to Ghiglia, from whom he had evidently heard:

DEAR OSCAR:

Still at Capri. I would rather have waited to write to you from Rome: I'll leave in two or three days, but the need to gossip a bit with you makes me take up my pen.

I can well believe that you must have changed under the influence of Florence. Would you believe that I have changed in traveling here? Capri, whose name alone is enough to arouse a tumult of beautiful images and ancient voluptuousness in my spirit, appears to me now as

essentially a springlike place. There is—to my way of thinking—a vague feeling of sensuality which is always present in the classic beauty of the countryside. And even (in spite of the English who invade everything with their Baedeker) of some dazzling, poisonous flower bursting out of the sea.

Enough of poetry. Besides, just think that yesterday (these are the kind of things that only happen at Capri) I went off alone for a country walk in the moonlight with a Norwegian girl . . . really a very erotic type, but very lovely too. I don't know exactly when I'll be in Venice—I'll let you know beforehand. I want very much to explore this city with you. Micheli? My God, how many of them there are in Capri . . . regiments!

How is Vinzio? He had started well on his little picture. Is he progressing or dragging his feet? Answer me. That's really why I write, *to have news of you* and the others. Best regards to Vinzio. So long.

DEDO

April 1st. Write: Rome, General Delivery

Mother and son left the island shortly afterward. Excited by the news of what his friends were doing, eager to join them and get to work himself, Dedo plagued Eugenia, who was already having second thoughts about Capri. The moonlight walk with the erotic and lovely Norwegian girl could not have been the only such incident, for Margherita wrote, "But from Capri Mamma could not leave too hastily, impressed as she was by the sordid atmosphere of vice which was soon to be exposed to the public." Some island scandal may have reached the mainland newspapers later on, but Margherita was reporting before the fact to show how eager Eugenia was to protect Dedo's morals. Quite apart from Dedo's pleas, Mamma was worried about conditions at home. She hated to think of Laura and Margherita alone in the house on the Via delle Ville.

Eugenia and Dedo went to Rome for Holy Week and then came home, Margherita wrote. But there were more stops at pretty Amalfi huddled along the scalloped and indented shoreline at the foot of a great, rocky mountainside sloping down to the water, then Rome, Florence, and Venice. In each city mother and son visited the museums, galleries, and churches and, wherever he was, thrilled and excited by all he had seen, thinking it over, thinking about his art and himself as an artist, Dedo continued to write to his friend Oscar Ghiglia. These five letters, all written in 1901 when Modigliani was seventeen, "bear eloquent witness," as Jeanne Modigliani says, "to his admiration for the worst of D'Annunzio, but also to his adolescent desire to embark on the discovery of his own personality." They do indeed show the overwhelming revelation of Italian painting to this young and eager artist, the stimulation to be found

in the big cultural centers, and the sense of the barrenness of Leghorn, which Dedo was so gladly leaving behind. The letters show what he was thinking at the time, the grandiose conclusions that moved him as he spilled his soul out to the preoccupied and increasingly unreceptive Oscar Ghiglia.

With Mamma he "did" Rome. The Borghese Gallery, the Palazzo Doria, the Terme Museum, the Vatican, the Sistine Chapel, the Museo di Villa Giulia, the ancient Roman ruins, the churches, buildings, and squares with historic and artistic significance. And, since it was Holy Week and Mamma said the pageantry, the music, and the service were so beautiful, perhaps they attended Mass at St. Peter's. He tried to draw, Mama encouraged him to paint, but he was too dazed and shaken even to try to express himself this way. Oscar would understand:

DEAR FRIEND:

I write to open my heart to you and to confirm my own feelings re garding myself.

I am myself the plaything of strong forces that are born and die in me.

I would like my life to be a fertile stream flowing joyfully over the ground. From now on you are the one to whom I can say everything: well, I am rich and fruitful with ideas now and I need to *work*.

I'm terribly excited, but it's the kind of excitement that precedes happiness and is followed by a dizzy round of activity uninterrupted by thought.

Already, after writing this, I think *it is good* to be so excited. And I'll rid myself of it by plunging again into the great struggle, facing the risks, carrying on the war with a great strength and vision unknown to me until now.

But I must tell you of the new weapons with which I'll again experience the joys of battle.

A bourgeois told me today—he insulted me—that I, or rather my brain was wasting away. He did me a lot of good. We should all have such a warning every day when we get up; but they don't understand us any more than they can understand life.

But I've told you nothing of Rome. Rome which is not only outside of me, but *inside of me* as I talk. Rome which lies like a setting of terrifying jewels on its seven hills, like seven imperious ideas. Rome is the orchestration with which I surround myself, the limited area in which I isolate myself and concentrate all my thoughts. Its feverish delights, its tragic landscape, its beautiful and harmonious forms—all these things are *mine* through my thought and my work.

I cannot tell you of all the impressions I've gathered here, nor of all the truths I've found in Rome.

I am going to start a new piece of work but already, after blocking and planning it, a thousand other ideas have sprung out of my day-to-

day life. You see how important it is to have a method and apply one-self.

Besides I am trying to formulate as clearly as possible the truths of art and life that I have discovered scattered among the beauties of Rome; and as their inner meaning becomes clear to me, I will try to reveal and rearrange their composition—I might almost say their metaphysical architecture—to create my own truth on life, on beauty, and on art.

Good-bye, my friend. Tell me about yourself as I've told you about myself. Isn't that the meaning of friendship: to write as one pleases about everything and to reveal each to the other and to ourselves?

Farewell.

YOUR DEDO.

Oscar, who had apparently returned to Leghorn for some reason, continued to be a poor correspondent. Dedo, now in Florence and apparently still tied to his mother, wondered and fretted and thought the deep heady thoughts that the great art he had seen engendered in him. His next letter was both plaintive and apologetic, and full of soulful theories of art:

DEAR OSCAR:

You had promised me the diary of your life from the day we last saw each other up to now.

As for me, I have broken my promise because I can't keep a diary. Not only because no important outside event has happened in my life, but because I believe that even the inner experiences of the soul cannot be recorded so long as we are in their power.

Why write when one is still feeling the effects? These are necessary developments which we have to undergo and have no importance except for the direction in which they take us. Believe me, from now on only that work of art which has been through a complete gestation period, which has taken shape and freed itself from the shackles of all the details which created and produced it—I repeat, only this work of art is worth being expressed and interpreted by style. The effectiveness and the need of style hinges on separating the idea from the man who produced it, and leaving the way open to those who cannot and should not express themselves. In other words it is the one vocabulary capable of exteriorizing this idea. One should consider all great works of art just as one does the works of nature. First in its aesthetic reality, then outside of the development and mysteries involved in its creation, the very thing which excited and moved its creator. But then this after all is pure dogmatism.

Why don't you write to me? And what are those paintings? I read the description of one of them in an article in the *Corriere* [Courier]. I cannot yet get around to painting; I am forced to stay in a hotel

here so you can understand how impossible it is for me to dedicate myself to painting at the moment. But all the same *I am working hard* mentally and in contemplating nature. I believe I'll really have to move away from here: the barbarism of tourists and vacationers makes it impossible for me to concentrate just when I most need to. I'll end up by going to the Austrian Tyrol to escape them. Don't tell anyone at home. Write to me at the same Hotel Misurina—Misurina. Good-bye.

Now write, and send me what you promised. The practice of observing the nature and landscape of the Alps will mark one of the greatest changes in my way of seeing things. I'd like to discuss with you the difference between the work of artists who have lived and communed with nature and the artists of today who find their inspiration in study and want to develop themselves in the great art centers.

Are you enjoying yourself in Leghorn?

While Dedo was being overwhelmed by Venice as he had been by Rome and Florence overhauling his artistic creed, reevaluating his prin-ciples as well as rededicating himself to his art—if only Mamma would let him be—Oscar Ghiglia seems to have been going through a personal crisis of his own in Leghorn. Just what had upended his values and made him question his life in art, we have no way of knowing, but it was no doubt a complicated matter involving his family, his future, and perhaps the girl he wanted to marry. He seems to have written more in anger and depression than in concrete terms, and Dedo, a loyal friend and in the throes himself, replied immediately in terms of love and pain and understanding:

DEAR OSCAR:

I got your letter and I'm terribly sorry I lost the first one which you say you sent to me. I understand your pain and your discouragement —alas, more from the tone of your letter than from what you have put down. I think I've grasped what's happened to you. I've gone through the same thing and, believe me, I feel for you sincerely. I don't know exactly what brought all this on, but I sense that you, with your noble spirit, have suffered a severe depression or else, with your right to happiness and a full life, you wouldn't be so discouraged. I repeat that I really don't know what it's all about, but I feel that the best remedy is to send you from here, from my heart which is so strong for the moment, a breath of life. For you were made—and believe me —for a life of happiness and intensity. People like us (if you'll excuse the plural) have different rights, different values than do normal, ordinary people because we have different needs which put us—it has to be said and you must believe it—above their moral standards. Your duty is never to waste yourself in sacrifice. Your *real* duty is to save your dream. Beauty herself makes painful demands; but these nevertheless bring forth the most supreme efforts of the soul. Every obstacle

we overcome means an increase in will-power and provides the vital
and progressive renewal of our inspiration. Hold sacred (I say it for
your benefit as well as my own) everything that will stimulate and
excite your intellect. Try to provoke, to freshen all these stimulating
forces which can alone push your intelligence to its maximum creative
power. This is what we have to fight for. Can we possibly achieve
such goals hemmed in by narrow moral values? Always speak out and
keep forging ahead. The man who cannot find new ambitions and
even a new person within himself, who is always destined to wrestle
with what has remained rotten and decadent in his own personality,
is not a man. He is a bourgeois, a grocer, what you will. You could
have come to Venice this month, but you decide, don't wear yourself
out, get used to putting your own aesthetic needs before your obliga-
tions to your fellow men. If you want to escape from Leghorn, I can
help you in so far as I can; I don't know if that's necessary. But I'd be
glad to help you. In any case you must answer my letter this time.
Venice has given me the greatest lessons of my life; I'll leave Venice
a better man, matured, it seems to me, as if by hard work. Venice,
head of Medusa, with its many blue snakes with their pale, sea-green
eyes, where the soul is engulfed and exalts the infini . . .

This last letter of Modigliani's to Oscar Ghiglia, all that remains of it,
ends in the middle of a word, the seventeen-year-old painter carried
away, invoking the spell of Venice, his soul engulfed by the beauties
around him and exalting—what? Did he mean *just* the infinite some-
thing? In this breathless but articulate letter, he had tried to clarify the
problems paralyzing Oscar, and had set down his own beliefs.

Returning home with Eugenia in the early spring of 1901, Dedo sought
and obtained the freedom he had to have. He was in Leghorn for only a
few days, Margherita recalled, "and having had a taste of the arts and
other ways of living he could never stand Leghorn again." He yearned to
get started, to join the battle and accomplish what he had in mind after
seeing the work of the great painters and sculptors. Mamma Modigliani
let him have his way because there was no other course.
She realized that Dedo, young, unformed, irresponsible, and careless of
his health as he was, must be given his chance just as his brothers had
been. Dedo could easily have reminded her that she had said nothing
when Emanuele, even though he had been arrested and jailed for his be-
liefs, had immediately resumed his Socialist activities in spite of the dan-
ger involved. So Eugenia allowed her youngest and dearest to leave the
nest. He must be a good boy, however, write often, come home regularly
on visits, follow the doctor's orders, and take care of himself. No smoking,
drinking, or chasing girls. He must work, prove to his Uncle Amedeo that
all the money spent on him had been a wise family investment.

Dedo agreed. He would agree to anything to put his plans into action. Oscar Ghiglia had evidently resolved his troubles and had decided to go to Florence to continue his studies with Fattori, who was teaching there at the Scuola Libera di Nudo. Another of Dedo's friends and fellow students in Micheli's class, Llewelyn Lloyd, was also going to Florence to be with Fattori. Dedo may have thought of joining them whether or not Mamma approved of his friendship with the older Ghiglia. In any case she would have to approve of his wanting to study with the respected Fattori, but Dedo had something else in mind. He wanted to go off on his own first, go back to Rome and spend time in the galleries there.

He went to Florence for a number of months, spent the winter in Rome, and then returned to Florence, where he had scarlet fever and a much-worried Eugenia rushed to nurse him. The facts and the time sequence blur here. It may have happened this way, and it does seem probable that Modigliani spent the winter of 1901–1902 in Rome. He did have a new interest, one which, oddly enough, he never discussed with Oscar Ghiglia in the series of letters they exchanged. But his first good look at sculpture had been in the Naples Museum on the early trip with his mother, and the hours and hours he had spent there examining the Greek and Roman bronzes had made a stronger impression than even he may have realized.

Rome was a cold, barren city during the winter months. The air was raw, it often rained, and Dedo was lonely. He obtained official permission to copy in the museums, but he preferred looking at the paintings and, particularly, the statues. Except for his sketchbook, no one would have taken Modigliani for an artist. He was a dead-serious, studious young man, dressed like an aristocrat in a neat dark suit, handkerchief peeping in a correct triangle from his breast pocket, stiff collar, white tie, and his shirt cuffs jutting exactly the proper length. His thick black hair was brushed back so that it rose in puffy wings at the side of his head, and he had cultivated a wispy mustache to go with the slight, curly beard that Margherita had noted earlier. Outside, he was all good manners and scholarly decorum; inside, he was overwhelmed by his impressions of Rome, which inhibited him from painting.

Venice in the early spring was a pleasant place, ever so much friendlier and warmer than Rome. He did all the museums and galleries, as he had with his mother, but he could linger at his ease, come back when he wished, and he was relaxed and analytical now. He sketched constantly; he managed to do a few paintings; and he found the girls amenable and receptive. In Venice he met a young artist as impulsive as himself. It was to him that Dedo first confided his ambition to be a sculptor.

Young men sense similar interests and find it easy to strike up friendships, but there is usually some tangible element that brings them to-

gether. In this case it must surely have been because the strikingly hand-some Amedeo Modigliani was making a drawing, probably of a pretty girl, when he caught the attention of Manuel Ortiz de Zarate. The Chilean painter—Ortiz as he was always called—who was to be such a loyal and devoted friend of Modigliani's in Paris—had been born in Como, the city at one end of the lovely lake. His father, Don Eleodoro de Zarate, an esteemed pianist or composer, had toured South America and Europe. The family was in northern Italy when Ortiz was born.

At the age of four Ortiz had returned to Santiago, gone to school there like the sons of other respected, well-to-do families, became interested in painting, and then had rebelled at the idea of studying engineering as his brothers and uncles had. One brother, Julio Ortiz de Zarate, also became a painter, but remained in Santiago all his life. Ortiz, however, fled to Europe. He was young, about Modigliani's age, but tougher and more mature, and boasted that he had been self-supporting since he had run away from home at seventeen. His confidence in himself impressed Dedo. Ortiz was a hulking, muscular youth who, with his big head, deep brood-ing eyes, and powerful features, looked older than his age. The two young artists liked each other immediately. Then and ever afterward, "They shared a wild love for the Italy of the Renaissance; they spoke Italian together, and Ortiz was very *'italienissant.'* Dante was the poet he quoted as often as Cervantes." [8]

Proud of his Spanish heritage and his ancient name, which dated back to the thirteenth century, Manuel Ortiz always referred to himself as a Basque as a matter of principle. His family came from the Province of Alava, poorest of the Basque provinces, and were more Castillian than Basque. Later, in Paris, he was hailed by Guillaume Apollinaire, poet, art critic, and confidant of modern painters, as Paris's one and only "Patagonian." All of the artists of Montparnasse at one time or another heard him declaim on the terrace either of the Dôme or of the Rotonde:

I, Manuel Ortiz de Zarate, Pinto, Carrera y Carvacal, am the accept-ed heir of one of the most glorious epochs of history. Yes, I am the last offspring of a mythology of heroes and princesses. The Ortiz de Zarates, along with the great Captain Francisco Pizarro, conquered Peru and Chile, those countries loaded with gold nuggets and diamonds. . . .[9]

Ortiz described his own proud background, and Dedo listened pa-tiently and then spoke of his family, their great ancestor Spinoza, and how the Modiglianis had once been bankers to the Pope. Ortiz looked at Dedo's sketches, and they talked art. They sat at a sidewalk café in the broad teeming Piazza di San Marco, sipping vermouth in the bright sun-light as flocks of pigeons wheeled over the great square. And here it was

that Modigliani "expressed a burning desire to be a sculptor, and bewailed the cost of the material. He only used paint *faute de mieux*. His real longing was to work in stone, a longing that remained with him throughout his life. . . ." [10] Ortiz went to Dedo's hotel room to look at his paintings. Recalling this, so many years after the fact, he could still remember the magnificence of Modigliani's pajamas.

Ortiz observed that Modigliani "was living in comfort, was quite the dandy, and, as usual, was very popular with the ladies." As to his paintings, they were hardly outstanding, in fact "quite academic, such as nearly all the other students were doing at that time." But it was Ortiz's descriptions of Paris and the artists of Montmartre that most excited Modigliani. Ortiz, who had apparently been in Paris before going to Italy, "was always pleased and amused to watch . . . [Modigliani's] sloe eyes glow with excitement as he told tales of his life in Paris, or replied to a machinegun fire of questions." Modigliani was so thrilled, as Ortiz recalled their talks, "that he was all for leaving Venice with Ortiz, to go to Paris straightaway, declaring that his Uncle [Amedeo] Garsin would surely see the necessity. But then the recollection of his mother dampened his enthusiasms. However, he presently recovered his spirits and promised Ortiz that he would come to Paris eventually, whatever happened—that nothing should stop him." [11]

Ortiz may have described how the Impressionists, so long ridiculed and ignored by the critics and public, were now accepted, recognized, and even a bit old hat. With Ortiz, Dedo admired Goya and particularly Rembrandt, who painted and knew people so intimately that Dedo was convinced he was a Jew, but he did not know the work of Degas, Renoir, Manet, Monet, Pisarro, Sisley, Guillaumin, and Berthe Morisot of whom Ortiz also spoke warmly. Then there were such extraordinary, pioneering individualists as Toulouse-Lautrec, Gauguin, and Van Gogh. And that much-despised and mysterious modern artist, now a recluse, said Ortiz, called Cézanne. They were strange, alluring names to Dedo. He had heard of the Impressionists, but he had little idea of their art or what they had tried to do. Micheli had mentioned them disparagingly, intimating that the Macchiaioli had long preceded them, painted the same subjects in the same style, but had never attracted as much attention as the imitative French Impressionists.

Ortiz went on to Rome, where the father caught up with his runaway son and tried to help him, but Ortiz would not be moved. But this was in 1904, some time after his meeting with Modigliani, who, after a short stay in Florence, had returned to Leghorn before embarking on an important project: his first experiment with sculpture.

<a~~>Chapter Four

*". . . A dilettante with a fine cultural background
who, among other things, . . . didn't know the
first thing about drawing."*

Modigliani's declaration to his mother, on his return to Leghorn
from Florence in the hot days later in the summer of 1902, that
he yearned to be a sculptor above all else, *not* a painter, was
probably as baffling as it was irritating. He had written from Florence that
he planned to stay there and that he had enrolled at the Scuola Libera di
Nudo. A certificate from the Institute of Fine Arts in Venice, dated May 19,
1903, the following year, bears a penciled notation to the effect that
Amedeo Modigliani had signed to enter Fattori's school on May 7, 1902.

Eugenia had been pleased. Florence was near enough so that she could
easily check on Dedo. He was carrying on his studies under Leghorn's
honored and respected Fattori, along with his friends Ghiglia and Lloyd.
And he must be happy and satisfied to be settled at last. Ah, but with
Dedo she might have known! As usual, with everything decided, sud-
denly he was back home, his plans overturned, claiming he *had* to be a
sculptor. He had a talent for painting. Professor Micheli said he showed
great promise—so now of course he had to go off in another direction!
Margherita overdid it, but she was right in saying that Dedo was capri-
cious and that he was wasting Uncle Amedeo's money and abusing the
family's patience.

Still, he was in amazingly good health, and Mamma, although skepti-
cal, was inclined to believe him. He was so sincere, so serious when he
insisted that his one great dream was to carve in marble. And he argued
with such persuasive charm. Eugenia may have asked him why he
couldn't be a sculptor right here in Leghorn, say in Gino Romiti's studio,
or perhaps she said that they could find him one of his own. Dedo made a
terrible face. To obtain marble one had to go to Carrara. Mamma sighed.

60 <a~

She had always backed her own, and Dedo was her favorite. She gave him money. Dedo hugged and kissed her and, bursting with his old enthusiasm for new places and projects, hurried off to Carrara, some thirty-five miles to the north.

Sculpture, so hard, so tangible, was the only real art—a solid creation from nothingness. To Dedo's unpracticed eye, aesthetically it must have seemed far more satisfying than painting. Still, if marble meant Carrara, then, as a corollary, it followed that if one wanted to carve in marble one first had to learn how it was done. Modigliani was not so much illogical as supremely confident of his own ability. He had studied and analyzed sculpture in the museums. He knew what he wanted to do and he felt artist enough; all he needed was a block of marble, a hammer, and a chisel.

All the evidence for Modigliani's sculptural activity at this time comes from a letter he wrote to Gino Romiti, presumably in the summer months of 1909. He had apparently discussed arrangements with his friend. Now he enclosed photographs of his sculpture, which had undoubtedly been taken locally, and he instructed Romiti to make enlargements that "should be 18 x 24 exclusive of the head." He asked Romiti to do them properly. He wanted three or four copies of each soon, and added that Romiti could have as many as he liked. Romiti was to send them on here to Pietrasanta, Via Vittorio Emanuele, in care of Emilio Puliti. He concluded with, "I hope to work and thus finish up and see you soon." [1]

He had carved more than one piece of sculpture, and they were, as they always would be with Modigliani, heads. Pietrasanta was a lovely little village five miles below Carrara. Perhaps Carrara and its great, gaping quarries had intimidated him. One simply didn't buy a block of marble as one did a bunch of grapes and then set to work. It would be natural to find helpful surroundings and a quiet atmosphere in which to work. Perhaps Emilio Puliti worked in marble himself. He could have been a stonecutter, a man who turned out tombstones and monuments.

One can imagine that Dedo found it a humbling and instructive experience. Sculpture was much different from painting—arduous, exhausting, time-consuming. Dedo could complete a sketch in minutes, a painting in a matter of hours, but marble was as unworkable as iron. The unyielding stone sullenly resisted his efforts at self-expression. What he attempted to carve never emerged as he conceived it, nor were there guidelines, a rough draft, for him to follow. The flying chips and dust made him cough as he sweated all day in the hot sun, hammering and chiseling. He bruised his knuckles, blackened a thumbnail when his hammer slipped; his arms ached and his fingers were swollen and bloody.

He was disillusioned and discouraged, but he persisted. Emilio Puliti

gave him some pointers, showed him how to hold his hammer, where to cut and chisel the marble most effectively. Perhaps Puliti, who so effortlessly hacked out one stereotyped monument after the other, also told Dedo to put aside the piece of marble he had given him. He would find Dedo some softer stone. Dedo tried again. He produced three sculptures: two recognizable heads and perhaps a woman's torso. They were poor things, pitiful and uninspired compared to the great, monumental statues that had excited him—the Roman and Greek bronzes in Naples; Verrocchio's equestrian figure of Colleoni dominating the square in Venice and his *Boy and Dolphin* in the courtyard in Florence; Michelangelo's *Madonna and Child* in the Medici Chapel, and just as possibly the work of Tino di Camaino, of Sansovino, the architect of Venice, or even of the Sienese, Neroccio.

Disappointed as he may have been, it was easy for Dedo to rationalize his accomplishment into a fairly successful first attempt. He had wanted to try sculpture and had done so. He would profit from the experience and try again. Undoubtedly he left his carved heads in Pietrasanta. They were too heavy to carry or ship and—no use deceiving himself—they weren't good enough to bother with. The enlargements served to show Mamma what he had done. It was all part of his artistic training, wasn't it? Now he planned to resume his studies in Florence, taking it for granted that Mamma would let him go. Remembering his exciting talks with Ortiz de Zarate, he may have sounded Eugenia out about Paris. It was a gentle probing. Dedo must resume with Professor Fattori, continue his course in Florence. Yes, Mamma.

Dedo appears to have attended few sessions at the Scuola Libera di Nudo in Florence. While he admired Fattori's work to the extent of talking Mamma into buying some of the old man's etchings, the classes seemed to have struck him as elementary and confining. With Micheli, once the fundamentals were absorbed and he could teach a pupil nothing further, you ended up having to paint like Micheli; under Fattori, for all his kindness and ability, it was much the same thing. Modigliani wanted to paint like Modigliani.

On top of that he was apparently having difficulties with Oscar Ghiglia, with whom he was sharing a studio. Oscar was now twenty-six, heavy, solid-boned, with a clipped beard and mustache that gave him a Pasteur-like appearance. He was a serious fellow, dedicated to Fattori and his teaching, and Modigliani, at eighteen, must have seemed ever more the incorrigible juvenile playing at art as he did at life. Dedo couldn't sit still and apply himself. He preferred talking and analyzing art to hard work at his easel or in Fattori's school. Now, after that silly and abortive experience with sculpture, Modigliani was talking about going to Paris, and wanted Ghiglia to go with him. And he used Nietzsche, which Oscar

had outgrown with a lot of other silly Leghorn notions, to back his argu-
ments.

Nietzsche said he believed only in French culture, and regarded every-
thing else in Europe that called itself "culture" as a misunderstanding.
And, Dedo insisted, the philosopher stated specifically that, "As an artist,
a man has no home in Europe save in Paris." Dedo bubbled and chat-
tered. There was so much to see, so much to do, so much to absorb before
one could form one's own art. All the rest, following the example of
Fattori, for instance, was exercise and repetition. Much better to spend
hours in the museums, to roam Florence sketching from life on the wing.
Besides, they were young and there were so many girls to enjoy.

One can see Oscar chiding him. He must sober up, settle down, get to
work and learn his trade in order to support himself. Dedo laughed and
quoted Nietzsche again: "Nothing ever succeeds which exuberant spirits
have not helped produce." Oscar said exuberance was for children. Did
Dedo want his mother and his rich uncle to pay his way all his life? He
must grow up! Oscar was sick of Nietzsche's philosophy and Dedo's other
idol, that self-infatuated maniac D'Annunzio. Very possibly, in love and
contemplating marriage, he looked askance at Dedo's girl-chasing. Nor
did he believe, as Dedo so fervently did, that artists had "different rights
or different values from normal, ordinary people because their different
needs put them above their moral standards."

That was nonsense. Artists were decent, hard-working people no differ-
ent from anyone else. They must behave, act in accord with God's princi-
ples, and be responsible as well as self-sufficient. He looked up from the
slick still life he was painting, the fruit in the bowl that seemed to
Dedo to come out so bejeweled and pretty-pretty on Oscar's canvas.
Would Dedo *please* stop interrupting his work and criticizing? If he
didn't like working with Fattori, let him get out. He could go to Venice,
if he chose, or even Paris, since nothing seemed to suit him in Italy.

Ghiglia was undoubtedly convinced that Dedo wouldn't amount to a
thing. He was personable, charming, and had a brilliant mind for his
age, but he was a trifler, a dilettante, an amateur. Perhaps the causes for
the sudden and irreparable break in friendship between Modigliani and
Ghiglia are not hard to find. Ghiglia must have married at some time in
1902 or early in 1903, since he had five sons, two of whom were born—
Valentino in 1903 and Paulo in 1905—in Florence. In a laudatory
chapter in *Laborers in the Vineyard*,[2] Giovanni Papini, who may have
known Modigliani briefly, speaks slightingly of the "strange" pictures of
Modigliani that today (his book was published in 1930) bring as much
as Cézanne's; and describes Oscar Ghiglia's art as a colored vision of his
feelings, and says that he paints his own soul. Papini, an atheist who
turned Roman Catholic and wrote a highly successful *Life of Christ*, saw

Ghiglia as a poet-painter, a psychological painter, a Christian painter.

A quarter of Ghiglia's life, according to Papini, was stern and difficult, with no compensating or romantic diversions. He adds that Ghiglia knew what it is to lead a wandering life, to incur the dislike of mediocre people (this sounds like an oblique slap at Modigliani), and to suffer sickness in exile and poverty. Fattori loved him in his early life and tried to prove it to him. Later on, Ghiglia found faithful friends (one gets the impression from Papini that Modigliani was among the unfaithful ones) and appreciative buyers, but as of 1930 he was not a success. Few people knew his work, and he lived by his labors month after month. In conclusion Papini, perhaps the only man in Italy with this conviction, said that on Ghiglia "alone it depends whether the fine story of Italian art shall register tomorrow one great master the more."

Ghiglia died in 1945, Micheli in 1926; both lived long enough to be aware of what their friend and pupil achieved and how he had surpassed them. Ghiglia especially, who had quarreled and broken with Modigliani, must have thought often about his friend, and perhaps gone back to the passionate letters Dedo had written to him in his youth. Dedo had told him ". . . Your *real* duty is to save your dream." Ghiglia had not done so.

In the same book Papini has an essay on Fattori,[3] who was seventy-seven in 1902, when Modigliani was in Florence. Papini assures his readers that Fattori's art was chaste and austere, that nature was his wealth. His pupils revered him, and these included Oscar Ghiglia and Llewellyn Lloyd. There is no mention of Amedeo Modigliani.

Modigliani left Oscar Ghiglia as a disciple of Fattori, a man prepared to marry, settle down, and live a conforming, respectable bourgeois existence. Oscar would have paintings as he had children, go to church, practice his religion, and live a dull God-fearing life. Dedo no doubt felt that Oscar had betrayed their friendship. He may have been aware of Oscar's attitude toward him as expressed by the writer and critic Ugo Ojetti:

> When he was a little over twenty and lived in Florence, Amedeo Modigliani adored the English pre-Raphaelites, and the walls of his studio in the Piazza Donatello were covered with photographs of frescoes and the works of the Sienese school. He was a handsome young man with tawny blonde wavy hair, a rather feminine manner, and provided with an inexhaustible amount of kindness and generosity. His more mature friends [Federico] Andreotti, Sacchetti, Ghiglia, considered him quite rightly a dilettante with a fine cultural background who, among other things, to quote Enrico Sacchetti, didn't know the first thing about drawing. He appeared to be well off and solidly supported by his family in his first steps in the artistic world.

Nobody would have thought, when he left for Paris, that he would undergo a life of hardship and distress in an atmosphere often bordering on tragedy.[4]

The inaccuracies here are obvious—Modigliani had black hair and his manner was not feminine—but if Ghiglia shared his friends' opinion of Dedo as a dilettante who didn't know the first thing about drawing, then he seems to have been shamefully shortsighted. As for his being well off, Dedo must have been expert at putting on an act that fooled Andreotti and Sacchetti. But Ghiglia should have known better. He was in all likelihood fed up with his aristocratic and opinionated young friend.

Because the Modiglianis had friends in Venice as well as in Florence, Eugenia couldn't have been too upset when Dedo wrote that he was going to enter the Institute of Fine Arts there. It's quite likely, too, that Dedo saw his brother from time to time while Emanuele was carrying on his activities for the Socialist Party. Still using money advanced by his Uncle Amedeo, Dedo lived in a comfortable room in a fine residential section at Number 22 Via Maggio. He always liked to live well when he first went to a city, moving only after he ran out of money. He enrolled at the institute on May 19, 1903, but, once again, he seems to have attended courses at the school rarely.

Either the teaching was too academic, too inhibiting, or Dedo preferred painting infrequently on his own or sketching from life as he roamed Venice. Here, as in Florence, Dedo savored the company of stimulating intellectuals with revolutionary ideas on art, poetry, literature, philosophy, and politics. These bright young men were patriots, fervent nationalists humiliated by the sick Italy around them. They saw their country as a cultural prison, and were tormented by a *mal du siècle,* which was to drive some of them to suicide.

Ripe with pessimism, they saw everything through black-colored glasses and spoke bleakly of the twilight oppressing Italy and their time. To them Italy was dead, living only on the moth-eaten, museum-enshrined heritage of past glories, torn and divided politically and socially, and now shamed and degraded before a world that had by-passed it. It was in their company that Dedo may have met Giovanni Papini. There was also Papini's friend Ardengo Soffici, painter and writer, who had lived in Paris for three years. He was introduced to Modigliani by a friend, Umberto Brunelleschi, who was also a painter. Soffici recalled Modigliani as a handsome young man with good and gentle features:

He had a graceful countenance and gracious manners; and what he said denoted a great intelligence and a serene frame of mind. We

spent many hours together during my stay in Venice, wandering around that splendid city, which he was showing me, or in a restaurant where he took us and where, while we ate some fried fish whose strong odor I still remember, our new friend told us about his research work on the painting techniques of the Old Masters. He also told us about his passionate research work on the art of the Sienese masters of the fourteenth century and especially of the Venetian Carpaccio, for whom he seemed to have a particular interest at the time. I noted on those occasions that he ate sparingly, in the Italian way, and that he put water in his wine when he did not actually drink straight water.[5]

Soffici's return to France prevented their continuing the acquaintance. They met occasionally later when Modigliani went to Paris, but for a long time they lost sight of each other. Their last meeting occurred in June, 1914, and Soffici sadly noted the terrible changes that had come over Modigliani, now a hopeless drunk and drug addict and so very, very far from the gentle, well-mannered boy who had watered his wine. Although Soffici did not fix the blame, most of the Italians either writing or commenting on Modigliani make a point (as has been intimated earlier) of the horrible changes that came over the artist *after* he went to France. They imply that they had *not* and *would not* have occurred in Italy—the *cara Italia* Modigliani always loved, spoke of fervently, longed to go back to, and where he had always been sober, peaceful, and tractable.

It's a debatable point and a meaningless one artistically: if France did ruin Modigliani, she also made him. If Modigliani had not gone to Paris, it is likely that no one would have heard of him any more than of Micheli, Ghiglia, Romiti, Natali, Martinelli, or other Leghorn friends who, at best, were never more than competent, craftsmen, third-rate painters. Modigliani's two-year stay in Venice is poorly documented. What he did, what he and his friends actually talked about, remain matters of speculation. But it has not prevented imaginative writers from filling the gaps and adding their own fuel to the legend.

André Salmon's highly colored *La Vie Passionnée de Modigliani* (published in the United States as *Modigliani: A Memoir*)[6] is a typical example of misleading biographical detail. In this book Salmon, a poet, critic, and writer, who lived in the Bateau-Lavoir and was a member of Picasso's set, devotes well over ten pages to long, imaginary conversations that Modigliani, Soffici, and Papini had in Venice. These take place at the Café Florian in the Piazza San Marco where Soffici, accompanied by Papini, supposedly encountered Modigliani by chance. Earlier Salmon has the three looking each over curiously at the Uffizi Gallery, with Modigliani sensing that these contemporaries of his were congenial, but failing to make their acquaintance because he lacked a suitable opportu-

nity. Although Soffici does his best to absolve him, it would seem that Salmon conveniently provided just such an opportunity.

Soffici has since clarified the matter:

> The books which have been written up to now about Modigliani (as with many other artists and writers) are, in truth, full of romantic fantasies, exaggerations, not to say lies. What my friend André Salmon has written concerning the relationship between myself, my friend Papini, and Modigliani contains so many inaccuracies that I must attribute it to failing memory or some account of Modigliani's that Salmon took for historic fact. I mean that Salmon repeats what Modigliani told him: the discussions and the exchanges, philosophic, aesthetic, and religous, etc., which are in his book.
>
> The truth is that my first meeting with Modigliani was actually in Venice (in July 1903) where I was accompanied not by Papini, but by Umberto Brunelleschi, a Florentine painter. Modigliani was there to study the early Sienese and the works of Carpaccio and Bellini. During the few days we spent together we naturally spoke of and discussed art and the aesthetic principles relating to it. But that's all.

Soffici indicates where accounts of this meeting can be found in his works. He also mentions seeing Modigliani later on in Paris and the changes that had taken place in him. He continues:

> . . . From my first meeting with Modigliani I sensed his great artistic talent and the richness of his poetic spirit, although his later work gave me surer proof. They have perhaps gone a little beyond what is reasonable in speaking of his truly great genius and comparing it to that of those who have conquered the ages.
>
> I feel that the reason for Salmon's questionable account is this: Modigliani followed the philosophic, aesthetic, literary, and artistic movement stirred up in the magazines: the *Leonardo* of Papini, *La Voce* of Prezzolini, and *Lacerba* founded by myself and Papini in Florence; a movement whose aim was to renew the spirit, the culture, and the art of Italy, which became brutalized by futurism; while in France the same need led to cubism. . . .
>
> Modigliani took a spiritual part in this idealistic task; he may have had conversations with Papini, confused these conversations with those he had in Venice with me; or he may have thought himself involved in the same movement, taking part in the same battles; and, finally, he must have talked to Salmon about all this and failed to sort out in his mind—already tormented by the fever of his life—his memories of things, of times, of places, etc. Without this explanation one would have to take it all simply as pure invention, something which Salmon is incapable of doing.

I hope that this clarifies the doubtful points of Salmon's account of the relationship between Modigliani, Papini, and myself. . . .[7]

Soffici's recollections of Modigliani explain what he was doing when he wasn't attending art school, enjoying himself, and running after women in Venice. Dedo was indulging in postgraduate work, as it were, educating himself in the galleries and museums with his "research work on the painting technique of the Old Masters" and his "passionate research work on the art of the Sienese masters. . . ." This was apparently not a leisurely affair, the idle study of the dabbler or amateur, but a hard, daily pursuit, which Dedo found more provocative and valuable than any of the courses at the Institute of Fine Arts.

The idea of going to Paris had fired Dedo's mind since he had met Ortiz de Zárate. It's possible that the two kept up a correspondence. Surely, whenever Dedo went home to Leghorn, as he frequently did, to rest, to get money, to be spoiled by Mamma, he brought up the subject of Paris, his eventual destination. More and more he felt that he had exhausted the resources of Italy and must go where art was free, alive, and unintimidated. In Florence the earnest, exciting discussions went on in cafés, bars, restaurants, or somebody's rooms late into the night. He mingled with young artists, writers, poets, lawyers, hangers-on, misfits.

Like them, Modigliani yearned for change. Like them, he took himself seriously and life hard. He wanted to live intensely, but his bourgeois background inhibited him. These lost, beaten men could no more laugh at themselves, their follies and the follies of the times they lived in than they could accept life as it was. They could not see the funny side of things, had no more appreciation of the comic or ridiculous than did D'Annunzio or Nietzsche. They would have indignantly denied that there was indeed *anything* to laugh at. They laughed bitterly when they did laugh. They were poor, sad, somber men looking for a cause and something to believe in.

His circle included artists about his own age, some of them onetime fellow students at the institute: Umberto Brunelleschi; Umberto Boccioni, who was to become a Futurist painter; Fabio Mauroner, sculptor and painter, with whom Modigliani apparently shared a studio in the San Barnaba section of Venice in 1903; [8] Mario Crepet, Cesare Mainella, Guido Marussig, and eventually the youthful Guido Cadorin, with whom he enjoyed some wild times in the next few years. All these men, with the exception of Mainella, became competent painters. Boccioni, of course, was to achieve fame as a Futurist, and would have achieved a greater reputation if he had survived World War I.

Even among such dissimilar artists Modigliani was outstanding as a young man, and has been so remembered by his friends. They recall that

he missed the classes at the institute and went to the restaurants and afterward to the houses of prostitution to draw. In the brothels he found excellent models who were always at their ease, and posed gladly, and doubtless he rejoiced in their informal nakedness in contrast to the formal, stylized nudity of the models in life class. They probably thought him cute, and Dedo may or may not have taken advantage of their services.

Paris, Paris, Paris. Dedo was ever more conscious of marking time and wasting it. The schools of Florence and Venice held nothing more for him. He was intrigued by the painting technique found in the old masterpieces. One could not ignore the past and its undeniable, never-again-to-be-equaled glories in painting and sculpture. But it should not possess, intimidate, and deaden. One should study it, as he had, then perhaps follow along, adapt and, finally, evolve to the point of producing honest, original personal art. But this couldn't be done in Italy.

While he was dissatisfied with his painting, he felt that his drawing had improved. It was simpler and more direct as he shed every remnant of Micheli. His brief adventure into sculpture, to which he meant to return, had strengthened his line, given it a three-dimensional quality. He painted a portrait of Fabio Mauroner. He may have tried etching, as Mauroner reported. He wrote home for money and he painted an occasional picture of a friend of Mamma Modigliani's.

On his visits home he constantly spoke of Paris, of going there to realize himself and his ambition. With someone as intense and emotional as Dedo, Eugenia was bound to be troubled. There was no keeping or holding her youngest. He would have to have is way, as always. Eugenia continued to fret about him, noting her doubts in her diary as late as February, 1905:

In Venice Dedo has finished [Leone] Olper's portrait and talks about doing others. I still do not know how he will turn out but, since up to now I have only thought of his health, I cannot yet, in spite of our financial situation, attach much importance to his future work.

Through Guido Cadorin, a most sophisticated boy for his age (he was born in 1892), Modigliani had a taste of the gay, naughty life in Venice. Cadorin, who became a recognized artist, told Jeanne Modigliani that he often visited churches with Dedo, presumably in the course of the latter's research. And at night, Cadorin, who was then a remarkably knowledgeable thirteen, says they attended "certain gatherings run by a Neapolitan of the minor aristocracy called Cuccolo or Crucculo." The baron, a fat little man always elegantly dressed in gray, picked them up in the evening at the Accademia and took them to

the Giudecca section of Venice. Here, along with two girls of the quarter, they all joined the baron in partaking of "the joys of spiritualism and hashish." Modigliani's daughter adds "that it was not necessary to go to Paris to discover the use of drugs . . . and Cadorin confirms this." [9]

The news of his Uncle Amedeo's death later on that year must have hit Dedo hard. He felt genuine grief at the death of this good, generous, and warmly understanding man, only forty-five. Amedeo Garsin's health had failed at the same time that his plans for business expansion had apparently faltered. From what Eugenia recorded in her diary of this sad event, Amedeo seems to have died suddenly and penniless. She is too pained to "take up the thread of that pitiful story." His death leaves a great void in her life, and she speaks of her complex affection for him, the love, the trust, and "our complete communion of spirit." But, adding more mystery, she says, "I realize that he never could have been happy and that it is better this way."

Uncle Amedeo's death shook Modigliani because it must have seemed the apparent end of all his hopes. With his uncle gone and no more money forthcoming, he would never go to Paris. His depression was probably apparent in his next letters, and explains Eugenia's sudden trip to Venice. She had reached a decision. She went to see Dedo toward the end of 1905 and brought him a beautifully bound copy of Oscar Wilde's *The Ballad of Reading Gaol*, "as well as a small sum of money to pay his traveling expenses to Paris." [10]

Second thoughts must have beset Mamma Modigliani on the long train ride from Leghorn. She longed to change her mind when she thought that, with Dedo gone, she would be left alone with two neurotic women —Laura, self-centered, convinced she was being persecuted, and off somewhere in the clouds, and Margherita, a whining, hysterical spinster. Then there were Dedo's health and the fact that he couldn't be trusted to take care of himself. But he was a man now, over twenty-one, with his own life to live. And his art was his life.

Eugenia Modigliani was more greathearted than she knew. As before, she would not kick her fledgling out of the nest, but if he insisted on flying off on his maimed wings—well, so be it. What money she had been able to collect wasn't much, only a few hundred lire,[11] but this amount (say three hundred lire, or about sixty dollars at the time) would pay for the trip to Paris and keep him going for several months, if he lived wisely and frugally (but could Dedo *ever?*), until she could send more.

Dedo was speechless when she told him. When he finally understood what she meant, tears came to his eyes and he trembled with joy as he kissed her. Mamma knew she had made the right decision when she looked at her son's shining, ecstatic face—never more beautiful than now. Perhaps she fought the impulse to get out her own handkerchief, and cry.

~~~Chapter Five

"He may have talent, but that's no reason why he
shouldn't dress decently."

Mamma had given her permission at last and flung the door wide, but it was Dedo's own compelling powers of persuasion that had secured his freedom. He had made his mother believe, as he did, that things were truly different for artists in Paris. Here, "in the capital of the world of art," he was confident of his ability to forge a career and to become self-supporting in no time at all. Dedo was naïve and overly optimistic, but he was young, brimming with enthusiasm, and could hardly be blamed for believing his own propaganda.

And he was certainly mindful of all the sacrifices that Eugenia Modigliani had made on his behalf. "He even promised his mother, half joking, half seriously, that he would repay her, in fame and money, all she had spent on him." [1] So wrote Douglas Goldring in his *Artist Quarter,* one of the first extensive biographies of Modigliani to be written in English, which was published in London in 1941 under the pseudonym of Charles Douglas. While Goldring was actually the author of the book, the Charles part of the pseudonym comes from Charles Beadle, an English journalist of long residence in Paris and a personal friend of Modigliani and his circle. Beadle did much research for *Artist Quarter* and also supplied special material for the book. In some chapters, when "I" is used, it is Beadle himself speaking from experience.

As it was, Modigliani never forgot the promise he made to his mother. Beadle himself bore witness to this: "When a few years before he died, he began to achieve a measure of success, the first thing he thought of was his desire to redeem it." Ultimately, after his death, Modigliani did indeed repay his mother in fame, if never, unfortunately, in money. The

cash all went to the dealers and the others who profited so greatly from his paintings.

One can easily imagine Modigliani's high state of euphoria when he left Leghorn for Paris, most likely in early January, 1906. A distance of about seven hundred miles, it was a long, tiring twenty-six-hour ride by train, and his second-class ticket had consumed about fifty lire of his precious funds. Mamma had cautioned him to hoard his money and live as conservatively as possible until she could send him more. And Dedo, who had played the saint since Mamma had finally said yes to Paris, probably assured her he would, without even hearing her.

In July, Dedo would be twenty-two. He was fit and in good health. He had given up smoking to please Mamma and for the sake of his lungs, which she worried about far more than he did. He would eat well, sleep well, preserve his strength, and come home for a visit (in triumph, he hoped) as soon as he could. He was smartly dressed and dashing in the good black suit that Caterina, the faithful, if foul-mouthed, family maid had turned out for him. The flowing black cape, which Mamma had given him and which had once been his Uncle Amedeo's, was the perfect finishing touch.

He was the exemplary young gentleman and sophisticate, and had somehow acquired the lordly ways of the aristocrat. He looked taller than his approximately five feet six inches because of his proud manner of holding himself, his bouncy walk, his outgoing friendliness and charm, and the robust strength he seemed to exude. From his appearance no one would have guessed that this handsome, genial young man had suffered from chronic illness or had been tubercular.

In any group of people Modigliani would have demanded a second or a third look: the rich, burnished mass of curly black hair; the deep-set, piercing black eyes below the broad forehead; the firm, good straight nose; the strong, uptilting chin; the smooth, white-marble-like complexion with the bluish tones of a heavy beard—so heavy that he had to shave twice a day to look his best. Dedo was personally neat, and liked to look and dress his best. He had experimented with a beard and mustache in his late teens, but now regarded such adornments as abominations. He preferred being clean-shaven.

The money Mamma had given him bulged large in his new wallet, a farewell gift from his Aunt Laura, and his suitcase, which had been Mamma's, was filled with clothing, personal articles, and his favorite books. He also carried his sketchbook, perhaps a new box of paints and a folding easel and painting stool. Among the art reproductions in his suitcase were prints and photographs of Simone Martini's *St. Clara* and Duccio's *Three Marys at the Tomb* from the Sienese school; some of the early Renaissance painters from the Tuscan school, and from the Vene-

tian painters, a three-color lithograph of Carpaccio's *Two Courtesans,* which he had bought in Venice in his Academy days. This last print, it has been said, he pasted to his walls wherever he went. It went everywhere with him, as did his Diamante edition of Dante.

What was Modigliani thinking as his train huffed on toward Paris? Many a famous artist had made the trek before him; many would follow after him. Picasso had made his first visit in 1898. Constantin Brancusi went in 1904, Jules Pascin in 1905. Gino Severini, another Italian, was also to go in 1906, as was Juan Gris. Why were they all impelled to go to Paris? Why did they feel confident they could find and accomplish there what they could not in their own countries?

The Italian artist was perhaps inhibited by the glory of the past. He could not equal the old masters. But in another land, away from the burden of his traditions, he could follow his own inspirations, and with skill acquired from long training, he had a good chance of producing something better than his fellow painters.

The only view of Dedo on his epochal train trip comes from Ludwig Meidner, a young German art student, who was to make a name for himself among the German Expressionists, and who met Modigliani in the fall of 1906 "in the semi-darkness of a bohemian restaurant on the Butte of Montmartre—the unforgettable *Lapin Agile.*" [2] Modigliani told Meidner that he had come to Paris by way of Switzerland. In Geneva he met a wealthy German lady who was traveling with her young daughter and who invited him to accompany them.

Just come from home, twenty-two, immaculately dressed, good-looking, ironical, and brilliant, Modigliani was "less interested in the no longer young mother than in her very youthful daughter." It amused him tremendously to flirt with the sweet little daughter without the mother being aware of what was going on. Dedo, being very charming and making them laugh, sketched both mother and daughter, and all the time it was the girl he was flirting with. The childish game delighted the little girl and delighted Modigliani. It was a wonderful, bitter-sweet joke.

Paris! Modigliani saw the great city with the startled eyes of a raw tourist and a foreigner. None of the sounds was familiar. The signs all seemed printed in the wrong language, and the quick, chattering, nasal French dissonances, which he heard on every side, were a babble. He was glad Mamma had taught him French and made him read and speak it at home. Nevertheless he felt tongue-tied.

Outside the railroad station, his suitcase resting against his legs, he stood on the sun-swept sidewalk as if blinded by the reality of Paris. It was mild for January. He stared at the fiacres, the big three-horse omnibuses that rumbled by, the wagons, and the carts. He looked at the pedestrians, the girls so slim and well dressed compared to those in Italy. Dedo

was probably an easy mark for the first cabbie who, spotting him as an unmistakable new arrival, pulled up beside him. He got in without thinking, only recovering as they clip-clopped up the majestic Champs-Elysées, and finally hearing the fiacre driver, who had been asking M'sieu's destination over and over. Dedo apologized and smiled. He wasn't sure where he wanted to go—some nice hotel perhaps—but it was a fine day and he'd like to look around.

Place Vendôme, the Arc de Triomphe, the Eiffel Tower, Nôtre-Dame, and all the landmarks . . . Montmartre, Montparnasse, the Latin Quarter, the Bois de Boulogne. When the fiacre pulled up to a "nice" hotel near the Madeleine, it was late afternoon. Dazed and sleepy, Dedo paid the smiling coachman, registered inside, and was shown to a big comfortable room overlooking the street. He had just the strength to wash up, eat a hearty dinner in the hotel dining room, then stumble upstairs to bed.

His life had truly begun. Everything that had gone before was scratched out, obliterated. The past was destroyed. Here he would find himself, paint, make money, and become famous.

Brought up in a comfortable bourgeois surroundings, Modigliani, although he liked to rail at the bourgeois, could not help behaving like one. He was not bohemian by temperament, nor did he like bohemians. He liked nice places, nice things, nice clothes. And now, since he had the money, he lived like an affluent tourist doing Paris, its churches, museums, and historic monuments as thoroughly and analytically as he had those of Naples, Rome, Venice, and Florence.

He spent hours looking at the treasures and masterpieces in the Louvre. He came back repeatedly, and, contemplating the majesty of the *Venus de Milo* and the *Victory of Samothrace,* he was again sure that he wanted to be a sculptor. The beauty of these two incomparable statues, broken and incomplete as they were, their incredible grace and their unearthly perfection of execution, moved him close to tears.

How amazing that the dedicated men who had produced these works of genius should be unknown and yet immortal. The achievements of the great Grecian sculptors exalted him. But as he gazed in awe at the statues, perhaps he remembered his own disappointing stab at sculpture, and felt defeated. Surely the Greeks must have had doubts as they stood before their shapeless blocks of marble. But they had had a dream and carried it through. It was exactly as he had told Oscar: the *real* duty of the artist was to save his dream, as these men had done.

Dazzled by Paris, Dedo put off getting to work. One had to acclimatize oneself, get used to the Parisian light, which was not so bright as Italy's, more golden perhaps, softer, more bland, quieter—and much more de-

ceptive. Now it was time to make his contacts. Dedo had written to Ortiz de Zarate, who had sent along his Montparnasse address. Ortiz seemed bigger, taller, and more self-assured than in Venice. Though he talked and carried himself like a real Parisian, Dedo had a few reservations about Ortiz. His two tiny rooms, one to work in and one to sleep in, were shabby and bare. Ortiz himself was casually dressed, needed a shave, and seemed tired. He had lost his old vivacity.

For his part Ortiz was troubled by the appearance of his friend: Dedo looked like a young-man-about-town with his black cape over his dark suit, his spats, and even a cane. He was so elegant that no one could ever take him for an artist, at least not the type Ortiz knew. Still, Dedo was as charming and endearing as ever, as exuberant as he had been in Italy, intoxicated with Paris and his freedom, and proud to be in the money. He insisted on paying for Ortiz's lunch, taking great pleasure in nonchalantly peeling the bills from his wallet.

Ortiz wondered that Dedo should stay on at a hotel near the Madeleine. It must be expensive and he ought to save his money. Besides, one couldn't very well paint or do sculpture in a hotel room. Oh, Dedo knew that—he looked over at Ortiz—but there was no point in hurting his friend by saying what he thought. An artist didn't have to look like a bum; that was what he had on the tip of his tongue. He assured Ortiz he would settle down to work soon. He liked Montmartre and planned to look there for a place to live. It was so pretty and quiet, almost like a peaceful village back home, and he knew it would be a good place to work.

In spite of his heady talk about art and his dedication, how difficult it must have been for Ortiz de Zarate, who had been through the mill, to take this boy seriously. Modigliani did not know what he was up against, did not realize what it was merely to survive in Paris. If he kept on wasting his time and recklessly spending his money, Paris would crush him as remorselessly as it had so many other would-be artists. But Modigliani was so happy, so excited, and such good, refreshing company, Ortiz kept his thoughts to himself.

With Ortiz as his guide, and later on alone, Dedo eagerly examined the work of the Impressionists and the moderns in the galleries, the windows of dealers, and the various two-by-four antique, odds-and-ends souvenir shops and *boutiques* that chose to hang the startling work of the "new" men. The Rue Lafitte was the place to look at paintings. The Durand-Ruel Gallery's big collection of Impressionists pleased Dedo with its technique and brilliant use of color, but, like Fattori, the Impressionists were of a school, and he wanted nothing to do with schools. Besides, the Impressionists were finished. He admired Degas and found a glimpse of Toulouse-Lautrec breathtaking, particularly his color and line.

Ambrose Vollard, a sluggish, heavy-set man who had an untidy little gallery on the Rue Lafitte, had supposedly been Cézanne's first backer, champion, and dealer. He had Cézannes, as well as the works of others on the premises, but one had to ask to see them. Dedo was curious about Cézanne, but probably too shy to ask the stolid Vollard to show them to him. He may have seen some Picassos hanging on a string in Berthe Weill's tiny *boutique* in the Rue Victor-Massé or possibly in Clovis Sagot's cluttered shop that, besides paintings and bric-a-brac, was still jammed with the drugs, patent medicines, and supplies of its previous occupant, an apothecary. Vollard did have on display some strange, fascinating paintings by this Picasso and some equally startling ones by Matisse, another name unfamiliar to Modigliani. Ortiz had met Picasso and knew of Mattisse.

It is impossible to know where Modigliani first saw the work of the moderns and what he thought of it. But what he did see was unlike anything he had been taught or had seen before. Nobody painted like that in Italy. It was unconventional, brutal, shocking, and repellent; it was also fresh, novel, stimulating, and fascinating.

Whether uncertainty plagued him or whether he felt he needed the discipline of a school, Modigliani enrolled at the Académie Colarossi on the Rue de la Grande Chaumière in Montparnasse. Ortiz could have told him about the school; he may even have suggested it. In any case it was ironic that he should begin his art on the street where his art and his life ended. For Modigliani the Rue de la Grande Chaumière was to be a painful and tragic thoroughfare.

It was at this time that Dedo met Sam Granowski, a colorful Russian Jew, a painter and sculptor, who recalled that Modigliani "was well dressed, sported a fine black cape, and looked healthy and prosperous." [3] It was an awkward meeting because Granowski spoke no Italian and only a word or two of French. They had to use gestures, signs, and drawings to communicate with each other. But Modigliani did get across the idea "that he was wildly keen about sculpture . . . but not busts, colossal monuments. He had dreams of commissions, not for commercial stuff but for something on the scale of Michelangelo." Granowski noted, just as others did who knew Modigliani at this time, that he was shy, reserved, did not smoke, and drank wine sparingly. Granowski must have attended the Colarossi school himself. He said that Modigliani had little to say, diligently attended the Colarossi, where he "made as much use of the model as possible, and had an odd way of hiding his sketch with his hand so that no one should see his work." Granowski evidently did see Modigliani's drawings, and described them as "almost classical in line."

So Dedo started off in Paris, just as he had in Florence and Venice, by going to art school. And surely when he wrote Mamma about what he

was doing, she could only approve. The Académie Colarossi was similar to many other accredited art schools in Paris. Founded in 1815, the Colarossi could boast of such outstanding students as Gauguin, Whistler, and Rodin. Instruction was given to beginners, as well as to advanced students, but Dedo apparently attended only life classes.

The first day Modigliani saw Picasso he was put off by his clothes. Ortiz de Zarate said that he and Modigliani were sitting on the terrace of the Café de la Rotonde in Montparnasse as Picasso walked by. Ortiz pointed him out as the man who had painted the startling canvases Modigliani had admired. Dedo was not impressed by this fellow walking his dog—this short, squat man. Picasso was well built for his size, with full, strong features and thick, shiny black hair. One thick lock of that hair cascaded from under his ugly workman's cap over one eye. He looked nondescript in his patched and faded blue overalls. His red cotton shirt with white polka dots, his blue jacket, and his grubby canvas shoes with holes did nothing to improve his appearance. Not like an artist at all! More like a plumber or a ditchdigger.

"He may have talent," said Dedo scornfully, "but that's no reason why he shouldn't dress decently." [4]

This was the supreme irony: that Modigliani, who despised the bourgeois, should be so bourgeois as to despise the bohemians. Especially so, since he was to become their "prince" and come to admire the works of Picasso as those of a master. Picasso and the others liked to play down the fact that they were artists: they wore the caps, clothes, and shoes of laborers. Modigliani wanted to look like an artist—or what he and the public assumed an artist must look like.

While Modigliani was getting his bearings in Paris, attending the Colarossi school, seeing Sam Granowski and Ortiz de Zarate, a compatriot opened a little restaurant that was destined to become famous because of its artist patrons and, perhaps, most of all because of Modigliani. Rosalie's, when it opened in 1906, was a small place, and so it remained. The restaurant consisted of a cramped room on the Rue Campagne-Première with four marble-topped tables. On its yellow-stained walls hung a few drawings and four or five paintings left in payment of, as Umberto Brunelleschi put it, "some not too good a meal." [5]

Rosalie Tobia told Brunelleschi, who had been a fellow student of Dedo's in Venice, that she had become acquainted with Amedeo, as she called him, in 1906 and that he felt quite at home in her restaurant. She mothered him, and they argued and shouted at each other in Italian. She had left Mantova in 1887 to come to Paris as the servant of a Princess Ruspoli. She was young, fresh, and beautiful and, from what she confided to Brunelleschi, after leaving the princess's employ, she went to work for

the painter Odilon Redon. It was here among the colors and brushes, Rosalie claimed, that she acquired her taste for painting.

One day a friend of Redon's asked her to pose. From that moment, her career was decided. She posed many years for Bouguereau. " 'Was that a great painter! Santa Madonna, what pictures! And what beautiful figures he did of me.' " Then she posed for Cabanel, for Hubert, for Courtois, for Carolus Durard, " 'and in all the museums of Paris and of the provinces and abroad you can see the beautiful Rosalie, naked as God made her.' "

When she got to a certain age and was neither one thing nor the other —too old to pose for nudes and still too young for character pictures, the ever practical Rosalie opened a restaurant. She found what she described as this " 'hole with tables, chairs, and kitchen utensils for which I paid all in all 45 francs.' " Rosalie did the cooking, her son Luigi, whom she had picked up along the way, waited on table, and occasionally a young girl helped him.

Rosalie's food was simple and hearty. Good thick soup into which one could dip coarse bread, a variety of pungent cheeses, stews, and a *spécialité du jour*. Rosalie darted out of the kitchen, her hair wrapped in a bright Neapolitan kerchief, her red face dripping sweat as she brandished a wooden ladle at a customer who had had the temerity to order a second dessert. It was his favorite, he explained, a purée of chestnuts and— Rosalie cut him off furiously. She wasn't running an elegant place for the filthy rich! He had already spent his five francs. It was her contention that no one should ever spend more than five francs for a meal.

Dedo listened and marveled. He would go back often because Rosalie reminded him of home, Leghorn, and Mamma. In time Dedo was to live permanently in Montparnasse, and Rosalie's became one of his favorite hangouts.

But now it was Montmartre that appealed to him, and he did two things: he shed his good, respectable bourgeois clothes, and with them, somehow, both the name and the image of Dedo of Leghorn. A few men and women would still call him Amedeo or, more infrequently, by the affectionate family name Dedo, but from now on nearly everyone called him Modi. So he was known and so he has been remembered.

In time, as he became known in Montmartre, was a fixture at the Rotonde and Rosalie's, and a walking legend on the streets of Montparnasse, the name became the man with a double meaning, a play on words. Modi was a *peintre maudit,* of that class of painters wretched and accursed, doomed and damned. Modi *le maudit* . . .

When he shed Dedo and Dedo's clothes, it appears to have been a gesture of identification, for he wanted to be known as an artist. It was also a declaration of independence. He must finally have been aware of

the amused glances of the artists he had met, and he must have overheard them say that he looked more like a bank clerk, a stockbroker, a lawyer or—shame—a typical bourgeois than the artist he claimed to be. Besides, there were practical considerations: one could hardly wear a clean white starched shirt and a neat dark suit while living in a tiny, dirty room and trying to paint and do sculpture.

He needed sturdy, comfortable clothes that could be laundered easily. Something practical and informal, yet with style. Something he could wear to complement his good looks, set him apart from the others, and still show him to be the patrician and the aristocrat.

His cash had dwindled. So much remained for him to learn and absorb, he knew he would not be self-supporting for some time. Meanwhile he had to pay rent, eat, and buy art supplies. Perhaps he sold his good suit to a secondhand store; perhaps he merely exchanged it for used clothing he found on its racks.

In photographs of him about the time he arrived in Paris, he wears an immaculate black suit with the lapels high, flat, and smartly notched. His vest crosses high on his chest, all six buttons buttoned; his trousers are tapered, his shoes pointed and definitely in the Italian style. His bow tie is black, wide, and jaunty; his pointed collar armor-plate stiff; and his starched shirt cuffs peep out from his sleeves an exact quarter-inch or so. He is the rich young aristocrat with his black cape, his spats, his gloves, and even the cane that some had remembered. (See photograph, following page 192.)

Now he changed both clothes and personality. His jacket and trousers were wide-ribbed corduroy, a rust color. With them he wore a yellow cretonne shirt, a scarlet silk scarf for a necktie, and a long scarlet sash wound around his waist for a belt. He topped this off with a wonderful big black broad-brimmed felt hat. Plucked from racks, dug out of bins and odds and ends, or perhaps from the wardrobe of a bankrupt theatrical company, Modi chose and assembled his new outfit shrewdly and well. No one else ever looked quite like him; no one else wore such colorful clothing so well; and, though for a long time his art was to be insignificant, without personality, there was no mistaking this colorful "character" in the flaring black hat, the rust-colored corduroy suit, the yellow shirt, and the scarlet scarf. From a long way off he was Modi, no one else.

With the bourgeois Dedo buried, Modi left Montparnasse and the Académie Colarossi to live and work in Montmartre. His clothes did not express the man he was, only the man he hoped to be. Underneath, he was still the shy, reserved Dedo of Leghorn who thought and acted like a bourgeois, with the deference and good manners taught him by Mamma Modigliani. He wanted a place to live by himself with room enough to paint inside and outside, a private courtyard where he could do sculpture unobserved in the fresh spring air.

Montmartre was the artist's domain. The great white cathedral of Sacré-Cœur, which dominated the five-hundred-foot Butte, the highest point in Paris, had long beckoned to him. He had finally responded to its pull. After the tumult of Montparnasse and Paris proper, it was an oasis of peace, of serene, charming streets, somehow as fortress-like, as hard to approach as a mountain village in the Apennines. To reach it you took the funny little funicular at the Place Saint-Pierre and were landed right at the Sacré-Cœur. Or you could persuade a fiacre driver to make the long haul up along the Rue Caulaincourt and the Rue Lamarck.

On foot from the south you climbed ever more steeply up the pleasant, cobbled, narrow, twisting streets, starting from Place Blanche, up the Rue Lepic, on past the Moulin de la Galette (scene of a famous Renoir painting), the Rue Norvins, and so to the top, breathless and shaky-kneed, to look back on all Paris. The Butte was no longer a real country village with farms and cows and windmills still grinding grain. Now the mills had been turned into bohemian dance halls like the Moulin de la Galette. But it was rural compared to other sections of Paris, and it reminded Modi of Italy and home.

Here he saw green lawns and woodland, great trees with spreading branches, charming old houses with windowboxes bursting with flowers. Long stone walls bordered the streets, and back of them were gardens with roses, shrubs, and trees. In every direction there were inviting alleys. And it was all dominated by the huge white Sacré-Cœur. In the Place du Tertre, a village green reminiscent of a pastoral, somnolent Pietrasanta, Modi put down his things, caught his breath, and had a good look around. The square seemed to be lined with cafés, all with red-striped awnings and terrace tables. Artists and shopkeepers sat around lazily on the terraces all day, and urchins would tell the shopkeepers when they had customers.[6]

On the four benches in the middle of the square, under the feathery green of the acacia trees, men and women sat contentedly chatting, arguing, or playing chess. Modi looked fondly at the skinny little girls skipping rope, at their disheveled brothers who yelped as they tossed a ball. Stout matrons and old women lumbered to and from the community water pump with their pails. They took their time, making conversation as they awaited their turn, laughing, jostling, sloshing water. In the background all around the Place du Tertre, Modi studied the old houses and buildings, yellow or reddish, smoky and picturesque, and the various stores that sold haberdashery, papers, candy, baked goods, and vegetables.

On one side was the Hotel Bouscarat. Opposite it, on the corner, a restaurant call Spiehlmann's, and there another, called the Coucou, Mère Catherine's *tabac,* a barbershop all in pale green, and other bars, cafés, and shops. Modi was soon to become familiar with them all. He looked

curiously at an artist painting the scene. This was so familiar a sight
that no one even bothered to glance at him, much less stand behind him
and stare at his easel as Modi had seen happen so often elsewhere. The
Place du Tertre was certainly worth painting, but Modi had never much
cared for street scenes any more than for landscapes or still lifes. They
were for the Fattoris, Michelis, and the others who produced what was
there and let nature speak for them, since they had nothing to say them-
selves.

〰〰〰Chapter Six

*". . . But what is sad is that, although we have no
money, we have kept the instinct which impels us
to use it as if we had a lot. It's a matter of old habit."*

The *maquis,* a pocked and scarred waste area, extended from back
of the Moulin de la Galette to the Rue Caulaincourt, the same
general vicinity in which the Avenue Junot now runs. It was a
tangled sprawl of rubble, broken foundations, junk, garbage, matted
rosebushes, brush, and scrub growth in which dogs, cats, and rats ran as
wild as jungle animals. The maquis also had a human population, many
of them strange characters indeed, some shady, some artists who lived
alone, apart, and liked it. Their homes were a peculiar assortment of
tumbledown shacks and shanties, which they had built themselves.

This shantytown had followed on the heels of the International Ex-
position of 1889, when the City of Paris had razed old structures in the
hope of erecting new housing along the Rue Caulaincourt. The buildings
had been torn down only on one side of the street at first, with here and
there a few that were partly destroyed or were by-passed completely. The
entire project had been delayed mostly because of construction problems.
Renoir, when he lived in what was known as the Château de Brouillards
at the end of the Rue Giradon, above the Rue Caulaincourt section, used
to cross the maquis four times a day. As a boy his son Jean [1] often ven-
tured into it with his mother and their maid Gabrielle, who was Renoir's
model, to hunt for snails among the dangerously prickly brambles.

The squatters remained unmolested because the ground was too soft
for the construction of apartment houses. But by 1906, when Modi moved
in, the engineers had solved the problem by sinking piles deep into the
ground. The project was moving again, and the maquis was doomed.
The jerry-built shacks were put up without regard to the first rules of
safety or sanitation, but they were free of taxes and legal controls, and

rents were accordingly low. The arrangement was satisfactory to both sides, as the property owners were "glad to make at least a little money out of land which could not be used in any other way." The tenants were given long-term leases, and promptly erected their shanties from odds and ends of material left over from the razing and the construction going on nearby.

"The taste of amateur architecture ranged from cottage types with sloping roof and windows festooned with Virginia creeper to ramshackle cabins covered with lengths of tarred felt." Other shacks combined old lumber and rusted sheet metal and had roofs of corrugated iron, also rusted, with gaping holes plugged with rags and oilcloth. Poking about and asking questions, Modi apparently managed to find an empty shack. He claimed it for his own, rented it, furnished it within his means, and moved in. With his love of comfort and good food, it must have been hard for Modi to settle down in a ruin.

But there were compensations: he had privacy; he was unencumbered; he was free to do what he chose when he chose. And he had so much to do! At last he had a place of his own and could prepare to be the artist he had come to Paris to be. He cleaned, he patched up, he repaired, and he made his shack livable. Then he wrote to Mamma, told her where to write him, and described his new home. It was in the country, it was small, and it was convenient. He was not more than a hundred yards away from Chez Placier, a little restaurant where one could eat most reasonably. *Prix fixe, vins compris, 1 franc 25*. Now he had to go buy some painting supplies, which were as expensive here as at home (hint!), but he was well, happy, sent his best love, and would write again soon.

Modigliani had never stopped drawing, nor did he ever. Now he found time to paint inside and to experiment with sculpture outside, behind his shack, when the weather was good. He had hammer and chisel, and found workable stone in the maquis—an old foundation stone not too heavy to move, a piece of masonry the right size. He worked, he read, he ate his meals at the Placier, and he explored the Butte tentatively. The legend has it—and it may be true—that just before he moved into his "house," he met Picasso, whom he knew by sight.

Modi, still living in a hotel near the Madeleine, was sitting with friends at a table on the terrace of a café on the Place des Ternes. Along came Picasso, looking poor and unhappy, under his arm a carton, presumably filled with drawings he hoped to sell. Modi, with no money worries at the moment, felt superior to those more unfortunate than himself.

"Is that you, Picasso?" asked Modi, hailing him. "They say you have talent. Have something to drink with us." And Modi gave him five francs.

Much later, when things had changed, it was Modi who was flat broke. A friend ran into Picasso and told him about Modi's incredible state of

affairs. Both went to see Modigliani, "I've come to pay back the money you lent me," said Picasso. "Here." He held out a hundred-franc bill. As he was leaving, Modi called after him: "Hey, you gave me one hundred francs instead of five. But I won't give them back. I've got to remind myself that I'm Jewish." [2]

Modi admired Picasso even more when he knew him. Picasso seemed to know precisely what he was doing and where he was going. He neither looked nor talked like any painter Modi knew: he was casual, confident, and maddeningly self-possessed. It could be a carefully cultivated pose, yet he seemed incapable of excitement. Picasso was offhand about his work. So was Ortiz de Zarate. To Modi, art was a deadly serious business. Their attitude puzzled him. He felt that neither man looked at it with his own dedication and purpose. But both men had a strong sense of direction that Modi lacked. He had a vision, but he couldn't see it clearly. Not yet. It was out there somewhere, elusive, tantalizing, out of reach.

Goodness and piety do not make a saint any more than paint and brush make an artist. Modigliani hadn't knocked about as much as Picasso, who was three years older. He lacked Picasso's experience, toughness, realistic approach to art. Modi was all romantic, idealist. Somerset Maugham put the problem perfectly when he wrote in one of his penetrating prefaces:

> Art is a mistress who takes more kindly to the lover who chucks her under the chin than to the lover who kisses the hem of her garment. She is indifferent to morals; no excellence of motive will enable you to write a good play or paint a good picture. A lofty purpose will not serve you so well as a competent technique.

Tormented by indecision, Modi would have maintained indignantly that you could not chuck under the chin what you cared so deeply for.

From the paintings Modi had seen in Paris, especially the work of Picasso and Matisse, he must have been aware of the failings in his own. He must have realized that his technique, formed by the academic training of Micheli and the schools in Florence and Venice and rooted in his own classic background, was inadequate for what he hoped to achieve. To remedy this he redoubled his efforts in the solitude of his icy, barren cabin and examined with interest the work of other artists his own age, especially those he met in the Bateau-Lavoir and elsewhere in Montmartre.

As spring came on, the cold damp rains let up, and the weather improved. Pretty, friendly girls were easy to find in Montmartre, and, after his first Spartan months in Paris, he gladly indulged in several casual liai-

sons. They all began with the eyes—with the exchange of warm looks of appreciation, a smile, a drink, an arm-in-arm walk back to the maquis and then bed. Modi had an unerring eye for young women with good figures. Almost invariably they gladly posed for him. But he overdid it: he made them pose too long, made them turn this way and that as he sketched and sketched, and forgot about the important business of making love.

Though he was never satisfied with his work, life was better and friendlier. He had begun to settle into Montmartre and Paris. He had a questing spirit and an iconoclastic one—although it was not evident to his friends—and he exulted in his freedom. And though he reached for the new and revolutionary, he never forgot the art of Italy. Not a day passed that he did not look at the reproductions of the old masters that he had tacked to the walls of his shack. He revered the grandeur and beauty of their accomplishment, their superb technique, their magical vision. Despite the scorn of the old masters the young artists of his acquaintance expressed, Modi was inclined neither to reject nor turn his back on the past. He was certain he would never be.

But he would no more have thought of discussing his problems with his work than he would have described his love affairs. The one was as painfully intimate, precious, and private as the other. Modi was assimilating, feeling his way, getting used to the light of Paris. Nothing looked the same here as in Italy, where the light was warmer, more brilliant, more intense. Surely the light in Spain must be just as different, but light didn't seem to bother Picasso.

Modi visited the Bateau-Lavoir. It is possible that he saw Gertrude Stein sitting for Picasso while Fernande Olivier, née Fernande Bellevallée, Picasso's lovely, voluptuous mistress, read aloud the fables of La Fontaine. Perhaps Picasso had her read them to pass the time or because they seemed appropriate for Miss Stein or, more probably, to keep Miss Stein from talking. Gertrude Stein was big, bulky, and mannish, with striking, perhaps even noble, features if you liked that kind of woman. Modigliani, apparently, did not, and Gertrude Stein did not like him. (In all her writing she was to mention him once, and then disparagingly.) Modi liked women who looked like women, and Gertrude Stein, being Gertrude Stein, liked artists who did not look so much like artists.

Picasso's studio was filled with canvases, arresting, bewilderingly different, and oddly original, though hardly pleasing to the eye. Modi would have liked to study the portrait-in-the-making of the fat American woman, but there were too many people around. Modi felt a stranger, timid and embarrassed among so many people who knew one another well. He thought that Picasso was remarkable, an exciting painter who painted for himself and as he pleased. He and his paintings were pure

Picasso. Examining his own work critically, Modi saw that it was competent but that it could not honestly be called Modigliani.

Modi had written home that things were going well, but he was pinched for money, as he would be or the rest of his life. Living in the grand style, he spent most of the money Mamma had given him when he left Leghorn. What little was left he used to rent his shack in the maquis. His mother sent him money fairly regularly—we can take Emanuele's word [3] for that—two hundred francs, or forty dollars, a month, which should have been adequate to take care of his wants in Montmartre, where living was cheap. Modi's major expenses were paints, brushes, and canvas.

But Modi had nothing thrifty or frugal in his temperament. In his aristocratic, improvident fashion, it never occurred to him to stretch his money. Money was to be spent, and when Modi had it he treated his friends to a meal and to drinks. Whenever he could, he picked up the check. Modi was wholly maladapted to the practical business of living by training and temperament. If he was improvident and undisciplined, he was also wholly giving in the guileless, generous way of children and the true aristocrat.

Modi considered himself a full-blooded Jew or, as he put it, *"un juif du patriciat,"* a Jew of the patrician class, by dictionary definition, "a member of an influential and hereditary ruling class in certain medieval German, Swiss, and Italian free cities." Leghorn, to Modi's way of thinking, obviously fitted this category:

The patrician Jew is poor not only because he scorns riches, but because the feeling for money is lacking in him. This is understood. The heirs of the race of David have in their veins since birth all the splendors which money brings—and which are the object of the appetites of men today—and by this very fact they have all the beauties and all the refinements. But what is sad is that, although we have no money, we have kept the instinct which impels us to use it as if we had a lot. It's a matter of old habit.[4]

It was said of him that, in 1905, though he never had enough to eat and used coffee for his gouaches because he hadn't the price of watercolors, he walked in public like a king. He was tall, slim, slender-waisted, elegant. His eyes were uncommonly brilliant. His very gestures cast a spell on everyone. Except for the fact that Modi arrived in Paris in 1906 and that he was, then and always, short, this description may well have been true. It is interesting because it proves that already he was many different

things to many different people. People saw him as they judged him and as he would remain in their memories.

Louis Latourettes met Modigliani at the Placier restaurant through an Italian musician friend from Florence. In his wide-brimmed hat, scarlet scarf, and corduroys, Modi stood out. Latourettes was also "struck by the rather feverish eyes of the consumptive, although he was very gay, with a charming naïveté which captivated everybody." [5] If Latourettes did detect the consumptive by the shine and brilliance of Modigliani's eyes, he is the only one who ever did so.

Latourettes, Modi, and the musician friend had a glass of wine at the Placier before ordering lunch. Modi, who had just received a letter from Mamma, showed it to his musician friend and prepared to read it aloud. He began, "My dear Dedo," and broke down. Tears streamed from his eyes. He covered his face and handed the letter to the musician. Latourettes looked at Modi in amazement. Not only was it unheard of—no one *ever* displayed such sentiment—the artists in Paris had only insulting things to say about their parents. But the awkward moment passed. The three friends ordered their meal and spoke of other things.

When they were finished, Modi, ashamed of his outburst, explained his homesickness. ". . . He had only left his mother and Italy some weeks before, for the first time in his life." To Modi it may have seemed only a few weeks. In fact it was several months, and while it was true he had never been away from Italy before, he had lived in Florence and Venice for several years, apart from Mamma and Leghorn. Perhaps he was moved by the nickname Dedo, the money from home, or the reminder of his failure, of his still unfulfilled promise to his mother.

As they left the Placier, Latourettes noticed that Modi was carrying a book by the philosopher-biologist Félix Le Dantec (1869–1917). Latourettes, a poet and financial reporter, was curious. Modi, who must have boasted of being descended from Spinoza, explained. "I'm mad about philosophy!" he said. "It's in my blood."

Latourettes, who lived in the Rue Caulaincourt, often ran into Modi on the Butte. They ate together at Chez Placier and A La Maison Vincent, a restaurant on the Place du Calvaire that had an Italian cook. Modi drank only wine, Vouvray, or Asti, and then in moderation. He showed himself a well-read, intelligent young man with a brilliant memory. Together they took many evening walks on the terrace of Sacré-Cœur when Modi recited long passages from Leopardi, Carducci, and especially D'Annunzio. It also pleased him to show his knowledge of Shelley and Oscar Wilde. To the surprise of Latourettes, Modi differed from other artists in refusing to talk about art. He probably felt too uncertain to talk about his own painting, too unqualified to discuss the work of his contemporaries and, having heard that his contemporaries

had to say about the classic painters, reluctant to expose his reverence for the old masters. He was shy and insecure. Poetry and literature were safer subjects.

Modi's friends in Leghorn had smoked and Modi had enjoyed it. But smoking had made him cough and, after Mamma had said it was bad for his lungs, he seems to have given it up. Now, in Montmartre, he smoked an occasional cigarette when a friend offered him one, and from time to time bought a pack.

But sculpture made him cough even more than smoking. He would chip and hack away at stones behind his shanty, stop to rest, then find himself coughing from the fine, abrasive dust that he breathed in. He would have such spasms of coughing and they were so persistent that he was frightened. He had such painful memories of his hemorrhage in Leghorn that he would go back to painting, sometimes using the neighborhood children as models. They were grubby, ragged, runny-nosed kids, too restless to stay quiet very long. They became deadly serious when they posed; their mischievous eyes would dull, smiles would vanish, and there they would be—grim, haggard-faced, tragic. Modi gave them few directions. They would remain frozen until he was through. When he gave them fifty centimes for candy, their smiles again transformed their faces.

The young women were better models. They didn't mind being posed and shouted at. Most of them stayed on to talk, cook a meal for Modi, and make love. Occasionally, as he had in Venice, he visited the brothels of the Rue Giradon, and drew there. But he favored the girls of the quarter who took in laundry. No matter how primitive his surroundings or how mean his life, Modi took pains to look neat and clean. Fastidious by nature, he shaved and bathed every day after work in a basin of cold water. He hadn't much of a wardrobe, but it was washed and mended regularly. So was his linen.

Modi found the services of these amiable laundresses quick and cheap. They were humble, understanding women, attractive for the most part, with good, sturdy bodies. They made fine models, posed gracefully and unself-consciously, and made love the same way. His attentions flattered them. Modi was as handsome as a god, kind, sweet, romantic. Practical girls, unsophisticated girls, lonely girls, girls with no future except laundering and more laundering until both their coarse red hands and their stringy hair were bleached white, how could they help loving Modigliani?

Modi scoured the maquis for wood and sculptural stone. Firewood was scarce, and so was good stone that was small enough to be moved. He became friendly with the workmen who were putting up the new buildings. Perhaps a quick on-the-spot portrait-sketch or two, or even a bottle of

cheap table wine, and they located some good stone for him, hid it conveniently out of sight in some bushes, and even loaned Modi a wheelbarrow to trundle it home.

Modi always liked odd characters and made friends with them. One of the choicest was a man called Deleschamps, who was a poet-coachman, furniture mover, and junkman, and apparently lived near Modi. Deleschamps had a habit of scribbling his verses on a slate that hung outside his shack. An ardent patriot, he wrote doggerel extolling Joan of Arc, "and he refused to move furniture for anyone he suspected of being antimilitarist." [6] Jean Renoir said his father described Deleschamps, or Deléchamps, as looking "like Rodin, but with 'more of a beard'—rather a difficult feat!" He raised pigeons, and had trained them "to fly in formation over Montmartre." When the Renoirs returned to Montmartre after being away for some time, the old man released his pigeons in honor of their return. Only a dozen were left by then and, as a true patriot would have it, four were painted blue, four red, and four were a natural pigeon white. Modi and he became great friends and often drank together in a nearby bistro. Deleschamps greatly admired Modi; he was deeply impressed by his fluent knowledge of poetry and philosophy. But Modi uncharacteristically took advantage of his friend. When the coachman was away from his shack, Modi sneaked over and erased the verses chalked on the slate. And, when Deleschamps came home and blew up at the desecration, Modi would "wriggle with laughter at the Jovian threats of the exasperated poet, who menaced with murder and sudden death everybody in the Quarter—except Modigliani!" [7]

In the Bateau-Lavoir, Picasso, their acknowledged leader, haphazardly presided over the circle that always congregated in his studio. Art, along with poetry and literature, was discussed, analyzed, and reanalyzed by these positive, opinionated, volatile, outspoken individualists. They must have fascinated Modigliani, especially Picasso. They created, produced, experimented. They were so immersed in their work, in the wonderful business of being young and alive and trying out their ideas, that it never occurred to any of them that they *were* the vanguard. Revolution was in the air, and they were all revolutionists.

The Bateau-Lavoir, which was to become a legend as the incubator of Cubism, was a big, sprawling, sway-backed ruin of a building at 13 Place Ravignan, which was to become Place Emile-Goudeau. (See photograph, facing page 193.) The home of artists and writers since Gauguin's day, its origin had been lost in time. It may have been a factory, certainly an impractical one, as it slumped atop the Butte dominating its small square, a gloomy, dingy pile of bare wood, worn timbers, glass-fronted warrens, and pigeonholes.

Apparently the imaginative Max Jacob had christened the building the Bateau-Lavoir because of the washing boats or laundry barges that were tied up along the Seine. The shaky, run-down structure creaked and swayed in the wind as the barges did in the river and, like them, it was entered from the top, the third floor, then down some ancient wooden steps, and into a subterranean double hallway angling crazily into a labyrinth of cubicle studios, each with a name on the door.

As in other Paris tenements there was, of course, no electricity, gas, or central heat. But the rent was cheap. Besides artists, the barren little rooms housed tailors, seamstresses, workmen, clerks, and a group of prostitutes. Once inside the Bateau-Lavoir, one could get lost, but down the winding, twisting, dark hallways, down to the right, up to the left, and over to the side, most of the traffic led to Picasso.

> . . . A largish room, dirty, curtainless, and in disorder. Unfinished canvases are propped against the walls. A small rusty stove, on which is a yellow earthen basin, serves as a washstand. A towel and a bit of yellow soap lie on a table among tubes of paints, brushes and a dirty plate containing remnants of a hasty meal. In one corner a small trunk, painted black, forms an uncomfortable seat. In another are a mattress on four small feet, a straw-seated chair, and easels. On the floor there is another litter of paints, brushes, bottles of paraffin. In the drawer of the one table lives a white mouse, which Picasso has tamed, looks after lovingly, and shows to everybody.[8]

Picasso no doubt impressed Modi more than anyone he had met because he was securely his own man, always developing his art, never repeating himself, always reaching out, changing, advancing. Never giving a damn, either, what anyone thought.

La Bande à Picasso, his gang, his club, had a varied and colorful membership, with new additions every day. There were also occasional visitors, friends of friends, and an assortment of strangers and hangers-on, who sat around, said nothing, and never returned. No one knew who they were, or cared. Picasso's studio had movement, action, pretty women, interesting conversation, and lively argument. Among the regulars were such painters as the bulky, muscular André Derain; the big, athletic, brusque Maurice Vlaminck (these two were good friends, Modi learned, and presently Fauves, under the influence of Henri Matisse whom Picasso had met at Gertrude Stein's, and who was also a visitor at the Bateau-Lavoir), and the cocky, elegant, Christ-bearded Cornelius Van Dongen. In time they would be joined by Georges Braque and Juan Gris, but now there were many Spanish friends of Picasso, either painters or sculptors— Manuel Manolo Huguè, Ignacio de Zuloaga, Paco Durio, Pablo Gargallo, Ricardo Canals, Ramón Pichot, and Angel F. de Soto.

Henri Laurens, another sculptor, tall, horse-faced, and solemn, was often there. So were other painters, writers, poets, and critics—Louis Marcoussis, Max Jacob (Picasso's one-time roommate and closest friend), Francis Picabia, Pierre Mac Orlan, André Salmon, Maurice Raynal, Pierre Reverdy, Roland Dorgelès, Paul Fort, the stout and impeccably-dressed Guillaume Apollinaire and his demure painter-sweetheart Marie Laurencin, and many, many others. Maurice Princet, mathematician extraordinary and financial expert, was another regular who lived in the Bateau-Lavoir. So did Van Dongen, Mac Orlan, Salmon, and Reverdy at one time or another.

The incredible and iconoclastic Alfred Jarry, who lived his stormy creations, also took a prominent part in the *Bande*. A poet and playwright, he was an alcoholic, a dope addict, and "wicked" by carefully cultivated reputation. One can imagine the still shy and innocent Modigliani being rather frightened of the cutting tongue of the brilliant and obviously mad Jarry. His language was foul, brutal as his writing, but his intelligence and imagination hypnotized his hearers, who had to agree with him that "Talk about things that are understandable only weighs down the mind and falsifies the memory, but the absurd exercises the mind and makes the memory work." [9] The Jarry legend started young. His was the first play to use the word *merde* on the Paris stage, in the first scene of his obscenely scandalous protest play *Ubu-Roi*, written when he was only fifteen. Now Jarry was Ubu-Roi himself, King Merde.

Sooner or later, everyone of consequence found his way to Picasso's studio: Gertrude Stein (some Frenchmen were already disrespectfully calling her "*cet homme-femme*") and her equally odd brother Leo; the actors Gaston Modot and Harry Bauer; art critics; almost anyone in the arts who could perform, produce, or contribute anything to the discussion. These young revolutionaries were happily overturning academic applecarts to create a new art world of their own—a twentieth century art for a twentieth century world.

Some of Picasso's band had qualms. Derain had written to Vlaminck in 1902, "*Nous n'avons ni à nous créer une nouvelle littérature, ni à découler d'un nouvel esprit. . . . Nous sommes des blessés des temps nouveaux.*" (It's not up to us to create a new literature, nor to proceed from a new spirit. . . . We are the wounded of the new times.) Picasso believed just the opposite, that the new century called for a great new nonrealistic art and that it was perfectly possible for the new artist to produce it. Picasso was to ask the same question as T. S. Eliot's Prufrock, "Do I dare disturb the universe?" but unlike Prufrock, who did *not* dare, Picasso and his friend Apollinaire were as eager to disturb it as Rimbaud before them. It was no wonder that the gang clung to Picasso, looked to him for reassurance and leadership. And his experiments—queer, ghastly,

childish, pink, blue, or whatever—were landmarks on the road ahead. Max Jacob said that Picasso and his friends "were determined to make many voluntary pastiches to be certain not to make any involuntary ones." [10]

A pastiche by definition is an imitation of sorts—of a work of art, literature, or music consisting of motifs borrowed from one or more. Modigliani, innocently searching for his own art, was also turning out pastiches at the time, but they were neither conscious nor voluntary. They were derivative and the best he could do, admittedly experiments, but at the same time discouraging failures. The paintings he saw at the Bateau-Lavoir and the talk he heard must have been deeply disturbing.

Modi was friendly and had friends, but few intimates. He was a loner in his early days on the Butte and he remained one. He saw no one regularly: he appeared at the Bateau-Lavoir, mostly to listen, and then disappeared. No one particularly noticed him either. He drank only a little wine, was quiet and subdued and—of all the judgments he would have hated—seemed bourgeois to his friends.

They were aware that Modi worked hard, although none of Picasso's gang ever saw him at work. His love affairs were talked about. His extraordinary good looks made him very popular with women and, as a consequence, he was often involved in jealous fights or arguments with other men over girls. Small and not especially belligerent, Modi, however, was always ready to fight any man who resented his attentions to a girl. He seems to have more than held his own in the frequent quarrels that broke out in the Lapin Agile and the Moulin de la Galette.

The way he flaunted his liaison with Madeleine, nicknamed Mado, who, according to Latourettes, had been Picasso's model and mistress two years earlier, makes us suspect that his admiration for Picasso was perhaps mixed with resentment. Mado, a svelte, seductive blonde, had been succeeded in Picasso's affections by Fernande Olivier, and apparently spurred Modi to an abundant production of painting. At one time, portraits of Mado could be found in the output of both Picasso and Modi.

If Modi was abashed, intimidated, and on the defensive at the Bateau-Lavoir, the gang accepted him with tolerant amusement. He was welcome to their informal meetings, but he was not of the preferred inner circle, by choice and attitude. Besides, there was the damning fact that he had not paid his symbolic membership dues: he had neither espoused nor produced anything new; worse, he had not repudiated the past. The few times he raised his voice, he defended the academicians and was lyric in praise of the lord masters. *Au fond* a reactionary, a confused dillettante. But if the gang couldn't take him seriously, they couldn't help liking him.

Being polite, neat, and reserved became him. When he did speak up, his remarks were often witty and pertinent; his command of poetry and literature was undeniable; his charm and gaiety were infectious. His pride, his insouciance, his high spirits, even his theatrical arrogance were endearing and amusing. Not an insider, no; nor yet an outsider. One had to be careful not to patronize this sensitive young man.

But the gang were doers and, with few exceptions, tough-minded, obstinate, resourceful, and sure of themselves and their ideas. It was all right to talk, strike poses, dress like a bohemian, break the hearts of susceptible women, but, if you were an artist, sooner or later you had to produce. As Modi mingled more and more on the Butte, his friends had increasing opportunities to evaluate him. And their verdict was clear: He would quickly fade out of sight. He fitted the traditional pattern of drink, women, near starvation. It was in the cards, inevitable. Modi was getting by now, but you could tell already . . . The proof? He was doing so damn' little, turning out even less.

But they were dead wrong. Working in exhausting spurts, Modi was at it every day, chipping away at the stone back of his shack or painting portraits—of a wistful neighborhood child, of a stoical laundress, of a passionate, voluptuous girl like Mado. In those early years on the Butte, Modi worked unremittingly; he was so absorbed, so intent that he drew all morning, all afternoon, all evening, and often all night by the light of one candle. During these frantic round-the-clock periods, Modigliani was turning out as many as one hundred to one hundred and fifty drawings a day,[11] in an intense search for a competent technique, a sure line, and a flowing style. He did not suddenly emerge as an incomparable master of drawing; it was something he worked toward indefatigably. It explains his achievement in that field; it also explains why the critic Claude Roy could write:

> . . . If some cataclysm had deprived the world of all Modigliani's paintings and spared the drawings, the latter would certainly have assured him a front-rank place as a superb interpreter of human bodies and faces, midway between Matisse and Picasso. Modigliani's drawings, portraits and nudes, all alike give that impression which is basic to the enjoyment of great works of art: a sense of fine economy. For in the last analysis all the qualities we most admire—elegance, concision, suggestive power and penetrating insight—sum up to this. Modigliani is one of the supremely gifted few who seems to say everything with next to nothing; in whose works a simple line, a brief allusion, a faintly indicated gesture suffice to bring before us all the infinite, incredible profusion of human life.[12]

"My damned Italian eyes are to blame."

I ndividually, the artists in the Bateau-Lavoir were not so formidable as they seemed in Picasso's studio, and bit by bit, Modi got to know them well as he drank with them and went to their studios to look at their work. He liked them though they were more advanced than he. They had also lived in Paris for a longer time. Of the group, it was perhaps Max Jacob, so gentle and considerate when he wished to be, who first cultivated Modi as a friend. Perhaps Max sympathized with Modi's indecision, sensed his gift; perhaps he was drawn to Modi because they were both Jews who had repudiated their faith; or perhaps, as Fernande Olivier wrote of Max, "his instinct drove him hard toward all that was pain and torment." [1] Modi had the same instinct.

Max Jacob was a pale, stooped, craggy-faced, sharp-nosed balding man who looked much older than his thirty years. He had an obvious distaste for women. Because of this and the fact that he had so many feminine qualities himself, women often provoked and teased him. He was glib with them, and too polite. Max once said to André Warnod's girl friend, "I'd like to be a carpet so you could rest your feet on my poor old ribs." [2] The girl was *toute pantoise*, absolutely astonished.

The son of a Jewish tailor and antique dealer, Max Jacob was born and brought up in Quimper, Brittany, where he had an unhappy childhood and had reportedly attempted suicide several times. At eighteen he went to Paris and barely managed to support himself at a succession of odd jobs, including teaching the piano, clerking in a shop, baby-sitting and caring for children, and as art critic for a little review called *Le Moniteur des Arts*. An early supporter of Picasso and a close friend, they had lived together in a two-by-four room with one bed. Picasso painted during the night as Max slept, then went to bed during the day while

Max was out working. They were an ironic and melancholy pair with a taste for disquieting people and a love of nonsense. Max earned a reputation for his hilarious parodies, miming, and buffoonery. A fine poet, he also painted exquisite watercolors and gouaches. He had an abrasive wit, a brilliant, literate mind, and a magnificent reading voice. *La Bande à Picasso* listened entranced as he read Verlaine aloud to them. Modigliani was bound to respect and admire a man of such talents and contradictions.

Max was also a homosexual, an ether addict, and a religious fanatic. He was a Roman Catholic convert, and had become deeply religious, eagerly looking forward to his acceptance and baptism in the one true church, and to converting others to it. He was sincere and ready to suffer for his religion. Once, in a dubious bar on the Rue Lepic, the ebullient Max did his best to convert a prostitute. But his proselytizing was misunderstood. A big Negro went to the defense of the beleaguered lady, and broke both of Max's thumbs. Max was also adept at fortune-telling with cards, predicting the future, and playing the mystic. He was supposed to have foreseen the earthquake and fire that gutted San Francisco in April, 1906. It seems that Max had met a San Franciscan in a restaurant and was preparing the man's horoscope when he turned up a certain black card. He had fled the restaurant in horror and rushed to the first church to pray. . . .

His homosexuality was a small matter: Paris, Montmartre especially, was full of queers, pimps, lesbians, thugs, apaches, murderers, whores, and perverts of every kind. No one raised an eyebrow at them. They were human beings, weren't they? And perhaps a little extraordinary for the very difference that raised them above the common ruck.

Max, when Modigliani knew him, shared a tiny littered room near the Bateau-Lavoir at Number 7 Rue Ravignan with another poet and painter called Elysée Maclet. The latter claimed that Max spent his nights keeping a vigil at the Sacré-Cœur from eleven until four in the morning, while Maclet slept in the single bed. Max apparently slept little. The dark room, facing an inner courtyard into which Max's neighbors threw garbage, reeked of ether, incense, and the fumes of a smoky kerosene lamp. There was one table, which was both desk and easel, and the walls were bare except for the signs of the zodiac done in green and pink chalk. Max gladly brewed coffee for his guests on a paraffin stove and was a remarkable host, for barren and miserable as the room was, it sheltered an extraordinary presence. The place "was somehow unique; one felt that an intelligence had taken refuge there." [3]

Max was a man of the world and often went out in society, sporting a monocle, a high hat, and a frock coat that was too big for him. He held a reception once a week at which he read his own poetry and led the con-

versation. When the tenants in the building complained about the smell of ether, Max assured the carping old ladies it was apricot brandy.

It was Max who brought home the erring sons of distraught mothers in the quarter. The grateful women tried to press money on him, but Max refused it. They did manage to leave a few coins hidden among the pages of his manuscripts spread about his dirty little room. Max, who was so poor himself, always gave the money to his own poor in the street.

Though Max bought his ether secretly, it was easy to buy. Flagons of it could be bought from any pharmacist for thirty centimes—very reasonable for an anesthetic, a drug, and a poison. Compared to sophisticated opium, it was a cheap drug for kicks. It went down easily enough after the initial fire and cold shudders, and left the drinker feeling elated and happy . . . then a quick sleep and pleasant dreams until, suddenly, one awoke in torment to a terrible night and an agonizing hangover all the worse for the aftertaste.

Sometimes early in the morning as Picasso's gang—sometimes with Modi along—came out of the Lapin Agile after it had closed, hilariously drunk and tired, Max talked them into following him into the cathedral. One can see the sodden crew lurching into the great, silent, gloomy basilica of Sacré-Cœur where Max would kneel to say his prayers in the Chapel of the Virgin "much to the astonishment of his pals, for this was invariably after an orgiastic night of mixed ether and alcohol." [4]

What did Max and Modi talk about? Certainly art, literature, poetry, philosophy, and Pablo Picasso, and perhaps Gertrude Stein, who was one of the few who understood the moderns and admired their extraordinary art. Max Jacob knew Gertrude Stein and could not have been unaware of the promotional value of this comparatively rich and increasingly influential American woman as the patroness of modern art. While it is hard to say what Max really thought of her, Gertrude's opinion of Max has been recorded by Alice B. Toklas, Gertrude's secretary-companion-shadow. It appears that Max had done a barefoot solo dance at one of Gertrude's parties and scandalized some guests. "Gertrude had not liked Max Jacob in those days. He was untidy and possibly dirty. Gertrude did 1ot like his humor." [5]

Gertrude's own unkempt appearance aside, it was no wonder that nearly all the artists were untidy and possibly dirty—in the entire Bateau-Lavoir there was one water tap for all the occupants, and no sanitary facilities whatsoever. (On the occasions when Max saw Modi, however, he had the impression that Modi somehow managed to shave and wash. He always looked well groomed.) As for Max's pungent humor, Gertrude was a prude, a bourgeois at heart; essentially humorless, she took herself very seriously.

Gertrude was Jewish, like Max and Modi. Like Max, however, she ig-

nored the fact and Judaism itself. Though he had attended services and made his bar mitzvah, Modigliani, an agnostic at best, and never a practicing Jew, was increasingly conscious of his Jewishness and more and more interested in Judaism. Certainly Max and Modi talked about being Jews. Even after the Dreyfus affair, strong anti-Jewish sentiment was prevalent in Paris: the best evidence was that people read the debased Edouard Drumont, who was still writing vicious anti-Semitic newspaper articles. Max was indifferent: his spirit suffered enough without inflicting journalism on it. But he was insistent that Modi make his peace with God, join the Roman Catholic Church as he had. After all, one must look toward salvation; one must believe in something.

As for Picasso and his Bateau-Lavoir friends, it was essential only that each know what he believed. One must know oneself above everything. Modi shrugged. Max wanted to see Modi's work. Modi had little to show and was dissatisfied with what he had done. He changed the subject.

Max has heard Modi praise the old masters. Modi seemed not to know that was close to heresy. Had nothing Modi had seen in Paris affected him—Lautrec, Gauguin, Van Gogh, Matisse, Picasso? Max asked. Oh, of course they had! He was troubled, moved, overwhelmed. But the old was part of the new. The others didn't understand that the past was alive, so much alive that it was the foundation on which Modi worked. What he was doing now was not what he wanted to do; but when he found his way, it would be the old *and* the new. It would be Modigliani as Picasso's work was Picasso.

Max had heard that whatever medium Modi chose, whether he drew or painted or chiseled in stone, his subject was always people. Did he think a subject was so important? During the course of their many talks in the Bateau-Lavoir, Max and Maurice Raynal had agreed that "the true subject of art was the idea in general and not life's peculiarity." [6] Picasso and his fellow painters felt the same. The great movement was away from Symbolism and romantic sentimentality toward a style that was impersonal. As Max later said in his *L'Art Poétique:* "The subject has no importance and the picturesque none either."

For Modi, only people mattered, their heads, their faces, their bodies. He wanted to put a searchlight on the person. In a nude the uncovered body was as expressive and meaningful as the face itself. People, then, Max—the wonder of them, the secrets back of the eyes, the brave fronts, the attitudes, the dreams, the ordeals, the damnations . . .

Perhaps Max understood what he meant. But there was no use commenting on Modi's romantic posturing, his sentimental thinking, his idealistic concepts. He really couldn't tell until he'd seen Modi's work. He was interested and he had dropped enough hints, but no invitation to visit Modi's shack was forthcoming.

Louis Latourettes, who saw Modigliani at the beginning, middle, and end of his nearly fourteen-year career in Paris, was apparently one of the few people invited to visit Modi's "studio" in the maquis, possibly because he was not an artist and had neither hinted nor asked to come. Latourettes found the ramshackle wood-and-corrugated-iron hut in a state of wild disorder, the walls covered with sketches, a few canvases on the floor, several sculptures in the corner.

The furnishings were "a couple of rush-bottom chairs—one with its back broken—a makeshift bed, a trunk used as a seat, and a tin basin and jug in one corner." A discerning man, Latourettes was immediately interested and soon convinced that Modi "had lots of promise but felt that, in general, the artist was rather uncertain of himself and fumbling for a road he had not yet found." Modigliani agreed with him.

"My damned Italian eyes are to blame," Modi told him. "Somehow they can't get used to this Paris light, and I often wonder if I ever will. But you can't imagine what I've conceived in the way of colors—violet, orange, dark ochre . . ." He gestured around the studio. "But none of this stuff is any good. All junk!"

Latourettes exclaimed in protest and pointed to some sculpture, a torso of the pretty actress who recited at the Lapin Agile.

"Ah, that's no good either. Just a misfire. Picasso would give it a good boot if he saw it."

Modi confided to Latourettes that, with the exception of Picasso, the only other painter he admired was the Douanier, Henri Rousseau. Modi was not encouraged by the comments of Latourettes, and when they saw each other again Modi told him he had destroyed all his work except for the statues and a few drawings. He had been doing some critical self-analysis and had reached some conclusions.

"One should judge without sentimentality," he said to Latourettes. "But, after all, that's only to begin in another and better way. In any case, I've half a mind to chuck painting altogether and stick to sculpture, which I prefer." [7]

He may have been receiving his allowance from home and he may have been spending it the minute he got it, but Latourettes remembers Modi as already being wretchedly poor. He peddled his drawings around Montmartre and he struggled to find commissions for portraits. He was paid next to nothing for his efforts.

What is striking is that even when Modi was desperate for money, when his poverty made his life almost unbearable, it never occurred to him to do anything but paint, draw, and sculpt.

Max Jacob took on dozens of odd jobs and wrote art criticism to support himself. Van Dongen sold newspapers on the street, sketched at the Moulin de la Galette, and drew for the newspaper *L'Assiette au Beurre*.

Vlaminck spent the night as an employee of the Decugis firm at Les Halles. Almost all the young artists in the Bateau-Lavoir struggled to find some means of support outside their art. Picasso was one of the few who never had, but he sold occasionally and now had promising patrons in Gertrude Stein and her brother. Matisse, as head of the Fauves and selling ever more successfully, was to have his own art school.

But Modigliani had come to Paris to be an artist and was temperamentally unable to do anything else. He had told Mamma that he would work hard, establish himself, become famous, and repay her all her money and reward her sacrifice. Nothing would stop him.

Latourettes is also the source of perhaps the most often-repeated story about Modigliani. He and Modi were having lunch at Spiehlmann's, a restaurant on the Place du Tertre. Other friends joined them on the terrace and talked of painting. Modi only listened. All the while the party at the next table talked so loudly it became impossible to ignore them—vehement young men given to shouting and table-pounding. And it was plain that they were dedicated Royalists and virulent anti-Semites. Their clichés and catchwords were poisonously familiar, typical of the diehards who mourned for *La Patrie,* which had suffered such a humiliating defeat by the Germans in 1870 and was still being defiled by maggots like Dreyfus and the rest of the Jews. They wanted power, a strong leader, and death to the Jews.

Modi's companions heard them, shrugged, and tried to carry on their own conversation. Modi fidgeted in his chair, looking daggers at the young men. Suddenly, he had had enough. He bounded to his feet, bolted to their table, and stood over them—a small, enraged man, shaking with passion, his fists working like a boxer's, his lips drawn back over his teeth in a snarl.

"I'm a Jew and—*je vous emmerde!* You bore the hell out of me with your dirty talk!"

Modi wanted to fight for his people, alone if he had to, no matter what the odds. No doubt his friends calmed him down. There was no fight. The Royalists, cowed by his ferocious passion, changed the conversation or left. But Modi's friends saw a new side of the quiet young Italian.

One of Modi's haunts was the Lapin Agile, a place of frantic, continuous talk, drink, music, and entertainment. Picasso's gang could be seen there almost any night except Tuesdays, which was reserved for the crosstown excursion to the Closerie des Lilas in Montparnasse for the poetry reading presided over by Paul Fort, known as the Prince of Poets.

The Lapin Agile, on the corner of Rue Saint-Vincent and the Rue des Saules, was a rustic cottage dating back to the end of the sixteenth century. Originally, it was "a shooting-box, built to the order of Henry IV,"

and later "the rendezvous of a band of highwaymen who infested the roads to Paris." As Paris spread to envelop the rural Butte, the cottage part was tacked on to the shooting-box, and "the place became a country pub, known as 'Ma Campagne,' ill-famed on account of its frequenters, who were mostly apaches and their women." Then, in the 1880's, Mère Adèle, a well-known inhabitant of Montmartre, took it over and called it Les Assassins because a local artist with a sense of humor had painted bloody underworld scenes on its walls. So the little tavern went on, Montmartre's artists mingling happily with gangsters and thieves, until 1903 when Aristide Bruant, "the chansonnier of the Butte," bought the place and leased it to Frédéric Gérard, known to one and all as Frédé or Père Frédé.[8]

The Lapin Agile (Agile Rabbit), derived its name from a former tenant, one André Gill, art teacher and political cartoonist. "Gill's studio had a rabbit painted over the door and was known as Le Lapin à Gill. . . ."[9]

Frédé was something of an artist himself, having studied at the Collège des Arts et Métiers. An actor and showman at heart, however, he preferred running a tavern for artists, of whom he was genuinely fond. He began with a spot he called Le Tonneau, then in the 1890's moved to La Zut, a carbaret on the Place Jean-Baptiste-Clément. The cabaret did poorly financially, but its owner found an original way to supplant his meager income. He peddled fish and paintings through Montmartre in a little cart pulled by a donkey called Lolo, who was soon to become as famous as its owner.

With the cart draped with seaweed garlands and paintings, Frédé followed "the patient Lolo . . ." as she "plodded up and down the narrow streets," yelling, " 'Fish and pictures!' " playing a guitar accompaniment. Frédé, then and later as owner of the Lapin Agile, looked and dressed, according to André Warnod's description, as a combination Santa Claus and Robinson Crusoe. He wore a tasseled stocking cap on his big head, and his bushy beard and mustache turned whiter every year. He was altogether glorious in his scarlet fringed vests and gaudy pantaloon trousers.

Outside, in front of the Lapin Agile, stood a few benches; in back, in what had been a little garden, was a table where customers ate and drank in good weather. But all the action was inside. Here over the door in heavy chalk was printed, "Man's first duty is to have good digestion," and further on was inscribed, from Rabelais, "Better to write of laughter than of tears." The Lapin was small, smoky, noisy, and as dimly lighted as any Montmartre street where gangs of apaches roamed. Because of this, Frédé kept an old pistol handy, and had already used it to keep thugs out of his cabaret. He also used it to break up riots.

Members of the underworld still came to the Lapin; their presence added spice and danger. One winter evening, a tough named Petit Louis put his razor to the throat of Henri Valbel. Another time some ruffians broke into the Lapin, put all the lights out, and started fighting and shooting. Frédé, ready for anything, shot and killed a man in the mêlée. But the Lapin was ordinarily a place of high spirits, constant singing, nonstop drinking, and inimitable entertainment. Its fame spread to Montparnasse, and artists trooped over nightly as if attending a private club presided over by Frédé.

The little cabaret had a small bar, and next to it, the long, narrow main room, filled with long tables, bare boards that were battered and shaky on their legs, splotched with wine stains, cigarette burns, nicks, carvings, gouges, and heel marks. Rush-bottomed chairs were set along the tables. A massive plaster statue of Christ on the Cross by a young sculptor named Léon John Wasley dominated the room and served as hat and coat rack. To its left in the corner was an enormous life-sized statue of Apollo playing his lyre; to its right on the wall, a huge, Indian Buddha-like bas-relief. (See photograph, facing page 193.) The walls were chockablock with framed poems, sketches, testimonials, souvenirs, gaudy posters for balls given by artists, and paintings. The outstanding painting was one of two Pierrots by Picasso. Much had been made of its presentation to Frédé, who later, according to André Warnod, sold the painting to Rolf de Maré of the Swedish ballet for five thousand francs. To one side of the main room was the little kitchen, the domain of Berthe, chief cook, house mother, and Frédé's wife. Another side room was supposedly reserved for members of the Lapin's inner circle.

The rule in the Lapin was *"Buvons un coup!"* and no one ever held back. They were all young and had no time for second thoughts. Gifted poets like Gaston Couté drank until they passed out. They were revived, stood up so they could recite more poetry and earn another drink or two before they passed out again. One night word reached the Lapin that Couté was dead—dead of drink, they all knew. "Man overboard!" the gang exclaimed.

Berthe would come out of the kitchen to take orders, and Victor, son of the cook and master of the follies, tended bar and helped wait on table. Picasso's band sat together, and with them, quiet, watchful, drinking only a little wine and smoking an occasional cigarette, was Modigliani.

Sooner or later during the evening Lolo, the donkey, was brought in, greeted with cheers, petted and fed carrots. But the plunking of Frédé's guitar was the heartbeat of the Lapin. In the middle of the floor, astride a bench or riding one of his famous barrels, he launched into his repertoire after announcing *"qu'on allait faire un peu d'art!"* The favorites were all bawdy, among them the marvelously disrespectful "Merde pour

le Reine 'd Angleterre," "Les Temps des Cerises," and "Rose Blanche." The Lapin's host had a distinctive, heartbreaking singing style. As he twanged his guitar, he sang with such an ecstatic inflection and so swooning a languor that a little death touched his listeners.

When Frédé stopped for breath, the others filled in with acts of their own: Jehan Rictus reciting poetry; Pierre Mac Orlan singing. One would think that Modi might have contributed stanzas of Dante, Leopardi, or the other poets he knew so well, but he was still shy and self-effacing, much more listener and observer than participant.

It was at the Lapin that Modi may have met Maurice Utrillo for the first time, a thin, dejected-looking young man who was to be his close friend. Utrillo joined Picasso's table, was greeted amiably, and a place was made for him at the long table. He was meanly dressed, his black hair long and uncombed, his eyes sunken and bloodshot, and his lined face, with its untidy mustache, scabrous and dissipated. He was very drunk, but there was something familiar about him. Modi might have seen him, as André Warnod had, painting on a miserable piece of cardboard on some street corner of the Butte, oblivious to everything around him. Or perhaps Utrillo was screaming drunk, trying to attack the *patron* who had refused to serve him. Or he may have first seen him passed out in a gutter.

Maurice Utrillo was the son of Suzanne Valadon, a fine painter herself, and once Renoir's model. He'd never had a lesson in his life, but painted amazingly well. His primitive style was like the Douanier Rousseau's, though they didn't paint the same things: Maurice always did Montmartre scenes, rarely with people. Frédé had taken some of his paintings as credit and hung them on the walls of the Lapin. Maurice would do anything for a drink. At twenty-three, he was already an alcoholic wreck.

Modi looked at the paintings. It was hard to see details in the blue-thick smoke and dim light, but he could see that the Montmartre scenes were done with dignity and strength. Though the colors were muddy, too thickly applied for Modi's taste, and the brushwork rough, the work was remarkable. Modi couldn't take his eyes off Utrillo, who sat slack and stupefied.

Drunk as he was, head lolling, mouth slobbering, hands shaking so that he could hardly bring the glass to his lips, Utrillo continued drinking. No one dreamed of stopping him. He listened intently to each speaker, clumsily turning toward them, straining to understand what they said. Modi pitied him.

Now Utrillo was on his feet, lashing out at Derain and Vlaminck, who hurriedly jumped up.

"You fuckers know nothing about painting! My mother Suzanne

Valadon and I—we're the greatest painters in the world! And you're full of shit, all of you!"

Hardly anyone in the Lapin looked around as the powerful Derain and the rangy Vlaminck easily subdued the clawing, shouting Utrillo and carried him outside. The singing, the drinking, the entertainment, the arguments, went on without a break, but Modi had been disturbed by the outburst. His friends explained that it was routine: Maurice fell asleep, passed out, or got crazy-drunk, as he just had, and made a scene. In any case they always saw that he got home. The poor fellow wanted to be one of them, but he couldn't. He had a mind like a child's—in fact, everything about him was childish except his drinking and his painting.

It was also at the Lapin Agile that Ludwig Meidner, the German painter, first met Modi. Meidner's reminiscences provide a revealing glimpse of Modigliani during these early Paris years. Meidner, born in a Silesian village, went to Paris for essentially the same reason as Modigliani and so many other foreign artists, and like another famous German artist, Oskar Kokoschka, Meidner's early work "coincided with the spiritual lassitude of the years before the First World War. . . . He was another who saw the period as a dying thing, although his reaction was not the fatigued vision of his more precious contemporaries but one of analysis and prophecy." [10]

Modigliani had felt the spiritual lassitude in Italy and had fled from the tired vision of his contemporaries. Meidner and Modi, who were the same age, had much in common, and were attracted to each other. In addition to being a foreigner and newly arrived like himself, Modi found it much easier to talk freely and uninhibitedly to Meidner than to other members of Picasso's gang. Besides, Meidner shared his reverent admiration for the old masters.

Except for Louis Latourettes, Ludwig Meidner seems to have been the only friend to visit Modi's studio in the maquis. The place was ugly and depressing, but Meidner says that he always liked to go there because it had an artistic atmosphere and he was never bored. In 1906, and until 1908 or 1909, Modi was not yet a drunkard or somber, cynical, and sarcastic as he was later on. He was lively and enthusiastic, high-spirited and imaginative, though moody.

Meidner, fresh from the narrowness of provincial art schools in his native eastern Germany, was overwhelmed by Modigliani's instantaneous responses to every kind of experience. When he spoke of beauty, Meidner thought he had never heard a painter speak with such fire. Modi showed him reproductions of early Florentine masters whose work was unknown to Meidner. What Modigliani had to say about them was even more

beautiful than the reproductions he cherished. Modi struck Meidner as an extraordinary mixture of intelligence, unself-consciousness, and exuberance, a man who delighted those who knew him. Yet he had the character of a painter, entirely tied to this world, sensual and unmetaphysical.

Modi seemed to Meidner to be epicurean in his search for every refinement of sensation. Although not yet a victim of drugs or drink, Meidner felt that Modi had the temperament to use them excessively once started. Even now, he liked to have users and addicts tell him about the effects of hashish, morphine and opium in exhaustive detail. The three dandies James Whistler, Oscar Wilde, and Gabriele D'Annunzio fascinated Modigliani, who was "eloquent in praise of their peculiarities." While too poor to be self-indulgent, he told Meidner he would like to be like them —to dress superbly, live well, and with all that have a talent close to genius. It is easy to imagine how the idea of astounding, of thumbing his nose at bourgeois society would appeal to Modigliani.

Even now, when he had ten francs Modi would treat everyone to a glass of vermouth and be out of funds in an hour. He was incapable of economizing. He was a patrician who would spend money as if he had it to spend, and live with the flair of his heroes, Whistler, Wilde, and D'Annunzio.

It was the fashion on the Butte to speak of escaping from home as if it were a prison, of denigrating one's parents and the old country that had no appreciation for art or artists. Not Modi. He spoke of neither his family nor Italy with irony or scorn. On the contrary, he was brim full of love and admiration for everything Italian.

When Meidner knew him, Modi was hard pressed for money, but he never asked for a loan. He was too proud to borrow. Meidner describes the system Modi used with the small restaurants of the Butte. At the beginning of the month he would pay for his meals and establish his credit. Then he would have his debts chalked up every day until the end of the month, when he would disappear from that restaurant, a permanent debtor, and repeat the process at a café in a neighboring district.

It worked because of his great charm. Modigliani had the gift of making friends wherever he went. He knew everybody and was welcome everywhere. But this did not forestall the day of reckoning. Meidner was with Modi on one of these days when the "cheated bistro owners tracked him down to his miserable abode and made a hellish row." Meidner and Modi had to talk in whispers. Every now and then Modi would ask Meidner to peep through the keyhole to see whether another "monster" was coming. Somehow Modi managed to put them off and to keep his serenity. Troubles and difficulties of this kind were part of the romantic life he liked so much, and were too petty to get under his skin.

But there were painful slights. Meidner accompanied Modi to a smart Quartier Monceau apartment house, to deliver a framed Utamaro woodcut to a Japanese art collector. In this instance Modi was a mess and made a bad impression. Harried by his debtors, he hadn't shaved in several days and ". . . his once clean coat now showed marks of numerous meals and paint brushes." In fact, he was so unprepossessing that the doorman refused to admit him to the building. He must have retired and tried to freshen up, because Meidner speaks of Modi trying to remove the spots from his coat with saliva, to no avail. He had to leave without delivering the woodcut.

On another occasion Meidner accompanied Modi on a visit to an old Italian painter who looked like Napoleon III. An odd man, he lived alone in a large room with everything he owned—bed, furniture, books, tubes of color, and paintings—heaped in the middle of the floor. He was somehow able to pick whatever he needed from this chaos without any trouble. Modi and the old man, Meidner says, yelled at each other in Italian and waved their arms melodramatically. Their exchange was so violent that Meidner was frightened. But Modi screamed happily on.

Meidner has only one comment about Modi's girls and mistresses of this period: "His morbid female acquaintances differed from those he painted later on"—hardly a flattering description of Modi's little laundresses.

We know that Modi was fascinated by Toulouse-Lautrec and by Gauguin at this stage. And though Whistler was in his artistic decline, Modi was interested in his work, especially in its delicate tones. He also knew and admired the obsessed, nightmarish paintings of James Ensor and Edvard Munch, a Belgian and a Norwegian, who were almost unknown in Paris. Among the younger artists, he praised Picasso, Matisse, Rouault, and some unnamed younger Hungarian Expressionists.

Meidner observed that in his first Parisian period, Modi painted only small portraits in thin colors, colors that he applied sometimes to very rough canvas, often to smooth cardboard. In their grayish-green tonality, the results were reminiscent of Toulouse-Lautrec and of Whistler. They were entirely different from the paintings of the Fauves that were then on exhibition at the Indépendants. To make his painting appear more transparent, "Modigliani covered them, when dry, with colored varnish in such a way that his pictures were ultimately covered with as many as ten layers of varnish. Then their pellucid iridescent tone was reminiscent of the Old Masters."

If no one painted exactly as Modi did, neither did any artist draw as peculiarly. He drew from life on paper. Before the drawing was quite finished, he put carbon paper on a second sheet underneath the drawing and made a simplified tracing of it. While Modi's paintings delighted

Meidner, he thought Modi's drawing too abbreviated and mannered.

Meidner's account—one of the few that does not mention sculpture—gives an idea of the influences at work on Modigliani. Besides those already mentioned, there was Gauguin, whose color and drama captivated Modi. Every day brought something new to open his eyes: now he and Meidner were "intoxicated with excitement" at the Salon d'Automne of 1906. The Fauves were again prominent, but for many artists, as well as for most of the public, the magnificent display of Gauguin's drawings, carvings, woodcuts, ceramics, and 227 paintings took the show. Everything in them was anti-Micheli: his color, the primitive majesty of his conception, his forceful decorative approach, the sacrifice of every respected method of composition and design to achieve his objective. Gone were three-dimensional reproductions; he ignored form and perspective; pointedly omitted details of motion, depth, and facial expression to create his own brilliant art or, perhaps, as Modi liked to think of it, "to save and realize his dream." Gauguin was Gauguin, unique.

∽∽∽ Chapter Eight

"I've been everywhere. There isn't one painter
that's worth anything!"

M odi moved from his shack in the maquis either because new con-
struction along the Rue de Caulaincourt forced him to or because
he couldn't pay even the very low rent that was asked. Sometime
during 1907 he had a studio at 7 Place Jean-Baptiste-Clément. He also
lived for a while at the Hôtel-Restaurant Bouscarat in the Place du
Tertre. During his early Paris years he moved so often, and sometimes
lived in the same rooms at different times, that it is impossible to say ex-
actly when or for how long he lived in any one place. And the testimony
of those who knew him is conflicting and vague.[1]

While Modigliani had met many French artists—Picasso's gang in-
cluded Frenchmen as well as foreigners—he frequented gatherings of a
clique of Italian artists. Even in the City of Light, the French were rather
cool to Italians. The academic artists and critics resented the new,
poisonous influence of foreign artists who were polluting the pure main-
stream of French culture. Gino Severini, an Italian artist who had come
to Paris about the same time as Modi, observed that his friendly, sensitive
compatriot was hurt by the French attitude.[2] The Chilean Ortiz de
Zarate, whose glowing accounts of Paris had influenced Modi in Venice,
felt it too; his daughter has said that there was a tendency to xenopho-
bia in Paris that brought foreign artists together in cliques.[3]

Severini had run into Modi on a Montmartre street and made his
acquaintance. The two soon belonged to a group of Italians that in-
cluded Gino Baldi, Mario Buggelli, and Anselmo Bucci. Bucci had
sought out Modi after seeing his work on display in a shop window.[4]
Bucci, who was studying art, was walking in the Latin Quarter with two
painter friends—the three musketeers, they called themselves—and

spotted a grubby little art shop at the end of the Rue Saint-Pères where an uphill street leads to the Boulevard Saint-Germain. The big omnibuses, pulled by three sturdy gray white-maned Norman horses, grazed the narrow sidewalk and splashed mud on the windows of the shop. Behind the muddied glass, in picturesque disarray, stood a plaster mask of Beethoven, aquatints of Manuel Robbe, two cats by Steinlen printed on cloth, yellowing photographs of Balestrieri's paintings, and statues by Rodin.

The shop was The Art Gallery, and Bucci knew its owner, Laura Wylda, to whom he occasionally sold a drawing. He describes her only as "a chubby, friendly poetess," possibly one of those kindly English spinsters who settle down in Paris, open little shops, and never learn to speak good French. On a winter evening in 1906, Bucci saw something new in the window:

> . . . Three women's heads, bloodless, haunting, lightly brushed in a monochrome *terre verdre* on small canvases, in a fluid style with a mistiness in the manner of [Eugène] Carrière, if you see what I mean.

Bucci admired the paintings, which were on sale for fifteen francs apiece. Miss Wylda told him that the artist was a compatriot, pronouncing his name A-me-deo Mo-di-glia-ni with difficulty, and advised Bucci to go see him in Montmartre. So the three musketeers decided to go up from Montparnasse, where they lived, to "the sacred Butte." They made their way to the Place du Tertre and, by chance, entered "a combination hotel and *estaminet* [a bar with girls and rooms upstairs] in one corner of the square under the foliage of the acacia trees . . . [and] asked about Modigliani." Without moving from behind his counter, Bouscarat the proprietor, called Modi, who "answered from his room and came down the steep stairway, a small curly-headed youngster wearing a red turtleneck cyclist's sweater, smiling through his splendid teeth."

"Italians?" he said, looking at Bucci and his friends. "Italian painters?"

Jews often have classic Roman heads, but Modigliani had the head of Antinoüs (a young man of legendary beauty, a favorite of the Emperor Hadrian, who was drowned in the Nile and later deified by Hadrian). He seemed like a good fellow, so they went out, down the stairs of the Butte, and "headed for the boulevards."

Modi had a "fixed and at the same time uncertain smile," but his "opinions were certainly well fixed and all controversial." Bucci's companions were still under the influence of the first *Biennale* in Venice, a biennial exhibit that officially recognized all its exhibitors. Bucci and his friends, with their conservative ideas and their worship of the old idols,

"were petrified by Modigliani's attitude." According to Modi "there was nobody" in Italy. "nobody and not a thing" in France. "Nobody" and nothing in the whole world.

A heated argument began. As they reached Faubourg Montmartre below the Butte, Modi walked ahead of the three musketeers in the crowd, "shaking his curly Antinoüs's head," and holding firm to what Bucci calls "his renewed and cruel denials of approved values." The sound of galloping horses on the stone streets stopped them short," as if to say, if 'there was nobody' in Paris, then there was no point in walking through that busy city."

The three Italians jumped on Modi for his heresy and, "still smiling [he] was forced into more objective and less arbitrary statements." Modi perhaps half believed what he was saying as he played the tough, experienced sergeant to the raw recruits. They pressed him, and now, as recorded by Bucci, came the clincher.

"I've been everywhere. There isn't one painter that's worth anything! I've been to Venice, visited all the studios. In Italy there's Ghiglia—there's Oscar Ghiglia and that's all."

Bucci and his friends, as might be expected, had never heard of Ghiglia. It was odd that Modi should praise his one time close friend after they had broken with such bitterness.

Modi continued to be arbitrary as the three friends tried to find out one contemporary painter he admired.

"And who is there in France then?" they went on. "What about Besnard?" (Paul-Albert Besnard [1849–1934] had studied in Italy and is considered "the last important academic painter.") Modi was generous with him.

"Able," he said.

Bucci and his friends were not satisfied and threw every name they could think of at Modi: Fantin-Latour, Puvis de Chavannes, Bonnat, Cottet, Manet, Monet, Sisley. Modi called them merely "able," which seemed to infuriate his questioners.

"Now wait! Do you mean to say there isn't one *real* artist in all France?"

"Well, there's Matisse. . . . There's Picasso. . . ."

Bucci adds that Modi was about to say "and me," but held back. The three musketeers were only vaguely aware of Matisse and Picasso. The little they had seen of their work had convinced them that it was not "painted" painting. Bucci is quite specific as to what they meant by this: "Whatever is expressed by means of color is painted."

Clearly, Bucci and company had not been indoctrinated with the modern spirit. And how ironic, and typical, that Modi should hold forth on the old masters to Picasso and his friends and be considered a reactionary

by them! Yet he dismissed the past, said nothing of his fervent admiration for the old masters, and praised the moderns as if only their art mattered with these men who were tied to the conservative school of painting. But then, Modi had a habit of saying the opposite of what he believed, though the work of Matisse and Picasso did excite him.

What is endearing in this childish exchange is Modi's belief in himself, his certainty—on the tip of his tongue, but modestly withheld—that along with Matisse and Picasso, he was one of the *real* artists in France. In one sense he had no doubts of his talent whatever; in another, he was consumed by doubts. He was proud. He had put on an act. He knew very well that Bucci and his friends had tracked him down *only* because it was an Italian who had painted those heads in Laura Wylda's window. Bucci had been impressed. He had realized how differently Modigliani thought, saw, and painted from himself and his fellow painters. And Modi had enjoyed outraging these blind academicians who were unaware that a revolution in art was going on.

When Modi arrived in Paris, he was doing the sort of drawing one does in school—nothing of interest or value. Impressionism was no longer satisfactory, but a solution was difficult. Gino Severini feels that it was very lucky for Modigliani that he turned up in Montmartre at the moment when artists were engaged in research and great experimentation. Here he was thrown in with artists in a culturally free city, men who were very intelligent, all aspiring toward something—some unknown, untouched aspect of reality. Painting had to be a means, not an end. Neo-Impressionism had tried to achieve beauty through color; painting had become its own end. The artists realized that painting could not be an end in itself, so they searched—Matisse with the Fauves, Picasso with everything, and Modi with the three heads Laura Wylda had exhibited. All this was very far from Bucci's ideas of "painted" paintings in which color expressed everything.

Picasso, Severini feels, was too much of an intellectual to be satisfied with Impressionism. He wanted a new art and his own art. Modi, already his own man, Severini says, never agreed with anyone. And he particularly disagreed with the principles of Futurism to which Severini was to subscribe. Futurism was based on color relationships, on a certain Impressionism, Severini explains, but Modigliani had no time for such intellectualizing. He was interested in the Genoese primitives, in Negro art; he was enthusiastic over the Venetians.

How much being in the right place at the right time contributed to Modi's development there is no knowing. Other artists who did not even make a ripple in the pool were also there. But then Paris was a catalyst for what was inside him. Even the paintings at Laura Wylda's were only a phase. It is interesting that, except for being painted on small canvases,

they were so different from the portraits Ludwig Meidner had seen—portraits painted at the same time in thin colors whose grayish-green tonality reminded Meidner of Toulouse-Lautrec and Whistler.

The first break with the classic norm established by the great masters came formally with the emergence of the Impressionists in France beginning in 1874. The name, as with the Macchiaioli and almost all new movements in the arts, was coined by contemptuous critics to describe the pioneers. In this instance it was a picture of Claude Monet's, which he called *Impression, Sunrise,* that evoked the sneering epithet Impressionist. Real artists, it was felt, portrayed things themselves, not amorphous impressions of things, people, and places.

The work of the Impressionists had sent shock waves to all countries (Modigliani had heard of them before coming to Paris) that changed the course of art profoundly and significantly. But other factors were also revolutionary, particularly when, in 1884 (the year of Modigliani's birth), as Maurice Raynal points out, science poked its inquisitive nose into the mechanics of art. Ignoring aesthetics, it put the phenomena of color under the microscope. Artists, teachers and students read O. N. Rood's *The Scientific Theory,* David Sutter's *Phenomenon of Sight,* and Michel Eugène Chevreul's *Principle of Harmony and Contrast of Colors.*

It was a scientific age for art as for everything else. An artist could no longer simply paint. He must ponder Chevreul's theory, ". . . when two objects of different colors are placed side by side, neither keeps its own color and each acquires a new tint due to the influence of the colors of the other object," or other theories passionately espoused by other men. The various theories had their detractors as well as supporters, and many spawned splinter groups that came to be labeled Neo-Impressionism, Realism, Symbolism, Synthetism, Expressionism, Naturalism, and the Modern Classical Renaissance.

When Modi reached Paris the Fauves were in existence. The accouchement of the new school had been attended by the usual scandal, public clamor, vituperation, and critical sneers of all "new" schools. This time the insulting tag was *Fauves,* Wild Beasts. Henri Matisse was the mighty main axle of the school, which ultimately counted among its members Vlaminck, Van Dongen, Georges Rouault, Albert Marquet, Raoul Dufy, Othon Friesz, and, briefly, Georges Braque. Adapting the uninhibited colors of the savagely brilliant works of Van Gogh and Gauguin, who were still controversial, their paintings had first come to general public attention in the Salon d'Automne of 1905. Their pictures were hung on the walls of a gallery in whose center was a small child's head by Albert Marquet, known as a painter and facile sculptor of classic trifles.

Louis Vauxcelles, art critic of the publication *Gil Blas,* allegedly

coined the name Fauves. The story goes that after looking around at the wildly colored pictures and then at Marquet's academic bust of the child, he exclaimed, "Look at that, will you? There's a little Donatello cowering in the wild beasts' cage."

The Fauves were pleased to be called wild beasts. They thought of themselves as bold innovators, not tame academic sheep. Their paintings were condemned as ugly, meaningless daubs that could be turned out by any cretinous five-year-old. Even the work of the Douanier Rousseau was skewered in that exhibition. So, again, was the painting of poor old, defenseless Paul Cézanne. This time the critic Camille Mauclair gleefully wrote, "His name will remain attached to the most memorable artistic joke in these last fifteen years. . . . M. Cézanne has never been able to produce what could be called a real painting." For the man who was soon to be canonized as the master of modern painting, this was, in fact, a mild review.

No more than the Impressionists did the Fauves spring into being because of an opprobrious label. They had been painting, even exhibiting, for years before their 1905 public explosion. Matisse, the original Fauve, had befriended and influenced Derain, who, in turn, had attached himself to the roughneck Vlaminck. Vlaminck from the start had used pure, vivid colors, and joyfully insisted that he despised the past:

> "It would be better," he wrote, sounding like a rampant bull, "to burn all the museums, those refuse heaps of the past filled with dead images that stink like rotten fish. I've never given a hoot about art when it comes to that. Not the art of Italy, Greece, or any country that's embalmed in the past. I want my colors hot enough to burn down the School of Fine Arts, and I want to use my brush to hurl what I feel without giving a damn about what's been painted before."

(Vlaminck was firing pointblank for maximum effect. In his memoirs, published in 1929, he corrected himself to the extent that he had lied about his not going to museums for the same reason people lied about not going to bordellos.[5]) He also sounded very like the later Futurists.

Vlaminck's ideas could only make Modigliani wince. The past mattered to him, always would. Derain, more intellectual and cerebral than his friend Vlaminck, a man who thought hard before he put brush to canvas, hedged—as he always would—but joined the Fauves. And soon turned from them to Picasso and then to Cubism, because it was the politic thing to do.

Modi must certainly have looked into his own motives as he listened to the arguments and the discussions in the Bateau-Lavoir. All right! The others had been around longer, knew more, had painted more. But the

solidarity, the strong composition, the perfection—the very mastery of the old masters remained the foundation on which he had to build. He applauded the pyrotechnics of the Fauves, but with his love of grace and elegance, one can assume he felt, as later critics did, that they had sacrificed everything to color. They painted in a slipshod, clumsy, childish style. Even their color suffered by the rigid application of the formula Vlaminck had ordained: ". . . One must paint with pure vermillion, pure Veronese green and pure cobalt." Nothing could be more satisfying than kicking the bourgeois in the teeth, but this was a deliberate attempt to startle by putting the wildest colors together on the tamest canvases. With them, as with another Fauve, Othon Friesz, it became a kind of stunt. Lions were bound to get sore throats if they roared all the time.

Modi was aware that the Fauves did not think alike. Vlaminck's point of view was tempered in Matisse and Rouault by highly imaginative creations. Having burst traditional bonds with color, they were no longer obsessed with it. It was, as with everything, a question of taste and maturity. It was interesting, though, that both Derain and Vlaminck turned from Matisse to Picasso; but perhaps even more interesting that Picasso had never turned to anyone except himself.

Modigliani had yet to "discover" Cézanne by the time of his death in 1906, in his sixty-seventh year, unknown and unhonored except by a discerning few. Cézanne's death was worth a scant paragraph in the newspapers, a scathing flurry in the art periodicals, and attracted no international notice whatever. His talent was damned and his genius denied with as much vehemence as they had been when he was alive. But then, who was Paul Cézanne that he should be mourned?

Paris, always the center of French political life, was seething with unrest. It ground on like an endless movie serial from crisis to crisis. Royalists, extremists of the Right and Left, anarchists, splinter groups, protested, agitated, rioted, organized mobs, set off bombs, and tirelessly found martyrs for their causes. Socialist and free thinking by background, Modi read the newspapers and was perhaps better informed on social and political affairs than his fellow painters, who cared little for anything except their art.

At this point, Modi was broke most of the time and owed money everywhere in Montmartre. He sketched customers from life in cafés and restaurants to scratch up enough to keep alive. His allowance arrived every month or, at worst, every other month, but it was never enough. The hard fact was slowly sinking in: success would be harder to come by than he had assumed. So far as is known, Laura Wylda had not sold his paintings, nor apparently did he give her more than the one lot to display. Modi was kept on the move in Montmartre, where it became harder and

harder to find a cheap, decent place to live and work. Now he began drinking more. He discovered hashish, and he became friendly with Maurice Utrillo.

But he found Paris stimulating. It kept the mind in ferment. Another novelty, Negro art, came along to stir up new discussion. It too had its influence. Though primitive art had been around for years and years, public interest had never focused on it. As far back as 1520, in Brussels, Albrecht Dürer had been impressed by the purity of some primitive objects from Mexico. Rembrandt may have seen other objects brought from Indonesia by the Dutch East India Company. Art from the South Seas had been taken to England by Captain James Cook in the late eighteenth century. But to the public, these were curios—crude, outlandish things made by ignorant heathen, unworthy of an enlightened, Christian public. This attitude changed in the nineteenth century as exploring continued, but it was chiefly the artists who first appreciated the work. There were exhibits in London and Paris. Gauguin and Van Gogh happened on a display of primitive art at The Paris Universal Exposition in 1889, and Van Gogh is reported to have found it "very beautiful." So it was nothing new. It needed "discovering" by the right people.

As late as 1906 only a few people agreed that these "crudities" were worth preserving. Ethnological museums, as such, were unheard of, and ordinary museums, lacking exhibiting facilities, flung the stuff in heaps in some dusty back room. Nevertheless—some African curios had drifted down to the public even before the beginning of the slave trade. Explorers, missionaries, sea captains, sailors, and travelers brought back carved heads in wood and ivory, statuettes, figurines, masks, and fetishes. They had been sold, exchanged, given away. Many had ended up on the shelves of little out-of-the-way shops. Perhaps some had been acquired as curios, as jokes, in the way that people nowadays buy such oddities as shrunken human heads and fossilized dinosaur eggs for "conversation pieces."

The actual discoverer of Negro art—the individual who came on the first example, recognized and appreciated it—remains a matter of controversy. Matisse is said to have stumbled on a carving in the curiosity shop run by Père Sauvage in the Rue de Rennes. Max Jacob thought the "new school" began with this. But according to Pierre Courthion,[6] the "new school" was founded on the night Max, Apollinaire, Salmon, and Picasso had dinner with Matisse at his apartment on the Quai Saint-Michel. While they were there, "Matisse took a small black wooden figurine from a shelf and showed it to Picasso, who kept fondling it all evening long." It was the first time Picasso had seen Negro sculpture. And the next day, Courthion goes on, Max went into the Bateau-Lavoir and found sheets of drawing paper all over the floor of Picasso's studio.

Max said, "On each sheet was a big drawing, almost the same: a woman's face with one eye, a long nose joining up the mouth, a lock of hair dangling on her shoulder." This same woman, grotesque and distorted, reappeared in Picasso's next paintings, and he added more until he produced his great eight-foot masterpiece and monstrosity, *Les Demoiselles d'Avignon*.

At the same time, according to another familiar story,[7] Vlaminck picked up a Negro statue in a bar "and bought it for a round of drinks." The little statue so excited him that he hurried over to show it to his good friend Derain, who immediately shared his excitement. Both knew they had something, and as André Malraux says, both rightly attached much importance to their find. Malraux feels that an artist's life is full of such encounters, but that he sometimes fails to realize how much they mean to him or prefers (as Picasso seems to have done) to keep them secret. "For a painter an encounter with an art of savages seemingly akin to his own is an exciting experience."[8]

Vlaminck proudly exclaimed that his find was nearly as beautiful as the Venus de Milo! Yes, quite as beautiful. Then, turning over the statue, Picasso announced solemnly, "*More* beautiful!"

But Picasso was in fact already familiar with primitive art because of the portrait that Max Jacob's brother had brought back from Africa. This Jacob, who was an explorer, had had his picture painted by a native—an amazing picture despite its flat composition and murky colors. What had struck Picasso most forcefully was that the artist had chosen to portray the brass buttons of Jacob's jacket uniform around his subject's head in a wondrous golden halo effect, disassociating the buttons from the uniform where they belonged, thus introducing an entirely new element. Now, where "Before, Picasso always used to lay down the dictum that when you paint a portrait you must make it resemble a plate . . . Picasso invented a new dictum: 'If you paint a portrait, you place the limbs alongside.'"[9]

Modi, who heard the talk at the Bateau-Lavoir, listened to Picasso, Vlaminck, Derain, and the rest of the gang, was perhaps able to study the statuette—if that was what it was—himself. Picasso appreciated an elemental quality in the little statue that was also in every human face, an almost frightening sameness. Modi, running his hands over the smooth-fronted, sexless figure, probably noticed the narrow, flattened head with the hair suggested by a few scratches, the humped-up forehead, the strange, closed slit-eyes, the slab-like attenuated nose, the lips set in a thick kiss. The texture was rough, in spite of the hand polish, indicating that it had been carved with primitive tools. The thing was primordial, hideous, brutal yet beautiful.

Beautiful. That was the amazing thing about it. Perfect in its way, al-

though it lacked every important element of European art in the last five hundred years. It upset everything Modi had ever learned. For Picasso that was perhaps the best thing about it. For Modigliani it was confusing at first. The blank eyes, the pursed mouth portrayed gentleness, serenity, mystery, and something ageless. The statue was shrine, ikon, totem, fetish, symbol, and portrait all in one. It was functional and decorative, spiritual and physical, fantastic and real, ugly and beautiful. Further, its innocent creator had produced an organic whole of which Modigliani felt he was incapable.

To Picasso such a view would seem too romantic. For Picasso the statue was more of an absolute: it was man, one man, and all mankind. What counted was ideas and nothing else. He was working on a big canvas now, which he had shown to no one; it was said to be entirely different from anything else he'd done.

Picasso, penniless yet secure, living badly but working calmly, influential and surrounded by admiring friends, must have made Modi envious. Picasso could go back to Spain occasionally to get a new perspective on his art. Modi, who often longed for Italy and the bright Mediterranean light, could not afford to travel and had to stay in Paris, whose light he had never got used to. No wonder he needed a drink and hashish now and then.

After the freedom of his shanty and the space out back where he could do his sculpture, it must have been difficult for Modi to adapt to a small, badly lighted box of a room in the Hôtel-Restaurant Bouscarat on the right-hand corner of the Place du Tertre. He was already behind in his rent, and Bouscarat, a tough landlord, had warned him what would happen if he didn't pay up. Money still came from home; Modi earned a little from sketches and, even more rarely, from the sale of an occasional painting on commission, but he never regarded the rent as an obligation.

Running up credit at restaurants all over the Butte in order to get a meal was an exhausting, humiliating business. It stretched his charm to the limit. Still, most of the artists and writers of the Butte faced the same problem.

But Modi's friends were more thick-skinned and resourceful than he. They took a shrewdly realistic view of their situation and a sophomoric glee in filling their stomachs by outsmarting the bourgeois. They waited until the early morning to pounce, the time when the well-to-do were still snoring in their beds before getting up to fetch the hot rolls, croissants, milk, and coffee—all neatly wrapped in napkins, the saucer tucked over the cup—that were delivered punctually to their doors. Then they sneaked into an apartment building or rooming house. When they had eluded the concierge, they really had to move. It was every man for him-

self. Those with the biggest appetites started at the top floors and worked down. It took good legs not to be caught. You had to be quick—scoop, gulp, munch, all in one—then on to the next door. It came naturally when you were famished.

Francis Carco and his friends could do this. Modi could not. Stealing from the rich did not appeal to him. Broke, starving, even drunk, he carried himself like a young prince—and princes never stooped to stealing.

He may have held back because, underneath, he was still the well-brought-up Dedo of Leghorn.

"You now have the right to consider yourself superior to all men. . . ."

M odigliani and Maurice Utrillo had become friends. They liked and admired each other from the start. A drink or two sealed their friendship. Perverse as he was, Modi might well have cultivated Maurice because of what Picasso and his gang said about Utrillo. But there was more to it than that: Modi felt a kinship with the tormented and the outcast. He never felt he was demeaning himself by befriending this wretched young man, who would cheerfully sell his soul for a drink, yet was capable of painting like an angel.

Maurice didn't know who his father was. He had been given a family name and been made legitimate through the courtesy of Miguel Utrillo, a friend of Picasso's in Spain, a painter, architect, and finally an engineer. Miguel had been more than just a friend of Maurice's mother, the already legendary Suzanne Valadon, who had posed for and been the mistress of so many distinguished painters, and who had become a fine painter herself. Even now, at forty-two, she was an exciting woman, lushly beautiful, fiery, passionate, with a voluptuous figure.

Maurice was thought to be the bastard of one after the other of the artists she had known so intimately—Puvis de Chavannes, Renoir, Lautrec, Rodin, Degas, and others. Suzanne always claimed that one Adrain Boissy,[1] who had gotten her drunk and raped her, was Maurice's real father, but on occasion she admitted that Miguel Utrillo was the man. Maurice always hated the name. He was Maurice Valadon, Monsieur Maurice, Litrillo (for the liters of wine he consumed), the Bateau-Ivre (Drunken Boat) to some, or as he begged people to call him, Maumau, his nickname from baby days when he couldn't say Maurice.

He had protectors and wardens, but no real friends. He was the butt of

jokes. Children ran after and tormented him on the street. He was often jostled, knocked down, and robbed by juvenile street gangs. Because he had been so hurt, Maurice was afraid of people. There were few human beings in his paintings of Montmartre walls, and they were unidentifiable little matchstick figures. He worshiped his mother.

Modi's friends could never understand what a civilized aristocrat like himself could see in an uncouth, simple-minded brute like Utrillo. Surely it was Maurice's art—brilliantly simple, guilelessly untutored, and forever his own—that had first interested Modi. He was also drawn to Maurice's shy innocence, his charming, boyish goodness, his fear and loneliness, all the qualities that were apparent, even behind the mask, before alcohol took over and he turned animal.

Maurice tried hard to be one of the boys with Picasso and the gang at the Lapin Agile, but all the talk about art was over his head. The gang couldn't help patronizing him. Maurice's forte was painting; his mania, drink. Now it was Modi who brought him home to his mother's studio at Number 2 Rue Cortot, on the Butte. Suzanne Valadon impressed Modi. She was beautiful. She exuded a maternal warmth and sympathy that probably reminded him of his own mother. She had the same unquenchable spirit. She painted in a style as vigorous, as crudely powerful as her own nature. Modi listened when she told him not to be discouraged about his work. They were always to be good friends, Modi thinking of her as his adopted mother, and Suzanne of him as her second son.

Only a year older than Modi, Maurice looked twice his age because of his addiction, his suffering, his wretched clothes, his haggard face. He had dark oily hair, a high forehead, firmly arched eyebrows, black eyes, sunken yellow cheeks, and a straight nose with a drooping black mustache underneath. In repose he had the sweet, tender eyes of a child's or hermit's face, but an ancient bitterness of mouth.[2]

The mechanical, fanatical smile exposed his character. He dressed like a scarecrow in collarless shirts covered with spots, trousers tied around his waist with twine, and old slippers. He had an aura of exaltation, pain, submission, hostility, distrust. He was ingenuous yet full of guile, and confused.

Maurice Utrillo was never the master of his own fate; he never did anything of his own volition.[3] His misfortune was wished on him; his alcoholism a disease, not a vice. He never wanted to be an alcoholic, but he became one, day by day, as drinks were forced on him by wagon drivers as he walked home from school. Nor did he choose to be an artist. His mother shut him up in his room for hours and made him paint, hoping to distract him and keep him from drinking.

Nor did he choose his subjects. He copied what was near him, reproduced what he saw around him. He used postcards, the poverty-stricken

street scenes of the Butte, the sad locales of Montmartre. He did not even choose his religious faith. It chose him in the depths of his degradation. He did not choose fame: it came to him without effort. He was indifferent to money: it neither made him happy nor gave him any better life than he had in the days of his picturesque misery. But even in his greatest extremity, Utrillo had an almost pure radiance, the sign of predestination to an uncommon fate.

This radiance must have attracted Modi to him. He could sense it in Maurice and in his paintings. Maurice could paint—no doubt about it. His art appealed to both the bourgeois and the poor. His Montmartre had grace, charm, portrayed in a clean, simple style as impossible to duplicate as the Douanier Rousseau's.

Maurice was an old story in Montmartre. He'd been a drunk and had been carrying on since he was fourteen. He had already been locked up for his alcoholism at Sainte-Anne Hospital, the first of many sanitariums and asylums to which he was to be sent for treatment.

The Bateau-Lavoir looked on and wondered. Could alcoholism be infectious or contagious with someone as impressionable as Modi, who was constantly with Maurice? It was inevitable. Modi wasn't selling; he wasn't working. He'd end up another Maurice. They shrugged helplessly. What could you do with people like that?

Bouscarat had by now given Modi final notice and threatened to confiscate his possessions. With this on his mind Modi walked the streets of the Butte. He came on André Utter, painting at an intersection. Utter was a big blonde-bearded, confident youth of twenty with plenty of experience in living. He supported himself by doing odd jobs. The freethinking, self-taught, ambitious Utter was fascinated with painting, and determined not to go into his father's plumbing business. He was deft and quick and had picked up all he knew by observing other painters at work, running errands for them, and generally hanging about their studios with big ears and eyes. He was a tough fellow, sophisticated beyond his years, like many others on the Butte. He'd been drinking since he was twelve, played around with women since adolescence, and took hashish with the boys.

Modi watched him paint and, as Utter recalled it, let drop that he was a sculptor. As a matter of fact, he'd just come back from London. Did Utter know the Pre-Raphaelites? Well, Modi had just exhibited with them. "Utter thought this strange, for the Pre-Raphaelites exhibiting then were a pretty hoary bunch." [4] Modi was evidently boasting, building himself up with outrageous lies. (Utter always considered him something of an actor and a show-off.) But after the small talk Modi got down

to facts and the jam he was in with Bouscarat. Utter, who was as broke as Modi, could suggest no solution. The problem resolved itself, however, in an unusual and what to Modi must have been a highly satisfying manner.

Several days after his talk with Utter, Modi was in bed asleep when a piece of the old, cracked ceiling fell on him in a pulverizing crash of dust and plaster. Modi, shaky and frightened, fought his way out of the room, banged on Bouscarat's door, and announced that the entire ceiling had collapsed on his head. He was angry and excited, and Bouscarat, roused from sleep, was just as furious and indignant. He accused Modi of being drunk and told him to get the hell back to bed. Modi called Bouscarat names and showered him with all the obscenities he knew. He was worked up, screaming, and in a few moments every guest in the hotel would be awakened. Bouscarat immediately told him to pay his rent and leave.

Modi, sensing his advantage, insisted that he had been badly hurt by the crashing plaster, that, "his head had been broken and his eyes blinded, that he was a great artist and would sue Bouscarat for hundreds of thousands of francs." This jarred the landlord. With the help of a shrewd lawyer Modi might be able to make his charges stand up in court. He tried to brazen it out, but now the other tenants were clustering around, demanding to know what the commotion was all about. Bouscarat thought fast.

"Just get out of your room, take all your rotten junk with you, and we'll forget this happened *and* your rent!"

Modi continued to protest because he enjoyed putting on an act for an audience, but he was delighted to get off so cheaply. The story spread through Montmartre and was told and retold with exaggerations.

Free and out of debt, Modi now had to find a place to live. He turned to his new friend André Utter. Together they combed the Butte for cheap lodging and discovered an old shed, as flimsy and sway-backed as his shanty in the maquis, part bulging wood and crumbling brick set on a mound, just where the Rue Lepic ended, in Place Jean-Baptiste-Clément. It had been a workshop used by carpenters, was now abandoned, and seemed the perfect studio for Modi. The rent was very little.

He liked its location, the small garden plot across the way on the corner of the Rue Norvins on which stood a single graceful cherry tree and, back of it, a small barrel-like water tower on a stilted platform. The tree was endearing, and he admired the view "across the square and down the Rue Ravignan opening on a vista of Paris stretching as far as the Meudon hills." Modi settled in happily. Soon he was working feverishly, as he always did after he moved, stirred by a sense of life beginning

again. Again everything seemed possible. The children, who swarmed in the area, were good models, and he had a new mistress to love and to paint and draw.

His friend Ludwig Meidner was a frequent visitor, and his reminiscences verify Modi's whereabouts in early 1907. Here Meidner posed for two portraits, one large and one small. The large portrait of Meidner was hung in the Salon d'Automne of 1907. Modi was overjoyed.

The first exhibition of Modigliani's work in Paris is generally given as 1908 at Salon des Indépendants. A study of the archives of Salon d'Automne shows that he did indeed exhibit, but a year earlier, in the 1907 exhibition held at the Grand Palais from October 1 to October 22. He is listed as MODIGLIANI (*Amédé*), *né à Livourne* (*Italie*), his nationality as Italian, and his address 7 Place Jean-Baptiste-Clément. His entries are listed as numbers 1285 and 1291, seven in all, beginning with *Portrait de L. M.* [Meidner] in oil; *Etude de tête,* also an oil; then five watercolors, including a *Tête, Tête de profil,* two *Etudes,* and lastly a Portrait (*étude*).

Modigliani's work went unnoticed, but that does not change the importance of the event in his young life. He was twenty-three, still a newcomer here, and thought to have sufficient talent to have seven of his works accepted in a reputable exhibition. The Salon d'Automne dated back only four years, to October, 1903, when it "was founded by the new Fauve group and by certain artists from the Salon de la Nationale, including the portrait painter Jacques-Emile Blanche and Frantz Jourdain, who acted as president. Matisse, Rouault, Marquet, and Bonnard were foundation members and all exhibited." [5] The members were all masters of today and the future; to have been accepted by them and entitled to exhibit with them could only have heartened the young and impressionable Italian.

In his whole career in Paris, Modigliani was to exhibit in only two official salons: the Salon d'Automne and Salon des Indépendants. The Indépendants came into being because the established academic painters controlled the salons, rigged the juries, and systematically rejected all the heretical or nonacademic pictures entered by the new, young artists. The Salon des Indépendants was an inclusive exhibition, all artists being permitted to enter whatever they chose. It originated in 1884 when "Several hundred artists rejected from the Salon of that year had come together to form an organization to hold no-jury exhibitions, calling themselves the *Société des Artistes Indépendants* (the same name the impressionist group had used for a while). Seurat was one of the leaders in the organization of the *Indépendants*. . . ." [6]

On the other hand, "The *Salon d'Automne* had been organized . . . by a group of thoughtful painters and liberal critics, who were equally

dissatisfied with the conservatism of the regular academic Salons, with their ingrown juries, and the anarchy of the *Indépendants* with no juries at all. The organizers of the Salon d'Automne solved the jury problem by selecting its members by lot." [7] There was still a jury, however—they hoped an unbiased one—and it was something of an achievement for Modigliani, a newcomer and beginner, to have his works selected.

Modi wrote a postcard to Meidner, who had returned to Germany, saying that two of his works—the large portrait of Meidner and a portrait of Modi's mistress—were at the salon, that Modi had attended the *vernissage,* or private viewing, and that his pictures were in a good location.

He must have written enthusiastically to his proud and worried Mamma in Leghorn. Barely away from home and he was doing fine: seven entries in the show, all of them well placed. Modi must have been excited, and his family too. Dedo was on his way. He'd soon become famous, successful, come home and pay Mamma for everything, as he had said he would. One can imagine Modi bubbling with joy. Success was in his grasp. He'd had a hard time lately, money was short, and he'd hated writing home for cash. But all that would change now. Amedeo Modigliani in the Salon d'Automne! If Oscar Ghiglia and his friends at home only knew.

Now Modi could only look ahead with optimism. He was very naïve, certain of his ability and talent, equally certain that his work would *have* to be singled out and appreciated. He was so self-confident that he was vulnerable, unprepared for the years of failure ahead. Out of his great hopes came the bitterness that was to poison him more and more in the empty, aching time of rejection still before him.

As for Meidner, when he returned to Berlin he took with him some of Modi's oils in the hope of finding German buyers who would pay from ten to twenty marks (two to five dollars) apiece for them. But there were no buyers. In the course of a year he did not succeed in selling "one of the exquisite little pieces." Today they are worth a fortune.

Meidner spent the next five years in Berlin hungrier and more miserable than before. With two artist friends, Richard Janthur and Jakob Steinhardt, he founded a group known as The Pathetic Ones. They exhibited under this name in Berlin in 1912. In the years before the war Meidner's suffering was intense. He became a "hater of the Fatherland" by the summer of 1916 when he was drafted into the army. Unable to paint in the army, he turned to writing. After returning from the war, he began painting again, but he was in a suicidal mood most of the time and his paintings "expressed powerful feelings about the world he professed to hate." [8] Working by candlelight, he lived in a sordid upstairs studio and endured a miserable Bohemian existence until the Nazis took over, when he fled to London, where he stayed. He was among the many

artists who knew Modigliani, briefly and intimately, never to forget him.

Compared to his contemporaries, Modi was late in understanding and appreciating Cézanne, although it must be admitted he had had few opportunities to see his paintings. Matisse had bought the *Bathers* from Vollard as long ago as 1899, when he could hardly afford it. Later, giving it to the Louvre, he wrote: "I have appreciated it for thirty-seven years. To it I have pinned my faith."

The Salon d'Automne of 1907 was important to Modi not only because it was his exhibition but also because there was a room devoted to the Cézanne Memorial Exhibition of forty-eight oil paintings. Modi must have spent many hours there. At the same time seventy-nine Cézanne watercolors were being shown at the Bernheim-Jeune Gallery. These posthumous exhibitions permanently established Cézanne's reputation, set it on the ascendant, and gave his work an ever-growing prestige and cash value.

Perhaps of as much significance as the exhibits to Modigliani and other artists was the concurrent publication of Cézanne's letters to his friends in which he set forth his theories on art—rules and beliefs that served to give impetus to what was known as Cubism. The letters also showed that Cézanne had often despaired but never lost faith in himself. ". . . I have a very good opinion of myself. I begin to feel myself much stronger than all those around me and . . . I have gained this good opinion of myself only after careful consideration."

It is altogether possible that Modi was heartened, pleased, even a little amazed, that one near contemporary believed as he did and shared his attitude to the old masters, ". . . the wonderful creations which the centuries have transmitted to us," where one found "strengthening and support like a bather on a wooden plank. . . ." That was what Modi felt, what friends like Vlaminck ridiculed. Cézanne's conclusions buttressed Modi's own beliefs.

To the reproductions and photographs of the work of the great masters, which he tacked faithfully to the walls of wherever he happened to live, Modi now added another talisman and source of inspiration. But this one he kept in his pocket, and "every time Cézanne was mentioned, Modigliani made a reverent face and with a slow secretive gesture took the reproduction from his pocket, held it up to his face with his hands folded like a breviary, drew it to his lips, and kissed it." [9] This was *Boy in a Red Vest,* which Ambroise Vollard had bought for about $600 in 1900 and which went for $616,000 at the sale of the Jakob Goldschmidt collection in 1958. It showed a farm boy in a wide-brimmed, straw hat, hair streaming down his forehead, his expression wistful as he stood at ease, right arm on his hip, left arm hanging loose, head turned slightly to the left. The dominant color of the portrait was the red of the boy's vest.

Red was reflected all through the painting, even in the boy's face and the flowing drapery behind him. But it was the solid composition, the sculptural and tonal values, the simple and masterly delineation of the boy's features that enchanted Modi.

He was humbly sincere in his admiration: Cézanne was a master.

Wherever he lived, no matter under what conditions of privation, women were essential in Modigliani's life. His mistresses, all pretty, affectionate, and well formed, were prepared to pose for hours, cook, clean, and make love at the whim of their man. Excepting the laundresses, they were romantic working girls who had lifted themselves from poor, lower-class backgrounds with the grand objective of bettering themselves by marriage. This called for an attachment with an estimable, higher-class young man with prospects.

These girls were prepared to accept the years of struggle facing a law or medical student, even an accountant or artist, before he began to establish himself and prosper in a respectable and remunerative profession. The wild, free years were fun, though difficult. But the future mattered, the reality of becoming a proper bourgeois wife in a proper bourgeois home. Modi, of course, was a poor choice with bad prospects, although his good looks and ardor were great compensation. He lived carelessly and recklessly; he could not and did not want to be domesticated. His volatile temperament was against his becoming established. Worse, he was too fickle, too dedicated to his work to be interested in marriage.

So none of Modi's girls stayed very long. In 1908 Modi was living with a little model, an acrobat on the side, who had posed for some of Modi's friends, including André Warnod. She did not like Modi's work, and spoke of him scornfully. When finally she decided to break with Modi, Warnod asked her why.

"Oh, I've had enough of painters. Now I want to be with artists."

"But I don't understand. After all, Modi is—"

"No, Modigliani is a painter. He's not an artist."

Some time later Warnod met the little model in the street, walking home with a full market bag, looking very happy. Warnod commented on her appearance, and she smiled contentedly. Yes, at last she was living with a real artist. And who was that? Warnod asked.

"A clown at the Cirque Médrano. *Un vrai artiste!*" [10]

Modi continued to make hundreds of drawings; he painted; he did sculpture, and he made the rounds of the dealers, those hardheaded gentlemen engaged in a business as risky and speculative as the stock market. Modi entered their lairs like a prince, and behaved like one. He neither bargained nor haggled; he neither pleaded nor cajoled. He had no tact, no patience. It was take it or leave it. If they hesitated, said it wasn't bad,

but why didn't he paint something like Picasso, Matisse, or Vlaminck, Modi left angrily.

He was touchy, offensively articulate, and hopelessly incapable of compromise either in art or business. He peddled his drawings and paintings up and down the Rue Laffitte and its vicinity: Ambroise Vollard, Paul Durand-Ruel's Gallery, Georges Petit's place, Berthe Weill's *boutique*, and Clovis Sagot's glorified junk shop. Sagot was full up on Utrillos and had enough Modiglianis for now. Sagot paid little but he did pay. That was more than the café and restaurant owners all over the Butte did. In a way they were all dealers who reluctantly accepted a painting they didn't like and didn't expect to sell—except perhaps to some sucker—for a hot-dish meal or a half-bottle of wine.

Père Angely was a retired lawyer's clerk so nearsighted that he had to hold paintings close to his face when he examined them. He had a big collection of pictures, all of them bought cheaply, and he hoped in time to hold a grand auction of his holdings "to provide a comfortable income for his old age." In that sense he was a gambler, but always ready to pay a few francs for a painting. Modi had no illusions about him. He laughed when he told Louis Latourettes, who had moved to the Rue Lepic near his shanty, about Père Angely.

"Now I've only got one buyer and he's blind!" [11]

Latourettes noticed that the bloom was off Modi. His rust-colored corduroys were laundered, he was clean-shaven, and he seemed as cocky and optimistic as ever but he had a nervous, furtive air. He coughed as he smoked cigarettes and, from all accounts, wine and hashish were ruining his already delicate health.

Modi was an infrequent visitor to the Bateau-Lavoir these days, but he must have gone to see that enormous painting of Picasso's—so strange, so brutal, so powerful. Everyone was talking about it, and Modi, if only at the urging of Max Jacob, would have had to see the painting that was to revolutionize art.

Picasso could only have been amused at Modigliani's inspection of his eight-foot-square painting. He had worked in secret on it for a long time. Now a succession of friends and Bateau Lavoir hangers-on were puzzled by it and exclaimed over it. If Modi had been startled by the primitive little statuette, the impact of this huge painting could only have been shattering. It contained five nude female figures, so twisted and contorted they resembled no women who had ever lived and only women a Picasso could imagine. The three figures on the left sectioned off into broad wedges and flat planes with no indication of where the back and frontal planes began or ended, since they were fused together at various points.

The women were shapeless, their breasts as convulsed as their bodies.

The two on the right had faces like brutal masks painted in parallel strokes of violent blue, orange, green, and red. Some of the women were holding draperies; one had her arms back of her head; another seemed to have no arms. Most shocking of all, there was not a single harmonious element in the entire painting. Everything jangled down to the incredible still life of fruits that stood on a tilting slice of table in the foreground, before the grotesque figures. The painting rang with dissonances; it was as jagged as splintered glass. To Modigliani it conveyed no meaning beyond affronting the eye, setting the nerves on edge.

If the color was violent, muddy, clashing, the drawing was crude, sloppy, as if Picasso had hurried it, the line blurred. The composition was so confused that the eye had nowhere to go. The nudes had too much motion, too much waving of arms and posturing. The final impression was that Picasso had deliberately ignored everything he knew, turned his back on his old techniques and successes to concentrate on giving the viewer a good hard kick in the guts. To Modi it seemed that everything had been sacrificed to the savage and primitive. All he could see was violence, brutality, angles, twistings, and contortions leading to the complete denial of beauty and life. He was stirred and moved as with the Negro statuette—this time perhaps to the point of revulsion. It was like a nasty little boy making faces in front of his obscene drawing. It seemed both the glorification and personification of ugliness.

Picasso knew it was ugly. He had explained to Gertrude Stein:

> Picasso said once that he who created a thing is forced to make it ugly. In the effort to create intensity and the struggle to create this intensity, the result always produces a certain ugliness, those who follow can make of this thing a beautiful thing because they know what they are doing, the thing having already been invented, but the inventor because he does not know what he is going to invent inevitably the thing he makes must have its ugliness.[12]

What was so clear to Picasso and Gertrude Stein was obscure to an artist like Modigliani, who was never to go Picasso's way, and at first to other artists, who were to follow Picasso. Most of Picasso's friends were confused by what he had done, but approved because it was Picasso, different, even world-shaking. Some of them laughed. Picasso heard Leo Stein and Matisse talking about the picture and concluding "that he was trying to create a fourth dimension." [13] Georges Braque, a recent friend of Picasso, was also baffled. His first comment was, "It looks as if you're asking us to eat cotton waste and drink kerosene," and, "To paint like this is as bad as drinking gasoline in the hope of spitting fire."

Braque was to change his mind, appreciate the painting, and find inspiration in it. To Matisse, the painting was an insult. He was furious at

this "attempt to ridicule the modern movement. . . ." As for Picasso's first important collector, even before Gertrude Stein, the wealthy Russian Sergei Ivanovitch Shchukin, he was so shaken by the painting that he moaned, "What a loss to French art!"

To Modi such a painting was only another powerful stimulant toward the resolution of his own art. Because he was a romantic, Modigliani may have insisted that the painting was a denial of beauty and life, whereas to Picasso it was rather a denial of the past and all the damnable conventions that hamstrung the brush and the imagination. He had smashed the old rules by ignoring them. Others might think it a stunt—and it might be a stunt—but to Picasso it was just another step along a new way, a signpost that would mean nothing as he kept going. He had set free his imagination, let it run away with itself. And if Modi asserted that he didn't want to paint ideas, that he wanted to paint life, that it was only real people he cared about and who excited him, Picasso had his answer ready: the figures in *The Avignon Brothel* were more real. In fact, no one in the street was half so real as these ladies.

The painting had no name when it was completed in the spring of 1907. In the earlier version, there had been two men (one a sailor with a cigarette), so it was first jokingly called *The Avignon Brothel* because the nudes flaunting their peculiar charms were reminiscent of "a certain house in the Calle d'Avignon in Barcelona," [14] and also—typical Bateau-Lavoir joke—because of "a ribald suggestion that Max Jacob's grandmother, a native of Avignon, was the model for one of the figures."

Picasso wasn't aware of it, but with this revolutionary painting he had invented what was to be known as Cubism, what Gertrude Stein says Max Jacob called the Heroic Age of Cubism. She affirms that it was, and offers a heroic explanation of how it came to pass:

> All ages are heroic, that is to say there are heroes in all ages who do things because they cannot do otherwise and neither they nor the others understand how and why these things happen. One does not ever understand, before they are completely created, what is happening and one does not at all understand what one has done until the moment when it is all done.[15]

The Young Ladies of Avignon, a title bestowed on the painting by André Salmon later on, became both a landmark and turning point in modern art, although it was long hidden away, shown only to intimates. Eighteen years were to pass before *Les Demoiselles d'Avignon* was reproduced in art publications; thirty, before it was shown to the public in an official exhibition. When Cubism became an accepted style, Picasso explained his motivation in much the same way, though more clearly, as Gertrude Stein had. Critics and the public to the contrary, a painter did

not create a school any more than an inventor announces, *"Now,* I will invent the electric light." It evolved, came about naturally. "When we painted as we did," Picasso was to write, "we had no intention of creating Cubism, but only of expressing what was inside us."

Perhaps the most agonizing thing to a young painter like Modigliani was the feeling that, at this stage, not only was he unable to express what was inside him; he did not know what was there to be expressed. Which led to the damning conclusion that, very possibly, Modigliani might have *nothing* to express inside him—nothing at all.

As he lay on his makeshift bed in the squalid carpenter's shop, caught in the disembodied dreams brought on by absinthe laced with hashish, one can imagine him tormented by the present, dreading the unpromising future. He had no buyers except for a blind man, no money, and now, very little impulse to work. He had struggled, he had taken his paintings to dealer after dealer, and they all turned him down in the same words.

"Monsieur Modigliani, it is useless to argue. You are a nice fellow, yes. Young, personable, and no doubt with a future. Certainly what you show me here is better than the work of ninety-five percent of the artists who infest Montmartre. But what does it mean? *Rien!* Your work is special and personal. One must learn to like it, *n'est-ce pas?* If I cannot do that, how can the public be expected to do it? I must have faith in you, no? I must be moved. Furthermore, I must be willing to take a risk, but I tell you I am not. That is not your fault any more than it is mine. So I am sorry. Truly sorry! What is that? I am to go to hell, eh? And you add *'Merde.'* Why, thank you very much! Ah, you artists. If your paintings were only as good as your tongues. Jules, show Monsieur Modigliani out. Quickly! Quickly!"

Nothing had worked out as Modi expected, nor would anything, to the day of his death thirteen short years hence. Broke, near starvation, his pride gone, it was all he could do to hang on to a dream and find life supportable. More and more, he was down to nerve alone. Like Maurice, who needed alcohol to gloss over the hurts and find escape from cruelty, horror, poverty, and people, Modi needed something. Wine, absinthe, and brandy helped, but he wanted more than the oblivion to an alcoholic.

Modigliani was not a devil-may-care, sophisticated young hellion deliberately seeking sensation in debauchery, sowing wild oats, and going to ruin through excess. Modi was rooted in unreality, unsure of himself, emotionally immature, unreasonably rasped by everyday life because of his unstable temperament. He needed a buoy to support him in the maelstrom, something to transport, uplift him, help keep alive his dream.

So he turned to hashish, which was easy enough to get. In Montmartre, experimenting with drugs was the smart thing to do. The sophisticated rich did it for an esoteric thrill; artists, as a means of exploring new realms of experience and to deaden the sense of failure. Some of them were bold enough to try opium, heroin, cocaine, or morphine, which led to addiction. Hashish was cheap and non-habit-forming. Everybody tried it—except the dull and fearful, the stable and mature, or the dope peddlers who put business before pleasure.

Pigeard, another self-styled baron and legendary character of the maquis, lived near Deleschamps, the fabulous poet-coachman, and was supposedly a painter who also turned out small yawls for a living. He also introduced his fellow painters to various artificial paradises.[16] Pigeard is generally accorded "the sad privilege" of first pressing hashish on Modigliani. But Modi had already tried hashish in Venice, and would have taken it again without Pigeard's help. Modi was epicurean in his search for the most refined sensations. He was interested in learning about drugs. Blame, if there was any, was Modi's, not Pigeard's, who only made the drug available.

Many hashish users, as with those who took opium, made a serene ceremony of taking it reclining either in the "dens" of suppliers or in their own rooms. Modi was the restless type. He didn't like staying at Pigeard's and took his hashish on the run or sitting at a café table.

Fernande Olivier was with them when Picasso, Maurice Princet, who gave Cubism its mathematical theories; Max Jacob, and Guillaume Apollinaire swallowed the bitter-tasting green hashish pellets in the Bateau-Lavoir and self-consciously sat waiting for the effects. They came in time, shocking and compelling, Fernande wrote. Princet, normally a cold, reserved man, bewailed the death of his wife, sobbing and beating his breast. Apollinaire, a sensitive poet and critic, a bon vivant, was convinced he was in a brothel, and talked and acted accordingly. Picasso was in agony, yelling that nothing remained for him. He had "discovered photography" and, having done so and achieved the ultimate, death was the only answer. Art was dead and so was he. Only the enigmatic Max Jacob revealed nothing. Perhaps he was too saturated with ether, his favorite "soother of grief," for the hashish to take effect, or perhaps his stupor, his quiet were expressive of the unspeakable, personal horrors he was contemplating.

Picasso was for a long time haunted by nightmares of Wiegels, a young German artist and a resident of the Bateau-Lavoir, who took too much ether and had hung himself from a beam in his room. There were other friends who were suicides for similar reasons, but it was not Wiegels's death, whose "funeral and . . . memory were celebrated in horrified remorse at the Lapin Agile," that stopped the use of drugs among the gang.

While Picasso liked to say, "Opium has the most intelligent of odors," he found that although his vision and imagination sharpened, he had less and less desire to paint, and "This threat of blissful sterility influenced him most." [17]

Modi, sticking to hashish, had no such fears. Hashish, or *Cannabis sativa,* is known by many names throughout the world: in Mexico and the United States it is called marijuana, and comes from the ordinary Indian hemp plant. It is not addictive. It does not upset the body's chemistry to the extent that one becomes sick without it. The hashish introduced into France from Algeria in the mid-nineteenth century was a tasty, nut-sized appetizer made of ground hemp tops combined with sugar, orange juice, cinnamon, cloves, cardamon, nutmeg, musk, pistachio and pine kernels. But the hashish pellets of Modi's day contained none of these refinements: they were a crude, adulterated brand made for cheap circulation. The effect of them in bulk, however, was on the whole the same. Baudelaire, Rimbaud, Verlaine, and other French artists and writers had used it, as well as other drugs. There were so many of the damned, the brilliant company of profane twilight artists who had always so appealed to French intellectuals. And Modi would soon take his place among the tormented ones, the legendary beautiful and damned, those smugly assumed to carry their own destruction with them, to seek death— Van Gogh, Gauguin, Pascin, and the other mad, drunken, drugged, and debauched—the *peintres maudits.*

Baudelaire, whose poems Modi admired and whose writings on the subject of drugs Modi certainly read with keen interest, found in hashish a transient paradise transcending "the hopeless darkness of ordinary daily existence," a means for man to satisfy his "Taste for the Infinite." But he observed that the dreams induced by hashish were never miraculous or unexpected; they were natural in that they were always in keeping with "the peculiar tonality of the individual." Hashish did not take a man outside his personality; his hallucinations were merely enlargements of it, of the self. "Man cannot escape the fatality of his physical and moral temperament. Hashish will be for man's familiar thoughts and impressions a mirror that exaggerates, but always a mirror."

Hashish, like alcohol, could make a man feel superior (a feeling Modi often had when he was sober), destroy inhibitions, replace timidity with confidence. It could also, as it did with Modigliani, bring out his latent penchant for exhibitionism. It brought on what was buried in his nature in the first place, sleeping like his tuberculosis.

From what Modi's friends observed as he continued to drink heavily, his system reached a point where his tolerance for alcohol was very low. A few drinks went a long way; a bottle of white wine became disabling. Drinking made him bitter, morose, belligerent, and aggressive. He went

out of his head sometimes and did crazy, unpredictable things. But he could also be a gentleman and a prince when in his cups. Some people found his behavior boorish and intolerable. They began to avoid him. Drink and drugs made him quarrelsome—with picture dealers, friends, even those who loved him.

Modigliani had always ignored his physical welfare; hashish on top of alcohol sapped his strength further. What would have been a mild "dose" to others was violent abuse to his body, already weakened by tuberculosis, so badly in need of good food and rest. But he was still a young man; his recuperative powers were remarkable, and he continued to look and act very much as always.

He drank more and more, but he was not yet chained to liquor as he was to become later. Nor was he enslaved to hashish. Habit was not addiction; habit was of the mind and the emotions. His immoderate use of hashish indicated a deep emotional imbalance. He wanted a pellet or two to achieve a state of paradise, a cigarette for the taste, and a brandy or two for the release. But he did not yet have a murderous craving for it as Maurice Utrillo had for wine. Hashish was a bad habit at worst, but a user could easily do without it.

So he went on using it, believing, as Baudelaire had written in his treatise *The Artificial Paradises,* that alcohol and drugs were a means of multiplying the personality, proof of man's endless desire to transcend himself, proof of his inherent grandeur:

> Man's incorrigible addiction to all substances, harmless or lethal, that exalt his personality, testifies to his greatness. He is always seeking to exalt his day-to-day existence and to take wing toward the infinite.

For maximum strength and effect, Baudelaire advised diluting hashish in black coffee, swallowing it on an empty stomach, and putting off dinner for several hours to let the stuff work unimpeded:

> You have now enough ballast for a long and strange voyage. The whistle blows, the sails are set and you have the curious advantage over the ordinary traveler of not knowing where you are going. You wanted it. Hurrah for fatality!

Scientists have meticulously defined the various stages following the taking of hashish. They begin with nervous excitement in step one; hallucinations and mental instability in step two; ecstasy and a period of deep serenity in step three and, lastly, step four, a conclusion of the hashish rapture in profound sleep.[18] Baudelaire noted that hilarity came on like an approaching storm, irresistible, ludicrous. Now came "a sensa-

tion of chill in the extremities and weakness in the limbs." The hands trembled; the head and the body were seized by an awkward stupor; the eyes dilated; the face paled; the lips thinned. Then the throat contracted, thirst dried the palate, and:

> You heave deep raucous sighs, as if your old body could not endure the desires and activity of your new soul. From time to time you shudder and make involuntary movements, like those nervous jumps which, at the end of a day's work, or during a stormy night, precede one's real sleep."

Now followed a new sensitiveness and a superior acuteness in all the senses—smell, sight, hearing, touch:

> The eyes have a vision of eternity. The ear hears almost inaudible sounds in the midst of a vast tumult. It is then the hallucinations begin. Exterior objects slowly and successively assume singular appearances; they become deformed and transformed. Then the equivocations begin, the errors, the transposition of ideas. Sounds take on colors and colors contain music.

For Modi it was worth it to be raised, if only for a moment, from the living dead, exorcised from his "habitation of mud" and transported "to Paradise in a single swoop." He could visualize it as he looked at the pills, which, in the company of André Utter, he bought from the scruffy "Baron" Pigeard in his shabby little place at the Château des Brouillards, the Castle of Fogs, a fitting name for the source of artificial paradises:

> Here is the drug before your eyes; a morsel of green jam, no more than a nutful, singularly odorous, to such a point that it sickens the stomach and makes one faintly nauseous. Here, then, is your happiness! It hardly exceeds the capacity of a teaspoon! Happiness with all its intoxication, all its follies, all its absurdities! You can swallow it without fear. No one ever died of it. It will not injure your physical organs. Later perhaps a too frequent appeal to this magic may undermine your will, perhaps you will be less a man than you are today, but the punishment is so distant and the future disaster to one's nature so hard to define! Tomorrow a little nervous fatigue. Do you not every day risk greater punishments for smaller rewards?

The best sensation of all came when a man reached that peculiar state of serene euphoria in which he was *compelled* to admire himself, a state when all contradictions disappeared, all philosophical problems became

clear, and all food was pleasure. It was then, Baudelaire said, that a voice spoke inside you:

> You now have the right to consider yourself superior to all men; no one knows or could understand all that you think and all that you feel; they would even be incapable of appreciating the good will with which they inspired you. You are a king unrecognized by the crowd and who lives alone in his belief; but who cares? Do you not possess a sovereign contempt that strengthens the soul?

And, cold sober, not under the influence of drugs, this sovereign contempt was to become a dominant part of Modi's personality. It put off his friends and those who wanted to help him—hurt, wounded, outraged them—but it kept Modi afloat. It kept him working, kept him fighting, kept him defiantly alive in spite of the ills that were to afflict him. In all the years of unceasing trial and effort, misery and failure, degradation and desperation, scorn and no recognition, Modi drew strength from the realization, whether hashish-produced or not, that he was indeed an unrecognized king, even a god. And from his airy throne he looked on his subjects with superb arrogance.

Modi drank and sometimes took hashish in the company of his two Italian artist friends, with whom he remained on good terms long after his early Montmartre days. Severini (who died in March, 1966) said that he and Modigliani, as with so many other artists, always shared everything they had. He remembered Modi as *"très gentil,"* very nice, kind, pleasant. But when Modi had had a little Pernod, he became very irritable and *"bagarreur,"* spoiling for a fight.[19]

Alcohol had the opposite effect on Severini: he became very gay; everything made him laugh. But the results, Severini admitted, were the same. While Modi became so enraged that his irritability landed him in one quarrel or fight after the other, Severini, who couldn't stop laughing, was likely to get into just as much trouble.

As Severini remembered him, Modigliani was not a gay man, not *"un homme souriant,"* a smiling man. He was always somewhat preoccupied, but nevertheless very *"gentil,"* considerate. According to Severini, they never quarreled, and in spite of his irritability, especially when he was drunk, Modi rarely had words with his friends. Severini had a great liking for him and, over and over, emphasizes how nice a person he was.

Modi's drunkenness and his drug addiction should not be exaggerated, Severini has said: it is untrue to say, as some have, that Modigliani only worked when, or because, he was drunk or under the influence of drugs. True, Modi often drank; true, he always had a little box of hashish with him and loved offering it to his friends. But Severini feels that this was

all in the way of a diversion, of resting more than anything else. It was common practice among artists of the time who were all so poor that absinthe often took the place of dinner.

One day Severini was eating a meal in a Montmartre restaurant. Suddenly Modi turned up at his side *"sans le sou,"* and looking very hungry. (Severini added that Modi did receive money from Italy, but it wasn't much and never lasted long.) Severini invited Modi to sit at his table and have something to eat, but there was a hitch. Severini had no money either and was dining on credit, courtesy of the management. They ate and they chatted, but all the time Severini fretted about the check and what he would do when it was presented to him.

Modi, always attuned to people, immediately grasped the situation. Hoping to make things easier for Severini, he passed him some hashish under the table. Severini accepted it in the spirit in which it had been given, but hashish, like alcohol, made him break into fits of laughter. When, in due time, the bill was placed on the table, there was a great row. The *patron* resented Severini's wild hilarity at such a moment, and was very offended.

Anselmo Bucci often saw Modi and they became "almost friends." Bucci says *almost* "because there was always that little amused and cynical half-smile that stood between us like a crystal pane." Perhaps it was a sign of the "sovereign contempt that strengthens the soul" that Baudelaire attributed to the effects of hashish.

But this did not prevent them from getting together, sitting at the Café Vachette over a drink, listening to the little orchestra, and making sketches. They said to each other, "Keep still for a moment. Don't move." Modi was interested in Bucci's work, and looked through his friend's portfolio with an attentive thoroughness that Bucci had seen in no other artist except Umberto Boccioni. On one of their outings, Modi did a "simple, straight drawing" of Bucci, which he signed, dedicated, and gave to him. Bucci describes it as "a marvelous *orthodox* portrait with no elongated neck, no blotches on the cheeks, a drawing such as he did in those days when his good angel held his hand." In looking at this drawing, dated 1907, Modi's good angel was Toulouse-Lautrec, for the line, the style, the feeling are much the same.[20] But Bucci seems to have had the negative Italian viewpoint that hereafter, Paris having worked its poison, Modi's art was unorthodox, unpalatable, and unworthy of its heritage.

When Bucci and Modi were drawing together in a café, either Modi or an unnamed cartoonist who was with him would take from his pocket a "mysterious little box, containing a repellent green mixture with a dreadful chemical smell." Modi looked at Bucci, his Gallic-Roman scowl turning triumphant as he ordered the waiter to bring some sugar cubes,

" 'Want some?' " he asked Bucci. " 'Hashish. Juice of Indian hemp. The real thing. From Bengala. *Cannabis indica.* Wonderful stuff. Gives one ideas!'

" 'I haven't eaten,' " Bucci countered.

" 'Neither have we. You have to take it on an empty stomach. We'll have a sandwich afterward to activate it. I'll pay for the sandwich. Soak the sugar well. Swallow quickly as we do. Drink some coffee.' "

And so, Bucci goes on, they got drunk on the drug which, Bucci explains, has the effect of exaggerating or exasperating shapes, ideas, and feelings. It intensifies states of mind and distorts them into a caricature of what they were: a gay mood becomes frantic, heedless gaiety; a gloomy mood, mortal agony and torment.

They continued sitting at the table, drawing. An hour passed before the drug began to work, beginning with a dizzy feeling. Then images began to distort; normal noises became uproarious. The head of the pianist leading the orchestra became smaller, then inflated enormously. In the growing feeling of excitement, the music itself became a din, a clamor, an uproar, a tumult.

" 'What a riot there is going on here!' " Bucci exclaimed.

" 'A riot, eh?' " Modi leered, and roared with laughter. Watching him, Bucci thought that his long eyes, his Roman eyes, had become Etruscan and ran toward his temples like arrowheads. " 'A riot, eh? A riot, he says!' "

Again Modigliani's repressed laughter broke out like a fever. Then, ha! ha! ha! it overcame him, took him away in a whirl, and I saw him float away becoming smaller and smaller as if I was seeing him through a reversed telescope, getting smaller and smaller, wriggling and contorting in his chair.

But I was no longer paying attention. A leaden lump surged from my stomach, stopped in my throat, and then started again, up and down, like the mercury in a thermometer. And what a terrible thirst . . .[21]

᭼᭼᭼Chapter Ten

"Un homme très bien élevé"

U ncomfortable as Modi's shanty was, he had privacy, he could work as he pleased, and the rent was insignificant. But now, as he was lying on his bed during the course of an afternoon, looking across at the painting on his easel, dreaming, thinking, planning what he would do next, he

. . . suddenly perceived that the wall facing the street was moving. As he stared in amazement, the wall of light timber and lighter bricks flopped out into the Rue Lepic beneath. For quite a while he was convinced that he was under a hoodoo, to which malignant influence he attributed his troubles—and they were many! [1]

This was so much like what had happened at Bouscarat's that it revived "his atavistic tendencies toward superstition."

Presumably, Modi shored up the walls and made rudimentary repairs, for he stayed on in the shanty. Appearances to the contrary, and since most people seemed to notice him only when he was drunk, carrying on with Maurice Utrillo, or under the influence of hashish, he drew and painted steadily. Occasionally he turned out sculpture. He painted on cardboard when he had no money for canvas, and sold what he could to Père Angely or to anyone else who would buy his work. He also began a series of preliminary sketches for a favorite sculptural project—a caryatid, the sculptured figure of a woman used as an architectural supporting column.

He painted the cherry tree that stood before his shanty on its little garden patch of green, the shoddy water tower behind it. It attracted him

᭼ 137

because of the delicacy of its pink blossoms in the spring sunlight amid all the bare ugliness around it. It was also perhaps a reminder of the beauty of Italy and of home. Later the painting disappeared, sold for a few francs, traded for hashish or a drink—neither Modi nor anyone ever knew for sure—but he always felt sentimental toward his tree. He watched it possessively as it sprang into leaf and the little cherries greened and ripened. Perhaps he looked forward to eating them, but the neighborhood children always anticipated him and stripped the tree first.

He was aware of the activities in the Bateau-Lavoir, of the endless discussions and experiments set in motion by that great, ugly picture of Picasso's. But he rarely went there or to the Lapin Agile.

His friends noticed a change in him. There were some who thought alcohol and hashish had improved him: he was no longer so refined and reserved, no longer the picture of the disdainful amateur and dilettante. He had become a man among men with the courage to speak out, contradict, hold his own in an argument. He was, surprisingly, witty. André Salmon was one of those who insisted that hashish was the cause of "the miraculous change that came over Modigliani's work. While up to this time Modi's painting was insignificant and worthless, he had within him, according to Salmon, the power of a great painter. He claimed that "One morning Amedeo Modigliani awakened transformed. A little no-account painter who went to bed fully dressed on a divan of the big store type awoke a great artist." [2] Before this hashish miracle occurred, Salmon, as an art critic, insisted that Modi was an artistic nonentity "or else that he [Salmon] should never have been allowed to judge the painting of his epoch."

While there is considerable merit in the latter part of this statement, it is enough to say that Salmon's opinions are fallacious and in the minority except among those who tend toward what André Malraux calls "a rather crude determinism" in modern biography. Speaking of Van Gogh's life, Malraux says that one can hardly imagine a medieval preacher Christian enough to love—out of charity of heart—an ugly, diseased prostitute, then consecrating his faith to art, then becoming a painter of genius, and finally going mad and killing himself; not in all periods do madness, syphilis, and epilepsy quicken art. Nor, as in Modigliani's case, do hashish and alcohol. "There are no more any predetermined forms of happiness or even of the irremedial than there are of the significance of the world; like history, life does not predetermine forms, but it calls them forth." [3]

It may be that Modi's art passed unnoticed by his friends because his drinking and drugging called attention to his person. Café and bistro owners were all unwilling amateur art dealers who exchanged drink for paintings. There were Modiglianis and Utrillos in almost every bar on

the Butte; no one took them seriously. It was easier to get a drink for a painting than a meal; the same with drugs. For ". . . nearly every addict will give a shot to someone suffering from deprivation, through a kind of free-masonry of vice, when he wouldn't give a penny for food or painting materials." [4]

There is no doubt that the drug helped Modi attract attention to himself. While he was always to be a loner, plagued by doubts that hashish eased away, he encouraged the impression that he was his own man, firmly in control of his art and his destiny. It never seems to have occurred to his friends that drink and alcohol were a cover. He passed as a gentleman in masquerade, yet he was also known as a prickly fellow, a passionate intellectual, and a devil with women. It takes effort to sustain a pose. Now, as in the years to come, Modi was better known as a character, an eccentric, than as Modigliani, painter and sculptor. He apparently found a somewhat juvenile, and understandable, delight in attracting this attention.

Painters of the "new school," which was to be Cubism, launched by Picasso's grotesquely marvelous painting, met for long discussions at A l'Ami Emile—Picasso and his friends, Apollinaire with his poet's viewpoint, Princet representing science and mathematics, Raynal aesthetics, and the many-sided Max Jacob. Modi often went to A l'Ami Emile with his friends, the painter Maurice Asselin and the poet Louis de Gonzague Frick. The little bar-parlor of this café, on the other side of the square from the Bateau-Lavoir, was to be decorated with two panels, a small one by Modi and a large one by Louis Marcoussis, a member of Picasso's circle. [5]

While Modi took part in the passionate arguments at Emile's, it was evident that with his devotion to the old masters, he was definitely not of the new movement. He preferred to talk poetry with Louis de Gonzague Frick, an extraordinary and unusual man, of a type that Modi always seemed to cultivate. Recalling Modigliani, Frick said of him, "Every night, when he was in good spirits, he was tireless in discussion, speaking more often of literary figures than of painters. Far from being ill-read as it was, he was expanding his intellectual and literary background with great earnestness." [6] Frick was always eagerly and expansively polite. He was well dressed, wore a monocle and a high hat. Like Apollinaire, he was a poet for the good of his own soul and a financial writer for cash, but only poetry mattered to him. It was surely this, plus his courtly manners, that endeared him to Modigliani. Frick was more exaggeratedly polite with women than with men, to the amusement of his friends, and never more so than toward the whores who haunted the Place Blanche or the Café Cyrano.

Frick created his own little legend. He once went to collect some

money due him from a busy banker, who handed him his money in an envelope and tried to shoo him out of his office. But Frick, having just completed what he thought his best work, insisted on reading it aloud. He gave such a remarkable performance and so impressed his hearer with his poetry that the banker doubled the cash in the waiting envelope. Frick thrust it carelessly in his pocket, bowed, and went out to silent applause.

He was exquisitely polite even as a soldier in wartime. In the mud-filled trenches, his uniform was impeccable. He was cool and detached as a messenger. On one occasion he strolled back to the colonel of his battalion, saluted, and said, as casually as though he were announcing mail call, *"Le commandant me charge de vous dire que Messieurs les Allemands attaquent."* (The commander has instructed me to tell you that the German gentlemen are attacking.) [7]

Modigliani could well appreciate such a man—gentleman, aristocrat, and poet. They sat together over drinks; they ate at Mère Adèle's chalet in the Rue Norvins where meals were forty sous, wine and Calvados included. Mère Adèle, who had operated Lapin Agile before Frédé, was another old favorite of the Butte.

Prince Constantin Lahovary-Soutzo was another interesting friend of Modi's at this time. Louis Latourettes describes him as a subtle and captious philosopher. The Prince and Modi talked for hours over drinks and smokes at Adèle's or the Vache Enragé, a dive on the Rue Lepic. Modi showed a filial devotion toward the older man, who, like Frick, remained calm and polite when arguing with the excitable, vociferous Modi.

Max Jacob was another of the cultivated, equable men able to hear Modi out and appreciate the talent behind the bluster and self-indulgence. Max, too, poor as he was, made an impressive appearance: a monocle clamped in one eye, a stiff shirt, narrow black tie, the old, heavy, very wide trousers that had belonged to his father in Quimper and a derby for street wear. Francis Carco called him a charming and precious friend, who walked the streets of Paris at night talking poets and poetry, a man rich in fantasy, imagination his only wealth.

In November of 1907, Modigliani made a friend who was to be his loyal backer for the next seven years. Dr. Paul Alexandre, still alive in 1966, has never forgotten his warm, happy relationship with Amedeo Modigliani. He owns most of the paintings of Modi's early years in Paris, perhaps twenty-five oils in all, as well as "portfolios crammed with drawings that go back from 1907 to 1912." [8]

Dr. Alexandre, who was to become a well-known surgeon, was then an intern at the Lariboisière Hospital, and his younger brother Jean was

either a dentist or studying to be one. Paul loved art, had always been partial to artists, and with his brother Jean had set up a colony for them in a tumbledown house at 7 Rue du Delta.

The purpose of the venture was to give painters and sculptors a place to live and work at little or no cost to themselves. The colony was supervised by Maurice Drouard, a sculptor, and a painter named Henri Doucet, who was the only one of the group to have "a contract with a dealer—the Galerie Charles Vildrac." [9] Drouard and Doucet screened candidates for the colony. Through them Modigliani met Dr. Paul Alexandre and was asked to join the Rue du Delta colony. While Modi seems to have taken some of his possessions and art materials to the colony and to have worked there on and off, it is not clear that he ever lived at the Rue du Delta.

Of all the members of the colony, Dr. Alexandre was undoubtedly most attracted to Modigliani. It might also be said that the good docor was the person in Paris "who first perceived his real greatness." [10] " 'What struck me most about Amedeo was that he was such a well-bred man! *Un homme très bien élevé,*' " he told Claude Roy.

Possibly Dr. Alexandre hinted at another meaning of the word *élevé:* a man "uplifted," who aimed for the heights and struggled to achieve them. It is significant that Modigliani, in his last years, wrote a poem telling of a "king . . . [who] weeps the tears of a man who could not reach the stars . . ."; and that, after his death, in a letter to Emanuele Modigliani, Modi's dealer and good friend, Leopold Zborowski, wrote of him, "He was a child of the stars for whom reality did not exist." In any case Charles-Albert Cingria, a close friend of Modi's at a later period, also thought him a well-bred man.

> I remember him as a courteous, reserved man. No doubt he drank too much and sometimes got a bit uproarious, but no more so than other young men of the day. What struck one was the quality of that uproariousness; however excited, he always remained a gentleman.

To which Roy adds:

> It is pleasant to have Cingria's eyewitness testimony that the too common conception of Modigliani as a vulgar brawler or an exhibitionist mountebank acting the part of the "outcast" painter, bugbear of the bourgeois, is a fallacy.

Dr. Alexandre, temperamentally so unlike Modigliani, was a generous man of broad interests who lived with his family in a comfortable, bourgeois home across from Montmartre on the Avenue Malakoff in the Porte Maillot section of Paris. He wore the formal, dignified clothes all doctors

of the period wore: stiff white wing collar, black four-in-hand tie, and a black, flaring swallowtail coat. A few years older than Modi, he had neatly combed short brown hair, a high forehead, surprisingly thin brown eyelashes, deep-set blue-green eyes, and big, jutting jug ears. His cheekbones were set high on his bony face, and his small thin-lipped, tight mouth was very red against his clipped, full brown mustache and beard.

The relationship between Modi and Paul Alexandre became intimate and remained close until August, 1914. The British critic John Russell wrote:

> Dr. Alexandre was then a young doctor, not long launched, but he had a rare eye for quality; and Modigliani, alike as a human being as an artist, seemed to him of such outstanding interest that he took it on himself to spare him all practical anxieties. And in the evenings, when the consulting room was closed for the day, he would share the takings with his new friend and the two of them would go out to see what Paris had to offer in the way of *le bel et le bien*.[11]

Paul Alexandre considered Modi charming and likable, an ambitious, intense, and talented artist who knew what he was talking about and who was busy evolving his own techniques, style, and method. It may be assumed that, as a good doctor, Alexandre took careful note of his friend's physical condition. Modi knew he had had tuberculosis, that he must take care of himself and hope that the disease would remain dormant, but the threat of it was always there. That it preyed on Modi's mind was apparent in his words and actions. His excesses were perhaps his way of defying fate, even as, ironically, it made that fate much more likely.

From the little that can be learned at this late date, Paul Alexandre believed that one should partake of everything life had to offer— smoking, drinking, whoring, even the taking of drugs if one were so inclined. While not going so far as to prescribe hashish, Dr. Alexandre approved of it and had experimented with it himself. Moderation was the keynote; excesses and abuses must be avoided. But then Paul, who was knowledgeable enough to lead, guide, and advise a little, would presumably never have risked his friendship with Modi by telling him what to do. Modi was not his patient, but his friend, an artist, and a fellow lover of art.

Modi talked about art to Paul Alexandre. He discussed the masters with the same fire and passion that had so moved Ludwig Meidner, and together they went to exhibitions of the works of Cézanne and Matisse, "the two painters who, with Toulouse-Lautrec and perhaps Steinlen and Boldini, most appealed to Modigliani."

Though Théophile-Alexandre Steinlen, a Swiss, and Francisque Poulbot, well known for his pictures of children and urchins, lived in the maquis and mingled with other artists on the Butte, it is doubtful whether Modi was personally acquainted with either of them. Steinlen was a warm, generous man whose paintings and etchings of unfortunates had tenderness and humility and a soaring line. Modi's admiration for his work and for the work of the now less-esteemed Giovanni Boldini, once a Macchiaioli with Fattori, then famous for his brilliant and sparkling Parisian society portraits, is understandable. Boldini had the meticulous shimmer, the precise technique, the marvelous texture of John Singer Sargent, with a dazzling bravura slickness that was all his own.

With Alexandre, Modi also toured the antique and souvenir shops looking for primitive art, the Musée Ethnographique in the Louvre, the Musée Guimet in the Place d'Iéna, and the ethnographic section of the Trocadero, where were row on row of figures, masks, and carvings done by American Indians and by the native people of the South Seas, Africa, and India. The wondrous simplicity of Negro and Khmer (the Cambodian civilization in Indo-China) art was to push Modi further toward sculpture of a new kind, but he had too little money to buy stone and confined himself to drawing and painting experiments.

Although Paul Alexandre was then earning little as a doctor, he bought regularly from Modi and paid what he could. Modi would leave a canvas or a drawing at Alexandre's home in the Avenue Malakoff according to a prearranged agreement, receiving sometimes *cent sous* (twenty centimes), ten or sometimes twenty francs.[12] On a few occasions he got more. Alexandre's purchases were as important to Modi as his verbal encouragement. But Modi, dreamy, impractical and unresourceful, lived badly and meanly. In winter, he often went to bed in an icy room without heat of any kind after having consumed perhaps only a croissant and a *café-crème* for his supper.

Alexandre liked particularly an Expressionist portrait called *The Jewess*, which differed from Modi's previous paintings. Its composition was balanced and firm, with dark tonal values in blues and greens. *The Jewess* herself was a succession of angles on a long neck, a sharply defined ridge over her eyes, an aquiline nose dominating a broad-planed bone structure, and a long, angular jawline. Her thick hair was topped by a dark, angular hat that merged into the blue-green-black background.

Who was this woman and how had Modi come to paint her? She was no sweet young thing staying with him for bed, board, and love. She was a big, statuesque older woman. Perhaps he had seen her walking on the Rue des Saules and had admired her Junoesque looks and carriage. She was cold, poised, and proud. Modi sketched her on the spot, told her that

he, too, was a Jew, and asked her to pose. He liked the way she held her head, her cool, implacable eyes, her rich lips, her powerful chin. She had had so striking a quality that Modigliani could not ignore her, and now he boldly transferred that same quality to canvas.

Alexandre bought this picture for a few hundred francs, surely the largest amount that Modi until then had ever received for a painting. At the same time, although never a boarder at the Rue du Delta colony, Modi fetched all his books and pictures in a wheelbarrow and also "gave a small picture to each of his friends there." [13] Modigliani had the right to take pictures back from the doctor to sell elsewhere, to exhibit, or to paint over as he chose. It is hard to believe that any other man would have agreed to so flexible an arrangement. It speaks well for the doctor that he was willing to relinquish the paintings if Modi found a client who could pay more. But who else would have paid "a few hundred francs" for a Modigliani?

The Jewess is the first painting of Modigliani's, so far as is known, to show the influence of Cézanne. His earlier known work, such as the oil portrait of Maud Abrantès, reflects the spirit of Gauguin combined with the Expressionism favored by Ludwig Meidner and other Expressionists of that time. Five stages of Modigliani's development have been set down by critics: the transition period of his first years in Paris, when he was influenced by Gauguin, Toulouse-Lautrec, Steinlen, and Picasso, to which this writer would add Matisse and the Fauves. That was followed by the Cézanne period exemplified by *The Jewess,* and simultaneously by a Boldini influence as seen in his first portrait of Dr. Alexandre; then came his sculpture, which was strongly influenced by primitive African art softened by Constantin Brancusi; and finally, "his hesitating return to paintings that were full of contradictions; and the fluent, coherent production of his last years." [14]

The "paintings . . . full of contradictions" contained traces of Gauguin and Cézanne, bright splashes of the Fauves, the solidity of the primitive African, and elements of Cubist form and content. "The fluid, coherent productions of his last years" included his nudes, many of the typical, long-necked, distorted portraits that have been mistakenly accepted as typical Modiglianis, as well as the serene paintings in which he

. . . turned back to his ancestor Botticelli and in a most daring union attempted to join the artist's sinuous elegance to the primitive power newly discovered in Negro art. Limiting himself solely to portraits and an occasional nude, he juxtaposed Botticelli's fluent line and urbane individualism with hieratic tribal memories of Africa, miraculously inventing a language of his own as authentic as those he combined. . . .[15]

Nevertheless, Jeanne Modigliani feels that the painter cannot be so neatly compartmented and his various styles and phases accounted for. Just a brief glimpse at Dr. Alexandre's collection convinced her "that these divisions are purely arbitrary." The few verified dates of Modigliani's paintings and sculpture "upset this whole chronology"; further, "an unprejudiced examination of his entire work, right up to his death, reveals that he was doing parallel research at one and the same time throughout his artistic career." Her conclusions seem to be thoroughly justified: Modigliani cannot be classified by neat categories.

In 1908 Modi carried on as usual, helped immeasurably by the friendship and patronage of Paul Alexandre, spending most of his working hours at the artists' colony. It was Alexandre who persuaded him to join the Société des Artistes Indépendants and to show at their salon later on in the year. Barring a few incidents, he got along well with Drouard, Doucet, and his associates. He still roamed Montmartre, ate, drank, and talked with his friends, Louis de Gonzague Frick, Prince Constantin Lahovary-Soutzo, Gino Severini, Max Jacob, who always had time for him, and André Derain from whom it has been said he learned much. He saw Picasso, young Juan Gris (a Spanish newcomer to the Bateau-Lavoir who called Picasso "Chère Maître"), Vlaminck, Van Dongen, Braque, Apollinaire, Princet, Marcoussis, and many others. They met on the Place du Tertre, then adjourned to the Coucou, the Azon, Spiehlmann's, or perhaps A l'Ami Emile to eat, drink, and continue their endless harangues on the new art.

In 1908 Picasso gave the Douanier Rousseau a banquet, which was to become an often-told, distorted legend, complete with banners, poetry, songs, comedy, tragedy, farce, and some drunken antics by André Salmon that discomfited Gertrude Stein and Alice B. Toklas. Modi had admired the paintings of the extraordinary Rousseau who was something of an older Utrillo without the alcohol—simple, straight, true, and a master of his own genre of painting. André Malraux says he was less a naïve artist than the interpreter of an immemorial language. He feels that even if Rousseau had never painted a canvas, he would still have set future generations dreaming. Those "who thought they were making of him a figure of fun were to hear long after his death, sounding in their ears, the waltzes played to them by the ghost of one they could never forget." [16]

Modi was not invited to the banquet. As he heard more and more about the dinner, the anecdotes, the hilarious byplay, the laughter and the jokes, he may have felt slighted. It proved what Picasso and his friends thought of him after all: He did not like their art; they neither liked nor respected his. To them he was a reactionary, a conservative,

blind to modern art and to what Picasso had done with his *Demoiselles d'Avignon.*

The new painters aligned themselves in two camps: Cubists and Fauves, Picasso or Matisse. Modi belonged to neither. He had been affected by their work but he was not "of" them. He listened to both sides. He found Cubism provocative. It stirred him while it discouraged him with his own work. He felt restless, enervated. Only Maurice Utrillo was unaffected by these alignments, and he was unaware of them, drinking himself under the table as usual, painting the same pastoral scenes of Montmartre's walls. But Modi, unlike Maurice, had neither a style nor a technique of his own.

At this point, Gino Severini approached him. Severini had a new idea in art—an Italian idea, more sweeping and iconoclastic than Cubism, an idea meant to overcome, surpass, and eclipse Cubism. Severini, a Tuscan, like Modi, from the small hill town to Cortona, had also been in Rome in 1901, where he had become friendly with the talented and original Umberto Boccioni, whom Modi came to know briefly in Venice later on. Severini and Boccioni had studied under Giacomo Balla, who had returned from Paris a devotee of the then current Divisionism. Severini was much more aware of what was going on in Italy than Modigliani. It must have seemed odd to him that Modi, so wrapped up in the old masters, should be ignorant of the work of such modern painters as Carlo Carra and Luigi Russolo, as well as of Balla and Boccioni and especially of the Futurist poet Filippo Tommaso Marinetti.

Of Marinetti, André Gide wrote in his *Journal:*

> This morning, work—or an attempt to work.
> At two o'clock there came a certain Marinetti, editor of a review of artistic junk called *Poesia.* He is a fool, very rich and very self-satisfied, who has never learned how to keep silent.[17]

Balla, perhaps Marinetti's first convert to Futurism, had created great public and critical controversy in 1903 with the exhibition of his *Dog on a Leash.* A remarkable vivid and original picture to some, it was the first attempt to capture motion on canvas. Balla felt he had added an extra dimension to painting, a new element, perhaps more important than anything either Picasso or Matisse had achieved.

The concept of motion was part of the Futurist Manifesto, a statement which redefined Marinetti's principles for painters. The Futurists hoped not only to supersede Cubism but also to transform and revolutionize art for all time. Their way was new and modern; they insisted it expressed the *only* significant twentieth century thought there was. Everything in literature, music, and art was nineteenth century and, accordingly, old hat and dead. Futurism was alive—the present and the future.

Futurism marked the revival and re-emergence of Italian painting, which the artists were convinced would recover a stature it had not had since the Renaissance. Futurism hoped to recapture the lead the French had taken. It was for junking the past and tearing down the museums. Its gods were motion and speed. Futurists believed that profiles were never motionless; to paint the human figure one must not paint it but the whole of its surrounding atmosphere. Science had changed the world to serve humanity. In the same way, art had to disown the past to serve the intellectual needs of the day.

As Severini recalls it,[18] Boccioni asked Severini to sign the manifesto and to find other painters in Paris who might also be willing to sign it. Severini thought of Modigliani, and probably sometime in 1909 asked him to sign it. But Modigliani was not interested. He liked color and paste, like the Venetians. Besides, he had come under the influence of Brancusi and turned to sculpture in stone—which, Severini felt, gave Modi's painting its peculiar character.

The Futurist Manifesto was finally published, after years of argument and propaganda, in April 1910, signed by Balla, Boccioni, Carra, Russolo, and Severini.

Aside from a discrepancy in dates, Severini's account seems a little weak. "Not interested" scarcely describes what must have been Modi's violent reaction to a statement that was against all his own beliefs. How galled he must have been at the Futurist claim, "We fight against the nude in painting, as nauseous and as tedious as adultery in literature." A little further on, the Manifesto argued that ". . . artists obsessed with the desire to expose the bodies of their mistresses have transformed the Salons into arrays of unwholesome flesh! *We demand, for ten years, the total suppression of the nude in painting. . . .*" The manifesto might contend that its signers saw nothing immoral in the nude, only in the monotony of the nude, but an infuriated Modigliani could only scream at the tyrannical rules and dirty minds of the Futurists. Men who glorified the machine, bombs, war! Men who did not "look on man as the center of universal life!" Men who compared the suffering of man to the suffering of an electric lamp! This was insanity on top of inhumanity.

Or he may have thought the manifesto too outlandish to be taken seriously. Another movement, another classification. Every artist he knew was putting a label on himself. Modi wanted no labels. He wanted only to be himself. He wanted an art of his own as Rousseau had, as Utrillo had. The others signed up, joined, and painted under the rules of the organization. Their freedom was gone. They were classified as "one of those." Right now he was classified as nothing and—he didn't have to be told—he *was* nothing. Only Paul Alexandre believed in him. *One man.* Modi drank more; he consumed more hashish.

His friends noticed that he was worse off than before. Except for infrequent spells of high spirits when he was hilariously gay, Modi was increasingly bitter, moody, despondent, and belligerent. They did not notice that he kept on working.

∽ ∽ ∽ Chapter Eleven

"To create like a god, rule like a king, work like a slave."

Either on his own or more likely through Dr. Alexandre, Modi got another commission sometime in 1908. His subject was a young woman who posed for a portrait wearing riding clothes. It was called both *The Amazon* and *The Horsewoman*. She was a round-faced, small-featured woman, a strong-willed, determined aristocrat with an inscrutable air. She was known only as *Madame la baronne de H.*

She was portrayed hatless in stiff white collar, black tie, and smart puff-sleeved riding jacket. Her left hand in a leather glove rested nonchalantly on her hip as she looked warily out of the picture. She revealed nothing of herself. The portrait was something of a caricature of a natty horsewoman, a supercilious Amazon, a socialite with whom Modi had nothing in common. One must presume that the baroness did not much care for the picture, for it soon became part of Alexandre's collection. The lady no doubt had expected something as slick and flattering as a Boldini portrait. And as in so much of Modi's work, there was no background, just the girl, poised and aloof, the paint applied thickly, the brushstrokes wide and sweeping.

The paint was thick, too, in the nudes Modi had done of a young woman who appears to have been a patient of Dr. Alexandre's. Apparently a prostitute being treated for venereal disease, she had a sad, pinch-lipped face and a small body. Her suffering was on every feature.

One can visualize her standing apathetically, unable to understand why any artist would want her to pose but not caring much that he did. She was no society woman like the baroness. She was not one of the complaisant laundresses or pretty, easygoing models who gladly posed for Modi before hopping into his bed. She had a round head, a short, thick

neck, and a thick, sulkily voluptuous figure that somehow complemented her sad, petulant expression. Modi painted her in columns and circles: first the stolid figure, one breast round and facing him, the other turned away, smaller and cone-shaped, as if her maker had tired after completing one.

Modi painted several studies of what was called *The Sorrowful Nude*. It had a raw quality, but compared to the sophisticated horsewoman in her elegant riding clothes, it had warmth and feeling. Modi cared for this sick, troubled woman whom life had kicked around, as he never could for the Amazon. He had caught her grief, responded to it with sympathy. *The Jewess, The Sorrowful Nude,* together with another nude of the same young woman, a study of a work in progress called *Idol*, and a drawing made up Modi's entries in the Twenty-fourth Salon des Indépendants in 1908.

They were probably as good as most, superior to some, but just five miserable orphans lost in the shuffle of the six thousand or so other exhibits. Fauve and Cubist pictures (the latter undoubtedly surrounded by people heatedly arguing), covered the walls. Henri Rousseau was also represented. His *Combat Between a Tiger and a Buffalo* and *The Football Players* had their partisans and detractors, but the Douanier was no longer the object of major ridicule with the Cubists around.

Modi was not content merely to be another participant. He wanted his paintings to be noticed and, proud artist that he was, he must have felt a sense of failure. Again his work passed unnoticed as it had at the Salon d'Automne the year before. He always told people that he painted only as a sideline, for reasons of health and because stone was expensive. Stone was available, but stone dust worsened his cough. Wood, however, would seem to be an ideal medium for his sculpture. One story tells of Modi buying a much-prized African mask in an antique shop. Whether he did or not, the idea of carving in wood probably came from the primitive art he had seen, especially the little wooden figurine kind of sculpture that had intrigued Matisse and Picasso.

But getting suitable wood for the work was another story. The problem was ingeniously solved by Modi and his friend Doucet of the artists' colony. The Metro was constantly being expanded and, not too many blocks away, the Barbès-Rochechouart station, as well as a new section of the subway, was under construction. Materials for the project were stored in open sheds. Modi and Doucet stole oak ties from the sheds at night.[1] This was the kind of lark Modi appreciated. He and Doucet must have gone back many times to get enough of the heavy oak ties for Modi to carve.

Probably all of Modi's wooden sculpture of this period were of the

exact dimension of the timbers used for crossties on the Metro. He must have done a number of them, but only one of his oak carvings survives. It is owned by a Mr. and Mrs. Deltcheff of Paris.[2] The head stands twenty-two inches high, a long, oval-shaped woman's face, with part of the uncarved crosstie protruding from the back of her head. The hair, parted in the middle, is done in stylized waves and braids. The forehead is wide. There are no eyelashes. The eyes are deep-set in their sockets; the nose is a continuous high-crowned slab; the lips are protuberant in the partly open pursed mouth. The head has no ears; the cheeks are broad and flat; the chin is rounded and firm, the neck on the long side.

The head has composure and mystery. This was done in 1908, and it is significant that this is his first use of the shut, or blank, eye, the elongated nose, and the long neck, all of which were to become the hallmarks of his painting. He may have gleaned these characteristics from the primitives, both African and Khmer, as well as from some elements in Picasso's work. But in taking over, adapting, using what he chose in other styles, Modi was following the pattern of most artists, for an artist, says André Malraux, extracts from the profusion of all that he has seen and experienced whatever serves him for modifying his earlier works. Building on what he has already done, he goes on, step by step, "and imposes order on the world through the very process of creation."

Thus ". . . when he noticed that a meditative look comes over a face when the eyelids are lowered . . . a Buddhist sculptor was moved to impart that look of meditation to a Greek statue "by closing its eyes." Malraux adds that if this sculptor *did* notice the expressive value of the closed eyes, "it was only because he was instinctively seeking amongst all living forms for some means of metamorphosing the Greek face." Malraux's conclusions have direct application to Modigliani's search for a new form of expression:

. . . The reason why the artist studies living forms so intently is that he is trying to discover, in their infinite variety, elements that will enable him to impose a metamorphosis on the forms already possessed by art—such as eyes that can be closed. There is a rich hoard in the cavern of the world but if the artist is to find the treasure he must bring his own lamp with him.[3]

There was no more market for Modi's wooden sculptures than for his pictures. Paul Alexandre does not seem to have cared for sculpture. There are no examples of Modigliani's sculpture in his collection. It is possible that he may not have known Modi was doing sculpture. Perhaps Modi did not take them around to him, or Modi may have exchanged a few for a drink, a meal, or a book. He may have given some to friends.

The rest were lost, mislaid, or destroyed. In any case, this period of sculpture was an interlude.

Modi often joined his fellow artists in their evening get-togethers in the Rue du Delta colony. They were an exuberant bunch, incited by hashish and alcohol. André Warnod tells of the group installing a little theater. They gave plays, skits, recitations, and parodies just as Picasso, Max Jacob, and their friends had in the Bateau-Lavoir. Modi surely enjoyed play acting and declaiming. With art forgotten for the day, they had loud, rough, and rowdy good times. And as always happens in such cases, there were misunderstandings, altercations, and someone got hurt.

Every Christmas Eve Dr. Alexandre gave a *reveillon,* or midnight supper, for his protégés. It was a lively celebration, with many guests. The late sculptor Alexander Archipenko spoke of being at one of these affairs when Modigliani was present.[4] Hashish added to the tumult of the *reveillon de Noël* 1908, and gave the party an exhilarating atmosphere. Everything had been prepared well in advance. There was a barrel of wine, with much food, and the room was decorated with paintings.

Modi was master of ceremonies as well as leader of the frolics. "What follies were committed that night!" says Warnod, reminiscing.[5] André Utter danced madly. Jean Marchand sprawled on a sofa, groaning, sobbing, because he had been told his beard made him look like Jesus Christ, and hashish made him believe it. But even this party paled next to the one given on New Year's Eve, a week later, by Warnod and his friends René Denefle and Richard de Burgue in their studio at 50 Rue Saint-Georges. Again, hashish sparked the evening and produced a bacchanal.

Modi presided at the door, dispensing hashish pills to all comers. Since it was New Year's Eve, the guests took them like candy. Then, as the evening progressed, the drug and plenty of alcohol put everyone into paroxysms of frenzy. Sometime near midnight a few of the guests conceived the idea of setting fire to an enormous tub of punch in the middle of the floor. The rum wouldn't burn, so they dumped the kerosene from a lamp over it. This time it caught fire, to cheers and screams. The flames leaped higher and higher until they caught the paper streamers decorating the studio. In no time, says Warnod, the whole room seemed to be in flames, but the laughter, the dancing, the shouting, and the music went right on. Miraculously, nobody was hurt and the damage to the studio was slight.

Perhaps it is true that Modi, as some say, started the fire, and burst "into a D'Annunzian invocation to fire." [6] Later he was to set fire to tablecloths and do some other startling things, but on these occasions he merely led the revels and contributed to the gaiety by making sure everyone was generously provided with hashish.

How long Modi remained in the carpenter's shanty in Place Jean-Baptiste-Clément is uncertain. It must have been an icehouse during the winter, and if it did have a stove Modi had no money for coal or wood to feed it. He is supposed to have said good-bye to Montmartre in 1909 and to have gone over to Montparnasse to live. He was to drift back and forth between the two quarters for some time.

Wherever he was living, he very likely spent most of his days at the artists' colony in the Rue du Delta. He sold an occasional picture and a great many drawings to Paul Alexandre, moved about the Butte, got drunk with Maurice Utrillo, took hashish with André Utter, and argued Cubism with Max Jacob. Always preferring to work alone and unobserved, he painted and carved in the Rue du Delta with Alexandre's tribe of artists only because the place was heated. Modi did a portrait of the sculptor Maurice Drouard. Drouard had bushy hair, ears set high on his head, big wide, implacable eyes with dark hollows under them, a good straight nose, a down-curving mustache, and a dourly intense expression, which was perhaps the outstanding feature on Modi's canvas.

But at about this time Modi broke with his fellow artists at the Rue du Delta. He left, apparently, after wrecking their studio in a drunken rage, probably because of an argument with Drouard. To destroy the work of other artists—even of those he no doubt considered third-rate at best—was inexcusable.

Then Modi crossed the Seine. Severini spoke of his taking up a vagabond life after leaving his shanty on Place Jean-Baptiste-Clément, sometimes sleeping at the Hôtel du Poirier (so named for the big pear tree in front of it) where he paid one franc a night, sometimes staying with friends or on a bench in the waiting room of the Saint-Lazare railroad station. Severini also says that with Gaston Modot, a one-time painter who became a star as a daredevil in silent films, Modi briefly shared an abandoned shack on the top of the Butte, called "La Maison du Curé." [7]

It seems logical that the news of his crime and desecration at the Rue du Delta colony had spread through the Butte and, overcome with shame and humiliation, Modi was only too glad to try his luck in Montparnasse.

Perhaps Modigliani meant to absent himself from Montmartre only for a while, but in time Montparnasse got into his blood as Montmartre never had. He continued to wander back and forth between the two quarters for the remainder of his short life, but Montparnasse was from then on to be his real home in Paris. Tarnished legend has enshrined Modi as the Prince of Montparnasse, King of the Bohemians; his affection for its streets, its bars, and its people is a matter of record. He equated Montparnasse with his beloved Rome.

"Rome does not yield herself at first sight," he told a friend. "It's no

use visiting Rome as a tourist; you have to have lived there a long time to penetrate her secrets. In the same way idlers imagine they know Montparnasse just because they've walked the area separating the Closerie des Lilas from the station. But it's in the little side streets, in the studios, in some bistro friendly to artists—it's in the informal atmosphere of these places that one comes to know Montparnasse." [8]

Shortly after crossing over to Montparnasse, Modigliani met Brancusi. Brancusi was a kind, simple, humble, dedicated man who combined the virtues of Utrillo and the Douanier Rousseau with the qualities of a hermit and ascetic. He was thirty-three when Modigliani met him, a solid, stolid man of peasant background from the village of Pestisani-Gorque, Rumania. He had taken to sculpture early. He had had a classical training and had cut and chiseled his share of traditional statues before moving to Paris in 1904.

He had studied with Jean-Antonin Mercié, a classicist, before he turned down a chance to work under Auguste Rodin, France's most renowned sculptor. Brancusi tended more and more to the abstract, to the essence of objects. Now he renounced Rodin, who, he felt, had ruined contemporary sculpture. What convinced him of this was the scathing critical reception of his own work when it was first exhibited in 1906. Although a mellower Brancusi changed his mind, and in 1952, in homage to Rodin, was able to say that Rodin's *Balzac* was the "incontestable point of departure in modern sculpture" and that Rodin himself had transformed the debased state of nineteenth century sculpture by making it "humane in its dimensions and significance of content." [9]

After Brancusi had exhibited in the National School of the Beaux-Arts, of which Rodin was president, friends and protectors of Brancusi, without consulting him, had tried to get him admitted to Rodin's studio. Rodin had agreed to accept him:

> . . . But I refused as nothing grows under big trees. My friends were very annoyed, not knowing Rodin's reaction. When he heard of my decision, he said simply, "At bottom he is right; he is as stubborn as I am. . . ." [10]

Brancusi's quarters consisted of two studio workshops and a tiny bedroom. He wore a protective skullcap and blue coveralls like Picasso's. For convenience and comfort he wore wooden sabots and made loud clacking noises as he walked. Although only a few inches taller than Modigliani, Brancusi seemed a much bigger man because of his bulk, his bulging shoulders and muscular arms. He had a great head and powerful frame, a thick shock of black hair, and, smiling his saintly smile, his teeth seemed

very white against his flourishing black mustache and beard. In repose he had a brooding, mystical, exalted air, something of patient resignation, too, as he stood among his beloved and unappreciated statues. It was inevitable that Modi would be impressed by this honest man—this genius.

Surely Modi had never seen such abstract sculptures as those pieces cluttering Brancusi's workrooms. They were not so much *things* as ideas of things, reduced and refined to an ultimate form that was smoothly, lovingly polished. It must have struck him that *all* of Brancusi's sculpture was egg-shaped. (The late Sir Jacob Epstein, who knew Brancusi, quotes Ortiz de Zarate as saying humorously that whenever Easter came around, the eggs reminded him of Brancusi.[11]) He worked in stone, wood, and metal, only in the hardest substances. No dabbling in clay for him; no puttering or modeling. Brancusi *had* to work on the raw material direct.

This was exactly what Modi had always believed: to carve direct was the only way. Nor could Modi have failed to notice that, although the sculptor's working and living quarters were cluttered, the floors were clean, his tools hung together in one place, and his materials were where he could get at them. Brancusi was orderly in his thinking as well as in his work and personal habits. The convictions he had reached were as solid as the marble he chiseled. An unflinching, unswerving man. Modi envied his certainty, his sublime independence, and his utter self-sufficiency.

From what others have written, Brancusi gave Modi food and drink and played Rumanian folk airs for him on his violin. All kinds of people—artists, curiosity seekers, students—who had heard of the great man, stopped in at his studio for a look around. Brancusi was always pleasant and courteous. He liked to cook, and offered his guests a delicious snack of little onions dipped in hot melted cheese, a Rumanian specialty. Nina Hamnett, an English woman who was later to become a close friend of Modi, wrote of Brancusi preparing a meal and serving it at the only table in the studio, a great solid lump of white plaster four feet in diameter, to which were pushed great homemade chairs carved from blocks of solid wood.

"I hate restaurants," he said, "and I eat at home. I go to the butcher in the morning and I buy beefsteaks by the meter."

You ate and drank well at Brancusi's. Before the steak came apéritifs, then a marvelous burgundy, a Pommard that Nina Hamnett found rather potent. Brancusi also told her a story about a marble statue called *The Princess* on which he had worked for fourteen years. It had first emerged as the figure "of a very beautiful woman with her head slightly leaning on one side and nude to the waist." But the princess herself hadn't liked it from the beginning and had refused to buy it. Brancusi

had "worked on it and worked on it until it was almost completely abstract and resembled" what appeared to Nina to be a male sexual organ. Others apparently agreed with her.

The statue, now in polished bronze, was exhibited prominently in the Salon d'Automne. It seems that the President of France came to the exhibit one day, took one look at the monstrosity in the center of the room, and sent for the police. "This is indecent," said the President. "I see nothing indecent," said the investigating police officer. "It looks like a snail." Then, wrote Nina, Brancusi was sent for. The President told him it was disgraceful to exhibit such a thing in the same place that Rodin had exhibited. Brancusi's reply was, *"Mais Monsieur Rodin n'a pas pris la place pour perpétuité."* (But Monsieur Rodin hasn't taken permanent possession of the place.) Nevertheless, Brancusi had to remove his phalluslike statue.[12] This no doubt also contributed to his early ill-feeling toward Rodin.

Brancusi reduced all his subjects to what, in his opinion, seemed their essences. Nudes, a bird in flight, a couple kissing, Prometheus—all became egg-shaped, cones, or shafts with a high polish and a smooth finish. He began with a complicated form and finished with it refined to simplicity. One of his best known axioms held that "Simplicity is not an end in art, but one arrives at simplicity in spite of oneself, in approaching the real sense of things."

Inspired and impressed by Brancusi's dedication and methods, Modigliani does not seem to have borrowed from Brancusi or been otherwise directly influenced by his distinctive work. When Modi again began to carve heads, they were recognizable heads with eyes, ears, noses, mouths, and they were Modiglianis. As others have said, Modi saw Brancusi as his revered mentor, not as his teacher and model. His relationship with the sculptor was on a high artistic plane. They did not drink or hell around together, although Brancusi did have his whimsical, impulsive side. In the early twenties, a café and restaurant, Le Bœuf sur le Toit, opened. It was run by Jean Cocteau and a man called Moïse. Those present on opening night included Marie Beerbohm, Mr. and Mrs. Picasso, Marie Laurencin, Cocteau, Moïse, the poet Raymond Radiguet, and Brancusi. On the spur of the moment, during the gay evening, Brancusi suggested that he, Radiguet, and Nina Hamnett leave immediately for Marseille.

Nina thought he was kidding, and went home. But Brancusi and Radiguet, in his dinner jacket, left on the train for Marseille a few hours later. Once in Marseille, says Nina, they decided to go on to Corsica. They hopped the next boat and stayed in Corsica for two weeks. "I have never regretted anything so much in my life as not having gone with them," Nina added.

But if Modigliani, himself capricious and impulsive, never seems to

have been aware of this side of Brancusi's nature, there was one trait he was to copy from the sculptor. Later on, Modi liked to scribble axioms and pithy sayings on the drawings he made of people. Most of them were pat and uninspired, a very few meaningful and profound:

> One maybe sometimes tempted to smile, a shade superiorly at the naive lyricism and Italian exuberance of some of the aphorisms Amedeo jotted down in the margins of his drawings.[13]

Modi probably acquired this habit from Brancusi. Since dutiful observers are not constantly present to record them, the famous sayings of famous men are remembered by repetition, not by chance. Brancusi must have drummed his beliefs into Modigliani during their conversations together, and it is worth examining his most memorable aphorisms,[14] in all of which Modi could find precious meanings for himself and his art.

"Beauty is absolute equity." This might have troubled Modi. "Things aren't difficult to make; what is difficult is putting ourselves in the state to make them." Modi had to agree. Translating thoughts and ideas into creative reality was always a problem. "When we are no longer children, we are already dead." Absolutely. Children had a fresh, original viewpoint. "Theories are samples without value. Only action counts." Right again. The Cubists were overburdened with theories. "The physique of naked men is not as beautiful as that of toads." Except for a few drawings, Modi was never to do a male nude.

Brancusi understood his art, but it was not for everyone. "Carving directly is the real road to sculpture, but also the worst for those who do not know how to proceed. And in the end, carving directly or indirectly means nothing, it is the finished product that counts." The rules only went so far before the artist took over. The Cubists were bound by rules, blueprints, and mathematical formulas. "Polish is a necessity demanded by relatively absolute forms of certain materials. It is not obligatory, it is even harmful for those who make beefsteak." Polish was never too important to Modi, who for reasons of health and expense was to work in soft stone rather than marble, but he did appreciate the indictment of Rodin and his followers as makers of beefsteak. Brancusi also had an answer for sculptors who worked in clay. "What good is the practice of modeling? It leads to sculpturing cadavers."

Although Modigliani had an element of mysticism, he was far more earthbound than Brancusi, who proclaimed, "Don't look for obscure or mysterious formulas. It is pure joy I give you. Look at them [his statues] until you see them. Those nearest to God have seen them." Brancusi had cut himself loose; he was in the clouds, heavenbound. "There is but one aim in all things. To get there one must get out of oneself." His last

aphorism is given as: "I am no longer of this world, I am far from myself, no longer attached to my person. I am *chez les choses essentielles.*" And he concluded that his "life was a succession of miracles," while Modigliani was always convinced that his was a succession of misadventures and misfortunes. But how he would have agreed with Brancusi in his axiom: "Fame doesn't give a damn about us when we chase her, but we turn our back and she runs behind us." Modi never stopped the chase, and it was only death that finally turned his back.

As for Brancusi's philosophy, "To create like a god, rule like a king, work like a slave," Modi had long thought of himself in just those terms, but sculpture, unlike painting, was laborious. It exhausted him and undermined his health.

The English critic John Russell is convinced of Brancusi's influence on Modigliani's art. "Brancusi loved to hammer his opinions home, and it seems safe to assume that Modigliani was firmly indoctrinated with his ideas as to what was, and what was not, a valid method of presenting the human head and body in sculpture." [15] This is a debatable point. The feeling persists that Brancusi's influence was only mystical. Meeting Brancusi, seeing his work and listening to the man, was undoubtedly like a laying-on-hands for Modigliani. It confirmed his long-felt conviction that his destiny was in sculpture. He would abide by the Rumanian's doctrines, foregoing abstractions as such, but always carving direct from stone, working toward the essential spirit of his idea, achieving simplicity on the way.

Obtaining marble or even borrowing it from Brancusi was out of the question. Modi decided to use soft stone. He may have been able to buy some or he may have obtained some from a sympathetic mason in the area. He was still experimenting, doing in soft stone what he hoped to create in solid marble. He dreamed of working under bright Italian skies, of chipping at the smooth, gleaming marble in his own country, perhaps in Carrara itself. He had had difficulties in Pietrasanta, so he probably told himself, only because he was an inexperienced novice. Since then he had learned much about sculpture and, now with Brancusi as an example, he would know better how to proceed, how to carve his ideas in that pure marble. He had no worries about medical prohibitions, if they did exist. He would spend time with Mamma, get some rest, and go on to Carrara with her blessing.

He seems to have been living at the Cité Falguière at this time. He did his sculpture in a little courtyard, when the weather was good, and often visited Brancusi. Oddly enough, although believing himself wholly committed to sculpture, Modi drew and painted as always. It was true that he had to make studies and preliminary drawings of what he planned to

carve in stone, but he could not stop drawing, and was always seen carry-
ing his big blue portfolio. It is also possible that he painted an occasional
portrait on commission. And he sold his drawings in cafés. His work
habits had not changed appreciably, but from now on he thought of him-
self as Modigliani, sculptor. In this connection Russell writes, "It was of
Brancusi, not of any living painter, that Modigliani wrote back with en-
thusiasm when he paid a short visit to Leghorn in 1909; before long his
mother was addressing him as 'Amedeo Modigliani, *sculpteur*,' when she
wrote to him in Paris."

If he did indeed destroy the work of his friends in the Rue du Delta,
Modi may have felt rather ashamed to face his friend and patron Paul
Alexandre. Perhaps the doctor had to look him up and talk things over.
Always thoughtful and kind when sober, one can believe that Modi went
back to Montmartre with Alexandre and made sincere apologies. The in-
cident did not harm the friendship, for in April, 1909, Modi was invited
to the Alexandre apartment on the Avenue Malakoff to meet the Alex-
andre family.

Surely on his best behavior, showing no sign of indulgence in either
alcohol or hashish, Modi made a splendid impression on the Alexandres
as a fine, upstanding, personable young man of intelligence, charm, and
good upbringing. This is not to say that in company Modi always put on
his company manners or that the Modi of five years later would have
been such a paragon among the Alexandres.

Modi was only three short years from his days in Rome. His poverty,
misery, and primitive living arrangements had been forced on him. He
had not embraced them as a true Bohemian would have. It is revealing
that in his *Fils de Montmartre,* André Warnod speaks of Modi as a
familiar figure at Dr. Alexandre's house, "gladly leaving the Bohemia of
Montmartre of which he had a horror." Modi lived as he had to, not as
he preferred. Warnod also says that Dr. Alexandre has happy memories
of his family, animated by Modi's conversation, enthusiasm, and charm.

Modi in the Avenue Malakoff was the old Dedo among equals, not
Modi the masquerader swaggering about the Butte. The family liked
him, and Paul's father, a formal and severe gentleman of the old school,
thought well enough of Modi's work to request portraits of himself and
his sons, Paul and Jean. A commission, especially a series of portraits, is
not a thing to be offered or undertaken lightly. Nor from the look of his
portrait, stern and reserved, was old Alexandre a type to be won over by
words or flattery.

Although Modi was full of Brancusi's ideas and a frequent visitor at
his studio, he now put aside the sculpture he was working on in his little
room at the Cité Falguière to paint the three Alexandres. Presumably
painted in their Avenue Malakoff apartment, the portraits are all formal.

Old Alexandre stared at the artist full face, knotty hands directly on his lap, a distinguished-looking man with resolute features. Lacking background details, as all Modi's portraits did, the picture had something cold, harsh, and dry about it which, very likely, was Modi's impression of the old man's personality.

Jean Alexandre was also shown seated, head tilted to the left, leaning on his right hand, but staring head-on, a dreamy expression on his handsome face with its long aristocratic nose and thin drooping mustache. Because he knew Paul well and was close to him, Modi's portrait of him had a warmth and a feeling the other two lacked. Modi was to paint three portraits of the doctor, in 1909, 1911, and 1913, over a period Claude Roy calls "the five crucial years of Modigliani's evolution." The three portraits "might well be titled Prelude, Variation, and Fugue on the Theme of a Face."

The first is "a bravura piece, displaying more virtuosity than originality." To Roy the line is elusive and imprecise; and, like Cézanne, Modi "relies almost exclusively on color for rendering volume and perspective. . . . This elegant, sophisticated portrait might have been signed by any of the five or six most brilliant portrait painters of the day." Certainly the sheen and slickness of Boldini, plus a touch of Whistler, are evident in the first portrait of Alexandre, with Modi's own *The Jewess* on the wall in the background. The changes from 1909 to 1913 are both significant and remarkable. Sculpture perhaps induced Modi to stress his line and Brancusi's ideas to simplify and economize every phase of his art. Explaining how Modi used a toned-down color "discreetly to suggest effects of modeling," Roy summed up the differences in the portraits:

> What is remarkable here is the way in which, while accentuating distortions and progressively simplifying his brushwork, Modigliani succeeds in producing in each case a better likeness, both factually and psychologically. Anyone who, like the present writer, has met Dr. Alexandre, cannot fail to be struck by the way in which, in each successive portrait, the model becomes all the more his natural self, the more the painter's creative self comes to the fore.[16]

One cannot say whether old Alexandre liked his portrait. Perhaps he wanted a clinical completeness, a classic portrait of himself in familiar surroundings in recognizable clothing. In executing commissions Modi was well aware of the artist's supposed obligation to please his sitter. This may account for his first bravura portrait of Paul Alexandre being so realistic, so much a scintillating Boldini. It was through Paul, too, that he received a commission for a portrait of a certain Monsieur Lévy, another straight, uninspired painting he did at the time and one which Mo-

digliani himself, according to his daughter, always considered "a very bad picture." But anxious to please Lévy as well as Alexandre, who had recommended him, Modi had not yet reached the stage of pleasing himself first. He was trying to get established, to earn money, to live—and to go back home for a visit.

◇ ◇ ◇ Chapter Twelve

"What a thrill I gave 'em!"

A postcard bearing a July 3, 1909, Leghorn postmark, carries a message from Eugenia Modigliani to her daughter-in-law Vera, Emanuele's wife, which reads:

> My dearest, Dedo has arrived. He is fine. I am very happy about it and felt that I had to tell you and send you a great big kiss.[1]

While Modi was "worn out, badly-clothed, and undernourished," he had not returned home a wreck. None of the letters written by Mamma Modigliani during this summer of 1909 give the impression that Modi was recuperating from the ravages of misery and alcohol. Eugenia was probably so glad to see him whole she would have made allowances, no matter what his condition.

Aunt Laura had apparently looked Modi up in Paris shortly before, and had found him living in miserable quarters in a beehive-shaped building known as La Ruche. He lived in one of the ten or twelve cell-like rooms on the first floor, Laura Garsin told Lamberto Vitali in 1946.[2] In any case Aunt Laura, having probably obtained his address from Eugenia, came to Paris from Marseille, and found her favorite nephew. No doubt she urged him to go home to Leghorn, and also generously advanced the money for his railroad ticket.

Aunt Laura went to Leghorn for her vacation that same summer of 1909. It is not known when she arrived, but it is conceivable that she shepherded him home. Aunt and nephew were soon busy writing philosophical articles together. Caterina, the family dressmaker celebrated for her tart language, was hired by the day, and she and Eugenia set about

outfitting Modi with new clothes. According to Margherita, he was both wasteful and ungrateful. With one snip of the scissors Modi shortened the sleeves of his new jacket and without hesitation ripped out the lining of his handsome Borsalino hat to lighten it.

While he was home Modi painted several studies of heads. He painted a portrait in red of his sister-in-law, Vera Modigliani, and two "studies," which were later among his entries in the Indépendants of 1910. He also seems to have used as a model Bice Boralevi, a twenty-six-year-old girl, "who had been a pupil at the Garsin-Modigliani school from 1892 to 1897." Bice Boralevi had an "interminable" neck, and Modi very much wanted to paint her portrait. It seems that Mamma was delighted at the prospect, since it would keep Modi home. " 'Posing this way, you'll make him stay quiet,' " Eugenia told her old pupil. Bice dimly remembers that "Modigliani's studies were somber in tone, the only bright note being a lace collar, and the features were very 'stylized.' " [3]

One of the big changes in Modi's absence was that the family had moved to the Via Giuseppi Verdi; the other was that Emanuele, more than ever a force in the Socialist Party, had married. Umberto had completed his engineering studies at Liège and had entered the ranks of his profession somewhere in Italy. Modi was the prodigal son come home. He enjoyed being spoiled. He savored Mamma's good food and the comforts of home. He found pleasure in painting his old schoolmate. It was probably easy for him to forego the little vices that were so necessary in Paris. Besides, hashish wasn't available, nor did he have the urge to use it.

He did his drinking and smoking at the Café Bardi among his old friends. Perhaps he visited Gino Romiti's studio and gathered there with his old classmates from Micheli's school—Benvenuto Benvenuti, Aristide Sommati, Lando Bartoli, Renato Natali, or any of the old group that were still around.

He would be expected to discuss Paris, its art and artists, what he had learned and seen. Modigliani very likely talked big. In many ways he was the same Dedo, good-looking, winning, witty, extraordinarily observant. But he had a tired, jaded, superior air about him that his friends attributed to Paris. It was difficult not to resent Modi's sophisticated veneer. He disparaged poor Micheli and Italian art; he mentioned people like Picasso, Matisse, and Rousseau, movements like the Fauves, Cubism, Abstraction, and things like primitive or African art about which his friends knew and cared very little. But he had little to show for his three years away from Leghorn. The rest of them—those who had stayed with painting—hadn't done too badly. They had sold portraits and exhibited successfully in Florence and Venice.

Too much publicity, praise, and attention was given the artists in Paris. Picasso and Matisse sounded like two more promoters of the ugly

and flamboyant, eager to show off and shock the public. One can imagine Modigliani finding himself in the strange position of defending all the things he himself had sometimes found fault with in Paris and picking holes in what he had most often praised to Picasso and his other Parisian friends. But no one could deny that, when Dedo wanted, he could draw rings around all of them.

It appears that one day, as the three friends sat around the Café Bardi, both Benvenuti and Modigliani set about doing a sketch of Sommati. Benvenuti couldn't get his right and, on his second attempt, Modi grabbed the paper and quickly completed the sketch portrait. Jeanne Modigliani, who saw Sommati many years later, feels that the sketch— now in Leghorn's Civic Museum—caught Sommati perfectly as the old man he is now rather than the youngster he was when Modi drew him. The two were good friends, and Modi was able to see in his young friend the bony facial structure of the old Tuscan that his daughter met— "shrewd, soft-hearted, and lonely, dust-stained with the ochre-yellow of Tuscany as he stood between the picture of his son who was killed with the partisans and the tender, rosy tints of some of his own simple, sensitive post-Macchiaoli landscapes." Sommati still owns an unreproduced, early drawing by Modigliani of a stevedore, which is "honest and unpretentious . . . reminiscent of the young Van Gogh's drawings of miners." [4]

Between eating, resting, putting on weight, looking up his friends, and writing articles on philosophy with his Aunt Laura, Modi enjoyed a brief vacation from work, but work was never far from his mind. As there has been confusion between his trips to Italy, so has there been confusion as to whether he left Leghorn to do sculpture on his first trip home in 1909 or on his last, which was probably in 1913, but 1909 is the more likely date. Emanuele recalls only one trip, but does not mention the date. He says that Modi painted and drew caryatids in Leghorn and wanted to go to Carrara to chisel his caryatids in marble, "in spite of the medical interdiction." Emanuele "secured him a job there as sculptor where all material necessities would be assured—that is to say, as the brother saw life, not Modi. Paris called, however, and back he came." [5]

Modi was charged with Brancusi's ideas, convinced that he must carve from the hard stone direct. Carrara was the place to do this. He was in good health, full of hope, and anxious to get on with his project. If Emanuele is right, it would appear, then, that at Modi's insistence, the family, as usual, overcame its doubts about backing him and Emanuele, with his political influence, did indeed manage to get him some sort of sculpturing job at Carrara.

Working in the sticky, unbearable heat of late July or August, Modigliani came up against the same problems that had plagued him when he

had first tried to work in marble in Pietrasanta seven years earlier. Chipping the laborious marble was too exhausting; the stone dust made him cough; he became ill and discouraged.

Before returning to Paris, Modi painted several other pictures that were to be among those he exhibited at the Salon des Indépendants in 1910. Eugenia's letters and diaries of the time mention "a legacy from someone called Castelnuovo," which was preoccupying the family. The will was complicated. Among the legacies were a late-Renaissance copy of a Greek statue of Hermes, a round pastoral landscape supposedly by Salvator Rosa, "a seascape by Tempesta, and a seventeenth-century, Neapolitan, oval picture of a beggar."

Eugenia wrote three letters to Margherita, who, one can't help thinking, had been sent off to visit Emanuele and his wife to avoid friction while Modi was at home. Eugenia spoke of the problems of the will, the season at the Pancaldis Bath, and then referred to her youngest son. "Dedo is out all day with a friend who has a studio." This was Gino Romiti. Modi spent some time at home, too. "Dedo and Laura are writing articles together, but they're too much up in the clouds for me." And finally, after the family art expert had given his opinion: "Dedo has seen the pictures, which he considers worthless, including the famous statue."

The picture of the beggar apparently appealed to Modi enough so that he took it to Romiti's studio and made a copy, whose "watered-down Cézannesque structure" reminds Jeanne Modigliani of the original. She thinks it "a modern interpretation of an old picture and not an authentic portrait done from a model." In this portrait, known as *The Beggar of Leghorn,* not of Naples, Modi has softened and blunted both the Cézanne influence and his own firm line, darkening the background, and blurring the features of the old man with his close-cropped hair, sightless eyes, hooked and almost broken nose, bony features, and walrus mustache.

As a companion portrait, Modi seems to have painted another beggar, this one a girl, *La Mendiante.* It was most probably painted from life. While the model may have been a friend of Romiti's, she has such feeling that it is hard to believe she was not an actual beggar. In Leghorn he would have to have gone only to the nearest church and ask the first thin, sad-faced girl he found begging on the steps.

Once again the composition owed something to Cézanne, but, unlike *The Beggar of Leghorn, The Beggar Woman* had a strong sculptural feeling, a firmer line. But mainly it has great compassion and innocence. To Modi's friends, if they saw the portraits, it must have seemed that Paris had undermined whatever talent Dedo had once had. To a pupil of Micheli and Fattori, *The Begger of Leghorn* was crude, unfinished, imperfect alongside the original. It was the same with *The Beggar Woman.*

Rather than portraying what was there, what the two beggars *really* looked like, Dedo had falsified their appearance by bringing himself and his feelings into the portrait. He had painted what he felt, not what he saw, besides introducing all the other affectations of technique and representation he had picked up in Paris.

Yet Dedo's friends in Leghorn couldn't help liking him, even though he was nothing but talk and dreams. He would never be as well known as Fattori, nor even have Micheli's good name. And that was too bad because he had had talent, and promise, as a true heir of the classic heart of Italy. Paris was ruining him.

Tanned, fit, and brimming with energy, Modi returned to Paris, probably in late September, wearing his new suit, carrying his two *Beggar* pictures. After settling down again in the Cité Falguière, he headed for Dr. Alexandre's to show him his latest work. But the doctor was out. Modi left the following impatient note.

Dear P. Have been in Paris a week. Paid a fruitless call at Avenue Malakoff. Want very much to see you again. Regards, Modigliani.[6]

Paul Alexandre thought well enough of *The Beggar of Leghorn* to buy it and add it to his growing Modigliani collection. Modi seems to have made a gift of *The Beggar Woman* to Paul's brother, Jean, who, if he was a dentist, may have accepted it in exchange for dental work. Modi was to have increasing troubles with his teeth up to the time of his death. On the evidence of the sculptor Jacques Lipchitz, who helped make his death mask, it was discovered that Modi had a complete set of false teeth.

Taking up where he had left off, Modi resumed his restless, frenzied life, smoking cigarettes, indulging his tastes for women, liquor, and hashish, seeing his friends, drawing constantly, and still alternating between painting and sculpture. Modi knew that tuberculosis was always a threat, that his stay in Leghorn had restored his strength, that his vices—if vices they were—endangered his health and his career. It was a case of not being able to help himself rather than of not caring. He could only live and work hard.

The drinks and the drugs, the frenzy these young artists brought to charging, headlong, at the blind wall of reality—or overleaping it in that wine-flushed delirium which gave wings to Utrillo's and Soutines's imagination and, in Modigliani's case, the hashish-tinged dreams that lifted him above himself into a world of light—all these were not the follies of youth which, as the saying goes, will have its fling, but indications of a febrile sensitivity wrought up to the breaking point.[7]

His second unsuccessful attempt to carve in marble must have worried him, but he had to admit the medium was beyond him. Watching Brancusi work so easily in blocks of marble and chunks of steel, Modi may have struggled to learn the causes of his failure. He showed Brancusi the studies and drawings of the caryatids he intended to cut in stone. He began a portrait of Brancusi, printing in Brancusi's studio for convenience and because his own quarters were unsuitable.

Brancusi was an imposing subject, and Modi was anxious to do him justice. He made his usual rough sketch on the canvas, then worked in Brancusi's great, shaggy, bearded and mustached head, tilting it to the left. The eyes were shadowy black under the strong bridge of the brow; the features had depth and sculptural solidity. The effect was of an intense, sorrowful, brooding man. Modi left the body and the background in outline and splotches. He never completed the portrait. He may not have been satisfied with it. It was a misfire.

On the other hand, it may not have been deliberately put aside. Perhaps Modi was interrupted after an hour's work; perhaps there was some other distraction; perhaps Brancusi had a caller, and Modi left, taking the unfinished portrait with him. And perhaps then he never happened to take it back to Brancusi's studio. In any case, during the winter he reversed the canvas, using the fresh side for a study of *The Cellist*. The abandoned *Portrait of Brancusi* can be seen today, the middle support of the canvas stretcher cutting across Brancusi's neck, boxing in his head. Claude Roy calls the rejected portrait an "admirable" one "with the tectonic dynamism of a great painter," although "it does not yet give an intimation of his ultimate developments." This marks another advance in Modi's art, the influence of sculpture showing in the constructional quality of the composition, the architectural building with planes.

It is likely that Modi was still preoccupied with sculpture, particularly with marble. He had learned how to cut, chip, shape, chisel, and fashion it slowly, carefully, patiently from Brancusi, but since Modi could not afford marble it may have been Brancusi who gave him a leftover chunk to use. From this he may have carved the 24¼-inch-high head, possibly the only marble sculpture of Modigliani's in existence, now in the collection of Jean Masurel in Roubaix, France.[8] Less finished than most of his heads, probably because of the difficulty Modigliani had working in marble, the top and sides are flat and scored, the features chiseled on the apple-smooth, roundly protuberant front surface. The sculpture has a sort of headdress from which smooth wings of hair, parted in the middle, project. The forehead is low, the eyes almond-shaped and blank, the nose a jutting slab, and the mouth small and pursed. The chin is rounded and massive.

Curt Stoermer, a German critic, visited Modigliani "in his ground floor

studio at 14 Cité Falguière (off Rue Vaugirard just beyond the Boulevard Montparnasse)." Stoermer appears to have been one of the few to have seen Modi at work in 1909. Stoermer observed of Modigliani:

> He had a tremendous urge to make sculptures himself. Having ordered a large piece of sandstone to be placed in his studio, he cut directly into the stone. Just as there were times when he loved idleness and indulged in it with the greatest sophistication, there were also times when he plunged himself deep into work. He cut all his sculptures directly into the stone, never touching clay or plaster. He felt destined to be a sculptor. There were certain periods when this urge started, and thrusting all painting tools aside, he snatched up the hammer.[9]

From this "large piece of sandstone," Modi might well have carved his biggest statue, which stands 63 inches high and is today in the collection of Gustave Schindler in Port Washington, New York.[10] The sense of mystery, serenity, and repose is strong in this slim-waisted, hourglass-shaped figure. The head is long and narrow, the eyes closed and puffed out, and the nose is a long, reversed exclamation point with the mouth, a smug round period, directly underneath. The breasts are rounded scoop-shaped medallions set exceptionally high on the narrow chest; the arms clasp the body low on the rib cage, and on the belly, where the navel should be, is another rounded, flattened medallion.

Modi evidently lavished great care on these enigmatic pieces that show the influence of Brancusi, African, and Khmer art, and perhaps of the Polish sculptor Elie Nadelman, whose work was exhibited in E. Druet's Gallery in April, 1909. Nadelman, an impoverished sculptor supported by Alexandre Natanson, co-founder of *La Revue Blanche* and the *Cri de Paris,* was a character Balzac might have invented, according to André Gide. He lived through six years of terrible poverty, isolated in his work-room. "He seemed to live on plaster." At a time when the Cubists were the rage, Nadelman had something new to offer. André Gide, who attended the preview of his exhibit at Druet's, described the work in his *Journal* for April 25–26, 1909:

> . . . Nadelman draws with a compass and sculpts by assembling rhombs. He has discovered that each curve of the human body is accompanied by a reciprocal curve opposite it and corresponding to it. The harmony that results from these balances resembles a theorem. The most amazing thing is that he nevertheless works from a model. He is young and has time to return to nature. But I am frightened by an artist who starts from the simple; I fear he will end up, not with the complex, but with the complicated.[11]

Nadelman's work supposedly had great influence on both Picasso and Modigliani. The critic and art dealer Adolphe Basler wrote that the sculptures "astonished Modigliani [and] were a stimulus to him." Picasso, said Basler, was disturbed by Nadelman's experiments.[12]

Good modern biographies of Picasso do not mention Nadelman. As for Basler—who said that "Modigliani seemed to abandon painting (in 1909). Negro sculpture haunted him and the art of Picasso tormented him"—*le papier se laisse écrire*—he was wrong. Modi never stopped painting. And that very winter of 1909–1910, he was making a series of studies—one of them on the back of Brancusi's portrait—for the most important painting of his career to that time.

Nor was it the art of Picasso that tormented him, it was Picasso. Like himself, Picasso was a triple-threat man. He could draw, paint, and sculpt. He was the leader in everything. He was miles ahead and he did everything easily, effortlessly, miraculously. Besides, he was successful; he had formidable patrons, wealthy collectors, influential promoters, regiments of frantically loyal followers. In fact he was riding so high that in October of 1909 he left the Bateau-Lavoir and took a comfortable apartment with studio attached at 11 Boulevard de Clichy. The old Bateau-Lavoir gang was breaking up. Picasso had become a bourgeois!

From the way he holds his instrument it is safe to guess that the man who posed for *The Cellist* was a serious musician, probably looking for employment in a symphony orchestra, presently making a meager living by playing occasionally at café-concerts or with pick-up groups. In Modi's painting he seems a lonely man who resembled Brancusi, though built on a much smaller scale. He has thick hair, growing long at the back of the neck, a beard and a mustache, and a pinched, sleepy air the uninitiated might take for scholarly dedication but which Modi recognized as the state of being cold, poor, and hungry. The man also lived in the Cité Falguière, where Modi must have heard him practicing on his cello, and conceived the idea of painting him as he played.

Since Modi did a series of studies, the cellist evidently posed over a period of time during the numbing cold Montparnasse winter. Jeanne Modigliani adds that, "Among other things, the sittings gave the poor devil a chance to practice in the warmth of his neighbor's wood stove." Modi rarely had enough money for such comforts as fuel and, in contrast to his usual penniless state, he must have been comparatively well off. Either he had just received money from home or Paul Alexandre had bought some pictures.

The cellist and Modi enjoyed each other's company, one devoted to music and the other to art. While not especially musical, Modi liked music and was especially fond of two melodies, according to the poet

Charles-Albert Cingria. One was Johann Sebastian Bach's *Cantata for Pentecost* "which a woman friend, who knew a little violin, played for him when they were together."

It could have been Modi's cellist friend who first played the *Cantata for Pentecost* (No. 68, "My Heart Ever Faithful . . .") as he posed, his bow sweeping across the strings, his eyes shut tight. Modi hummed the melody as he worked, and it stayed with him. His other favorite was a sentimental Leghorn song that he often sang:

> *Sono un impiegato a cento lire il mese.*
> I work for a hundred lira a month.
>
> *La moglie porta il vestito di raso*
> My wife wears a dress of silk
>
> *E il capello colle penne nere . . .*
> And a hat with black feathers . . .[13]

Modi's diction and rhythm were perfect, but he sang badly out of tune. The ditchdigger brother of the waitress at Rosalie's restaurant had reminded Modi of this with polite authority. *"Quando si canta bisogna intonare,"* he said helpfully (When you sing you must put the tone on the intervals). Modi would have resented such advice from anyone else, but the man was a fellow Tuscan, and Tuscans greatly admired the musical doctrine of Aristoxenus of Tarentum, handed down over the centuries—the reeds, the open countryside, the authorities, and the stones of Tuscany. This was *sapere ornato,* or embellished knowledge, another favorite expression of the ditchdigger.

On those frigid, blowy winter days in the Cité Falguière, the cellist sat with his back to the hot stove, holding his pose. Modi sat facing him, painting. It went well. It was a portrait of a cello as well as of its player. Modi used the pale yellow, orange, and red of the ochres, green and blue and gray-blue white for the figure and background, and for the cello a warm, rich blend of brown and red-rust. The poor musician sits in a bare, squalid room, and Modi captures him compassionately, with an acute tenderness.

This portrait, which is known as *The Cellist, The Cello Player,* and *The Violon-Cellist,* has much of the quality of his early *The Jewess,* combining "the crispness of Lautrec's line with Cézanne's volumetric construction and the nervous vehemence of the Fauve palette . . ." Claude Roy believes.[14] Dr. Alexandre told Jeanne Modigliani that it was "better than Cézanne." She does not share his excessive admiration for the portrait, but considers it "one of the most complex and significant works of a period in which all his contradictory tendencies met."

During the winter months of 1910, the Seine overflowed its banks from the runoff of heavy snows and rains. The river rose so high that tugs and barges were left stranded on adjoining low-lying streets. At the Pont de l'Alma the river rose nearly to the shoulders of the four historic statues of soldiers on the bridge supports. All the bridges were impassable. Paris turned out to watch the spectacle of the roaring, ice-laden Seine foaming through the city.

The Russian ballet was also in the news that winter. Headed by Sergei Diaghilev, it presented an extraordinary series of ballets with its great star Vaslav Nijinsky: among others, *Schéhérezade* with music by Rimsky-Korsakov; the dazzling *Firebird* with music by the shy, talented young Igor Stravinsky whom Modigliani was to meet and sketch later on.

In the art world, where the various movements rose and fell in a sort of cultural stock market, the Fauves were in decline; the Cubists, under the leadership of Picasso and Braque, were gaining, and, in the wings, the Futurists were the dark horses, preparing an earth-shaking exhibition of their own. It must have struck some of Modi's friends that he had missed a great chance for recognition by not jumping on the Futurist band-wagon. He would obviously never achieve recognition on his own. He had already thrown away his one big chance by not affiliating himself with the revolutionary Italian movement at the beginning.

But Modi's interest lay in the current Indépendants exhibition, which, in the sense of showing what they had done during the months of hibernation, was for artists what the spring collections have become for today's *couturiers*. The Twenty-sixth Salon des Indépendants was held on the Cours-la-Reine, Pont des Invalides, alongside the Seine, from March 18 through May 1, 1910, and the catalogue listed 5,669 numbers, with each artist permitted a maximum of six items. The catalogue entry for Modi was given as follows:

MODIGLIANI (Amédée) born in Italy, 14, Cité Falguière, Paris.

| | No. |
|---|---|
| —*Le joueur de violon celle* | 3686 |
| —*Lunaire* | 3687 |
| —*Etude* | 3688 |
| —*Etude* | 3689 |
| —*Le mendiant* (property of M. J. A.) | 3690 |
| —*La mendiante* (property of M. J. A.) | 3691 |

The first four pictures were for sale; while the last two were listed as belonging to M. J. A., undoubtedly M. Jean Alexandre. The two studies were both of Bice Boralevi, or one of Bice and one of an elephant-eared, bearded gentleman Jeanne Modigliani calls only Piquemal. *The Beggar*

of Leghorn and the studies of Bice Boralevi were painted in Italy, she says; the others were done at the Cité Falguière. Nevertheless, the feeling persists that Modi painted *The Beggar Woman* in Romiti's studio as a companion picture to his *Beggar*.

Modi's work was hardly conspicuous among the Cubists, the group efforts, the anecdotal paintings, the showy nudes so much like those condemned in the Futurist Manifesto, and the hundreds upon hundreds of competent, routine, undistinguished pictures. In such an enormous flamboyant exhibition, Modi's paintings were quiet and undramatic in the obvious way.

Modi, although consumed by doubts as all artists are, was convinced of his talent. He believed that *The Cellist* was a good picture; he had been cheered by Paul Alexandre's praise and by the praise of those friends who had seen the portrait. He may even have raised his hopes on the basis of their flattering comments on the "new" Modigliani. Like all artists, especially those who had struggled for recognition, Modi read the art columns of the newspapers and suffered agonies waiting for the reviews. He had yet to be mentioned by the critics, but he hoped to be, to have some mention of his work—something to cling to, something to show Mamma, something to prove himself to his friends, *something . . .*

One reputable art critic was Arsène Alexandre (no kin to Paul and Jean), who made his home in Montmartre and knew Picasso and his band. "The tribe of critics, with their sheep-like propensities often derived from sheer ignorance or lack of courage, mostly followed his lead, though there were some slatings, naturally, from the classical school." [15] What critics had to say about painting mostly proved nothing. They were all against everything that was different, new, fresh, and untried. This was probably the principal reason why Picasso refused to have his work exhibited. He painted what he chose when he chose. When it came to selling a painting, he disliked haggling. In the early days he let his paintings go for what he could get to keep going. Now he had a dealer, and exhibitions mattered less than ever

The sensation of the Twenty-sixth Indépendants was a painting called *Sunset over the Adriatic* by one Joachim Raphael Boronali. Boronali, however, was a fiction. The picture was a well-publicized hoax cooked up by two practical jokers, the poet and newspaper man Roland Dorgelès and André Warnod, who fed Frédé's donkey, Lolo, oats to quiet her, then held a blank canvas to her tail, to which a brush had been attached, "and the wild daubing started." The two men, with Lolo allegedly doing the work, emptied tube after tube "until the whole canvas was covered, producing an extraordinary mixture of shades of colour and weird effects." A bailiff or notary made out a document certifying that he had witnessed the proceedings that had taken place at the Lapin Agile. "The excellent

Lolo was the success of the exhibition and the only wonder is that the two practical jokers were not assassinated by a horde of infuriated Cubists led by Picasso." [16] The motives of Dorgelès and Warnod have been variously interpreted. It seems that Dorgelès did not like Cubism and "bet that he would exhibit a painting that was more original and revolutionary than anything done by the Picasso gang."

Perhaps the Cubists were piqued by an asinine trick, but they could appreciate a good joke on themselves. Besides, they were shrewd enough to realize that they could not have dreamed up better publicity for either the Salon, Cubism, or themselves. As it was, the hoax seems to have been leaked to the press for maximum sensation. There was a great to-do over Boronali's *Sunset over the Adriatic* in both *Le Matin* and *L'Illustration*, photographs of the amazing painting itself, and even of Lolo creating the masterpiece. The public no doubt flocked to the exhibition to see the picture, and had a good laugh at the expense of "those crazy artists." More important, for good or ill, the spotlight was on Cubism.

Inexplicably, Modigliani is supposed to have aroused enough interest among the critics—particularly the influential Arsène Alexandre—to convince himself that he had at last arrived. Jeanne Modigliani says that Alexandre, "when faced with the works that the Italian painter showed at the *Salon des Indépendants,* was enthusiastic in his praise of Modigliani." [17] Goldring wrote that ". . . his celebrated picture of the violin-cellist . . . made a stir and was much commented on." He adds that, "Thanks to an art critic of renown, one Arsène Alexandre . . . , Modigliani was almost launched," and that Modi was careful to send his mother only the favorable press clippings.[18] In neither case is Alexandre's praise documented.

So far as research can ascertain, only two critics mentioned Modigliani's name, and Arsène Alexandre was not one of them. One was Guillaume Apollinaire in *L'Intransigeant.* Apollinaire, doing his bit for art and his friends, wrote a column a day on the Salon from Friday, March 18, through Monday, March 21. In one of his four columns he mentioned Modigliani's name:

> Let me cite Modigliani, [André] Lhote, the view of Cameret and the Nude by Jack, and let us pass on to Rousseau, le Douanier . . .

Another friend of Modigliani, André Salmon, did much the same thing in a long review taking up a page and two columns in the March 18, 1910, issue of *Paris Journal.* The piece, headed "Le Salon des Indépendants," had an introduction by Charles Morice, but, in all the vast space allotted him, Salmon only just managed to mention Modi's name:

>After mentioning Jean Biette, a good still-life painter, and Modigliani, victim of the "radicals" [*des "purs"*] of this unforgettable room, I'll conclude by paying tribute to the *douanier* Rousseau, author of a "Paradise on earth" which . . .

The fact that Modi was cited at all counted for something. Perhaps Picasso, Derain, Vlaminck, and other painter friends of Modi's also had nice things to say about *The Cellist*. Perhaps Arsène Alexandre spoke of the portrait enthusiastically in conversation and this was passed on to Modi, but there is no printed evidence of his favorable words on *The Cellist*. The only conclusion possible is that Alexandre's alleged review of Modigliani's work is based on an often-repeated, erroneous source and that Modi so magnified Apollinaire's and Salmon's notice and the praise of his friends that he deluded himself into thinking that his career was launched at last.

No doubt that Apollinaire and the others were sincere. Modi had proved that he was much more than a dilettante and a reactionary. He had worked hard, and *The Cellist* did have merit, although, by comparison with the publicity given Lolo's *Sunset over the Adriatic,* it might as well not have been exhibited at all. Seeing his name in print thrilled Modi. He had something to show Mamma at last, and he saw it only as the beginning of great things to come.

"*Quel* 'swing' *je leur ai appliqué!*" he said. "What a thrill I gave 'em!" [19]

It was childish. It wasn't even true. It was Modi.

For a time Modi apparently drank to his own success and wandered about, ready to show anyone his clippings from *L'Intransigeant* and *Paris-Journal,* apparently doing no work at all as he basked in rosy dreams of the future. But nothing had changed for Modi. Only Paul Alexandre continued to buy his pictures. The dealers were still not the least interested in his work. The small dealers pleaded that they lacked the necessary capital to launch an unknown; otherwise . . . Yes, always otherwise. Other dealers looked at his clippings, told him that he had possibilities, but it was risky business taking on pictures by a painter who must still be rated as a newcomer. They were overstocked as it was. For Modi it was a futile, weary, exacerbating business. He hadn't the temperament to be gracious and sell himself. He had only the time, a terrible and increasing need, but nothing else.

Modi saw them as greedy shopkeepers, dirty bourgeois, commercial bloodsuckers interested only in cash on the line, not in beauty and art as such. Probably none of the dealers came out and said so, but there was more involved than just Modigliani's personality. His paintings were too

specialized and hard to sell. The public could take to a Utrillo immediately. Van Dongen, Vlaminck, Derain, and the rest conformed to a trend, had recognized labels. So did Picasso, Braque, Matisse, and Rouault. Modigliani's work related to nothing. It was too individual. A prospective buyer—if anyone except Dr. Paul Alexandre could be so foolhardy—couldn't picture a Modigliani on his walls.

It was perhaps during this desperate time that Modi figured in an incident later recalled by his friend Maurice Vlaminck. Modi had found a merchant eager to buy his drawings at the modest price he asked. But the merchant, no doubt seeing that Modi was down on his luck and hoping for a reduced rate, kept lowering the price he was prepared to pay. Modi may have begun by asking thirty-five francs for a sheaf of drawings. They argued back and forth until the merchant hit ten francs, which he finally dropped to a last offer of five. Modi, struggling to control his temper, grabbed a knife from the counter, jabbed a hole through the drawings, and tied a string through them.

Following his nose, Modi went straight to the narrow door at the back of the shop and found what he expected: a foul-smelling latrine. Next to the rudimentary toilet was a nail on which were hung torn squares of paper. It was on this hook that Modi hung his sheaves of drawings.[20]

Painting and doing sculpture when he could, Modi persisted in trying to sell his work. Day after day, burdened with canvases and packets of drawings, he was out on the streets, slogging along, going without food from morning till night. His corduroy suit, once Caterina's pride, was faded and worn; the knees of his trousers were thin and shiny. Francis Carco found him stranded toward the end of one of these nights in the Delta, a café on the Place Rochechouart. He still carried the canvases he had dragged all over the city. An old customer of the Delta always finished by buying one for a tiny sum. The sculptures Modi made in 1909 jammed his studio. He gave them away to the few friends who came to see him or to the infrequent buyers of his paintings.[21]

It was now that Modi's misery began. He drank and drugged more heavily than ever, roamed back and forth between Montmartre and Montparnasse, and emerged as a *peintre maudit* and became a legend. He had naïvely counted on the muted praise of *The Cellist* as his springboard to success. He had been credulously optimistic. Success had eluded him, as it always would. Here he was, in his own opinion easily the superior of most artists in Paris (and perhaps not too far wrong in this arrogant estimate), yet scorned, unknown, starving, and beaten. Once he got over the shock of what had happened and accepted it, he'd go on fighting as before.

∽∽∽ Chapter Thirteen

"I do at least three pictures a day in my head. What's the use of spoiling canvas when nobody will buy?"

Though Paul Alexandre still bought Modi's paintings and drawings, believed in him, backed him as always, it was not enough. Now failure poisoned and embittered Modi's spirit, ate into his pride. With his superstitious turn of mind, it confirmed his belief that just as he was doomed to die young, so he was doomed to die unsold and unrecognized, his promise to Mamma unfulfilled, his great debt to her unpaid. Success was vital. He must make haste, focus attention on himself somehow, force people to take notice of Amedeo Modigliani.

The old Bateau-Lavoir gang was climbing up the ladder without a slip. Picasso, of course, was nearest the top. A dirty bourgeois now, selling right and left, he had cleared out of the old run-down place after a sensationally successful exhibition at Vollard's. No salons for Picasso! The dealers came to him and begged for his work. The fad for Cubism was sure-fire for him. For Braque too. Matisse was affluent, and so well known he was being exhibited in New York. Derain and Vlaminck had left the Butte and were prospering. Along with Matisse, Rouault, Friesz, Manguin, and Marquet, their work had been hung at the First Post-Impressionist Exhibition at the Grafton Galleries in London.

Only Max Jacob remained in Montmartre and lived as always. André Utter, although no success, had nothing to worry about because of his liaison with Suzanne Valadon, who always seemed to find a market for her work. As for Maurice, he was a captive, painting and selling in spite of himself, in and out of sanitariums, but always on a leash. Yes, everybody was thriving and taken care of but Modigliani. And where *was* Modi anyway? Had anyone seen him lately? Did anyone know what he was doing? No one knew. He was never still, always on the move.

When he was in Montmartre, his friends thought him in Montparnasse, and vice-versa. More often than not he could not be found at all, and they guessed he was off somewhere enjoying an affair with a new girl, in drunken collapse in an unknown studio, or on a hashish cloud in the Château des Brouillards. Very often he was. But he was also watching Brancusi work or sitting by as Cardoso painted. Amedeo de Suza Cardoso and Modi had a lot in common besides first names. Cardoso's widow, years later, told Jeanne Modigliani of the "extraordinary friendship" that existed between the two men.

Three years older than Modi, Cardoso had also reached Paris in 1906. A Portuguese of wealthy background, he had decided to be an architect. Once in Paris, however, he turned to painting and had a studio in the Cité Falguière in 1909, close to other Portuguese artists there. Very possibly, he ran into Modi in the neighborhood. Happily married, devoted to his wife, sober and hardworking, he was "very handsome, proud in the grand manner, a bit of a buffoon, but capable of exquisite gentleness." In sum, ". . . a more truculent but happier version of Amedeo Modigliani."

Cardoso was "a marvelously inventive painter, whose experiments often preceded those of Fernand Léger or Robert Delaunay." He was aware of the trends in modern art and thinking, and "for intensity of color and lyric inspiration, some of his pictures are superior to those of the best-known artists of that time." The stylization of both Cardoso's nudes and portraits resemble Modigliani, differing only in the former's "more highly colored use of drawing in pencil, pen or brush, and the more decorative value of his line." In contrasting the two, Jeanne Modigliani feels that it is the "sculptural value of Modigliani's drawing that stands out," whereas "Cardoso's line is an arabesque, an end in itself, or is used to suggest color; Modigliani's is an outline meant to suggest volume and depth of plane." [1]

While neither friend imitated the other, they could share ideas. The similarity of their approach to art does "show the intimate freedom with which the two artists compared experiences." Jeanne Modigliani adds that, ". . . Cardoso was not only Modigliani's one intimate friend during that period but was also the only person with whom he could ever work." The five years—from 1909 to the beginning of World War I when Cardoso returned to Portugal—were perhaps the most frantic, frustrating, sporadically productive years of Modi's life. Sympathetic, steady, stable, Cardoso could only have been a healthy influence on him. Modi was welcome to work in the warm, comfortable studio Cardoso acquired in the Rue du Colonel Combes in Montparnasse. He could stay for a meal any time, and Cardoso would certainly have lent him money if Modi had asked—gladly.

But Modi didn't and never would. He was too proud. Nor would he ever ask favors of anyone except a woman with a lovely face and figure, and then, unconsciously, with his eyes. Generous and understanding as Cardoso undoubtedly was, it is an exaggeration to call him Modi's one intimate friend at this time. What a man wants, feels, looks for, and finds in his various friends differs in every case. Modi was just as intimate, if not more intimate, with Max Jacob, Maurice Utrillo, Ortiz de Zarate and, a little later, Moïse Kisling, Chaim Soutine, and Leopold Zborowski.

Modi often stopped in at Max Jacob's room at 9 Rue Ravignan to talk, drink, listen to Max's poetry reading, argue Cubism, burst into long flights of Dante and Verlaine, or to grumble and complain. It was no use telling him he had missed the boat by not joining the Cubists or the Futurists, or to advise him to stick to either sculpture or painting. Modi would not listen. Discouraged after his failure, his bitterness made him nasty and irascible. One evening Modi visited Max, and the two had a meal at the Azon. They ate on Max's credit, which, fortunately, was good for a change. They had a pleasant time. Modi hadn't had too much to drink and was able to hold up his end of the discussion. They went on to another café, more and more absorbed in their conversation. Max was enjoying himself, for he "loved to talk and particularly to play around with an idea and deliberately complicate the issues, until he got his adversary mystified." The give-and-take proceeded smoothly as they drank. But now, "as so often before, Eve appeared on the scene." Two pretty girls across the room began to make eyes at the handsome Modi.

Modi did not seek them out, nor had he ever any need to. He couldn't help responding "to their signs and signals," all the while paying less and less attention to Max's brilliant argument. And now Max, never interested in women, became irritated with his friend.

" 'Listen, Dedo! If you're more interested in common or garden chickens than in philosophy, you'll never be worth a hoot as an artist!' "

Modi, now well along in drink, could not come up with a suitable riposte. He leaped to his feet like a stage hero in a dramatic scene, banged on the table so violently that he overturned a bottle of wine, and "bawled various absurd epithets." Then he hurled one final bomb:

" 'I won't be insulted by any damned *French* Jew!' "

With that he turned on his heel and hurried out of the café. Max shrugged and, ever-philosophic, ordered another bottle of wine, produced his "smudgy sketch-book, and fell to drawing heads and gestures that interested him through the smoky atmosphere of the bistro." Ten minutes later someone came up to his table.

" '*Eh bien, mon vieux,*" said Modi affably, "have you got a 'round' [a coin]?' "

Max felt cautiously in his pockets and brought out all he had—four francs. "He gave Modi two. Without a word the latter walked away." [2]

On another occasion an affluent writer friend invited Modigliani to dine with him in a restaurant. When the time came to pay the check, the writer casually handed the waiter a thousand-franc bill to be changed. In 1910 it was rare for an artist to see a thousand-franc bill. Modi was astonished.

" 'Money is such a contemptible thing,' " he remarked. " 'I don't know how you can carry such filth in your pocket. The only thing that isn't contemptible about it is the pleasure that such a large sum represents. What do you say we blow it all tonight?' "

" 'My dear Modi,' " said the writer, " 'I'd do it willingly, but this money isn't entirely my own. Of the thousand francs in my pocket, six hundred and fifty of them belong to my mother. I can only spend the three hundred and fifty of them that are mine.' "

" 'But couldn't you reimburse your mother later?' ' "

" 'How could I do that?' ' " his friend asked.

" 'Well, with the inheritance from your father, for example.' "

" 'You must be joking!' " Modi began to argue volubly after this reply, then became angry. To pacify him the writer added: " 'Look, Modi, my experience shows that you hate money when you have none. As for my mother, tomorrow morning I have to give her the six hundred and fifty francs I have for her.' "

To mollify Modi further he held a hundred-franc note out to him. Now Modi shot to his feet, superb in his wrath, and banged his fist on the table so that the glasses and plates rattled.

" 'I propose a heroic deed, and you respond by offering me charity! I don't need any of your alms, and you are a coward. *Bon soir!*' "

And with that, Modi executed a third-act exit. The next day the writer received the following note from him:

Words are useless. You know this truth too well to have given any value to mine. Words are useless. Isn't it only actions that count? You had the goodness to offer me a vital loan of one hundred francs. Naturally I'm not asking for this amount, but nothing in the world could tell you how much twenty-five francs would be useful to me, nor how much courage I showed in refusing your offer. I am sad if my refusal offended you and I remain your friend in withdrawing my refusal, that is in accepting the twenty-five francs if you can still give them to me.[3]

Schaub-Koch adds that all of Modigliani's character is expressed in this story.

The great change in Modi came after 1910 and was brought on by the

stifling of his hopes in the Salon des Indépendants. As bitterness hardened his personality, he was increasingly galled at the way fame overtook his contemporaries one after the other. Of Modi's friends and acquaintances, ". . . Many of them frankly had not liked him, considered he was a nuisance, and so had avoided him. But then, as a malicious wit once remarked: 'Nobody really knew Modigliani, for he didn't know himself—he was always too drunk!' No doubt only those who loved him and admired his work would stand for his often stupid eccentricities, due to alcoholic excess." [4] It isn't surprising that Modi, so often denied what his friends obtained so easily, should demand so much of them. But it was far more than the majority was prepared to give.

Surely one of the few loyal and much-put-upon was Max Jacob, who seems always to have thought and spoken of Modigliani as Dedo. Max was surely one of those who loved Modi and admired his work. He observed Modi and understood him as few men ever did:

> Picasso said: "There's only one man in Paris who knows how to dress and that is Modigliani." He didn't say that as a joke. Modigliani, poor as he was, even to the extent of having to borrow three sous for the underground to go to the literary evenings at the Closerie des Lilas, was not only refined, but had an eclectic elegance. He was the first man in Paris to wear a shirt made of cretonne. God knows this fashion has got all over the world, and with what variations! He had color harmonies in dressing that were all his own. And since I am talking about clothes, I'll tell the tale of a corduroy coat. It belonged to Picasso, was as stiff as armour, and had a turned-down collar lined with woolen cloth, very Spanish in style, and it buttoned—if you *could* button it—right up. Picasso having got a bit fatter, gave it to me. But I could never wear this hard shell and I made a present of it to Dedo, who wore it with his usual chic. We gummed inside it the story of this coat.
>
> Dedo (in these days) had done little but sculpture and enormous drawings, vaguely colored. These works denoted a knowledge of Oriental and Negro art. Everything in Dedo tended towards purity in art. His insupportable pride, his black ingratitude, his haughtiness, did not exclude familiarity. Yet all that was nothing but a need for crystalline purity, a trueness to himself in life as in art. He was cutting, but as fragile as glass; also as inhuman as glass, so to say. And that was very characteristic of the period, which talked of nothing but purity in art and strove for nothing else. Dedo was to the last degree a purist. His mania for purity went so far as to make him seek out Negroes, jail-birds, tramps, to record the purity of the lines in his drawings.
>
> I think that Dedo was frightened of color that was not pure. Chez Dedo this wasn't to be in the fashion but a real need of his temperament.[5]

Louis Latourettes, who was to run into Modigliani at various times in his career, put down some interesting impressions of Modi during what must have been the winter and spring of 1911. Modi was low, doing nothing and, in answer to a question of Latourettes's, said he had nothing to show him. When Latourettes scolded him, Modi gave a memorable reply that has often been quoted. One can imagine him shrugging, smiling ironically as he said:

"I do at least three pictures a day in my head. What's the use of spoiling canvas when nobody will buy?"

Modi was sleeping wherever he happened to be these days. Sometimes in an empty studio in the Bateau-Lavoir; sometimes in the scabby little Hôtel du Poirier nearby; and sometimes, after having obtained hashish at "Baron" Pigeard's, he flopped down in a room in the Château des Brouillards. Latourettes even came on him one morning as he slept under the table that stood in front of the Lapin Agile. According to Latourettes, Modi had shocked his friends when, forced to leave his shed in Place Jean-Baptiste-Clément for the usual reasons, he piled his work on the terrace and set fire to it. He laughed as the flames consumed them and said it didn't matter; they were scrawls of his childhood and not worth much.

Between disappearances to Montparnasse, Latourettes again came on Modi when he was living in the Couvent des Oiseaux, an abandoned convent on the Rue Douai, across the Place Blanche. The old building had been taken over by squatters, Bohemian artists, and a kind of itinerant acting troupe that had set up a theater in the old gardens of the convent. Modi had somehow moved in with them after falling in love with one of the young actresses in the company. He was working again, doing portraits and nudes, and told Latourettes that he had completed a bust of the actress, which was one of the best things he had ever done.

Modi seems to have written home infrequently, mostly brief postcards, but he tried to inform his family of changes of address. One can imagine Mamma Modigliani being puzzled and worried over her Dedo. Her letters kept having to be forwarded, and the money she managed to scrape up never reached her son when it might have done the most good. He spent what he had quickly paying his debts, treating his friends over protests, buying art supplies, indulging in hashish and absinthe, and scattering the bills as if they were so many cabbage leaves.

He may have used his Cité Falguière quarters as a studio while living elsewhere, but the chances are that Modi left there, then returned again, only because he couldn't pay the rent at the time. Everything turned on money and, specifically, the rent. Perhaps, as in Latourettes's account, Modi did burn some of his work. If he did, it may have been in anger at

being evicted and sheer annoyance at the thought of having to move all his stuff again. It has often been claimed that Modigliani was intensely self-critical and thus given to destroying both his paintings and sculpture, and for this reason little of the work of his early years in Paris exists.

Much closer to the truth is the fact that Modi, in his haste to escape an infuriated landlord and possible arrest, had to leave his paintings and sculpture behind as he fled one address after the other. The owners, who neither appreciated the value of these abandoned creations nor liked them, threw them out. It was an old, old chapter in the story of the battle between wayward tenant and wily landlord. In Modi's case, a number of landlords and concierges lived to regret the fortune they had deliberately flung to the winds. The landlord of his Cité Falguière studio used Modi's confiscated canvases to reupholster the family furniture. After the artist's death, with Modi's paintings worth hundreds of francs more every week, the man tore chairs and sofas apart. "But his good wife had carefully scraped off as much of the 'dirty paint' as she could, so a dealer's offer of ten thousand francs for the lot fell through. The poor fellow is said to have had such a fit of rage that he died of apoplexy." [6]

Between flashes of industry and of being the old charming Modi, he was more and more intolerable. He fought, he made scenes, he was ejected from cafés, he was in brawls with Maurice Utrillo. His nightly adventures invariably led him to the police station and jail on charges of breach of peace, drunk and disorderly conduct, and simple assult. Every day there were stories of his clashes with Maurice in some bar, incidents in the rowdy nightclub section around Place Clichy, then the police, jail, and the whole business over again the next night, like a scene in a nightmarish play by Alfred Jarry. Modi was going to pot, they said. Pale as a ghost, haggard and thin as death, coughing his guts out, out cold in Montmartre, in a stupor in Montparnasse, or dead drunk in a jail cell.

At this point, for the first time in his life, he seems to have needed money so badly that he consented to do commercial work. A shop owner was willing to pay him a few francs a day for lettering signs, repairing faded old paintings, and altering crude new ones bought as bargains and soon regretted by their purchasers. To an aristocrat of Modi's taste, nothing could have been so degrading, so humiliating. The greatest indignity was being asked to paint over photographs, adding flesh tones and the rest. Perhaps it was Max Jacob who got him the job. Max had often earned his bread doing things he disliked. So had many other artists. If Modi could only have said, "What the hell, it's a living," done his job, and then taken up his creative brush, he might have been able to support

himself after a fashion. But he was royalty; art alone was his kingdom. All he wanted was "To create like a god, rule like a king, work like a slave."

All the artists Modi knew took summer vacation trips on a shoestring to get out of Paris, to see the country, to refresh themselves in a new setting. If things had gone well, Modi would doubtless have gone back to Leghorn for another visit. He may have thought of taking a little trip, or his friends may have encouraged him. But he had no money. Then Guillaume Apollinaire, the critic and poet, perhaps urged by the thoughtful Max Jacob, took an interest in Modi's work. Latourettes met Apollinaire at Modi's room in Montmartre at 39 Passage de L'Elysée-des-Beaux-Arts.

Apollinaire, then only twenty-one, had been born in Rome either Wilhelm or Guglielmo Apollinaris de Kostrowitsky, the illegitimate son of a Polish father, once a colonel in the Papal Guard, and an Italian mother euphemistically known as a courtesan. He was brought up in Monaco, Cannes, and Nice, and was always a brilliant student. His mother supported her fatherless child as an *entraineuse* or dance hostess. When Apollinaire was twenty they drifted to Paris, where he worked in a succession of odd jobs, ending up in a bank, all the while writing poetry and criticism. He gravitated to Picasso and his circle and came to know many writers.

He was "in affluent circumstances, compared to others." "Dark, full-faced, fairly tall, looking well fed, . . . [he] always smoked a pipe." His friends esteemed him as an Oscar Wilde because of "his presence and the style and manner of his wit." His head, one of them said, gave him the air of "a degenerate Roman emperor." Apollinaire always lived comfortably, was a bourgeois compared to his artist friends, and was always able to earn money writing. He was stingy with his money, finicky about small things, and a crank about his personal possessions, particularly about having his bed mussed.[7]

He held a salon every week, but his apartment was small and guests overflowed into the adjoining bedroom. The rule still held, however: no sitting on the bed; no wrinkling the covers. Apollinaire was such a stickler for keeping his bed immaculate that he forced his mistress, the well-bred painter Marie Laurencin, to make love in a chair.

Besides being an ardent backer of Cubism, Apollinaire was busily making a name for himself as a critic. He was always among the first to recognize the best and latest in modern art and literature. He did not set the trend, but he was among the first to spot one—especially *the* one. Later he coined the word "surrealism" for the new art to come. He wrote for money when he had to, but never discussed such distasteful work as his

"learned prefaces to pornographic masterpieces, included in the well-known *Maîtres de l'Amour* series, published by the Bibliothèque des Curieux."

Both brilliant men and superior poets, Apollinaire and Max Jacob were totally different in temperament. Apollinaire was shrewd in business. He would work to make money and was loath to part with it. Max, on the other hand, an impractical mystic, would give a friend his last sou, but never knew how to make money. Their temperamental differences resembled those that distinguished Modi and Picasso. Picasso was astute, controlled, imperturbable; while Modi was always impatient and obsessed, beset by the fear that he would die before he had fulfilled his ambitions and achieved fame. He sensed that his time was short.

Apollinaire might have become rich and famous if he had not died in 1918; even so, he was a legend in his lifetime, and with the republication of his *Alcools,* is now recognized as a major twentieth century poet. A bust by Picasso that is supposedly of Apollinaire but is actually of Dora Maar, stands in the Place St. Germain des Près.

Apollinaire apparently managed to sell a few of Modi's pictures. One wishes that he had continued to promote Modi's work, though it could not have been an easy task. Apollinaire was wholly oriented toward modern art and Cubism, yet it seems likely that he found buyers for Modi's pictures out of pity.

In any case, Modi now had some money, and according to Latourettes, proposed to take a trip to the "bord de la Loire." Before leaving, he made a typically grandiose remark on what he hoped to find on the banks of the Loire.

"*J'y retrouverai les Medicis que j'aime tant.*" (I will rediscover the Medicis whom I love so much.)

Latourettes believed he got only as far as Orléans. In fact, Modi spent all the money from the sale of his pictures at once, and would never have made any trip at all if it had not been for his Aunt Laura Garsin.

Dedo's family must have known that he was in desperate circumstances most of the time, and must have worried about his health. Clearly, something had to be done, and Laura, who was so fond of her nephew, was closest to Paris. It would be logical for Eugenia to write to her in Marseille and suggest that she go to Paris as she had before. It would do Dedo good if she could persuade him to leave Paris and take a vacation with her. Jeanne Modigliani writes that "Laura Garsin tried to arrange for a quiet stay in Normandy, a sad attempt on the part of two such troubled spirits." A letter shows that Aunt Laura did go to Paris, saw Modi, and told him that she would pay for the trip.

This letter, written by Laura Garsin to the Italian art critic Lamberto Vitali, in 1916 says:

In August, 1911 . . . more worried than ever, I decided that I must tear Dedo away from his Parisian setting and arrange for him to lead a healthy, quiet life in the country, if only for a short time. Récha Rothschild [apparently a family friend] was spending the summer in Normandy, and I asked her for the address of a *pension* or small apartment where we could spend the autumn by the sea. Knowledgable and obliging as ever, she was able to find me a small house for rent, and pretty in the bargain, at Yport, a village of the Seine-Inférieure. I cannot remember what excuse Dedo gave for not leaving Paris with me. I only remember clearly that when he did join me at Yport in the beginning of September, he had already been given his traveling money three times over. There was no mystery as to how he had spent the first two advances I had sent him: he was buying some colors and settling debts. Up to that point I understood his behavior and approved.

What was not understandable and unpardonable was his arrival at the Villa André in an open carriage, soaking wet. With the little money left over from the third draft after he had paid his traveling expenses, he suddenly decided to treat himself to a trip to Fécamp. He had heard of the beauty of its beach, a few kilometers from Yport, and in spite of the downpour he wanted to enjoy the view without wasting any time.

You will understand what a weight his amazing folly placed on my shoulders. I felt that I had made an enormous mistake in bringing to such a damp climate an invalid who cheerfully exposed himself to all weathers. I was haunted by the terrifying idea that I would find myself with no means of heating the house, with no means of avoiding a return of Dedo's illness, in a village where I knew no one except the peasant woman whom I had taken on as a maid-of-all work.

No! it was impossible to do anything to help him. We left Yport—Dedo must have thought because of a whim of mine—without, so far as I can remember, having spent even a week together.[8]

Sad attempt it was. But before Modi had left for Yport, and undoubtedly one of the excuses that delayed his departure, was the sensational theft of Leonardo da Vinci's *La Gioconda* from the Louvre on the afternoon of August 22. The museum's most famous picture had been lifted from the wall on a Monday (the day the Louvre was closed to visitors), and removed from its frame. The only evidence of the theft was the glass and the frame on a back staircase.

The press screamed headlines, stories were planted, rumors multiplied, and suddenly—of all people!—Modi's benefactor, Guillaume Apollinaire, was arrested and thrown into Santé Prison as an accomplice in the plot. They said he had done it as a joke to show how lax the Louvre was in guarding its treasures or, more than likely, as a publicity stunt for Cubism. The police had insulted Apollinaire in jail, treated him like a

common criminal, turned his apartment upside down, and even ripped his mattress open just in case the rolled-up *Mona Lisa* might be hidden inside.

Apollinaire was released from custody after a week, but the rumors went on. By this time Modi, with just about enough money left to make Yport, decided to join Aunt Laura.

Jeanne Modigliani is rather hard on poor Laura. She feels that her letter clearly betrays the faults of the good aunt. She sees avarice in her fretting over having to send Modi his travel money three times; thoughtlessness in her for not having considered the dangers of the fall climate; a fierce selfishness in her inability to understand the escapade to Fécamp, in her fear of responsibility for her nephew, and in her final cry "No! it was impossible to do anything for him." If the letter exposes Aunt Laura's faults, it also betrays Modi's.

For Aunt Laura to take the trouble to haul Modi off for quiet and rest was perhaps unrealistic, but it was kind and courageous—and far more than any other member of the family had done for dear Dedo. Modi would probably have been amazed that his Aunt Laura should have been so concerned about him. Considering the strain she was under, Laura deserved a medal. Who else ever treated Modigliani to a vacation and paid his fare three times over? Both aunt and nephew were sick in their own way. Laura's actions and reactions were perfectly rational, but only four years later, in 1915, she was to be confined in a mental hospital.

As always Modi was glad to be back in the familiar surroundings of Paris. Perhaps the brief stay at Yport had helped him more than it had his aunt. It broke the deadly pattern of his life enough for him to plunge back into the struggle with renewed vigor. He ate at Rosalie's little restaurant in the Rue Campagne-Première almost daily. He also stopped by either the Café de la Rotonde or the Café du Dôme to drink, to sell drawings he had made, or to do quick sketches of customers on the spot for a few francs. The Rotonde was soon to become the "clubhouse" for Picasso and his friends, and for many other painters, sculptors, and writers. In time the Rotonde and its genial owner, Libion, with his fondness for all things artistic, were to become even more famous than the Lapin Agile and Père Frédé.

Modi carved some heads in limestone, and these, along with some studies of caryatids, were shown at Cardoso's studio in the Rue du Colonel Combes. Apparently Cardoso arranged the private exhibition on his own initiative; certainly Modi would never have suggested it or permitted anyone except a very close friend to hold it. Refreshments were served. Guests invited to drop by for a look at Modi's sculpture were

Apollinaire, Max Jacob, Picasso, Derain, Ortiz de Zarate, among others. It was a social occasion, too, but important enough so that photographs of the exhibits were taken. Modi prized the snapshots and carried them with him. They exist today, which is fortunate, because the heads themselves seemed to have vanished.

Modi's theories on sculptoring technique had changed a few degrees. While he still argued that working "directly in stone" was paramount, according to Jeanne Modigliani "it made little difference whether the stone were hard or soft." What was important was imparting a feeling of hardness and solidity to the stone, "and that depended entirely on the sculptor." This new idea seems to be one of rationalization. Repeated attempts had proved to Modi that he could not use marble successfully, quite apart from its cost and the damage the dust did to his lungs. So his theory of imparting a feeling of hardness in soft stone compensated for his inability to work in hard stone itself.

One imagines that Brancusi urged Modi to such a conclusion. Relaxing fixed standards and substituting new ones encouraged Modi to go on with sculpture, and these four busts were the result. All four have long, perfectly oval heads, closed eyes, long triangular slab noses, and tiny mouths. They are serene, majestic, yet mysterious and disturbing. They have a touch of Brancusi, something of primitive African art, something of Khmer art, but mostly they are wholly Modigliani. There are no other statues like them. They are strangely reminiscent of the huge, monolithic stone heads found on Easter Island, and they share with those primitive heads, some of them weighing fifty tons, varying in height from ten to fifty feet, a brooding quality and a sense of mystery.

Surely the guests at Cardoso's said nice things about Modi's statues. They were original, fresh, and striking. But for all that they were unsalable. Except for the heads he showed at Cardoso's, Modi did not enter an official exhibition that year. His last salon experience had disillusioned him. Now, savoring all the nice things his friends had said about his heads, he really thought of himself as a sculptor.

If anyone had had the temerity to ask him what he planned to show at the next Indépendants, he would have answered, as Cézanne had to Manet in 1870, *"un pot de merde."* Off to the side, doing his own art, Modi remained so little known and unrecognized that some of his friends believed that he had given up as an artist. Wasn't he drunk and carousing all the time? So rumor had it now, so legend confirmed it later, *ad nauseam.*

"Work regardless of anyone and achieve mastery," Cézanne had said. "The rest is not worth Cambronne's word." General Cambronne, commanding one of the last squares of the Old Guard at Waterloo, was sup-

posed to have said *"Merde!"* to the enemy when they demanded he sur-
render. To Modi it was an all-purpose word that perfectly expressed his
feelings toward critics, fellow artists, foes, and life itself.

Now Modi painted his second portrait of Paul Alexandre. This was
superior to his first—freer, looser, more meaningful, more Modigliani. He
also did a few portraits on commission, one of the pince-nezed, wing-
collared, smart René Chanterou and of other friends of Alexandre's. The
doctor continued by buy a painting occasionally—watercolors of carya-
tids and, always, sheaves of drawings.

Now that he was in Montparnasse, Modi was seeing more of his old
friend Ortiz de Zarate. Ortiz had been married about a year to a lovely
Polish girl he had met in Italy. Through the influence of his wife, Ortiz
had given up the remunerative business of "copying" pictures in Rome.
Now he was determined to paint what he chose in Paris. To ease them
through this period Ortiz's composer father arranged for a study grant
from the government of Chile. It was small, but it helped support the
couple while Ortiz painted and tried to sell his work. Ortiz knew Picasso
and began to flirt with Cubism. He was a talented artist who did mostly
nudes, landscapes, and still lifes. His style varied from the classic to the
avant-garde. Later on, depending on the critic, he was called Romantic,
Spanish, or Ecole de Paris.[9]

Ortiz shared Modi's love for the old masters, and especially admired
Daumier, Goya, Rembrandt, and Cézanne. He did many still lifes, be-
cause they were practical and the materials were at hand. While it must
sometimes have seemed to him that, like Derain, Ortiz was always paint-
ing bowls of fruit, Modi had the habit of helping himself to the edible
still lifes whenever he came by. He gobbled the fruit as if he were starved,
and usually he was.

Whenever Modi went back to Montmartre he was likely to run into
Maurice Utrillo, or rather, Maurice invariably managed to find Modi
without actively looking for him. The reunion was always tumultuous
and celebrated with wine and absinthe, not in discussions of painting
techniques, politics, and philosophy. And each agreed that the other was
the greatest painter in the world, and meant it seriously.

In the matter of their greatness, neither would suffer contradiction.
When they reached the stage where alcohol made compromise impossible,
they fought. They swung at each other in whatever café they happened
to be: bottles toppled, chairs and tables were overturned, women
screamed, and the manager ran for the police as they rolled over and over
on the floor. Subdued by the police and hauled off, bruised and bleeding,
the two were still of the same mind about themselves.

"It's just as I said then, Maurice. You're the greatest painter in the
world."

"No, Modi, you are. You're the greatest."

"Shut up! You're the greatest and the best, damn it!"

"Like hell, I am! You are, Modi."

Before they could be locked up, they were at it again and had to be forcibly separated. When at last they collapsed in their cells, they snored in drunken sleep until morning. Maurice often woke up, screaming, out of his head. He smashed his fists bloody against the bars and rammed his head against the walls as if he were trying to kill himself. He was subdued and tied up quickly before he injured himself badly. At other times, Modi would stumble on Maurice in some obscure bar; they would embrace and toast each other. Maurice would drink to insensibility; Modi would stop just short of that and was able to play the good shepherd to Maurice, whom he dragged home.

The next day he would escort Maurice back to his mother's apartment on the Rue Cortot. He felt like a jailer himself now. André Utter puffed on his pipe and scowled at these two disreputable friends. Suzanne, sloppy in her worn bathrobe, looked anxiously at Maurice, hurried to make coffee, and behaved exactly like a tired, worried mother of forty-six. Perhaps she reminded Modi of Mamma. At least Maurice had a home in Paris, and someone who cared for him. Modi was alone, always alone.

From seeing them so often in her little restaurant, Rosalie had vivid memories of the two painters. She recalled that Utrillo was Modi's best friend:

Often they shared whatever little money they had. Often they woke up on a studio mattress in each other's arms. But they quarreled and beat each other up. When Modigliani came in and saw Utrillo, he would give a berserk yell. "Rosalie, either you throw out that drunk or I won't come again!" Then Utrillo staggered to his feet and threatened him with a bottle in his hand. "Don't come in, you know, or I'll smash your head. Rosalie, throw out that piece of trash or I'll slaughter him."

One day in winter Modigliani came in like a fury. Utrillo was sleeping with his head on the table. "Coward! Pig! Murderer!" shouted Modigliani. "I have fed you, given you a roof over your head, let you my overcoat for half an hour and you've left me freezing the whole day. Give me back my overcoat. Understand?"

But Utrillo looked at him without replying. He had sold it for a few coins to a rag merchant in the Rue Delambre. When they were on good terms they both helped me peel potatoes and string beans. It was a pleasure then. . . .[10]

∽∽∽ Chapter Fourteen

*"A beef steak is more important than a drawing.
I can easily make drawings, but I cannot make a
beef steak."*

No matter how time, experience, and circumstance embittered him, the romantic never died in Modigliani. His vision of a wondrous Beatrice who would one day come into his life remained a glittering promise. He began every new love affair—and there were many—with the hope that in this lovely, desirable creature who had given herself to him he had at last found the woman of his dreams. Modi could neither help falling in love nor being loved. He had a reputation and a manner, and unforgettable good looks. He was still a beautiful man. He walked like a young god—or so nearly every susceptible young woman thought. He was pale with glossy black hair, flashing eyes, and his smile, if now a little twisted, was radiant and provocative.

Modigliani's appearance was as deceptive as the stories that he was *always* drunk, drugged, poor, and miserable were untrue. Some thought him haggard, emaciated, and run-down; others professed to see little change in him. Archipenko remembered Modi as small, handsome, and robust, never showing signs of illness. One can only conclude that, since he was still a young man, his stamina and recuperative powers made him resilient enough to rebound from undernourishment, absinthe, and hashish.

Now came a series of love affairs, in rapid succession, stormy, and eventually part of the legend. Montparnasse was as parochial as Montmartre. Modi was to have a starring role in its history as its Crown Prince and the last of the Bohemians. The stories of his love affairs were to be repeated over and over, exaggerated, invented. Modi was always desirable to women—romantic, gentle and kind, gallant and courtly, a "fantastic" lover. His liaison with one lovely matron began at the Closerie de Lilas.

Modi was sketching of a summer evening, ". . . a conspicuous figure . . . in his corduroys and red scarf." A few tables away sat the wife of a wealthy businessman with her husband and his party. Perhaps they were slumming, come to Montparnasse "to see the artists at play."

The two noticed each other from the start. Modi began to draw her, and now the lady, ". . . flattered at having been noticed by an honest-to-goodness artist, and an Adonis at that . . . ," wanted very much to meet him. So Modi came over and, a double brandy before him, "opened his famous sky-blue album and displayed his wares." The lady was far more interested in the artist than in his art. Modi was also a model gentleman that night, so witty, so charming and irresistible that members of the party bought his drawings and he found himself "commissioned to paint a portrait of the strange beauty."

Modi was prompt where women were involved. He arrived as asked and began to paint the portrait in a summerhouse in back of the matron's home. Love bloomed quickly. Modi was soon living in the summerhouse and "painting in a high state of excitement." The lovely lady was also "in an abnormal state," it seems, and "Modi must have introduced her to his favourite artificial paradise." The love affair went on and on, "Modi painting furiously all the time." The lady's husband was mysteriously absent these weeks, "probably abroad on business." But, as in a novel, he returned unexpectedly to find his wife posing in the nude.

Naturally he protested indignantly. There was a vicious argument; he screamed at his wife, and she yelled right back at him. Jealous and infuriated, "he threatened to strike her, and to throw her lover out by force, but Modi turned on him with such ferocity, screaming menaces and angrily grinding his teeth, with wide-open glittering eyes flashing like a crazy demon's, that, crying that he was being attacked by a lunatic —and he wasn't far wrong—the man fled."

The couple must have thought the husband was scared off for good. He didn't come back, and the loving and painting resumed. Goldring thinks the man was terrified of the lunatic Modi or else he consulted his lawyers about how to proceed without a scandal. Detectives watched Modi and his lady. During one of Modi's absences, the lady was kidnaped. All he found in the empty summerhouse on his return were his paintings. Some of them are among Modigliani's best nudes.

This love affair, which had elements of farce and melodrama, ended in tragedy. The lady became addicted to drugs and had to be confined to a nursing home, where she died. Some people thought that she was an addict before she met Modi and had spotted him as one.[1]

Modi must have grieved over his loss and the injustice of its tragic end. With the exception of a limited number of commissioned pictures, his

paintings of the women he loved give the impression that he was genuinely fond of them.

It was like Modi to take out whatever sorrow he felt in wild bitterness, wilder actions, cheap showmanship, and flamboyance. Liquor and hashish swamped and suppressed the sweet, sensitive, kindly side of his nature, broke down his inhibitions, and spurred him to all kinds of excesses. Unable to focus attention on his art, he became pathologically obsessed with focusing it on his person. Being conspicuous became absolutely essential.

If the rumor and gossip of Montparnasse had appeared in a local scandal sheet, Modi would have made headlines every day: barking at his friends, making scenes, throwing things, insulting dealers and potential clients; setting fire to tablecloths, taking his clothes off in public (or trying to), wandering down to the sleazy all-night dives in the worst sections of Paris, where he got involved with women and then came close to being knifed by their jealous escorts or beaten up by pimps, apaches, dope pushers. The way Modi carried on in public did not sit well with his friends. Picasso's reported comment on Modi's behavior was bitter:

"It's a funny thing. Utrillo can turn up drunk anywhere, at the Bourse or the Place d'Italie, but Modigliani's always drunk right in front of the Rotonde or the Dôme."

The inference was that Utrillo got drunk as he breathed, aimlessly and wherever he happened to be, while Modi's drunks were calculated, staged.

Francis Carco explains matters bluntly:

> One felt that, sober by nature, Picasso had it in for those who drank too much for involving him in antics against which he had no recourse. That Utrillo or Modigliani were drunk for the most part did not exasperate him, but it did annoy him that they took advantage of their drunkenness to escape his control. In fact neither "Monsieur Maurice," whose misadventures were beyond counting, nor Modi ever gave any importance to Cubism; Picasso was much too intelligent not to regret that these two very great painters were able to attach themselves to a tradition, which especially in Montmartre, allowed them to stay free. Both of them, in a time when paintings were not selling, had amateur collectors. Naturally prices were low, but the junk shop owners of the Butte, the short-order cooks, and the cheap wine merchants paid up to fifteen francs for a carton of Utrillos, and Modigliani, shut up in the cellar of his shop by an art dealer, received a twenty-franc gold piece every evening for his labors.[2]

To admire his art, while perhaps not caring too much for the artist himself, is in the natural order of things. Picasso was to own several Modiglianis and was known to have stood in front of them nodding approv-

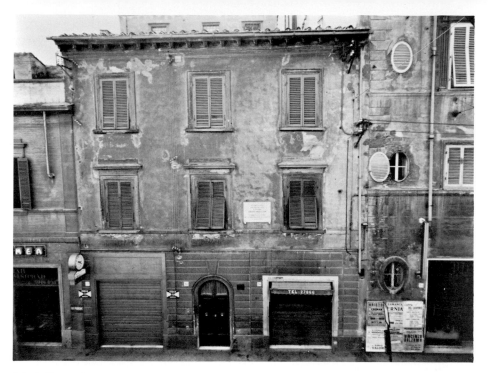

Birthplace of Modigliani at 33 Via Roma, Leghorn, once a well-to-do residential section of the seaport. *(Aldo Durazzi)*

Plaque erected at Modigliani's birthplace in commemoration of the seventy-fifth anniversary of his birth, July 12, 1959. *(Aldo Durazzi)*

Modigliani's mother, Eugenia Garsin Modigliani. *(Courtesy Vallecchi Editore)*

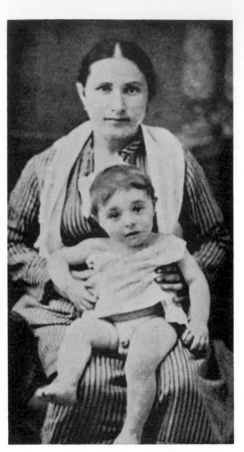

Modigliani as a baby on the lap of his nurse *(balia)* who is wearing the traditional striped dress of her calling. According to Jeanne Modigliani-Nechtschein, the artist's daughter, this photograph was part of a family album stolen during the early days of World War II. *(From* Artist Quarter, *1941. Courtesy Faber and Faber)*

Year-end theatricals at Eugenia Modigliani's school in 1897. The thirteen-year-old Modigliani is second from the right in the top row. Bice Boralevi, whose portrait Modigliani painted on his first trip back to Leghorn in 1909, is third from the right in the first row. *(Courtesy Vallecchi Editore)*

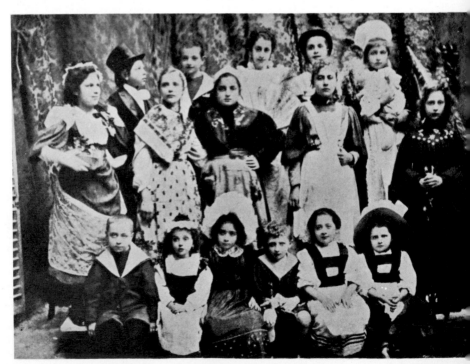

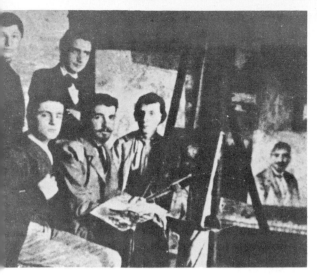

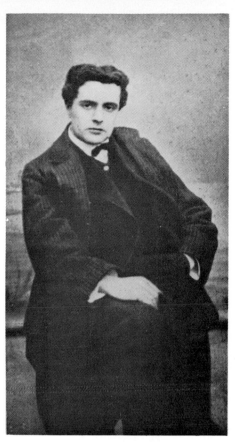

ABOVE. A Sunday-afternoon session at Gino Romiti's studio in Leghorn in 1901. All of Modigliani's friends attending Guglielmo Micheli's art school are present except for Oscar Ghiglia. Standing, left to right: Aristide Sommati and Lando Bartoli; seated, left to right, Modigliani, the bearded Romiti, and Benvenuto Benvenuti. This photograph was also part of the family album stolen during early days of World War II. *(Courtesy Vallecchi Editore)* RIGHT. Modigliani in 1904, aged twenty. *(From* Artist Quarter, *Faber and Faber, London, 1941)*

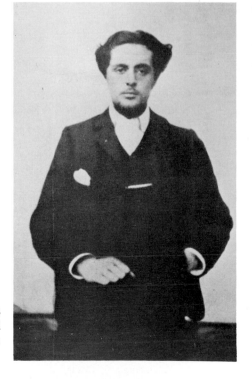

Modigliani as he looked in his early twenties before leaving for Paris. During this period he was experimenting with a mustache and a beard. *(Courtesy Vallecchi Editore)*

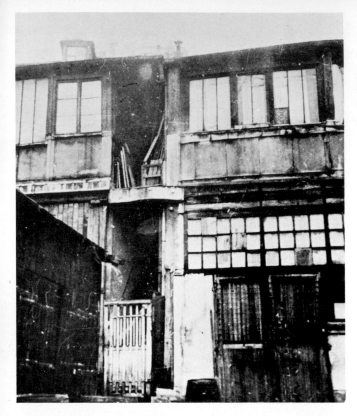

The famous Bateau-Lavoir at 13 Rue Ravignan, now Place Emile Goudeau, which might well be called the cradle of modern art. (H. Roger Viollet)

Père Frédé (Frédéric Gérard) playing the guitar for his guests at his much-frequented Lapin Agile in Montmartre. With no drinks in sight and the company so decorous, it is obvious that this was a carefully posed photograph. (Courtesy Pierre Cailler Editeur)

Rosalie Tobia sitting at one of the little marble-topped tables in her famous hole-in-the-wall restaurant on the Rue Campagne-Première, Montparnasse. (Courtesy Pierre Cailler Editeur)

ingly, murmuring, "Good, good." Picasso still has one or two Modigliani portraits in his collection. He had more. There is evidence that he over-painted a Modigliani portrait, an act which may have expressed his feel-ings at the time, though he later regretted his action. This occurred in 1917 when Picasso was living in the suburban Montrouge section of Paris, and Big Bertha's shells were terrorizing the city.

On one occasion, finding the din too great, he searched the house for a canvas on which to work, and finding none he picked on a painting by Modigliani which he had acquired. Setting to work on it with thick paint which allowed nothing to show through, he produced a still-life with a guitar and a bottle of port.[3]

While Picasso might be excused on the grounds that he had nothing to paint on, a sober and rational Modi would never have been guilty of such desecration.

Perhaps there had been other occasions when Picasso said or did things at which Modi took offense. Modi said as much to Anselmo Bucci, al-though Modi does not explain and there is no way of knowing to what he refers. Six years after he had first sought out Modi, Bucci saw great changes in him:

Years went by. Then he came where I lived with Adulaire in the Rue Caulaincourt. He was astounded. What, no women? How come you have no women? You haven't invited any woman? Apart from that he was almost normal. But this normalcy in 1909 was already less and less frequent. He went to live in Montparnasse, where he spent most of his time in the two Cafés, the Rotonde and Rosalie's, which he made quite famous. One only saw him in bars. At an artist's ball [Bal des Quatres Arts] in 1912 a bunch of half-naked gladiators and Ro-mans, of which I was part, spread through Montparnasse at dawn.

We found Modigliani at the Café de la Rotonde, where he practi-cally lived; he was dead drunk as usual. I wasn't drunk enough to fail to see the mark of the fierce claws of Paris on the Antinoüs of the Place du Tertre. He came forward, dirty, with a foul breath, glazed eyes. He was laughing, with a sardonic monotonous simper. He was laughing, running his hands through his battered curls and showing his black teeth.

Just the sight of him sobered me. But we kept on drinking.

"It appears that I am one of Picasso's victims!" he kept saying. "But look here. Listen, listen to me. I was telling Salmon: what they print has no importance. You understand? Do you follow me? One can print whatever one likes. Whatever one likes."[4]

How Modi came to think of himself as one of Picasso's victims, and what it was that had been written (about him?) that had led Modi to

such a conclusion, is difficult even to guess. Furthermore, it would be a mistake to draw any conclusion from Picasso's attitude: with an inconsistency which would have done credit to Modigliani, Picasso was friendly toward *all* serious artists, including many he did not like. Modi had always been welcome in his studio to look around, have a bite to eat, perhaps borrow some colors or a brush, and to talk. One could not, however, expect Picasso to seek out Modi.

To assume on the basis of evidence such as Bucci's and that of others —many of whom made authoritative statements from casual observation, gossip, and hearsay—that Modigliani was *always* drunk and in a hashish daze is illogical and untrue. Bucci saw Modi in 1906, then not again until 1909 when Modi looked him up on the Butte. Three more years elapsed and, on a big party night for young artists, Bucci runs into Modi in the Rotonde and says flatly that he was "dead drunk as usual." This was no more than an opinion, nor was Bucci, out on the town in masquerade costume with his fellow artists, in any position to be an objective reporter.

No man could be drunk *every* hour of *every* day and still turn out drawings, paintings, and sculpture. Modi's delicate constitution could not have survived such abuse, nor could he have accomplished all that he did. In the long history of artists, writers, poets, and painters, driven by temperament and misfortune to soothe their lacerated sensibilities with alcohol or drugs, there is no evidence that any of them created "under the influence." From Poe to Baudelaire, Coleridge to Rossetti, down to Dylan Thomas and Jackson Pollock, the record is consistently clear that with few exceptions, their work was done either before or after, but never *during*. Paralyzed by alcohol, numbed with hashish hallucinations, gripped by painful hangovers, artists were as incapacitated and as incompetent as the next man.

"The legend of the debauched artist is just a legend," [5] wrote Jacob Epstein, the sculptor. Now, as well as later when conditions worsened for him, Modi's hashish-induced excesses and drunken exhibitionism were never the constant, continuous states that they were said to have been. As a few perceptive people have pointed out, Modi was not around all the time; no one saw him every moment of every day, but when Modi was "on exhibition" *that* particular day—sure enough!—he *was* surly drunk and disorderly, thus confirming the impression of some friends and detractors that this was his natural state. He might have gone on quietly for weeks, working hard, conferring with Brancusi, seeing Cardoso or Ortiz, having a meal with the Alexandres in the Avenue Malakoff, living inconspicuously and miserably as always. Then he would go on a binge with Maurice, have a brawl on the streets. He would be thrown out of the

Rotonde, ranting, screaming, falling in the gutter. The inevitable consensus? Modi was at it again, poor bastard.

But Modigliani impressed some people quite differently. Jacob Epstein was one. In 1912 Epstein was an experienced and mature thirty-two. He was in Paris engaged in creating the Oscar Wilde Tomb in Père Lachaise Cemetery (which was temporarily banned). It was then he "made the acquaintance of Modigliani, Picasso, Ortiz de Zarate, Brancusi, and the other Montparnasse artists":

> . . . Modigliani I knew well. I saw him for a period of six months daily. . . . All Bohemian Paris knew him. His geniality and esprit were proverbial. At times he indulged himself in what he called "engueling." This form of violent abuse of someone who had exasperated him was always, I thought, well earned by the pretentiousness and imbecility of those he attacked, and he went for them with gusto. With friends he was charming and witty in conversation and without any affectations. . . . In appearance Modigliani was short and handsome, and quite contrary to general belief or the impression given in his pictures, robust and even powerful. Later he had many girls of the quarter after him. . . .[6]

Epstein admired his mettle, the fact that Modi wasn't afraid to say what he thought:

> Once I was with Modigliani, he was greeted by two chic young gentlemen. I asked who they were; he answered, "Snobs' d'Art." He always hit the nail right on the head. "We working artists," he said, "suffer from 'les snobs d'Art.' " [7]

Modi's indictment covered a wide range, not only of chic young gentlemen, but also art critics, art dealers, art collectors and, especially, some artists themselves.

Modigliani undoubtedly liked Epstein for the bold originality of his art and the refreshing vigor of his personality. Epstein was a big, solid man with a mane of black hair, fierce eyes under beetling brows, a big eagle nose, a determined mouth, a big round "glass" chin, a thick neck, and a pugnacious appearance. (See photograph, facing page 225.) They were also both Jews:

> I remember that Modigliani was intensely proud of his Jewish origin, and would contend with absurd vehemence that Rembrandt was Jewish. He gave the reason that Rembrandt was Jewish on account of his profound humanity.[8]

Like Modi, Epstein had been devoted to art since childhood. He was also the first and only artist in his American bourgeois merchant family,

and had left home and country to find himself. He had his own strong opinions. While admiring Brancusi's work, he did not share either Brancusi's or Modigliani's convictions that sculpture was sick, that modeling in clay was puttering in mud, or that the only good sculpture was carved direct in stone. But Epstein listened and laughed and enjoyed himself. From the way he spoke of his work, from his attitude during the controversial Oscar Wilde Memorial and his scorn for those who refused to allow it in the cemetery, it was plain that Epstein had found his way. He belonged to no movement; he bore no label; he was not burdened by tiresome, conforming, cerebral theories of art. He was Epstein, nothing else, as Modigliani was striving to be Modigliani.

That they were close is proved by their attempt to find a studio where they could both live and do sculpture:

". . . We thought of finding a shed on the Butte de Montmartre, where we could work together in the open air and spent a day hunting for vacant grass plots for huts, but without results. Our enquiries about empty huts only made the owners or guardians look askance at us as suspicious persons. However we did find some very good Italian restaurants where Modigliani was received with open arms. . . ." [9]

Like Modi, Epstein was enchanted with Negro and primitive art. He felt that it "showed heroic expression and eternal verities." It was unusual for Modi to want to live and work with another artist, but his studio was small and uncomfortable, and he was lonely. Epstein has left a vivid picture of Modi's quarters, presumably in the Cité Falguière:

His studio at that time was a miserable hole within a courtyard and here he worked. It was then filled by nine or ten of those long heads which were suggested by African masks and one figure. They were carved in stone; at night he would place candles on top of each one and the effect was that of a primitive temple. A legend in the quarter said that Modigliani, when under the influence of hashish, embraced these sculptures. Modigliani never seemed to want to sleep at night and I recall that one night, when we had left very late, he came running down the passage after us, calling us to come back like a frightened child. He lived alone at the period working entirely on sculptures and drawings.

. . . When I knew him he had not attained fame outside of Montparnasse and only rarely sold a work. Drawings which he made in the morning he would try to sell at café tables for anything he could get for them. We had meals at Rosalie's, the Italian woman who had been a beautiful model, and there Rosalie would admonish him. She had motherly love for her compatriot and would try to restrain him from "engueling" her other clients. She tried to make Modigliani settle

down and be less nervy and jumpy. He was peculiarly restless and never sat down or stayed in one place for long.

Rosalie had a large collection of Modigliani's drawings in a cupboard, set against multitudes of free meals. I suspect, because, as I said, the old Italian had a kind heart for him. When he died in 1921 [actually it was 1920], she naturally turned to this cupboard for the drawings, as dealers were after them but, alas! for Rosalie's hopes, the drawings, mixed with sausages and grease, had been eaten away by rats.

A painting by Utrillo, which I remember on her walls, was later cut out of the plaster and sold to a dealer. Modigliani would say, "A beef steak is more important than a drawing. I can easily make drawings but I cannot make a beef steak." [10]

The last is probably one of the most realistic statements Modi ever made. It also shows how well aware he was of his limitations and how honest his values. Modi was present when Utrillo painted the mural mentioned by Epstein. Utrillo burst into Rosalie's with—amazingly for him—money in his hand and demanded several glasses of white wine all at once. He was already quite drunk, in his stocking feet, and couldn't remember what had happened to his shoes. One of the few artists able to paint under the influence of alcohol—and in his case it was sometimes hard to tell when he was not—Maurice "took it into his head to get the ever obliging Rosalie to send for some pastels from a near-by shop and with lightning rapidity sketched on the wall the Lapin Agile and a corner of the Butte." And at this point Modi popped into Rosalie's:

> After falling into each other's arms they, of course, began thoroughly to celebrate this unexpected meeting. But presently no more cash was forthcoming from either, and Rosalie, generous though she was, refused credit, judging they had both drunk as much as they could stand. That was enough. The tempest was let loose. To Modi's torrent of abuse in Italian (for they were compatriots, from the same district), Rosalie riposted with a fluency and a power of vituperation that almost exceeded it. Utrillo, meanwhile, accompanied the duet in French, making such a row that the passers-by became alarmed. Such passages of oratory never interfered with the mutual liking Rosalie and Modi had for each other.
>
> "But look," cried Utrillo, when the two principal antagonists were breathless, "what I've just painted! That's worth more than a wretched bottle or so of wine!"
>
> "Maybe," retorted Rosalie, gasping, "but I can't cut my wall to pieces to pay my wine merchant." [11]

Maurice was right and Rosalie wrong. As Epstein wrote, a wealthy collector did have the entire plaster wall removed with Maurice's painting

intact. Rosalie was given a good sum of money in exchange, and the impromptu mural—proving it was "worth more than a wretched bottle or so of wine"—multiplied in value through the years.

Modi probably offered hashish to Epstein as he did to all his friends. But Epstein was neither impressionable nor easily influenced. He did, however, note how Modi felt about the drug. Modi was apparently convinced that ". . . hashish would lend him help in his work," and Epstein concluded that ". . . certainly the use of it affected his vision, so that he actually saw his models as he drew them." [12]

But Epstein, who apparently never took the stuff, seems to have misunderstood the nature of hashish. Modi was unable to work as it took numbing effect, after which it brought on deep sleep. Hashish affected Modi's vision only when he was under the spell of the drug—at which time drawing and painting were beyond him. He also told Charles Beadle that "hashish enabled him to see and compose extraordinary combinations of colors," [13] but Beadle accurately points out that Modi always painted from life and that his portraits depended on the mood of his models as much as on his own. Further, no striking color combinations are particularly evident in Modigliani's paintings, and critics agree that color was never his strong point.

It would seem, then, that Modi was deceiving himself and misleading Epstein. The colors he saw were illusions, an exotic background to hallucinations. Modi took hashish to experience the miracle that intensified everything in life and to savor the artificial paradise it offered.

Modigliani's characteristic distortions, the elongations—the oval head, the eyes black, black slits, or almond-shaped and without a pupil, in green, gray, or blue tints; the long straight slab nose; and the long, long swan's neck—were already evident before 1912. They were to become his trademark, and sure proof to some people that all his paintings were alike. But they were not all alike. Modi used these characteristic distortions only when he painted subjects who fitted them. Many people, particularly those who have seen very little of his work, have never understood this important difference.

How Modi hit upon his particular "distortions" was a mystery that fascinated his friends and, much later, the critics and the public. Various fanciful explanations have been advanced, most of them hinging on the strange influence of hashish and absinthe, either alone or in combination. André Salmon, poet, writer, and charter member of Picasso's Bateau-Lavoir circle, insisted that Modi had never painted a good picture until he took hashish. He went to bed one night and, the next day, awoke a genius. [14] André Utter also maintained that Modi's great vision came about after "an alcohol and hashish orgy chez Pigeard . . . ," when ". . . Modigliani suddenly gave a yell and, grabbing paper and

pencil, began to draw feverishly, shouting that he had found 'the Way.' When he had finished he triumphantly produced a study of a woman's head with the swan neck for which he became famous." [15]

Charles Beadle himself "once flippantly observed to Modi, and meant it flippantly, that he got his 'swan-neck' inspiration from glimpsing a mistress through the neck of an absinthe bottle—empty, of course, as the absinthe would be inside him!" Beadle felt that, flippant or not, he was being logical and that Modi's distorted style was the result of "his alcoholic vision that fired his imagination." Otherwise Beadle disagreed with both Salmon and Utter, arguing that the absinthe inside Modi "could never by itself have produced the talent to enable him to make such marvelous use of distortion." [16]

While Salmon's judgment depends on a theory that is palpably false, Utter can be excused as another man with a crowded and unreliable memory, soured by faded dreams of what might have been. He was a talented painter. He died in 1948 but he never achieved the heights of Suzanne Valadon, Maurice Utrillo, Amedeo Modigliani, or any of his contemporaries. Nor did he have their ability. In time, before he broke with Suzanne, Utter became little more than an artistic pimp for his stepson. He sold Maurice's pictures, and greedly kept for himself most of the money they brought in. Later, he himself drank heavily and became thoroughly embittered.

Charles Beadle's reasoning lay closer to the truth, but it was not the whole truth. Alcoholic vision, hashish vision, or both, the stuff of primitive art, a face seen in an oily puddle, through a cloud of cigarette smoke or the curve of a wineglass—Modi would have said that he had no style, that he sketched and painted what he saw and felt in the faces of his models. Every model affected him differently, and his rapport with each was different. There might be a kernel of truth in all the theories, but they were the science fiction of art. They explained nothing. Style was work. He was Modigliani and he painted what he saw as he saw it. *That* was his way.

No man has better explained the forces moving an artist than André Malraux:

> A man who is destined to become a great painter begins by discovering that he is more responsive to a special world, the world of art, than to the world he shares with other men. He feels a compelling impulse to paint, though he is well aware that his first work doubtless will be bad and there is no knowing what the future has in store. After an early phase of pastiche, during which he usually copies near-contemporary masters, he becomes aware of a discrepancy between the nature of the art he is imitating and the art which will one day be his. He has glimpses of a new approach, often with the aid of masters of an earlier

age. Once he has mastered one by one his color, drawing, and means of execution—once what was an approach has developed into a style—a new plastic interpretation of the world has come into being, and, as the painter grows older, he modifies still further and intensifies it. Though it is not the whole of artistic creation, this process almost always enters into it, and each of its successive operations involves a metamorphosis of forms—a fact which until quite recently was overlooked completely.

Modigliani had always had a dream of what his art should be and, as he had written to his friend Oscar Ghiglia, the artist's real duty was to save that dream. As for facets of style taking form from experience, Malraux goes on:

> Giving form to the unconscious does not involve unconscious action on the artist's part. Though it means nothing to those who are indifferent to art (as religious experience means nothing to the agnostic), artistic activity, far from being haphazard, is governed by strict laws which, though at some points they impinge on everyday experience, are independent of it; indeed no work of art is the expression, instinctive or inspired, of any such experience. Though Cézanne or Goya, Van Gogh, etc., may have dealings with the outside world these dealings are of no amiable order—they have dealings solely with a "filtered" world. Cézanne said, "The thing is to paint as if no other painter ever existed," and forthwith paid another visit to the Louvre.[17]

It has always been assumed that no women, such as those Modi painted with long oval faces and swans' necks, ever existed in real life, but Jacob Epstein gave evidence to the contrary:

> I was amazed once when we were at the Gaîté Montparnasse, a small popular theatre in the Rue de la Gaîté, to see near us a girl who was the image of his peculiar type, with the long oval face and a very slender neck. A Modigliani alive. It was as if he had conjured up one of his own images.[18]

Besides hashish, Epstein noted that Modi "was influenced by *Les Chants de Maldoror,* which he carried in his pocket and to which he would refer as *'une explosion.'* " It was a book he treasured, read, reread, and recommended to others, and carried with him like a Bible. Adolphe Basler wrote that he never met Modi without a book. He saw books all over Modi's hole-in-the-wall room at the Cité Falguière near the Hungarian painter Czobel. The sonnets of Petrarch, Dante's *Vita Nuova,* Ronsard, Baudelaire, Mallarmé, the *Ethics of Spinoza,* and an anthology of Henri Bergson's. Modi read and discussed literature, art, and philosophy. Basler adds that he didn't wait for the Surrealists to discover Lau-

tréamont. When André, the waiter at the Café du Dôme, threw Modi out for being drunk and disorderly, Basler remembered that André had picked up the *Chants de Maldoror*, which had fallen out of Modi's pocket in the scuffle.[19]

Very little is known about the author of *Les Chants de Maldoror*, which R. H. Wilenski calls a "horrible nightmare fantasia" and which seems to combine equal parts of Poe, Baudelaire, De Sade, Kafka, and Joyce. He was Isidore Ducasse, who took the title Comte de Lautréamont. He was born in Montevideo, in 1846, went to Paris about 1860, and in 1868 persuaded a publisher named Lacroix to publish his book. Wilenski does not deny "the imaginative fertility and the literary genius" that make these prose poems so powerful and compelling, but, he adds, "it is also impossible to deny that the book in many places is sadistic and obscene." [20]

André Gide had also found the book extraordinary. In his *Journal* entry for November 23, 1905, he recorded, "How does it happen that I didn't know it until now? I have even begun to wonder if I am not *the only one* to have noticed it. . . . Here is something that excites me to the point of delirium. He leaps from the detestable to the excellent." Gide then cites a passage and says, "What mastery in the 'sheer cussedness' of these lines." Three days later Lautréamont is still on his mind. "The reading of Rimbaud and the *Sixth Chant de Maldoror* has made me ashamed of my works and disgusted with everything that is merely the result of culture. It seems to me that I was born for something different." [21]

It was a metaphor of Lautréamont's that suggested the fundamental method of the Surrealists. The key words came when Lautréamont said that a situation was "as beautiful as the encounter of an umbrella and a sewing machine on a dissecting table." And this telling phrase also appears in *Les Chants:* "I let fall one by one, like ivory balls on a silver platter, my sublime lies."

While the Surrealists were to find convenient propaganda in *Maldoror*, Gide and Modigliani admired its hypnotic beauty, its power and horror. Besides being spellbound by its flights, its imagery and hallucinatory quality, Modi perhaps felt an affinity for its author. He sympathized with poor Isidore Ducasse, probably also a Jew, who had no right to a title, but dubbed himself Comte de Lautréamont. He was a man of genius, who lived a sad, horrifying life. He died young and unknown. His fame came only long after his death. He had written only *Les Chants,* but that was a masterpiece.

Modi too liked the macabre, and had a tendency to wallow in it. Charles Beadle recalls a visit Modi insisted they make to a Montmartre Cemetery in the rain and gives it as a sample of Modi's preoccupation

with death and the gruesome. Standing together among the tombstones, they quoted lugubrious passages of *Maldoror* to each other. Beadle is convinced that this preoccupation with the macabre in Modigliani "partly accounts for his love of Lautréamont, another who died miserably and achieved posthumous fame. Maybe those who are doomed in this way have a sort of elective affinity." [22]

But there were other appeals in Lautréamont besides the macabre, and there were many sides to Modi's nature. The macabre was apparently not apparent to Jacob Epstein in the six months they were close friends in 1912. Remembering these days long after the painter's death, Epstein wrote that "Modigliani's liveliness, gaiety, and exuberant spirits endeared him to hosts. . . ." The lover of the macabre and the lover of life: Modi was both and a consummate actor who enjoyed being stage center whatever his mood. Besides, "one man in his time plays many parts." And Modi seems to have played them all, and his audience always said confidently, "There! That's the real Modigliani."

～～～ Chapter Fifteen

"How elegant it is to be successful!"

The high tides of the new art movements sweeping over Paris seemed neither to affect nor to interest Modigliani. He ignored the work of Giorgio de Chirico, also an Italian, whose paintings *Sabou-dian Enigmas* had first been exhibited at the Salon d'Automne. The Salon des Indépendants, too, had shown some of Chirico's Paris-inspired pictures, which had come to the attention of Picasso and Apollinaire. Picasso admired them; so did Apollinaire. And Apollinaire became Chirico's close friend and was to call him "the most astonishing painter of his time" [1]—praise indeed, considering how Apollinaire felt about Picasso.

Meanwhile, the Futurists had made good on their promise, faithfully followed the precepts of their manifesto and, in February, 1912, held their first exhibition in Paris amid considerable publicity and fanfare. If Modigliani attended, he would have agreed that the paintings had motion, magnificent technique, and brilliant composition. They were not "static" Cubism, but they seemed like tricks on top of tricks—manufactured masterpieces. The outstanding paintings were by his friend Severini (*La Danse du "Pan Pan" au Monico*) and Boccioni (*La Rue entre par la Fenêtre*). The public grasped Futurism more easily than they did Cubism or Fauvism "because the notion of rapidly changing images had been made familiar by the cinema, [then a popular novelty in Paris], and because at bottom the Futurist pictures were more illustrative than architectural or aesthetic." [2]

The Futurists battled to grab the limelight and extinguish Cubism. They buttered up critics, harangued Picasso, and flattered Apollinaire without success. Apollinaire was interested but loyal to Cubism and hard

at work on a book about the movement, *Les Peintre Cubistes: Médita-tions Esthétiques,* which was published in 1913. But he did observe, as Fernande Olivier did, that the Futurists tried to be as dramatically novel in life as on canvas. After meeting Severini, Apollinaire noted that he wore ". . . socks of different colors . . . one sock . . . raspberry red and the other bottle green; this Florentine coquetry is mistaken here for absent-mindedness and café waiters point out the oversight to him in tactful whispers." [3]

Fernande's comments were more pointed. Explaining that the Futurists wore different-colored socks to match their neckties, she said that, "In order to get maximum exposure at the Café de l'Ermitage, which had become the place to eat since Picasso had moved to the Boulevard de Clichy, they pulled their trouser legs high and found two legs, one green, one red, coming out of their shoes." [4] It was a brave try, and the Futurists were to have a brief success before being forgotten.

The Fauves died hard. While there were many Cubists, Picasso and Braque, who now began their artistic "marriage" (and often produced pictures so similar in style that neither could identify them as his own), were the strongest and most creative, with Gris a serious, individualistic third. Cubism was established and spreading; it had crossed borders and oceans to become international. As it gathered momentum the critics kept jabbing at it viciously with such jibes as, "It is the swan-song of pretentious impotence and self-satisfied ignorance." Only Apollinaire in *L'Intransigeant* and Salmon in the *Paris-Journal* (and of course Gertrude Stein vocally) hailed and defended Cubism. They were men of taste and discernment but, like stockholders in a parent company, they were hardly impartial.

In his hard-boiled way Francis Carco was not far wrong in saying that those who defended Matisse and Picasso were not unmindful of the fact that the Impressionists had enriched their partisans.[5] Dealers were well aware of this. Art standards had become so confused that it was no longer possible to separate investment from enthusiasm or the candor of taste from speculation. The cynics agreed that admiration and understanding were out of the question; what mattered was getting in on a good thing. The new artists, Carco wrote, had turned the art world upside down and thrown all critical judgment out of balance. There were no guidelines to the new art because the break with old was too complete.

Carco met Picasso by chance, one day, at an Impressionist exhibition. As they contemplated the Monets, the Sisleys, the Renoirs, and the Pissarros, Picasso said to Carco, "Look at that, will you? Everywhere you look in these paintings you see what kind of weather it is. You never see the paint." [6] Carco adds that he could have come back with, "You see too much of it in your work." But what was the good? So far as Carco

was concerned, the case of Picasso was so paradoxical that it was beyond argument. In any case art was on the road to where the formula was "anything goes!" Apollinaire had given his benediction in *Méditations Esthétiques* when he proclaimed: "This is the hour of masters. . . . One may paint with whatever one likes, with pipes, stamps, postcards, playing cards, candlesticks, bits of oilcloth, collars, wall paper, daily papers." [7]

Did he mean it? Yes, and again no. "Cubism is a necessary evil," [8] Apollinaire finally admitted, and, before that, he had confided to Carco, "If the Cubists ever try to use color, they're through!" [9] Some critics feel that this is exactly what happened. But Cubism was simply a phase of modern painting—interesting, important, and especially "necessary." Painting was changing, but loyalties, always passionate in art, remained fixed. The Cubists had sunk the Fauves to the extent that Matisse was to have his own Cubist period. The challenge of Futurism had been met and overcome. The important thing was not to get out of the limelight.

Modigliani played no role in these charades. It was not alone that he refused to join movements: when you looked at his work you realized he hadn't the qualifications even to be a supernumerary. Now Cubism and Futurism were competing for cash, public attention, critical esteem, and the championship of novelty. Surely Modigliani sensed this as his friend Carco did. He was not a bohemian by choice. While he craved success and recognition for himself, to prove himself to his family and friends, and also to live comfortably and in style, money was never an end in itself.

In the honorable, romantic sense, Modi would not prostitute his art for cash. Not only *would not* but also, it would seem, was unable to, even if he had wanted to. Money was good only for spending. As an aristocrat he saw it as something owing to him by divine birthright, a prerogative of those superior in intelligence, culture, taste, and manners, and therefore of no special consequence. "He was poor and drank a little too much, but he had the bearing of a prince," Rosalie told Umberto Brunelleschi. " 'A man who has no money should not die of hunger,' he used to say when I tried to get him to pay his bill. I told him that my supplier didn't give on credit. 'I'll give you drawings—pictures [said Modi]. . . .' " [10] Rosalie didn't care for either.

There were times when he could neither buy, beg, borrow, nor steal stone. Modi's heads called for delicate chipping, and the features gave him trouble because of the soft stone he used. Epstein was aware of this difficulty in Modi's ". . . exceedingly interesting carvings with curiously elongated faces and thin, razorlike noses that would often break off and have to be stuck on again." [11] These minor disasters must have been infuriating. They would never have happened if he used marble, but he couldn't work in marble and this knowledge must have frustrated him

further. Nor did he have the patience for the cunning technique of patching and plastering the broken piece back on with mortar. And he was forced to use the most common materials for his uncommon sculptures. Epstein wrote, "He would buy a block of ordinary stone for a few francs from a mason engaged on a building and wheel it back to his studio in a barrow." [12]

Sculpture so obsessed him that his ideas cried for execution on the spot, and Modi used the stone where he found it.

> If Modigliani ever had formulated his ideas in writing they could have been almost identical with those expressed by a younger contemporary, the American John B. Flannagan, who wrote as follows: "To that instrument of the unconscious, the hand of the sculptor, there exists an image within every rock. The creative act merely frees it. . . ." According to Flannagan, the sculptor's goal is ". . . the austere elimination of the accidental for ordered simplification . . . the greatest possible preservation of cubic compactness . . . even to preserve the identity of the original rock so that it hardly seems carved." [13]

Many legendary stories have come down of various statues done by Modi on building sites, open lots, and back gardens and then being either lost, abandoned, or incorporated into a foundation. Only a few have been authenticated, one of them being handed down by Luigi Tobia, Rosalie's son. A new building was about to be constructed in an overgrown lot on the Boulevard Montparnasse, a few blocks from Rosalie's on the Rue Campagne-Première, and a supply of foundation stone had been dumped there, where Modi came upon it. Lovely stone, all clean, new, and inviting. Smooth and gleaming, alluring and irresistible as the undefiled body of a beautiful woman. One can imagine that Modi took one look, went back for his hammer and chisel, and set to work. Utterly preoccupied he came back later in the summer evening to work secretly, undisturbed in what he now considered his own private open-air studio.

Modi worked hard and happily until one day he staggered into Rosalie's, well past the dinner hour:

> Rosalie scolded him for wanting food at that hour but, as always, served him. But he wouldn't eat; neither would he go away. Luigi says he looked queer, wasn't violent as usual, but very sad. Finally, when Rosalie was comforting him in her motherly way and trying to persuade him to leave, he burst into tears, saying that his heart was broken, as he had been to "the funeral." They couldn't make out what he meant, thinking it was some drunken fantasy, until brokenly he told them how he had worked on the statue, which had nearly been

finished, when, passing that afternoon, he had seen the callous work-
men, burying his beautiful carving—that is, of course, placing the
stone in its due place in the foundation. He had protested and appar-
ently made a scene, but they had laughed, said he was crazy, and
driven him away.[14]

The lost statue was a symbol of his life, his failures—his inability to
sell his paintings, the little recognition he had received with *The Cellist*
at the Salon, his broken promises to his mother, the burial of his hopes,
the funeral of his dream. But Modi did not give up, did not kill himself.
He persevered, not on principle or from some superior constitutional re-
sources, but only because he had the effrontery—in spite of the evidence
to the contrary—to believe in himself, his art, and his dream. He contin-
ued because he could not help himself, because it was the only important
thing in his life. Alcohol, drugs, and women, not necessarily in that
order, sustained and nourished him, made life bearable, and reaffirmed
his convictions whenever they faltered. The agony lay in giving the vision
life—in stone, on canvas, and on paper.

Another sculptor who was to become famous, Jacques Lipchitz, met
Modigliani the same year as Jacob Epstein. In his writings, in interviews,
and in his biography, Lipchitz fixed the date as 1913, but in the course of
a long interview [15] he said their meeting occurred in 1912. This is the
year Modi entered some sculpture in the Salon d'Automne—a series of
heads that Lipchitz saw at his studio. Lipchitz has written vividly of their
meeting:

> For some strange reason, when I think of Modigliani now, I always
> associate him with poetry. Is it because it was the poet Max Jacob who
> introduced me to him? Or is it because when Max introduced us—it
> was in Luxembourg Gardens in Paris . . .—Modigliani suddenly
> began to recite by heart the *Divine Comedy* at the top of his voice?
> I remember that, without understanding a word of Italian, I was fas-
> cinated by his melodious outburst and his handsome appearance: he
> looked aristocratic even in his worn-out corduroys. But even after I
> had known him a long time, Modigliani would surprise us often with
> his love and knowledge of poetry—sometimes at the most awkward mo-
> ments. . . .
> We often discussed poetry—Baudelaire, Mallarmé, Rimbaud—and
> more often than not he would recite by heart some of their verses. His
> love for poetry touched me, but I admired even more his obviously re-
> markable memory.
> But now, when I think back to the time when I first met Modigliani,
> in the Luxembourg Gardens, I cannot disassociate that glorious scene

—the Parisian sunshine, the beautiful greenness around us—from the tragic end of Max Jacob, marvelous poet and delicate friend. When I heard about Max's sufferings in the concentration camp of Drancy early in the German occupation of France, when I read about him lying among other martyrs on the dirty floor, dying slowly and painfully, immediately the scene in the Luxembourg Gardens came vividly to mind.

The *Divine Comedy* recited by Modigliani and the hell suffered by Max Jacob together make a pathetic image worthy of Modigliani's memory. He knew what it was to suffer, too. He was sick with tuberculosis which killed him; he was hungry and poor. But he was at the same time a *riche nature*—so lovable, so gifted with talent, with sensitivity, with intelligence, with courage. And he was generous—promiscuous, even—with his gifts, which he scattered recklessly to the winds in all the hells and all the artificial paradises.[16]

Lipchitz was only twenty-one years old; Modi was twenty-eight. For all his youth and inexperience, Lipchitz was by nature more mature and responsible than Modi and, in some ways, than the mystical Max Jacob, who was thirty-six. He was born Chaïm Jacob Lipschitz in the village of Druskieniki on the Niemen River in Russia and had come to Paris in 1910 to be a sculptor. Here he had promptly had his name altered to Jacques Lipchitz by a bewildered police official unable to make out the Russian spelling on his birth certificate. A hard worker who understood that creation demanded clear eyes, strength, and health, Lipchitz ate regularly, turned in at a decent hour, and got up early. He was frugal and methodical. He saved his money, paid his bills, and was always on time for appointments. Dependable at home as a boy, Lipchitz was just as dependable away from home. Exactly the reverse of Modigliani, who always remained a puzzle and a trial to Lipchitz, who became his dear, good friend. Modi spoke French with an Italian accent and enjoyed rolling his "r's." His friend Charles-Albert Cingria noted this especially when Modi used the word *admirrable*. His eating habits, which were to shock Lipchitz, had not seemed unusual to Epstein or to Cingria, who wrote:

What he liked in restaurants was fish. Not a single fish, nor even a single slice; many little fishes perfectly salted and grilled (there in the word *grillé* he rolled the "r" beautifully). A thick smoke of parsley, the fish and the oil came through the square opening of the kitchen. We gave ourselves a treat.

Don't think that we didn't drink. We all did, he and I and others, we drank a lot. I don't think wine is made for any other reason. As to this business of Modi's terrible drinking there has been a lot of talk. It's an exaggeration. Italians are never drunks. The French are only

rarely. To drink is not to be a drunkard. . . . Modigliani was very reticent.[17]

Lipchitz was appalled and worried by Modi's behavior:

Often after this initial meeting with Modigliani, Lipchitz invited him and Max Jacob to be his guests for lunch or dinner. With amazement Lipchitz, who was a healthy animal with normal appetites and an uncomplicated zest for food, observed Modigliani beginning his meal by placing heaps of salt and pepper on his dish which he ate to revive his palate jaded by drugs and alcohol. . . .

Modigliani was courteous, serious, amiable when he was sober; irritably and crazily ugly when he had had too much hashish and brandy. Already he was sick with the tuberculosis which was to kill him. In the midst of eating he would suddenly be doubled up with a paroxysm of coughing. Lipchitz held his breath, expecting him to strangle at any moment. When the coughing spell subsided, Modigliani swilled his wine. Lipchitz cringed. What private hell did he hope to escape from? He found it impossible to believe that Modigliani could not control his impulse. One knew a man through his purse, his glass, his anger. Modigliani owed it to himself, to his art. There was no excuse he thought. This was not of the same order of license which Jacob allowed himself. The kernel of Jacob's genius was not at all impaired. Lipchitz could not bear to see the chameleon necromancy so swiftly change the man. For the remainder of the meal he sat on tenterhooks, relaxing when Modigliani seemed his intelligent self, writhing when he babbled incoherently or showed signs of illness, asking himself fearfully, how will it end? [18]

It was consistent with Lipchitz's nature to fear for his friend, to question and to pass judgment on his actions. Modigliani, who rarely passed judgments on others and on himself only in secret, was of a different temperament, "an unhealthy animal with abnormal appetites," if you will. He knew what was the matter with him, what the odds were. But he had too much to do to take care of himself, and no such inclination. As Lipchitz wrote, "He said to me time and again that he wanted a short but intense life—*une vie brève mais intense.*" [19]

On the day they met in the Luxembourg Gardens, Modi asked Lipchitz to visit his studio at the Cité Falguière. Lipchitz went because he was especially interested in seeing Modi's sculpture:

When I came to his studio—it was spring or summer—I found him working outdoors. A few heads in stone—maybe five—were standing on the cement floor of the court in the front of the studio. He was adjusting them one to the other.

I see him as if it were today, stooping over those heads, while he explained to me that he had conceived them as an ensemble. It seems to me that these heads were exhibited later the same year in the *Salon d'Automne,* arranged in stepwise fashion like tubes of an organ to produce the special music he wanted.

Modigliani, like some others at the time, was very taken with the notion that sculpture was sick, that it had become very sick with Rodin and his influence. There was too much modeling in clay, "too much mud." The only way to save sculpture was to start carving again, direct carving in stone. We had much heated discussions about this, for I did not for one moment believe that sculpture was sick, nor did I believe that direct carving was by itself a solution to anything. But Modigliani could not be budged; he held firmly to his deep conviction. He had been seeing a good deal of Brancusi, who lived nearby, and he had come under his influence. When we talked of different kinds of stone —hard stones and soft stones—Modigliani said that the stone itself made very little difference; the important thing was to give the carved stone the feeling of hardness, and that came from within the sculptor himself; regardless of what stone they use, some sculptors make their work look soft, but others can use even the softest of stones and give their sculpture hardness. Indeed, his own sculpture shows how he used this idea.

It was characteristic of Modigliani to talk like this. His own art was an art of personal feeling. He worked furiously, dashing off drawing after drawing without stopping to correct or ponder. He worked, it seemed, entirely by instinct—which, however, was extremely fine and sensitive, perhaps owing much to his Italian inheritance and his love of the paintings of the Renaissance masters. He could never forget his interest in people, and he painted them, so to say, with abandon, urged on by the intensity of his feeling and vision. This is why Modigliani, though he admired African Negro and other primitive arts as much as any of us, was never profoundly influenced by them—any more than Cubism. He took from them certain stylistic traits, but he was hardly affected by their spirit. His was an immediate satisfaction in their strange and novel forms. But he could not permit abstraction to interfere with feeling, to get between him and his subjects. And that is why his portraits are such remarkable characterizations and why his nudes are so frank. Incidentally, I would like to mention two other artists whose work influenced Modigliani's style, and who are not often mentioned in this connection: Toulouse-Lautrec and—Boldini, who years ago enjoyed the reputation of being one of Europe's most prominent and most fashionable society portraitists.[20]

The heads Lipchitz saw in the cement courtyard outside the studio at the Cité Falguière were entered in the Salon d'Automne of 1912. The catalogue for the Tenth Salon lists: "Modigliani, Nos. 1211–1217— Heads, decorative ensemble." There were apparently seven in all and,

while Modi was evidently pleased to have them accepted, they could not have been even the "relative success" he claimed they were in a letter to his brother Umberto. The letter is not dated, but must have been written late in 1912. Modi thanked his brother for some money he had sent and also enclosed a sketch of an Egyptian idol. On paper he was self-analytic and surely more sanguine than he had any right to be. But Mamma would see the letter, and her spirits, as well as his own, had to be kept up. After thanking Umberto "for the unlooked-for help," Modi wrote:

> . . . I hope in time to sort matters out; the important thing is not to lose my head. You ask me what I plan to do. Work and exhibit. *In pectore* [at heart] I feel that in that way I'll end up getting on the right track sooner or later. The *Salon d'Automne* was a relative success, and it is comparatively rare on the part of those people, who pride themselves on being a closed group, to accept things *en bloc*. If I make the same good impression in the *Indépendants,* I'll have made a definite step forward. And how are things with you? Best regards to my Aunt Lo [a nickname for Laura]. Write to me if you can. Love.
>
> DEDO [21]

But Modi did not enter the Indépendants or, indeed, any exhibition until 1919. The winter of 1912–1913 was a bad one: he became severely ill, and collapsed. According to one source, he was found unconscious in an abandoned shack in Montmartre, and was rescued and cared for by Epstein and the painter Augustus John. The Baroness d'Oettingen, a wealthy Polish woman prominent in artistic circles in Montparnasse, later wrote about what happened to Modi that winter.

He was living at 216 Boulevard Raspail, and the concierge, to whom Modi paid his rent, sat by a big stove that sent its heat down the snow-covered path toward the bottom of the garden to a *baraque* or hovel that was Modi's home. His hands that winter were frozen, and as red as big tumors. His hovel was full of stone, debris, and rough drafts of statues. Baroness d'Oettingen intimates that something terrible happened to him, and the police had had to intervene. His "studio" was such a cluttered mess that to carry their stretcher in and out, the police had to use mountaineering technique of a kind they would have used to save an injured climber on an Alpine glacier.[22]

An interesting sidelight on Modi's collapse is included in *Artist Quarter.* If it is true, it shows that one member of the Modigliani family was for the moment thoroughly fed up with their erring, wastrel artist:

> Brunelleschi records that, hearing of Modigliani's lamentable condition while he was passing through Rome, he sought out his barrister

brother, then a Socialist deputy, in a café frequented by politicians of his party, and, although he did not know him personally, presented himself and his friend's case. According to Brunelleschi, the deputy brother retorted scornfully *"Je m'en fous. I don't give a hoot. He's a drunkard and his drawings make me laugh."*

A cruel retort, which Emmanuel Modigliani denies, yet we have no reason to doubt Brunelleschi's word, and, moreover, it was a quarter century ago. [*Artist Quarter* was published in 1941.] Lots of people change their minds in that space of time. In passing it may be noted that—apart from his always devoted mother and his few intimate friends, who had no money—many people became most appreciative of "Dedo" and his works after he was dead and celebrated! [23]

If Emanuele did make the cruel retort, it is understandable. A black-sheep brother could only be an embarrassment to a rising politician.

For some time Modi had apparently been playing with the idea of returning to Leghorn, where he could recuperate in the warm sun, and benefit from Mamma's good care. He seems to have discussed the matter with Paul Alexandre, one afternoon in 1913, when he came to the doctor's apartment with a packet of drawings and watercolors he said he had chosen especially for his friend. Dr. Alexandre remembers Modigliani as being very tired and worn out after an exhausting period of sculpture that had absorbed him for the last two years.

"He had abandoned sculpture during the past few months," Dr. Alexandre recalls, "and it was during the month of April [1913] before taking the trip to Italy, which he had been talking about, that he left a group of sculptures at my house with the intention of picking them up on his return. He arrived with a handcart loaded with sculptured stones, about twenty pieces in all, I believe." [24]

Money remained the big problem as always, however. Even had they been rich, none of Modi's friends would have dared offer him a loan. Cardoso, as it was, was the only one with independent means, but Modi had never taken kindly to charity. But now came a bit of good luck.

Epstein took the English painter Augustus John and his wife, Dorelia, to Modi's studio. It would seem to have been the same studio from which Modi had been carried out on a stretcher a short time before. John bought a couple of the heads that Modi was working on at the time. The studio was "covered with statues all much alike and prodigiously long and narrow." John recalled that Modi described himself as a decorator and told him, "I make garden statuary." He also says that Modi returned with him and a friend (who is not identified but must have been Epstein) to Montparnasse after the transaction.

It must have been flattering to Modi to have his work admired and purchased by an established painter. John recalls him saying, *"Ah,*

comme c'est chic d'être dans le progrès," and pressing into John's hand "his well-thumbed copy of *Les Chants de Maldoror,* his Bible." [25]

John was a strikingly bohemian figure, bound to appeal to Modigliani. Nina Hamnett, a painter and friend of Modi's, described John as "a tall man with a reddish beard, in a velvet coat and brown trousers, striding along; he was a splendid-looking fellow . . ."; [26] and Wyndham Lewis spoke of him as "a great man of action into whose hand the fairies stuck a brush instead of a sword." [27] With John it was no question of buying Modi's work to get him out of a jam or to oblige Epstein:

> The stone heads affected me deeply. For days afterward I found myself under the hallucination of meeting people on the street who might have posed for them and that without myself resorting to the Indian Herb. Can "Modi" have discovered a new and secret aspect of "reality"?

Augustus John, Epstein, Modi, and Jack Squire roamed Paris together. Squire was tall, red-faced, genial, and very British in his passion for cricket. He loved poetry, wrote good parody, was a mainstay of the Georgian Poetry Group, and editor of the *London Mercury.* He was a heavy drinker. The foursome must have had a good time together. In his account John notes that, in an allusion to racial prejudice, Modi had complained of his lot on one occasion:

"Alors, c'est malheureux d'être juif?" said John. "So it's tough being a Jew, is it?"

"Oui," replied Modi, *"c'est malheureux."*

Jacob Epstein exploded in violent dissent.

What John paid for the two heads he does not say, but Nina Hamnett says that ". . . he [John] gave Modi several hundred francs for them." Miss Hamnett, who knew Augustus John, adds that "Modigliani said he was tired of Paris and the vile existence he lived, and pined for Italy." Much more extraordinary is the fact that Modi, perhaps for the first time in his life, decided to budget his funds; for, says Nina, "He asked John not to give him all the money but enough to get to Italy, where he could live very cheaply, and send him the money in small sums at a time" [28]

Using the advance from Augustus John, Modi presumably bought his train ticket to Leghorn. But before leaving Paris, it would seem he was unable to resist celebrating with his friends. Emanuele recalled that "Amedeo returned very ill and looking like a tramp, to the horror of his mother." [29]

As before, Modi returned home—this time really ailing, run-down, and tired—with no successes to boast about. Still, the fact that the Salon

d'Automne had accepted seven of his statues *en bloc,* and that Augustus John bought two heads must have heartened him considerably. He was encouraged to go on, continue with his sculpture in Leghorn, and perhaps settle for a few years—perhaps even permanently—in a climate and surroundings more beneficial to his health than Paris. For his second stay in Leghorn, how he looked and what he did, one must depend on accounts of his Italian friends.

One fact is certain: his head was shaved, which is proof that he had been seriously ill, undoubtedly confined to a hospital, since shaving the hair to the scalp for sanitary reasons was standard hospital procedure at the time. Neither Augustus John nor his Parisian friends speak of this, but there is a snapshot of Modi (following page 224) standing with his hands on his hips next to one of his heads, which is supported on a platform. Looking straight at the camera, his face healthy and full, Modi is wearing an open-necked checked shirt with a knotted kerchief at the throat and a sash wound around his waist. It is the *only* photograph of Modigliani in which he appears with his hair cropped close to the scalp. "When he was photographed with one of his sculptures a look of the greatest pride and elation would come over his face." [30]

There are no letters or documents referring to Modi's second trip to Leghorn, and Eugenia Modigliani discontinued her diary after 1910. But Vera, Emanuele's wife, and Ida, Umberto's wife (the next to the youngest Modigliani had apparently married between 1909 and 1913), do have vague memories of Modi's return.

Modi was cared for by his devoted mother and again provided with a new suit made by Caterina. But his first act was to look up his old friends. Their reports say that he was in bad shape. His old friends "scarcely recognized their Dedo in this pale, ragged, aggressive stranger, who burst into the Café Bardi one summer afternoon, demanding in a small, high-pitched and imperious voice, "Is Romiti here? And Natali?" [31]

This was the kind of thing that was perfectly normal at the Rotonde, the Dôme, or Rosalie's, when Modi wanted to know about the whereabouts of his friends. But in Livorno one did as the Livornese, and this seems to have marked Modi as queer from the beginning of his visit.

Modi's jack-in-the-box appearance at the Café Bardi has been well described:

His head was shaved like that of an escaped convict and more or less covered by a small cap whose visor he had ripped off. He wore a linen jacket, a vest but no shirt, his trousers were held up with twine, and he had espadrilles on his feet. Another pair of espadrilles dangled from his fingers. He said he had come back to Leghorn because he was so

fond of this cheap, comfortable footwear and also for some *torta di ceci* [a chickpea tart about the size of a small round pizza with an inch-thick crust]. Then he added, "How about a drink?" and ordered an absinthe.[32]

Recalling Modi's visit, Razzaguti, Romiti, Natali, and another friend called Miniati, have testified that he would not discuss painting, behaved as if he were no longer a painter, and always had with him snapshots of his sculpture. He was very anxious that his friends admire his work, ". . . elongated heads with great straight long noses and a sad secretive expression. Some of them seemed identical, the necks like the heads all long and round."

> Dedo was most enthusiastic about them [the snapshots], looking them over with pleasure and satisfaction. But the rest of us, on the contrary, didn't understand the first thing about them. . . . At that time he was without a doubt a fanatic about this primitive sculpure. I [apparently Silvano Filippelli] can still see him holding these photographs, inviting us to admire them . . . all the while his enthusiasm and sadness increasing with our indifference.[33]

Even in Paris when no dealer would handle him and he had no buyer outside of Paul Alexandre, Modi's friends had expressed appreciation of his art. But not here, and understandably so. His Leghorn friends had not grasped his reasons for going to Paris in 1906; they had been baffled by Modi and his art when he returned in 1909; now, when he should least have expected it, Modi was appealing to his old comrades for understanding.

One would think this indifference would have quenched Modi's enthusiasm. He had suffered many affronts, but this one, on home grounds, was much more personal. It is incredible, too, that these "friends" seeing how much his sculpture meant to him, could not have let drop some grudging words of praise, even if they lied a little. If their attitude explains much about them, Modi's continuing with his sculpture after such indifference is even more extraordinary.

He may still have dreamed of going to Carrara, but that was out. The only thing left was to work in Leghorn. But he needed help, and instead of turning to his family, who had done so much for him, he turned to his unsympathetic friends. As Silvano Filippelli recalls, he wanted them to find him a big room to work in and some stones of the type used to pave Italian streets. Modi begged and insisted so much that his friends decided to do as he asked. They got him some stone and arranged for him to use a big room—probably an empty storeroom or small warehouse—near the market. Filippelli then says that Modi, who had

struck Razzaguti as an eccentric, "a phantom who came and went when you least expected it," vanished like a phantom:

> . . . Beginning with the day he got the room and the stones, he disappeared and we didn't see him again for some time. What he managed to do with those stones in that big shed, none of us ever knew. God knows what he did during those days. But he had certainly made something, because, when he decided to go back to Paris, he asked us where he could store his sculptures that were in the shed. Did they really exist? Who knows? Perhaps he took them with him or perhaps he followed our friendly advice. We had answered him as one man: "Throw them in the canal." [34]

And Romiti, who recalled seeing at least one of the sculptures, told Jeanne Modigliani that they referred to *le Canal des Hollandais* or the Dutchmen's Canal.

Modi could not take the sculpture back with him, considering its size and the weight, not to mention the expense of the shipping. He had already attended the "funeral" of one of his works in the foundations of a building on the Boulevard Montparnasse. Far better, then, for him to supervise the drowning of his own unwanted children, the poor stone bastards no one appreciated. Modi must have acted on such pointed advice, doing the deed alone, probably using a borrowed handcart from the marketplace, loading the statues on one after the other, trundling them to the water's edge. Splash! Claude Roy is sure this is what happened:

> Modigliani was subject to these moods of iconoclast destructiveness. Even before that, in a fit of drunken fury in Paris, he had "liquidated" the work of several of his friends in a studio on the Rue du Delta. This time it was on himself that he vented his rage. Presumably he had shown his work to some brother artists at Leghorn and they had disapproved of it. Modigliani took a handcart, loaded it with all the pieces of sculpture he had been working on, and dumped them *en bloc* into the nearest canal. They are still there. Leghorn and its canals were heavily bombed during the recent war, but many feet of mud and water have formed a thick protective covering over the statues condemned to a watery grave by Modigliani. It is to be hoped that some archeologically-minded frogman will one day go in search of them and restore them to their place in the sun.[35]

One doubts that Modi "drowned" his statues in a mood of destructiveness. To lift, carry, haul, and heave his statues into a canal called for a different frame of mind. The statues were thrown to watery oblivion whole. If he had really wanted to destroy them, a sledgehammer could have done the most effective job.

It was done sadly, bitterly. He longed to return to Paris. People might not *buy* your sculpture there, but a few looked, admired, criticized and never advised you to throw them into the Seine.

He went back to his mother's house, put on the new suit Caterina had made for him, and made arrangements to return to Paris. Perhaps he told Mamma that he could pay for his ticket with the money a well-known English painter had paid him for two statues. He was doing better. He had many friends in Paris. His work was appreciated and admired and he would soon be having sales. All he needed was to keep working.

Leghorn has a museum devoted to the honor of its great artist Giovanni Fattori. It has a civic museum, which Modigliani visited as a child with his Grandfather Isaac. This museum has only a few drawings by Modigliani. Leghorn also has a small, exclusive collection of Modigliani statues, but only the fish can see them.

~~~ Chapter Sixteen

*"When an artist has need to stick on a label, he's lost!"*

I n February, 1913, Modigliani inexplicably missed a chance to have his work presented to the American public as one of the modern European artists exhibiting in the great show at the Sixty-ninth Regiment Armory in New York. The Armory Show, so sensational and scandalous that it aroused both critics and public and shocked such distinguished part-time art reviewers as President Theodore Roosevelt, significantly changed the course of American art. Matisse and Picasso had already been exhibited in New York. For the others, including Marcel Duchamp, whose *Nude Descending a Staircase* was *the* great shocker, it was the first showing.

Arthur B. Davies, head of the Society of Independent Artists, was organizer of the show along with Walt Kuhn, another outstanding painter. Kuhn and another painter, Walter Pach, scoured Paris, criss-crossed the city by taxi to obtain representative works of contemporary European artists. Among the approximately sixteen hundred entries, the catalogue of the exhibition, besides Matisse, Picasso, and Duchamp, contains the names of Braque, Rouault, Derain, Dufy, Vlaminck, Fernand Léger, Othon Friesz, Wassily Kandinsky, Augustus John, Odilon Redon, Jacques Villon, Francis Picabia, and such lesser painters as Henri Manguin, Albert Marquet, and Amedeo Cardoso. The modern European sculptors included Brancusi with *The Kiss*, Archipenko, Epstein, Manuel Manolo, Oscar Miestchaninoff, and Aristide Maillol.

Modigliani knew nearly all of these artists, and some, like Derain, Cardoso, Brancusi, Vlaminck, and Epstein, were close friends. In their intensive sleuthing for modern art in Paris, it seems odd that Kuhn and Pach should not have uncovered Modigliani. His work in painting or

sculpture was as strikingly original as the work of any of the other artists. Besides, judging from the catalogue, which lists eight paintings by Cardoso, the organizers put no limit on entries. There was no reason in the world why a Cardoso should be in the Armory Show and not a Modigliani. Modi's painting and sculpture were known to most of Parisian artists.

The only explanation is that Modi had no dealer: his work was not presently hanging in any windows; he had no coterie backing him. The others had; they were more public-relations conscious. When the grapevine spread the word that two Americans were looking for entries for a big exhibition in New York, the word spread fast. Of course, Modi was difficult, not one to solicit favors. He had to be asked directly. Perhaps he couldn't be found at the time; perhaps he was off drunk somewhere; perhaps the entries had to be assembled in a hurry with the assistance of impatient dealers who refused to be bothered with a troublemaker like Modigliani.

Or perhaps it was fate again, conspiring against Modi. He wasn't modern, certainly not *avant-garde,* not a Cubist, Fauve, Futurist, or anything dramatic in that sense. But that many lesser artists should have been accepted and Modigliani omitted remains something of a mystery—and typical of the Modigliani luck.

Modi's return from Italy was remembered by his friends. When his train deposited him in Paris, he hopped into a taxi to go to the Rotonde. Unlike Leghorn and the Café Bardi, he did not have to ask if his friends would be there. They were. The instant his taxi pulled up to the curb and he stepped out, a familiar figure in a new black Borsalino, a new corduroy suit, and a flashy red scarf, shouts of greeting went up.

What a difference from his reception in Leghorn! These were his *real* friends. They knew, understood, and loved him. No apologies, no explaining was necessary. Things looked good for him. He had money; he felt rested, rejuvenated, eager to get back to work. The waiters brought drinks, glasses were raised to Modi, and everyone settled down for a long session of talk to fill him in on what had happened in his absence. The party went on and on:

> Unfortunately, as was usually the way with Modigliani, once started on a "celebration" he was unable to stop. On the following night he had to be put out of the café; roaring drunk, and the festivities attending his return ended, for him, in the police station.[1]

Nevertheless Modi took hold of himself and set to work. He put aside his disappointments of Leghorn, especially the tragedy of his "drowned"

statues, and got promptly back to art. He had money enough to pay his rent, to buy new editions of his favorite poets, and to get all the necessary material for both painting and sculpture.

Temporarily freed from worry, Modi worked hard, although his personal habits had not changed. He had given them up during his short stay in Leghorn; now he resumed chain-smoking cigarettes, drinking, and taking hashish as he pleased; but this did not keep him from painting and doing sculpture.

Modi continued going from dealer to dealer. They refused to touch his paintings and were appalled by his bulky, unconventional sculpture for which—outside of rich lunatics—they could conceive no market whatsoever. Anyway Cubism and its offshoots were the absolute rule. There were few exceptions—freaks like the Douanier Rousseau, who had died in 1910, and Maurice Utrillo. Modi knew this well enough, and his friends probably never tired of intimating that for an artist nowadays, "d'être dans le progrès," it was mandatory to be Cubist. Not Modi, though. Charles Beadle asked him just "what he called his 'manner.' "

"Modigliani!" he snapped haughtily. "When an artist has need to stick on a label, he's lost!" [2]

It was during this period that Modi met the sculptor Ossip Zadkine, a Russian Jew six years younger than he. Like his contemporaries, Zadkine had rebelled against and rejected the academic tradition. He had begun to carve stringy religious figures in wood and stone. In the view of the late Alexander Archipenko, Zadkine at this stage seemed to be trying to revive Jewish sculpture. Very likely he was experimenting just as Archipenko himself was, and the others—Lipchitz, Henri Laurens, Oscar Miestchaninoff, Brancusi, Maillol, Epstein.

Zadkine's reminiscences, in a special number of the publication *Paris-Montparnasse* devoted to Modigliani, help fix the date of the second trip to Italy as 1913:

It was the spring of 1913. Montparnasse lived its last quiet days of the "English quarter" before the avalanche which was to upset its streets and corners, setting fires everywhere. My first meeting with Modigliani dates from this spring. He came from Italy wearing a suit of gray velvet. The bearing of his head was magnificent. His features pure. His crow-black hair, set over his powerful forehead and looking close-shaved from nearby, cast a blue shadow on his alabaster features. It happened on the Boulevard Saint-Michel where all young people met, where all friendships began, then we saw each other again at the Rotonde. . . . Modigliani then wanted to do sculpture. He no longer wanted to live in Montmartre, all his earlier painting was somewhere in a hotel, Cité Falguière. Never mind! He had a studio at 216 Boulevard Raspail. I must go see him; see his sculptures. . . .

Modigliani's studio was a glass box. Coming near, I saw him lying on his tiny bed. His magnificent gray velvet suit seemed to be floating aimlessly in a raging sea as if petrified in the expectation of awaking. Around and everywhere the white sheets of his drawings, which covered the walls and the floor, made fluttering wave crests in a cinema storm, immobilized for the moment. He—so beautiful, so fine in the oval of his face—was awaking, unrecognizable, yellow, his features strained.

The goddess hashish spared no one. . . .

Lifting up the sheets of drawings, he showed me his sculptures, the stone heads with their perfect ovals. Perfect eggs along which ran noses like arrows toward the mouth, they were never finished as if from shame, never wholly sculptured for a mysterious reason.

We saw each other later at Picasso's, Rue Schoelcher, where in the huge studio Negro masks pointed their admirable grimaces before launching their conquest of Paris. . . .[3]

Zadkine has told the same story several times, but there are minute variations in each account, little nuggets that cast fresh light on the personality of Modigliani.

In a recent book about Montparnasse, Zadkine added a few details. The breeze coming in the open windows stirred the drawings, each held to the walls by a single pin, and "One would have thought wings were beating over the sprawled painter."

He got up and put on his suit which the wind and rain had changed to a mother-of-pearl color. As he didn't always shave, his handsome features were often covered with several days of brambly beard the color of blue ink.

We were often without a cent, because he quickly blew the money that came from Leghorn and I myself, by the twentieth of each month, had spent the advance my father sent me from Smolensk. The lack of money didn't spoil our confidence in life; we walked quietly to the Vavin intersection and we sat on a terrace waiting, like fishermen, for an old friend to rescue us with a loan of three francs so we could eat at Rosalie's.[4]

Zadkine remembered seeing Modigliani lying inside his glassed-in studio naked and asleep:

He had drawings pinned up all along the walls, together with photographs of Italian paintings. . . . It was autumn and Zadkine saw them all fluttering slightly with the wind as though they were the waves of the ocean, and Modigliani lying asleep as though he were drowned.[5]

Elsewhere Zadkine has recalled that Modi "looked like a young god disguised as a workman out in his Sunday best. His clean-shaven chin had a small cleft in it. His smile was delightful. He talked to me immediately about sculpture and the advantages of direct carving in stone. . . ." Modi showed him "some of his early pieces, with which he said he was not dissatisfied." There was a new head, "solid and oval in form with eyes the shape of olives." [6] Perhaps Modi spoke of his dream of creating a great Temple of Beauty to be supported by an endless chain of his beloved, kneeling caryatids, which he called *colonnes de tendresse*. It was the type of big-scale statuary he had mentioned to Sam Granowski in the course of their first meeting back in 1906.

All his life the caryatid continued to be an obsessive, recurring theme. He produced them in hundreds of preliminary studies, drawings, basic sketches in pencil, crayon, watercolor, and gouache. Rather than the standing figures of women that the Greeks and Romans used as supporting columns for their temples, Modi's caryatids were always kneeling to bring out the lovely curve of the back. But so far as is known he managed to carve only a few.

Both Modi and Zadkine were good listeners and more than willing to exchange ideas, but no more, for each set his own course. Zadkine was quick to understand Modi's hard, unswerving course:

> All that is important if you want to understand Modigliani well. He did not explain anything; we did not discuss sculpture itself. His only response to my comments as a professional sculptor was a pleased laugh which echoed through the shadows of the lean-to he used for an outside studio. There were other carved heads lying about on the hard earth, most of them still in the rough stage.

But in the next few years, as the war broke out, Zadkine was also to note something sad and significant. Modi thought of himself as a sculptor, wanted to do sculpture more than anything else even though he couldn't sell a single piece, much less give it away to his friends. And yet,

> Little by little the sculptor was dying.
> Portraits of Rivera, of Kisling, of Soutine, some drawings, too, were pushing back those stone heads, and one found them all outside unfinished, washing themselves in the mud of the yards of Paris, embracing its magnificent dust. One big statute in stone, the only one that he had carved, lay with her head and stomach under the gray sky. The unfinished mouth held an inexpressible terror. . . .[7]

Zadkine, it goes without saying, was cut from a different mold. His nerves were not lacerated and he did not wander about in a state of

constant exasperation. Like Lipchitz, he was calm, sober, resourceful, and always knew where he was going. Nothing flustered him. He was industrious; he had good habits. He neither abused his body nor the gifts nature had given him. Charles Beadle, while evidently admiring the man and his art, writes of him wryly:

He occupied a small cellar, and his inseparable companion was an enormous dog, a Great Dane, I believe. It was so big that one wondered whether he, or the dog, slept in the courtyard for it seemed impossible that both could find room in the tiny studio crowded with sculptures. Zadkine, at this period, wore a Russian smock and had his hair cut *à la Russe* and fringed over his forehead, which gave him a startling resemblance to his own images in wood. He was already beginning to emerge from obscurity. One evening I found him at the Closerie des Lilas, dining all alone in state, in a bourgeois black coat, before a bottle of wine and regular fixings. Later he passed along the Boulevard Montparnasse just a little too upright, but decidedly happy. There is no Zadkine "legend." [8]

The Modigliani legend unwound and grew; new chapters were added as in a motion-picture serial. The most memorable legends concerned women. Modi's idyll with Gaby occurred at this period. Modi was so handsome, so attractive to women and so sure of his power over them, that he assumed that they were all his for the asking and, even with happily married women, was astonished when they rebuffed him and declined his offers. Gaby had a reputation as a seductive woman. She was older than Modi, a little faded, no longer the tempestuous beauty of the Latin Quarter, but still radiant, blessed with intelligence and a superior figure. She was mad for Modi. She and Modi had looked at each other, met, and fused. Happy in love, as always, Modi stayed away from his friends at the Rotonde and Rosalie's. He looked sleek, well groomed, and did not depend on liquor and hashish so much. Gaby, of course, had another lover, a man of parts, ostensibly a lawyer without a practice, a composer who never wrote music, and a poet without a line of verse to his credit. But he did write checks. Gaby said of him that he was a man of honor and checks: the honor was nonexistent but the checks, happily, "always honored."

The news of their liaison soon reached Gaby's lover, who decided something must be done. Man about town "and polygamous by instinct," the affair mattered little to him. But his "honor" was at stake, and it required calling Modi to account. A friend of his arranged for an "interview" at the Café Panthéon on the Boulevard Saint-Michel. It was no contest from the start. The lover was waiting when Modi arrived. Modi was

"gay and insouciant as usual, his hat slightly awry and his red scarf over one shoulder of his corduroys." The lover, immaculately dressed in the latest style, watched him, frozen-faced, and ordered him to take a chair.

Modi sat down, asking a waiter to bring them a bottle of wine. The lover said that "he had good reason to believe that the name of Modigliani had been linked to that of the lady under his protection."

Modi, his liquid southern eyes sparkling with malicious fun, admitted the soft impeachment, cunningly timing his avowal to coincide with the arrival of the sommelier. As the waiter balanced the dusty bottle in its cradle and began to pour out the wine, he followed up his confession by an effusive panegyric on Gaby's beauty and charm, declaring that no man, particularly no artist, could have failed to be smitten, and that, moreover, not only was he flattered by the association of their names but he could assure monsieur that he also, as well as she, would one day be equally honoured by the memory of their association with a great artist and . . .⁹

The lover tried to interrupt, to halt the flow of words, but it was hopeless. Every time he opened his mouth he "was brushed aside by a gesture and a speeding-up of rhetoric, for to stop Modi when started was an impossibility." Modi finished by raising his glass and asking his rival to join him in a toast "to the most beautiful and charming woman in Paris." The toast drunk, the lover again struggled to take the initiative.

"That is as it may be, m'sieu, but I wish you to understand that I will not permit—"

Modi jumped in quickly with, "And, moreover, m'sieu, I assure you that I have painted not one, but several pictures of Madame in the nude—"

Now the lover had to shout his indignation to be heard: "I beg you to understand, m'sieu, that in no circumstances will I permit—"

Modi came in over his words strongly: "And I, m'sieu, assure you that I shall be delighted to present you with a painting that one day will be worth thousands and will immortalize one whom you adore. But you are not drinking, m'sieu, I beg you! We will again, if you permit me, toast one whom I shall have the honor both to have loved and to have made immortal. Have a cigarette, cher m'sieu?"

It worked. Modi's charm, flattery, and positive approach overwhelmed the vain, precious snob. He believed every word. It was indeed a good thing to be associated with a "great artist," and the portraits of Gaby might very well be worth thousands of francs. (Modi was bluffing, but it may be that, at the back of his mind, he was altogether convinced that his reputation and his art *would* turn out just as history proved.) Soothed, even gratified, the lover accepted a cigarette and showed he was a gentle-

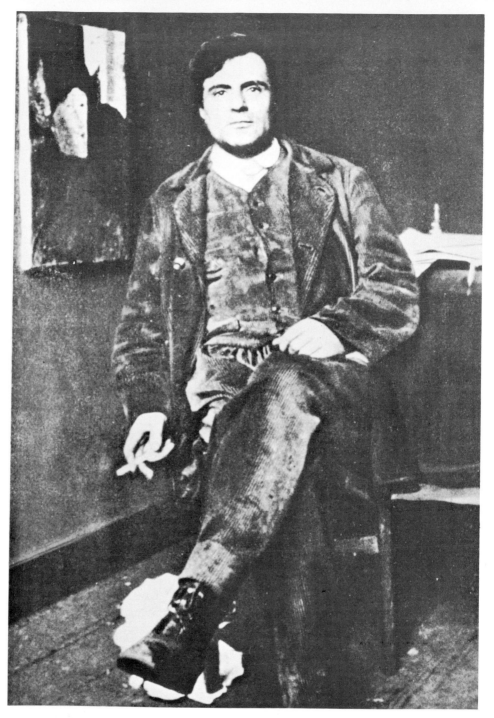

Modigliani in his studio, wearing his familiar corduroy suit.
*(Courtesy Vallecchi Editore)*

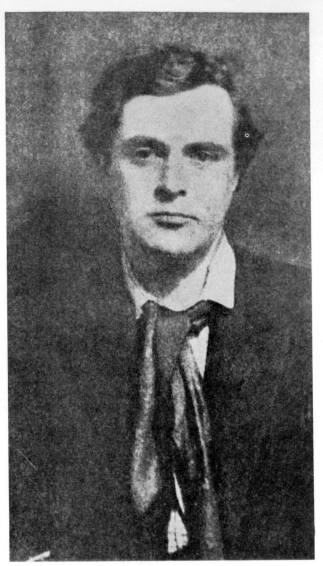

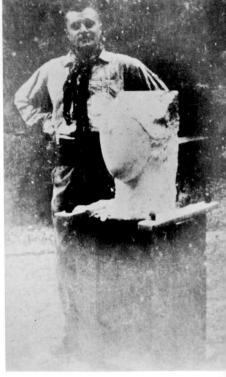

The only existing photograph of Modigliani showing him with one of his sculptures and with short, clipped hair. This snapshot was probably taken in the late summer of 1913, following his return to Paris from his second visit to Leghorn. *(Courtesy Maurice Lefebvre-Foinet)*

Modigliani, probably during the early years in Paris, in a dark, peak-lapeled jacket and with his usual flowing scarf-necktie. *(From Amedeo Modigliani by Ambrogio Ceroni, Edizione Del Milione, Milan, 1958)*

Modigliani, Picasso, and André Salmon standing in front of a café, possibly the Closerie des Lilas, in 1915. They all seem unusually neatly dressed for what must have been some special occasion. *(From frontispiece Omaggio a Modigliani 1884-1920, January 25, 1930, Milan, edited by Giovanni Schweiller)*

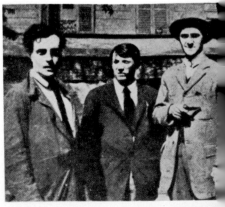

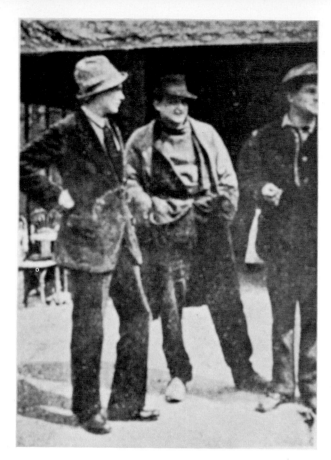

Modigliani, cigarette in hand, is on the right. According-ing to Jacques Lipchitz, this snapshot was taken in front of the Café de la Rotonde in 1915. Lipchitz himself is in the middle, hands in his pockets; the man in the slouch hat, left, is the painter Duret, brother of the composer. *(From special number of* Paris-Montparnasse, *No. 13, February, 1930, Paris)*

Maurice Utrillo, left, on display with his mother, Suzanne Valadon, and her husband, André Utter, all three painters and good friends of Modigliani. *(Photo Harlingue-Viollet)*

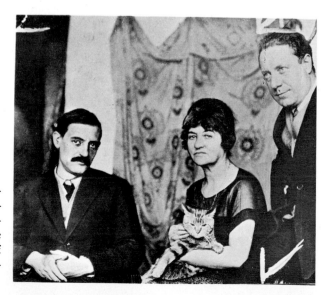

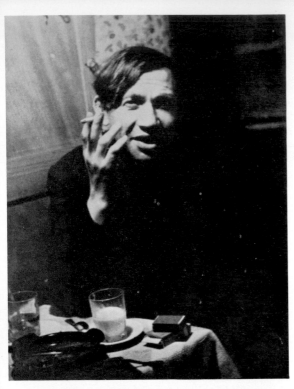

Chaim Soutine. *(Photograph courtesy of The Museum of Modern Art, New York; by permission of Mme. Marcellin (Madeleine) Castaing, Paris)*

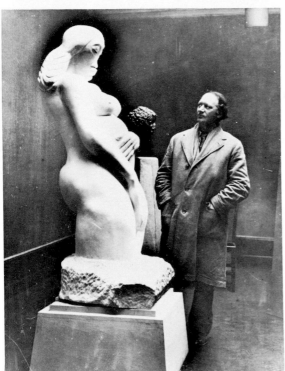

Jacob Epstein and his statue *Genesis,* 1941, which seems to show unmistakable traces of Modigliani's sculptural influence. *(United Press International Photo)*

Moïse Kisling (1891–1953) shortly before his death. *(Black Star)*

man by asking Modi "to do him the honor of accepting another half-bottle of the excellent Château Clos de Corvé, 1904." The evening progressed convivially in further praise of Gaby and the consumption of good wine. At closing time they were eased out of the Café Panthéon by the managment and, arm in arm, they strolled up the Boul' Mich' "at half-past two in the morning, hiccoughing eternal friendship."

While Modi had liaisons with many women, legend has made it hundreds and hundreds and even today there are old white-haired women in Paris who claim to have been his loves. Modigliani's daughter, Jeanne, became annoyed by all the stories told about her father. "I'm fed up," she says, "with all the old mistresses who come and cry on my shoulder." [10]

The portraits Modi did of Gaby prove that during a period when he was supposed to have abandoned painting completely for sculpture, he had not. Nor did he ever. Because the dates of his paintings are so inaccurate, it is hard to tell which ones of his nudes are Gaby. She could well be one of his many *Nu assis,* a long strand of hair trailing over one shoulder and down her right breast. Her head is tilted on her left shoulder, her eyes shut, her mouth pursed, her expression serene and sad. Hair disarranged, head turned languidly to one side and down, Gaby had a Madonna-like repose that Modi felt compelled to put on canvas.

Nudes could sometimes be disposed of, but not to dealers. Along with other artists, Modi was aware that proprietors of certain small shops, bars, and restaurants had a clientele among respectable bourgeois who appreciated "ripe" nudes in private. Modi's, with their shimmering flesh tones, voluptuous bodies, and frank depiction of pubic hair, were shockers. Nudes were worth ten to fifteen francs apiece, cash on the spot and no haggling, with maybe a few drinks thrown in to help consummate the sale. It hurt, but he needed the money, and these procurers were more honest and less hypocritical than most reputable picture dealers.

These sales were probably rare. Modigliani was never prouder or more arrogant than where his work was concerned. No matter that his art was unsold and unrecognized, he knew it was good. Many of his friends, though they may have regretted Modi's impracticality in not jumping on the Cubist bandwagon, thought the same. Gustave Fuss-Amoré and Maurice des Ombiaux have written that it was Modigliani who brought back the tradition of the open-air art exhibitions of the Pont Neuf. He did not do it intentionally, they say—it was not in his nature—but at the behest of his friends. Following their advice, no doubt with the misgivings born of experience, he gathered a crowd on the Boulevard de Montparnasse by showing his paintings on the sidewalk, set against a tree, a bench, a wall.

Passers-by stopped to look, were held by the novelty of his work, and

began to bargain in loud voices. Nothing could be more unnerving to Modigliani than their crude comments. They knew what they liked but would only buy cheap. Modi was hardly a tactful salesman. He told them what he thought of them, turned the arguments into altercations, and drove the customers away. Presumably there were no sales. Fuss-Amoré and Des Ombiaux sum it up: "No one is more aggressive than a bourgeois in front of a painting he doesn't understand." [11]

In 1913 Modi painted his third portrait of Paul Alexandre, the one later to be called *Paul Alexandre Before a Window Pane.* Dr. Alexandre remembers that some time before the end of the year Modigliani left a package for his friend with the custodian of the clinic where the doctor worked. "It was my portrait, the last one he did of me, and the only one of me which he painted—an extraordinary thing for Modigliani—for which I did not pose." [12] Apparently among the few oil portraits that Modi had painted after two years of steady sculpture, at first glance it looked less like the doctor than the first brilliantly stylized portrait *à la* Boldini and Sargent; on second glance, much more.

Both the brushwork and composition were simpler, the doctor's face a long oval rounded at the top by his hair, pointed at the bottom by the beard. The nose was elongated and slabbed as in Modi's sculpture, the eyes green and pupil-less, the features deliberately distorted. Modi had profited from working in stone. The line was sculpturally strong. Comparing the three portraits, each done two years apart, a discerning viewer would have to agree with Claude Roy that, with each painting, Modi had produced "a better likeness, both factually and psychologically," and that the last was far superior to the others because of its distortions.

While Paul Alexandre was a good, loyal, devoted friend, who believed unwaveringly in Modigliani and his work, their friendship was formal compared to those Modi had with Ortiz de Zarate, Maurice Utrillo, Moïse Kisling, Amedeo Cardoso, Foujita, and others.

Modi's oldest friend in Paris was Manuel Ortiz de Zarate, and now, more or less a permanent Montparnos, Modi was to see a good deal more of him. From what the artist's daughter, Laure de Zarate Lourie, has said,[13] her mother, Hedwige, liked Modigliani well enough, although she tended to be wary of him because of his reputation. She realized his eccentricity, acknowledged that he was *"très beau"* and at the same time *"très malade."*

Ortiz had responsibilities now as head of the family. The De Zarates had a daughter, Laure, born in 1912. A friend with Modi's habits and irresponsible ways could be regarded only as a bad, a distracting influence. Modi would drop in when Ortiz was working. He often brought hashish with him and liked to have his friend take it too. And money was a problem: as we know, Ortiz had lost his government study-grant after

buying a small Gauguin canvas at Pont-Aven in Brittany. His style was changing, too. He had been seeing Picasso, now that the latter lived in Montparnasse, and was gravitating toward Cubism. Soon he would have a contract with the dealer Léonce Rosenburg, a backer of the movement.

Yet Ortiz's friendship with Modi remained warm and sustaining, and it endured. They were much alike. Ortiz, too, had his impulsive, eccentric side. "He was mad, but debonair. His thick, heavy paint did not lack a certain strength. After a brief waltz with the Cubists, he anchored himself in moderate realism. . . . I can still see him with his great head, his big eyes, his thick sensual lips and his tiny derby . . . , he was a good madman, sweet and gentle . . ." [14]

Zadkine also knew *"ce personnage curieux,"* Ortiz. He was "a childish revolutionary. He knew no half-measures for those who antagonized him: it was either the guillotine or the stake. Fortunately, no one took him seriously." [15] It was difficult to take seriously an odd fellow who, at a time when everyone wore high shoes, walked about barefoot in sandals. This was a reminder of the antique virtues, of the truth Ortiz claimed to have discovered in the old ways of dressing. It was Ortiz who, in 1913, helped Brancusi inscribe on the Douanier Rousseau's tombstone the touching lines written by Apollinaire:

> Hear us, kindly Rousseau,
> We greet you
> Delaunay, his wife, Monsieur Queval, and I
> Let our baggage through the customs to the sky,
> We bring you canvas, brush, and paint of ours,
> During eternal leisure, radiant
> As you once drew my portrait, you shall paint
> The face of the stars.[16]

Modi, a slight man, envied Zarate's size and muscular build. If he was odd, a foreigner in Paris, proud of his country and intoxicated with his romantic heritage, then so was Modi. Ortiz, who was to have many troubles before he died of cancer in Los Angeles in 1946, was gay, ebullient, appreciative of feminine beauty. He loved life, art, and poetry, worked hard, lived hard. In short, he was the kind of man Modigliani liked best.

So was another man, a chip from the same block, a painter who was to achieve greater fame than Ortiz and create his own legend. (See photograph, facing page 225.) Seven years younger than Modigliani, Moïse Kisling was born in Cracow, Poland, and at an early age showed such talent at mechanical drawing that his parents were convinced he would be an engineer. He attended the Academy at Cracow, studying art under the well-known Packiewicz who had been a friend of the Impressionists and

taught Kisling to paint the Impressionist way. Kisling came to Paris in 1910 and lived in Montparnasse.

A Jew, Kisling was never troubled by that fact as Modigliani was. Less volatile than Modi, Kisling played as hard as he worked, chased the girls, drank, enjoyed parties and good times, but never became unhinged in the process. He, too, could be stubborn and abrupt, a difficult case with dealers, and exuberant. His exuberance and his magnificent gestures endeared him to Modigliani. There was the time he sold a painting for a hundred francs. Then, walking along the street with Modi, he spent all hundred on flowers which he impulsively gave to the women passing by—not just to pretty women, but to the ordinary, the young, the old, the beautiful, the ugly.

Besides Kisling, at this time (1913) Modi had two other good painter friends who were as impoverished as he was and who also lived in the Cité Falguière. Both were to become famous. One was the Japanese Foujita Tsugouharou, who was twenty-seven and always called Foujita; the other, Chaim Soutine, nineteen, a pathetic Russian Jew, emotionally scarred by life, with an extraordinary raw talent Modigliani was one of the first to appreciate.

Foujita came from Yokohama, where his father was a well-fixed government official. He had a regular allowance, resumed his art studies in Paris, was befriended by Ortiz de Zarate, and introduced by him to Picasso and his circle. Along with painting, Foujita was intent on absorbing the Greek way of life in Raymond Duncan's school—dressing, dancing, and learning to weave in the prescribed fashion.

Foujita was conspicuous in Montparnasse, an accomplishment in itself since the quarter was filled with eccentrics. He was always welcome at the Rotonde, where he added an exotic touch. He was a small man. He wore his black hair in bangs over his forehead; black horn-rimmed glasses framed almond-shaped myopic eyes. He wore gold earrings in his pierced earlobes. A postage-stamp mustache made a black daub under his nose. He wore a wide-brimmed hat from Brittany, a checked gingham shirt he'd sewed himself, a black velvet blouse, and extraordinary trousers. He looked, it was said, like an owl with a penguin's body.

Sometimes, à la Raymond Duncan, he wore garlands around his brow, a white toga, and sandals, for the dance sessions in the park. At other times he wore a kimono and toured the Louvre as a Japanese. Foujita was not self-conscious about his clothes. He dressed as he did for aesthetic reasons. Kisling in his blue "boiler" or workman's suit and Modigliani in his corduroys were being practical. Foujita was an expert in jiu-jitsu and could disarm or send much bigger men sprawling. He was also very popular with women, who found him "cute."

Foujita's studio was on the second floor of the Cité Falguière; Sou-

tine's and Modi's across from each other in the inner, ground-floor court-
yard. Foujita told an interviewer that in 1913 Modi was doing only
sculpture at the time, adding confusingly, "He had hardly begun to draw
and he gave drawings to his friends, or for drinks. He was always drunk.
He recited Dante, but since I was an oriental, he used to recite Tagore
for my benefit." [17] Modigliani had, of course, been drawing since he was
a child, and had continued to do so daily since coming to Paris; the port-
folios that Dr. Alexandre owns attest to this. As to his being drunk all the
time, this is the recollection of still another contemporary who remem-
bered Modi being drunk whenever he happened to see him. Foujita also
said that Modi was always scowling and making faces. His favorite ex-
pression was *"Sans blague!"*; his reaction to most comments this same
simple, general-purpose "No kidding!"

Next to Foujita, who grinned permanently and was confident and
articulate, Chaim Soutine was a brutalized waif totally incapable of fac-
ing the world. Chaim was the tenth of eleven children of a starving-poor
Jewish tailor in Smilovitchi, a dreary village twelve miles out of Minsk.
He had been an artist from infancy. Before he could talk, the story goes,
he crowed with joy at the rainbow patterns of sunlight on the dirty wall
by his crib. At seven he stole a kitchen knife and swapped it for some
crayons. For this his father locked him in a dark cellar for two days with
only bread and water to eat. The cellar was alive with rats. Misunder-
stood and unhappy, he ran away from home several times, did badly at
school, and was expelled.

Soutine's family, all thirteen of them, lived in a dirty one-room hut.
The father must have been startled by little Chaim who, from the age of
four, wandered around the village scratching designs on the walls with
pieces of charred wood. Theft and expulsion from school were bad
enough. But now came the worst: he broke the old Jewish law against
representing the human figure. Chaim had had the audacity to do a por-
trait sketch of the village rabbi. The rabbi's son and another bully beat
him up so badly that he apparently had to be hospitalized. The old
Hebraic law forbidding the representation of the human figure had been
in force since the Renaissance but, as Jeanne Modigliani points out, was
not observed by Mediterranean Jews. It was therefore possible for
Amedeo Modigliani to consider an artistic career; it was not possible for
Chaim Soutine or for Marc Chagall.

Some accounts say that Chaim's family sought damages and, on the
strength of the twenty-five rubles thus collected, sent their son to Minsk
to study art. Another story has the frightened rabbi, afraid the parents
would go to the police, giving the father hush money and advising him to
send the boy away to study the "damned" profession of art, if that was
what he wished. Chaim went to Minsk with another boy who longed to

be an artist called Michel Kikoine. Later the two went on for more study to Vilna where they met another art student, Pincus Kremegne.

Only thirteen at the time, Soutine had had no formal training, and failed the entrance examination at the School of Fine Arts in Vilna. He was helped by a sympathetic teacher and by Kremegne, who had already taken the primary course. Soutine worked as a photographer's assistant, and then, miraculously, a kindly doctor, who took pity on him, gave him money so he could study full time. When Kremegne went to Paris in 1912 because he had heard that artists there were honored as artists without regard to race or nationality, he wrote to Soutine that it was just as he had been told: in Paris Jews were treated as equals and were free to paint as they pleased. Soutine persuaded his doctor friend to pay his way, and left on the long trip to Paris and eventual fame as a great painter.[18]

But Soutine was unhappy at the Ecole des Beaux-Arts and began painting on his own in a cubbyhole at the Cité Falguière. Constant frustration, poverty, and personal torment turned him into an abnormally shy and frightened man.

When he met Soutine through Kremegne or Lipchitz, it was inevitable that the warm, friendly Modigliani should take a paternal interest in Soutine. They became close friends. Perhaps Modi recognized himself as he had been in 1906, newly arrived in a bewildering and overwhelming Paris. Soutine was always to be a recluse, living in isolation from the main stream of art and from people. Sullen, embittered, unwashed, filthy—there were to be many legends about him. To Lipchitz:

> Soutine was always an enigma, a mixture of such idiosyncratic impulses that he found himself constantly posing the question, Is Soutine good or bad or just neurotic? Not quite sure whether to like him or to pity him, continually perplexed by the protean faculty of the painter.[19]

Modi, of course, never troubled himself with such academic questions. Certainly there was no mystery there for him.

Soutine was even more unprepossessing than Maurice Utrillo. He was an ugly, thick-set man with the features of a Slavic peasant. (See photograph, facing page 225.) His stringy, greasy, dark hair hung over his left eye. His big broad nose looked pushed-in, and his thick lips were always set in a sullen expression. He had the look of an awkward farm hand in his soiled, baggy clothes, a clod whose ears were as dirty as his nails, who had fleas, who never took a bath, and smelled unwashed. Yet the aristocratic, fastidious Modi felt protective toward Chaim. He was attuned to Soutine's suffering, to his unequivocal dedication to his art. Maurice and Modi, who lived riotous, tormented lives produced serene paintings; on

the other hand, Soutine, who lived like a mole, exploded on canvas. A capped volcano, repressed and inhibited in a fearful paralysis, Soutine's emotions were released in his paintings. They teemed with frenzied color and shuddering visions. People, objects, and places plunged, staggered, and reeled in his canvases, a world in the shock of an earthquake, fissures yawning on every side with chaos and cataclysm to follow.

Soutine was "so obsessed with death and destruction that it led him to distort, even to mutilate all the subjects he touched with bitter almost sadistic joy." [20] He and Modigliani shared a melancholy, a tragic sense of life. Equally, as another critic says, in Soutine's "work as a mature artist there is an entire range of his reactions to tragic themes which is not tragic at all. It is instead exuberant and joyous." [21] Which is true of Modigliani. While Modi did not see the world as Soutine did, he respected Soutine's vision. Only when he was drunk did he perhaps allude to Soutine's odd style. There is a familiar anecdote in which Modi, feeling the effects of drink and trying to steady himself, said, "Everything dances around me as in a landscape by Soutine." [22]

Soutine painted. Nothing else. He painted and painted with a trance-like absorption that kept him at his easel for hours, unaware of time, until he collapsed from exhaustion. His startling paintings were totally unlike the Cubists and as different in their own way as Rousseau's, Utrillo's, or Modigliani's. He lived worse than Zadkine's dog, eating less, never cared for. He feared women, but he was a healthy animal who needed and took them when he could with an avenging brutality that was further proof of his abnormality. He used women to get back at his father, at people, at life for the cruel and degrading treatment he had borne. Much later, after the war, when Soutine's fortune was made through the purchases of the Argyrol millionaire, Dr. Albert Barnes, Lipchitz told Soutine that he had arranged to send money to his hard-up parents through a friend who was returning to Lithuania. Lipchitz suggested that Soutine might like to do the same for his parents in Smilovitchi.

> Soutine's harsh reply was, *"Qu'ils crevent!"* [Let 'em starve!] Lipchitz knew how very poor they were and his astonishment must have shown clearly in his face. By way of explanation Soutine told him, "You don't know how they treated me." His father seemed to have taken repressive measures against him such as locking him overnight in the poultry cage as punishment for wrongdoing and Soutine nursed an implacable hatred of him.[23]

Another tenant of the Cité Falguière was a remarkable Negro model called Aicha Goblet, who had been bareback rider in the circus, dancer, and actress. Sometimes she cooked for Kisling, Foujita, Soutine, and Mo-

digliani. Very often the men were penniless, and Aicha advanced them money she earned modeling to do the marketing. Aicha considered herself a Flamande. She said that her parents were Flemish and that she was born in a mine in Hazebrouck, "the only Negress in the family." [24]

Aicha was Jules Pascin's favorite model for a time. She was also a pet of Libion, patron of the Rotonde, who was a father to all the models who congregated there. She remembered that Modi had been very handsome. She met him soon after she came to Paris, when she was posing for Jacob Epstein. Then he had been, said Aicha, "very quiet, scarcely speaking at all," and she thought him "rather a dull young man." She said she saw little of him because he lived on the Butte, but saw him a few years later at the Rotonde, "just before his collapse, in 1912." It made her heart ache to see the good-looking Modi such a wreck. He was thin, emaciated, and so drunk, noisy, and insulting that Libion often had to eject him from the café.

Aicha is far more lyrical in her brief contribution to the issue of *Paris-Montparnasse* dedicated to Modigliani:

> How beautiful he was, my God, how beautiful! It was the sculptor Epstein who introduced us. We often went out together. He was then living on the Rue de la Grande-Chaumière. I loved the painter but also, very much, the sculptor. . . .[25]

After Aicha had cooked dinner and washed up, the men returned to their tiny studios. Perhaps Modi tried to talk them into going down to the Rotonde for a drink or two while he made some sketches; perhaps Modi stayed on, drank the last of the wine, went back to his room and put candles on the heads of his statues to chase the dark away.

Across the courtyard he watched Soutine light the kerosene lantern whose feeble light turned his room into a cave of spiderwebs. Barely able to see, Soutine picked up his palette and bent over his easel. He looked happier now than he had all evening. Modi could see the chicken carcass Soutine had obtained from the nearby slaughterhouse, dangling from a rafter by a string. Flies buzzed around the horrible thing, and the stench reached him from there. Soutine liked his still lifes *very* still and *very* dead. The chicken had been ripe to begin with—that was why Soutine got it free—and he had put off painting it until the colors had turned biliously rotten and beautiful, as he put it. The reds, the right red; the blues putrefied so that—Modi's nostrils twitched. Soutine knew what he was doing.

∽∽∽ Chapter Seventeen

*"A god in a dustbin!"*

Although there was no interest in his sculpture, Modi continued to carve and chisel wherever he happened to be living. He drew every day; he still did a painting from time to time, but portraits were a vocation, something he did on the side.

In 1913 there was another exhibition of Elie Nadelman's work. Nadelman's sculpture was simple, and as smoothly executed as Brancusi's, but more realistic. His figures were recognizable at first sight for what they were, lightened by comic touches. Modigliani never cared for the humorous or anecdotal in art. His own sculpture was tending more and more toward the architectural and the timeless. Still, Nadelman's fresh approach and clean line gave Modi ideas.

But Modigliani seemed to be running down. Zadkine had observed, "Little by little the sculptor in him was dying." The truth was that everything in him seemed to be dying. Paul Alexandre was still around to buy, advise, and encourage, but he was preoccupied with his own career. Brancusi was always available as mentor and friend; so were Cardoso, Ortiz, Kisling, and Max Jacob. But in the period 1913–1914 everyone Modi knew seemed to be prospering except himself. They were all selling, furthering their careers, taking one important step after another toward recognition. Vollard had bought Vlaminck's work; Van Dongen was established as a society portraitist and famous for his parties; Rosenburg was handling Picasso, Braque and Derain; Apollinaire and Salmon were making reputations as poets and critics; Carco's first novel had been accepted by *Mercure de France;* even Max Jacob had buyers for his gouaches.

Only Modigliani was outside the magic circle. He went from failure to

failure and lived the same degrading life. He had friends ready to help in any way they could, but Modi sought no help. His pride, his aristocratic spirit forced him to submit to such destruction. He sustained himself for days on a *"petit pain de trois sous,"* all he could afford to buy. But, in all his suffering, he knew the value of his work. "He did not die of misery, rather he lived on it." [1]

More and more he became the impossible Modi of legend, raging at his best friends, lashing out bitterly at everybody. As he sat at the Rotonde, the saucers accumulated at his place, showing how much he had drunk. The generous Libion watched nervously, wondering if Modi would be able to pay, hoping he would not act up and have to be thrown out. Modi's friends invited him to sit at their tables. Sometimes Picasso would look at Modi's portfolio, it is said, and praise his drawings. A good word from a successful artist must have anointed some of Modi's wounds, but he must also have chafed at the story that one of Picasso's paintings was reported to have brought thirty thousand francs at the Druet Gallery.

Picasso had not changed with success: he lived better and dressed more like a gentleman, but he was still Picasso. Cubism was not the inflexible religion for him that it was for some of his disciples. He pursued his own ideas. Modi admired and resented him as much as ever.

Modi's friends acknowledged his talent, particularly Carco, and did their best to recommend him to their dealers. One did take a chance and sign him up. When some time had passed without a picture sold, the dealer promptly broke the contract, which provoked a quarrel and reinforced the accepted belief that Modigliani was absolutely impossible. Then the word went out among the dealers not to touch him. He was an Italian madman. As for Modi, "The grasping tendency and the vulgarity of the merchants disgusted him." [2]

There is a story that Modi left a picture at some gallery—"A picture on which he had gummed a popular song—a most unusual lapse in the Picasso manner." Modi dropped by later and found that the dealer on his own had substituted a Baudelaire poem for the scrap of popular song. Modi was furious and called the dealer a pretentious idiot. The dealer snapped back that if Modi thought him such a fool, then he wouldn't buy any of his rotten pictures.

"I don't give a damn! *Je vous emmerde!*" Modi was penniless but still in top form.

Having had the final insult, Modi grabbed his painting and marched off. "Material success in life depends, alas, more upon character than on talent." An artist, like all creative people, must have the knack of selling his work. Given the proper technique, an expert can sell an inept painting where a poor salesman cannot sell a masterpiece. The sober Modi was

winning and charming, but not as a salesman. He couldn't compromise. His prickly temper got the best of him, "even if the next meal or, worse, next shot of dope, depended on . . . conciliation. . . ." [3]

Modi must have felt that nothing was solid underfoot, that he foundered at whatever he attempted. Dedicated as he was to sculpture, although stubbornly unwilling to face the hard facts, he may have had some inkling that he lacked the strength and that his life was too disordered for the serious, enervating business of carving directly, even from soft stone. Yet to be forced to give up sculpture as his friends—especially Max Jacob—seem to have urged him, to admit failure, was unthinkable. He had to go on. To do so he depended on alcohol, drugs, and someone to love.

Once again Modi disappeared. He wasn't seen at his studio, at the Rotonde, Rosalie's, or at any of his old haunts. More often than not he was with a girl he would meet in a bar, staying with her a day, three days, a week. No longer a young god, he still had a great attraction for women. He wandered back to Montmartre, looked up Maurice, went on epic drunks with him. He went to hashish and alcohol parties at "Baron" Pigeard's. He sat next to Suzanne Valadon, "My elected mother" as he called her, telling her of his sufferings, finding surcease in her affection and sympathy. He came in saying, "I have been through Dante's hell tonight. Ah, wonderful hell!" Then he fell asleep in a corner, his arms wrapped around "Suzanne's great German sheep dog." At other times he came bouncing up the stairs, stripped off his clothes, and came into the apartment stark naked, "dancing wildly."

> Suzanne and Utter would stand him in a tub of water in the kitchen and clean him up before putting him to bed. Suzanne understood drunks. To her and Utter he was, like Maurice, not an object of scorn, not just a noisome alcoholic. He was a gifted spirit, a fine artist battered by demons, and they loved him. If he were mad, so to a point were they also touched with madness. Every artist was touched by it. [4]

They knew his "deep compassion for the dispossessed; the humble, the simple people." They were aware that he "could burst into tears at the sight of a sick child, or insist that a ragged little girl take the last sou from his pocket." Long after he quit the Butte for Montparnasse he came back with paintings and drawings to show Suzanne and Utter. "Their admiration was impassioned and sincere." Inspired by Kisling, when he did make a sale, he sometimes arrived with "armloads of hothouse flowers," proclaiming "Ah! But they are our beautiful Italy!" Then he "would sing them boat songs from his native Leghorn," and pour out stanza after stanza of Dante.

At other times, in less lyrical mood, he would steal one of their paintings and sell it, using the proceeds to launch a spree. Once he brought a prostitute and camped with her on the studio floor for a week, consuming quantities of hashish pills and engaging in a protracted sexual orgy. Even when he fought with them, smashing one of his canvases on Utter's head because he would not give him money for dope, Suzanne and Utter felt no resentment. Whatever Modigliani did, they understood and loved him.[5]

It was a period when Modi seemed to be running away from himself, from the reality of failure. He ran faster and faster, sank deeper and deeper. He wandered into dives frequented by vicious, depraved people. He drank and declaimed poetry to them. A lordly Byron in rags, a degenerate noble prince, he fascinated women, and their escorts glowered at him. In his drunken innocence, he had no idea how close he came to being murdered in an alley by a jealous thug.

Modi was amused at some of the situations he found himself in. Later, he told Charles Beadle of a time he remembered in a bar where men and women were milling around. He was very drunk. It was all as in a dream until he felt someone yank his arm and he woke up. Strangely, he was unable to move. The sun was shining. He struggled, but he seemed to be held in a vise. Two streetcleaners were standing over him, laughing their heads off at his predicament. He looked down at himself in amazement, slowly realizing what had happened. He had evidently passed out in whatever bar he had been in, been dragged out, and jammed into a trash barrel, folded like a jackknife.

The helpful streetcleaners had pried him out. He fell on his face when he tried to stand. His circulation had been cut off, his muscles cramped and paralyzed. What a fix to be in! It had been a prank, though. He had felt in his pocket and found a few francs, "enough to buy drinks for himself and his rescuers, who carried him, covered with filth, into the nearest bistro."

But he was annoyed because his sketchbook was gone and so were his identity papers, although Beadle says that Emanuele Modigliani later explained that Modi's papers were false and that Emanuele had had to forge them because "Modi was everlastingly losing his passport." And how did Modi sum up the incident to Beadle?

" 'A god in a dustbin!' said Modi laughing, as if it were a splendid joke."[6]

Other escapades ended in the police station. Modi was rarely kept in jail longer than overnight to sleep it off, and was never arraigned before a judge. By now, the police knew him as well as they knew Maurice Utrillo, so often his companion. But the police had taken a page from the bar owners, profiting from art. Partly as a speculation some of the

shrewder police officials had begun to cultivate artists. One of them, named Descaves, the brother of the writer Lucien Descaves, sometimes invited Modi and Maurice to his home, as he did Kisling, Derain, Vlaminck, and Anders Osterlind, a young Swedish painter. Descaves, who later specialized in Modigliani drawings, represented himself as a wholesaler, buying in lots, ten paintings for a hundred francs.

Another strange figure, who would certainly have helped Modigliani more if there had been any profit in handling his paintings, was the Polish critic and part-time art dealer Adolphe Basler. Basler was very sharp, adept at squeezing out his money in small sums, but he was also devoted to art and painting, and the few books he wrote on the subject have endured. He admired Modigliani, was a good friend, and probably bought a number of his paintings. Fernande Olivier in her *Picasso et Ses Amis* has left a devastating portrait of him as "a fat little man with soft, wet hands, the wise, devoted air of a beadle, reserved except for compliments and unable to drop enough of them. He was flattering, conciliating, and intelligent. He seemed to be present to see, to hear, to retain and, especially, to profit." [7]

But perhaps the slickest, shrewdest dealer of them all was Chéron who turned a fat profit from the paintings of Foujita, Modigliani, and Utrillo in particular.

Modigliani's *Portrait de M. Chéron,* which was exhibited at the Perls Galleries in New York, shows a mild-looking man with receding brown hair over a high forehead, a big head, smallish eyes with almost no eyelashes, a big, flattened potato nose, a small, slit mustache, and a tiny mouth. Chéron is wearing a bowtie, a white shirt, and a brown suit. The portrait, in the collection of Mrs. Evelyn Sharp, is dated 1917. The date is certainly wrong. Modi was under contract to Chéron only for a few months in 1913; in 1917 he had a contract with Leopold Zborowski. It is possible that he owed Chéron a portrait under his old contract; but this seems unlikely. The painting was probably done either in 1913 or early in 1914. Modi rarely saw or painted his male subjects with the distortions characteristic of his female subjects.

It is hard to say how Modi came to know and work for Chéron. The chances are that he was among the many dealers Modi had approached on the Rue de la Boétie. Chéron, a onetime bookmaker and wine merchant in Beziers, in southern France, decided to become a picture dealer after he married the daughter of a dealer named Devambez, whose gallery on Place Saint-Augustin was one of the best known in Paris.[8] Chéron, who had no background in art and no real interest in painting except as merchandise (like many another art dealer of the period), was a common, ignorant, belligerent man. But he had a flair for accumulating

and selling his merchandise. He cultivated impoverished artists like Modigliani and Utrillo only because he was short of capital. He knew they were willing to take whatever they could get for their work. Considering his vulgar streak, or perhaps because of it, he was far more aware of the value of publicity than posh art dealers like his father-in-law.

Chéron had the idea of printing a little brochure in which he made a case for picture collecting as a financial speculation that could pay great returns. He advised his readers and his clients to buy young talent when it was beginning. You had only to be patient for a few years, and then, who knew? Chéron was able honestly to describe how only a few months earlier such clients as Utrillo, Modigliani, and Foujita had sold for two or three hundred francs and that then, about 1920, a good Utrillo was worth several thousand francs, a Modigliani eight to ten thousand francs, and the price of a Foujita was rising every day.[9]

So far as Chéron's character was concerned, judgment varies. Foujita, who was under contract to Chéron for seven years to deliver two gouaches and two watercolors daily, speaks of him with bitterness. "He liked to get painters drunk and then gave them a contract to sign." [10]

One cannot doubt that this is how Chéron got Modigliani to sign. Matters had gone beyond the point of desperation with him. In order to survive, Modi submitted to becoming a hired hand of Chéron. The latter was no philanthropist. As a hardheaded businessman, what Chéron really wanted was a captive painter. That was what Modi became. He worked in the basement of Chéron's shop on the Rue de la Boétie. Chéron provided paints, brushes, canvas, a model, and something to drink. Modi "invariably demanded a bottle of brandy. . . . That was his medium, he insisted, with a laugh that ended in a coughing fit. . . ." [11] The pay was a *louis,* a gold piece, worth twenty francs at the time, to be paid after the daily stint.

The model was Chéron's young maid of all work. Modi usually used a girl for a few sittings, then shooed her away and completed the canvas as he pleased. How he handled that problem this time we do not know. Chéron, we presume, visited the basement often during the day. An artist on the premises represented a considerable investment, and Chéron expected a good return for his money. Some say that he expected masterpieces for his twenty francs a day, at least one finished painting, preferably two.

Although by all standards Modigliani was being well paid, if, that is, Chéron actually gave him a gold *louis* a day, it was still not enough for Modi. The story goes that at about ten o'clock one morning, someone knocked on the door of Sylvain Bonmarriage, author of *Hamlet aux deux Ophélies.* It was Modi, "tall, slim, dignified, and pale."

"Can you lend me ten francs?" he asked. "Alexandre isn't in Paris, and Chéron won't give it to me. I haven't a cent to buy a meal with."

Bonmarriage had no money either, but he was ready to help. Modi waited. As he dressed, Bonmarriage considered borrowing a *louis* from Davesne, proprietor of the Clairon des Chasseurs, who had often obliged him in the past. They walked over to his place, but unfortunately Davesne was out. So they continued on to the Boulevard Rochechouart, where Bonmarriage met a friend who lent him twenty francs. Instead of taking the time to thank Bonmarriage, Modi grabbed ten francs and marched straight into an art shop. Bonmarriage, who followed him, watched as Modi spent the money on paper, pencils, India ink, and even an eraser— ". . . there was two cents thrown out the window."

"But you never use an eraser," Bonmarriage chided him.

Modi smiled and shrugged. "One never knows what can happen." He looked around and saw the time by a street clock. "Seven after twelve. Now you'll have to ask me to lunch."

And Modi said it so grandly that Bonmarriage obliged.[12]

But Schaub-Koch felt that Chéron was a "skilled dealer" who set Modi up in his shop, provided him with everything he needed to paint, and paid him twenty or thirty francs a painting. Chéron was probably neither an enlightened dealer nor a rapacious one. Whatever he was, he got Modi painting again. He is supposed to have locked Modi into his basement and taken away his clothes, which is hard to believe but possible, knowing how difficult Modi could be on occasion and knowing what little we do of Chéron.

Jacob Epstein records what Brancusi told him:

> . . . Of how at one period he had rescued Modigliani out of the clutches of a rapacious dealer, who had practically immured him, in order to exploit him, in a cellar. He was without decent clothing and ashamed to go out. Brancusi had gone and bought a pair of trousers and a jersey, so that he could make a get-away." [13]

Fernande Barrey, Foujita's first wife, who brought the Japanese artist to Chéron's attention, did not take so severe a view of Chéron as Foujita did. She said only that it was true that Chéron didn't like to pay up, but he was never wholly to blame. Artists didn't always treat him well either. They often played nasty tricks on him. She had happy memories of the lunches—*"moules marinière et haricots rouges"*—that Chéron's maid served in the basement of the store . . . the same basement where, for several months, Modigliani worked for fifteen francs per day.[14] The fact that Chéron lunched with guests in the "basement" changes one's image

of the basement. It was evidently quite habitable, not the black dungeon one at first imagines it to be.

Edmond Heuzé, another artist who worked for Chéron, said that poor Chéron was much maligned, that he was generous toward the people he liked. When Soutine came to deliver a load of paintings, he left after having removed two "as his commission," and, says Heuzé, Chéron let him get away with it, even though he had paid for the lot.[15] Chéron himself always considered that he had treated Modigliani honorably. He told the critic Florent Fels:

> At least Modigliani had no reason to complain about me. He came to my shop about ten o'clock in the morning. I shut him up in my cellar with all he needed for painting and a bottle of cognac, and my maid, who was a very pretty girl, served as his model. When he finished, he kicked at the door, I opened it and gave him something to eat. And a new masterpiece was born.[16]

The truth again, as with so much about Modigliani, lies somewhere between legend and report. Ironically, Modi did produce masterpieces in Chéron's basement and left the memorable portrait of his jailer that has already been described. But despite the money and the discipline provided by the contract, the arrangement finally did not work out. More than money and a jailer, Modi needed a friend, a man of superhuman patience, tolerance, sympathy, and understanding.

The rupture with Chéron followed some incident of the sort described to Epstein by Brancusi. Modi was not fool enough not to know he was being exploited. He could only despise such a man, particularly since Chéron could sell his pictures at a profit when Modi could not.

Léon Indenbaum, a sculptor friend of Modigliani's, remembers when Modi worked for Chéron. He gives the impression that Modi hated the dealer. As he tells it, it was Chéron who asked Modi to work for him at his place in the Rue de la Boétie. Modi, down on his luck as usual, went to Chéron's, looked around the shop, and asked where the studio was. The dealer took him down to the cellar, where there was a tiny window. Apparently there was just enough light to paint by. Modi found the "studio" satisfactory and agreed to work in it. Then he asked for a model. Chéron pointed to an old woman in the shop, and Modi promptly made a scene. To try to economize a little, the model Chéron had suggested was his wife.

Indenbaum also says Modi worked for Chéron for only a few days when a really terrible row ended the arrangement. And there is evidence that Modigliani hated Chéron. One night at the Rotonde, Modi, already drunk, caught sight of Chéron. A split second later the table was upset

on the floor, and Modi had seized a chair with the intention of killing Chéron.

Modi blew hot or cold about everything, certainly about people. When he liked them, he liked them with his whole soul. When he didn't, there was trouble. How he felt about a model or subject showed in his signature on the painting or drawing. Indenbaum is certain that Modi always signed his drawings, that you could know his feelings by his signature, and that his drawings, in fact, could be classified by the signature he used. The drawings he threw away were never signed.[17]

Free from "jail," although probably still under contract to Chéron, Modi resumed his old ways, dabbling at sculpture, painting a little, drawing at cafés, and drinking heavily. Max Jacob now tried his hand at furthering Modi's career. Max, who perhaps had in mind Gertrude Stein's enthusiasm for Picasso, realized the importance of getting the right person interested in Modi. The person he had in mind was Paul Guillaume, a well-dressed, cultivated intellectual, who supposedly became an art dealer at the suggestion of Apollinaire. Guillaume had first collected primitive African art, then had bought some pictures from De Chirico, and was at this point interested in promising modern painters.

Knowing how Modi felt toward dealers, particularly after his experience with Chéron, Max arranged the meeting very shrewdly. He told Modi that he was going to meet Paul Guillaume the next day at five o'clock at the Dôme. He wanted Modi to be there with his portfolios. Modi was to show his drawings to people at a nearby table. Knowing Paul, Max was sure he'd want to see the drawings and that he'd go over and have a look for himself. Max said, "Picture dealers only frequent Montparnasse to find out what painters we admire, to profit by our natural sense of art values. If he sees you surrounded by admirers, he'll surely buy something."

Max was clever in appealing to Modi's conspiratorial sense. Besides, Modi "loved a joke and everything went as scheduled. Paul Guillaume appreciated his drawings, those portraits which were so recognizably like their subjects, yet which didn't have a single feature that was *juste*. Yet it wasn't caricature. On the contrary, it was the very soul of the model." Very much interested, Guillaume asked if Modi painted as well. No, said Modi flatly, no doubt considering himself a sculptor. Astounded, Max told Paul not to believe him, that Modi painted wonderful portraits.

Unwilling to have words put in his mouth, fiercely independent and anxious to speak for himself, Modi had to be perverse. As Max Jacob told it, "Modigliani was furious and swore that he didn't, which was true at that particular moment." Confused and put off, Guillaume then left the pair, and Jacob, who had a right to be angry with his friend, merely advised him, "Do your portraits large, on canvas, and put some rose be-

tween the features." [18] Modi would do nothing of the kind, and remained irate.

Despite the impression Modi made at the Dôme, Guillaume did become interested in his work and even rented him a studio. He bought his pictures and represented him faithfully—if hardly as enthusiastically as Leopold Zborowski—until Modi's death. Guillaume was an aesthete and a gentleman, hard put to stomach so bohemian a rowdy as Modi, but still appreciative of his work. Guillaume was a languid, careful man, however, who was unwilling to take great risks or to advance generous sums to unknown artists.

Nevertheless Jacob had done his best for Modi. Guillaume might have made Modi recognized and prosperous if Modi had cooperated. But Modi was Modi, as no one knew better than Max Jacob.

Infuriated by Max's effort to do him a favor, Modi seems to have disappeared again. He turned his back on Montparnasse, wandered back to Montmartre, and there met a woman who was to be one of the great loves of his life. She is immortalized in some of his finest portraits.

Exactly when Modigliani met Elvira, familiarly known as La Quique, remains a matter of conjecture, but early in 1914 seems the most likely time. The 1919 date on all existing portraits of Elvira is arbitrary, and 1914 is the more probable date despite Paul Guillaume's statement to Giovanni Scheiwiller that Max Jacob had introduced him to Modigliani in 1914 when he was living with Beatrice Hastings,[19] and despite Madame Hanka Zborowska's statement to Francis Carco that Modi had painted Elvira in the winter of 1917.[20]

On the night he met La Quique, he was drinking his way down the Butte and made his way to the Place Blanche, "the nightland of Montmartre, to Chez Graff and the Café Cyrano, haunts of the lightest ladies and their friends." In one of these dives, "he met a very handsome young woman, little more than a girl, who was a professional courtesan, known as 'La Quique.' Once more it was 'a stroke of lightning' [un coup de foudre], as the French call it; he was madly in love with her and she with him."

Except for portraits, which are a tribute to her haunting beauty, little is known about La Quique. Modi's friends do not seem to have met her. Only her name is mentioned in their reminiscences. The idyll seems to have been brief but passionate and—for the most part—a private affair. Elvira's background would have remained a complete mystery except for the excellent detective work of Charles Beadle, who, in the course of his research for *Artist Quarter*, extracted the details from ". . . A certain Madame Gabrielle D., who has known the Butte for longer years than it

would be discreet to mention." It took several bottles of wine to get the story.

Madame Gabrielle D. knew Modigliani, but avoided him "as he always was a spoilsport with his noisy ways." But newly arrived on the Butte, he had struck her as a "quiet, inoffensive . . . uninteresting youth." As to La Quique, Madame Gabrielle D. had once been a member of the same touring theatrical company, had known her well, and had vivid memories of her friendship with Modigliani. Elvira was a Marseille girl; her mother, a laundress. Her father was supposed to have been "a Spanish naval officer," and the illegitimate Elvira, Madame Gabrielle always felt, ". . . certainly looked Spanish with her huge dark eyes, rather Bourbon nose, full pouting lips, and provoking breasts." La Quique ". . . was a lover's term of endearment, rather intimate, originating in Marseilles," and Elvira "was a girl made for love."

Unruly, impetuous, always in trouble, Elvira was a nuisance to her mother. She was the leader of her own street gang, annoyed the neighbors, who "hated her," called her "a nasty, impertinent hussy," and predicted she would come to a bad end. She ran away from home a number of times and lived with a gypsy band for months. "Her mother openly cursed her, saying she'd had enough and hoped the little beast would go away and stay away." Which, at fourteen, was exactly what Elvira did, but what she did in the next ten years no one knew. It was 1906 when Madame Gabrielle met her in the touring acting company. She was twenty-four and looked twenty. "Everybody loved her, for she was really beautiful and so funny." She told marvelous stories of Marseille; she could sing and dance; she had a good voice. But it was her manner: "Those big electric eyes, looking down her longish nose, those pouting lips, and the real Spanish swing of her hips—brought men in crowds."

Lovable as she was, Elvira continued to be a troublemaker. The women in the company were glad when she left suddenly. She had "a protector." No one could find out who he was or where he took Elvira, but she talked about her adventures like a real Marseillaise when she next saw Madame Gabrielle. She told of going to Berlin with a Dutch baron and taking singing lessons, "of other men with yachts and cars and châteaux, . . . gambling at Monte Carlo, where . . . she won a fortune in a night and spent it as quickly." La Quique "was a crazy one with money" and "couldn't live without champagne."

But things hadn't gone too well after this. She had taken to sniffing cocaine, ruined her voice, and had been forced to appear in *café-concerts* in grubby restaurants. Further on down the line, she met Modi. Madame Gabrielle had witnessed a crucial episode in their love affair, one bound to be told and retold. It was "killing," she said, recalling that she had

come home early, at about one in the morning, and that "there was a lovely full moon." As she and her companion crossed the Place Ravignan into the Place Jean-Baptiste-Clément, they "heard a piano going full blast, playing a Spanish scherzo, and a woman's voice, wild and hoarse." The music came from a neighboring house. They had to stop, of course. She explained that, at one side of the shed Modigliani was living in, "there was a bit of garden, about the size of a handkerchief." It was here that they saw an amazing sight.

Well, a woman in a kimono, nude to the waist, with her hair down, was dancing madly, and opposite to her was Modigliani, in trousers only, capering about like a lunatic and yelling like a demon. Every moment he would turn his head and scream: "You pig-headed calf! You pig, son of Madonna!" at a lighted window in that big house at the back, in the Rue Norvins, where lived some kind of Treasury fellow. As we stood laughing he dropped his trousers—Modigliani, not the Treasury chap—and started to caper around her.

Oh . . . , but he was beautiful there in the moonlight, like a faun, and we all said what a shame it was that he drank like that. Then the woman dropped her kimono and the two danced nude. And then a gang of brutes who were passing started shouting and yelling, and he picked her up. She threw her head back at the moment and I recognized her. As they disappeared into the shed, I screamed: "Vira! Elvira!" . . . Oh, but they were beautiful, those two, but quite mad with *that,* of course." [*That,* meaning drugs.]

Seeing her old friend, Madame Gabrielle wanted to go right in to see her, but her companion prevailed on her not to. She went the next day, however:

. . . You never saw such an awful hole in your life: Bottles, dirt, and pictures and sketches all over the place. There was one, I remember, a big one of her—Elvira. A nude. But then I don't like his work. He was still stark naked and dead asleep, but she was warming some coffee. I took her out of that pigsty and we had déjeuner together and a long chat. I never saw her again for I wouldn't go to see her while that lunatic was there. Shortly afterwards she left him, and I don't wonder, although he was beautiful.[21]

Beadle then asked Madame Gabrielle what had happened to Elvira. She said that "some aviator fellow . . . , who had known her as 'La Quique . . . ,'" had told her "that she had been shot in Germany as a spy." Madame Gabrielle believed the story. Elvira was the kind who would tackle anything, and full of cocaine ". . . she'd have charged a German Army Corps! She spoke German, as I told you, and . . . , after

all, it was the man who told me so and not she who came from Marseilles, as I do!"

The story of the tempestuous relationship between La Quique and Modigliani could perhaps not be better told than in the words of Madame Gabrielle looking back some twenty-seven years. Modi and La Quique were madly in love and were equally fond of liquor and drugs. And yet, in spite of squalor and distraction, there were "pictures and sketches all over the place" to prove, as usual, that Modi had not forgotten painting for a moment.

It is likely that Madame Gabrielle is referring to a studio at 13 Rue Ravignan, the street number of the Bateau-Lavoir, that Paul Guillaume said he rented for Modi in 1914.[22] Why the portraits of Elvira have all been arbitrarily dated 1919 can be explained only by trouble with the landlord once again. Modi did not pay his rent. He was kicked out and all his work confiscated. Then in 1919 the ruined portraits of La Quique were reclaimed and Modi did them over.

Modi painted and sketched Elvira when he chose. He often would not sell the portraits he did of his sweethearts. Guillaume seemed anxious to buy those of La Quique, but Modi would not take his portraits and drawings of Elvira—or, for that matter, any others he had lying around —to Paul Guillaume, which may account for the abrupt end of his affair with Elvira. Money ran out for food, drink, and drugs, and still Modi would not part with a painting. Or perhaps one morning after getting drunk on absinthe and hashish and making rapturous love, he awoke and found her gone. It was not unexpected. All his affairs, like his life, were brief and intense.

∽∽∽ Chapter Eighteen

*"It's infuriating to be doing nothing but pushing
a paintbrush about: their faces will need bashing
for another three hundred years."*

Modi went back to live in Montparnasse as if he had never been
away. With Elvira gone he had other girls, as usual. He sold his
drawings at the cafés, and painted desultorily. He saw Paul Alexandre from time to time, and all his artist friends. He peeled potatoes
and fixed string beans for Rosalie; the Rotonde was always his base.

There is no record of what Paul Guillaume had to say about Modi's
being evicted from the room Guillaume had rented for him or even that
he knew of it. Modigliani had not produced as promised. It was up to
Modi to get in touch with Guillaume, and perhaps he did and sold a few
paintings.

Somehow he had accumulated enough money—perhaps he had received some from home—to find new quarters in Montparnasse. This
may have been the room he was known to have occupied at about this
time at 16 Rue du Saint-Gothard. Rosalie told Umberto Brunelleschi of a
time when Modi had managed to get hold of some money, and decided
that he wanted a clean studio with decent furniture. And of course he
had to have a housewarming party to celebrate. It had been talked about,
and the details were well remembered. Rosalie knew them; so did
Brunelleschi, one of the Italian artists who knew Modi well, for he recalled being at the party.

I don't know how many bottles were emptied. Sometime during the
evening some lunatic grabbed the cord of the kerosene lamp and
started pulling the thing up and down as you would a bucket in a well.
Modigliani accompanied this performance with "Go! Go!" and soon
had everyone in an uproar.

Then later on the cord broke, the lamp fell, and the kerosene spread over the wooden floor. "Hooray! Hooray!" shouted Modigliani, wild-eyed. The broken lamp must have started a fire. He smashed a chair and threw it on the flames. It was like a signal. Now all the furniture was smashed and added to the bonfire which followed.

Amedeo was like a crazy man, hoarsely shouting, "The flames go up! The flames go up!" If the firemen hadn't come, the whole building would have gone.

Do you know what he said the next day when I told him he was a criminal? "It's useless. I'll never get used to living like a bourgeois." [1]

Brunelleschi saw Modi at various stages of his career in Paris, from innocence through dissipation to miserable death, and felt he knew him well. Now he was seeing Rosalie in her little restaurant some twelve years after Modi's death and he was aware of Modigliani's ghost in the shabby little place. He remembered Modi as he had been as a young man when they attended the same art classes in Florence, so shy, well dressed, behaving like a kid out of school. He remembered him, newly arrived in Paris, visiting Brunelleschi in his first studio:

Then little by little, as he ran out of money he tried to find inspiration for his sick mind in wine and drugs. I saw him in rags staggering along the boulevards and the streets of Montparnasse, shouting and cursing, finally falling in a gutter and staying there lifeless.

Now Rosalie told him about the drawings Modi had given her. She liked Bouguereau's paintings. Modi's figures gave her a bellyache with their long twisted necks and their twisted mouths. His drawings made her feel sorry for Modi. She hid them in the cellar or flung them in a cupboard when he gave them to her. Brunelleschi hoped that Rosalie had retrieved them, because they were now worth thousands of francs apiece:

He left her notebooks stuffed with drawings that the poor old woman threw into the cellar, furious at never seeing a penny of his money. And sometimes, delayed by the warm wine, we lingered on and on at the bistro, talking by the light of a single candle. From time to time some big rats, sick of eating Modigliani's drawings, came upstairs and went toward the tiny kitchen, still holding pieces of the drawings in their jaws. [2]

Yes, it hurt Rosalie to be reminded again and again of the fortune she had thrown away.

"Santa Madonna!" she exclaimed to Brunelleschi. "Don't I know! The mice ate them all. Whoever thought that one day those scrawls could have made me rich! I should have guessed it, though. Now and then well-

dressed people came to ask about him and looked with interest at the pictures hanging on the walls. I thought they were crazy. One day two American gentlemen came looking for him. They wanted to see his paintings. I sent for him at his studio, but he wasn't there. An hour later they found him at the Café de la Rotonde as stewed as they make them. He'd had a row and was all torn and full of bruises. 'Come on! Come on!' his friends told him, 'the Americans are at Rosalie's, and they want to buy pictures.' But when they saw him in that state they left without a word."

The Russian novelist, poet, and critic Ilya Grigoryevich Ehrenburg knew Modi at this time. He had "never met another painter who lived poetry so deeply." Modi quoted Dante often, and Ehrenburg recalls the serene lines of the *Purgatorio* in which the poet and his companion, having climbed to a height, sit down and gaze quietly at the path behind them. Modi could also recite by heart verses of Villon, Leopardi, Rimbaud, and Baudelaire.

Ehrenburg recalls that Modi's favorite poem of Baudelaire was "The Albatross." It describes how sailors amuse themselves catching albatrosses, "the great sea-birds, that follow the ship slipping over the bitter deeps, like idle traveling companions." Caught and held out of its element, the bird is a pitiful object. *"Ce voyageur ailé, comme il est gauche et veule!"* (How clumsy and feeble this winged traveler is!) One sailor teases him with his pipe, while another mimics the cripple who once soared so boldly and beautifully. The poem concludes: "The Poet is like the prince of the clouds/ Haunting the storm and laughing at archers;/ Exiled on earth in the midst of catcalls/ His giant wings prevent him from walking." [3]

Modi undoubtedly identified himself with the albatross, so powerful and majestic in flight, so helpless and crippled as a captive on deck. Painting portraits and doing sculpture, Modi soared skyward, but in the everyday world he was as clumsy and feeble as the trapped albatross. Ehrenburg remembered some lines in his own *Poems About the Eves,* dated April, 1915, which went: "You sat on a low step, Modigliani, your cries were those of a stormy petrel. . . . Oily gleam of a lowered lamp, blueness of warm hair. Suddenly I heard the thunderous Dante's dark words roaring out, spilling over. . . ."

Ehrenburg felt that the legend of the hungry, perpetually drunken Modigliani, the last of the bohemians, was true and false. Modi drank and took hashish, "but not for love of debauchery nor longing for an 'artificial paradise.' " And he did not enjoy going hungry; he ate with a hearty appetite and never sought martyrdom. On the contrary, ". . . more than others, he was made for happiness." He loved "the sweet Italian language, the gentle landscape of Tuscany, the art of her old masters." Modi did not *begin* with hashish. If he had wanted to, Ehren-

burg feels sure that Modi could have painted portraits that would have pleased both critics and buyers from the start. In so doing he would have had money, a big, comfortable studio, and the recognition that followed easy success. But "always straight-forward and proud," Modi ". . . knew neither how to lie nor adapt himself."

Modi's good looks always struck Ehrenburg as purely Italian. He remembers seeing Modi on good days as well as bad. When he was calm, he was exceptionally courteous, his pale face clean-shaved with just a touch of coarseness about it, and his eyes gentle and friendly. And when Modi was frantic, black bristles sprouted all over his face and he screamed piercingly like a bird—"perhaps an albatross."

Modi told Ehrenburg the old story about his grandfather, who was a native of Rome and had wanted to grow grapes, and about how he had bought a small plot for the purpose, in defiance of the papal edict. He told him, too, how the Romans had once celebrated the carnival in the old days: "The Jewish community had been obliged to put up a Jewish runner who, stripped naked and to the yells and whistles of the merry crowd, including bishops, ambassadors, and ladies, had to run three times around the city." The story had moved Ehrenburg so much at the time that he wrote a poem about it. Modi felt the Jews had been the objects of cruel sport and that they still were.

When Ehrenburg and Modi were sitting in a café on the Boulevard Pasteur, there occurred an incident similar to the one at Spiehlmann's Restaurant in Montmartre during Modi's first years in Paris. Ehrenburg, unaware of anything unusual, was quietly copying some poems Modi had shown him. Suddenly Modi jumped to his feet and angrily faced the cardplayers at the adjoining table.

"Shut up!" he told them. "I'm a Jew and I could tell you a thing or two. Understand!"

The men bent over their game and did not reply. Modi put the money down for the check, and said in a loud voice, "A pity we came in here, for it's a place where swine go."

They went out of the café. Ehrenburg asked Modi what the cardplayers had said to offend him.

"Always the same old thing," said Modi scowling. "It's infuriating to be doing nothing but pushing a paintbrush about: their faces will need bashing for another three hundred years." [4]

In the endless round of arguments with artist friends, perhaps few of Modi's adversaries were so volatile or given to screaming so excitedly as the Mexican Diego Rivera. Rivera, two years younger than Modigliani, was a political as well as an artist rebel. He had studied at Mexico City's School of Fine Arts, where he choked on a forced feeding of Spanish

academicism. Finally, he reached the same decision as many other artists who had preceded him to Paris.

Diego Rivera managed to be conspicuous in Montparnasse without having to work at it. Lipchitz first thought of him as "a violent Indian with a big stomach," and then, more accurately, as "tenaciously dedicated, jocular, ebullient, expansive, and for all his ponderosity extraordinarily gay." [5] Modi, at least on his good days, might have been described in much the same way, except for his size. It is perhaps not surprising, therefore, that a warm friendship developed between the two. To be liked, to be accepted as a man and as a painter was an overwhelming experience for Rivera.

Again, like Modi, Rivera liked to drink and could put away a large amount of liquor. But he had neither the capacity of a Falstaff nor the wit to stop in time. Unlike Modi, excess made him neither combative nor ill. Drunk, he bumbled along in "a somnambulist trance during which he lost all consciousness of place or time." [6] He had the same eye for beauty and women as Modi did. At the moment he was keeping house with an artist named Angelina Beloff. He learned Russian from her, and soaked up Communist ideas from her and from other Russian friends as well. Called the "wild cowboy" for his extremist views, ". . . Rivera was ardent in his belief that social injustices could be rectified through Marxism," and ". . . insisted that the world powers would soon engage in conflict. . . ." [7]

Most artists argued political theories hotly, often superficially, but never with the vitriol, virulence, and thoroughness reserved for painting. Rivera basked in the friendship of Picasso, whom he regarded as the godhead of modern art, and of Apollinaire, who had hailed him in a poem as a blithe Mexican spirit. Not completely at home in France, which was a tame, flat country compared to Mexico, Rivera was committed to Cubism because it was so violent a reaction to academic painting.

Aside from the serious aspects of art, Rivera enjoyed the camaraderie, the shop talk, the side trips to Majorca and Spain, the gamy side of Parisian life. Rivera painted Cubist portraits of several artist friends and would undoubtedly have painted Modi if Modi had held still long enough. Restless and elusive, Modi lunged along the streets, jumped up and down in anger or delight, gestured and grimaced, came and went. It would have taken a Futurist to paint him.

There is probably only one portrait of Modi done from life, a sketch by André Derain which Modi later used to do a self-portrait. Modi, on the other hand, left a portrait of nearly every important artist of his time. Rivera is among them.

Rivera bubbled like lava. He was Falstaff; he was Gargantua, Pantagruel, Rabelais, too. He had some Shylock in him, and a dash of the

savage Indian. His head was an immense pumpkin on top of a balloon of a body. Modi could not distort Rivera's features in what was becoming his style—the flattening and lengthening of the head, the stretching and slabbing of the nose, the elongating of the neck. What he managed to accomplish with Rivera is proof of his ". . . versatility, of his psychological insight as a portrait painter and the adroitness with which he adapted his technique to the temperament of the model before him," Claude Roy has said. As he was to do with Max Jacob and Soutine and so many others, "In each case Modigliani renewed his palette and created an appropriate style." [8]

The portrait emerged with three colors predominating: orange-yellow for the background, light-blue for the face, and blue-black for the hair. The facial outline, the jolly slit-eyes, the small tight mouth with its thick sensual lips—the line was strong and sculptural. Rivera's mobile, wily features seem to jut out of the canvas, dominate it, make one forget his gross body as one did in life. The size of the man, his heartiness, his fire, strongly appealed to Modi. They enjoyed each other's company and charged at each other in their adopted tongue—Modi in his Italianate French with the exaggerated rolling "r's" and Rivera in his terrible Spanish-Mexican French.

The story goes that Rivera, while living off and on with Angelina Beloff, and perhaps to show his independence, accepted Modi's invitation to room with him, at least until his portrait was completed. Modi painted three portraits of Rivera and, as with Paul Alexandre, got closer to the core of his personality each time. It was not easy because, as Ramón Gómez de la Serna explained, Modi was ". . . obviously wrestling with the problem of getting . . . something of the reputed savagery, smoldering sensuous fire, fantastic imagination, and mighty irony Diego was famous for." [9] But it was more than that. ". . . Overriding all else, in everything he did, was a passionate interest in the human individual, in the mystery and meaning of a personality. He was not content simply to create a pattern of 'colors assembled in a certain order'; he created living beings, with the order or disorder that comes of individual temperaments inscribed in their faces." [10]

Lipchitz, Brancusi, and Léon Indenbaum [11] were neighbors in the Rue Montparnasse and, in the evenings, they met at Rivera's. Picasso came too. It was on one of these evenings that Modi started one of his paintings of Rivera. He did it on the floor. It was the period of red portraits outlined in black. There Diego stood, towering above Modi, as Modi painted him, looking up from the floor. Indenbaum thought Rivera looked like a sort of Arab sheik with his curly beard, round face, and heavy eyes.

Modigliani was drawing every day at this period in his life. A little

later, Paul Guillaume had Modi work for him. And after doing several portraits of Guillaume, Modi took to painting furiously. This was the period, too, when he sold himself by the day. Indenbaum recalls that Modi's asking price was a model, paints, twenty francs, and a liter of rum.

It was the late winter of 1914. Nina Hamnett, the young Englishwoman who had spent five exciting days in Paris two years earlier and helped Epstein strip the tarpaulin off his "indecent" Oscar Wilde Memorial in Père Lachaise Cemetery, had been in Paris only a few hours. She was just twenty-four; independent, high-spirited and free-thinking, inordinately proud of her body and infatuated with sex. A painter of some talent, she was determined to continue her studies in Paris. She had gone straight to Montparnasse where the artists lived and taken a room in the dingy Hotel de la Loire on the corner of the Boulevards Raspail and Montparnasse. "The bed was very short and had a feather mattress, the room looked on a courtyard and smelt horrible." [12]

Nina was a friendly sort, ever obliging, happy natured, naïvely uninhibited, perhaps even a little featherbrained in her charming way. She had a way of knowing everybody who was anybody then and in the years to come. After leaving her hotel she headed straight for Rosalie's on the Rue Campagne-Première, which her friend Jacob Epstein had recommended. Sitting alone at one of the small, marble-topped tables, she had just begun to eat:

> Suddenly the door opened and in came a man with a roll of newspaper under his arm. He wore a black hat and a corduroy suit. He had curly black hair and brown eyes and was very good looking. He came straight up to me and said, pointing to his chest, *"Je suis Modigliani, Juif,* Jew," unrolled his newspaper, and produced some drawings. He said, *"Cinq francs."* They were very curious and interesting, long heads with pupil-less eyes. I thought them very beautiful. Some were in red and blue chalk. I gave him five francs and chose one of a head in pencil. He sat down and we tried to understand each other and I said that I knew Epstein and we got on very well, although I could not understand much of what he said.

Nina then goes on to describe Modi as she saw him. She says that he drank a great deal of wine and absinthe when he could afford to buy it.

> Picasso and the really good artists thought him very talented and bought his works, but the majority of people in the Quarter thought of him only as a perfect nuisance and told me I was wasting my money. Whenever I had any money to spare I would buy one of his drawings.

Sometimes they would come down to three francs. Every morning he would come to the Rotonde with his drawings and he generally collected five francs before twelve o'clock. He was then quite happy and able to work and drink all day.[13]

The most significant word in this account, taken from Nina Hamnett's revealing, peculiarly written, name-dropping autobiography, *Laughing Torso,* is the word "happy." Of all the many people who knew Modigliani and wrote about him, Nina is one of the very few to apply the word to him. Undoubtedly she was conscious of happiness and good times because she was the product of a mean, repressed, and inhibited childhood.

Everyone was furious at her for having been born a girl. Her father, a domineering Army officer, packed her off to live with her grandmother, who found her an impertinent child, a self-starting hellion. Sent to a high-class academy for young ladies at Westgate-on-Sea, Nina promptly ran away. Later, she managed to suffer through her education at the Royal School in Bath, an exclusive school for officers' daughters. She wanted to paint, and finally got permission to attend the London School of Art.

London and art school were eye-opening experiences. She drew from nude models, though she had never dared look at her own body in the mirror. Now Nina had a good look. She was delighted at what she saw, considering herself superior to anything she had seen in life class. And so began Nina's long, passionate love affair with her body, the "laughing torso" of her reminiscences.

In London, Nina pecked away at art, got home late at night, and had to listen to her father scream about her virtue. Nina could hardly wait for her first sex experience. She would gladly have given herself, if asked, but no one asked.

She became friendly with the distinguished Walter Richard Sickert, the foremost British Impressionist, and gladly posed for an odd young man named Henri Gaudier-Brzeska. He was an expatriate French sculptor, poor and unknown, living in London with a forbidding Polish woman he introduced as his sister, really his mistress, Sophie Brzeska, whose name he had attached to his own. After finishing his preliminary sketches of Nina in the nude, Henri promptly stripped and insisted that she draw *him* in turn. Nina did; then they had tea. She helped steal a piece of marble from a stonemason's yard where tombstones were displayed, and from this he carved a torso of her, later to be produced on the jacket of *Laughing Torso* and, according to Nina, put on permanent exhibit in the Victoria and Albert Museum. (See photographs facing page 384.)

Nina "thought he was the most wonderful person I ever met." He gave

her sound advice. "Don't mind what people say to you. Find out what you have in yourself and do your best, that is the only hope in life." It was a philosophy that Nina was to follow religiously.

Still a virgin at twenty-two, Nina finally decided to hand herself over to the first man she met and liked. Luckily she chanced on "a most beautiful creature" with green eyes and hands like the Angel in the National Gallery's Filippino Lippi painting. The young man rented two rooms on Fitzroy Square and set up a 10:30 P.M. rendezvous. Nina was punctual, the beautiful creature blunt. "Will you take your clothes off?" he said. Nina, who had no trouble combining romance with a clinical approach, did not hesitate.

> So I did and the deed was done. I did not think very much of it, but the next morning I had a sense of spiritual freedom and that something important had been accomplished.

All her worries vanished once her virginal hysteria was out of the way. She was a free woman at last, finished with her family, who had always wanted her to be a lady "when a lady was the last thing I wanted to be." Nina had never liked women as well as men. Most females she despised as fools, gutless half-wits. Males were utterly different and superior and, with the outstanding exception of her own body, better and more efficiently made. Nina had felt that way since seeing statues of Venus, Hercules, and the Dancing Faun in the Antique Room of the London School of Art, where she had "had an irresistible desire to get a hammer and chip off the plaster fig leaves that seemed . . . ugly and silly." 14

Paris thronged with eager, fascinating men on whom Nina could generously bestow the great prize, her body, and she had an endless chain of males, men she was soon to pick up, adopt, and befriend like some benevolent animal lover gathering stray cats and homeless dogs from the street. It seems odd that Modi never took Nina to bed. She tries to make it clear that in all the time she knew him—seeing him daily until the outbreak of the war—nothing happened between them.

Perhaps it was because Modi was so intensely virile, accustomed to doing the choosing, the pursuing. Under her chirping conversational French, Modi must have sensed her willingness and her fear. Nina was an endearing and amusing young woman, tittering nervously over wine, shuddering and stiffening at the touch of Modi's hand on her knee yet unable to take it away and afraid of his overpowering maleness. After a session with a virtuoso like Modi, one can hardly imagine Nina saying ". . . I did not think much of it." But she was wary. Modi was the type of man she appreciated—beautiful, poor, proud, and princely. He seemed lonely and lost, and Nina felt she had the body that Modi would

cherish and admire. But Nina had to choose her partner and lay down the ground rules. She had the generous spirit of a heart-of-gold prostitute but a penchant for weak, passive good-for-nothings. She sensed Modi's great physical appeal, and resisted it. Nina did not seek, take, give, and enjoy: she offered herself as a precious gift. Sober and sweet, Modi was a delight, but with alcohol and hashish, he was nasty, capable of anything, perhaps even rape—although it is difficult to imagine Nina Hamnett being raped.

Modi must have asked her to his studio often, but Nina was careful to go only once, as she "was rather frightened of him." She repeated this to Douglas Goldring, and added, ". . . to tell the truth, his eccentricities of behaviour rather alarmed me, and there was never anything of a sentimental nature between us." [15]

Nina was the sentimental one; Modi was always uncontrollably and aggressively himself. Unwavering in his dedication to art, he was not seeking a pillar to lean on. Nor was he a bohemian waif, a confused or lost soul waiting to be adopted by Lady Bountiful who would confer her incomparable body on him. Modi liked fiery, voluptuous women, keen, intelligent women, beautiful and unusual women, but not laughing torsos. He wanted a La Quique or the Beatrice who probably did not exist.

Nina wrote that at the time she knew Modi, he did not paint, only drew and did sculpture. "He always regarded sculpture as his real métier, and it was probably only lack of money, the difficulty of obtaining materials, and the amount of time required to complete a work in stone that made him return to painting during the last five years of his life."

Nina visited him when he lived in the Boulevard Raspail in a small studio with a garden. He often worked outside and had nailed a watch to a tree so he could see the time. Modi kept odd hours. He would come home drunk at two or three in the morning, set to work on the stone, and ". . . the neighbours, hearing the tap, tap of his chisel, decided he was 'louftingue,'" cracked or crazy.

The afternoon Nina went around for her visit, Modi showed her his latest sculpture, "a long head with a very long nose that was broken." Modi told Nina that "un soir il a tombé et il a cassé son nez." Nina knew better. "What had really happened was that Modi came home feeling rather gay, bumped into it, and knocked it over. It is now in the Victoria and Albert Museum and its nose has been mended." Nina also tells of a hot, stifling evening when Modi, feeling no pain, stripped naked and stretched out to sleep in the flower bed by his studio:

In the early hours of the morning two cats had a love affair on the roof, and during the howling period, slipped and dropped down on his

naked body. He woke up with a scream and ran up the Boulevard Raspail into the arms of an astonished policeman.

Nina may have heard this amusing story somewhere, but inasmuch as it has never been told by anyone else, Nina must have seen him crash into the policeman or—all denials of a romantic attachment between them aside—she may very well have been lying next to him in the flower bed. Nina writes that Modi came to the Rotonde every night and sat beside her, implying that it was he who sought her out, when it was his long-established habit to touch base at the Rotonde every day. He drew all the time, says Nina, and she found it fascinating to watch him. When wine and absinthe got the best of him, he stopped drawing, put his head on her comforting shoulder, and went to sleep. Nina claims that she found this embarrassing ". . . and sat straight up feeling proud but rather foolish." She made no effort to leave.

She went to Van Dongen's studio, near the Boulevard St. Michel, on Thursday afternoons. Friends, critics, and hangers-on came to these salons. Negro boxers and other devotees of the sport sparred in a corner. Nina watched with interest. Van Dongen had arrived as a painter and was a great social success. Lipchitz was present at "his remarkable parties," but did not approve of them or of "inordinate carousing." Nina never passed moral judgment, enjoyed good times to the full, and always liked to participate if given the chance. "One day they asked me to dance, so I took off all my clothes and danced in a black veil. Everyone seemed pleased, as I was very well made."

She also met Zadkine and sat at a table with him at the Rotonde during the evenings. Zadkine drew, but, unlike Modi, he did ". . . still lifes in pen-and-ink of glasses, packets of cigarettes, and pipes, or anything else that was on the table." Saturday night was the big night. The Rotonde shut down at 2:00 A.M., after which Nina and her friends headed for the all-night spots on the Boulevard St. Michel. The Russian artist Marie Wassilieff, Zadkine, Modi, Nina, and some others wandered into a bar on the Boul' Mich', where

the atmosphere . . . was very different to that of the Rotonde. There were many painted ladies and dull students of the Sorbonne, and sometimes businessmen who bought everyone drinks. We drank cheap red wine, and talked and laughed and sang. Zadkine and Modigliani bought me a large bunch of roses; I had a marvelous time and at seven-thirty A.M. they accompanied me to my hotel."

After the Rotonde had closed, Modi used to chase her up the Boulevard Raspail, something a drunken man would hardly be capable of.

Modi knew who he was after. "He could always see me because of my loud stockings," Nina goes on. "One night he nearly caught me so I climbed up a lamp-post and waited at the top till he had gone." The image of Nina Hamnett perched on a lamppost, waiting for a hot-breathing Modi to go away, is hilarious. If he nearly caught her that time, it is difficult to believe that he could not have caught her any time he wished.

Modi's Italian friends never ceased to bemoan the changes Paris had made in him. Nina, on the other hand, had no trouble accepting and appreciating Modi as he was. She had the maturity and sophistication to take people as they were, not to wish them any different—a quality noticeably lacking in many more intelligent, even distinguished people.

Ardengo Soffici, who had known Modi in Venice in 1903, seen him occasionally in Paris, then lost sight of him, was sitting with friends on the terrace of the Café de Rotonde on a summer evening in June, 1914. As they talked, a man pushed through the crowd on the terrace, rushed to his table, grabbed both of Soffici's hands excitedly, and called him by name:

> . . . Only then did I recognize Modigliani. But what a change! Dressed most untidily, no tie, his neck bare, his hair rumpled, he was wild-eyed and feverish and looked possessed. His face, once so handsome and limpid, had become hard, tormented, violent; his gentle mouth was distorted in a bitter snarl and the words that came out of it were disconnected and full of sadness.
>
> Since he had come quite near me in his violent heartiness, I got the full impact of his breath reeking of cognac doctored with ether. He was in fact quite drunk, as he was practically every day as I was told afterward. When we separated after this painful exchange, we hadn't been able to talk about anything of significance such as our life, our ideas, our art. . . . It was our last meeting. . . .[16]

Soffici's impression of Modigliani is certainly different from Nina Hamnett's. She makes no mention of the Mr. Hyde in his face, and indeed never seems to have seen Modi sick or ailing.

While he seems to have sold his drawings regularly, Nina reports, there were times when there was no market for them. One day in 1914 Modi, in the company of his friend Sylvain Bonmarriage, entered the Café de la Source on the Boulevard St. Michel. Modi, it appears, hadn't eaten and had sought out Bonmarriage in an effort to "get by"—something Modi had an uncanny ability to do. Just then Bonmarriage saw a certain Madame Teischmann sitting at a table with her brother Arnold Held. The lady was rich, a great art collector, and given to following the advice of the critics on the *Revue Indépendant*. Bonmarriage made the neces-

sary introductions and "discreetly" informed her of Modi's present distress. Modi took out his portfolio of drawings. Madame seemed interested. Now Arnold Held offered Modi a five-hundred-franc note for the drawing the artist had shown his sister. Madame, a true collector, asked Modi to sign it. In a typical Modigliani gesture, ". . . the painter took a big crayon and put a gigantic signature across the five-hundred franc bill." [17]

This was an extraordinary amount for Modi to receive for one drawing. It was a dramatic exception to the usual five francs. And there were a few other bonanzas, such as the "six or seven times that an admirer bought a picture on a whim from Modigliani for 300, 500, or 1,000 francs." [18] Modi, in each case, "spent all the money" in one night, not on himself alone, of course, but on Ortiz, Foujita, Kisling, Soutine, and the rest of his friends. When Modi had it, which was rare, he invariably blew it, which was routine.

∽ ∽ ∽ Chapter Nineteen

*"I'm afraid I never quite realized the horrors of
Montparnasse. I was Minnie Pinnikin and thought
everyone lived in fairyland as I did."*

In the summer of 1914 Modi often dropped in at Marie Wassilieff's
art school in the Avenue du Maine where Nina was studying.
Sketching classes were held from five to seven in the afternoon.
Fernand Léger, an established Cubist, was the chief instructor. He tried
to take Modi in hand, but got out of patience with him: the blindly
stubborn Modi would not listen to reason.

Léger had his own individual art, but as professor of the Marie
Wassilieff academy he believed in steering his pupils in the right direc-
tion: the hapless Futurists aside, if you weren't a Cubist, all that re-
mained was to be a simple-minded primitive like the drunken Utrillo. As
many as forty or fifty people attended the sketching classes.

Modi usually sat on the floor, and drew. A long stairway led to the
workshop upstairs. When Modi was drunk, the students could hear him
stumble up the stairs. Nina adds: "If he was too far gone we would chase
him out. Sometimes he would make terrible noises and frighten the old
ladies in the class." [1] One suspects, from the last sentence, that Modi was
putting on an act, thoroughly enjoying his solo performance before a
captive audience. Nina also performed. She did her one-and-only smash
act as Modi and Zadkine drew her dancing naked.

Marie Wassilieff thought that attending sketch classes did Modi good.
All the women, except herself, loved Modi very much. At that time he
was doing sculpture, "and nothing was coming out of it." He began to
make drawings—he had been doing it all his life, of course—and Marie
told him to paint. *"Paint:* I will give you color and canvases." So, accord-
ing to Marie, he set to work in her studio and did portraits of Max
Jacob and Apollinaire. [2]

Marie undoubtedly helped Modigliani, as many others did, but hardly to the extent she believed. She was a kind, generous woman, but a willful eccentric who developed into a full-blown Montparnasse character. She was tiny, almost dwarfish, with a frightful wig, like a clown's, and wore high shoes of the kind Charles Perrault's Puss-in-Boots wore. She came to Paris from Russia, "beautiful as a madonna," with money of her own, and called herself an anarchist. She had not been in Paris long when she had an unusual experience. She was sitting on a park bench. A little old man came up to her and began to flirt. She visited his studio and saw his pictures. He played the violin for her. When he proposed to her one day, Marie was hardly flattered and turned him down. The man was Henri Rousseau, the Douanier, and "his breath was like the dead." [3]

Marie desperately wanted a soulmate, and looked for him on café terraces all over Montparnasse. She even made a pilgrimage to Lourdes, asking God to perform such a miracle. Marie finally found her man in the person of an Arab or a Hindu, who vanished, leaving her pregnant. This was during the war when Marie was running a canteen for artists. The meals were dirt-cheap, and even Lenin and Trotsky ate for fifty centimes. Because of them Marie was suspected of being a Mata Hari, and was arrested by the police. She was also thought to be Trotsky's mistress. Brought to court after her child was born, she made an impassioned speech vindicating herself. After the war she gave up art to produce a "shocking" ballet, which she had written. When the ballet was banned, Marie was so angry she left Paris, and retired.[4]

Bastille Day was celebrated with a riotous party that went on and on without stopping. Nina got a costume for the occasion. She bought "a pair of French workmen's peg-top trousers" on the Avenue du Maine and, from Modigliani, she "borrowed a blue jersey . . . corduroy coat . . . and a check cap." To complete the apache effect Nina bought a large, fake butcher knife "made of cardboard and silver paper at the Bon Marché." Then she got dressed, went out alone and, as luck would have it, ran into Modigliani at the corner of the Rue Delambre and the Boulevard de Montparnasse. Either her costume was convincing or Modi knew how to go along with a gag, for Nina says, "He did not recognize me and when I produced the knife he ran away." She went on to the Rotonde, where she fooled the waiters, then to a street fair outside the Closerie de Lilas. Back to the Rotonde again, "and we danced in the streets all night and kept it up for three days. Afterward everyone retired to bed for at least a day." [5]

Fancy-dress balls were given several times a month "in a big café in the Avenue du Maine"; the admittance fee was three francs, "and everyone went." Nina usually wore her apache costume, and acted the part well

because she was slight and small-busted. Modigliani does not seem to have worn any masquerade at these parties, possibly because he was already in costume. At any rate, a photograph of one of these occasions in Nina's book shows Modi dressed as usual. (See photograph facing page 384.) He did not like "funny" dress. He did like something wistful and romantic.

A self-portrait, dated 1915, shows him in Pierrot costume, with a long neck, frilly collar, and one eye sightless. The face is mottled and flecked with green. The expression is hardly clownish, but rather contained, tranquil, and sad. Over his signature Modigliani has written *Pierrot* in big letters across the chest. The portrait is now in a Copenhagen museum.

Marie Wassilieff gave an annul party in her workshop which Modi attended in 1914. Nina tells how they "collected" Modi and the American sculptor Wilhelm Hunt Diederich, "who had just had a great success at the *Salon des Indépendants* with his *Lévriers (Grayhounds)*." Hunt, who was dressed as an Arab, "brought a huge copper kettle from his studio which he filled with beer, and we made Modigliani carry it." Nina, the name-dropper, noted that "Guillaume Apollinaire was there."

> After a time Modigliani decided to undress. He wore a long red scarf round his waist like the French workmen. Everyone knew exactly when he was going to undress, as he usually attempted to after a certain hour. We seized him and tied up the red scarf and sat him down. Everyone danced and sang and enjoyed themselves till the morning.[6]

This matter-of-fact reaction to Modi's compulsive disrobing is certainly disarming. Nina and Modi had more in common than either realized: Nina's nude dancing was a form of high spirits and infatuation with her own figure; Modi's undressing was a pathological exhibitionism, the frantic business of attracting attention on impulse.

Modi could not have put into words why he stripped, if indeed he was aware of doing so, but Nina was honest enough to write, "I did not want to dance and only pranced about for fun and to be admired." Marie Wassilieff called her "Gothic," but that did not explain why she had to dance at a party Hunt Diederich gave for some Russians. Nina began in a veil to the music of balalaikas, then removed the veil. One of the guests, "a French millionaire," wanted her to dance in a cabaret. Nina refused. Hunt then "did a frieze round a lampshade" of her dancing, and "The millionaire consoled himself by buying it for a respectable sum of money. . . . About midnight a disturbance was heard outside accompanied by loud bangings on the door. This was Modigliani, who always appeared if he heard that I was dancing anywhere. Hunt threw him out. I was rather sorry as we could have sat him down in a corner."

The Diederichs, Nina wrote, were good friends of Modi's. That very evening they, with Modi, Marie Wassilieff, and herself, ate together at Rosalie's. Diederich's wife, Mariska, "was a Russian, [who] designed and herself carried out, very beautiful embroideries." The Diederichs bought Modi's drawings "and were very good for him." She also tells a story of Modi selling "a stone head for a hundred francs," about this time. This may be the head that John Russell says Edward Roworth, "another English enthusiast," bought from Modigliani in 1914 and which is now in the Tate Gallery.[7]

Nina fell in love with another beautiful young man whose portrait she had seen in the Salon d'Automne. It showed "a youth of about twenty with a pale face and slanting eyes, with his coat-collar turned up. He looked sad and hungry." Nina was so impressed that she stood before the portrait for a long time. To top it off:

> That night at the Rotonde he walked in. He did not seem to know anybody. For months I stared at him and when Modigliani slept on my shoulder I looked over his curly head at the young man's pale face. He fascinated me and disturbed my thoughts. I worked in the mornings at Wassilieff's and visited Museums in the afternoons. I drank *café crème* at the Rotonde. Life was so exciting I had no time to drink. Sometimes if anyone was rich we drank champagne at fifty centimes a glass.[8]

Life was indeed full and exciting for Nina. One of the most celebrated incidents of the early summer was the duel Kisling fought with a man named Gottlieb. Nina says only that Kisling had a dispute with Gottlieb, a duel was arranged, and Diego Rivera was one of the seconds. Standing in the early dawn in the Parc des Princes, at the far end of the Bois de Boulogne, the two went at it before the lens of an enterprising movie cameramen. The sabers were dull, clumsy, and much safer than pistols. Little damage was done, but honor was assauged as sabers swished and blood was let.

Kisling sustained a trifling cut on the nose. It was said that plaster was applied very carefully over the cut in order not to hide the dried blood. Patched and wounded, Kisling made a triumphal entrance at the Rotonde. There to hail and congratulate him, among others, was Modi, who is supposed to have said, "It seems only natural for Poland to be partitioned for a fourth time." Crespelle says, however, that it was Kisling himself who cried, "Fourth partition of Poland!" just after he was nicked and the hostilities declared at an end.[9]

Motion pictures of the duel, which were shown the next night, proved it had not been a fake, kept the gossips happy, and helped perpetuate a legend. For Kisling it was an amusing experience. The celebration went

on all day and late into the night in the back room of the Rotonde. Nina saw Kisling every evening at the Rotonde with the rest of the crowd. She observed that "He wore his hair with a fringe . . ." and ". . . was thin and very good looking." Kisling was also a close, understanding friend of Modi's who let Modi stay at his studio and use his art materials, as he pleased.

Like Jacob Epstein, Nina joined Modi and others who went to the Gaîté Montparnasse on the Rue de la Gaîté, "a music hall rather like the 'Old Bedford.' " It was a weekly affair. They paid fifty centimes apiece for gallery seats and, one night, twelve of them "sat in a row on a very narrow and hard plank. Modigliani sat on the end and pushed and pushed. We all pushed together and he fell off the end, so in disgust he left us and went to the bar." As to the show, "There were very funny and very vulgar revues with the usual bedroom scenes and simple-minded jokes that made the French workpeople roar with laughter."

Modi, by this time, was a well-known troublemaker, a mean, combative drunk avoided by his friends, a fellow no taxi driver would open his door to, a surly character barred from the subway by the wary Métro guards. Yet Nina Hamnett seems to have been able to take him with exceptional equanimity. Nina had been confused, unhappy, and lonely; she was soon to know about pain, hangovers, failure, lack of money and recognition. Perhaps it is not surprising that she came to have a clearer, more honest, and less lurid vision of Modigliani than many of his cronies. For an artist who neglected her talent and frittered away her time on friends, liquor, parties, and enjoyment, for a lighthearted woman who died at sixty-six, poor, almost unknown, unproductive, and an alcoholic, Nina has left an astonishingly accurate picture of the true Modigliani, unvarnished by legend and untainted by romantic fiction:

> Owing to the fact that he had T.B. and also drank a lot, and there-fore had hangovers, I expect Modi had some pretty miserable moments. But during the time when I knew him there were certainly "bright in-tervals" in his life and many periods when he seemed as happy as the rest of us. For this reason I cannot help thinking that some of the ac-counts given of his uniformly tragic existence are rather exaggerated. A man may live quietly for months without anyone noticing it; but if he then breaks out and gets roaring drunk, as of course Modi often did, then everyone remembers it and records it. Non-recognition of his genius by the dealers and the connoisseurs probably afflicted him more deeply than lack of money. . . .[10]

Both Douglas Goldring and Charles Beadle, who together were the "Charles Douglas" of *Artist Quarter,* were aware, like Nina, of how the legend outstripped the artist:

. . . But we must not get the picture out of focus. No doubt there were weeks, perhaps months, during which Modi jogged along fairly quietly, doing portraits of his friends—who of the Montparnos wasn't sketched by Modi some time or other, in those days?—dining with Kisling or Carco, and leading a comparatively normal Montparnasse existence. But when he got money from home, or by the sale of a picture, he usually celebrated the occasion by being drunk or drugged for several days together. During the inevitable hangovers he must many times have reflected bitterly on his brave words on leaving his mother: *"Tu verras, maman, moi, je te donnerai plus que les autres!"* [11]

That summer, presumably in the middle of July, 1914, Modigliani met Beatrice Hastings, the extraordinary woman to whom he was attached for two frenzied years and who was to exert such an influence on his art, his thoughts, and his life. The facts surrounding the first meeting of this mismatched pair are confusing. Ossip Zadkine insists that he introduced them:

"Yes, I was the one who introduced Beatrice Hastings to Modigliani." Memories came alive in the peaceful studio . . . Beatrice Hastings, a tall Englishwoman pliant as a Sienese primitive . . . , the drugtaking, the many whiskies drunk at the Rotonde and the Dôme . . . , the terrible arguments with the drunkard, the blows: Modigliani saying "There's the Englishwoman swilling the stuff again!" . . .
"Yes, I introduced Beatrice Hastings to Modigliani," says Zadkine again. And he evokes the evening when, seated with Beatrice at the Rotonde, he saw Modigliani coming toward them. The latter immediately desired the poetess and began his rough siege. Discreet, Zadkine left them to themselves. . . ! [12]

In contradiction to Zadkine, who always thought well of the English poetess, as she is always called, there is Nina Hamnett's calm, straightforward account.

Friendly, vivacious, Nina Hamnett's version may not be wholly accurate; but she had no reason to distort it. She knew so little about her new friend, only that Beatrice was intelligent and fun. She writes about her with generous admiration:

One day Beatrice Hastings came to Paris. She had been a great friend of Katherine Mansfield's and was a very talented writer. She edited the *New Age* with Orage. It was about the most interesting and well-written paper in London before the war. She had an introduction to me. She was very amusing. I introduced her to Modigliani and we all spent the evening together at the Rotonde. They drank absinthe, as Beatrice had some money. They gave me one too, and I felt very dar-

ing, as I had never tasted it. After my first sip, which I thought horrible, and reminded me of cough drops, Hunt Diederich appeared and threw the rest into the umbrella stand. I sat with Beatrice and Modigliani in the evenings, and one evening the young man with the pale face came in. I said to Beatrice, "I think that young man looks very interesting and I should like to meet him." To my embarrassment she darted over to him and brought him across. He seemed very shy and did not say very much. Zadkine came in later and asked us all back to his studio. Beatrice, I, and the young man went along. The young man and I sat on the roof among the chimney pots until the morning. I thought him very interesting and romantic. . . . I was by this time desperately in love with him.[13]

Nina finally did marry the pale young man she had yearned over for months. His name was Edgar, and they were temperamentally unsuited for each other and for marriage. They lived together briefly and stormily.

Beatrice had, in fact, been in Paris since May, perhaps earlier. She was living near Katherine Mansfield. She refutes Nina's account in a letter to Douglas Goldring, who hoped to interview her to gather material on Modigliani for *Artist Quarter*. The letter is dated September 17, 1936:

. . . I am not so severe as once on people who write simply for money, and I certainly don't think there is anything sacrosanct about Modigliani, but why I should hand over to anyone else what I could say myself if I wanted to beats me. I haven't read any "lives" of him by anyone, but I glanced through a page Lahr showed me in Nina's collection. She is all wrong about my meeting with M. She did not introduce us, nor do I remember being with her in the café at that date. I don't say she wasn't there, once or twice when I was there with M. Everyone was there, more or less, but M. and I had met before I ever saw Nina, and we did not meet in the Rotonde for the first time. I tell the story in "Minnie Pinnikin," an unpublished book that I can't be bothered about with Musso and Hitler preparing to shake hands and bust up Europe. . . . I should like to help you but I don't see how. This letter is all buts and ifs. You see no one can deal with Modigliani but me, Max Jacob and Picasso. He is a complicated subject. . . . The devil himself could not have tempted M. to sit on an office stool. Do you realize that you are dealing with the "bohemian" pur sang? And a medium into the bargain. If you come my way some day, I will dictate you something. What a book there is to be written of that period!

Is Nina Hamnett as mischievous as ever? Tell her that I have forgiven her some since I realized that she was often half starved. I'm afraid I never quite realized the horrors of Montparnasse, I was Minnie Pinnikin and thought everyone lived in a fairyland as I did. I am in a fairyland now playing (that is doing only what I like) all day long

with now and again a suddenly ghastly glimpse of a world going mad. But it wouldn't listen to me anyway.[14]

In another letter, Beatrice agreed to an authorized interview, but stipulated that she must see the proofs of the book. The chapter "The English Poetess" in *Artist Quarter* is so discreet and flattering that one believes that Beatrice did in fact approve it, whether or not she supplied any material. She is not mentioned by name; she is credited with having helped Modi and encouraged him in his work. It contains these sentences:

. . . The story of their relations with one another can be told only by herself. Perhaps, one day, she will write her memoirs, and then we shall know more about Modigliani's real character than anyone else has so far been able to reveal.[15]

But "Minnie Pinnikin," the book in which Beatrice reveals the story of Modigliani and herself, remains unpublished and is presumed lost or destroyed. Beatrice herself and her poems, novels, and other works are also forgotten, lost in the yellowing files of *The New Age* in libraries. Beatrice lives on only because of her liaison with Modigliani, who immortalized her in many drawings and oil portraits. How it would pain Beatrice Hastings to be remembered only because of a man!

It is possible that Beatrice may have been primed about Modigliani before coming over to Paris. The following "Anecdote" is from *Paris-Montparnasse:*

One day in London a friend of Modigliani, an American sculptor, [this must be Jacob Epstein] met an English society woman, a cultured writer who was at loose ends.

Over there in Paris, Modigliani needed help and protection. "Go to Paris, Mrs. H . . ." said he. "In Paris there is a painter who is a beautiful man and a genius." Mrs. H . . . arrived without a word of warning and, coming to Montparnasse, saw an excited blue devil doing Negro dances on one of the tables of the Rotonde.

"Modigliani!" she cried.

He jumped to the ground. . . . They left arm in arm.[16]

Most baffling of all, however, is an alleged statement about Modigliani and his art by Beatrice—source, occasion, and date unknown—which has been handed down through the years in French, English, and American books. As one comes to know this devious and complex woman, there is no doubt of the authenticity of the language. It reads like part of an in-

terview, a tart, succinct reply to a leading question: "Now what about this Modigliani? What was he *really* like?"

A complex character. A pig and a pearl. Met in 1914 at a *crémerie*. I sat opposite him. Hashish and brandy. Not at all impressed. Didn't know who he was. He looked ugly, ferocious, greedy. Met again at the Café Rotonde. He was shaved and charming. Raised his cap with a pretty gesture, blushed to his eyes, and asked me to come see his work. Always a book in his pocket. Lautréamont's *Maldoror*. First oil painting was of Kisling. Despised everyone but Picasso and Max Jacob. Never did any good work under drug.[17]

Beatrice Hastings spent all her troubled life manipulating words, ideas, and people. Here she was making good use of a favorite weapon, the cold, clipped half-truth.

It was easy enough for writers and painters to meet in Montparnasse, and it was characteristic of Beatrice to credit herself with having made a conquest. As a writer and an editor of *The New Age,* Beatrice was already well known in English literary circles. She had been successful in concealing the details of her past. Although not born Hastings, she never revealed her maiden name to anyone. She was equally secretive about her age. She passed for younger than she was, and nature amiably assisted her in the deception. If the age on her death certificate is correct, she was sixty-four in 1943, making her birth date 1879, and Beatrice five years older than Modi.

Beatrice was a South African, not from Cape Town as has generally been thought, but from Port Elizabeth, where her father, John Walker Haigh, a native of Huddersfield, had a produce business.[18] He married and raised a family of three sons and four daughters, of whom Emily Alice Beatrice was the fifth in line. Beatrice's father was a member of the prosperous middle class, a good, prolific family man, and a quiet pillar of the community.

Beatrice was surely a misfit in so respectable and well-to-do a family. Always willful and nonconforming, she apparently kept to herself, writing, thinking, and doing much as she pleased in her adolescent years. Expected to obey her elders unquestioningly, she must have been as headstrong and troublesome as La Quique growing up in Marseille. One can imagine her the terror of her family, plunging from one sticky situation to the next, both in Port Elizabeth and later in more sophisticated Cape Town, where she apparently married a "boxer" named Hastings. He may have been Alexander Hastings, a blacksmith, who lived in Salt River, a tough suburb of Cape Town. As there is no record of any boxer named Hastings in Cape Town around this period, her husband's profes-

sion may well have been one of the many canards with which Beatrice studded her life.

Considering her family, Beatrice's hasty marriage to a lower-class "pugilist" could only have scandalized the Haighs. (She may even have been pregnant at the time. Beatrice looked on childbirth with loathing and became an expert on abortion.) It is likely that her parents wanted her to leave, and since she had often dreamed of returning to the land of her fathers to make her literary mark, Beatrice must have been delighted to oblige.

Later on, Beatrice told a few intimate friends in London that she made sure she would have a permanent income while abroad. One of her brothers was editor of a Cape Town newspaper, eminently proper and fearful of scenes. It was no trick at all, said Beatrice, to make him guarantee her an allowance of about ten pounds a week. If she ran short of cash, she intended to blackmail her brother into sending more by threatening to turn up in person at his Cape Town office. She boasted that she had told her brother that no matter how badly in need of money she was, she would always keep enough in reserve to be able to carry out her threat.

Once again Beatrice mixed outright lies with half-truths. Sixty-odd years ago Cape Town had a population of 100,000 and seven newspapers, none of which listed a Haigh as editor. The truth seems to be that it was the family who provided Beatrice with her allowance. Since she never returned to South Africa, the terms may have been contingent on her staying away permanently.

Beatrice may have gone to England by way of the United States, for she gives some trenchant observations of New York in her "Pages from an Unpublished Novel" in issues of *The New Age*. South America may also have figured in her past. Beatrice wrote that her favorite brother, a military man, soon joined her in England. She regarded him as a hero, but was careful not to identify him by name, although she did say that he was the author of a superior novel called *An Ethiopian Saga*.[19] (The New York Public Library has a copy of *An Ethiopian Saga* by Richmond Haigh published by Henry Holt of New York in 1919. It is a short novel of African native life written in pseudobiblical style. Parts of the book originally appeared in *The New Age*, and it is dedicated "To Beatrice and H. E. H.") Beyond this, intensive research in Cape Town has turned up no further details about Beatrice's "hero" brother or about a newspaper editor-brother. Apart from being fanatically loyal to her favorites of the moment, the lasting impression of Beatrice is that she was a skilled and artistic liar.

At some point after her arrival in England, Beatrice must have divorced Hastings, if she had not already done so before leaving South

Africa. She always kept the surname Hastings, however, even though she seems to have married for a second time in England. Her death certificate lists her as "Beatrice Thomson otherwise Beatrice Hastings . . . Literary Authoress believed widow of Lachie Thomson. A pugilist." Exactly when Beatrice married Thomson is not known, but it seems that she never lost her fondness for boxers. One would guess that she arrived in England some time in 1905 (the year before Modigliani came to Paris), although it might have been earlier. Then twenty-six, she looked around London briefly before going on to stay near or with relatives at Leeds in York-shire, not too far from her father's native Huddersfield.

Beatrice claimed to have visited London in 1906 to attend a theosophi-cal lecture, and there, after looking at him across the crowded hall, she managed to meet Alfred Richard Orage, the brilliant young editor of the controversial Fabian weekly *The New Age*. Determinedly clever at cover-ing her tracks, Beatrice's word cannot be taken seriously, especially since it is known that Orage lived in Leeds from 1893 to early in 1906. It seems likely that they knew each other before this "climactic" meeting in London. Orage had been teaching school in Leeds and writing on philos-ophy on the side; he had become interested in theosophy and was soon in demand as an expert lecturer on the subject. Besides being worried about his career, his marriage was also breaking up.

Already an admirer of Beatrice's intelligence and a warm friend, Orage left Leeds for London in 1906 when he was thirty-three. In the spring of 1907, he was named editor of *The New Age*. Beatrice had been anxious to get into literary work. It would now seem that she joined Orage in London as mistress and editorial right arm. She lived with Orage on and off during a stormy seven years. She broke with him and *The New Age* in 1914.

Philosophy, literature, social causes, and the occult attracted Beatrice and Orage to each other. But when Beatrice dropped everything and fled to Paris it was because ". . . their domestic affairs became intolera-ble." [20]

Gorham Munson, the American critic, calls Orage "a great editor and great teacher of writers." While on a visit to the United States, Orage once said, "I write writers" [21] *The New Age* had the reputation of being the liveliest intellectual weekly in London. It published contributions from such distinguished writers as George Bernard Shaw, G. K. Chester-ton, Hilaire Belloc, Havelock Ellis, and Arnold Bennett. It first pub-lished Ezra Pound's verse, according to Beatrice, and was first to see merit in such different writers as Katherine Mansfield, William McFee, Van Wyck Brooks, Henry Miller, Richard Aldington, and others. Later *The New Age* printed articles on Picasso, reproductions of Cubist paintings, and published Marinetti's *Futurist Manifesto* in full.

At the time Beatrice had Socialist sympathies: she believed that women should have the vote (although she became militantly antisuffragist as well as antifeminist); then and later, she proudly proclaimed herself "crusading and anti-philistine." Beatrice started off on the paper with an article that "outraged both men and women, feminists and anti-feminists, and led to heated correspondence." Her piece was "a lurid plea for State protection for women from the horrors of giving birth," the type of thing Philip A. Mairet says was "a typical example of her pugnacity." Beatrice claimed "for women a sort of military glory in the fatal field of parturition," and scandalized *New Age* readers by "conveying a sinister implication that children are mostly an iniquitous imposition by men upon women and that childbearing is a gross infirmity of the weaker sort of women." [22]

During her tenure she contributed forty-eight poems under her own name, and thought highly of them. Poet, critic, novelist, essayist, and literary what-have-you, Beatrice wrote a stream of articles under such arch pseudonyms as Beatrice Tina, Alice Morning, and D. Triformis. Her mordant style, venom, slashing wit and invective did indeed give *The New Age* a sophisticated edge it had hitherto lacked. These qualities also engendered hate, jealousy, and revenge, which did not bother Beatrice. There was never any doubt in her mind that *she* was *The New Age*. Her talents impressed many people.

> . . . She was the one woman who held her place for years amongst the regular writers of the paper and she did it by sheer force of character and volume of production. Her verse, derivative, as most of it is, is of great variety and facility, and her critical articles disclose a mind which, if lacking in balance, is of the widest range and reading. She became much more than a contributor. For a long time she was a strong—perhaps often determining—influence in conducting the literary side of the paper; for she worked in the closest collaboration with the editor.[23]

When Katherine Mansfield, fresh from New Zealand, brought her stories to *The New Age,* Orage was "delighted with the stories." But Beatrice maintained that it was her understanding of the New Zealand girl's talent and her unstinting praise that induced Orage to publish them.[24] Twenty-two in 1910, Katherine was small, fragile, high-spirited, animated, and unquestionably gifted, though not sure of her gifts. She was also as sensitive, shy, and uneasy as a thoroughbred. Although she was nine years younger than Beatrice, the two women greatly resembled each other.

They became close friends. Katherine looked on Beatrice as her social, moral, and literary mentor. Beatrice, quick, sure, confident about every-

thing, began to dominate Katherine's life, her personal affairs, and her work. Always nervous and hesitant—she even spoke in an uncertain voice—Katherine blossomed under Beatrice's hypnotic influence. It soon showed in her writing.

Katherine was in Beatrice's power when she wrote her short story *At Lehmann's*, "a crude protest of the horrors of childbirth—a diatribe against" what Katherine condemned as "the ugliest fact in human life." [25] Beatrice had successfully infected Katherine with her feelings toward men, their criminal domination over women, and the diabolical trap of childbirth. The victim of an early, unhappy marriage, Katherine was ripe for Beatrice's daring, sophisticated philosophy. Yet, all the same, she had yearned—and would always—for a child of her own. She had already been pregnant in 1908–1909, but not by her husband, and had had a miscarriage. Now, while working for *The New Age*, she became pregnant again by another man whose name is not known. Katherine was forced to have an abortion.

Beatrice made all the arrangements. The incident could only have left Katherine more than ever dependent on Beatrice. In late 1911 Katherine began to shake loose from Beatrice when she met John Middleton Murry, writer, critic, and co-founder of a little progressive literary magazine called *Rhythm*. Murry, who was ultimately to marry Katherine, was far different from any other man Katherine had ever known. A brilliant intellectual, Murry was a gentle, understanding man, and he loved her.

Beatrice fought Katherine's attachment to Murry in every way she could think of. One can imagine the vicious scenes and bitter letters that followed Katherine when she finally left *The New Age* to live with Murry and write for *Rhythm*, "a cackle of witch's laughter pursuing them from Cursitor Street." [26]

The disagreeable business with Katherine was a prelude to Beatrice's inevitable break with Orage. Beatrice did not like being possessed, especially by one man. Gorham Munson recalled an occasion when Robert Frost spoke to him about Beatrice in Munson's house sometime in 1929 or 1930:

> Frost told of an evening at T. E. Hulme's flat in, I suppose, 1913. I suppose Pound took him there. Orage was in the group but Frost, the country man from New Hampshire, was more impressed by Orage's mistress, Beatrice Hastings. I believe she talked anti-feminism and declared that she had notches on her bed for every man who had slept with her. This talley of men impressed Frost no end.[27]

No wonder then that, early in 1914, in the witch's lair on Cursitor Street, the domestic life of Beatrice and Orage shattered. Beatrice

later explained that in May, 1914, she left London for a few months, confident that Orage would beg her to come back. But the war broke out; Beatrice thought she was valuable as a Paris correspondent, and stayed on for two years, sending her weekly "Impressions of Paris" and other articles to *The New Age*. Her memory seems to have been faulty, for the files of the paper show that the first "Impressions of Paris," signed with the well-known pseudonym Alice Morning, appeared in the April 29, 1914, issue of *The New Age*. Beatrice must have arrived in Paris in April and, if she did not meet Modigliani until July, she spent three profitable months in Montparnasse looking around, getting to know people as she awaited the hurry-home call from Orage.

That she had heard all about Modi, long before they were introduced either by Nina Hamnett or Ossip Zadkine, is certain. The war and a chance to report on it gave her a marvelous excuse to stay on in Paris. It meant novelty, excitement, and a new future. Orage could hardly deny the importance of having a member of *The New Age* staff in Paris. It was good for Beatrice's literary reputation, and valuable experience for her as a writer. But Modigliani was another important reason why Beatrice stayed in Paris.

Beatrice had never seen as vitally handsome a man as Modigliani. What a change, what a welcome difference from the tame creatures she'd known in London—the limp, impotent windbags like Orage and that literary fribble of Katherine's, the calf-eyed, soft-shelled Murry. Modi drank. He doped. But he had a brain, good manners, the soul of a poet, the charm of all Italians, and an infinite capacity for making love.

And Beatrice may have discerned the genius in him. Beatrice knew how to unearth talent once she had tapped it. She'd done it with Ezra Pound and Katherine Mansfield, among others.

~ ~ ~ Chapter Twenty

*"I look like the best type of Virgin Mary without
worldly accessories, as it were."*

It was Bismarck, discarded and discredited by the militant Kaiser
William II, who was supposed to have predicted that "Some
damned foolish thing in the Balkans" would furnish the fuse to
ignite the next great war. Exactly that occurred on June 28, 1914, when a
Serbian nationalist shot Archduke Francis Ferdinand, heir to the throne
of Francis Joseph of Austria-Hungary, at Sarajevo, but hardly anyone
recognized it as such.

The Continent was blissfully at peace. People were enjoying them-
selves. Europe drowsed in a comforting bath of permanent security, alli-
ances, prosperity, and good living. The modern age was here at last.
Progress was everywhere. Electricity was lighting up the darkness; air-
planes and automobiles had captured the public imagination. The world
seemed better, safer, and more peaceful than ever before. Life, particu-
larly in Paris, was gay and hectic.

And so it remained even into August after France had belatedly mobi-
lized and her armies were confidently massed to meet the onrushing
Germans, finally to be revenged for the humiliation of 1870. The change
in Paris was gradual, yet it was sudden, too. The slow awakening from
delightful dreams and then the bucket of ice water in the face: the
Boches invading France! Belgium was crumbling; the army was retreat-
ing; the Huns were at the gates of Paris! *"Aux armes les citoyens!"*

The rumors, the stories drifting back from the front were hardly worse
than the facts. For Frenchmen, their duty was clear; for foreigners—
strange how all the Germans in Paris, the painters, writers, poets, even
the art dealers had vanished nearly a month ago after the Bastille Day
celebrations—their allegiance was immediately suspect. They had to

register, get special papers from the police, or run back home to safety, in case Paris was overrun.

Nina Hamnett had been painting, enjoying herself extravagantly, and living with her pale young Edgar with whom she was "desperately in love." Nina was like so many others when war broke out. "I knew nothing whatever about politics or the European situation and it did not worry me at all." But the bad news soon overwhelmed her. Eating alone in a small restaurant in the Avenue du Maine, she "was suddenly seized with an indescribable feeling of horror. I turned cold and sick and laid down my knife and fork to stare at the blank wall opposite, unable to eat. I thought that something terrible was about to happen and imagined that it would take the form of a punishment for me having had such a good time." [1]

The artists of Montparnasse were as patriotic as the next bourgeois, if less noisy about it. Art was meaningless in war; artists were useless. As the mobilization notices were posted, year by year, class by class, they became disgusted and then resigned. In the interval before leaving for the ranks, the parties grew wilder. There came a time when every writer, poet, painter, and musician got drunk and stayed drunk. After an orgy of wrenching farewells, Montparnasse was drained of its manhood. The cafés were abandoned. The Rotonde and the Dôme yawned emptily. On the terraces now, drinking, talking, and sketching, were the rejected and the unfit, sullen, apologetic, and pathetic. There were the German-oriented neutrals who enjoyed seeing the proud French get their licks, and said so openly; there were also the bemused foreign artists—Picasso, Gris, Zadkine (who enlisted later on), Archipenko, Foujita, Soutine, Kremegne, Kikoine, Lipchitz, de Zarate, Modigliani, and others.

The rest had gone to war, including some foreigners like Kisling, who didn't have to go but enlisted in the Foreign Legion, and Apollinaire, who went into the artillery. Picasso's set was shattered forever, his circle sundered. He had spent a happy summer holiday at Avignon with Braque and Derain, all three experimenting together, replacing Cubism's pale colors with bright, clean ones. Now it was over, but no one knew how finally and irrevocably, though Picasso sensed it. Recalling that tragic, tumultuous period, he said, "When the mobilization started I sent Braque and Derain to the station. I have never seen them since." [2]

This was not literally true. Both men served with distinction (Braque was seriously wounded), survived the war, and Picasso *did* see them again. But they were not the same; neither was he, nor art, nor the times.

Modigliani, proud, aristocratic, and romantic, would have joined his artist comrades in battle if he had not been held back by his Socialist beliefs and, if those would be overcome, by his physical condition. Of Modi's good friends there remained Ortiz de Zarate (who tried to enlist,

but was turned down for a minor heart condition), Max Jacob, Soutine, Foujita, Lipchitz, Brancusi, Rivera, and Maurice Utrillo. Two of Modi's good friends left Paris: Amedeo de Suza Cardoso to go home to Portugal in response to his parents' plea, and Dr. Paul Alexandre to serve in the army medical service.

Margherita Modigliani said in her short biographical account of her brother: "At the time of the declaration of war we wanted him to come home. Emanuele wanted him home, but he contributed to his support. But Modigliani persuaded his relatives that he could only live in Paris. . . ." [3]

Ilya Ehrenburg writes that Modigliani's brother, then a Socialist member of parliament, arrived in Paris at the end of 1914 on political business, and saw Modi. "It is said he [Emanuele] was greatly upset to see his brother in a distracted state and put it down to bad companions and to the Rotonde in general." [4]

Emanuele had seen his brother looking much worse when Modi had returned to Leghorn the year before. He had also heard reports on his condition from mutual friends. Modi's state was certainly no surprise to Emanuele.

The war brought curfews, rationing, and the usual inconveniences. Bars were shut down, liquor banned, German-owned stores broken into by vigilante groups. Writing "Impressions of Paris" as Alice Morning in the August 13, 1914, *New Age,* Beatrice Hastings told how all cafés closed at 8:00 P.M. and only men walked abroad at night. In the August 27 issue, she wrote that absinthe was outlawed. Now Modi and Beatrice drank brandy and whiskey.

Nina Hamnett said that foreigners were given two weeks to get the proper papers and register with the police. Nina did so, but, although she implored him to, her man Edgar refused, apparently thinking "that he was superior to the police force." Everybody seemed to run out of money. Paper was refused; only gold and silver were accepted. Nina ate at Marie Wassilieff's canteen every evening along with Modi and other artists. When the two-week registration period was up, the police appeared at the studio Nina was sharing with Edgar and arrested him. Edgar had a German last name and was believed to be a spy. He was kept in jail, and Nina, not knowing how long he would be held, left for Dieppe and eventually England, much against her will.

Nina had been told the war would be over in two months. The attacking German forces believed this; so did the defending French. But as the Boches overwhelmed one strongpoint after another, the French Army retreated until it seemed that Paris itself was in danger. As the government weighed whether to evacuate the city, and clamped down on news, the public finally realized that the army was not invinci-

ble after all. The main streets and boulevards of Paris were clear of traffic. The newspapers suspended publication, and crowds gathered about the news kiosks, peering anxiously at the brief single-page hand-outs tacked on the walls.

Throughout the ordeal, the summer weather was superb. Paris reigned as always, the queen of cities at her radiant best under blue skies and a beneficent sun. Fountains sparkled and shimmered in the squares; the air was like crystal. The tourists were gone; the big hotels were like empty barns. The streets were ominously quiet except for such strange sights as flocks of sheep being shepherded across the Place de la Concorde toward the freight yards of the Gare de l'Est as meat for the troops.

On August 29, as in a Futurist painting brought to life, Paris was bombed from the air for the first time. The same plane scattered leaflets announcing that the Germans were at the gates of Paris as in 1870, and warned, "There is nothing to do but surrender."

Paris was blacked out for the first time that night. Now the calls of air raid wardens and police, *"Garde à vous!"* became as familiar as the whine of engines overhead. The Germans sent a plane or two over Paris every day around six o'clock in the evening, a time when most Frenchmen were enjoying an apéritif and thinking about dinner. A whole city braced itself for the spectacle of a bombing.[5]

It was in this atmosphere that Modi's liaison with Beatrice began. He lived with her in her studio in the Rue de Montparnasse and later in Montmartre. As with his other mistresses, Modi did many paintings and drawings of her.

Modigliani is supposed to have abandoned sculpture for good and taken up painting again as soon as the liaison with Beatrice Hastings began. Beatrice is generally given credit for Modi's return to painting, and she may have encouraged him in this, but many other factors influenced his decision. For one thing, good stone was more difficult than ever to obtain. Modi had very little money, his stamina was waning, and carving in stone still brought on coughing spells. Besides, there had never been much demand for his big, unwieldy statues.

But, when they lived together in 1914, Modi still seems to have been preoccupied with sculpture. He was trying something new, in the manner of Archipenko. Zadkine visited Beatrice's studio on the Rue de Montparnasse, and saw Modi's "big drawings of caryatids where the figures, the bodies of children sustained with difficulty the weight of an Italian sky heavy and blue." Zadkine noticed that it was the first time Modi used color in his drawings. It was also in this studio that Modi began to paint portraits of Beatrice and "where he continued to make sculpture but in polychrome." [6]

This is the only evidence there is that Modigliani experimented with a form of painted sculpture. Apparently not one of these statues has survived, but it does prove that Modi was doing sculpture through 1914 and possibly into 1915. His unpainted stone heads were left largely neglected for a long time. Beatrice prized such a head; later, Leopold Zborowski kept one on the balcony of his apartment on the Rue Joseph-Bara, and one remained for years, even after Modi's death, in the garden of the Cité Falguière. It can perhaps be said with some justification that Modi usually worked on sculpture between love affairs. When he lived with a mistress for any length of time—Beatrice, La Quique, and all the others—he drew and painted them from life. This was a measure of his devotion and practicality: when he had a house model, he used her to advantage, in and out of bed.

But of all the women Modi had known, Beatrice was the only intellectual. She had her own views on art. This added a new dimension to their passion—infinite complications. Love had never run smoothly for Modi, but quarrels and disagreements had tended to confine themselves to earthy matters, not to books, poems, words, and theories. In addition to the conflict of their personalities, Beatrice was the most virulent type of superintellectual. She was a man-eater from the time she became nubile, with chips on both shoulders and a compulsion to prove she could surpass any man in any field. Underneath her pert, frankly sensual façade, Beatrice quivered with neurotic jealousy, resentment, spite, and vindictiveness.

She cultivated Max Jacob, a poet like herself, an intellectual who spoke good English, a waspish critic whom she could appreciate. Moreover, unlike her relations with other men, nothing sexual disturbed the equilibrium between them. Beatrice was probably responsible for the publication of Max's article "Extracts from Unpublished Volumes" in *The New Age* on February 18, 1915; and she wrote of his *La Côte*, "a charming book of Breton verse . . . by one of the few classical critics in the world."

Max's opinion of her is not on record. But most of Modi's French friends referred to her as *"la poétesse anglaise"* and spoke slightingly of her intellectual pretensions. She spoke in her bad French of her poetry but never showed it to anyone; people concluded that she had never written any and was a fraud in this as well as in other respects: they did not think her capable of loving Modi, of loving anyone but herself.

One can imagine the arguments that took place between them. She seems to have hated the poetry Modi loved, and liked the art he despised. If her name had first attracted Modi, he soon learned that she was not Dante's Beatrice.

Her state of mind and the course of her passionate relationship with

Modigliani can be traced in part through the dispatches she mailed to England and which were published weekly in *The New Age* under the heading "Impressions of Paris." It speaks well for Orage that he continued to publish the work of his former mistress without, apparently, editing a line. Either he recognized Beatrice's value to his paper or he was far more fair-minded than she ever gave him credit for. Beatrice's early dispatches read like a diary. They contain a great deal of personal comment that must have meant little to readers of *The New Age,* and they differ greatly from her last columns, which stick strictly to literary business.

In her column for November 5, 1914 (in which she also speaks of being half delirious with influenza), she writes, "Somebody had done a lovely drawing of me. I look like the best type of Virgin Mary without worldly accessories, as it were." One would have to know Beatrice to realize that she was referring to a drawing of herself in the nude, undoubtedly by Modi. She also writes vehemently of *Les Chants de Maldoror,* which she loathed, calling its author, Lautréamont, "a poor, self-tormented creature for whom, had he lived, no earthly refuge was possible but an asylum." She even goes further in comparing the harm *Maldoror* had done with the harm done by drugs. They were two poets together and, from all accounts, would never agree. Modi is said to have quoted Dante and other poets he loved to her. Beatrice retaliated with Rosetti, Milton, and her other favorites that Modi was bound to dislike. Opinions and being right in this passionate ménage mattered terribly. It became a deadly game: each one hated and excoriated all the poets the other loved.

Their ambivalence, the love and the hatred that drew them together and then turned them into fighting demons, comes through clearly in Beatrice's writings. In her column for November 26, she tells of being asked about the artistic movement in Paris. "A sculptor, talking to me, hoped for the freedom of the 'line' in art. I said that modern art and architecture seemed to be nothing but 'line.' 'Line imprisoned,' he replied, 'like a German regiment under its own officers. Enough of geometry!' " This is Modi speaking, Modi with his love of purity, his hatred of Cubism. In the next few paragraphs Beatrice rants on about drugs and stoicism, comparing the drugtaker with the stoic.

Modi was using hashish as always, and certainly offered some to Beatrice, who apparently neither liked nor approved of the stuff, and told him so. Léon Indenbaum, Modi's sculptor friend, had a studio in the courtyard of 53 Rue Montparnasse, where Beatrice lived. Every morning, Modi used to knock on his door and come in to see him. At that time, Modi was not drinking, under the influence of Beatrice. But he was taking hashish. He was quite *"parti,"* gone in his dreams. He would smile like an angel, sit down, and ask for some tea.[7]

In the same column Beatrice seems to go out of her way to condemn a

French classic, which Modi admired (a copy of which Nina Hamnett found on his bed on her return to Paris), *Les Liaisons Dangereuses* by Pierre Choderlos de Laclos, which Beatrice thought not so much a shocker as a highly moral book, "a sulphuric epistolary romance much devoured by the mothers of France and said to have been largely responsible for the modern severity toward young daughters." After first having tested her arguments on Modi, Beatrice seems to have found further relief by tearing the book to pieces for the readers of *The New Age*.

The next dispatch, dated January 7, 1915, and signed "Alice Morning," told Orage perhaps more of the doings of *The New Age*'s Paris correspondent than he cared to know:

> By way of being very joyful on Christmas Eve, I gave a mad party. It wasn't meant to be mad, but it went; because half the people turned out to hate the other half and so everybody had to strive like anything to make things go. We strove and we strove; we played and sang to each other; we improvised, we dashed out and fetched guitars, we danced, we offered each other all the cakes and drinks we had our own eyes on. And at last things went. And then Sylvia came in with apologies and that perennially green hat and we lowered the lights while she recited De Musset's *"Nuit de mai."* And I wept nearly. But what a poem! They don't write like that now. And that is to say they are not poets at all, and know nothing of eternal and universal beauty.
>
> > "Think'st thou that I am like the autumn wind
> > That breathed up the tears on a tomb
> > Making more of woe than of dew?"
>
> To hear the muse speak like this, one must have been upon the mountains or have lived in lyre-builded Thebes.

Beatrice had her own romantic streak, much like Raymond Duncan's, which demanded Grecian-robed figures skipping on the greensward, hair unbound, eyes on the filmy clouds caressing unseen mountain peaks.

On January 14, she praised Max Jacob's poems and translated one of them, "La Fille du Roi." Again she fulminated against hashish. She told of its being available in Paris at twopence a pill and of a girl she knew going to pieces on it. Beatrice makes it clear that she was not taking drugs. But she was drinking. On January 28, 1915, Beatrice brought Picasso under Alice Morning's notice: "By the way, Monsieur Picasso is painting a portrait of M. Max Jacob in a style the mere rumor of which is causing all the little men to say that of course Cubism was very well in its way, but was never more than an experiment." She added that this time his style was rumored to be almost photographic, simple and severe. She was also rather proud that she was now "indignantly barred" from

Picasso's atelier (then at 5 Rue Schœlcher) because she had been rude about Rousseau's portrait of himself and Madame.

On February 4, 1915, in the course of her rambling comments, Alice Morning had a few words to say about a sculptor in the area, "The moulder down in my court, who has returned from Italy, has no notion of being controlled by the things he makes. 'Ha!' " I heard him address them. 'Dirty pig of earth, stand up!' " The sculptor could not have been Modi because he had not been to Italy recently nor did he mold in clay. Nor was he Indenbaum. But he could have been another fiery, handsome Italian named Alfredo Pina, who was to be one of Beatrice's lovers.

In next week's *New Age* Beatrice wrote a curious column—the only one to mention Modigliani by name—in which she speaks of an unexplained fire that almost destroyed her apartment. The mysterious nature of the fire leads one to think that a very angry Modi, who had a propensity for starting fires, might have been the culprit:

> I nearly succeeded inadvertently in getting my place burned down by a flame of wrath. I was remarking carelessly that the value of works of plastic art has to be settled by the critics because, of course, artists seldom knew their good work from their bad—when the fire broke out. We quenched it somehow but the moment was grave. Perhaps I meant what I said all the same. For example, I possess a stone head by Modigliani which I would not part with for a hundred pounds even at this crisis; and I routed this head from a corner sacred to the rubbish of centuries and was called stupid for taking it away. Nothing human, save the mean, is missing from the stone. It has a fearful chip above the right eye, but it can stand a few chips. I am told that it was never finished, that it will never be finished, that it is not worth finishing. There is nothing that matters to finish! The whole head equally smiles in contemplation of knowledge, of madness, of grace and sensibility, of stupidity, of sensuality, of illusions and disillusions—all locked away as a matter of perpetual meditation. It is readable as Ecclesiastes and more consoling, for there is no lugubrious looking-back in this effulgent, unforbidding smile of intelligent equilibrium. What avail for the artist to denounce such a work? One replies, that one can live by it as by great literature. I will never part with it unless to a poet; he will find what I find and the unfortunate artist will have no choice as to immortality. But I don't think artists understand or bother much about immortality. . . .

Beatrice can be forgiven much for her admiration and her penetrating comments on this stone head by Modigliani, which she refused to part with. She understood his sculpture and saw its worth, but she misunderstood what he meant by immortality. He had thought about it and it bothered him: a short, intense life left little time to achieve it.

Beatrice went on to write, in the same article, that she had been keeping pretty much to herself lately and didn't know what Montparnasse had been doing. She had remained indoors ". . . nursing a sick wasp and writing a comic romance. The wasp strays in, eats a little honey, warms itself, tries to sting, and travels out to some winter lair. I suspect it is more sleepy than sick." Modi is the sick wasp. He lived with her and he didn't live with her. He was sick or drunk, or both. He wandered in, made love to her, treated her tenderly, ate a meal. Then there would be a stinging round of arguments and Modi would buzz off to his own studio, to the Rotonde, or to Rosalie's.

There is a gap in Alice Morning's "Impressions of Paris," from March 11 to April 8, 1915. Beatrice apparently moved from Montparnasse to 13 Rue Norvins in Montmartre, during the week of March 11. Her explanations for her silence sound false. She blames it on the flu, but in Katherine Mansfield's letters there is evidence that Beatrice was partying and drinking heavily exactly at this period. She was to leave as forceful an impression on Montmartre as she had on Montparnasse. Zadkine considered her charming. She had read some of her writing to him. He felt that she was a very nice person without much temperament.

Zadkine, who kept on with the pretense of keeping Beatrice anonymous, said that "Miss Y possessed expressive language in her poetry, and a sort of Stendhalian humor. She thought herself superior to the poets of her time, and later, when she moved to Montmartre, she had gatherings. Modigliani got drunk very quickly on a single glass and then he recited Dante." [8] Foujita said that Miss Y loved eccentricity and carried a live duck around in "a wicker osier basket." [9] And Blaise Cendrars, poet and a good friend of Modigliani, called Miss Y ". . . an hysteric . . . an *activiste* [pro-German] accosting all males and intoxicated from nine o'clock on. She was infatuated with Modigliani, who was libidinous, like all Italians. There were frightful scenes of jealousy. They drank together, they fought, they beat each other. Modigliani used to push her out the windows into a patch of briars." [10]

Marie Wassilieff said that Miss Y, who "was at first very beautiful with curly hair . . . later was more haggard than Modigliani." She explained that because he slept in Beatrice's apartment, he assumed the place was his, and said, "Hand over the key, give me the key. Madame, I am at home. It's no longer yours." Marie added that Beatrice wisely had another made for herself.[11] The key also figures in the recollections of Marevna Vorobëv, a Russian woman artist who knew both Modi and Mrs. Hastings and attended the tumultuous parties in the Rue Norvins. She described Beatrice as ". . . intelligent and subdued, and at the same time mischievous. She led a most restless and agitated life. Not only did she get a taste for drugs, but she stupefied herself with alcohol and was

always in search of adventures with men who were vulgar bohemians like herself." [12]

Miss Vorobëv tells of a time Beatrice was locked out of her apartment. She went down to the Rotonde to get the key from Modi. He ". . . welcomed her by shouting that she was nothing but a pest, that he had had enough of living with her, and that he could not stand any more of her." A terrible brawl followed, Modi insisting all the time "that the apartment belonged to him, and that he did not want her to set foot there again." Finally Beatrice got her key and went home. Modi was then kicked out of the Rotonde for good and supposedly condemned to patronizing the Dôme henceforth.

Modigliani's fear of Beatrice is attested by Fernande Barrey, Foujita's first wife. Miss Barrey confessed that she had once had seven magnificent drawings of Modi's and had used them to light her fire. No one thought they were worth much in those days, she explained. Fernande thought of Modi as a comedian. When Libion threw him out of the Rotonde for making too much noise or trying to pick a fight with some guests, Modi came back, pushed open the door dramatically, and proclaimed: "I return to tell that you are a ruffian, Mr. Libion!" Then he slammed the door, glad to have fooled the owner. Fernande also remembered the night Modi lay down on the streetcar tracks in front of the Dôme, announcing that he wanted to die in public. He had to be kidded along. Finally, someone said to him, "Listen, Amedeo, get up, you're worth more than that."

He got up. He was a braggart and a show-off, said Fernande. Only Beatrice Hastings frightened him. She was a nasty woman, but a woman of the world. She walked about holding a little basket with two lids in her arms, like the child in the Chocolat Menier advertisement. They called her the poetess, but no one saw her poems. When Modi saw her coming to the Rotonde to fetch him, he said in a panicky voice, "Cachez-moi, c'est une 'vache'!" (Hide me, she's an old bag!) Fernande added that Beatrice was the stronger of the two and was the one who walked out on the affair. [13]

Long before Beatrice walked out, however, her life was to become incredibly complicated, even for a bohemian in Paris. If Modi was frightened of her, Katherine Mansfield, who reappeared in her life in 1915, was even more so. Katherine and John Middleton Murry came to Paris, where they met Modi's friend, a companion of the Lapin Agile, Francis Carco. Carco, born in New Caledonia of Corsican parents, was drawn to Katherine. When he left to join the army he gave her the key to his apartment, and she lived in it until Murry took her back to London. Katherine could not forget Carco, and with Murry's indulgent consent,

returned to France and went to Gray, a cavalry depot where Carco was stationed. Here, in a farmhouse where Katherine stayed, their affair was consummated. Later Katherine wrote a case history of their troubled relationship in her story "Je Ne Parle Pas Français."

She returned to Paris to stay in Carco's apartment. She wrote long letters to both Carco and Murry and filled her *Journal* with her reflections. She saw a great deal of Beatrice, who by then had been Modi's mistress for eight stormy months. She wrote to Murry on March 21, 1915:

> B's flat [13 Rue Norvins, Montmartre] is really very jolly. She only takes it by the quarter at 900 francs a year—four rooms and a kitchen, a big hall, a *cabinet* and a conservatory. Two rooms open on to a garden. A big china stove in the *salle à manger* heats the place. All her furniture is second-hand and rather nice. The faithful M. conducts her shopping. Her own room, with a grey self-colour carpet, lamps in bowls with Chinese shades, a piano, 2 divans, 2 armchairs, books, flowers, a bright fire, was very unlike Paris, really very charming. But the house I think detestable. One *creeps* up and down stairs. She had dismissed D. and transferred her virgin heart to P., who lives close by. Strange and really beautiful though she is, still with the fairy air about her and her pretty little head so fine, she is ruined. There is no doubt of it. I love her, but I take an intense, cold interest in noting the signs. She says "It's no good me having a crowd of people. If there are more than four I go to the cupboard and nip cognacs till it's all over for me, my dear," or "Last Sunday I had a fearful crise. I got drunk on rhum [sic] by myself at the Rotonde and ran up and down the street crying and ringing bells and saying 'Save me from this man!' There wasn't anybody there at all." And then she says with a faint show of importance, "Of course the people here simply love me for it. There hasn't been a real woman of feeling here since the war. But now I am going to be more careful."
>
> Myself, I am dead off drink. I mean the idea of being drunk revolts me terribly. Last time I was drunk was with B. and the memory stays and shames me even now. We were drunk with the wrong people. Not that I committed any sottise, but I hate to think of their faces and—ugh! no—I shall not drink again, like that, never—never.

The initials, rather than the names themselves, remain in the latest editions of Miss Mansfield's letters, but the people they represent have been identified in nearly every case. Antony Alpers, Miss Mansfield's biographer, and others have identified "the faithful M." as Max Jacob. As a solicitous friend of Beatrice he would have delighted to do her shopping. D., who is cited as dismissed, is Modigliani referred to by Beatrice as Dedo, his childhood family name. P. was once thought to have referred to Picasso in whom Beatrice was interested and on whom she may perhaps

have had designs, but Picasso lived then at 5 Rue Schœlcher in Montparnasse, which was not "close by." The P. to whom Beatrice had "transferred her virgin heart" was no doubt the handsome Italian sculptor Alfredo Pina, who is still remembered by Zadkine and Lipchitz. Marie Wassilieff told Frederick S. Wight, "The liaison [between Modi and Beatrice] did not last, and she took up with another Italian named Pina." [14]

In a letter to Murry, dated March 22, 1915, Katherine told of an ugly scene that marked the end of her friendship with Beatrice and that she could never forget:

> . . . At B's this afternoon there arrived "du monde," including a very lovely young woman, married and *curious*—blonde—and passionate. We danced together. I was still so angry about the horrid state of things.
> . . . I can't talk about the tea-party tonight. At any rate it isn't worth it really. It ended in a great row. I enjoyed it in a way, but B. was very impossible—she must have drunk nearly a bottle of brandy and then at 9 o'clock I left and refused either to stay any longer or spend the night there. She flared up in a *fury* and we parted for life again. It seemed such utter rubbish in the face of all this—now. A very decent and pleasant man saw me home happily—otherwise I think I might have been sitting in a Y.M.C.A. until this moment—it was so dark. But a lovely evening—very soft with rain falling. B. makes me sad tonight. I never touched anything but soda-water and so I realize how other people played on her drunkenness, and she was so . . . half-charming and such an *utter* fool.

On March 27, 1915, Katherine again spoke of Beatrice in a letter to Murry:

> . . . I think O. [Orage] wants kicking—just that. Of course, what is peculiarly detestable is his habit of lying so charmingly—his "I should be delighted, Katherina" rings in my ears. B. I have not seen her since her famous party. It's an ugly memory. I'm glad it happened so soon. I think next morning she must have felt horribly ashamed of herself, for she was drunk and jealous and everybody knew it. I am thankful I stood so firm. I feel so utterly superior to her now.
> To tell you the truth, both of them are bitter because they have nearly known love, and broken, and we know love and are happy.

Katherine soon returned to England and John Middleton Murry. He was always her choice. They were finally married after waiting six years for her divorce. The decision was never exactly final for her. Katherine continued to brood over Carco for some time ("Je Ne Parle Pas Français"

was written in 1917), and Katherine, Murry, and Carco all wrote about their relationship. Katherine took the literary laurels in her biting short story in which Carco certainly recognized himself in the slick, nasty, woman-chasing, fox-terrier-faced Raoul Duquette.

Murry had the scholarly and discreet last word in his biography of his wife, his own autobiography, and the editing of Katherine's *Journals, Letters,* and *Short Stories.* But Carco hit hardest in his best-selling shocker *Les Innocents,* which was published in 1920 and is still popular as a French paperback. In the novel he used, verbatim, passages from the letters Katherine had written to him during the course of their affair. They are part of the narrative. He also has a character named Beatrice, a mannish pervert, a painter and war correspondent. Beatrice has tried everything for kicks, even murder, having strangled someone in South America.

In a scurrilous pamphlet about *The New Age* and Orage that Beatrice published in 1936, she took note of Carco's novel. She said that after the book was published ". . . Katherine began to play the saint and prate about the good." When Katherine died of tuberculosis in 1923, it was Beatrice's categorical opinion that Katherine Mansfield had "twittered her way out of a world she had fouled wherever she went." [15]

*"There are needs which demand immediate satisfaction."*

After Katherine Mansfield's departure, Beatrice seems to have struggled to get a grip on herself. She resumed her "Impressions of Paris" in the April 8, 1915, issue of *The New Age*. Since Modi did not know she was dallying with Pina, Beatrice perhaps found her efforts to deceive him tiresome, and occasionally took a holiday from Paris.

All the time he lived with Beatrice—fighting, arguing, and sleeping with her—Modi kept his own room, stopped at Rosalie's and the Rotonde, saw his old friends, indulged his old habits, and lived much as always, with one important difference: in Beatrice, he had a permanent model whom he was to paint more times and in more moods than any other woman with the shining exception of Jeanne Hébuterne, the love of his life.

Beatrice had a round, fresh prettiness, a sweet face, the whole more aesthetically satisfying than its parts. (John Russell calls it "an idiosyncratic bun-face.") [1] Beatrice looked somewhat like Katherine Mansfield, a comparison that, at this stage, Beatrice would have loathed. Her forehead was broad; the eyes were set wide under thin, curved brows; the nose was long and uptilted, the mouth surly when not smiling, the chin smooth and firm; the ears were on the small side. (See photograph, facing page 384.) She had an interesting, unreadable countenance, and a good, spare figure with small breasts, a flat belly, and smooth, symmetrical, smallish hips. Modi experimented in his paintings of her with new colors, lighter pigments, hats to change her appearance, her hair done in different styles, sometimes hanging to soften her expression.

One of the most distinctive nudes shows her standing limp and loose, holding a sheet with both hands just below her waist. Her head and body

are turned slightly to the right; her hair hangs in one big strand over her left shoulder. She seems exhausted and browbeaten, as if she and Modi had just made tempestuous love, and he had ordered her to pose as she was. She almost seems to weave a little, abject, her head to the side and down. Beatrice has never seemed that weak and defenseless.

It is a quick sketch, a little shadowing around the left side from neck to hip, and on the right, from armpit to hip again. No other background of any kind. A simple sketch, a perfect little love poem—perhaps a poem of hate too. In block letters Modi wrote "Beatrice" on the left side of her head next to the bunched hair; then, below the right hip, he put "Modigliani" in his familiar longhand signature.

Modi painted Beatrice in a wicker chair several times: Beatrice before the piano, Beatrice before a door, Beatrice with her hair parted in the middle, Beatrice in her various odd hats, Beatrice strangely gentle and transfigured with her long hair flowing, wearing a simple checked dress. He painted still another Beatrice, this time in a broad-brimmed feathered hat, a regally aloof woman, knowing, calculating, cool, and on the canvas by her small right ear he wrote "Madam Pompadour," the English spelling of Madame making clear his meaning. Perhaps he called her Pompadour teasingly because Beatrice was so much like the mistress of Louis XV, beautiful, malicious, witty, dangerous, and powerful.

He put titles on his pictures, sometimes a descriptive word or phrase that seemed appropriate to the subject or appealed to him. On his drawings he was more likely to write some bit of personal philosophy or an aphorism. On one sketch of Beatrice,[2] Modi wrote *"Stazione Livorno Cipressi di oca del Ricovero Keats."* which some people have mistakenly identified as a verse by Keats, presumably because Beatrice often quoted Keats or because Modi thought Keats had lived in Leghorn as Shelley had. Perhaps he was attempting a reference to Keats's convalescence under the goose-cypresses of Leghorn, where Keats never was. The reference remains obscure.

A line from Dante or another favorite poet was also usual on his drawings, but he favored aphorisms *à la* Brancusi. There are four on one drawing in particular,[3] now in a private collection in Rome. They are scrawled on a sheet of paper with two Stars of David. Modi was probably doodling when he drew the six-pointed star of Solomon's seal, a Jewish symbol made from two triangles, one placed over the other, but they certainly show that he had Judaism on his mind.

The writing has been done over four dimly sketched faces. On the right side of the paper, which Lamberto Vitali dates as of 1914–1915, is the heading "The Emerald Index." Under this appear four aphorisms. "What is true—is equally true in three worlds." This is followed by a Star of David, then "What is on high is just like what is low"; "Don't say:

don't do that; but say: Do That," and "The Empty seeks the Full, and the Full seeks the Empty." Under this and the heading "l'Arline," Modi wrote "You will only possess what you have already conquered," and "I will forge a cup and in this cup will be the receptacle of my Passion."

In the upper left he wrote, "No, integrity does not lie that way." Under this is another Star of David. Then to one side he wrote "the flamboyant style," underlined it, and put down one after the other "3 designs," "3 worlds," "three dimensions." What he intended from this mystical philosophizing no one can now say. But one can imagine Modi being proud of his aphorisms, trying them on Beatrice, who could only have ridiculed them.

If she had a favorite poem of her own composition, it was probably one of a trio published in the June 9, 1910, issue of *The New Age*. In fact Beatrice thought so well of it that she reprinted it again (minus the two last stanzas) in a magazine called *The Advocate;* which she published herself in 1941:

### THE LOST BACCHANTE

We rushed from the forest at break of day
The last of our mad god's train;
We had wakened the night in cursing the rite
Of mortal who loves in vain.

I stopped to recover my vest of hide;
They trod me down triumphing loud:
And there's no reply to my strident cry—
Whither went yon trampling crowd?

My body is red with wounds of rage,
But I'll bathe in the mountain lake
And I'll ease my spite by blessing the rite
That mortal maid did make.

I'll tear my robe from a tiger spine
I'll bind up my ruddy hair
In a band of tendrils plucked from the vine
And ivy grapes will I wear.

And I'll leap the meadows toward the city,
Where the mortals dance tonight,
And wrench from the breast of the loved one pity,
And fill it with mad delight.

I'll work in the milky heart of the maid
With magic I'll ripen her bosom scanty,
Till her lover gasp nor know that he clasp
No mortal maid, but a lost Bacchante.

The poem described Beatrice—what she was, how she felt—so very well: a votary of Bacchus, a drunken reveler.

While "The Lost Bacchante" is a dreadful poem, still it cannot be denied that Beatrice *was* a poet in her own light. French writers—particularly André Salmon—have taken pleasure in pointing out that they never saw any of her poetry and doubted that she had ever set down a single line of verse. But her poetry was published, even in Paris. The table of contents for the May, 1921, issue of *Action,* an art review edited by Florent Fels, lists Beatrice Hastings as a poetry contributor along with Salmon, Vlaminck, and others.[4]

Paul Guillaume also played a part in Modi's return to painting. Perhaps prompted by Max Jacob, Beatrice seems to have asked Guillaume to tea at her house in the Rue Norvins and cultivated him for her lover's benefit. Guillaume spoke good English. He was well read, literate, and a gentleman who dressed as a gentleman. For his part, Paul Guillaume was always sure of his influence on Modi. He wrote to Giovanni Scheiwiller, a biographer of Modigliani:

> In 1914, all through the year 1915 and a part of 1916, I was the only buyer of Modigliani and it was only in 1917 that Zborowski represented him. Modigliani had been introduced to me by Max Jacob. He was then living with Beatrice Hastings, worked at her place, at the painter Haviland's place, or in a studio I rented for him at 13 Rue Ravignan, or in a little house in Montmartre where he lived with Beatrice Hastings, and where he painted my portrait.[5]

Modi now took Guillaume seriously enough to consider him as his dealer. In one of his portraits of Guillaume, he put the words *Novo Pilota* in a corner of the painting. Guillaume would now be his "new pilot" and steer him to success. For all his good reputation and encouragement, Modi, however, seems never to have warmed to him. This is evident in his portrayal of the elegant dealer with his fussy, perfectly fitting clothes, his careful grooming, his black fedora set rakishly on his head, his high-arching nose, his stiff collar and beautifully knotted tie. He holds a cigarette languidly in a gloved hand. The eyes are bored and tired; the neat little mustache seems to twitch. His expression is smug and sophisticated.

Guillaume's interest, like the interest of all entrepreneurs, was apparently in the product itself, *not* in the producer. He was not particularly taken with Modi's nudes, his portraits of friends, of women, and children done over and over again. He would have preferred more variety, perhaps a Cubist phase, still lifes of fruits, pipes, and guitars *à la* Picasso, even a landscape or two. A dealer took tremendous risks. Guillaume had to hedge his bets to be safe. Besides, you never knew about artists. Modi-

gliani had something—Guillaume did not know what—and it just might pay off as de Chirico and Chagall had. But Modi was difficult to deal with and, at the moment, terribly hard to sell.

Guillaume is supposed to have told Leopold Zborowski: "There's nothing French about it [Modi's painting], and that's a great pity because the young man has a real gift." [6] It is an ironic comment, but other people were to say the same. It was the now familiar French-Italian argument over Modigliani. If Guillaume did indeed make this remark to Zborowski, "then there is certainly some justification for reading into Modigliani's portraits of Paul Guillaume a discreet retaliation on the artist's part." Claude Roy feels that portraying Guillaume's eyes "with a vacant, supercilious stare," the way ". . . a cigarette dangles loosely in the hand," gives the impression of "self-conceit," thus betraying Modi's "involuntary rancor." [7]

Modi may have had reasons to want to get even with Guillaume, who promised so much at first and yet did so little for him by comparison with Zborowski. Guillaume paid Modigliani little for his paintings. An affluent man, he lived comfortably, yet he seems not to have been generous. An incident that turned on paying a sidewalk photographer in Nice and attested to by the painter Léopold Survage shows Guillaume to have been a thoughtless man where money was concerned and, worse, an out-and-out cheapskate.

The 1915 double portrait called *Married Couple,* or *Bride and Groom,* has always been used as proof of Modigliani's awareness of Cubism. It now hangs in the Museum of Modern Art in New York. The portrait apparently stems from a drawing Modi made late at night at the Rotonde when a middle-aged pair in evening clothes dropped by the café. They were dignified and respectable. The man's wing collar and stiff-bosomed shirt struck Modi as a kind of protective armor; the woman's sleek hairdo, her big hoop earrings, her strapless evening gown combined to give her a mantle of bourgeois snobbery.

Modi sketched the man standing like a king at his wife's side, hair parted in the middle, curling mustache bristling; his wife, seated securely below him, queens it blankly over the crowded tables of the Rotonde. In the painting, only the woman's head, neck, and one shoulder show. The man's high hat is cut off at the brim. Only his flat face, winged collar, white tie, and big stiff shirt front appear. It is a satiric portrait—distinctive, yet as impersonal as a passport photograph—this bourgeois couple, caught in hard, straight lines, a juxtaposition of ovals. There is a curious line down the man's triangular slab nose, through his mustache and chin, down to the division of his shirt front, which makes the bottom of his face seem to twist, the features to overlap. A Cubist element is perhaps present, but it is a shrewd adaptation, a pure Modigliani experiment.

Although he was painting again, Modigliani thought about sculpture and apparently still kept a number of heads in his studio. Berthe Weill says that Modi dropped by her boutique in 1915 and asked her to come see his sculpture. She observed that he was in a fine state and almost fell on her. *"Esprit si fin et cultivé. Tête superbe! Est-ce vraiment ivrogne?"* she asked.[8] Modi was always worked up these days, but he was distinguished and cultivated. With a superb head. Was he really a drunkard? Utrillo, who had also visited Berthe's shop about the same time, certainly was.

Utrillo had brought in a painting on cardboard, a snow scene. (*Effet de Neige*). He asked only ten francs, and begged her to buy it. He was so excited that Berthe hesitated. Maurice was back the next day, now asking *cent sous seulement*. But he was in such a frightful state that the good Berthe would not buy it. She refused to take advantage of him. Max Jacob was also in a state of nerves because of the war. Berthe had seen him passing her shop in tears, lamenting, "They're killing my brothers. It's awful." She thought him pitiful, a *femmelette* (an effeminate man).

Modi painted portraits of many of his friends, including Frank Burty Haviland, who was a disciple of Picasso and had a comfortable studio in the Rue Schœlcher in Montparnasse. Beatrice Hastings and Modi often visited him. Haviland came from Limoges, where his father was a wealthy and well-known manufacturer of porcelain. Frank was the wonder of his fellow artists because of his affluence, his easy life, and his smart clothes. He was known as *"le riche,"* but, says Fernande Olivier, was a *mesquine* (stingy) type.[9]

Patrick Waldberg has written more honestly and charitably of Haviland, who ". . . Already in his youth . . . was in love with art . . . [and] came to Paris at eighteen to paint." His good friends were Modigliani, Max Jacob, Picasso, and Manolo Hugué. It was on a trip to Cerdage, in 1909, with Manolo that the two "discovered Céret, a little fortified town just by the Spanish border," which was to be such a landmark to Picasso, Braque, Derain, Gris, Soutine, and many other artists.

Haviland "bought a château and land in the Roussillon and there started cultivating vines," but he had bad luck, lost his money, and had to dispose of all his possessions. Today, after leading "a Spartan life in the last quarter of the century," he is curator of the small art museum in Céret. Waldberg recalls having seen many art treasures in Haviland's château—sculpture, fine works by Utrillo, Derain, Picasso, Renoir, Modigliani, and "Roussillon landscapes by Frank, firmly painted, in the harsh colors of the tramontane country."[10]

Modi's portrait of Haviland has striking features, an appealing, defiant air, a small, thin-lipped mouth as capriciously infantile as Beatrice's. Modi painted him in left profile, looking down at his right hand, which

is covered with dots of color almost in the manner of the *pointillists*. The profile is sharp; the line clear and sure. There is no swan neck because Haviland did not conform to this vision. Haviland's neck is cut short by a rich red scarf knotted at the throat. Though it is Modigliani in conception, it contains traces of styles Modi had seen, appreciated, and made his own—something of Cézanne's composition, Lautrec's line, the sad blue of the early Picasso, perhaps even a little of Seurat's stippling in the features and background, and the vibrant colors of Matisse and the Fauves. The whole painting has a melancholy flavor about it that is what Modi caught as the essence of Frank Burty Haviland. It is a portent, too. Haviland was never well known. He lived on only in this portrait, as is the case with so many others who sat for Modi.

Modi now did paintings of his friends one after the other. Kisling always looked Modi up when he came home on furlough. Early in the war, he was wounded at Carency and sent home to recover. Modi did a seated Kisling, a big full-face head, and several drawings. He painted a stunning portrait of the bearded sculptor Henri Laurens, with a long, thick neck, the right side of his face pure red, and other unusual distortions. He did Picasso straight and full-faced with thoughtful eyes and a faintly smiling mouth. At the bottom of the portrait he wistfully wrote the one word *Savoir*. Modi might be jealous of Picasso, might call him a dirty bourgeois, but he admired him. This was acknowledgment. Picasso *knew;* he had the knowledge, the breadth that encompassed art.

His other paintings included heads of women, a young man called Raymond, a lovely serene portrait of a young girl in a black dress with a white collar and apron that he himself had titled at the top *La Jolie Menagère*. He did one of an appealing stout girl with a ruddy face that he called *L'Enfant Gras;* another seated girl, a shawl over her shoulder and a wan face, was *La Petite Louise*. On a painting of a woman done in oil and crayon on paper, he wrote *Rosa Prosprina*. These are all dated 1915. There were to be many more in 1915 and every year after until his death.

Modi still did sketches at the Rotonde and offered them for sale. In deciding on a sitter, Modi, with his large sketchbook under his arm, would enter a café, glance around looking for a likely woman or a married couple, and sit opposite them. He did so discreetly, being *de beaucoup de noblesse,* a man of great nobility. The woman would look up. Modi would open his sketchbook, gesture with his hand to show her how to hold her head, and the woman would pose as indicated. If the result did not satisfy him, Modi tore up the drawing and threw it away. He worked until he was satisfied; then he signed the sketch and offered it to the lady.[11]

Sometimes he was paid cash; sometimes it was a drink. Modi was al-

ways ready to exchange a drawing for a drink. The painter Gabriel
Fournier speaks of his dramatic entrance into the Rotonde,

> standing well back on his legs, his noble head proudly flung backward,
> and holding the pose for an instant, his faraway gaze going beyond the
> narrow limits of the room. His aristocratic charm was not spoiled by his
> big sweater with its roll collar, nor his shaggy, curly hair, which only
> added to the nobility of his handsome face.[12]

Fournier thought Modi a charming fellow. Even in the act of getting
horribly drunk, Modi used to proclaim, "Alcohol kills!" Modi could no
longer do without it. Fournier still remembers the look Modi gave him
the day he refused Modi a glass of gin in exchange for a bundle of draw-
ings. Modi stared him down and spat out the words, "There are needs
which demand immediate satisfaction."

Fournier, a distinguished painter himself, has happier memories of
Modigliani. Modi liked Fournier and enjoyed roaming Paris with him.
Together they often made fruitful excursions to the picture galleries on
the *rive droite*. Modi "gave himself to reflections from which his own art
profited." He marveled before the Renoirs, saying, " 'The Parisiennes as
seen by Renoir are *so* Parisian. They have all the charm and natural
grace of a real Parisienne. And especially that femininity that one sees in a
woman only in Paris—no one has painted it like Renoir. . . .' " Modi
admired the work of Pierre Bonnard just as much, according to Fournier,
but Seurat didn't appeal to him. " 'It's complicated,' he said. 'I don't like
that.' " [13]

Inasmuch as this was one of the few occasions on which Modigliani
made an authenticated comment on his contemporaries, Picasso and
Matisse excepted, it is interesting to take note of his esteem for Renoir
and Bonnard—the first, forty-three years his senior; the second, seven-
teen. Not only were they much older; they had nothing in common with
the Fauves, the Cubists, or any of the modern school. They were practi-
cally *passés*. Yet Renoir, whom Modi was to meet in embarrassing cir-
cumstances in a few years and who was to die in 1919, and Bonnard, who
outlived them both by many years (he died in 1947), were both giants. The
art of both these painters, like their lives, is happy: they shine, they
glow, they love, they inspire. Of Bonnard it has been said, "No one has
ever made such a poetic fairy tale out of the most ordinary objects of
our daily lives." [14]

In a sense Renoir and Bonnard might seem to be the last artists Modi-
gliani would admire. But the same qualities that exalt and give radiance
to their paintings can be found in the old masters that Modigliani loved.
Modi never tired of going back to the Louvre, nor did he ever stop roam-

ing the galleries of Paris to look at the art of the day. Little of Renoir or Bonnard can be found in Modigliani's paintings, which are so very different, yet much of their youthful spirit is in his work, their sense of beauty, tranquillity, serenity, all the more remarkable considering Modi's short, tortured life.

Charles Beadle, the "I" in "The English Poetess," Chapter Twenty-one of the pesudonymous Charles Douglas's *Artist Quarter,* was an English journalist, writer, adventurer-explorer, and author of a travel book called *Witch Doctors.* He knew Beatrice Hastings, Modigliani, and many of Modi's circle of friends well. Malin Goldring, the wife of Douglas Goldring who actually wrote *Artist Quarter,* has unflattering memories of him. At the time *Artist Quarter* was written Beadle was down on his luck. The research materials he delivered were practically illegible. "He requested money in advance almost every week by unstamped letters, before having sent any copy at all." [15] But Beadle's memories were rich.

In 1915 when he met Modi, Beadle lived in the Place du Tertre near the "charming little cottage of four rooms, giving on to an enclosed garden," which Beatrice had rented at 13 Rue Norvins. Beadle felt that Beatrice "did all she could to keep him [Modi] out of mischief and encouraged him in his work." This is a debatable judgment, but Beadle liked Beatrice and they had "one great interest in common": both were "keen gardeners," eager to grow English flowers, and "had planted hollyhocks, roses, nasturtiums, wallflowers, and so on," in their respective plots.

Beadle's studio garden had a superb view of the whole of Paris, and here even in wartime they held "delightful dinner parties during the summer months." Beatrice and he had long conversations on gardening that annoyed Modi, who misinterpreted "this botanical intimacy . . . owing to his jealous Italian temperament." Modi was always jealous of his women—something Beadle seems to have been ignorant of—and especially in the case of the volatile, complicated Beatrice. Modi kept close watch on her and refused to let Beatrice pose for Kisling. He did not want his friend Kisling to see her nude.[16]

Kisling had come on Beatrice Hastings at the Rotonde. She was a striking sight, "sitting at one of the small, round, marble tables wearing a stringed bonnet and carrying at her side a basket filled with flowers."

She wore, or rather was costumed, with that audacity that is only admitted in Montparnasse, in an exquisite Kate Greenway dress. Kisling invited her to come pose for him as she was, and the appointment was made. She didn't come. They arranged another appointment with the same result. Then Kisling, meeting Modigliani and Beatrice, re-

proached her for breaking her word. "I'm responsible for that," said Modigliani, "because I am opposed to Beatrice going to your place. When a woman poses for a painter, she gives herself to him." What a marvelous time was ours when painting, on this point, touched both the heart and the soul.[17]

What most incensed Modi was that Beatrice and Beadle spoke English in his presence. Beadle once called on Beatrice and Modi with his girl friend, Suze. It was a summer evening; the windows and doors were open onto the walled garden. Modi and Beatrice were "at home, and on a table was what we called the 'twixty' bottle of brandy because it was never full and never empty." Everyone had drinks. Beadle and Beatrice ventured out into the garden "to discuss some ailing plant or other," and came back in, still talking English. Modi didn't like it and showed it, "although he was not yet anything like drunk." "With feminine cussedness" (although surely just to annoy her lover), Beatrice insisted on sticking to English even though Beadle, "for the sake of peace . . . dutifully replied in French."

Modi went on drinking. The more he thought about the slight, the angrier he grew. Soon he had "worked himself into the beginning of one of his frenzies." Beadle hurriedly decided to leave, hoping Beatrice could pacify Modi. But Modi held him and Suze back with a melodramatic gesture "and stormed at the poetess. 'Oh, I understand very well! But as it's like that, you can have him, and I'll have Suze!'" Knowing Beatrice better than Beadle did, it was a natural assumption on Modi's part and a logical solution. Beadle and Suze fled "before the contending armies made contact."

Another time, after dinner in his studio, Modi, "full of drink and drug," decided to do a drawing of Beadle. "He did so, producing his usual purity of line with a hand that was steady as a machine. The sketch finished, he just toppled over and passed out." As in all Modi's portraits, it did not resemble the sitter but portrayed what Max Jacob liked to call "the splendour of the soul." What struck Beadle as particularly odd was that Modi had titled the drawing *Le Pèlerin*, the traveler, and showed Beadle "in shorts, open shirt, bare arms, with a Tirai hat on my head and the head of a hunting dog between my thighs." Beadle was certain Modi didn't know he had spent many years in Central Africa, adding significantly, "but his poetess friend always insisted he was a medium." Beadle says that later on, when it was on exhibit in Leopold Zborowski's gallery after Modigliani's death, the drawing was stolen. (If so, someone profited. A pencil sketch called *Le Jeune Pèlerin*, done in 1915 by Modigliani, was on sale in the Perls Gallery, New York, in 1951. According to J. W. Alsdorf, who owns the Modigliani drawing in the frontispiece and

has owned as many as forty of Modigliani's sketches, the price range for them runs from $2,500 for a poor one to a high of $6,000 for a superior one, with the average price being $3,500.)

Beadle and Modigliani discussed the subjects that most interested them—primitive art, painting in general, and drugs. Modi had set ideas on African art, "the why and wherefore of it." Beadle contradicted his theories. He explained that Negro sculptors did not understand art in the Western sense, "and had no word for it . . . neither . . . had those wonderful draughtsmen, the artists of the Dordogne caves and others in prehistoric times." Modi was both "interested and indignant," and demanded an explanation. Beadle told him that primitive artists were "magicians of the tribe" and witch doctors. They also argued "about the disassociation Picasso had discovered in the portrait of Jacob's brother by a Negro," in which the primitive artist had put the buttons of his sitter's uniform around the head. Beadle insisted that the artist had not done so either consciously or intentionally but haphazardly.

Modi took "cocaine as well as hashish, which has a terrifically stimulating effect at first," Beadle adds. Since he took alcohol on top of both, it does not surprise Beadle that "he had fits of noisy violence and outbursts of insane quarrelsomeness, even with his best friends." In Modi's case, "it was an abuse that was evil." Modi also confessed to him "that he loved the oblivion that the drugs gave him." Under their influence "he was happy, free from worry, and perfectly certain of his own talent." Beadle sensed that Modi was "gnawed by the knowledge of his disease," and so he was, but acknowledges that this was no way to treat it. He is convinced that if Modi had "submitted to a strict regime he would still be alive," adding, "What his art would have been like is, of course, another problem."

Beadle has amusing memories of Modi at this period. There was the night when they had a long dinner at the Café Savoyard on the Rue Lamarck. Modeste Assel, the owner and "a good sport," let his favored clients hang around after the wartime closing hours. Drinks were then on the house. They kept at it till early morning. Over the restaurant lived a charming girl called Simone whose lover, Oiseau, was a squat fellow "not much taller than a stork." Coming out of the café with his friends, Modi suddenly jumped up on the awning framework, banged on the window, and shouted in loving tones, " 'Open, sweet one, fairest of thy sex! Simone! It is I, thy faithful lover, thirsty for thy kisses! Thou art more beautiful than—' "

At this point the window was flung open and there stood the Bird, "in pyjamas, revolver in hand."

" 'Not at three paces! Not at three paces!' protested Modi, backing

away. Then, when he was safely on the ground: 'You, you head of a calf, how dare you disturb the sleep of a beautiful girl? Aren't you ashamed of yourself? Why don't you stop at home with your wife, you monstrosity escaped from a circus! You—' "

Another time, late of a wet, cold afternoon in fall or winter, Beadle met Modi far down the Rue Caulaincourt. He had no coat. Beadle never remembers seeing Modi wearing one. His eyes were brilliant. Beadle could tell he was "excited more with hashish than with alcohol." Modi wondered where Beadle was going.

"Oh, . . . just wandering up the hill," Beadle said.

Modi took his arm and suggested, "Let's walk in the cemetery. I adore cemeteries."

Beadle hesitated, not too much liking the idea, but Modi insisted. Beadle reproached him for being macabre.

"That is the basis of philosophy," Modi replied.

"Hmm, so said Rabelais," said Beadle, agreeing with him.

" 'Yes,' repeated Modi, 'I like contemplating death. It's not far off.' "

Beadle protested that this wasn't so at all just as "a racking cough shook" Modi, who looked about eagerly as they tramped "the muddy aisles between the tombs." Now another idea seized Modi.

" 'Wouldn't it be magnificent,' he said, when the fit [of coughing] had passed, 'if we could only contemplate our own cadavers?' "

The notion so excited him that he began to declaim an appropriate passage from *Les Chants de Maldoror*. Beadle remembered the quotation; looked it up. He says that Modi's rendition was "letter perfect." He reproduced the following lines (here translated) of Lautréamont in the original French:

> Here, it is just as among the living; each pays the tax in proportion to the richness of the domain he has chosen for himself; and if some miser refuses to deliver his share, I have ordered that action be taken as with a process-server: there is no lack of jackals and vultures who want to have a feast! I have seen ranged, under the flag of death, the one who was handsome, the one whom life has not disfigured! The man, the woman, the beggar, the sons of the king; the illusions of youth, the skeletons of old men, genius, folly, laziness, and their opposites; the one who was false, the one who was sincere, the mask of the selfish, the modesty of the humble, vice crowned with flowers and innocence betrayed!

As Modi acted out this scene, reminiscent of the one in *Hamlet*, "A passing gravedigger, with his tools, had stopped to stare at the figure indulging in this strange harangue." Then, moved "by the dramatic beauty

of the words," Beadle, in turn, "was spurred into recalling an apt quotation from the same *Les Chants de Maldoror*," which he knew by heart. First he faced "the goggle-eyed gravedigger."

" 'Grave-digger,'" he announced, "it is beautiful to contemplate the ruins of cities, but it is more beautiful to contemplate the ruins of human beings!' "

Modi was enchanted. Beadle writes that he "stared a second, and then literally flung himself on me to kiss both cheeks, to the amazement of the gravedigger, who turned away muttering about crazy folk who ought to be shut up."

Modi continued to be lonely, restless, and tortured even as he lived with Beatrice. Very often "late at night, or early in the morning," Beadle tells of being "awakened by a tapping on the studio door, for the garden gate was always open."

" 'Who's there?' " Beadle called out.

" 'Dedo. Have you got a little artificial paradise?' "

Ever discreet and kindly toward a fellow English citizen, particularly a lady, Beadle imagined "that Modi's life with the poetess must have been pretty turbulent"—a magnificent understatement in itself—and goes on, generously, "but until she gives the world her own account of it the anecdotes of outsiders should be accepted with reserve."

Most puzzling of all, since Modi never wrote to his family about any of his girls with the exception of Jeanne Hébuterne, is the statement that "His barrister brother tells me that Modi once said that at first she attempted several times to keep him in the house—for his own good, no doubt—but that he broke his way out through the window into the street." It may well be that when Emanuele visited Paris late in 1914, Modi may have told him about Beatrice or, very possibly, Emanuele may have met her with Modi at the Rotonde.

Since there is evidence that Modi also flung Beatrice bodily through the window when at his worst, Beatrice must have had quite a bill for glass replacement.

If Modi was so frightened of Beatrice that he begged friends to hide him when she tracked him down at the Rotonde, it is just as true that Beatrice was terrified of Modi. That she had reason to be is justified. We know that on one occasion, which was witnessed by a number of people, Modi was so carried away that he came close to killing her. Nor would Beatrice have kept a revolver so handy if she trusted Modi.

"She had such a terror of his homecomings that she asked a male acquaintance to sleep in a cabin at the end of the garden, to protect her when he was violent," Beadle wrote. Beadle goes on to say that that night "the man friend was asleep in the cabin and was awakened by howls and yells. The man got up hurriedly and saw Dedo in the middle of a gar-

den, brandishing a revolver." In any case, "The poetess had also snatched one from a drawer in her room." The confrontation was dangerous, for this crazy pair was quite capable of shooting each other down. Then "The really scared friend had an idea."

" 'D'you know what pavilion you're in?' he demanded dramatically. 'This belonged to the house of Dr. Blanche (situated a stone's throw away). These pavilions were cells for violent lunatics! They say that those who have died come back at night to take possession of the living!' "

This proved to be an inspiration. "For a moment the pair were flabbergasted. Then they broke into laughter"—presumably they kissed and made up. Beadle concludes the sentence, "and for that night there was calm in the cottage." [18]

Beadle carefully refrains from identifying Beatrice's "male acquaintance," but surely she was clever enough to pick as a bodyguard a man who knew Modi and could pacify him without inflaming his jealousy. This and the fact that the man knew the history of Montmartre well enough to use it point to Max Jacob as Beatrice's unnamed protector. Only Max would have known that the house near Beatrice's had belonged to the renowned Dr. Blanche, after whom Place Blanche had been named, who had run a sanitarium and had cared for such famous alcoholics and mental cases as Verlaine, De Musset, and De Maupassant. And only Max would have thought of alluding to the ghosts that haunted the garden. It was, after all, Max who wrote:

> *On connait bien peu ceux qu'on aime*
> *mais je les comprends assez bien*
> *étant tous ces gens-là moi-même*
> *que ne suis pourtant qu'un babouin.*[19]

> We little know those we love
> but I understand them well enough
> being all those people myself
> who yet am only a baboon.

∽∽∽ Chapter Twenty-two

*"Modigliani, don't forget that you're a gentleman.
Your mother is a lady of the highest social stand-
ing."*

The private combat between Beatrice and Modi became constant.
Their public battles were to be reported by many people. It was
unnatural for Modi to be faithful to one woman for long, and
Beatrice, the lost bacchante, had to assert her superiority, had to show
that no one man could possess her. She was now and had for some time
been enjoying a furtive affair with Alfredo Pina.

Modi believed that his women should remain anchored to the hearth
in the Latin manner, to conform and behave—something Beatrice prided
herself on never doing. Modi once took Adolphe Basler almost by force to
the Rue Buci, where Modi had an appointment with Martin Wolf who
worked in the antique shop of Ernest Brummer. Wolf, so thin and sickly
he was hardly able to stand, spent his days polishing the Negro, Greek,
and Roman sculpture in Brummer's boutique and his nights as an artist.
Modi found Beatrice there and proceeded to make a jealous scene. In this
instance Beatrice, perhaps in an effort to have the shop sell Modi's sculp-
ture, may have arranged an appointment. But Modi, quick to take
offense at nothing, suspected an affair between Beatrice and poor Wolf.[1]

Beatrice's protective instincts, her efforts to shield Modi as well as ap-
peal to his better self, are apparent in a story told by Ilya Ehrenburg.
Modi was a prey to unrest, horror, and rage, Ehrenburg recalls. One
night in Modi's studio, which was littered with rubbish, there were
crowds of people attending what had presumably begun as a party, in-
cluding Rivera, the poet Max Voloshin, and a number of models. Modi
was in a very excited state, and Beatrice Hastings kept saying to him in a
pronounced English accent: "Modigliani, don't forget that you're a gen-
tleman. Your mother is a lady of the highest social standing."

The words acted on Modi like a spell, he sat quietly for a moment,

calm and reflective; then he couldn't bear it any longer and started to batter the wall. "First he scratched away the plaster, then he tried to pull out the bricks. His fingers were bloody and in his eyes there was such despair" that Ehrenburg could no longer bear to watch. So he left, going out "into the filthy courtyard strewn with fragments of sculpture, broken crockery, and empty crates." [2] In the entire short life of Modigliani, there is perhaps no more pitiful or overwhelming episode.

Quiet desperation was a chronic state with acute periods. Utrillo's broke out violently in near insanity; Soutine attempted suicide; and Modigliani anesthetized himself with alcohol and hashish. Desperation was something he lived and fought with daily. It would not stay bottled up within him. When it burst forth, it was appalling. Beatrice, it must be said in her behalf, tried to sustain him, struggled to bolster his confidence and self-esteem even if it meant appealing to his bourgeois pride. Modi's despair always spilled over in gatherings.

Beatrice could be charming, but some corrosive quality of character made her arguments with Modi degenerate into bitter fights. Modi often smacked her when, as the concierge put it, *"il avait un coup de sirop dans le nez"* [3] (had a snoot full). The lovers reached a point when they disagreed on everything; they fought and threw things so that neighbors along the Rue Norvins merely nodded to themselves and said, "Uh-uh, that crazy couple is at it again." It was even said that when Beatrice would cry out, "Help, he's killing me!" nobody paid attention. Perhaps Modi did come near killing her. But Beatrice did her share to provoke him. It is conceivable that Modi found out about Alfredo Pina or, rather, that Beatrice ran out on Modi to save her own life.

Jacques Lipchitz remembers a time when Modi arrived at his room excited and disheveled. Modi had been drunk and had had a fight with Beatrice. Then Beatrice had done something unspeakable.

"Do you know what she did to me?" he said in amazement. "I came home, we had a fight, and I took her hands and bent them backward until she was on her knees on the floor before me. And then you know what she did? *Elle m'a mordu aux couilles!"* (She bit me in the balls!) [4]

Apart from Katherine Mansfield's report, the only eye-witness account of a party at Beatrice Hastings' is in the autobiography of the Russian painter Marevna Vorobëv, Rivera's mistress and mother of his illegitimate child. Marevna noted that Modi, "At the height of his drunkenness," had the compulsive ". . . habit of undressing, under the curious and eager eyes of some more or less faded girls, English or American, who took pleasure in frequenting Vasilev's [Marie Wassilieff's] canteen."

He would stand very upright and start by undoing his girdle [by this she means the sash he used for a belt], which must have been four or

five feet long; this done, he would let his trousers slip down to his ankles, then slowly pull his shirt up to his head, or take that off, too, and display himself quite naked, slim and white, his torso arched.

"Hi, look at me!" he would cry. "Aren't I handsome? Beautiful as a newborn babe or just out of the bath. Don't I look like a god?"

And he would start reciting verses. If it was not Dante, it would be from a little book which never left him: *Les Chants de Maldoror* by Lautréamont; or perhaps he would sing in Italian. The words of his songs were not easy to understand: he seemed to be always repeating the same one: *capelli biondi, vestita bianca.* [Blond head, white coat.]

Marevna and her friends trooped over to the Rue Norvins in Montmartre "to see Max Jacob, Modigliani and his friend Mrs. Hastings." They went in through a little garden up some steps from the street, and entered a ". . . well-lit room, in which were a small bureau, a table, chairs, a sofa, and shelves of books." Beatrice was a good hostess, for "A mountain of sandwiches awaited us, and bottles of every kind, to the delight of us all." Those present that evening were, besides Marevna, Katya and Ilya Ehrenburg, Vitya Rosenblum, the sculptor Paul Cornet, the parliamentary reporter André Delhay, a Greek philosopher called Mitrani, "and Carmen, a girl from Montparnasse." Marevna explains that Rosenblum, "engineer and mathematician, the son of a Russian Jew, baptized and a Catholic, was a virgin and very religious—even bigoted; and he wished Max Jacob to be a good Catholic," something Max was trying hard to be.

It began as a good, scrappy party. Soon, however, it was a brawl between Beatrice and Modi:

They went for each other like fishwives, and the end of it was that Modigliani seized her by the shoulders and threw her through the window panes. She screamed, and all I could see were her legs and thighs; the rest of the unfortunate poet, painter and dancer [Marevna is way off here] was in the garden! Everyone rushed to look and to help her. I took the wrong door and found myself in a dark room lit only by light which came in through the open door; there I saw Vitya kneeling in the middle of the room, making great signs of the cross.

"O God, save us from the accursed one and preserve us from sin," he was repeating in Russian, and touching the floor with his forehead.

Beatrice, in bad shape, was hauled back inside and put on the sofa. "She was wretched, poor woman, with her long flat breasts daubed with blood; she was sober now, and she wept, while Modigliani repeated: *"Non mea culpa, non mea culpa."* Marevna thought it strange "how their love was always so terribly violent: drinking made them quarrelsome." She says she preferred seeing Modi alone because, then, he was a

different person. Now the party went on. Mitrani, who had been making love to Carmen, was "excited by the shouts and tears, and by the blood, panted with passion and pulled Carmen into the garden; we heard them walking on the broken glass." Beatrice was attended to, wrapped in a Scotch plaid blanket, and given coffee "as Modigliani told her jokes to distract her thoughts," and the party went on.

Things broke up at dawn, the place like a battlefield. Modi was singing *"Capelli biondi, vestita bianca"* as he methodically tore what was left of the wallpaper off the wall; on the floor the bearded Mitrani and Carmen lay in each other's arms; Beatrice was prostrate "with her head under a sofa cushion," and Max was "on the floor with his head against the sofa, holding a missal in his hand." As the others walked out in the yard, past "broken glass, crushed plants, dirty plates on the ground, paper, food," Marevna comments that the company was "not pretty to look at, but we were not damaged or bloody."

> "What an evening," said André Delhay.
> "Yes," said Ehrenburg, "it was most moving, thanks to the actors. Now some hot coffee would be welcome."
> "Seeing that Englishwoman naked gave me goose-flesh," said Cornet. "Modigliani flattens her between two planks."
> "You must be a bungler of a sculptor," I said. "You don't understand anything about a modern woman. You saw her belly, her thighs and her legs? Well, they're worth something."
> At this moment Vitya, who had been about to say something, lost his balance, fell, rolled down the steps and broke his spectacles.[5]

Marevna Vorobëv was to attend other such parties, which turned into orgies, and writes, in particular, of one at Kisling's apartment later on. The guests all drank and sang. "Every Jack had his Jill. Max Jacob was lying on the carpet with a very good-looking young man—a poet, if I remember rightly. In short, it was a somewhat spirited requiem mass." She didn't like such affairs, was shocked by some of them, and says that "neither Rivera, nor Picasso, nor Matisse, Derain, Vlaminck," when she knew them, "went in for this sort of orgy." Max Jacob, the mystic, she writes, "finally escaped from this hell to take refuge in quietness and rectitude." She thought both Max and Modi had genius, "but their genius affected them differently." She believes that Max's "terribly critical and analytic intelligence enabled him to struggle against it all," while Modi, "too soft and weak, was incapable of struggling and allowed himself to be drawn down the slippery slope." [6]

André Salmon told of another incident that happened when Modi and Beatrice were near the end of their affair. It happened at Rosalie's. Modi

sat by himself. Beatrice preferred to sit at another table. "Modi has no regrets. Everything seems to promise that he is on his best behaviour." More people came in. Modi continued so subdued that a former student-treasurer "in a studio of l'Ecole des Beaux-Arts," decided to sit opposite him and—of all unfortunate subjects—began to talk painting. The man wore a beard; he was smug and all-knowing. His argument was exactly what was necessary "to upset Modigliani's calm and fire the powder.

"'You can say what you like against the teaching of the school. It isn't less true that Lucien Simon has taught us how to bring home the bacon.'"

The commercial aspects of art had always sickened Modi. "Disgust transfigured Modigliani's handsome Italian face . . . and he made a determined effort to strangle the academic painter." The women present shrieked. A screaming Rosalie tore out of "her kitchen, ladle in hand." Salmon and his friends "were bound to intervene when the rats fled scandalized." After they "had rescued the painter from Modigliani's strong arms, he told his friends what they should do with the offender.

"'Kill him, the swine!'" Then, still struggling to get at the fellow, Modi added, "'That's your job, you whose tongue is French! Kill him! Kill! Kill!'" [7]

While Salmon does say that "Certainly Amedeo was wrong to get mad, more wrong to beat up his interlocutor . . . ," he does admit that Modi "couldn't be anyone but himself. . . ." Summing up, he writes, "Absurd and magnificent. A little embarrassing. Genius is sometimes like that." Absurd and magnificent it was. To belittle the incident with "a little embarrassing" proves how few of Modigliani's friends understood his passion for truth. Modi was prepared to fight for his beliefs, to fight for his art. Salmon and others like him were not. They were smarter, more successful, more adaptable. They lived much longer than Modigliani, but they missed immortality by a wide margin. They lacked genius.

Ironically, the end of the affair with Modigliani coincided with the end of Beatrice's writing career on *The New Age* and all connection with the now hated Alfred Richard Orage. As the years passed, she was to become more petulant, more embittered, more eccentric, and convinced that she was persecuted. After August, 1915, Beatrice's writing for *The New Age* had changed in tone: the light touch was gone; there were no more references to her personal life.

Now she sent translations of French poems and indulged in endless literary discussions, mostly heavy going. The last of her contributions to *The New Age* appeared in the August 10, 1916, issue. Interestingly, Katherine Mansfield was back as a contributor in the November 4, 1916, issue with a story called "Stay-Laces." In 1917 she was to have ten pieces

in *The New Age*. Clearly, Katherine was "in" with Orage once more; Beatrice was permanently out.

Having been rejected by Orage and his paper, Beatrice decided to remain abroad. She had her income and she had "friends." She was still in Paris when Nina Hamnett returned to it after the war, in 1920. Beatrice's own account of her doings is contradictory. She says that she was off the pay list of *The New Age* in December, 1916, no longer got the paper, and had had a definite break with Orage.

So Beatrice visited relatives, traveled, and indulged her insatiable appetite for new studies. After she left Paris, she went to the South of France, and wrote to no one. In 1931 she returned to England after years in the French provinces and Switzerland. Her hatred for Orage became a fixation and for the twelve years Beatrice spent in England until her death, she was shrill in her denunciations of him. She believed that her books were kept from publication by a male conspiracy. She started several little magazines in which she reprinted some of her old poetry, saw to it that *all* her poetry was available to the public in pamphlet form, and then turned to writing on theosophy.[8]

She had loyal friends and some influence, but her personality steadily undermined her. She quarreled with all her earlier associates, alienated most of them, and ended with a crew of bogus amateur theosophists who hung on her words. She appears to have remained pecky and quarrelsome to the end of her life. Always right, always claiming she had been wronged and cheated by others, she was truly worthy of the cruel epitaph she had written for Katherine Mansfield, who, acknowledged as a great writer, had died of tuberculosis in 1923: it was really Beatrice who "twittered her way out of a world she had fouled wherever she went."

On October 31, 1943, Beatrice was found dead at her home at 4 Bedford Row, Worthing. On her death certificate the coroner put down as the cause "Asphyxia from Carbon Monoxide poisoning due to inhaling coal gas. Suicide while mentally unhinged." Beatrice would have contradicted the silly man as a matter of course—the *world* was unhinged, not she—but for once silence was enforced on her. Beatrice's will was simple and to the point. Her sole executor was a Miss Doris Lilian Green, 8 Cambridge Road, to whom she bequeathed "the whole of my household furniture from beds to tintacks, all my clothes and jewelry whatsoever and wheresoever situate."

Beatrice expressed a desire to be cremated, adding ". . . if Miss Green will kindly throw the ashes down a hill, or in a field, I shall be obliged." About her literary productions, she was just as specific. They were all bequeathed to the British Museum, "published and unpublished . . . In case of refusal, I bequeath same to the first public library who puts a

claim." There seems to be no record of Beatrice's literary works having reached the British Museum but, interestingly enough, about three months before her death Beatrice did offer them to the Museum. Beatrice's papers may be hidden in the recesses of the British Museum or they may have been destroyed. According to Antony Alpers, biographer of Katherine Mansfield, Beatrice's next of kin, a parson and his wife (the latter perhaps a sister), promptly destroyed all her papers after her death.[9]

Beatrice's pathetic desire to will her works to the British Museum makes her seem a little more human. She admired Modigliani as a painter and sculptor, and would certainly not begrudge him his fame, a fame that has also given her immortality as the subject of portraits, nudes, and drawings.

As the war dragged on, most of the men left in Paris were over fifty; younger men were conspicuous and suspect. Artists suffered a moral setback as well as an economic one. French artists rejected for military service were a pitiful group, covering their shame with petulant defiance; foreign artists had a protected status and, knowing in what a poor light they were regarded by Parisians who had given husbands and sons to the cause, were inclined to be aloof and detached.

Like Beatrice, Modi was given to expressing unpopular beliefs about the war. But underneath he was just as stirred up about German outrages and victories as the next Frenchman. Modi's pacifist fervor often offended people, "especially . . . strangers, during the war years," and he came near being punched in the nose on many occasions. Still, according to his friend Sam Granowski:

> Carried away by the enthusiasm of others, he decided, although he had been excused military service on medical grounds in Italy—and anyhow Italy was not then in the war—to volunteer. But at the recruiting station they all had to stand in line, each awaiting his turn. Growing more and more furious and possibly thirstier and thirstier, Modi stuck it out for more than an hour, and then suddenly, proclaiming his originally avowed political faith, went off in a rage.[10]

Maurice Utrillo had done much the same thing. André Utter had been one of the first to join. Before leaving, Utter had gone to the town hall and married Suzanne Valadon with whom he had been living for five years. She was forty-nine to his twenty-eight. Fired up by seeing others leave for the front, and hating the Germans, Maurice had "presented

himself at the army recruiting station in the Rue Ordener and volunteered for military service."

Somehow Maurice passed the physical and was told to go on "to the training center at Argentan." Thrilled at being in the army and the prospect of fighting for his country, Maurice celebrated royally. As a consequence ". . . he arrived at Argentan in such a wild, drunken fury that he was flatly rejected." Depressed and distraught, he passed through a dark two-month period—"days of hallucinations, nights of maniacal screaming and windowbreaking, rabid tirades against the Germans." Maurice "lurched about the streets in pursuit" of the pregnant women he hated, ". . . frothing at the mouth and howling madly." [11]

It was during this time that he painted his superb *The Cathedral of Rheims in Flames,* a tribute to his beloved Joan of Arc, who had crowned the Dauphin there. It was also an "indictment of the German savagery." It had been copied from a postcard, Maurice never having seen the cathedral. Then one day, "in the Place de la Bourse, where he had outraged a crowd of citizens by his particularly unlicensed conduct," the police nabbed him. Poor Maurice was confined to La Santé prison, then sent to Villejuif as a confirmed lunatic.

Modi's other desperate friend, Chaim Soutine, is alleged to have attempted suicide at La Ruche. The story has never been verified, but considering the times, Soutine's terrible poverty, and his terrible moodiness, it could well have happened:

> He [Soutine] lived briefly on the Left Bank in the Cité Falguière, but seemed to have found the combination of loneliness and acute penury in a strange land too difficult to bear. He moved to La Ruche with his friends Kikoine and Kremegne whom he knew from Vilna. Their poverty and despair was so dire, Lipchitz heard, although he was never certain of the accuracy of the story, that at the beginning of the war, Soutine and Kremegne were both found hanged and were cut down just in time.[12]

Maurice Raynal has written that Soutine found La Ruche so hopelessly depressing that he tried to hang himself and was saved *in extremis* by his compatriot Kremegne.[13] The accounts are not clear. Later on, Kremegne was angry with his contemporaries for not doing him justice and because the fame he felt was due him was stolen from him. And everyone in Montparnasse knew who had stolen that fame: Soutine.

Kremegne's first friends were Chagall and Modigliani, his neighbors at La Ruche. He remembered Chagall as being ungenerous, not liking to lend money, "a reproach constantly repeated in Montparnasse." But

Kremegne, "a cold little Slav," became animated in speaking of Modi. He was indignant at the novels built around Modi's legend:

"All they write about him is commercial," he says. In the film about Modigliani [*Modigliani de Montparnasse* with Gérard Philipe as Modi]—enough to make you vomit!—they show how he stole some sugar one day when he was dying of hunger. That's a lot of foolishness! Modigliani was never hungry and, besides, he was an aristocrat. Much too proud to steal sugar.

He always earned enough to eat, but he was a bohemian. When he was given a hat or a coat, he hurried off to dicker with a second-hand dealer so he could drink. I saw his fall and, after his death, I inherited his last pair of shoes. Brand new shoes he only wore once or twice . . . The first time I wore them, they led me straight to a bistro!

Modi! . . . yes, Modigliani, I was the one who introduced him to Soutine. . . .[14]

Like Kremegne, Zadkine also complained of all the lies written about Modigliani. He insisted that it wasn't true that one day, with Utrillo, Modi had stripped naked in a *pissotière* (street urinal), as had been said. Even when Modi was drunk, said Zadkine, he never stopped being an aristocrat. Modi had elegance even when drunk.[15]

Modigliani lived in La Ruche "The Beehive," briefly in 1911 (when Aunt Laura found him there), again in 1912 or 1913, and returned in 1915 or 1916 to meet members of the Jewish art colony who had settled there. Modi had begged Lipchitz to arrange it. Many of the Jewish artists who had lived in La Ruche before the war had left. "Chagall had gone back to Russia to get married and was mobilized into the Russian Army." Now a little reception for Modigliani ". . . was held in Chagall's studio, which in his absence was being used by a man named Maisel . . . a retoucher of photography."

Born a Jew and now an agnostic at best, Modi still felt drawn to Judaism and constantly questioned his Jewish friends about it. There was a yearning in the way he sought answers, a sense of wanting to belong as well as a holding back. He was, Lipchitz felt, a "harassed soul." But this occasion was gay, convivial. Modi must have been touched at their warmth. They knew him by name, recognized his talent, and accepted him as one of their own. They ". . . served hot wine and *canella*, jabbered away in Russian, French, and Yiddish. Modigliani was made to feel thoroughly welcome and from then on came often. He painted Indenbaum's portrait, Kisling's and Soutine's. That occasion was also the beginning of the historic friendship between Soutine and Modigliani." [16] Once again the dates are blurred. Kisling was then living in an apartment at 3 Rue Joseph-Bara, which was where Modi painted him; Modi had met Soutine earlier.

Léon Indenbaum recalls the portrait that Modi painted of him. He first knew Modi in 1913 when Modi, still doing sculpture, "wore a fine beard, like Caracalla," and lived at 216 Boulevard Raspail. That year Indenbaum, younger than Modi, had sold some things and had a little money. To help his friend out a bit, as Indenbaum explains it, he bought a head of Modigliani's for two hundred francs. Indenbaum says that this was enough to live on for three months (perhaps for him, but certainly not for that generous spendthrift Modi). Because the head was big and heavy, Indenbaum did not take it away with him. The sculpture stayed on and on in the cluttered Boulevard Raspail studio until, one day, Modi came up to Indenbaum at the Rotonde.

"*J'ai vendu ta tête!*" he said, coming straight to the point. "I sold your head!"

"*Tu as bien fait,*" said the understanding Indenbaum. "You did the right thing."

As to the portrait, Indenbaum remembers that it was around two o'clock in the morning when he came on Modi drunk on a bench outside the Rotonde. Indenbaum was just coming out of the café when Modi recognized him and called his name. Indenbaum says that he sat on the bench beside Modi. Modi put his hand on his shoulder, and the two stayed that way for half an hour, without saying a word. Then Modi said, "*Tu as de la couleur? De la toile?*" (Have you got paint? Canvas?) Indenbaum said he did. Now Modi said, "*Demain je viens faire ton portrait.*" (Tomorrow I'll come do your portrait.) And the next day, Modi arrived at nine in the morning, clean and freshly shaved, in a blue-checked shirt with a black string tie.

Indenbaum explains that this was in the early years of the war, 1915–1916, at which time a collection of paintings destined to be disposed of in a lottery for the benefit of a sick woman, an "*amie*" of Diego Rivera (undoubtedly Marevna Vorobëv, judging from her description of a mysterious illness of hers during this period [17]), had been deposited in his studio. There was a little of everything in the room. Modi asked, "Where's the canvas?" and Indenbaum told him to help himself. Modi picked up a painting, looked at it, and put it back again, shaking his head. He did this several times. Indenbaum says that Modi, unlike Soutine, who loved working on old canvases, wouldn't paint on just anything if it seemed too good to him. (Leopold Zborowski used to search for cast-off paintings and make Soutine paint over them.) Finally, Modi chose a small still life and started painting Indenbaum's portrait over it. He came three successive mornings. After the third sitting the painting was finished. Modi looked at, signed it, and gave it to Indenbaum.

Indenbaum, a man with a conscience, would not accept it, but Modi insisted, saying, "*autrement tu me fâcheras.*" (You'll offend me if you

won't take it.) Indenbaum finally accepted the portrait. This may have seemed to Modi an appropriate way of repaying Indenbaum for the sculptured head Indenbaum had bought and that Modi had sold.

A year or so later, in 1916–1917, Indenbaum was married and had a baby a few months old. He had no money. Indenbaum took the portrait by Modi to Chéron's on the Rue de la Boétie, and sold it for forty francs. Coming out of Chéron's with the precious cash, whom should he meet but Modi. The honest Indenbaum told Modi what he had done.

"*Tu as bien fait*," he said. "*Je te ferai un autre.*" (You did the right thing. I'll do another for you.)

Modi forgot about it, and Indenbaum never reminded him.[18]

Chagall returned to La Ruche after the war and has rich memories of his days there. He thought only of his work, and painted on his linen, his sheets, and his pajamas for lack of canvas. Best of all, he liked painting at night; it exalted him. Thoughts of his native country brought him back to his senses as he lived this upside-down life. He was in a perpetual trance, he says, which annoyed his neighbors in La Ruche. "The Modiglianis and the Soutines had a good time with models. When they came home drunk in the middle of the night, they threw their shoes in my window. " 'Ah, so you're still turning out your cows!' " [19]

Modi caroused, but hardly Soutine, who was so dirt-poor he didn't have a decent pair of shoes. The rest of La Ruche's artists were also too poor to heave their shoes through Chagall's window—chamber pots, yes, but not precious shoes.

Lipchitz and Chagall, who did not drink, took no part in the carousing of their friends, and were a little self-righteous about it. While Soutine and Modigliani raised hell, the other two, both sober, frugal, mature, responsible men, worked industriously.

Yet, for all their carousing, Modigliani and Soutine were as dedicated and hardworking as either Chagall or Lipchitz. Soutine worked so assiduously that he forgot to eat, and kept on into the night until he keeled over from exhaustion. Chagall and Lipchitz were more charitable to Modi than to Soutine, the dirty, smelly, queer mole of a man. But then, Chagall had some scores to settle.

When Chagall was about to leave for Russia, just before the war, the news spread throughout La Ruche. Soutine came running to him and asked if it was true. Chagall says, "He was horrible, and I have always loved beautiful faces."

Soutine, understandably, wanted Chagall's studio, but Chagall said he was coming back after his vacation. He left, but first twisted a coil of stout wire around the door handle twenty-five times. Inside his studio were hundreds of his paintings. When he came back in the spring of 1923, he found the wire gone, a new lock on the door, and a new occu-

pant inside. Chagall, appalled and incredulous, angrily demanded an explanation. The answer was unsatisfactory.

Thirty-seven years after it happened, Chagall was still bitter. All his paintings had vanished, more than 150 of them. They had been sold. Chagall says he found many of them with collectors who refused to part with them because they had been paid for. He came upon his easel in another studio and was told he could have it back for ten francs. Chagall told an interviewer, probably through his teeth, "I know who sold my canvases, but I can't name them as some are still alive." [20] To stay away nine long years and expect to find nothing changed after the privations of war was more than a little naïve.

∽∽∽ Chapter Twenty-three

*"I envy you for the opportunity of proving our
friendship by making such a sacrifice."*

After Beatrice left him, Modi appears to have suffered a temporary col-
lapse. Somebody, probably Max Jacob, found him unconscious
in a littered studio in the Bateau-Lavoir and notified Charles
Beadle.[1]

Whether Modi was unconscious from alcohol, malnutrition, or the
effects of both, or whether it was some prevalent illness such as influenza
is not clear. Whatever it was, Modi's friends once more apparently nursed
him back to health. It could not have been too serious an illness.

Modi recuperated quickly. He was soon busy painting again and deep
in a briefly memorable love affair with another of the ever-willing candi-
dates for his charms. No matter what happened to him, Modi carried on
somehow. His allowance from home seems to have stopped. Now, en-
couraged by Paul Guillaume, he painted more steadily than ever before.
In a postcard marked, "received in Florence, July 7, 1916," Modi wrote to
his mother that he thought for a moment that he might be called back
for military service, even though he had been given a medical discharge,
and that he felt a slight wish to return to Italy, 'but . . . I carry on
here.' " [2]

Death was in Modi's inheritance, death by tuberculosis—or consump-
tion as it was sometimes called—and death because of insanity. In 1915
Modi's Aunt Gabrielle Garsin committed suicide after throwing herself
from the top of a staircase. Eugenia Modigliani must certainly have com-
municated the sad news to her son. She must also have written of the
tragedy to Dedo's beloved Aunt Laura Garsin, who had lost her
mind. . . .

Apparently after having been silent for some time, on Friday, November 9, 1916, Modi sent a postcard, in French as usual, reading:

My dear Mamma, I am a criminal to leave you so long without news. But—but so many things have happened. First of all, I have moved. My new address is 13 Place Emile Goudeau XVIII. But in spite of all this commotion I am relatively happy. I am painting again and I'm selling some of them. That means a lot. I'm very pleased that my brother is in munitions. As to Laura I feel that if she keeps her intelligence, and I add her marvelous intelligence, that's very important. I am greatly touched that she thinks of, remembers, and interests herself in me even in the state of forgetfulness of human affairs in which she now finds herself. It seems impossible to me that she cannot be brought back to Life, that such a person cannot be brought back to normal life. Give my father a hug on my part when you write to him. Letters and I are enemies but never think I forget you or the others.

> a big kiss,
> DEDO" [3]

Indeed many things had "happened" to him, none of which he explained in any detail: his affair with Beatrice Hastings; his ties with his "new pilot" Paul Guillaume; his association with Leopold Zborowski, and his liaison with Simone Thiroux.

The brother he mentions no doubt was Umberto, the engineer, not a rabid pacifist and Socialist like Emanuele. Umberto was evidently doing what he was best fitted to do for the Italian war effort. As for Aunt Laura, Modi had always been close to her. He was moved that she still remembered him, confined as she was and suffering a "nervous breakdown" or severe mental depression.

The reference to Modi's father, Flaminio, is baffling. Modi was always apparently on affectionate terms with his father, judging from his reference, and Eugenia Modigliani, although separated from her husband for a long time, seems never to have lost touch with him completely. As to why she should have been writing instead of speaking to Flaminio, one cannot say: he may have moved away from Leghorn or perhaps he was off on business.

A week later, on a card dated November 17, 1916, Modi was still apologizing for not writing and reassuring Mamma about himself:

"DEAREST MOTHER, I have let too much time pass without writing, but I don't forget you. Don't worry yourself. Everything is fine. I'm working and sometimes I'm harassed, but I'm not hampered the way I was before. I wanted to send you a photograph, but they didn't turn out too well. Send me some news. A big kiss.

> DEDO" [4]

The reference to being "harassed" and "hampered" undoubtedly concerns money. Interpreting this postcard, Jeanne Modigliani says that 1916 was an auspicious year for Modi inasmuch as Zborowski was able to give him a monthly allowance sufficient to enable him to work. Paul Guillaume has been quoted as saying "In 1914, through all of 1915 and a part of 1916, I was the only purchaser of Modigliani, and it was only in 1917 that Zborowski became interested in him." The facts, insofar as they can be ascertained, bear out Guillaume to a point. By June of 1916, Leopold Zborowski was a great admirer of Modi's work. He appreciated it to the extent of wanting to represent Modi but was then in too poor a financial condition to do anything about it. Nevertheless, during the latter part of 1916 Zborowski apparently *was* associated with Modi and had clearly begun to represent him. Guillaume is wrong in saying that Zborowski became interested in Modi only in 1917.

As in the earlier postcard, Modi's reference to "working" probably referred to his painting for both Guillaume and Zborowski, besides his own occasional private sales. Again the postcards—this and the earlier one— reflect a basic optimism concerning his work. Certainly everything was not "fine"; but if we can judge from the existing correspondence, Modi never wrote home whiningly or complainingly, asking for money. Not that he ever had to, for Eugenia Modigliani was acute enough to read between the lines. Besides, she could have heard about her Dedo through Emanuele's Parisian contacts and from the Italian artists who traveled back and forth from Italy to Paris. Modi's casual, reassuring tone is a credit to his strength of character and to his high regard for his mother and his family. He also had his great pride.

Just who suggested Modi to Zborowski and exactly when the latter had the idea and began to represent him are matters for conjecture. Indeed, the details of their early relationship remain uncertain, although they can be put into some logical order. Guillaume says "and a part of 1916," implying that he was not a purchaser of Modigliani the remainder of that year, nor was Zborowski. The fact remains that there are portraits of Zborowski, his wife, Hanka (Anna); and Lunia Czechowska, a young married woman who lived with them, all dated 1916. So it seems fair to assume that Zborowski was "interested" in Modigliani before 1917 and had even managed to conclude an arrangement with Modi in the latter half of 1916. Zborowski was also probably advancing Modi a small weekly allowance by November, when Modi wrote the two reassuring postcards to his mother.

Guillaume was probably the first reputable dealer to appreciate Modi's work and to take a chance on him. There are portraits of Guillaume, also dated 1916. And Guillaume's remarks show an understandable resentment of Zborowski, who was a poor, dogged art peddler rather than a

professional dealer. Guillaume was careful; he hated taking risks against his better judgment, and apparently he had difficulty finding buyers for his Modiglianis. Zborowski was an amateur of art and yet he has been acknowledged as the man who made Modigliani, who established him as a modern master.

Modi was his own man, not the type to meet and make polite small talk with potential clients and collectors as dealers expected artists to do. Nor was he amenable to suggestions as to what to paint. He no doubt made this plain to Paul Guillaume. Their relationship was stiff, formal, and awkward compared to the relationship Modi was to enjoy with Zborowski.

We know it was Modi who recommended Soutine to Zborowski, with indifferent success at the beginning. Soutine put off Zborowski and was always anathema to his lovely, aristocratic wife Hanka, who regarded Soutine as a brute and a boor. He may well have been both, but he *was* a great artist, as Modi had recognized from the start, Zborowski in time and, finally, Paul Guillaume. When, later, Dr. Barnes showed great admiration for Soutine's work, Guillaume did not make the same mistake he had made with Modigliani. With a rich American eager to gobble up the entire market in modern French art, Guillaume plunged on Soutine.

The Marne battles had finally reversed the series of unrelieved disasters for the French, who were heartened by the heroic resistance of their soldiers and by the exhilarating incident of the taxis to the Marne when troops were rushed to the front lines by Parisian taxicabs. About six hundred cabs had been commandeered by the military government to run a continuous shuttle service that brought up a total of about six thousand soldiers to help throw back the Germans. This magnificent improvisation, so different from notorious Prussian efficiency, was the sort of drama an artist could appreciate. Otherwise, the war had become a deadly stalemate, a chess game where the same trenches were taken and retaken at terrible cost in both enemy and Allied lives.

Besides their hit-or-miss, late-afternoon bombing sorties, the Boche persisted in their efforts to demoralize the people of Paris with night plane raids. These raids generated excitement and a kind of hysterical defiance. As the air-raid signal whined, the wardens cried, *"Garde à vous!"* and saw that the streets were cleared. But there were people who wilfully disobeyed orders, refused to take cover in order to watch, almost daring the bombs to hit them. Modi, of course, was among these "death teasers." [5] After drinking with his friends, he joined in watching the spectacle as the sirens whined and the antiaircraft guns hurled shells aloft at the languid zeppelins caught in the glare of searchlights.

It was not easy to go home quietly after the big show. The air raids so

aroused Modi that sleep was out of the question. But the cafés were all closed, and there was no place to go, so Modi wandered the streets. As he walked he recited poetry and sang to himself. Attracted "by his vociferous chanting," he was overtaken by two policemen on bicycle patrol, who demanded his papers. Modi had had no papers of any kind since "the episode of the ashbin," when his sketchbook and identity papers had disappeared. But he did not panic nor was he the least abashed. "He plucked off a bundle of sketches from his pocket and, slipping one off as from a wad of notes, handed it over. One policeman looked at him indignantly."

He told Modi not to play the fool. Modi calmly handed over another drawing, only to anger the policeman still more, then peeled off a third. A potential spy for all they knew, he was ignominiously hauled off to the station house, which was in "a quarter where he was *not* known to the police." The *commissaire* asked his name.

" 'Modigliani!' he said, as if announcing the Kaiser himself."

The police found on him a letter from Emanuele, now a Socialist Deputy in Rome; this convinced them that they were not "dealing with a dangerous spy." The police released Modi and wrote to Emanuele, "who did the necessary and . . . added a letter stating who he was and asking those 'whom it may concern' to address him direct if his brother were found again without papers." [6]

Modi was probably unaware of the fraternal hand that extricated him, and would have resented it had he known. Illogical as it may seem, it pleased him to think that his name and drawings had managed his release.

Magnificently arrogant, Modigliani had a sure sense of identity. He never doubted his worth, and he was proud of proclaiming it to the world. In this, he had much in common with Oscar Wilde, whom he so much admired. Wilde, on first arriving in the United States in 1882, had supposedly been asked by customs officials what he had to declare. "Only my genius!" he had promptly replied, more than living up to his advance publicity. Modigliani had the same vital spirit. His belief in himself, in spite of endless setbacks, failures, defeats, was more sustaining than alcohol or hashish.

This same feeling of his own worth, the immortality of his work, accounts in part for Modigliani's openhandedness, even carelessness with his work. He abandoned sculptures with a lighthearted confidence that, because he had brought them into existence, it was enough. The legend of Modi's lost statues has been proved partly true. One such statue was found, reclaimed, and eventually put on permanent exhibition. The story is told in a biography of Lipchitz:

. . . Before the war a house was going up on the Boulevard Mont-
parnasse, but during hostilities the half-finished building was aban-
doned with stones and mortar strewn about giving the structure the
appearance of a crumbling ruin.

One day Modigliani wandered into the yard, hunted among the
many scattered stones for one that suited his purpose and settled him-
self with his chisel to work upon a sculpture. Afterwards, with that
characteristic recklessness of his, that wanton disregard of his talents,
he had simply walked away leaving his work to the elements and the
future. Winds came, storms, the sculpture toppled over and eventually
was broken. Someone took the pieces.[7]

This is a typical misunderstanding of Modigliani's motives. He did not
leave the statue out of wanton disregard of his talents. He carved the
simple figure of a woman kneeling on one knee, arms over her head and
folded so that her elbows were at ear level, her hands lightly against her
back, and her upraised forearms subtly supporting a slab. A clean supple
body, strong and graceful with a fine, curving back on which Modi
lavished hours of delicate care. The statue was too heavy to move, and he
felt no regrets leaving it there. He had done what he had set out to do,
drawn out of the stone what he had seen in it. Anyway, there was no
market for his sculpture and never had been. He had carved it for him-
self, no one else. He was like a poor servant girl giving birth to a beauti-
ful, unwanted child in the bushes. The caryatid was his love child, but he
had to leave it. And, if someone had argued with him, spoken of his
"characteristic recklessness" or "wanton disregard of his talents," Modi
might have asked, What did it matter what happened to it so long as it
had been done, so long as it existed?

The statue, wherever it was after being taken from the building lot,
languished unknown until months after Modigliani's death in January,
1920. Then it seems that Dollie (Madame Pierre) Chareau, wife of the
architect, got hold of Lipchitz and told him that she and her husband
had been offered "a broken piece of sculpture" as an authentic work of
Modigliani. The Chareaus were interested, but would buy the piece only
if Lipchitz certified it as authentic. The sculptor "came to see them and
recognized the piece immediately." Why he did is not further explained.

He knew Modigliani's work well, however, confirmed the sculpture as
genuine, and urged the Chareaus to buy it. Because it was broken and
"imperfectly put together," he volunteered to put it right. Since Modi
had "conceived it under the open sky and allowed it to remain there,"
Lipchitz felt, "He must have wanted it to be close to nature." He thought
then that it should be garden statuary (which was exactly what Modi
had told Augustus John he made). So the caryatid was mounted on a

pedestal in the Chareaus' garden. There it stayed until its owners sent it to an exhibition in San Francisco, probably the Golden Gate International Exposition, before the Second World War. The Chareaus later recovered it in New York, where they spent the war years. Mrs. Chareau had to put it up for sale after her husband's death. Thanks to Lipchitz, who had also fled to the United States, his dealer Curt Valentin bought the statue for his gallery. Then "Valentin sold it to the New York Museum of Modern Art where the charming *caryatid* came to rest at last at the top of one of the stairwells."

The bombing raids on Paris continued; the foreign residents took them with equanimity. In one instance Rosalie Tobia managed to find a practical solution when ". . . she was confronted with the problem of coping with an air raid and preparing food for her customers at the same time." Rosalie was doing her shopping at the central markets just as the air-raid sirens sounded. Here she was trapped, knowing that Modigliani, ". . . who was scheduled to peel potatoes for his food that day, was waiting at the restaurant for her," and that "other hungry artists" would be there too. It was a long raid, and she was far from the Rue Campagne-Première. Her basket filled with supplies, Rosalie squatted "on the subway steps in the center of the markets and worried." The subway stations and tunnels were used by the public as shelters during the air raids; the power was switched off, and "There was no means of transportation either above ground or below it." What to do? Poor Modi waiting . . .

Suddenly an idea came to her. She hoisted her basket onto her head and marched down the steps. Ignoring the crowds on the platform, she made her way down onto the tracks and disappeared into the tube. Under the river to the left bank she went plodding along the ties. She knew where she would have changed trains had any trains been running, and accordingly she changed lines at the proper station as she trudged up the slope of the left bank on foot. At last she emerged in triumph at the Place Denfert Rochereau just a short distance from her restaurant. The air raid was still on and the power still off, but art was saved.[8]

The story is typical of the sturdy, indomitable, irascible Rosalie.

Nina Hamnett returned to Paris from London, and showed the same hardy spirit as Katherine Mansfield in overcoming the red tape and restrictions of war. Her Edgar had been released from jail and had written to Nina, who borrowed five pounds from a friend, and hurried over to join him. She went with him to "live in La Ruche, near the Porte de Versailles, his mysterious residence." Nina earned a little money posing for an American sculptress; Edgar kept on with his art. He had "found a

large spider in the garden and did drawings of it every morning." Nina
called on Modi.

> Modigliani was living in the **Rue St.** Gothard [actually 16 Rue du
> St. Gothard] and Edgar and I went to see him. He had a large studio
> which was very untidy and round the walls there were gouache draw-
> ings of caryatids. They were very beautiful and he said, "Choose one
> for yourself." The bed was unmade and had a copy of *Les Liaisons
> Dangereuses* and *Les Chants de Maldoror* upon it. Modigliani said
> that this book was the one that had ruined or made his life. Attached
> to the end of the bed was an enormous spider-web and in the middle
> an enormous spider. He explained that he could not make the bed as
> he had grown very attached to the spider and was afraid of disturbing
> it. This was the last time that I saw him as, soon afterwards, he went to
> Nice.[9]

Once again Nina shows her appreciation of Modi's art, and Modi, his
generosity in giving away his work to people he liked. Beatrice Hastings'
biting condemnation of Lautréamont and of Choderlos de Laclos had no
effect whatever on Modi, who maintained that his bible, *Les Chants de
Maldoror,* had ruined or made his life. Keeping an enormous spider in its
great web as a pet at one end of his bed was a macabre conceit thor-
oughly in line with *Maldoror.*

The year 1916 was an active one for Modigliani, perhaps the most ac-
tive since he had given up sculpture to devote all his time to painting. A
number of charming portraits of young girls, including his *Little Girl in
a Striped Dress, Girl in a Sailor Collar, The Servant Girl,* and *Lucienne,*
were done that year. Modi left many of the most beautiful portraits of
children and adolescents ever done by any great artist. He must have
loved them because he painted so many of them in a time when his con-
temporaries did not. He "showed their tenderness, their bewilderment,
their smiles, their surprise or their melancholy." He was enchanted with
the mystery and loveliness of young girls turning into women. Of one
such magnificent portrait now in a private collection in Basle, it has been
said, "In this small figure, so pure and simple, there glows that tremulous
enchantment of a beauty that is just forming, the springlike and fragile
grace of an age of transition." [10]

The portrait *Little Girl in a Striped Dress* is undoubtedly of the same
thoughtful, sensitive, serious child that Modigliani had portrayed in  his
often-reproduced *Girl with Braids.* "Modigliani was fond of this little
model, and painted her many times, sometimes with a small friend of
hers, and in the dark striped dress that sets off the light of her enormous
eyes. . . . She may have been the daughter of a concierge or shopkeeper
in Montparnasse." Undoubtedly she was one of the crowd of appealing

kids who hung around the area where Modi lived. He seems to have seen something special in her, for ". . . in that fragile, astonished face, in the heartrending appeal of that small pigtail, in those over-large ears, Modigliani found one of the highest motifs of his poetry of the people." [11]

The same year Modi painted Max Jacob bald and hatless and, again, wearing the high hat that his old friend liked so much. He also did portraits of a Monsieur Lepoutre and a Monsieur Deleu about whom little, if anything, is known. These were probably done on commission, for Modi was still a painter for hire who could be employed by the day at the same price of twenty francs a sitting, a model, paints, and a liter of rum. The price fluctuated with what the market would bear, however. In his case, he always found that the market would bear very little, and his price was flexible.

The more steadily Modi painted, the more he refined his art and, oddly, the more casual his methods became. Painting his friends, Jacob, Kisling, Picasso, and, either in 1916 or 1917, Jean Cocteau, usually in Kisling's studio at 3 Rue Joseph-Bara, Modi proceeded in a disarmingly informal fashion. Emile Schaub-Koch, who knew Modi and must have seen him at work, describes his methods. As Modi's production intensified, he painted for his own pleasure without wanting to sell, something he had to let others do for him because he was totally incapable of doing so himself. He painted eagerly, more often than not without an easel or palette; nor did he even own a box of colors. Modi arranged the sitting by setting two chairs opposite each other, sitting on the first, and standing his cardboard or canvas on the seat of the second.

Without bothering to arrange a pose, he stared at his model for several minutes, then made a rough sketch, usually in India ink. This done, he looked up at his model again. Now he turned to one of his friends who happened to be around, Soutine, Kisling, or Jacob, asked him to get the four or five tubes of color he needed and, once he had them, squeezed out the needed colors on the first piece of wood that came to hand. Finally, he set to work with amazing virtuosity and, in one or two hours, the work was done. The nudes took longer. Where in his early years he had used a decorative line and décor, now for him décor was where the work was hung.

When Modi found himself in front of someone he was going to paint, he concentrated on the expression of the feelings he saw in his sitter's face, not on the features themselves. It was part of the process of creation. Then Modi began painting, paying no attention to his model, preoccupied with conveying through his drawing the essence of what he had discovered. This approach produced an unexpected result that not only had nothing to do with the subject but was also disconcerting. Through a series of recalls, retouches, and improvements through successive compari-

sons between the model and his first rough sketch, Modi always succeeded in capturing something powerful and moving in his subjects. He caught a manner or a resemblance that *was* the subject.

Modigliani understood the complexity of his sitters' feelings. He painted them as he understood them. Study of Modi's drawings is fruitful, in this respect, for all feeling comes from the drawing. Color, as Schaub-Koch explains, only adds charm to the pictures of such different artists as Maurice Quentin de La Tour (1704–1788) or Tiepolo, but a portrait by Modigliani adds something more. Modi evolved with the Cubist painters who were his friends. They tended to give their pictures colors by giving them complementary tones in the seven fundamental colors. This produces pleasant harmonies and what Cézanne, among others, called unity.

This same unity dominates all of Modigliani's paintings, but—and this accounts for so few of them being sold or appreciated in the artist's lifetime "unfortunately no one understood this until it was too late and some imbecilic critics have only seen 'a certain poverty of means or manner.'" Such critical strictures on Modigliani's art are still common today when he is accused of being limited in technique and subject matter.

> For a knowing observer who takes the trouble to see, unity results in a feeling that dominates and that graphic, plastic, and color techniques only tend to brighten and fulfill the whole. This develops a fatal simplicity that is the foundation of an aesthetic. The suppression of all unnecessary details, of all sterile symptoms is vital. But that brings forth a richness, not a poverty of means, especially if one realizes that the radiance of an individual thus manages to populate a world which is a painting.[12]

As Malraux puts it, "The language an artist of genius discovers for himself is far from enabling him to say *everything;* but it enables him to say what he *wants* to say." And this was something Modi had searched for all his artistic life, built on his experience in both painting and sculpture.

> The author uses his early works as a starting-off point and not with an eye to "perfecting" them; he uses them thus because they confirm the personal system of relations synthesizing the facts of visual experience which his genius substitutes for life itself. It was this total substitution that Cézanne looked for in what he called his "realization." Genius is not perfected, it is deepened. It does not so much interpret the world as fertilize itself with it. . . . This creative freedom is the hallmark of genius, the density of the work of art is its "realization," and the masterpiece its most favored expression.[13]

Art was a kind of radioactivity, Schaub-Koch thought, and Modigliani, as many of his sitters, including Cocteau, acknowledged, exerted his influence on his model. Once the portrait was done Modigliani vanished, but "his precious facility of emanation continued and even made his surroundings quiver with it. He painted and drew as others walked and talked, by pure physical aptitude, and we all know how his work gave out a spirituality." Modigliani had a deep sense of friendship, which he said was the noblest sentiment of man. But Modi "asked of his friends more than they could give."

Modi once gave his friend Sylvain Bonmarriage, the novelist, a fine, small portrait of a woman who owned a dairy shop (crémière). Bonmarriage was delighted with the painting and proud to have it on his wall. Then one day Modi came over to his room.

"Listen, old man," he told his friend, "I'd just as soon tell you without preamble: I have a buyer for that painting I gave you. He's willing to pay four hundred francs. You're not going to let me miss this opportunity, are you?"

Bonmarriage nodded, took the painting from the wall "slowly, sadly, reluctantly, letting his eyes linger on it as if he wanted to impress it in his memory." He handed it over without a word. Modi could only find these words with which to thank him:

"I envy you for the opportunity of proving our friendship by making such a sacrifice." [14]

During 1915 and 1916 Modigliani's paintings were among those a number of his friends exhibited in a small, improvised gallery at 6 Rue Huyghens where, perhaps for the first time, the arts seemed to have been combined with a social atmosphere. The works of modern painters were shown; there were readings by modern poets and music by modern composers. The date of the exhibit has sometimes been put earlier in 1915, but Lunia Czechowska recalls that it took place in June, 1916. [15]

"La salle Huyghens," as it was called, was not a gallery at all but the studio of a Swiss painter named Lejeune. Blaise Cendrars, a fellow countryman, had talked him into lending it as a poetry and art center of Montparnasse:

It was the high point of the Montparnasse adventure, and everyone, who has a name today in painting, literature, poetry, and music, made his debut in the basement located at the end of the courtyard. One saw there the work of Kisling, Waroquier, Modigliani, Matisse. And in this setting the composers of the group of six: Satie, Auric, Honegger, Poulenc, Milhaud and Germaine Taillefer had their works played by Ricardo Vinès. Worldly Paris mingled in these sessions with artists in sweaters, who had come from the Rotonde and the Dôme and made a smoke screen with their pipes around these elegant people. There were,

in this dingy, badly-heated studio, moments of rare artistic quality of a kind that occurs but several times in a century.[16]

La salle Huyghens was a center of *avant-garde* work, a collection of the latest thing in the arts. The sculptor Ossip Zadkine mentions the exhibition in the Rue Huyghens studio:

. . . where we each have a wall, Modigliani, Kisling, Durey and I, and where, for the first time, the "Six" play their works. Cocteau and Cendrars read their poems. During this time they began "taking care" of Modigliani. I think he saw through those who were taking care of him, but he said nothing. And then he loved Mademoiselle H . . . , his friend who was then his only friend. A real person for she was good and had a beautiful soul.[17]

Mademoiselle H refers to Jeanne Hébuterne, but since it is definitely known that Modi did not meet her until July, 1917, it would appear that his paintings continued to hang on a wall in the Rue Huyghens studio well into that year. Kisling's remarks, also recalled ten years after Modi's death, are much more emotional than Zadkine's:

What can I say of him that is new? That he was almost a brother to me, that I loved him and often admired him? And that Salmon and I did everything to assure his burial. They stole my documents, my photographs, and newspaper men of all the countries of the world came to cull them. Here is the catalogue of an exhibition that was held in that famous room, at 6 Rue Huyghens. That's fifteen years ago! "La Lyre et la Palette" presented in this order:

> Kisling, Matisse
> Modigliani, Ortiz de Zarate
> Picasso

Modigliani exhibited fifteen portraits of which those of Madame Hastings and Paul Guillaume inaugurated "Negro" art. What a period . . . Cendrars praised Erik Satie . . . and Cocteau, and all the others. Poor and great Amédée.[18]

Lunia Czechowska speaks of the many painters who congregated at the Rotonde and were given free drinks and *café-crèmes* by the sympathetic, art-loving proprietor, Libion. She adds that many of them were well known, but most of them were still struggling, including Modigliani. She writes that, after having seen an exhibition of Modigliani, Zborowski told her with a sort of intuition: "He is a very great painter. I am sorry that I don't have enough money to allow him to work without having to draw on café terraces." She adds that Zborowski was so obsessed with the idea of Modigliani's greatness that he forced himself to earn fifteen more

francs a day and offered this amount to Modigliani in exchange for his production. Madame Czechowska says that Zborowski also agreed to furnish canvas and colors. "This is how he began his career as an art dealer." No doubt it happened in much this way, but there were other circumstances which led to Leopold Zborowski's becoming Modi's dealer.

Madame Czechowska says that in June, 1916, Zborowski took her and her husband to an exhibition of Modigliani, which could only have been the gallery at 6 Rue Huyghens. Afterward, they went to sit on the terrace of the Rotonde with some other painter friends. Then, as they sat there, she saw crossing the Boulevard Montparnasse "a very handsome young man, wearing a big, black felt hat, a velvet suit, a red scarf. Pencils stuck out of his pocket and he carried under his arm a big carton of drawings; it was Modigliani." Spotting her unerringly, for she was a provocatively lovely young woman, Modi went over and sat down next to Lunia. She was struck "by his distinction, his radiance, and the beauty of his eyes. He was at the same time very simple and very noble. How different he was in his least gestures, even to his way of shaking your hand."

Although a young married woman, Lunia was impressionable, and her writings betray that she instantly fell in love with Modi, although she was always to insist that theirs was an exalted spiritual attachment, of the soul alone. As she recalls it, Modi sketched her as he talked—no doubt charmingly and winningly. She says it was only later she realized that, while he gladly gave away his drawings, he often refused to sign them. She remembers a woman who asked Modi to draw her portrait. Modi willingly did as she requested, but absolutely refused to sign it. In her case, says Lunia, she insisted. Modi obstinately refused. Finally, he took the drawing and filled the whole page with his signature. She remembers his sure, beautiful hands, the way he traced lines on paper without ever correcting them, and how in a few pencil strokes the drawing was done.

Lunia admits that she was very young and very timid at the time. Now she was terrified when, after only a few minutes and in the presence of her husband, Modi asked her to go out with him that evening. Lunia explains that so far as Modigliani was concerned she was alone. He also expressed so warm a sentiment for her that he appeared to expect Lunia to abandon everything in her life and follow him. "Poor dear friend," she writes, "what seemed so natural to him was so outlandish to me!" Then Zborowski—and not Lunia's husband as one would expect—came to the rescue. He explained that they had decided on their plans for the evening, and politely invited Modi to join them. Modi, says Lunia, refused. He turned toward her, held out the drawing he had made, and asked her to come pose for a portrait the next day.[19]

Modi had no doubts where susceptible young women were concerned. Lunia was pretty and fresh; she blushed and palpitated. She was over-

come and showed it. Modi knew what he was doing, knew the signs, looked for them. He had made his pitch, given Lunia his best line, guessed she was attracted to him, and waited for his reward. What did he care about husbands? Modi knew how to handle them. His affair with Beatrice Hastings was all but finished. He was soon to establish a liaison with Simone Thiroux who had had her eyes on him for some time. But for Modi, any woman was fair game, any time, any place.

Lunia did have her portrait painted by Modi. She was afraid of him but she was also attracted to him and wanted to please him. She saw to it, however, that suitable arrangements were made. Since Modi had no studio she went the next day to Sunny Hotel, a little place on the Boulevard de Port-Royal, where the Zborowskis were living.

Here, says Lunia, he did his first oil portrait of her, which shows her in a black dress and is now in the museum in Grenoble (and possibly the first Modigliani bought by any museum). She says that afterward they became great friends. Modi was "a charming being, fine and delicate. I knew that he loved me, but I felt for him only deep friendship. We went out often together and vagabonded around Paris: in those days, he didn't drink." This is hard to believe because Modi always drank, except for those early months in Paris, but Lunia does explain that Zborowski had already told her that he liked to drink as he painted. Lunia never would forget the first time she posed for Modi:

. . . Gradually as the session went on and the hours passed, I was no longer afraid of him. I see him still in shirtsleeves, his hair all ruffled, trying to fix my features on the canvas. From time to time he extended his hand toward a bottle of cheap table wine (*vieux marc*). I could see the alcohol taking effect: he was so excited he was talking to me in Italian. He painted with such violence that the painting fell over on his head as he leaned forward to see me better. I was terrified. Ashamed of having frightened me, he looked at me sweetly and began to sing Italian songs to make me forget the incident.[20]

The Zborowskis moved into their apartment at 3 Rue Joseph-Bara in 1917.[21] Lunia went to live with them, all the while keeping possession of her apartment on the Rue de Seine. Her husband was at the front, she explains, and had entrusted her to Zbo's care while he was away. As for Zbo, he was like a brother to her. Madame Czechowska makes no further mention of her apartment, but its very existence, when she speaks of going out often with Modigliani and vagabonding around Paris with him, makes for some eyebrow-raising. And she never again mentions her husband in her memoirs.

She does, however, speak of another man needing her badly, of her being kind to him, in spite of Modigliani's annoyance. She writes of

Zborowski's desire that she be nice to Modi and of how she held back because she knew that Jeanne Hébuterne loved him. Lunia was also aware that Modi loved her in his way at the same time that he loved Jeanne, or so Lunia says.

Despite the fact that her memoirs are often more poignant for what she obviously does not or *would* not say, one has to believe that she was true to herself and her beliefs as a decent, respectable married woman. No matter how much he pleaded, it does not seem that Lunia ever gave in to Modi. It is clear that Lunia wanted to change, make over, reform Modi, to save him from himself. Fortunately for her, one feels, the matter was out of her hands.

∽∽∽ Chapter Twenty-four

*"So what! I want a short but intense life."*

**M**odigliani told Lunia that during his early days in Paris, he had fallen in love with a woman who gave him the taste for alcohol and even drugs. If one did not know Modi's background, personality, and the fact that he had experimented with hashish before going to Paris, one could almost gloss over a good deal to believe this. It would appear that Modi, always ready with a line, told the susceptible Lunia exactly what she hoped to hear, and she took his romantic nonsense to heart. She believed that Modigliani would have been a better man, and enjoyed a long, fruitful life if he had only been attached to a good, sensible woman like herself. She says he was really not an alcoholic, not so much, one infers, because he may have been one, but because someone like herself could never have been so devoted to a common alcoholic.

Lunia assured herself that Modi drank only when some problem tormented him, overlooking the fact that Modi was *always* tormented. She knew that his health was delicate and that excesses worsened it. (Jacob Epstein, however, always spoke of him as being sturdy and robust, and Modi must indeed have had a strong constitution as well as amazing recuperative powers to have withstood the abuses to which he subjected himself.)

In spite of his gentle character, Modi managed to have violent quarrels when he was drinking, Lunia says, but never with his friends. Max Jacob, Kisling, Ortiz de Zarate, Lipchitz, Rivera, and others have testified to the contrary. She is equally wrong in saying that Modi had few friends among the painters, "most of whom envied this enthusiastic and cultivated dreamer. His real friends were Utrillo, [Léopold] Survage, Soutine, and Kisling." She omits Jacob and de Zarate. Actually, Modi had many

friends among painters, but few envied him anything but his good looks and success with women. Only a few really liked him, because he made himself so hard to like. And possibly only one or two understood the purity of the man that was inseparable from the purity of his art.

What Madame Czechowska has to say about Utrillo shows her compassion, her soft heart, and her lack of understanding of alcoholics. Modi had affection and pity for Maurice, who, in 1916, was again in a sanitarium. Modi suffered more than any of them because of the shameful surroundings in which Maurice had to live, says Lunia, felt deeply for him, and many times asked her to accompany him and take Maurice for a walk. As it was, Lunia went to the sanitarium every day to visit Utrillo with the Zborowskis. They brought canvas, paints and, incredibly, what seems to have been a little bottle of crème de menthe, though all drink was forbidden him.

Lunia found the visits painful. The asylum was sinister and the inmates pathetic. But Utrillo had an easel and painted landscapes from postcards. Much like Van Gogh in his period of confinement, Utrillo persisted in doing what mattered most to him.

One day Madame Czechowska managed to trick the attendant, probably by concealing the bottle somewhere on her person, and passed some wine on to Utrillo. She explains that she did it only because he demanded it so often that she did not have the heart to refuse him. After making sure that they were alone, Lunia took out the bottle, and Maurice jumped on it, trembling with excitement. He was so eager to uncork the wine that the bottle slipped between his hands, fell to the floor, and broke. Then he threw himself to the ground and lapped up the wine, spitting out pieces of glass as he did so.[1] Lunia never brought wine again, in spite of Maurice's pleas.

The treatment of the mentally ill, even in 1916, was not much different from that of the Middle Ages. Little could be done to help or treat them. From time to time Utrillo was allowed to leave the asylum for two or three days. One day he managed to escape, and appeared at the Zborowskis at six o'clock in the morning, wearing only a shirt and trousers.

> . . . He had passed the night in a Montparnasse bistro and had spent all his money; then he went on drinking, leaving as security his overcoat, his hat, his jacket, and his shoes. Zbo found the bistro in question, recovered his clothing, and took Utrillo back to the asylum.[2]

Many conflicting impressions of Leopold Zborowski have been left by those who knew him, a number of them unflattering, but that he was a good, devoted, loyal man, indefatigable in the cause of Modigliani and, later on, of Soutine and other artists is the opinion of most. Those who

claim that he was interested only in exploiting Modi, in making money on him, that he lived high after Modi's death, cultivating the rich, wearing a big fur coat, and driving a limousine, will have to explain Zborowski's self-sacrifice and relative poverty. He was also broke when he died in 1932. But those who had had no faith in Modi's work when he was alive, who plunged only when his paintings had a market, managed to make fortunes in Modiglianis. They, not Zborowski, were the greedy, grasping, and self-serving.

It is probably natural that the protector of a painter of so much legend and controversy as Modi should be misinterpreted and maligned, particularly by those who rushed to get their uncomplimentary impressions into print while there was a market for them. Surely the most improbable estimate of the man comes from Marevna Vorobëv, who describes Leopold Zborowski as

> . . . a Polish poet, who also liked to sniff cocaine . . . a Polish Jew, who with the help of the drug, took himself for a second Rimbaud. I do not know how he cast up at Montparnasse: what I do know is that he had dragged out a wretched existence until the day when a Polish woman took him in hand and rescued him from penury and madness. She lived in the Rue Joseph Bara, and together with her he began to "protect" some painters, among them Modigliani, who was the first, and Soutine. He proposed to take me up, too, but he wanted me to change my name from Marevna to Stebel, and I refused.[3]

This outrageous account is so at variance with even the worst that others have said about Zborowski that it is hard to give it any credence at all.

If Modigliani "had not met Zborowski, who was a poet first and dealer afterwards, . . . he might never have been widely known." Douglas Goldring, this time speaking on his own in the epilogue of *Artist Quarter,* feels that "Zborowski is the real hero of this story." If he had been writing an opera libretto or a film scenario "on Modigliani themes and calling it 'Montparnasse,' Goldring would have made "the lovable, patient, tragi-comic Polish poet the central figure." Only the self-sacrificing "life of Zborowski would be bearable on the screen; . . . Modigliani could only be tolerated in brief glimpses. . . ."[4] The recent film based on Modi's life seems to bear out Goldring's opinion.

Leopold Zborowski, known familiarly as Zbo (or Zboro), was born in the village of Zaliszckyki, Poland, in March, 1889. A poet who became a picture dealer by accident, Zbo had a thick black mustache and beard and a serious, dedicated air. (See photograph, facing page 385.) He looked enough like Lenin, who was then in Paris and frequented the Rotonde, to be sometimes mistaken for him. Zbo's parents, who were fairly well off

and left Poland for Canada while Zbo was still a boy, left Zbo behind in care of his elder sister.

Zborowski, like Modigliani, was sickly as a boy. He was both rheumatic and had a heart condition. He was an avid reader who was lost in romantic dreams, and solitary because he was unlike the sports-loving boys of his own age. He studied at the university in Cracow, where he "took the degree of *Licencié ès lettres*," which is similar to the American Master of Arts degree.[5] Zbo began writing poetry of a special kind:

> He was a member of the *Groupe du 41ᵉ Degre* . . . a Constructivist school of poetry . . . with its extremists just as Cubism had in painting. Zborowski was the "nightingale" of the group. Though he railed against the poetry of old Poland, each of his poems nostalgically evoked his native land.[6]

He came to Paris in 1913 "to study French culture at the Sorbonne" and also because ". . . the climate of Cracow was considered unhealthy for him." At the outbreak of the war he was trapped in Paris and unable to keep on with his studies. His only talents were literary. He had recently married Hanka Cirowska, "—daughter of an old and wealthy family of Polish aristocrats and a Madonna-type—who was studying to become a teacher."

Zbo was used to poverty, and demanded "little of life as far as material things were concerned. A friend, when asked how Zborowski lived in those days, replied: 'How *does* a poet live?' " Zbo hung about the Rotonde, knew and met the artists, poets, and writers who congregated there, and spent hours on the terrace "drinking an interminable *café crème* and scribbling in his notebook, young, pale of face, melancholic of eye, and bearded."

During the early years of the war, Zbo kept on writing poetry and looking for ways to support himself on the side. At one time he "was hired by an agency to address envelopes at the rate of three francs the five hundred, working by artificial light while summer called to him from out of doors." [7]

Lunia Czechowska says that Zbo, a childhood friend of her husband's, came from Lwow and arrived in Paris in June, 1914. Considered an enemy alien at the outbreak of the war, he was confined to a concentration camp, and when the government gave interned Poles their freedom, he came out ailing and very depressed. At this stage, says Lunia, he had to depend on his friends to keep alive, but he did earn money by unearthing rare books from the secondhand stores and stalls. He also sold engravings, and one day sold a miniature, whose value he didn't know and which he had bought only because it appealed to him, for the astronomical sum of fifteen hundred francs.

Zbo seemed to have a sales knack but, more important, he was sensitive to art, Lunia says.[8] It was only a step from literary middleman to art dealer. Though he became an excellent salesman, he was never really a good businessman. In any case he began to think of selling pictures. He liked the idea of helping painters who, while expert at expressing themselves on canvas, had neither the time nor the inclination to sell their work. On top of this, Zbo was moved by the plight of Montparnasse's indigent, floundering artists, particularly a lost one like Amedeo Modigliani.

Zbo recognized Modi as an artist of outstanding talent and personality who was literally wasting away for lack of recognition. Zbo had watched Modi sketching, seen him drunk and vituperative, and must have been aware that Paul Guillaume was gingerly handling his work on a vague no-commitment, commission basis. Zbo was apparently convinced that Modi needed guidance and understanding from a loyal, sympathetic dealer who would also give him a contract, pay him a weekly salary, and break his neck to establish him.

The friendship that was to bind Zborowski and Modigliani was "an example of the attraction of opposites," the one ". . . sober, patient, long-suffering and gentle in the same degree" that the other ". . . was doped, drunken, irritable, and violent." [9] But both had intellectual and poetic natures; both had a romantic and idealistic turn of mind. Zbo was happily married, devoted and faithful to his lovely distinguished wife. He drank moderately, liked to smoke a pipe, never had any desire for drugs. His only weakness was poker, which, given his total inability to bluff, he played badly.

Jacques Lipchitz believes that Moïse Kisling introduced Zborowski to Modi and urged Zbo to become Modi's dealer. But it was Fernande Barrey, Foujita's first wife, according to her own account, who suggested to Zborowski that he represent Modi, as he was already doing for other young painters.[10]

The exhibition on the Rue Huyghens had enhanced Modi's reputation, even though La Jolie Menagère, which later made all Modi's work go up in price, had then found no buyers at two hundred francs. Modi had printed the title across the top of the portrait of this young girl, who was either a housekeeper or waitress, in a black dress with a white collar and apron. She was seated with her hands in her lap, a market basket hooked over her left elbow. To her right was a cupboard filled with china. She was a sweet, pretty, appealing girl with a black ribbon in her hair, blank eyes, a funny nose, and an endearing, quirky mouth.

Zbo was not in a position to pay Modi a steady income. In 1916 he seems to have fallen ill and gone to Nice to convalesce while his wife Hanka carried on his small art business. She later told Modi's friend

Francis Carco of her early association with Modi, and while Carco, like most of Modi's friends in Montmartre and Montparnasse, is inaccurate about dates and circumstances of which he had no direct knowledge, Hanka's account seems plausible.

Meeting Modi on the street in Montparnasse, Madame Zborowska agreed to pose for three portraits. Modi promptly sold two to a neighborhood barber. The portraits seem to have been nudes, and were probably done in the Zborowskis' rooms with Lunia Czechowska serving as chaperone. His agreement with Hanka was that he would give her the third portrait in exchange for her having sat as his model.

Modi did paint the third portrait, but since it was still wet after the sitting, he had taken it back to his room. As luck would have it, says Carco, a buyer turned up the next morning and paid him ten francs for it. Soon after this transaction Madame Zborowska arrived at Modi's at the time he had appointed to turn the portrait over to her. Modi was sorry. He shrugged and gave her a lamely truthful explanation:

"You know how it is. I needed that money."

Hanka did not bother to argue with him. She went home, sold a painting of Derain's and another of Kisling's, and cleared enough to pay for her husband's return trip to Paris. It was the middle of the war, Carco says, and somehow Hanka did not have the proper identification papers on her person to manage the details of getting Zbo back to Paris. And so—a nice human touch—it was a contrite and obliging Modi who expedited matters in his own name.

Once back in Montparnasse, Zbo sold another picture of Derain's for a thousand francs to a Norwegian named Halworsen and was able to put Modigliani under contract. From then on, Modi took to painting in the Zborowskis' rooms in the Sunny Hotel, Boulevard du Port-Royal. He was very punctual, Madame Zborowska told Carco, working in the afternoons from two to six. He relied on Zbo not only to buy charcoal, paints, canvas, and whatever other supplies he needed, but also to choose his models.

Hanka told Carco that

. . . contrary to what others have pretended, Modi always behaved toward us in the most correct fashion. He never once came to the hotel drunk. He got up late, went to have lunch at Rosalie's in the Rue Campagne-Première, then came to our room and set right to work. In a sitting of several hours, he usually managed to finish a painting of medium size. The others took him double or triple the time.[11]

Modi scarcely drank a bottle of wine at a sitting. Zbo paid for it—their contract stipulated that all of Modi's supplies be paid for, including his

room, which was then in a little hotel almost opposite the Café Procope in the Rue de Buci. He was paid twenty francs a day, but spent them quickly and came back to the Zborowskis at night, asking for an advance on the next day's work. The Zborowskis had barely enough money to pay him by the day as it was; they were often obliged to turn out the light and pretend that they were not at home. To keep Modi in funds Zbo had to borrow money on other paintings; Modi's were not selling.

Modigliani continued to make drawings, and according to Hanka Zborowska, they were bought in lots of tens by a brother of Lucien Descaves. On those nights they left the room lights on, which Modi came to recognize as a good sign. Later in 1916, Mme. Zborowska and her husband left the Sunny Hotel for an apartment in the Rue Joseph-Bara. As the war went on, the painters had a more and more difficult time. "Sometimes," said Hanka to Carco, "just so we could have a little something to eat, I went to the grocer and bought a kilo of beans (*haricots rouges*), which Modi shared with us."

The nudes, about thirty of them, were all done in Zborowski's apartment during the winter of 1917. Modi would begin by drawing, then rest a moment before taking up his brushes. When a model didn't please him, instead of complaining as so many painters did, he vented his annoyance

by exaggerating the expression of bourgeois dignity he found in their features. But never an obscenity, nor a reproach. His only manner of protesting was in laughing, sometimes all during the sitting, or in declaiming passages of Dante which he knew by heart, or of Rimbaud or Verlaine. Then one knew that he shouldn't be annoyed.[12]

In telling the story to Carco, Hanka Zborowska apparently took pains to stress Modigliani's gentlemanly attributes. No doubt Modi tried to behave at the Zborowskis, especially in the presence of Hanka, who was not only beautiful but a lady, always. A good, honorable woman and devoted wife, Hanka seems determined to remember only the finer things about Modi, as many people do looking back on some dear, difficult departed. But ordinary people have no legend to contend with.

During this time, Modi certainly did not neglect the girls, who were as essential to him as alcohol. Before becoming permanently attached to one in particular—and apparently rather against his will at that—Modi enjoyed a number of temporary affairs. Worn and used as he was, he was as attractive as ever to susceptible women.

Modi apparently knew who Simone Thiroux was, and she knew him long before they got together. She had watched him make his lordly en-

trances and exits at Rosalie's, sighed over his glowering good looks and wished, as her girl friends did, that he would find her desirable. Simone had seen him with Beatrice Hastings, observed him sketching at the Rotonde, and heard all the stories about him. Simone yearned for him. Modi liked to do the pursuing. Besides, he preferred stormy, passionate women like La Quique and Beatrice. Simone was no challenge. She was already in love with Modi, longing to give herself for the asking. Modi did not ask right away.

Those friends who spoke of Beatrice Hastings as *la poétesse Anglaise* seem to have referred to Simone Thiroux as *La Canadienne*. According to her friends Dr. and Mme. Dyre Diriks, Simone, the daughter of a Canadian father and a French mother, respectable, well-to-do people who had died when she was a baby, was born and raised in Canada. She was brought up by relatives, "an aunt of very narrow views, and an uncle, a prelate of some sort." Her strict upbringing was constantly in conflict with her essentially happy-go-lucky nature and generous, easygoing bohemian view of life.

She was a sickly child and, like Modi, tubercular from an early age. She loved music, played the piano well, and her dream was to live in her mother's country and to study—some say medicine—in Paris. Once she came into her inheritance from her mother at twenty-one and was a free agent at last, Simone promptly left Canada for Paris, where she lived with another aunt on the Rue Huysmans in Montparnasse.

According to the Diriks, Simone was a very nice, pleasant, kind girl, who could not conceive of evil, who could be good to the point of stupidity (although this last opinion of Marguerite Diriks seemed a little exaggerated to her husband, who did not think Simone stupid). She did not seem, however, to realize the relative importance of things, especially the importance of her health. She took no care of herself at all, and to the very end was negligent in the extreme, in spite of the advice and concern of all her friends.

She was blue-eyed and fair-haired, something between *blonde cendré* and *châtain clair,* which is a comparatively dark shade of blonde. Simone was of average height, more or less heavily built but not fat, had drooping shoulders and a very beautiful *"décolleté,"* which she was very proud of and displayed on every possible occasion. She always wore very low-necked dresses.

Léon Indenbaum recalls that she had a peculiar look about her, with curious eyelids, as in the portraits of certain angels whose lower eyelids are a little swollen.[13] Independent and with money to spend as she pleased, Simone enjoyed the bohemian way of life in Montparnasse and indulged the same wild generosity that had so often made Modigliani

penniless. She gave money to friends, lent some to others, and never saved a penny. Careless and wasteful, she never thought of mending her stockings or washing her soiled underclothes: it was easier to throw them away and buy new ones. While she had money, Simone was Lady Bountiful. "To help artists with paints and cigarettes, to buy boxes of sweets or food for their women, was her delight, and Heaven knows in those war days a Rothschild could have gone broke helping everybody." [14]

Gossip at the time had it that she was rich and that Modi blew her money on drugs and drink. This was denied by Madame Diriks. "In all Modi's love affairs he could never have been accused of running after women for the sake of their cash; that was as alien to his character as the inability to keep money himself was part of it." [15]

Simone did not study medicine in Paris, so far as is known. The mistaken notion that she did may be because she worked as a nurse at the Cochin Hospital. She does seem, however, to have taken her *baccalauréat,* or Bachelor of Arts degree, before coming to Paris, and then gone on with her studies, probably at the Sorbonne, while living with her aunt in the Rue Huysmans. Simone had spent or given away most of her inheritance by the time she met Modi. She hadn't enough to pay her school tuition at the time and ". . . when they were together she was giving lessons in English, and Modi was as usual running about with his blue sketchbooks and as vainly as ever soliciting dealers." [16]

Simone was pretty, though her complexion was purplish; her figure was good, though her flesh was very soft; and, while she lived for a time without doing anything in particular to earn a living, Dr. Diriks said that she was neither promiscuous nor a prostitute. She was one of those girls who are crazy about art. They themselves are half-model, half-artist, of a type very familiar in Montparnasse at the time. She confessed to unshakable admiration for Modigliani, and showed it by taking him to his room when he was drunk and helping him get to bed. "Accustomed to putting Modigliani to bed, she ended by going to bed with him herself, and it was thus he gave her a child." [17]

Modi painted Simone many times, but she was not interested in his art so much as she was in him. After his battles with the spiteful Beatrice, he found himself loved for himself by a faithful, loving, undemanding young woman. Beatrice, however, did not drop out of sight. One evening at the Rotonde, Simone and Modi were seated at a table when "the lady of the Butte" entered the café, perhaps with Alfredo Pina.

There was a furious row, for which Modi was no doubt largely responsible. One result of it was that a broken glass cut La Canadienne over the eye, leaving a scar that she bore for life. Libion, at the time

exasperated by his continual troubles with the police, had them all put out.[18]

Defended in the line of fire, then taken care of solicitously, Simone must have been convinced that Modi truly loved her. No doubt she expected this to make all the difference in their relationship. If love was a bond, the fact that both were tubercular may have seemed another, equally strong. Modi probably never mentioned it, but he coughed a great deal, and Simone knew all the symptoms of the disease. Destined to be lovers, it was somehow fitting that they were similarly afflicted—and doomed. The night of the Battle of the Rotonde provided an occasion for a blissful and passionate reunion. Now their affair had official status in Montparnasse. There was no doubt that Modi was her man. Simone had blood and a bandaged wound to show for it. Soon she could have something else, or so she claimed as Modi continued to deny everything.

Jacques Lipchitz remembers Simone coming to the sittings for the famous portrait Modigliani did of Lipchitz and his wife, Berthe, in the winter of 1916–1917. Lipchitz, a compassionate man, knew that Modi was then having a particularly hard time of it. So Lipchitz asked Modigliani to paint a double portrait, on the pretext that he wanted to send it to his parents in Russia.

Nothing could be more impractical than crating and shipping a painting to tiny Druskieniki in Lithuania. Besides, Lipchitz already had a wedding photograph of himself and his wife. But Lipchitz was now under contract to Léonce Rosenburg and had a little money. This was his way of helping Modigliani, who, Lipchitz knew, was too proud to accept a handout. Zborowski was getting nowhere, though he was tireless in his efforts to sell and establish Modigliani.

Lipchitz was not merely a good, softhearted soul who did his friend Modigliani a favor. Lipchitz had a high regard for Modigliani and truly appreciated his work. But he could just as well have commissioned Kisling, Rivera, Gris, or any of the other painters he knew so well to paint his portrait if all he had really wanted was a good likeness to show his parents. One gets the impression that, as a sculptor, Lipchitz perhaps admired Modi's sculpture and his drawings more than his paintings. He has said that Modi was a better sculptor than Brancusi, who was only a craftsman. His commissioning the painting was a generous act by a fellow artist and sympathetic friend. The result was a memorable dual portrait that is now in the Art Institute of Chicago.

Lipchitz asked Modi what he charged. "You know my price: ten francs a sitting and a little alcohol." Lipchitz agreed, and it was arranged to begin the next day. When Modi arrived, all three discussed how the por-

trait should be done. Then Modi made a series of drawings with his usual incredible speed and skill, and Lipchitz notes that "it was a remarkable talent of which he was capable even when intoxicated. However, one could not do a portrait of him [Modi] because he could not be counted on to maintain the pose. He fidgeted, smoked, sometimes was almost palsied. Lipchitz tried many times but never succeeded." [19] Lipchitz does remember one occasion when he and Modi challenged each other to execute a portrait sketch as they sat across a café table. But Modi was drinking heavily and was so unsteady that Lipchitz couldn't follow his movements. Yet Modi took hold of his pencil delicately, Lipchitz reports, and beginning with the eyes as always, captured a controlled and sensitive likeness of him.[20]

To help decide on a pose, Lipchitz showed Modi the wedding photograph of Berthe and himself. The formal sitting began the next day. Modi arrived at one o'clock with a box of paints and an old canvas, one he had experimented on or had already used. Lipchitz provided brandy, and Modi drank from the bottle as he worked. The three, all gifted, intelligent people, talked animatedly during the session, so much so that it seemed no work was being done. But it was: Modi worked right through from one to five o'clock in the afternoon until he had finished.

Lipchitz, who had counted on the sessions going on for some time so Modi could "earn" some money, was startled. Using his best psychology, he said to Modigliani:

"You know, we sculptors like something with 'matière,' something more substantial and built up. Don't you think you ought to work on it a little longer?"

Modi had put his canvas on one chair and sat down on another. He began "by making their eyes, then working around them very swiftly, silently, getting up at times to glance critically at his models and at what he was doing, pausing now and then to take a gulp of alcohol from the bottle . . . [until] . . . he said, 'Well, I guess it's finished.' "

Now he shrugged and said indifferently that he was willing to go on, if Lipchitz wanted to ruin it. So, Lipchitz said, Modi went on working on the portrait for two weeks until Modi and Lipchitz—and probably Berthe—tired of the sittings. Lipchitz is of the opinion that this is the longest time Modigliani ever spent on one painting.

All through the sittings the weather was raw and dreary. As so often happens during Parisian winters, it rained constantly. Simone dropped in periodically, Lipchitz recalls, with scarves, wraps, dry shoes, and rubbers for Modi. She hovered over him. Lipchitz "was impressed with her tender solicitude," but Modi "was displeased by her ministrations." He referred to her as *"une poule mouillée,"* literally a wet chicken, but a disparaging phrase meaning a chicken-hearted person, a milksop, or "softy." It does

not sound from this as if Modi were particularly enamored of Simone
Thiroux, but it may be that he was embarrassed by her concern and
wanted to show the Lipchitzes that he was a tough, independent fellow.

It was probably that same winter that Modi turned up at Lipchitz's
place at about three o'clock in the morning, banging loudly on the door
with his fists. Lipchitz and his wife, Berthe, were startled at being sud-
denly aroused from sleep at so early an hour. Lipchitz answered the door
sleepily, opening it on a Modigliani who was "emaciated, reeling, his eyes
red-rimmed." In a thick, shaky voice he said, "I remember seeing a book
of François Villon's poems on your shelf and I want it." Lipchitz knew
better than to remonstrate with Modi in his present condition. As he tells
it:

> . . . I lighted my kerosene lamp to find the book, hoping he would
> leave so that I could go back to sleep. But no; he settled down in an
> armchair and began to recite at the top of his voice.
> I was living at that time at 54 Rue du Montparnasse in a house oc-
> cupied by working people, and soon my neighbors began to knock on
> the walls, on the ceilings, on the floor, shouting, "Stop that noise!"
> This scene is still vivid in my mind: the small room, the darkness of
> the middle of the night interrupted only by the flickering, mysterious
> light of the kerosene lamp, Modigliani drunk, sitting like a phantom
> in the armchair, completely undisturbed, reciting Villon, his voice
> growing louder and louder, accompanied by an orchestra of knocking
> sounds from all around our little cell. Not until he exhausted himself,
> hours later, did he stop.[21]

Modi kept on until just before sunrise and then, ". . . his passion
spent, he pulled his exhausted body out of the armchair and staggered
off" without a word. Lipchitz's neighbors complained about being "kept
awake the entire night." It must have taken a great deal of explaining,
but Lipchitz managed it. "They were on good terms and harmony was
restored."

Lipchitz worried about Modi. He felt that it was "The absence of rec-
ognition, the debacle of war, and . . . [Modi's] own private hell . . .
which drove . . . [him] to greater and greater extravagances of sexuality
and drinking." Lipchitz "could not bear to see him so destructive of his
talents." He scolded and argued, "hoping to halt the downward plunge
which was taking place before his own eyes." As always, Modi resented
advice "and turned on him savagely."

"You talk just like my family!" said Modi.

"But you're shortening your life," Lipchitz argued.

*"Tant pis! Je veux une vie brève mais intense."* (So what! I want a short but intense life.)

Maurice Vlaminck, now extraordinarily successful compared to Modi, vividly recalled him that bitter year:

> One winter morning in 1917 I saw Modigliani standing on a street island in the Boulevard Raspail. With the haughty air of a general in charge of army maneuvers, he was watching the taxis streaming past. An icy wind was blowing, but the moment Modi saw me he came and said, quite casually, as if referring to something he didn't need in the least: "Look here, I'll sell you my overcoat, it's much too big for me and should fit you nicely." [22]

Whether Mamma Modigliani had sent the overcoat from Leghorn, whether Zborowski or even Simone had insisted he have one for the sake of his health, Modi would not wear it. Certainly the overcoat would never have done for the bulky Vlaminck, who was a good head taller than Modi. Shortly after failing to sell the coat to Vlaminck, Modi tried to sell an old suitcase to Ubaldo Oppi, an Italian artist living in the Place Emile-Goudeau. But Oppi did not have the price of a meal himself.[23]

Vlaminck, who knew Modi well, said: "I knew him when he was hungry. I saw him when he was drunk. I saw him rich with a little money. But I never saw him lacking in dignity or generosity. Never did I find in him the least vulgar sentiment." [24] Vlaminck remembered Modi sitting at the Rotonde, "dashing off sketches at lightning speed and passing them on to the people at the other tables, with a lordly gesture, like a millionaire handing out banknotes to a mob of sycophants." [25]

While Modi hungered for fame, not only for his own ego but "to justify himself to his mother and make her proud of him," [26] he continued to despise money. He used it when he had it, and the more he needed it—which was all the time—the more generous he was when it fell into his hands. Vlaminck recalls Modi being in a café somewhere and sitting down next to a down-and-outer of his acquaintance, a fellow painter or perhaps a poet. Then, as they talked, Modi suddenly uncovered a twenty-franc note underfoot.

*"Tiens!"* he exclaimed, feigning surprise. "Someone *is* getting careless. Looks like you're in luck this time, old man. Well, I've got to be going."

Modi pushed the bill toward his friend with his toe, got up, and rushed outside as if on some important errand.[27] Charles Beadle also was a witness to a similar incident one winter afternoon at the Café Vavin. Modi, well along in drink himself, had offered one of his sketches to a drunken Englishman for five francs, but the man belligerently insisted that he

take ten. Modi held out for five francs and another double brandy. Now a friend of Modi's wandered into the place. Modi demonstrated in pantomime that this "great and famous poet" was poor and starving. Modi turned his pockets inside out and rubbed his stomach forlornly.

The Englishman grunted, handed over his bulging wallet to Modi, who took out a wad of bills, peeled off a hundred-franc note, and gave it to his friend. He put the rest of the money back in the wallet, turned to thank the benefactor, only to find that he had gone to sleep in his seat. Beadle watched as Modi carefully replaced the wallet in the Englishman's pocket without disturbing him.[28]

Modi changed domiciles so frequently that it was impossible to know exactly where he was living at any given time. After his affair with Beatrice, he lived for a time with Soutine, and seems to have holed up at Soutine's intermittently thereafter whenever he found himself without a bed. Soutine's place was a filthy garret infested with bedbugs.

Léon Indenbaum remembers witnessing one of their battles against the bedbugs. It was the middle of July, and suffocatingly hot. Indenbaum, Jacob Epstein, and Pincus Kremegne were walking back to La Ruche at about two o'clock in the morning. As they passed the Cité Falguière, they saw faint light showing in Soutine's room; the door stood open. Curious, they went inside. Indenbaum says the studio was enormous and, since it was built of corrugated iron, it had accumulated the intense heat of the July day. Near the door he found Modigliani and Soutine lying next to each other on mattresses, with water splashed all around their little island to discourage the bedbugs. Both had candles beside them and books in their hands. Indenbaum recalls that Modi was reading something of Dostoyevsky. Even in these circumstances his book excited him.

"Ça c'est quelqu'un!" he said, slapping it for emphasis. "There's a great writer!" [29]

When Zborowski became Modi's dealer, he rented Modi a room in the Hôtel des Etrangers on the Rue de Racine, and later a room in a hotel on the Rue de Buci, which Simone probably shared with him periodically in the course of their liaison. During the winter of 1917, Modi apparently worked regularly in the Zborowskis' apartment in the Rue Joseph-Bara. But wherever he lived, he was likely to disappear for days, either because he got drunk, was locked out by the landlord, or deliberately wanted to stay away from the possessive Simone. At such times his friends became anxious. Simone would be sick with worry; Zborowski full of solicitude.

During the winter—probably of 1916–1917—Modi disappeared for several days. Simone kept dropping in at the Zborowskis' apartment in

the Rue Joseph-Bara to ask for news of Modi. She feared he might have been beaten up in a drunken brawl and was lying somewhere injured and unconscious. She worried that he had been run over by a car, or perhaps tumbled into the Seine and drowned. Zbo did his best to soothe her. He went out and telephoned the hospitals, the police stations, the morgues. Modi couldn't be located.

He reappeared as mysteriously as he had gone, staggering into the Zborowskis' rooms ". . . penniless as usual and in a deplorable state, unable to give any account of where he had been . . . hungry and filthy." It was a bad time for Zbo, who was penniless himself and, between making inquiries about Modi, had been walking the streets all day trying to sell his paintings. By the time Zbo returned, not having sold a single painting, Modi was sleeping it off on the sofa. They told Zbo how Modi had suddenly popped in.

> Zborowski said nothing, but went into his room and presently emerged in worn summer clothes, carrying a parcel under his arm . . . and went off with his only winter suit to the pawnbroker.[30]

Zbo acted from his finest instincts: he neither quibbled nor lectured. Modi was hungry. He had to be built up so he could begin painting again. Zbo had not only not sold anything of Modi's; there was no indication that he ever would. Yet, he continued to believe in his friend. He never gave up. He was dogged and tenacious, ready to sacrifice everything for Modi. While he expected his household to get by on the meager supplies in the larder, he thought nothing of pawning his clothes to get good, warm, nourishing food inside the painter.

Léon Indenbaum remembers another side of Zborowski, a practical, realistic dealer who disliked seeing Modi give away samples of his matchless art. Zbo was often with Modi when he sketched in the cafés. Indenbaum tells of an occasion when Zbo saw Modi tear a drawing he had just done from his sketchbook. Zbo thought Modi was going to throw it aside, so he put his hand out to catch it as Modi dropped it. But Modi didn't drop it: he held it out to the person he'd been drawing. Modi, says Indenbaum, gave one look at Zborowski, who at once pulled back his hand.

Zborowski, Indenbaum thought, was like a little dog beside Modigliani, and terrified of him. A whole legend has grown up around Zbo, who was, in fact, rather a *"pauvre type,"* or pitiful kind of man. From 1916 through 1920, one could buy a Modigliani drawing from Zborowski for twenty francs, and a painting, for forty.[31] But for all that it is easy to get a mistaken impression of Zbo's character. Zbo's nature undoubtedly let him be used as a whipping boy by Modi. While some may have

thought that Zborowski was merely protecting his investment by taking abuse from Modigliani, Zbo's devotion was real and it may have made him understand Modi's need for a friend who could also be an outlet for his wrath. Besides, Modi had always had it in for dealers, and with Zbo, as with the others, when friends like Indenbaum and others were around, Modi liked to show who was top man, that no dealer, not even Zbo, was putting anything over on him. Emile Schaub-Koch confirms the information that Zboro, as he calls him, sold a good portrait by Modigliani for thirty or forty francs, adding that this did not happen every day. He says that Modi was paid sixteen francs a day and often got his money in advance.

Some painters who had dealings with Zbo, Ortiz de Zàrate for one, felt that Zbo was tight with his money, withheld what was owed them, and made them come back time and again to collect. Schaub-Koch explains that as Zborowski was not a patrician Jew, like Modi, he liked to get paid himself, and that sometimes Modi got only *"cent sous."* Whatever the details, Modi always got his money. Zborowski never spared himself trying to sell Modi's paintings and made every sacrifice to keep Modi in funds. His faith was evidently so strong that Modi really believed in Zbo. On the days when Modi painted regularly in Zbo's apartment, he always arrived with the greeting, *"Eh bien, ça va? Tu as vendu?"* (Well, how goes it today: Have you sold anything? [32]) Regrettably, for a long time—and how it must have pained Zbo to say it—the answer was, *"Non, pas encore."*

Painting regularly, at last backed and supported by an honest dealer who, if he had no luck in selling, never stopped believing in him and trying to make his reputation, Modigliani was now more than a familiar, picturesque Montparnasse figure. To the impressionable and legend-prone he was the *peintre maudit,* the Prince of the Bohemians. To his friends—including those who really didn't like him as a man—he was recognized as an artist of great and unusual talent. His eccentricities and exploits continued to attract more attention than his art. It never occurred to anyone that the more neglected he was as an artist, the more difficult, cranky, and intolerable he became as a person.

The artists who remained in Paris enjoyed each other's company. Open house was held at the Lipchitzes on Sundays. The gatherings, with their impromptu entertainment, poetry recitations, arguments about art, dancing to a wind-up phonograph, the singing and quarreling, were much like those of the great old Bateau-Lavoir days. Picasso, Matisse, Gris, Rivera, Jacob, Salmon, the Cubist painter Jean Metzinger, and the poets Pierre Reverdy and Blaise Cendrars, the last an old friend of Modigliani's were among the guests.

Modi was not especially at home among these artists and friends who were successful, recognized. He argued, drank to the point of being violently ill, and made himself otherwise offensive. He was so often drunk that it seemed as if he lived to drink rather than to paint. Lipchitz clearly recalls an embarrassing scene at one of these parties. Modigliani, who was drunk, happened to be sitting next to the exuberant Rivera at dinner. Then, very loudly it seems, Modi announced, "When I sit beside a Negro, I want to vomit." [33]

It was a startling remark under any circumstances. But it is by now clear that Modi was not himself. He had never been either intolerant or bigoted about color or religion; when he was drunk, however, he was often deliberately objectionable. So, too, was the blustering, boastful Rivera, who invited abuse by baiting his friends. Modi's remark was probably only one of many that were part of the rough exchange the two friends indulged in.

Dr. Dyre Diriks, who first knew Modigliani when he himself was about fifteen years old, says that while Modi gave an impression of importance, even of an aristocrat putting on an air of vulgarity, Modi certainly was *not* vulgar. He did have some vulgar habits when he was drinking. For example, he would spit on restaurant tables, a habit, Dr. Diriks says, that was understandably disagreeable to the people seated at the table. But one had the feeling that it was a vulgarity done deliberately to shock people. Except for this intentional vulgarity Modi was otherwise an eminently intelligent man.

The doctor feels that Modi matured early, that when still very young he understood things that older people did not. In this he was very like Rimbaud, whose poetry he understood with astonishing insight. His great quality was *finesse,* and Dr. Diriks characterizes him as an *"homme très fin."* *Finesse* is difficult to translate: it is perhaps a combination of qualities—intelligence, sensitivity, and beauty.

Dr. Diriks believes Modi had a fine spiritual quality, that he was a princely character, a *seigneur,* with an impressively wide culture. Dr. Diriks suggests—and the same medical evidence has been offered in explanation of Katherine Mansfield's difficult, moody personality—that a good part of his prickly character and erratic behavior, perhaps even his drinking, could be attributed to his illness. Tuberculosis, he points out, tends to give its victims more or less chronic bad temper and makes them feel tired all the time. One efficient—if medically unsound and harmful —way to overcome chronic fatigue and its accompanying exasperation is by drinking; another is by using drugs.[34]

One of the remarkable things about Modigliani is the startling clarity with which his contemporaries recall him. Ilya Ehrenburg, who was impressed by Modigliani both as an artist and as a man, remembers him as

another Nostradamus, the noted French astrologer whose prophesies often came true. One time the police came to question Ehrenburg because his neighbor, a shoplifter, had hidden stolen goods in the wardrobe in Ehrenburg's room. After he was released, Ehrenburg went to the Rotonde where he saw Modi and told him the humiliating details. Modi smiled and said, "They'll lock you up in the *Santé* soon. You want to blow up France and everyone knows it." Later, just as Modi had predicted, Ehrenburg was arrested by the police and charged with subversive activities.[35] (Beatrice Hastings, it will be recalled, had described Modi as a "medium.")

Another evening, early in 1917, Rivera was at the Rotonde with Boris Savinkov and Max Voloshin. Ehrenburg sat with Modigliani and a model called Margot. At a nearby table the artist Fernand Léger and Lapinski, the revolutionary, were talking seriously. Later, Modi made them all go to his place, where, for hours, they discussed the war, the future, and art. Ehrenburg remembered their talk vividly, and attempted to put down the gist of it.

Léger expected the war to be over soon, when the great business of rebuilding and reconstruction would begin. He was optimistic about the future. The politicians would be driven out, and people would find their inspiration in science, technology, labor, and sports. Voloshin didn't believe that was inspiration enough. Machines would take over, and he preferred Léger's canvases to machines. Besides, the war had made men automatic tigers. . . . Now Modi had his say:

"You're all a lot of bloody innocents. Do you think anyone is going to say to you: 'My dear fellows, take your choice'? You make me laugh. The only people who make a choice today are the ones with self-inflicted wounds and they get shot for it. When the war is over, everyone will be put in prison. Nostradamus was right. Everyone will have to wear a convict's uniform. At the most, the academicians will be entitled to wear checked trousers instead of striped ones."

Léger, Lapinski, and Savinkov did not agree with Modi. As for art, Léger thought a new approach was needed. Rivera said this was hopeless. No one in Paris needed art. Art was dying. And Modi's argument was wrong because the worst was now behind them. The Socialists could—here Modi interrupted:

"Do you know what the Socialists are like? Bald-headed parrots. I said so to my brother. Please don't take offense: the Socialists are better than the rest, all the same. But you don't understand anything. Thomas, a minister! [Albert Thomas, 1878–1932, French Socialist; Minister of Munitions, 1916.] What's the difference between Mussolini and Cadorna? [Luigi Cadorna, 1850–1928, Chief of Staff and Commander-in-Chief of the Italian Armies, 1915–1917.] Rubbish! Soutine has painted a marvel-

ous portrait. There's a Rembrandt, believe it or not. But he'll be put behind bars like everyone else." Modi turned to Léger. "Listen, you want to organize the world. But the world can't be measured with a ruler. There are people. . . ." [36]

It was at this point, says Ehrenburg, that Rivera shut his eyes—always a dangerous sign. Recognizing that he was going into one of his periodic fits, Ehrenburg and Modi edged toward the door. Rivera erupted, hoisting the 220-pound Voloshin from the floor as if he were a midget, but he quieted down before any damage was done. It was a familiar performance.

Modigliani was pessimistic about the future, even the revolutions to come: people would not be able to choose what they wanted; what was to come would be forced on them just as before. His remarks about the only people who make a choice being the ones with self-inflicted wounds were strangely prophetic of his own fate. Artistically, Modi had made his choice and suffered from self-inflicted wounds in the process; as it were, he would be destroyed for it.

He favored the Socialists, but he was not deceived. He had obviously told Emanuele what he thought of his precious Socialism and its inept and bungling leaders like Thomas and the agitator Mussolini who was no better than General Cadorna. It was Soutine who mattered to Modigliani. And the people who would not be organized or measured with a ruler.

In all his wanderings at this time, the parties he attended, the long discussions in cafés, the figure of Simone Thiroux is conspicuous by her absence. If this was in fact a love affair, the love was expressed only on poor, heedless Simone's side. No man truly in love would call his girl a *poule mouillée* in the presence of others, as Modi had done before Berthe and Jacques Lipchitz. He would undoubtedly have broken with Simone in time, but the break came quickly when she told Modi she was expecting a baby—*his* baby. It seems only natural that Simone, a careless, impulsive young woman who did not "realize the relative importance of things," as Dr. and Mrs. Diriks put it, should become pregnant. Perhaps she did it out of love; perhaps she hoped to bind Modi to her permanently—or perhaps it was just a mistake.

Her insistence that she was carrying Modi's baby seems to have enraged him. Modi vehemently insisted that he was *not* the father of the child before it was born; and even afterward, when the baby's remarkable resemblance to him was noted by a number of people, he denied it just as vigorously. Whether or not he was the father will very probably never be known. There are many indications that he was—and he may have known it himself—but even those who are convinced that Modi was the father of Simone's child admit that there is no proof.

In any case, Simone and Modi quarreled bitterly, and the affair was over. One version of the genesis of the affair comes from Luigi Tobias, son of Rosalie of the famous restaurant, who said that Simone made a bet with some girl students who frequented the restaurant that she could get the handsome Modi as a lover. When Modi learned of this later, his vanity was wounded and he cast her off, saying, *"V'la la fille impudique!"* [37] But Simone was guileless, and it is doubtful that she ever calculated Modi's seduction. The story sounds more like speculation than fact.

A more convincing story comes from Modi's friend Lipchitz, who says that the cause of Modi's outrage was finding Simone in bed with another painter, a girl-chaser who was a close friend of Modi's.[38] After that, there was no reason for Modi to believe he was the father of the child, and his anger with Simone is understandable.

The intervention of friends failed to reconcile the couple. There is, besides, no evidence to suggest that Modi suffered more than wounded vanity at the end of the affair.

~ ~ ~ Chapter Twenty-five

*"Through the eyes she gives sweetness to the heart which no one can comprehend . . ."*

I t is often hard to fathom what lovers or husbands and wives see in each other. Outsiders either like the man and find his woman companion unappealing, or vice versa. What is rare, in or outside marriage, is for the man and the woman to be equally admired and appreciated. Sometimes this is because one personality is dominant and forceful; the other, no more than a gentle, complementary echo. This was the case with the next woman in Modi's life, his last and—some insist— his only true love, Jeanne Hébuterne.

Modigliani met Jeanne Hébuterne during the artists' carnival of 1917, when she was a student at the Colarossi Academy in the Rue de la Grande-Chaumière, the same school at which Modi had studied in 1906 on arriving in Paris.¹ According to the legend, Jeanne Hébuterne was nothing more than a sweet, humble, submissive girl. But, as with many quiet, retiring people, there was considerably more to this young woman of nineteen. It is proved not only by her actions, by what various people have said of her, but most convincingly by Modi's unqualified dedication to her. She was the only woman he ever declared his intention of marrying, and the only woman whom he regarded as his wife, though they were never, in fact, married.

Perhaps they met at the art students' ball just before Lent or shortly after Easter. Jeanne's parents, in a sworn statement made before a notary on March 28, 1923, testified that they had met in July, 1917. It is possible that they met at the Rotonde or the Dôme.

Jeanne Hébuterne was the well-brought-up daughter of a rigidly respectable, Roman Catholic, bourgeois family. Her parents were not native Parisians. They came apparently from the town of Meaux (Seine-et-

Marne), which French art reference works list as the birthplace of the Hébuternes' only son, André, who became a competent if undistinguished painter. They were pious, hard-working, middle-class people of a demanding type.

The Hébuternes of the world tend to be unimaginative, frightened, and sheeplike. They set such high standards and expect so much of their children that, whatever course they take, the children are bound to stumble and fall. In this case Jeanne and her older brother André had minds of their own. Nevertheless, it must have been inconceivable to the Hébuternes that their only daughter should let herself be seduced and corrupted, and incomprehensible that her seducer should be Amedeo Modigliani, who was not only a penniless, profligate artist, but a foreigner—and a Jew!

Achille Casimir Hébuterne worked in a notions shop, where he was *chef de comptabilité,* or chief cashier. He seems to have been a stocky, humorless, self-important man with a spade-shaped beard; he wore stiff collars and a black frock coat. An accountant with an aptitude for figures, he apparently tried to deal with people and ideas in the same manner; everything added up correctly if one could only see it the right way. A skeptic and nonbeliever in his daring youth, he became a rabid convert to Roman Catholicism, which was the faith of his good, solid wife, born Eudoxie Anaïs Tellier. In the early war years, "as an ardent neophyte," it seems he used to read Pascal to his family as they peeled potatoes. It was his fondness for seventeenth-century literature that had converted him from atheism to passionate belief. But, paradoxically, he does not seem to have used Blaise Pascal's philosophy to account for what was to blight and ruin his life. If he wondered how Jeanne could bring herself to love a man like Modigliani, he should have recalled what Pascal wrote in his *Pensées:* "The heart has its reasons which reason knows nothing of."

Jeanne was annoyed by these family readings to which she was forced to listen. Still, Jeanne Modigliani feels that it was the father's influence that led his daughter not to shy away from abstract thinking. Madame Hébuterne admired Plotinus, for whom the great virtues were political and social and concerned man's relations to his fellow men. Plotinus was also a mystic in his belief that "unification with the highest, with God . . . is attained only when the soul, in an ecstatic state, loses the restraint of the body and has for a time an immediate knowledge of God." This may explain in some measure how Jeanne Hébuterne regarded her relationship with Modigliani.

The Hébuternes were an outwardly happy family, secure, with all the proper values and the only true religion—invaluable assets in a crazy world at war. All would have gone well, it would appear, if it hadn't been for art. First, it was André who was permitted to go to art school,

probably because he was a man; then Jeanne was allowed to follow in his footsteps.

At nineteen, Jeanne was quiet, moody, unhappy and, like so many young people, incapable of communicating with her parents. But she *was* gifted. Her drawings and paintings prove it.

From all that has been said and written of her, Jeanne emerges as a shy, modest, reserved girl wholly devoted to Modigliani, whom she adored out of mind. Modigliani's feelings toward Jeanne are well documented: they can all be found in the twenty-five portraits or more that he painted of her. They rank among his finest, most memorable, most haunting work. They immortalize Jeanne in what amounts to a series of love letters, poems, valentines, and garlands, done on canvas, testifying to his undying devotion to the one woman who gave up everything for him. He called her his best beloved.

Jeanne was not beautiful, according to Dr. Dyre Diriks, whose wife became a friend of the troubled Simone Thiroux, but she had unusual and interesting features. Intelligent and reserved, she did not make friends easily, but she had a strong personality.

At the Colarossi Academy, Jeanne Hébuterne did become friends with Jeanne (or Germaine) Labaye, who was known as "Haricot Rouge" because of her red hair. The two girls met Modi and Roger Wild, who was later to marry Mlle. Labaye, at the Rotonde. Roger Wild claimed to have met Modi at the Colarossi back in 1906, but his memories are vague and it is unlikely. But they did know each other. As in the case of Beatrice Hastings, several people claim to have introduced Modi to Jeanne, but no one can prove it, and, in any event, it is of little importance. In the Montparnasse of that era, it was easy for artists and art students to meet: they went to the same parties, frequented the same cafés, and often sketched in the same classes. According to Wild, Jeanne, known as "Noix de Coco" because of her nut-brown hair, and her friend went regularly to the Dôme or the Rotonde at the apéritif hour, where they met Modi and Wild. The four often saw each other at Rosalie's or Les Trois Portes, another restaurant popular with artists.[2]

Chana Orloff, the sculptress, knew Modi well. She said she saw him every day from 1913 to 1919 (a palpable untruth, since no one saw Modi *every day* for six years). She found the smell of alcohol on his breath distasteful, but she admired the artist: "His figure made me think of Michelangelo's *David*. *'Serrez, serrez-moi la main'* so Modigliani presented himself to me, a notebook of drawings under his arm, his eyes vague, his gestures sweeping—theatrical. Whoever offered a glass had the reward of a drawing." She believed that Modi needed several drinks in order to work. After he had downed three, *"sa main marchait seul"* (his hand worked on its own).[3]

She became involved in Modi's life, she says "when I introduced him to Janette X," meaning Jeanne Hébuterne. Jeanne, it seems, was a student at the Ecole des Arts Décoratifs, as was Chana. (The Ecole Nationale des Arts Décoratifs is a free school in Paris for decorative and industrial artists.) That Jeanne attended both this school and the Colarossi is confirmed by Chantal Queeneville,[4] another close woman friend and fellow student.

Jeanne's friends "were far from imagining what her destiny had in store for her." Chana Orloff describes her as "thin, slender as a Gothic statue, with two long braids, her eyes blue and almond-shaped." This was how Jeanne looked when Chana introduced her to her Montparnasse friends. She adds significantly: "She was at first involved with Foujita, but when she met Modigliani she only had eyes for him." Jeanne, who "was from a petit bourgeois family," often visited Chana Orloff with her brother. Chana Orloff said that André greatly admired his sister at the time, but "later condemned her without pity." It was a little after this that Chana ". . . learned that she had left her family to follow Modigliani."

Foujita has discussed "Jeanne X." He said that her father was some sort of minor official at the Bon Marché department store, that she arranged her hair in two braids, and that she was about seventeen when she was first seen around the Rotonde. He "had an affair with her at the same time as Modigliani, but it only lasted for about a month, and she concealed it from Modigliani, who was sincere." Foujita granted that her drawing was talented. In answer to a direct question as to what Jeanne was like, Foujita said that she "was *vicieuse et sensuelle . . . maladive, pale, maigre, mysterieuse . . .* the student type." [5]

The first meaning of *vicieuse* is vicious; the second, "given to vice." Foujita might seem in a position to know because he had an affair with her, but if Jeanne left him for Modigliani, his views are unlikely to be objective. In point of fact, they do not jibe with the observations of others. It may be that Foujita's memories of Jeanne are irksome. But the rest of his description is more accurate; sickly, pale, thin and—above all—mysterious.

If it is a mystery that Jeanne Hébuterne should be drawn to a drunken, unsuccessful painter whose good looks were wasting away and who already had the mark of death upon him, it is no less a mystery to understand what Modi saw in her. She had youth. She was piquant and interesting but hardly beautiful. Her personality, particularly after La Quique, Beatrice Hastings, and other spitfires Modi had loved, was spectacularly colorless. Perhaps their sudden and urgent attraction can be partially explained by the fact that Modi was a romantic and that Jeanne, as an admirer of Plotinus, had intimations of immortality through him.

It is possible that with Modi she experienced a "unification with the highest."

The affair with Foujita and with Modigliani, at least at the beginning, may have been an experiment, a pleasant interlude, and highly reassuring to a shy, introspective girl who had just become a woman and was forever hearing her friends talk about men and their success with them. Now she knew beyond a doubt that she had charm and appeal for the opposite sex, but Modi was demanding. Not only did he "sweep her off her feet"; he overwhelmed her. For Jeanne it was the great mystical experience of her life. For Modi she was the Beatrice he had been searching for all his life and never hoped to find, the epitome of the wondrous woman of whom Dante had written:

> . . . So gentle and modest when she greets others that every tongue trembles and is still, and eyes do not dare to look upon her . . . who shows herself so pleasant to whoever gazes at her, that through the eyes she gives sweetness to the heart which no one can comprehend who has not known it: and it seems that from her face moves a sweet spirit full of love that goes to the soul with the words: "O sigh."

Leopold Zborowski had good reason to be pleased about Modi's attachment to Jeanne Hébuterne. This was no Beatrice Hastings who would fight and get drunk with him, no Simone Thiroux who forced herself on him. Jeanne was so different from all the others, the great band of beauties he had loved and painted and sketched one after the other. She was young, sweet, and shy. Modi had gone out of his way to proclaim that he loved her, something they had never heard him say about any other woman. Jeanne would do him good, take him in hand, make him take care of himself, lead a regular life, work hard, save his money, reform him.

Lunia Czechowska does not reveal her thoughts about Jeanne, but reading between the lines of her memoirs, one senses a certain ineffable regret that it was not possible for *her* to be the one to take and make over Modi: he was a real artist; ordinary people cannot appreciate or understand those beings whose souls are constantly tormented. Lunia is convinced that alcohol was not necessary to his genius, that it was only a refuge and a stimulant which helped him forget his troubles. "Perhaps," she says, "we could have cured him, Jeanne Hébuterne or myself, but we knew him too late." [6]

While Zborowski was impressed by Jeanne Hébuterne and Modi's declaration that she was "his best beloved," others who had known Modi longer were not so sure that he would change. "Some of his friends thought, or rather hoped, that Modi's evident deep attachment to la

Hébuterne would make him slow down on the drinking and drugging, but alas! the hopes were vain." [7] Hashish and alcohol were so essential to Modi's way of life by this time that he would do almost anything to get them.

Aside from a few drawings, the paintings, and a strange document Modi drew up in acknowledgment of his pledge to marry her, all that is known about Modi and Jeanne comes from the memories of those who knew them. What emerges is a reflection of the truth. Some of those who observed them and their relationship were capable of special insight, making the judgments of others seem carping and superficial. The painter Gabriel Fournier, a good friend of Modi, oddly enough, knew Jeanne long before Modigliani did.[8] They had both lived back of the Panthéon not far from each other, and Fournier had quickly noticed the young woman with the long, blonde braids, pale complexion, and the strange turban.

Jeanne must have been striking in her way. Yet Fournier says that she was a silent, self-effacing young woman, that he cannot remember a single sentence she ever spoke. She never said a word. Madame Zborowska, who looked after Jeanne, told Fournier that she herself could not remember ever hearing Jeanne talk. She lived in adoring contemplation of Modi; at the Rotonde she sat all curled up in her corner, listening with "enraptured" eyes as her beloved declaimed.

Gino Severini, the Futurist painter and Modi's good friend, who had married the daughter of Paul Fort, "the Prince of Poets," on August 28, 1913, also knew Jeanne Hébuterne before Modigliani did. Severini said she had great talent. He also recalled a remark made by a certain Pierre Albert Birot, who once described Jeanne as *"une petite chercheuse; elle ira loin. . . ."* [9] Jeanne was a girl looking for something: "a little searcher or seeker; she'll go far. . . ." But this is an inadequate generalization save to convey the idea that Jeanne's eyes were on the stars: she longed for a great mystical experience, something or someone to believe in, serve, devote her life to. She found it in Modigliani.

Perhaps Léon Indenbaum provides the richest store of memories for an understanding of Jeanne and her feelings toward Modi. He also recalls her as a *"petite chercheuse."* Indenbaum said that she had the head of a Gothic madonna, and agreed with Dr. Diriks, who compared her to certain statues in Chartres. She had long plaited hair, which came down below her waist, and was very *"douce,"* gentle. She showed a very great sensitivity in her drawing. Indenbaum felt that the lovers were destined for each other. *"Cette personne,"* he said of Jeanne, *"c'est l'être qui devait aimer Modigliani."* Jeanne was the one person who was somehow made to love Modi. She could understand him; she could feel for him to quite a special degree.

In cafés or elsewhere in public, Jeanne and Modi used to sit together without speaking. They sat and sat without exchanging a word. Jeanne was of a great *"docilité"* (tractability). Modi was *"le Bon Dieu,"* God himself to her, and she absolutely worshiped him. When he wasn't drunk, so much the better; when he was, he was; it made no difference whatever to Jeanne. Indenbaum recalled a scene, which usually took place around two o'clock in the morning after Modi had been thrown out of the Rotonde. It happened frequently if he picked a quarrel with someone he disliked. After being forcibly ejected, Modi quietly sat on a bench near the café. Jeanne, whom he had left at home, would come looking for him. Indenbaum saw her find Modi on his bench and sit next to him. Modi put his arm around her shoulders, and there they would sit for hours, without speaking a word.

Indenbaum heard Jeanne talk so seldom that he could not remember what her voice was like. To him, Jeanne seemed to live in a sort of interior ecstasy. He thought her *"jolie dans sa finesse,"* pretty in her fine way; not shy, but very *"secrète,"* very *"fière, droite,"* very secretive, proud, upright. *"Elle était fine, éthérée, mais pas maladive."* She was fine and delicate, ethereal, but not sick-looking. Indenbaum considered her *"une toute petite femme qui n'était pas petite,"* a tiny little woman who wasn't tiny. She was small, but she didn't seem small with her long, long braids and her *"étirée,"* drawn-out look. While Indenbaum couldn't remember whether her eyes were blue or brown, he was struck by her *"regard lumineux,"* her clear and luminous gaze. Jeanne had, at the same time, a *"regard très ouvert,"* a very open, frank mien. (See photograph, following page 384.)

She wasn't expansive, rather *"intérieure,"* closed in, *"enfermée mais en même temps très ouverte,"* that is, reserved but in a very open and frank way. Nor did Indenbaum think her either self-effacing or timid. Jeanne carried her head straight and high; she looked one full in the face. Even so, *"On aurait dit qu'elle regardait un monde en elle,"* she seemed to be contemplating an interior world. Indenbaum feels that Modi was everything to Jeanne: father, brother, husband, fiancé. Modi with his arm around Jeanne's shoulder symbolized their relationship: he protected her; she felt *"à l'abri,"* sheltered in his arms, and looked up at him in silent, ecstatic worship.

Indenbaum never knew the Hébuternes. He had never heard Jeanne or Modi talk about the affair, but he had no hesitation in saying that the reaction of Jeanne's family had been disgusting. They had told her, in substance, *"Fais ce que tu veux, tu n'es plus notre fille. . . ."* Although this translates "Do as you please, you are no longer our daughter," it amounts to the old curse hurled in countless melodramas by fathers at daughters who are not to darken the family door. Reviled and expelled

from her home, Indenbaum believes that Modi filled the empty place in her heart: she became *his* child. Jeanne never spoke of Modi, nor could Indenbaum ever remember hearing him speak of her, adding that it wouldn't have been like Modi anyway.[10]

Léon Indenbaum saw Jeanne as a dedicated young woman of character and substance who knew what she wanted. She wanted Modigliani at all sacrifice, at all cost. And if she was Modi's child, Modi saw in her the one woman, the great love of his whole life, the repository of all his devotion. Yet despite the long-looked-for miracle that had come into his lonely, miserable life, Modi remained true to himself. To the despair of his friends—and especially the patient, long-suffering Zborowski—he did not change.

The only change, if change there was, appeared in his paintings. But still Zbo sold nothing. There was still no market, absolutely no demand for Modigliani, but the portraits kept coming. The style and composition were sure and firm; the pictures more limpid, more tranquil, more serene. His health worsened; he did nothing to help it. By now his despair was so entrenched that he probably no longer cared whether his work was recognized and appreciated. He had Jeanne. Perhaps without realizing it, he was painting as he had always wished, fulfilling the principles he had set down in a letter to Oscar Ghiglia back in 1902:

> Your obligation is never to waste yourself in sacrifice. Your *real* duty is to save your dream. Beauty herself makes painful demands; nevertheless these bring forth the most supreme efforts of the soul. Every obstacle we overcome marks an increase in will power and produces the necessary and progressive renewal of our inspiration. Hold sacred (as I must myself) all that will exalt and stimulate your mind. Try to provoke, to arouse all the fruitful stimulants that can possibly force your intelligence to its maximum creative power. This is the cause for which we must fight. Can such goals possibly be achieved within a narrow circle of morals?
>
> Always speak out and keep forging ahead. The man who cannot find new ambitions and almost a new individual within his own strength of character, who is always destined to struggle with himself to discover what has remained rotten and decadent, is not a man. He is a bourgeois, a grocer, what you will.

Jeanne Hébuterne gave him strength to go on. Modi had written Ghiglia:

> . . . But I think the best remedy is to send you from here, from my heart which is so strong for the moment, a breath of life, for you were made, believe me, for a life of joy and intensity.

Surely Modi felt that he, too, had been made for a life of joy and intensity. There had been little joy, however, and Modi had filled the gap with intensity. Now Jeanne gave him joy: she was the breath of life that had made his heart strong for the moment. Now the rest would fall into place.

How long Jeanne went with Modi before leaving her family and going to live with him is hard to say. Jeanne evidently did not spend the nights with Modi, but returned to the family apartment on the fifth floor of 8 bis Rue Amyot. The Hébuternes were responsible parents, eager to learn all they could about the man courting their daughter. It is reasonable to guess that André knew a great deal about Amedeo Modigliani. The family could easily have found out more in the Quarter, since Modi had long been a character in Montparnasse. What they learned about this Italian, this Jew, could only have been disheartening. But they did nothing, said nothing.

Then, inevitably, matters came to a head. Disowned and insulted, Jeanne left home to join Modi.

Simone Thiroux was now in the last months of her pregnancy. Modi had refused to see or have anything to do with her, although friends had tried to arrange a reconciliation between them and to force Modi to acknowledge his paternal responsibility. Modi was adamant. He had seen what he had seen: Simone in bed with a good friend of his. She was a shameful slut and he was *not* the father of her child.

Jeanne must have known the story, since it was all over Montparnasse. Though she may not have known Simone personally, she certainly knew her by sight. Simone had many friends in Montparnasse, a number of whom thought Modi had treated her badly. Simone still made the artists' circuit to Rosalie's, the Dôme, and the Rotonde. She was expecting her baby in May (1917). Her money was gone, and she was struggling to support herself by teaching and posing. According to Douglas Goldring, Jeanne and Simone became

> . . . close friends—a truly Montparnassian situation. Together they would be sitting in the Rotonde. Modi, seeing them, would scowl furiously and beckon to Jeanne to come to him. As always in the case of such tragic affairs, the partisans of Modi calumniated Simone and Simone's friends never forgave him. Fortunately Mme Diriks, who was naturally furiously indignant at Modi's conduct, whether he was a genius or not, befriended her, and when the time came saw that she was well looked after in a nursing home.[11]

But this is one of the few instances in which Goldring was wrong. Dr. and Mrs. Diriks have said that Simone and Jeanne were not friends at

any time. Jeanne's one great friend was Germaine Labaye, Roger Wild's wife. Mrs. Diriks says that she herself knew Simone only *after* her quarrel with Modigliani and did not know what brought it on. Simone never spoke of Modigliani and herself, how they had met, or what it was that divided them. Mrs. Diriks came to know Simone through a friend, Mrs. Fritz (Camilla) Sandahl, by which time Simone no longer had anything to do with Modigliani.

Mrs. Diriks knows of only one occasion when Simone saw Modigliani during this period. Simone always insisted that the child was his, and one day she told Mrs. Diriks that she was going to see Modigliani at the Hôtel des Mines, where he was then living, to try to get him to acknowledge the child. No doubt needing moral support, Simone invited Marguerite Diriks to accompany her. Once at the hotel, however, Mrs. Diriks did not go up with Simone to Modi's room. She does not know what happened or what was said in the room, but she thought it obvious that Simone would be unable to get Modigliani to acknowledge the boy as his.

Both Dr. and Mrs. Diriks think the boy was, in fact, Modigliani's, but they admit that no one can be absolutely sure. Mrs. Diriks says that after the interview with Modigliani at the Hôtel des Mines, Simone hurried off to see someone else. She wonders whether Simone was trying to get this "someone else" to acknowledge the child, whether Simone herself had doubts about which man was the father of her child. In any case, she was again rebuffed. Mrs. Diriks knows nothing more about it. But she has heard no evidence strong enough to make her believe that the child was not Modigliani's.[12]

Simone must have been desperate. She had little money and no place to live. She apparently was no longer permitted to share her aunt's home on the Rue Huysmans. Her family would have nothing more to do with her after the Modigliani affair, especially not with an illegitimate child. From the description the child may well have been Modigliani's: he was a charming little boy, very beautiful, with a *"tête de cherubin,"* an angel face, which was one reason why the Diriks thought he was Modigliani's son.

"Modi's denial of paternity [was] ridiculous," according to Fritz Sandhal, who had known Modi for years. Simone was reckless and careless, but never promiscuous. Sandahl was convinced that Simone genuinely loved Modi "and that his refusal to acknowledge the paternity of her son wounded her deeply." He does feel, however, "that Modi was never seriously in love with her." As confirmation of this, he tells of an occasion when Modi went out of his way to deny his paternity. Sandhal was walking along the Rue Campagne-Première when Modi—who was probably eating at Rosalie's—" . . . drunk and excited, rushed out and

shouted after him: 'You may tell that woman that I'll never have any-
thing more to do with her and that I'm not the father of her child!' " [13]

Sandahl, a Swede who had known Montparnasse since 1911, was prob-
ably one of the few people to know the three important women in Modi's
life—Beatrice Hastings, Simone Thiroux, and Jeanne Hébuterne. He
thought Beatrice "charming, cultivated, but extremely jealous." Simone
seemed "a gentle, rather weak character, not at all profound, but loving
the good things of life, fond of dancing, laughing, and having a merry
time." His observations on Jeanne are strikingly similar to those of Léon
Indenbaum. She was "strange" with ". . . a queer, almost mystic, expres-
sion in her brooding eyes. . . . She talked little and never smiled; . . .
her lack of gaiety and her silence were the result of her life with her un-
sympathetic, narrow, bourgeois family." He regarded her as ". . . driven
inwards, repressed to the point of perpetual melancholy." He felt
strongly that "There is no question but that she adored Modi and he
adored her." And, exactly as Indenbaum put it, Jeanne was ". . . the
woman of his life, and to her he was a god." [14]

If Simone's baby was born in May, 1917, it must have been in June
when Simone went to see Modi in his room in the Hôtel des Mines. Pre-
sumably Zborowski had taken the room for Modi and was paying the
rent. But now that Modi and Jeanne were together, a hotel room would
not do. Zbo believed the attachment to be permanent, and thought
highly of Modi's new love. He ". . . hoped that Modigliani, now that he
was emotionally satisfied, could find the energy to reform his disorderly
way of life." [15] It was a vain hope, but Zbo seems to have been an opti-
mist and set about finding larger quarters for them. They needed a real
home, a room in which Modi could paint, and a bedroom adjoining. In
the early summer of 1917, Modi and Jeanne rented rooms in an old
apartment building at 8 Rue de la Grand-Chaumière.

Nina Hamnett, who worked in the studio years later, has described it:

The studio consisted of two long workshops, up many flights of
stairs. Gauguin had lived on the floor below. It was next to the Acadé-
mie Colorossi. The house looked as if it were going to fall down at any
moment and one could see the sunlight shining through part of the
wall. There was a fire escape on the wall on the inside of the window.
It was a rope ladder with wooden rungs attached with an iron hook.
No one ever dared to go down it as we thought that the wall and the
house would probably come down too. I believe Modigliani climbed
down on one occasion. The studio was exactly as he had left it, and
parts of the walls had been painted different colours to make different
backgrounds. The staircase was lopsided, as it had already slipped
about two inches from the wall. I was rather nervous at first about

going up and downstairs, but it seemed to be quite safe. In the studio underneath lived Ortiz de Zarate, the South American painter. . . .[16]

Zbo planned carefully. Lunia Czechowska and Hanka Zborowska dusted, swept, and mopped the rooms. They painted the walls a cool gray, put in a stove and left the ceilings as they were because they were too short to reach them. Since they had no money for curtains, they daubed whitewash decorations on the windows. The furniture consisted of a divan, a table, and a few chairs. "Modi himself decorated the walls in orange and ochre, after the Primitives' scheme of colour." [17]

It was a modest domain, says Lunia, but it was Modi's. At last he was finished with anonymous hotel rooms in which there was hardly space to go to bed. Here Modi could cook and receive friends. Lunia says that she will never forget the day when he took possession of his rooms; "his joy was such that we were all shaken by it. Poor dear friend, finally he had a corner of his own." [18] Lunia makes no mention of Jeanne Hébuterne.

Modi could paint at home now, but he seems to have gone on just as before, painting as he chose, at Kisling's, or at Zbo's apartment, which was in the same building. Jeanne was often alone. She was his "wife," and he treated her in the Latin tradition, as Ortiz de Zarate did his wife. The men wandered and stayed out as they pleased; the women remained at home unless the men chose to take them along. But we know that Jeanne would go out to look for Modi when he didn't come home. Sometimes she had to look all over Montparnasse for him, at the police station or in jail.

Madame Zborowska told Carco that Modi was amiable and cooperative when he painted in her husband's apartment, but she told Goldring that "Modi was always difficult—that is, cranky—even when there was nothing to grumble about." When he came in to paint, he did nothing but complain that the room was freezing, "in spite of a roaring fire." Madame Zborowska felt that "he seemed to work better when he was vexed about something imaginary or real, or in a state of deprivation of alcohol or drugs." [19] Meanwhile Zbo was sweating to sell Modi's work and keep him in funds. Zbo also had to provide rent money, food, paints, and coal to heat the rooms so Modi's models could pose for him in the nude. It was a wearing and constant struggle.

Paulette G. (later Jourdain), who lived with the Zborowskis, was a " . . . witness to his [Zborowski's] innumerable acts of self-abnegation, carried to the point of folly." Although Zbo handled other artists, he devoted himself singlemindedly to promoting Modi in a way he never had before and never did again with any other client. Modi was a poor gamble from the start. Everyone had long given up on him. Not only was his work impossible to sell; the painter himself was an impossible fellow. But

once Zbo was convinced he could help Modi, he abandoned his own literary ambitions. Zbo evidently refused to deceive himself: he realized that his gifts as a poet could not be compared to Modi's as a painter; that Modi was a newcomer, an alien, an innocent who knew nothing about the chicanery in art.

Recalling the days when she had lived with the Zborowskis and mingled with painters every day, Paulette told Douglas Goldring, "Artists are very trying; they are capricious, tyrannical and hopeless egoists." She was greatly attached to Modi, thought him infinitely charming when sober but, otherwise, "really impossible." Zbo always welcomed Modi to meals at the apartment. Modi came grudgingly, then complained about the food, and refused to eat what had been put on the table. Zbo, patient and enduring, gave "that tired yet affectionate smile of his," and, if he had a few francs in his pocket, went out ". . . to buy . . . something to tempt his highness's appetite, which was, of course, destroyed by alcohol." [20]

On one occasion when Modi failed to show up at Zbo's as promised, Zbo went over to Modi's and found him sprawled on the divan, staring at the ceiling. He was in a nasty mood. Zbo asked him why he hadn't come to breakfast. Modi said nothing. Zbo told him the model had been waiting and had stayed till noon. Gently Zbo asked what was the matter. Modi replied with his favorite all-purpose expletive, *"Merde!"* He said he didn't have the proper paints to work with. Zbo explained that he had bought what was needed the day before. And now Zbo, guessing that Modi had sold the paints to buy himself a drink or two, told Modi to come along for a meal and they'd buy new colors on the way. He still had a little credit.

Zbo tried always to humor Modi, to keep his drinking to a minimum, though he understood that Modi needed alcohol to keep going. On still another occasion Modi complained that the apartment was cold. It was freezing outside, but Zbo had built up a good fire in the room where Modi was about to paint. The model had taken off her clothes as Modi entered. Now she was waiting as he paced the room, grimacing and grumbling. He couldn't paint in this place! Modi said, shivering. It was as icy as the steppes of Siberia. The model, waiting nude, disagreed. Why, the place was like an oven. Modi frowned and turned up his coat collar. He was freezing.

As he paced and the model waited, Zbo went off tactfully on an important errand. Modi paced, grumpy, chain-smoking the cigarettes that had been put next to his palette table as usual. In a little while Zbo was back. He put a glass and a bottle of rum on the table.

"There, Dedo, that'll warm you up a bit."

Modi drank half a glass straight and soon began to paint. Zbo allowed

Modi a certain "ration," but it was never enough. He'd balk at painting and then "the usual comedy" followed: it was too cold to work, he didn't feel right. He paced the room, he chain-smoked. At last, according to Paulette, "he pleaded so gently and nicely that she couldn't refuse, so she went out and bought half a bottle of rum with her own money. Modi, of course, was penniless. Then . . . he began to work like a demon, drinking a shot every five minutes. At the end of an hour's posing, the bottle was empty." [21]

The stories of how Modi tried to rehabilitate Chaim Soutine, teach him table manners, and transform him into a gentleman are only part of the legend, Jeanne Modigliani says. She is skeptical of those who say that Modi showed Soutine how "to blow his nose with a handkerchief and to clean his nails." [22] She adds that even today Madame Zborowska reddens with anger at the mention of Soutine's name and juts her pointed chin forward on the most Modigliani-like neck one could ever hope to see. She could not stand the dirty, evil-smelling, brutalized, pathetic Soutine in her home. And even the good-hearted Zbo hesitated to take on Soutine's work despite Modi's insistence that he was a great painter.

Soutine, though a very timid fellow, knew his own worth. He lived folded in on himself, without help or encouragement, Lunia Czechowska thought. The realism of his work was a reflection of his soul. She found his figures ugly, but his colors beautiful. He had a strange passion for painting gamy sides of meat because the rich colors of the decomposing flesh fascinated him. Soutine greatly admired Modi and was very touched by his interest and kindness. Modi made Soutine understand that, though he was poor, his soul and his heart overflowed with riches. [23]

Soutine was not accustomed to drinking nor to eating enough to satisfy his hunger. Very often, on the occasions when he was invited to share a meal with the Zborowskis, he fell asleep at the table. And once, at Zbo's table, Lunia remembers when Modi took advantage of this, picked up his paintbrush, and did a portrait of Soutine by candlelight. Carco wrote that Soutine worked all day. At night he took what he'd done over to Zbo's apartment in the Rue Joseph-Bara, squatted in a corner, and pleaded with Modi to recite poetry. Later on, Zbo recited for him. Presumably Hanka, Lunia, and Paulette had gone to bed before the poetry sessions. [24]

One day Modi enraged Hanka Zborowska by painting a portrait of Soutine on one of the doors of the Rue Joseph-Bara apartment. Modi was very likely perpetrating a joke on the Zborowskis. He had reported for work; Zbo had paints available but no canvas. Modi jumped at the chance to put Soutine's haunted face on Zborowski's door. It was a head-and-shoulder portrait, full length to the knees, and showed Soutine slouching, wearing what seems to be Modi's big black felt hat, crushed in.

It is much too big for him. So is his own ragpicker's uniform, which hangs loosely on his body. Soutine's head is tilted forward and to his right. His lumpish features, squashed-in nose, thick lips, with garish daubs splattered around his head and the rest of his body in colorful outline, take up most of the door.

"Well, the door's done for, it seems," Zbo said.

"No, it isn't," Modi protested. "You'll sell its weight in gold!"

Madame Zborowska agreed, but with one reservation. "Yes, but while we're waiting, we'll have to have *that* portrait before us the whole time."

Soutine meanwhile had disappeared, afraid that he would be reproached if he stayed on. It was several weeks before he nerved himself to show up at the Rue Joseph-Bara again. In the interval, the Zborowskis got used to living with the door. And, after Modi's death, his prediction proved true. One hundred thousand, one hundred and twenty thousand, and one hundred and thirty thousand francs were offered for the door. According to Carco, the last amount was what an American paid for it. He had to remove the door, frame, and casing to take his prize away in one piece. The door is now listed as part of a private collection in Paris.[25]

Modi brought not only Soutine to Zborowski's attention but Utrillo. He also praised Soutine to Lipchitz.

During Lipchitz's early years in Paris he visited the Flea Market in the hope "of finding some treasure among the scattered dirt and debris." On one visit, accompanied by "his stonecutter," Lipchitz was attracted by "a large . . . painting on cardboard. It confirmed his feeling that folk art was beautiful and spontaneous, but not as expressive as carefully conceived inventions of mature and seasoned artists," and he thought it an excellent painting. It was a scene of the Rue des Saules with the dome of the Sacré-Cœur in the background. The setting and the way the leaves were handled gave the canvas what Lipchitz calls "a Rousseau, folkish smell." He did not like the tremendous blue signature of the artist, and tried to scratch it off; but he still wanted the painting. The price was ten francs, too high for a man who had only twenty francs to his name. Lipchitz offered four francs, prepared to compromise at five, but the stonecutter advised him not to buy it.

Later, in Montparnasse, they ran into Modigliani. Lipchitz told him about the painting he had seen at the *marché aux puces*. He had wanted to buy it but it had been too high for his pocketbook.

"How much did they want for it?" said Modi.

"Ten francs."

"And what was the signature?"

"Maurice Utrillo V."

Modi extended his arms wide at this. *"Malheureux, malheureux!* That

happened to be a painting by one of the greatest artists we have. It's worth *at least* one hundred francs. Go back and buy it. Go on back quick!"

Although Lipchitz hurried back by Métro, the painting had been sold by the time he got there. His biographer adds that Lipchitz "was not over disappointed. He had indeed added another dimension to his growth. It was true. His eye could see at last." [26] But the real point of the story demonstrates again how discerning an eye Modi had and how generous with his praise for the excellent work of his friend. Modi knew as he knew that Soutine's was good, and as he had known all along that his own work was good. Modi's generous spirit was rare among his contemporaries.

Modi could also be ungenerous, according to John Storm, who writes that ". . . discouraged by failure to win recognition, he became increasingly bitter, and his dissipations became more violent. 'Ah! to have the world at my feet as Maumau has!' he would exclaim. And then in a jealous fury he would revile his friend." [27] This is ironic, if it is true, but not very convincing, because Maurice did *not* have the world at his feet, though his simple Montmartre landscapes were easily appreciated and sold well, if for very little.

Modi was always pleased at Soutine's least success, even when a sale brought only enough for Chaim to buy a pair of shoes or something else he needed badly and had never had. One day Soutine brought Zbo his latest painting, some lovely autumn flowers. Zbo wondered how to go about selling it. Finally, he decided to try it on Gustave Coquiot, a noted art critic and collector. He thought Lunia should do the selling job because Coquiot liked her. So Lunia and Hanka went off together with fifty centimes, all they could scrape together, which was barely enough for bus fare. If Coquiot refused to buy the painting, they would have to walk home. Once at their destination, Lunia left Hanka on a bench on the Boulevard des Batignolles and went up to see Coquiot.

Fortunately he was home, but his big apartment, filled with lovely things, beautiful paintings, and curios, quite intimidated Lunia. He was a great talker, amiable and cultivated. Fortunately, he liked Soutine's painting, but the condition of the stretcher and the back of Soutine's canvas, which was soiled and spotted, nearly killed the sale. As Lunia talked with Coquiot, she was convinced he would not buy it. She was depressed at the thought of the long trip home on foot carrying the big canvas.

Coquiot kept her talking for an hour, while she thought of Hanka on her bench, and Zbo and Soutine waiting expectantly in the apartment. Just as Lunia was leaving, Coquiot said: "I'm taking your painting, but the price is too high. Since I'll have to put it on a new stretcher and have

it mounted over a fresh canvas, I can only give you seventy-five francs."
To herself Lunia said, "Thank God, we're saved." Zbo had set a mini-
mum price of fifty francs. She and Hanka were delighted, Lunia espe-
cially so at having sold to an expert collector like Coquiot.

Zbo, says Lunia, kept only twenty-five francs for himself and gave the
rest to Soutine. And Soutine, on Modi's advice, hurried off to buy himself
a pair of shoes. Lunia adds that, "Several years later Soutine lived at the
Crillon and only wore silk linen." [28] After Soutine became successful, his
extravagance amazed many people.

Modi drew and painted several portraits of Soutine in his high-necked
Russian blouse, hands on his lap, his expression sullen, churlish, sleepy.
His hair was a lofty, bobbed tangle; his eyes, heavy; his nose pushed in;
his lips, full and sensual. He was forever the lost, runaway, friendless boy,
brooding, dirty, frightened, inarticulate in everything except his art. He
still lived in the slaughterhouse area near La Ruche in the Rue Dantzig.

When he roamed Paris, it was the butcher shops that attracted him. He
liked to look at the decaying meat hanging in the windows and to fre-
quent the little café where the slaughterhouse workers gathered in their
off hours, their big knives tucked in the belts of their bloody aprons as
they slugged down beer and wine. They apparently gave him leftover
odds and ends of meat to paint, and he seems often to have peeked into
the abattoirs to watch them at work, cutting and slashing enthusiastically
as they waded in guts and gore, their hands running with blood.

Death, dead flesh, the brilliant blues, reds, whites, and yellows of de-
caying meat hypnotized Soutine. Modi loved to tell how Soutine painted
a whole side of beef, as in Rembrandt's study that he had admired in the
Louvre. Soutine supposedly asked Zbo's help in obtaining the beef. Zbo
wondered if something smaller wouldn't do, say a sheep or a calf, but
Soutine was adamant. It must have taken a mass effort to get a side of
beef into Soutine's room.

It was during the hot summer; the meat was hung from a beam on a
worn piece of rope tied fast to one protruding rib. To most people it be-
came a repulsive mass of flesh and bone. To Chaim Soutine it was a beau-
tiful sight. He delighted in his trophy, exclaiming at the colors that were
so alive. They changed every minute, but they were still too red-blooded.
He would have to wait until they were right. For contrast, as he waited
for the beef to "ripen," he arranged to have Paulette sit for him so he
could do a study of her pale hands. His side of beef would be his master-
piece. There wouldn't be another like it in the world, except Rem-
brandt's in the Louvre.

Already flies were streaming in through the open windows, buzzing
hungrily around the beef, which was beginning to smell. It was Paulette's
job to switch away the clouds of flies blackening the rotting meat. By the

end of the second week the stench was overwhelming. The other tenants in the building complained volubly to Soutine, who, completely absorbed, ignored them. The beef had become too washed out, colorless, so he obtained some fresh blood from the slaughterhouse and poured a bucketful over the carcass. Blood dripped in pools on the floor. The tenants protested to the police and to the sanitary authorities. A decision was handed down.

Soutine protested. Zborowski also. Enthusiastic about the work he had already done, and quite comprehending the point of view of the artist, Zborowski offered to indemnify the furious neighbors—not quite knowing where he was going to get the money. One of the inspectors, who was apparently an amateur of painting, remarked: "I don't understand why he doesn't get another side of beef! *Voyons,* he can't see the colours of this one for the flies." [29]

Ah, but he could, Soutine maintained, waving his arms and setting hundreds of flies in motion. La Petite—Paulette—was chasing them away so he could see the marvelous colors. The inspector said Soutine had a point, but it did make for an unsanitary situation, didn't it? Soutine objected. He wanted this beef! The color was perfect now. The inspector was dubious, but said he would do his best. *Tiens!* What if they sent in a veterinary surgeon. He would inject something into the meat that would "stop the disgusting but natural decay." Soutine screamed in anguish at this. Why, it would change all the beautiful colors!

The remainder of the story is lost, but Soutine got his painting done. It is considered a great one. Compared to Rembrandt's *The Flayed Ox* in the Louvre, Soutine's side of rotted beef looks very much like a man's brutally maimed body, the neck having a resemblance to a human head.

The odor of decay and death clung to Soutine's gamy paintings for years, much to the distress of collectors.

As Murillo said of Valdès Léal, as he stood before his famous portrait of the bishop eaten by worms, which decorates Seville's chapel of Chartreuse, it is possible to say of Soutine's paintings that one "can only look at them by holding one's nose." [30]

It was easy to understand what Modigliani admired in Soutine's work. It was not death and decay. Soutine knew exactly what he was looking for, what he wanted to do, and how he wanted to do it. And he painted with spirit, with untiring dedication in a way that was entirely his own. It was not a question of angles, little forms, obeying the tenets of Princet or the specifics of Cubism, Futurism, or any other "ism." His system was simple, clear-cut, unique.

Utrillo painted Utrillos, Soutine Soutines, and now Modigliani was painting Modiglianis. He had the technique, the vision, the insight, the rapport with his sitter, and—at last—the ability to realize his dream:

> From the moment he really hit his stride as an independent artist, Modigliani's art was remarkably independent of his life. We can tell from the pictures when Beatrice Hastings came into his life and when she went out of it; when Paul Guillaume began buying his pictures; when Leopold Zborowski took over the management of his career, such as it was; and when his acquaintance with known persons such as Léon Bakst, Kisling, Blaise Cendrars, and Picasso reached the point at which he painted their portraits. But these are questions of subject-matter, not of substance. No one could tell from the work whether he was ill or well; poor or rich; happy, even, or unhappy. The legend, here is almost invariably either harmful or misleading; the facts, in many respects, are gone forever . . . The few stories about him that are reliable relate almost always to moments of wild excitement, whereas for most of the time he was reserved and gentle, spoke hardly at all, and went out rarely. . . . Mostly he just got on with his work, as he had set himself to do as a boy not yet seventeen. . . .[31]

The accomplishment was long, arduous, and man-killing. But the work remains and speaks for Modigliani—as he had always wished—better than he could himself. Today, as always before, the real workman stands revealed in his work. The rest is legend, all too often inadvertently fed by the artist himself. Malraux says that whereas, in person, writers try to entertain, puzzle, and charm, in their books they tend to give different interpretations of themselves by avoiding ". . . the expression of any thing that is not the finest flower of their intelligence and sensibility." Then Malraux puts his finger on what makes artists different from ordinary people:

> The ordinary man puts up a struggle against all that is not himself, whereas it is against himself, in a limited but all-essential field, that the artist has to battle.[32]

Modi entertained, puzzled, charmed—and repelled. While he lived the riotous legend, Modi struggled with himself and got on with his work, winning gloriously on canvas and losing ingloriously to alcohol, hashish, exacerbated nerves, malnutrition, and tuberculosis.

∽ ∽ ∽ Chapter Twenty-six

*"Landscape! My God, don't make me laugh. Land-scape simply does not exist!"*

On pleasant afternoons Jeanne sometimes sat with Modi at the Rotonde as he talked with friends, discussed poetry, argued the good and bad points of Cubism with Max Jacob, or sketched from life. She was with him one evening at the Rotonde when a stranger showed great interest in the magnificent silhouette of a woman that Modi took out of his sky-blue sketchbook. Modi was in a good mood, and sober. Jeanne was by his side, silent and worshiping, "his guardian angel." The stranger asked Modi how much he wanted for the drawing. Modi, smiling for a change, quoted "a modest price." The amateur collector thought it too much. Perhaps he hoped to beat the price down or perhaps he really believed "that the Montparnos were a troop of beggars from whom one could acquire masterpieces for almost nothing." [1]

The man had asked; Modi had replied. Now Modi reverted to type. He said nothing, but he tore the page from his portfolio, ripped the drawing into four pieces with two brisk motions, and let them drop at the stranger's feet. *Voila!* That was Modi's answer. You paid the going rate, or you could go to hell.

Jeanne also seems to have been present during his famous argument with Diego Rivera over the merits of landscape. This incident, which swelled the Modigliani legend, seems to have occurred on the terrace of the Rotonde on a late summer afternoon in 1917, and was recorded by Ramón de la Serna, Rivera's observant friend. Picasso was there. So was Apollinaire in the ugly leather-turban bandage he wore after being invalided out of the army with a serious head wound. The argument probably began as a discussion of painting techniques and subjects. As Modi shouted, gestured, and bounced in his chair,

366 ∽

. . . Rivera quarreled while he trembled with laughter, his face full of bitterness that made his eyes cross more than ever and twisted his face completely with spasms of laughter.

Modi insisted that only people mattered in painting; Rivera, just as insistently, that landscape and nature were important. Modi regarded these as meaningless background.

"Landscape!" he shouted. "My God, don't make me laugh. Landscape simply does not exist!"

As the dispute went on, De la Serna noted that Picasso had ". . . the attitude of a gentleman waiting for a train, his beret jammed down on his head to his shoulder, resting on his stick as if he were a fisherman patiently waiting for a bite." [2]

If asked for his opinion, Picasso would probably have said that both painters were right and both wrong. Naturally favoring Rivera, De la Serna felt that Modigliani wanted only to excite Rivera. But it was more than that. For Modi landscape had never existed. He had not painted one since leaving Micheli's class as a boy. Rivera, a Cubist convert, was the wrong man in the wrong place at the wrong time, painting the wrong things. (Perhaps he knew it, since he was soon to leave for his native Mexico.) Hemmed in by flat, pavemented, built-up, overcivilized Paris, he longed for the mountains, the volcanoes, the exotic scenery, the primitive beauty of his homeland. All this time Jeanne sat by her lover, ". . . a young blonde of Pre-Raphaelite type . . . with her hair combed in *tortillons* [spiral twists of braids] on her temples, like two sunflowers or ear pieces the better to hear the argument."

Modi also had clashed over political ideas. His pacifist convictions kept cropping out. During the war it was often wiser not to say what one thought, but Modi could not restrain himself. André Durey, a painter friend, remembered meeting him on the street one night, very drunk, clinging to Jeanne's arm, so obstinate and unmanageable ". . . that she begged Durey to help her to get him home." Jeanne and Durey quieted Modi, who allowed himself to be taken to his room, then lay on his bed reading docilely. Durey was apparently about to leave and Jeanne was thanking him for helping her when ". . . all of a sudden he [Modi] jumped up in a fury and began to smash everything he could lay his hands on, shouting: 'Down with the Allies! Down with the war!' " [3]

Modi had a knack for alienating the people who could have helped him. A friend of Durey's admired Modi's paintings, and Durey had talked the friend into coming up to Modi's to see them. Modi displayed the paintings. The man picked up the one he liked and asked the price.

"That's fifty francs. And you can take this other along too."

"I wish I could but I'm in no position to buy two of them right now."

"I told you, you could have them both for fifty francs," said Modi expansively. "Go on, take 'em both!"

"Oh, but I couldn't do *that*," the man objected. "It's not fair."

Modi was furious. "Then you can't have either one and you can get the hell out of here! *Je vous emmerde!*" [4]

It is hard to believe that Modi, who had a deep sense of friendship, which he thought the noblest sentiment of man, took pleasure in maltreating his friends. Granted that he asked more of his friends than they could give (with the shining exception of the extraordinary Zborowski), it was not malice that made him wreck their efforts on his behalf. It was rather his bad health, his irascible nature, and the constant state of exasperation in which he lived.

Modi's illness had, as Dr. Diriks and others suggest, something to do with his drinking, yet Jeanne Modigliani explains his need for alcohol in another way. She notes that Lipchitz, Zborowski, and even little Paulette had "resigned themselves to the necessity of providing Modigliani with a bottle of wine or cognac during sittings." She goes on to say that "Alcohol made it possible for him to maintain his creative force at a high pitch." It also made possible staying alive, accepting failure, even swallowing with a minimum of bitterness the success of those contemporaries whom he knew had less talent than himself.

As for the pitch at which Modi worked, Jeanne Modigliani says:

> If the question as to why Modigliani drank is a purely psychological one, the question as to why he *had* to finish a picture at one sitting and why, after taking a rest from the job, he was unable to take it up again, is of fundamental importance. Perhaps to his knowledge that he had only a few years to live was added the anxiety of an artist tortured by conflicting aesthetic problems, and easily discouraged. He never ceased to long for the sculpture he had been forced to abandon, and it was this consuming regret, even more than his excesses and his poverty, that undermined his mental stability and his own faith in himself.
>
> We can see this torment, purely artistic and neither mystical nor metaphysical, in the continual reappearance of sculptural tendencies in all his work up to the very end. . . . [5]

There seems to have been nothing to compel Modi to finish his portraits at one sitting. It is true that the longest time he gave to one portrait—the dual one of Jacques and Berthe Lipchitz—was three or four hours a day over a two-week period, but that was at Lipchitz's request because he wanted Modi to make as much money as possible from the job. What is of interest is Modi's agreement to stretch out the sittings and his warning, "All right, if you want me to ruin it, I'll go on." The portrait of the Lipchitzes was not ruined, but it would seem that at the end

of the two-week sessions the portrait was little different from what it had been two weeks earlier.

Modi simply worked quickly. He made numerous preliminary sketches, often following them with what he termed "studies" in oil before turning out the final portrait. After these preliminaries he knew exactly what he wanted to do. Madame Zborowska told Carco that it took him only several hours to turn out a medium-sized portrait, that the larger ones, including nudes, took him double or triple the time. Modi did not *have* to finish a portrait at one sitting. If anything compelled him to work fast, it was the philosophy he had described to Lipchitz: a brief but intense life.

He was now doing the finest painting of his life in a style that was deft, sure, quick and—most important—polished and accomplished. While he craved success and recognition, they were no longer paramount: he had "saved his dream," he had realized his genius and was fulfilling it on canvas.

At this stage it seems hardly likely that he was burdened by "the anxiety of an artist tortured by conflicting aesthetic problems." He had found his way. Nor was he easily discouraged—at least not by aesthetic problems. What did discourage him was Zborowski's continued inability to market his work.

Modi still liked to think of himself as a sculptor first and a painter *faute de mieux,* as he had told Ortiz de Zarate years before in Venice. He had sculptures around him when Zbo took him over, and Zbo appears to have stored several of Modi's large heads on the balcony of the apartment on the Rue Joseph-Bara. Modi continued to see Constantin Brancusi from time to time. No doubt he did long to do sculpture, which he had been forced to abandon, but it seems altogether too much to claim, as Jeanne Modigliani does, that "it was this consuming regret, even more than his excesses and his poverty, that undermined his mental stability and his own faith in himself."

To insist that Modigliani was ruined by his inability to be the sculptor he longed to be does not make sense. To say that this torment is evident "in the continual reappearance of sculptural tendencies" in his painting and drawing is also an exaggeration. It is more likely that Modi's experience as a sculptor made him a better painter, gave his drawing and painting the special quality that was Modigliani: a remarkable solidity with an exquisite simplicity, his knack for saying so much with so little; his love affair with pure line. As Carco said: "His drawing suppressed the lines little by little. It suggests. It keeps a moving and noble style." [6]

Zbo was unrelenting in his efforts to sell Modi's pictures. He made the rounds of dealers, critics, and collectors, amateur and professional, day after day, carrying the paintings under his arm. Home on furlough, Cor-

poral Francis Carco, long a friend of Modi's and a collector of his draw-
ings when he could afford them, visited Zbo often and was shown the
pictures on hand.

Zbo had to run out to buy a candle, since the electricity had usually
been cut off for lack of payment. Then he would lead Carco "into a nar-
row room without furniture, where, in a corner, was a pile of canvases."
Here, by flickering candlelight, Zbo displayed his marvels, his eyes glow-
ing as he caressed them with passion, praised them, and cursed the rotten
luck hounding Modi:

> "What poetry!" he exclaimed ecstatically, then began to pace excit-
> edly. "And what a shame it is!" he said over and over. "Why, only the
> other morning I brought fifteen paintings over to a dealer and asked
> for only a little money—oh, just a very little—to give Modigliani, but
> the man wouldn't even listen to me. 'Take 'em away,' he said. 'I'm not
> buying, you hear?' Why wouldn't he buy? I'd have let the fifteen can-
> vases go for nothing if he at least appreciated the pictures. But no! No-
> body wants them. Nobody! How stupid they are. They're just not used
> to them. But you'll see—later on—not before too long—they'll pay a
> whole lot for these same canvases they won't even look at today.
> They'll all want Modiglianis. And now Modi hasn't a penny and
> suffers so terribly."

Sold by Zbo's eloquence, Carco decided on a nude. Zbo asked if he
really liked it. Carco told him it was very beautiful. At this, "Zborowski
gave a cry of sheer joy and illuminated the picture with the candle flame.
'Look, isn't it a beautiful painting? Atch! Magnificent! Magnificent, isn't
it?'"

Carco agreed with him fully. It *was* magnificent. Unquestionably a
masterpiece! Now Zbo turned to Carco and pointed to the painting, the
nude Carco wanted to buy. Zbo had decided that he wouldn't sell it to
Carco. He would give it to him because Carco loved it. Carco protested.
What about the money for Modi? Zbo brushed this aside. "No, take it. I
am pleased that you like it. Don't worry about money. Tomorrow a man
is coming to buy some old clothes. He'll pay twenty francs. That's
enough."

Zbo accompanied him to the door, carrying the nude, stubbornly refus-
ing the little money that Carco was able to offer. It was Carco's first
painting of Modi's—he had bought only drawings before—and he says,
"The next morning when my concierge came to do the room, she nearly
dropped dead on seeing the picture over my bed." [7]

Later on, after acquiring more of Modi's nudes, Carco decided to rent
his apartment on the Quai du Louvre. The concierge who showed the
place to prospective tenants chastely covered the offending paintings with

newspaper. Earlier, Madame Masquelier, concierge of Carco's Quai aux Fleur apartment in which Katherine Mansfield had lived so briefly and unhappily, also gave him a hard time about the nudes.

"Monsieur," she informed Carco uncharitably, "you'll surely come to a bad end from looking at such horrors!" Then, standing under one of the nudes, she added, "Take a good look now. Do I only have a single eye? Do I?" Finally, when Carco had the patience to hear her out, she took advantage of his weakness to make sly insinuations. "To think of making love to such a creature—that would be pure depravity. Look at the way they're painted all red like that . . . they must have some sort of skin disease!"

The more I lived with the Modigliani nude I had bought, the more I liked it; but none of my friends did. They laughed at it and said I was a fool, a *crétin*. But all the same, I saved up to buy more from Zborowski, who delightedly shouted the fact from the roof tops. Often I would gaze at the beauty and music of his work and imagine his awful life and his absorbing passion to paint, and I'd close my eyes. He was there standing before me, half drunk, asking: "You like my painting, eh? But why? You understand it? . . . You love it—as you do women? Ah! ah! ah! . . . Yes, that's the way!" [8]

Carco was soon convinced of Modigliani's genius. "The day came when, infected by his [Zborowski's] enthusiasm and my own opinion," the novelist wrote a magazine article about Modi's paintings. Carco was again in the army, but his visits with Zbo left a strong impression. In his *Bohème d'Artiste*, he recorded that during one grim week the Zborowski household had to make do with *haricots rouges* every day. He also tells of a visit when he sat in a room next to the living room when Zbo put a painting on an easel to show to a prospective buyer. As the buyer considered the picture and was making up his mind, Zbo pretended to look out the window at some movement in the street.

By chance, as Carco tells it, a big family, who lived in the building on the ground floor opposite, were directly in Zbo's line of sight. It was their habit, mother, father, eight children, and grandparents, Zbo had observed, to sit down to eat regularly at noon. Now, as Zbo watched, they unfolded their napkins, and the servant passed the plates. At this point Carco joined Zbo. He advised Zbo to pay some attention to his client or he would queer the sale.

"But look over there." Zbo put his head against the window. "It's two days since I've had anything in my stomach."

When Zbo had about given up on the sale and was concentratedly watching the family eat *perdrix aux choux* (partridge with cabbage), the client took out his billfold.

"Four hundred francs," said Zbo. "Only take it away quickly. I regret it already," he added, with a last look at the gluttonous family, "but you have my word."

Carco says that for the next two weeks, at least, the Zborowskis and Modi ate well.[9] Six years later the same picture sold for thirty thousand francs.

Zborowski had so many humiliating, disheartening experiences selling Modigliani's paintings that his will to go on seems as impressive as Modi's. The two were well matched in devotion and dedication.

The sales Zbo did put through with infinite labor often backfired on him. For example, Zbo persuaded a Polish tailor to buy five superb Modiglianis for five hundred francs. Zbo spent the money immediately for food, rent, debts, and to keep Modi in funds. The next day the tailor showed up and demanded his money back: his wife thought the paintings were awful! Zbo hadn't so much as a franc left. He hid in his bedroom as Lunia made up a cock-and-bull story to calm the excited tailor. They averted a scandal by borrowing money and selling whatever they could. After Modi's death, the tailor wanted to buy back the same five paintings at much higher prices, but Zbo—all credit to him!—flatly refused to sell to him.[10]

An art critic, always on the lookout for a comer, bought three big Modigliani nudes from Zborowski. He was a tight customer, a bargainer who pushed down the asking prices so that he bought the first nude for 300 francs, the second for 275, and the third for 265. As the critic was about to make an offer on a fourth painting, Zbo prudently called off the sale.

"If I've been keeping count," he said, "I'm going to end up owing you money." [11]

Dealers regarded Leopold Zborowski as no art expert, as a half-baked poet who sold paintings. He had no idea how to manipulate pictures, painters, and clients to his own advantage. Kisling, who was a client of Zbo's, said that Zbo never kept books and was a poor businessman. Dogged, tenacious, lovable, Zbo was "essentially the poet, always with his head in the clouds." His idealism and his "anarchist principles," prevented him "not so much from making money as keeping it." He was impractical, took "utterly insane risks, . . . was far too confident in human nature and was rather easily fooled by clever talkers, especially those who knew how to flatter him. He was a born 'sucker,' as they say."

Kisling remembers a distinguished dealer who had a new gallery on the Rue Riche Pons. Zbo begged him to display five Modiglianis in his windows, but the dealer scornfully refused. Zbo swallowed his pride and, to give Modi the break he needed, did some crawling. If the dealer put the paintings in his display windows, Zbo would *give* him the pictures. The dealer's reaction was the same. Years afterward the dealer had to pay several thousand francs for the same canvases.[12]

It went on and on: Zbo was turned down and Modi's paintings were laughed at. The consensus sided with the judgment of Carco's concierge and the Polish tailor's wife. Gustave Coquiot, the art critic who bought the Soutine flower painting, "was one of the first to buy a Modiglaini nude." [13] If he did, he must have bought it at a modest price. Goldring says that Coquiot "had sung the praises of the painter from the early days of the Violincellist in 1912." Coquiot seems to have written about Modigliani's paintings after Modi's death. Diligent research shows that he never mentioned him earlier, no more than did Arsène Alexandre, another critic credited with boosting Modi as far back as the days of *The Cellist*.

An outsider in the trade, Zbo had to visit galleries over and over merely to arrange interviews with self-important dealers. Then a day came when Modi was so flat broke and in such viciously low spirits that Zborowski swore not to rest until he had sold some of his paintings. He enlisted the aid of Ortiz de Zarate. The two friends tramped all over Paris from dealer to dealer, shop to shop, collector to collector. All in vain. Finally, after being passed on from clerk to clerk, Zbo and Ortiz were ushered in to see a noted man, identified only as "one M. G. [quite possibly Maurice Gangnat, an early buyer of Cézanne and a good friend and collector of Renoir], known for his eclecticism, divination of coming genius, fine spirit, and generous heart." [14] How did M. G. receive Modi's work? Zbo might have known.

"Get 'em out of my sight! I can't stand looking at such horrors. I'll tell you what I will do though: you tell this miserable fellow to look after his health and never paint another picture, and I'll give you five francs. How's that?"

This was one of the few times Zborowski ever seems to have despaired. He was exhausted. He dropped by the Rotonde as he reached Montparnasse. His friends asked what had happened, and he told them the familiar depressing story. Then Ortiz de Zarate had an inspiration. He picked up two of the pictures and walked several blocks to the barbership he habitually patronized. Big, bold, confident, Ortiz marched straight up to the owner and put the matter to him:

> Do me the favor . . . of buying these two pictures for two hundred francs. They're by one of my friends who has a terrible need of a little money. I assure you, I, Ortiz de Zarate—and you know me—that he is a painter of the future, and you'll be making a thundering good stroke of business. [15]

The barber, a Belgian, took Ortiz at his word, and never had cause to regret it. Shortly after Modigliani's death, according to Goldring, the barber was paid forty thousand francs for his two portraits while ". . . the famous M. G. on the other hand, paid tens of thousands of dollars for the canvases he had refused to buy for a few dollars."

Modi could be as nasty to the faithful Zbo as he was to other friends. Sometimes he deliberately remained away from the Rue Joseph-Bara. No use asking why. Modi was Modi—irascible, cantankerous, unreasonable. Did Zborowski think he was a bourgeois who kept regular hours? *Merde!* He'd object to every suggestion of Zbo's, argue, then stalk off in a fury. Kisling, home on furlough, had given Modi free use of his apartment. It had heat; it was spacious; and Kisling would even see to it that free models were available. Modi's reply, "The hell with you and your offer!" Later Kisling and Zbo would meet on the street or at a table at the Rotonde and worriedly ask each other the same question, "Have you seen Modigliani?"

Jacques Lipchitz has said that Kisling was wonderful to Modi, that Modi often painted in Kisling's studio, used his canvas, sometimes even painted over Kisling's own work. Lipchitz recalled that one day Modi, in a particularly nasty mood, and probably drunk, quarreled with Kisling in Kisling's studio. Modi accused him of all sorts of things, concluding with, "You are trying to speculate on my work!" The unjust charge naturally infuriated Kisling who, Lipchitz says, was so angry that he promptly threw Modi out of the studio, and all his portraits and drawings after him.[16]

In an important sense, Zborowski's prodigious efforts on Modi's behalf were not in vain. All Modi's artist friends, as well as artists who knew him only by reputation, were by now well aware of his talent and his worth. Modi had sketched all his contemporaries, most of whom were already established. Although not a Dadaist, nor any more interested in Dadaism and its principles than he had been in Futurism, Modi was a contributor to *Cabaret Voltaire,* a thirty-one-page, Dadaist magazine published May 15, 1916, in Zurich. Only five hundred copies of the publication, billed as a *recueil littéraire et artistique,* a literary and artistic collection, were printed. Hugo Ball was the editor.

The magazine contained Dada poetry as well as art. There were contributions by Jean (or Hans) Arp, Blaise Cendrars, Wassily Kandinsky, Guillaume Apollinaire, Picasso, Tristan Tzara, Filippo Tommaso Marinetti, and other Futurists. If Modi saw the magazine, he may have been amused by the explanatory notes for bourgeois readers on the first page. His contribution was a portrait of Jean (or Hans) Arp, the French painter, sculptor, and poet, whom Modi and Max Jacob had met at Marie Wassilieff's artist canteen on the Avenue du Maine back in 1914. Oddly enough, in the table of contents Modi was listed as "L. Modegliani."

Probably because of his contribution to the magazine Modi was asked to exhibit at the Dada Gallery in Zurich in 1917. Arp was "The typical artist of the movement . . . ," and with ". . . the Rumanian poet

Tristran Tzara, the German writers Hugo Ball and Richard Hulsenbeck . . . in February 1916 . . . founded the Cabaret Voltaire, a literary club, exhibition gallery, and theatre hall all in one. . . ." The public was shocked by the screwball, *avant-garde* "entertainments" put on there. People banged and thumped keys and bottles "to make music until the audience, nearly crazy, protested." There were also some oddball antics with poetry. But Modi's paintings, probably sent out by Zborowski, were hung in the Cabaret Voltaire along with those of Arp, De Chirico, Max Ernst, Lyonel Feininger, Kandinsky, Paul Klee, Oskar Kokoschka, Franz Marc, and of course, Picasso. They "were exhibited in a very eclectic manner." Much like Futurism, which Modigliani abominated, the Dada movement was "designed to undermine by every possible means the traditional bases of culture and social order." [17]

Zbo, only too glad to expose his client outside hostile Paris, probably hoped to attract some Swiss buyers. But they were not forthcoming until two years later when Francis Carco finally was able to do an article on Modigliani for a Swiss publication. From a public-relations point of view, it was valuable for Modi to exhibit with outstanding contemporaries, even if he was no Dadaist. Neither was Picasso, for that matter. Just at this time, ". . . when he was beginning to be better known and appreciated, Modigliani might have made all the money he wanted, if only he had played his cards better, been less difficult with dealers, and consented to welcome visitors to his studio." [18] But Modi had never played his cards right, nor did he know how. If he had, it is conceivable that he would have made money, but then he would not have been Modigliani.

Paul Guillaume, who played an ambiguous role in Modigliani's career, was slick, knowledgeable, and shrewd. He saw to it that he held good cards, shuffled the deck to come up with artistic aces, and played them close to his vest. Carco tells an amusing story that seems to establish Paul Guillaume's character once for all. Speaking of modern art and the example of the old masters, Carco touches sarcastically on the inspiration provided by Negro primitives, and describes Paul Guillaume holding a Negro statuette out to him in his gallery as two young critics stood by. Guillaume said that it was of the finest period (*"haute époque"*) of primitive art, and began to rub the statuette on the carpet.

" 'What on earth are you doing?' one of the young men exclaimed.

" 'I'm giving it the sheen of the centuries,' said Guillaume imperturbably.' " [19]

Guillaume knew very well that a certain cynicism was an important part of every dealer's makeup.

One can only wonder at the kind of contract Modi had with Zborowski—a contract that apparently permitted Modi to deal with Guillaume, sell independently, and dicker for commissions at the same

time that poor Zbo paid him a weekly salary. Guillaume on one occasion visited Modi's apartment and was greeted with unusual courtesy. He left the Rue de la Grande-Chaumière apartment with two nudes, Goldring says. A rival dealer arrived hard on the heels of Guillaume, met a less friendly reception "but, not being a fool, also left cash." This kind of dealing and Modi's always ending up flat-broke, was what ". . . drove . . . Zborowski to despair." The good, faithful Zbo ". . . who, instead of hashish, wasted money in crazy generosity and cards, giving himself heart disease by playing poker." [20]

It seems odd that Modi's friends never managed to do more for him. Why didn't Van Dongen push Modi's work or introduce him at his fabulous parties? Why hadn't Picasso recommended him to his dealer, Kahnweiler, or to Rosenburg who represented Picasso during the war? One must conclude that they learned about Modi the hard way; that it was impossible to do favors for a man who didn't want favors done for him:

> . . . As the stories of his [Modi's] rudeness and ferocity got about, many who would have liked to help were shy of approaching him. But he was unbelievably haughty and could not tolerate the slightest suggestion of patronage.[21]

One man who apparently tried and failed, was the young, worldly-wise, charming darling of the intellectuals, Jean Cocteau, who "could on the morrow have brought duchesses, and, better still, high-class dressmakers, who had begun to replace the former as patronesses of the arts." [22] Modi had painted a remarkable portrait of Cocteau in either late 1916 or early 1917; the dates vary. Claude Roy, who says that Modi painted Zborowski, Cocteau, and an early portrait of Jeanne Hébuterne within the space of a few weeks, feels that the "dominant geometric element" in the portrait of the poet is "the acute angle," whereas in that of Zbo it is "the circle" and with Jeanne's "the oval":

> So as to convey at once the nimbleness and sparkle of Cocteau's wit and his elfin cast of face, Modigliani imparted to his line and indeed to the whole composition, an angularity and a nervous restlessness at the opposite pole from his rendering of Zborowski's face, which with its mild-eyed meekness reminds us of a faithful sheepdog's. . . .[23]

Of this same portrait Franco Russoli has written:

> . . . In his painting and in the very beautiful preparatory drawing in the Pecci-Blunt collection in Rome, Modigliani shows the "Luciferine" intelligence, the ruthless and attractive sharpness of this writer whose sureness and cold penetration were so far removed from Modi-

gliani's romantic, pathetic and equally profound way of feeling and judging; shows it through the air of exasperation in the vertical figure, through the sharp angles, crisscrossing dryly, through the crystalline jerkiness of lines and volumes.[24]

Cocteau's recollections of Modigliani are as touching and understanding as one might expect from so sensitive a poet. In his Preface to the Russoli book, Cocteau tells of being asked by a television interviewer whether Modigliani was "mad." It was a point-blank question. Cocteau replied unhesitatingly "that by the standards of our age he must be, because instead of selling his drawings he gave them away." To Picasso and to me, says Cocteau, "The myth of a mad Modigliani seems particularly strange." They lived near him and with him and were never aware of it. But how different it was then!

> . . . At Montparnasse, we could afford the luxury of being poor. Poverty was something gay, something we should find impossible today; much too expensive. The result is that we are now showing our dear Modigliani in fancy dress: but this theatrical character has nothing to do with his painting.
> He was always proud and rich, when we knew him; rich in the real sense, drawing the elongated portraits of his friends and wandering from table to table at the Café de la Rotonde like a fortune teller.
> Was he handsome? I have been wondering, since I saw Gérard Philipe portray him in a film. No. He was something better. And he greeted mockery with his terrible laughter.[25]

Cocteau tells of his portrait, "which in America rose in value from 5 francs to several million," and was painted by Modi in Kisling's studio in the Rue Joseph-Bara. He describes how, at the same time, Kisling painted a picture of him posing for Modi and also showing "Picasso in a black and white checked shirt drawing on a table behind us." Their life, says Cocteau, was simple and violent in those days. "Modigliani epitomized it. He drank, of course, but then who didn't?" Cocteau was on military duty in Belgium, and returned to Paris, Picasso, and his friends in Montparnasse only on furlough. He remembers vividly their evenings together and how, at dawn, Modi would not go home. "He stamped and laughed and danced like a bear before Rodin's statue of Balzac, and unravelled a red belt, miles long, while Kisling, his nurse, kept a hold on one end of it."

Enlarging on this in his own little book on Modigliani, Cocteau says he has only to shut his eyes to see Modi on his feet, pawing the ground in a sort of bear's dance. Over and over Kisling said to him, " 'Let's go home. Come on, let's go home.' " Modi wouldn't. He shook his curly head, no,

no. They tried to talk him into it, while Kisling used force, grabbing at Modi's red sash. Now Modi changed the pace. He raised his arms in the Spanish-style, snapped his fingers, and turned round and round as his sash unwound interminably and he pulled away from Kisling. "Modigliani broke into terrible laughter and danced more energetically than before."

Modi was handsome—handsome, serious, romantic. Cocteau praises the supreme elegance of the drawings of Modigliani, the aristocrat of their group. His line, so fine that it seems a specter of a line, never becomes muddy, avoiding this with the suppleness of a Siamese cat. Modi does not distort features, nor upset their symmetry, nor knock out an eye, nor elongate a neck. All these things "arrange themselves in his heart." That was how he drew them at the Rotonde, where he never stopped drawing, and Cocteau mentions the multitude of portraits in existence, sketches of Modi's friends about which no one knows. In these drawings, Cocteau feels that Modi was judging them, weighing them in the balance, loving them, contradicting them. "His drawing was a silent conversation. A dialogue between his line and ours."

Cocteau explains that if Modi's models happened to look alike, so did Renoir's young women. Each recorded his models in his own style, in an image carried within himself. It was Modi's habit to search for faces that corresponded to this image; it was a requirement, in a sense, of the men and women he chose to draw. To the old charge made by the unobservant that Modi's subjects all look alike, Cocteau answers that it is the same false similarity these "blind" people see when all Chinese or all Japanese or all Negroes look alike to them. Further, the "alikeness" of Modi's expression is the framework, for Cocteau, through which Modi asserts his own personality. It is the medium by which the mysterious elements of his genius are communicated. "Modigliani's portraits, even his self-portraits, do not reflect his exterior line, but his interior line, his noble spirit—acute, lithe, dangerous, similar to the horn of unicorns." Cocteau makes clear that Modi was not at all like those caricaturists who frequented the terrace of the Rotonde with a carton of drawings under their arms, looking for customers, doing instant, one-minute sketches. Rather Modi reminded Cocteau of those superbly contemptuous gypsies who sit at a table and read your palm. After posing for Modi, you did not quite know what to make of the drawing, but then, neither did you quite understand what the gypsy told you about your fate from the lines in your hand.

In refutation of what others have said, Cocteau insisted that Modi did not draw to order. Cocteau thought, too, that Modi exaggerated his drunkenness, his snarling, his uncalled-for laughter "as a defense against the bores that he insulted with his arrogance":

He was like those models in Rome who at one time waited for paint-
ers on the Spanish steps. His hair was short and curly, his beard (which
would have been a thick one) darkened his hollow cheeks. A dark fire
lit his whole being, and passed even into his clothes, to give even their
negligence a dandified air. He was gay, witty, charming; and, as none
of us ever had the least notion of success, he lived royally in the glory
bestowed on him by our group, for whom commercial values and the
problem of the general public simply did not exist.[26]

If this is not sufficient tribute to Modigliani, his art, and his genius,
Cocteau's final paragraph in his Preface to Russoli's book is as magnifi-
cently honest a summing up as has ever been made:

The task of building up his legend I will leave to others. I can only
speak of the brotherly friendship shown to me by the simplest and no-
blest genius of that heroic age.

Cocteau, who was always closer to Picasso than to Modi, and worked
with him, makes a definitive judgment here, which is also a subtly quali-
fying one: Modi is not the greatest, the supreme genius of that heroic age,
but "the simplest and noblest," with the implication that this may, in-
deed, be something better. The subtlety of Cocteau's understanding, the
sensitivity of his vision, make it all the more difficult to accept Modi's ap-
parent indifference to him, especially since he was influential and could
have done so much for him if Modi had allowed it. Cocteau tried. He
did it cleverly, but Modi was not taken in.

On on occasion Cocteau, presumably when the group was gathered in
Kisling's studio, went to the trouble of arranging a fine still life for
Modi's benefit. A deft combination of "some cakes, flowers, a bottle, and a
siphon," that was a practical and artistic triumph. Modi did not bite. He
*never* painted still life, ". . . and he resented anybody interfering in his
affairs. Moreover, Cocteau had made the mistake of supplying a full bot-
tle of alcohol!" [27] Still lifes, particularly in the Cubist vein, were in de-
mand, and Paul Guillaume had allegedly complained to Zborowski that
while Modi had talent, it was a pity his paintings were not more
"French" in technique and subject matter.

By the time Modi died in January, 1920, Cubism had been reduced to
"a kind of parlor game limiting all art to such still lifes as could be com-
posed from objects found in a studio or café." But, far more than most of
his contemporaries, Modi "did not believe that the end of art was in the
geometric analysis of a wine bottle or Spanish guitar." [28] As he is sup-
posed to have explained to his friend Leopold Survage: "To do any work,
I must have a living human being—I must be able to see him before
me." [29] Modi's antipathy toward still lifes was not affectation.

People—living subjects—were evocative. Modi drew inspiration from them. But more than his refusal to paint fashionable pictures, what seems to baffle and exasperate Douglas Goldring, as well as others, is Modi's penchant for refusing the helping hand, for harassing poor Zborowski, and for being fool enough to snub Cocteau, whose influence he could have used to such advantage.

While a Matisse went to great lengths to assure himself favorable publicity and convince the press that he was just an ordinary man, Modi knew he was different from everybody else. His very name, he felt, should proclaim his identity. When the police stopped him late at night as he wandered around the blacked-out streets of Paris and asked for his name and his papers, hadn't he roared, "Modigliani!" as if everyone should know immediately who he was.

∽ ∽ ∽ Chapter Twenty-seven

*". . . I order you to take all that filth out of the
window!"*

During the busy summer of 1917 Modi found himself commissioned
to paint Léon Bakst, a cultured and discriminating Russian who
was also a skilled portrait painter and an outstanding scene de-
signer. Bakst, whose best student at his St. Petersburg art school had been
Marc Chagall, had made his great reputation with his designs for Sergei
Diaghilev's Ballets Russes. Accustomed to drab décor and academic
sets, Parisian audiences had been stunned by the color, the richness and
splendor of his sets and costumes for such ballets as *The Specter of the
Rose, The Afternoon of a Faun,* and *Jeux.* Bakst had achieved the status
of minor celebrity and wealthy patron of the arts.

One day when Bakst expected Modigliani at his big, luxurious apart-
ment at 112 Boulevard des Malesherbes, close to the Place Malesherbes,
Bakst asked a young writer friend who had been visiting him to stay on
and watch the sitting. The writer was Michel Georges-Michel, who
records that Bakst said to him:

Don't go just yet. I'm expecting somebody who really is "somebody"
—the Italian painter and sculptor Modigliani, from Leghorn. He is
doing my portrait. Here's a line-drawing he's done for it. Look at the
care he has taken. All the features in my face are etched as if with a
needle and there's no retouching. I'm sure he must be poor; but he has
the air of a *grand seigneur.* He really is "somebody," I assure you.[1]

Georges-Michel was immediately interested and excited. He explains
that he was deep in a novel at the time, which, apparently erroneously,
he gives as the year 1919. The accepted date of Modigliani's Léon Bakst

portrait is 1917,[2] and inasmuch as Modigliani was away from Paris in 1919 and did not return to it until May 31 of that year, it seems more logical that he painted Bakst in 1917. Furthermore, Modi had barely eight months to live on his return. His health was failing; he was in no mood to accept portraits on commission; and, from Georges-Michel's description, seems more the Modi of 1917 than of 1919.

So far as novels about art and artists were concerned, Henri Murger had set the style in 1851 with his classic *Scènes de la Vie de Bohème* on which Puccini based his opera *La Bohème*. Georges-Michel's book was to be its modern successor, since he "had just discovered a new kind of bohemia, more liberal and infinitely wider in its significance, in the Montparnasse quarter, to which there flocked painters, sculptors, and intellectuals from all over the world, bringing with them their own very individual ideas." It was in this section, "so full of ferment," that he searched for "a hero who would represent the quarter and the new bohemia, as well as the struggles and aspirations of its habitués." Georges-Michel had asked for advice on a suitable protagonist for his novel. Since everyone seems to have suggested Modigliani, Georges-Michel chose him, ". . . changing his name to Modrulleau, and that of his mistress, who was known as 'Noix de Coco' to 'Haricot-Rouge.' "[3] So it was that his *Les Montparnos* was born.

Now he was about to meet the hero of his book.

Presently, into the studio walked a tall, upright young man, who had the lithe, springy gait of an Indian from the Andes. He was wearing espadrilles and a tight-fitting sweater. And in his pale face, which was shadowed by a shock of thick hair, his eyes burned beneath their sharp, rugged brows. I learned afterwards that the intensity of his gaze, which seemed to be fixed on some distant object, was unfortunately due to the use of drugs. . . .

Modigliani went through the formalities as quickly as possible, as if he were in feverish haste to set to work; the tea Bakst had prepared for him grew cold.

He applied the paint to the canvas slowly but firmly, all the muscles taut in his cheeks, jaw and hand. He replied briefly but courteously to our questions, but his whole attention was concentrated on what he was doing. Apart from his work, he showed no sign of interest in anything, except when Bakst talked to him about Utrillo. And when a visitor dropped in and asked why Utrillo painted only gloomy subjects, Modigliani answered less in bitterness than in anger:

"You have to paint what you see. Give a painter some other place to live than in a slum. How shocked the collectors and the art dealers are because we give them scenes of horrible suburbs, with trees twisted like salsify and blackened by soot and smoke; or else indoor subjects, where the dining-room is next to the lavatory! And since we are obliged to

live like rag-pickers on the outskirts of town, we simply make a record of what we see. Every period has the painters and poets it deserves, as well as the subjects that go with the life they have to lead. In the days of the Renaissance, painters lived in palaces, wore velvet, and enjoyed the sunshine. But when you think of the squalor a painter like Utrillo lives in, and how many hospitals he has been in, from Picpus to Fontenay, you don't have to ask why he doesn't paint anything but walls covered with fly-specks, and leprous streets, and an endless series of railings!" [4]

Modi always walked with a bounce, but he was certainly not tall. As for Modi's "intensity of gaze," which Georges-Michel attributed to Modi's unfortunate use of drugs, this, we may suspect, is the writer at work, finding in the original the qualities he had already given his prototype. Modi did not like being observed as he worked; he certainly must have been annoyed at being questioned as he painted. His courteous replies speak well for his sobriety on that day. Since his whole attention was concentrated on what he was doing, it is natural that he showed no interest in anything but the work at hand. His portraits took his whole attention.

Many quotations are ascribed to Modigliani, but these have never amounted to more than a few sentences or, at most, a brief paragraph. That Michel Georges-Michel should recall so long a statement word for word across the cavernous distance of thirty-seven years (his book was first published in 1954) is beyond comprehension. This was before the days of the tape recorder, and it is doubtful that Georges-Michel took down Modi's extensive remarks as he heard them. Rather, he recalled what his fictional character Modrulleau would have said under the same circumstances. Even granting that Modi must have said something similar, this pretentious set speech rings false.

Maurice Utrillo did not live in a slum, nor was he a realistic painter. He loved Montmartre and the other sections of Paris that he painted. They were beautiful to him, and he made them serene and beautiful in his paintings. It was a matter of individual feelings. What did surroundings or a way of life matter? As a sheltered schoolboy in Leghorn, hadn't Modi always preferred to find his subjects among the people, outside Micheli's studio? Beggars, stevedores, laundresses, seamstresses, prostitutes, ragamuffins. Utrillo loved the walls of Montmartre. Modi loved living, breathing, suffering human beings, whose faces mirrored what they felt, what they thought and experienced. Similarly, Soutine painted what he saw with his mind's eye, not just with his observer's eye, as did Lautrec, Gauguin, Van Gogh, Rembrandt, and Modi's beloved old masters. They painted what they saw, but it was informed by what they felt.

Modigliani's behavior at the sitting shows that to him a commission

was a commission, to be accomplished quickly and painlessly. It meant instant cash. Yet Léon Bakst was not a subject of Modi's own choosing, nor, any more than had been the case with Cocteau, did he care that the Russian was important, influential, the kind of man who could further his career. In the commission business Modi knew how important it was to please the sitter: it was the only good insurance for future sales. You became a popular society portrait painter famous for decorative studies of prominent figures in politics, literature, and the theater—a prosperous Van Dongen painting the Louis Barthous, the Paul Painlevés, and the Anatole Frances for cash and artistic glory.

No wonder then that Modigliani got right to work, and put off all questions except, possibly, those silly ones about Maurice. He wanted to get done without benefit of a little rum or brandy, to get away from these nosy, overcivilized people, and back to Jeanne.

Modi painted Bakst in his elegant mottled robe, its rich collar wrapped about his fat neck. His hair was close-cropped in the Russian manner, his forehead broad. His eyebrows were thin and circling, almost meeting the upcircling lines under his eyes, so that Bakst seems to be squinting through a natural pair of pince nez. His eyes were small, upslanting ovals; he had big, jug-handle ears, a long, heavy nose, a mustache dangling like thin, limp asparagus, a small, lopsided cupid's-bow mouth, sagging jowls, and a double chin. Modi gave him a look of inscrutable amusement, a smug twinkle in the eyes, a knowing quirk to the mouth. Here was a shrewd, sophisticated, strong-willed, worldly man. No distortions for Bakst; no swan's neck, either.

Modigliani sober, working quickly and efficiently with the utmost concentration, could not quite have jibed with the already legendary character Michel Georges-Michel had chosen for his *roman à clef*. But Modigliani must be Modrulleau, and vice versa: he must be the classically doomed hero prepared to account for his nasty habits and nastier life in satisfactorily romantic fashion. A reckless, heedless, damned life must have a pat explanation. Even so careful a critic as Alfred Werner lets the legend get the better of him when he says that at a certain point in his life ". . . we lose all trace of 'Dedo,' the dreamy, pampered youth from Leghorn, and enter a phase that might be termed 'Modigliani the Damned.'" Werner bases this judgment on a statement made by Modrulleau in Michel's *Les Montparnos*.

In speaking of Modi's exhibitionism, of his being carried to extremes, of his drunken rages, Werner feels that

. . . Georges-Michel draws a good picture of Modigliani when he has the hero Madrulleau [*sic*] exclaim: "I need a flame in order to paint, in order to be consumed by fire. My concierge and the butcher boy

 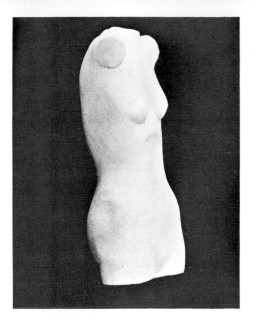

LEFT. Nina Hamnett, ever the happy bohemian, as she looked in 1920, with her hair bobbed, and smoking a cigarette. *(From* Laughing Torso, *Ray Long and Richard R. Smith Inc., New York, 1932)* RIGHT. Nina Hamnett's much-esteemed *Laughing Torso* by Henri Gaudier-Brzeska, carved from a piece of marble stolen from a stonemason's yard in Putney by Nina and the sculptor. *(From* Laughing Torso, *Ray Long and Richard R. Smith Inc., New York, 1932)*

LEFT. A fancy-dress ball in the Avenue de Maine in 1914. Nina Hamnett is seated prominently in the foreground. Modigliani, not in costume, is second from the right in the last row. Frederick Etchells, another friend of Nina's, is fourth from the right in the last row. *(From* Laughing Torso, *Ray Long and Richard R. Smith Inc., New York, 1932)* RIGHT. Beatrice Hastings (born Emily Alice Beatrice Haigh) as she looked in Paris in May, 1927, ten years after her affair with Modigliani. Then about forty-eight, her hair bobbed in the current style, she had lived abroad since 1914. *(Courtesy John Beevers)*

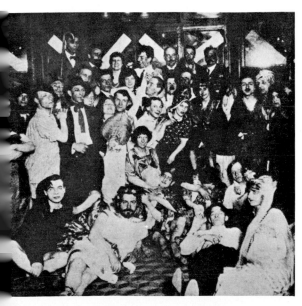 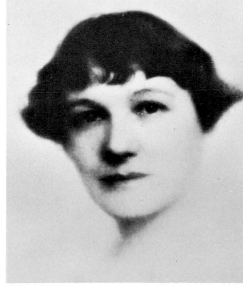

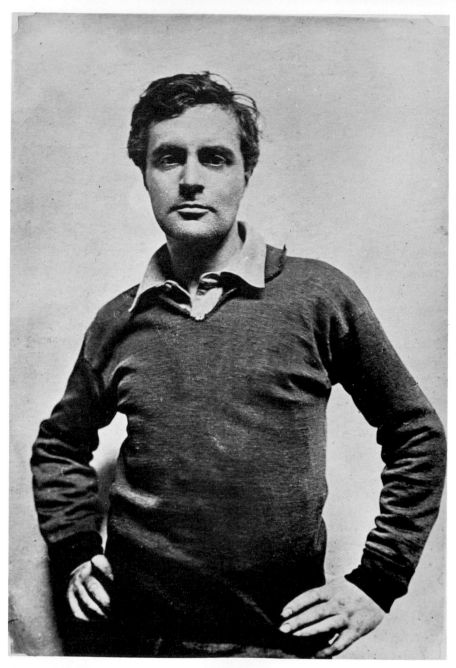

Another well-known photograph of Modigliani, who looks deceptively fit and healthy. This was probably taken around 1917. *(Marc Vaux)*

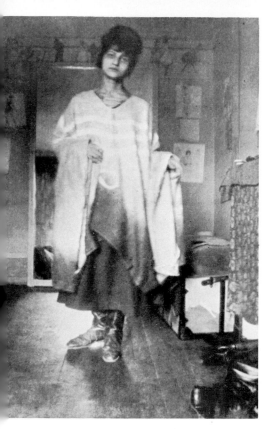

Jeanne Hébuterne costumed for an art students' ball in 1917, shortly before meeting Modigliani. She was nineteen. *(Courtesy Vallecchi Editore)*

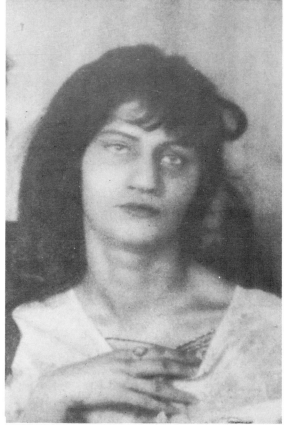

Another badly lighted, unflattering, straight-on photograph of Jeanne Hébuterne. Just as these photographs differ, so Modigliani never made a painting or drawing of Jeanne in which she looked the same. *(Courtesy Vallecchi Editore)*

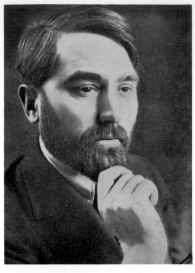

Leopold Zborowski (1889-1932). *(From Art-ist Quarter, Faber and Faber, London, 1941)*

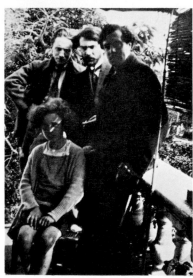

Modigliani on the terrace of the painter An-ders Osterlind's home in Cagnes-sur-Mer in 1917 or 1918. Standing, left to right: Oster-lind, Zborowski, and Modigliani; seated, Os-terlind's daughter. *(Marc Vaux)*

LEFT. Paul Guillaume, Mme. Alexander Archi-penko, and Modigliani snapped by a street pho-tographer on the Promenade des Anglais, Nice, probably early in 1919. *(From* Les Arts à Paris, *Paris, October, 1923)* RIGHT. Another photograph of Guillaume and Modigliani strolling on the Pro-menade des Anglais. Again Modigliani looks like a hired man in hand-me-downs next to the natty, fas-tidious Guillaume. *(From "Modigliani dal vero" by Anselmo Bucci in* Panorama dell'Arte *by Marco Valsecchi and Umbro Apollonio, Lattes Editori, Turin, 1951)*

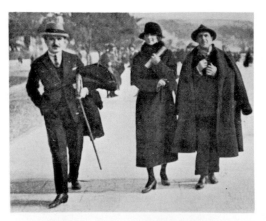

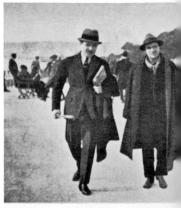

have no need of alcohol, especially if it does them no harm. They must conserve their precious lives. . . . But as for me, my life, it is important only because of what I put on canvas. . . . So what difference does it make if I give an instant of my life, if in exchange I can create a work that, perhaps, will last." [5]

Few novelists, in writing of painters, have ever searched out and recreated the inner lives of their subjects. Even Zola bungled the job, using his old and good friend Paul Cézanne as Claude Lantier in *L'Œuvre* and *Le Ventre de Paris*. He managed chiefly to rupture his friendship with Cézanne. Georges-Michel's Modigliani-Modrulleau has perpetuated a legend and irreparably distorted historical fact. It would have been far better if both Zola and Georges-Michel had emulated Francis Carco. Carco wrote fiction only about the underworld he knew well. About art and about artists, with whom he was equally familiar, he wrote only nonfiction, including a biography of Utrillo.

Georges-Michel produced a best seller, incarnated the *peintre maudit* legend about Modi, and did for Montparnasse what Henri Murger did for the old bohemia. It is partly thanks to him and his flame-devoured Modrulleau that much of Modigliani remains entombed in case-hardened anecdote and very strange fictions.

One of the most exciting events in the artistic circles of Montparnasse of 1917 was the marriage of Moïse Kisling, one of its most popular figures, best painters, and most eligible bachelors. The wedding could not have been a livelier occasion: the guests drank and carried on as wild bohemians were expected to do. Lipchitz speaks of ". . . more than forty of them . . . tipsy, shouting and quarreling at the Rotonde, Leduc, later at Kisling's quarters." His "only recollection was that of being utterly submerged in an alcoholic haze." [6]

As one of Kisling's closest friends, Modigliani was among the guests. Probably the gayest and most party-loving artist, Kisling, a Jew like Modigliani, Chagall, Kremegne, and Soutine, had none of their complexes about race. An extrovert, Kisling was an open, uncomplicated man, committed only to enjoying life and painting distinctive pictures. Gabriel Fournier remembered him as "sensible, intelligent, cultivated, obliging, generous, and affectionate." [7] He was so popular that his studio in the Rue Joseph-Bara was to Montparnasse what Picasso's in the Bateau-Lavoir had been to Montmartre in the old days.

Kisling was tough, too, and Libion often asked his help in dealing with unruly drunks at the Rotonde. Michel Georges-Michel had a fight with Kisling at the Coupole the first time they met: ". . . perhaps it was because of our row that I subsequently wrote *Les Montparnos;* poor Kisling

will never see the film version in which I gave him a prominent place in spite of our quarrels." [8] He adds that Apollinaire and Blaise Cendrars brought them together, but he never mentions the cause of their quarrel.

Kisling never had so hard a time as other artists of Montparnasse. Like Soutine, he was the son of a tailor but not "a shamed Jew, or one of those self-effacing beings easily frightened." He received an allowance of 300 francs a month from home, and "during the war he inherited 25,000 francs bequeathed by Chapman Chandler, an American sculptor, killed in aerial combat." [9] Back in Paris, convalescing from a wound before returning to military duty, Kisling decided to marry Renée-Jean Gros, daughter of Commandant Gros of the *garde républicaine*. No one could ever understand how the clowning, rowdyish Polish painter managed to arrange such a respectable marriage, particularly since in announcing the news to his friends at the Rotonde he said, *"Merde!* I'm marrying the daughter of an officer."

Renée Kisling, however, had quite a forceful personality of her own. She was to quarrel with Modigliani often and, like her husband, was to prove a chronic party-giver who could go on untiringly all night and into the next day. Renée hated to see parties break up and was furious with guests who had the temerity to leave early. Gabriel Fournier once planned to leave one of Kisling's parties early, knowing that they always ended up with the guests dead drunk and "pissing in boxes of drawings." He told Kiki, the famous model, of his intention, and she warned him not to leave. Renée would probably break his jaw if she caught him. Undeterred, Fournier tried to sneak out, made it to the stairs, and was overtaken by Renée who struck him in the eye, blackening it nicely. Renée later wrote him a letter of apology.

The best description of Kisling's wedding celebration comes from Chana Orloff. After the ceremony of the *mairie* of the XIV^e Arrondissement, bride, groom, attendants and guests went to the Rotonde en masse. Here, the *patron*, good old Libion, generously offered champagne on the house to the Kislings and their guests. Toasts were joyously drunk, much champagne consumed, and then "Kisling, *en grand seigneur*, invited everyone to dinner." [10]

Chana Orloff had her suspicions from the start: "Such openhandedness worried me a little, but my husband and Modigliani next to me merely remarked: *'On va bien manger.'*" From there, the wedding party proceeded hilariously through the streets to the restaurant identified by Lipchitz as Leduc, where they ate well, as Modi and Chana's husband had predicted, and the waiters hustled about bringing food and drink for everyone. If the *patron* of Leduc's had his doubts, there was nothing he could do but serve the wedding party.

In the midst of the meal, when Kisling was sufficiently ripe, he told his guests, "I shall dance the dance of chastity." He pulled his shirt out of his trousers and he galloped around us; after which he declared, "You take care of the bill," and he skipped. There was a moment of stupefaction, then a general "every man for himself." But the *patron* was at the door with a policeman. How we got out I don't know, but we felt no resentment toward Kisling, and we went to his place to continue the celebration.

What follows is unbelievable to relate. The drunks were making a frightful racket on the stairs, and a sculptor amused himself tearing up a collection of Kisling's drawings and scattered them down on the head of the concierge. Kisling, at the highest pitch of rage and aided by several of his companions, managed to throw the sculptor down the stairwell from the seventh story. But miraculously he clutched and clung as he went, and he survived. To the present day he has a searing recollection of his flight. Once more two policemen were waiting at the door when we came out.[11]

Because he was such a good fellow and so consummate a joker, Kisling got away with sticking his friends with the bill at Leduc's. They felt no resentment at his having the gall to pull the rug out from under them at his own wedding party. And what a celebration at his place afterward! Fist-fights, riots, almost a murder, and policemen all around! Who was the sculptor who tore up Kisling's drawings? Was Modigliani among those who helped revenge Kisling by tossing the sculptor down the stairwell? No evidence can be found on these matters. It would seem that, as with Lipchitz, all present were "utterly submerged in an alcoholic haze."

Chana Orloff accompanied her husband; other wives, sweethearts, and mistresses were present. Jeanne was probably there too, although Madame Orloff makes no specific mention of her. If we believe Michel Georges-Michel, Jeanne was with Modigliani at what Lipchitz says was the second event, after Kisling's marriage, which made 1917 ". . . lively . . . for all its bad news." This was the opening of the ballet *Parade* with music by Erik Satie, book by Jean Cocteau, and costumes and sets by Picasso.

It was held at the Châtelet Theater, and ". . . the huge auditorium was packed to bursting, and with a turbulent audience, out to make trouble." [12] Lipchitz explains that besides being

. . . Picasso's first contact with the ballet of Diaghilev . . . He was to show Cubism to the public at large for the first time. . . . Cocteau . . . decided to employ the symbolism of the circus or sideshow so dear to the Cubists, selecting two acrobats, a Chinese juggler and others to create a kind of human scenery. Apollinaire wrote the program text de-

scribing a point of departure for the New Spirit in this ballet: "a sort of sur-realism . . . promises to modify the arts . . . in a universal joyousness" using the term *surrealism* for the first time.[13]

Lipchitz, who attended the premiere with Juan Gris, found the result "unpretentious and gay." Many of the first nighters did not like it, but just as many "were delighted and applauded loudly." Assuredly, it was a *succès d'estime*. Lipchitz adds that "Gris had certain reservations about Picasso's descent from Olympus to the domain of the vulgar," but there were other practical considerations. "Perhaps after all Cubism was going to find its audience. Perhaps it was not all hopeless. The struggle was going to justify itself. They waited the day when their own work would be received with appreciation."

The business of force-feeding Cubism to the public in a sensational manner was certainly one of the reasons why Modigliani could never be a part of it or of any art movement. Movements were too planned, too cynical; they lacked truth, purity, poetry. Modi was not enamored of form and technique for their own sakes and could not swallow their self-hypnosis. Lipchitz records an anecdote that touches it off perfectly. "Once, when they came upon a triangular-shaped drinking glass, Gris, who revered the triangle because it was 'so accurate and endless a form,' said with his usual naïveté, 'You see, we are influencing life at last.' This was exactly the sentiment Picasso had expressed to Gertrude Stein when, on seeing a camouflaged truck pass on the Boulevard Raspail, had excitedly exclaimed, "Yes, it is we who made it, that is cubism." [14]

Michel Georges-Michel, who, as the jacket blurb for *From Renoir to Picasso* puts it, ". . . plays the role of Boswell—not for just one man, but for all the great French masters of the last four decades . . . ," reported the opening of *Parade* in the vein of a frenzied gossip columnist. He tells how Montparnasse was in a dither over the forthcoming ballet and how he and Diaghilev gave out tickets all through the quarter:

All the painters came, and stood about in their sweaters and working clothes, pushing their way among the fashionable ladies in the boxes. There were the most extraordinary combinations of people, some of the most picturesque of them in the Director's box, presided over by Missa Edwards, in black-and-white satin, and with Picasso wearing his customary jockey's-cap and garnet-red pullover. In the box where I was there were half a dozen painters from the "Cubist" cafés, and among them the melancholy "Noix-de-Coco," Modigliani's fiancée, Mlle. Hébuterne; the Citron sisters, Hélène Perdriat, Lagar, Ortiz de Zarate, two actresses from the Comédie Française; and, in the next box, Maurice Rostand![15]

Rostand was apparently a known homosexual. Georges-Michel says that one of the Citron sisters taunted him on this point and that ". . . M. Rostand gave her back as good as he got" with this thrust, "Mademoiselle, in your presence, I should imagine I was at most a lesbian."

Typewriters were part of the orchestra playing Satie's score, "stark by way of reaction against the nouveau-riche in art." After the overture "a storm of whistling broke out, followed by frenzied applause and yells." Now, according to Georges-Michel, a woman painter claimed that Rostand, whom she called disparagingly Mauricette, annoyed her. " 'There's only one way of disgusting him. . . . Let's make love.' And she began to undress. . . ." Georges-Michel, not content with this shocker, would have his readers believe that love-making went on all over the theater. "There was such almost erotic excitement in the rhythm of the music, in the lighting, in the dancing, that those spectators who were not fighting or shouting 'Bravo!' were performing like the couple in my box." The idea is ridiculous, of course, and the ballet was not especially erotic. If Modi appreciated its novelty and freshness, he cared as little for *Parade* as he did for other Cubist effusions.

Modi's habits remained as fixed as before. Jeanne Hébuterne seemed to have no demonstrably beneficial influence on his life. Salmon called her "that flapper become woman but still keeping her air of a girl," and Goldring adds that it had been expected that she ". . . would develop some feminine ruse to put some order into his life, and above all, that she would manage to get hold of some of the money that he threw away as fast as he received it." Then, showing considerable lack of understanding, Goldring says, "Alas, she seemed to have no other object in life than to please Modigliani and be loved." [16]

He might also have added "and to love even more in return." To love unhesitatingly, unquestionably, and absolutely. Jeanne, who had a stronger personality and will than she is usually given credit for, was the only one of Modigliani's women who loved him enough to submit entirely to his whims. No reforming, no criticizing, no feminine ruses—if she were capable of them—but only love and more love, total and undemanding.

How blind then to cry alas! she had no other object than to please her man and be loved. This was what he needed and what Jeanne was ready to give to keep him happy, relatively unworried, and at peace with her and himself. This almost saintly wisdom, this wondrous ability to act on it brought her to the only *modus vivendi* that could possibly "save their marriage." It would be remarkable that so young and inexperienced a girl should so early in her union with Modigliani hit on the only way to

get on with her lover if it were not that she loved him completely. As no other dealer could have abided the ill-treatment and abuse Modi heaped on Zborowski, so no other woman would have subjected herself to Modi's whims. She had the capacity to give herself totally to him.

It was the supreme act of her love; and she did it gladly, without thinking. The fact that she was intelligent, of a strong, arresting character, and had undisputed artistic gifts is also a testimony to the extraordinary personality of Modigliani as well. As he had searched for her all his life, so, it seems, had Jeanne searched for someone like him. "A pair of star-cross'd lovers," they might be, but they were also well matched, a perfect couple.

No one saw in Modi what Jeanne saw in him, as witness how she loved and suffered and died for him. And no one saw in Jeanne what Modi saw in her, as witness the remarkably beautiful portraits he left of Jeanne, the legacy of his one great love.

Modi continued to stay out all night and roam the streets with his friends. One of them was the late Blaise Cendrars, born Frédéric Sauser-Hall in Switzerland, "intellectual vagabond" and devotee of the bohemian life. Cendrars had lived in La Ruche before the war and had known Modi during Modi's early years in Paris. Later Cendrars had wandered over the world. He had enlisted in the Foreign Legion at the outbreak of the war, lost his right arm under fire at Champagne the next year and now, a veteran with an empty sleeve, was something of a hero to his friends. In the 1920's Ernest Hemingway used to see Blaise Cendrars at the Closerie des Lilas "with his broken boxer's face and his pinned up empty sleeve, rolling a cigarette with his one good hand. He was a good companion until he drank too much and, at that time, when he was lying he was more interesting than many men telling a story truly." He did have annoying habits, though. Hemingway says "there was a strong feeling Cendrars might well be a little less flashy about his vanished arm." [17]

Cendrars took life as it came. He never cautioned, never advised, never had regrets, not even for his lost arm. He did not feel it necessary to comment, preach, or moralize as Lipchitz, Zborowski, and others felt compelled to do. If Modi were damned—which Cendrars didn't believe—if he were intentionally wrecking his talent and his life, it was strictly Modi's business. Cendrars continued to respect and like Modi without calling him to account for his actions, no matter how suicidal.

Cendrars once ran into Modi along Place Germain-des-Près in the early hours of the morning. Modi had been up all night, and looked it. He greeted Cendrars like a brother. They were both broke, hungry, and anxious to find a good breakfast somewhere. It was a great joke. They teased each other as they walked along the sidewalk at a good clip because it was chilly and the pallid sun gave little warmth. When they

reached the Lutheran Church on the Rue d'Assas they stopped short at a strange sight. Out of the rows of trash cans ranged on the pavement, dozens of small arms, legs, and heads of miniature corpses seemed to protrude.

They quickly identified the corpses as little sculptured figures, statuettes, some by sculptors they had heard of but then mostly unknown and later to become famous. At first they couldn't understand why these *objets d'art* had been thrown away as junk. Cendrars seems to have come up with the answer. The Rue Fleurus gave off the Rue d'Assas, and it was there that the American woman Gertrude Stein, who was such a good friend of Picasso, Matisse, and Gris, lived. According to reports, she and her brother Leo, who lived with her, had had an argument. Leo had cleared out his possessions so he could go home. He had not been able to take along his whole art collection. It was sad, wasn't it? All this good work dumped out with the trash. But it would provide them with just the good breakfast they needed.

Modi grabbed all the little statues he could carry; Cendrars did the same with his good arm, and they hurried over to the nearest *boutique antiquaires*. But it was still only seven thirty in the morning; the little antique and bric-a-brac shops were not yet open. The two friends were freezing, so off they went to the nearest bistro, ordered two bottles of Beaujolais, drank up and, warmed and refreshed, walked off leaving a heap of statuettes in payment. They told their friends of their find, and soon the ashcans of the Rue d'Assas were raided to their bottoms. The raiders profited. So did the antique shops, who bought up the overflow of Leo Stein's art treasures at bargain prices.[18]

Modi's health began to deteriorate once again toward the fall of 1917. He painted when he had the strength, but more and more he slacked off, bitter over not being recognized. It was probably then that he had a fierce quarrel with Zborowski, and vanished from Montparnasse. That same night he turned up at the apartment of Suzanne Valadon, his corduroy jacket soaked with rain but carefully shielding some precious bundle. It was late. Modi was very drunk. Suzanne and her husband, André Utter, apparently home *en permission*, let him in. He unwrapped what he had been carrying, placed on the table ". . . a full bottle of brandy, a silent witness to his comparative wealth, thanks to the poet-dealer."

He insisted on knowing where Maurice was, and when Suzanne told him that he was in bed, Modi started for his bedroom. Suzanne prudently barred the way, telling him not to be stupid. "Modi glared at her, torn between anger at being baulked and affection for Valadon. Sulkily he sat down." He suggested they all have a drink. Suzanne demurred. So did

André. Modi protested that he wanted to drink with *someone,* and demanded a glass. Utter and Suzanne had to play along.

They brought him a glass. "He poured out half a glass of brandy and drank some." Now Suzanne suggested that he take off his wet things and spend the night on the studio sofa. Modi said nothing. He picked up his bottle of brandy, jammed it up under his jacket, and ". . . without looking at either walked out of the house. Where he spent the rest of the wet night is not known, for the Métro back to Montparnasse had long ceased running. Naturally, such escapades are scarcely advisable for a consumptive." [19]

Something was clearly bothering Modigliani: he was so irritable, exasperated, restless, and driven that he was intolerable. "Neither the friendship of the Zborowskis nor his love for Jeanne could diminish his fatal alcoholic craving," but that does not explain the problem, which was lack of recognition, the same terrible lack that had plagued him during his entire eleven endless years in Paris. Modi's sculpture, painting, and drawing had been praised by knowledgeable friends and artists through the years, but he had remained unknown, unrecognized, unappreciated, and unsold.

Jeanne's love, the patience, devotion, and help of the Zborowskis had nothing to do with how he felt. He was proud, arrogant; he thought of himself as a god and he had his reasons. Utrillo said of him: "We had our differences, but he was a god. May the Lord keep his soul in grace. . . ." [20] But even gods have their doubts. Jeanne loved and believed in him; Zbo recognized that he was a great painter, had genius, would sell soon, had only to be patient. Nothing had changed for him.

In 1917 Modigliani painted a portrait of a Dr. Louis Devraigne. It has overtones of Van Gogh, but for all that is strongly Modigliani. The close-set eyes, the fine long nose, the sweeping mustache and spade beard, every detail of the portrait shows how Modi felt about the doctor who is staring straight at Modi with an honest gaze. Modi admired him.

How they met is not entirely clear. The dealer Chéron, who still had some Modigliani paintings in his shop, may have sent Dr. Devraigne to Modi. Devraigne "bought some Modiglianis from Chéron and helped the painter by taking care of him, his friend [Jeanne] and their child in his last years." [21] Drs. Alexandre and Devraigne are both said to have given Modi their old clothes, though this seems unlikely, since Modi was not the kind of man to wear hand-me-downs, though he may have pawned them.

Dr. Devraigne was an obstetrician, so it is not likely that Modi consulted him about his own health. But he may have been a friend of Paul Alexandre, and he may have treated Jeanne, which gives rise to the speculation that Jeanne may have been pregnant in 1917, and had a miscar-

riage. This would account for her family's severe treatment of her and for Modi's adamant refusal to acknowledge Simone Thiroux's child as his. Modi was proud of his child by Jeanne.

Possibly it was Dr. Devraigne who helped Modi and Jeanne in the difficult years of their affair and through Jeanne's pregnancies. In any case the portrait is a tribute to his friendship for them.

In spite of quarrels, interruptions, and absences, which he never bothered to explain, Modi kept returning to Zbo's apartment to paint. The building, 3 Rue Joseph-Bara, was almost entirely occupied by painters and sculptors, according to Lunia Czechowska,[22] and they were particularly close to Kisling and Per Krogh (the Norwegian painter whose wife, Lucy, was the great passion of Jules Pascin). The concierge of the building, on whose head Kisling's torn-up drawings had been rained during his riotous wedding party, was an extraordinary tough old biddy of about sixty-five. Small, round, sloppy, and disheveled, she had a crooked nose and, Lunia thought, looked like a witch. Her room was so small and littered that she could hardly move about in it. It was very dark, too, in spite of a window facing the street, but *la mère* Salomon, as she was called, never opened it. She kept watch through a window facing the stairs, and no one passed her observation post without being checked on by the old girl. The postman left the mail on her window, where the tenants picked it up.

*La mère* Salomon was absolute mistress of the building. Everyone was a little afraid of her. Only Kisling could charm her. He was good to her and paid a cleaning woman to sweep the halls. On the occasions when Madame Salomon had to do the job, Lunia says, she complained loudly, screamed that the building was not a barracks, and often slammed the door to keep what she called "tramps" from entering. The tramps, Lunia explained, were Modigliani, Soutine, Utrillo, and other people who came to see Zborowski. Kisling had asked all the tenants to help pay the cleaning woman's wages, but they were so lax in putting up their share that he ended by paying it all himself. When their terrible concierge became more aged and feeble, Lunia goes on, it was Kisling who took care of her.

Modi's fortunes, like his health, remained low, and Zbo was as unsuccessful as ever in selling his work. One night, broke and hungry, Modi went to the Closerie des Lilas and came on a Mme. Biebenstein, a Scandinavian woman whose portrait he had painted, sitting at a table waiting for her husband. When she saw Modigliani, she invited him to join her for a drink. But Modi refused. M. Biebenstein arrived shortly, repeated the invitation. This time Modi accepted it. To salve his pride, M. Biebenstein asked to buy one of his drawings, and Modi went through the motions of selling him one. Later M. Biebenstein visited Zborowski

and gave him a thousand francs with instructions that they be given to Modi in installments of a hundred francs. Modi was not to know where the money came from. Modi had been paid 500 francs for the portrait of Mme. Biebenstein. It's an interesting footnote to this story that in 1926 M. Biebenstein sold it for 35,000 francs. Today it is worth much, much more. Schaub-Koch says that similarly painful stories are attached to nearly every one of Modigliani's paintings.[23]

Zborowski was a sensitive man, but nonetheless did not always understand Modi. There were the times when a woman would be posing for Modi in the nude, and Zbo, out of curiosity, would go into the room to watch Modi at work. Modi hated such intrusions: for him they were "like the violation of a sanctuary." Lunia, therefore, often stood guard outside the door to prevent just such interruptions.

One day, however, an exquisite blonde came to pose for the pink nude Francis Carco bought later on. Zbo was unable to control his curiosity. He walked into the room and provoked a violent drama. Zbo fled and went for a walk with his wife.

Lunia rushed in and pushed the frightened model into a room to dress. She then went into Modi's room. Modi was slashing angrily at the canvas with his brush. She had a hard time convincing him that Zbo had stumbled into the room by accident, and managed to talk him out of ruining the unfinished painting.

This story makes it sound as though Zbo liked to have a peek at beautiful young women in the nude and as though Lunia devoted herself to preventing the unseemly interruptions that so annoyed Modi. Both suppositions may be partially true, but it is also true that Zbo was endlessly solicitous about Modi and wanted to make sure that he had everything he needed, including alcohol. And Lunia's motives may not have been quite so exalted as they seemed. Hadn't Modi prevented Beatrice Hastings from posing for Kisling in the nude on the grounds that, when a woman did so, she gave herself to the painter? Such a man certainly needed watching to protect the models and Zborowski's good name. Besides, even if the models were willing, Lunia, who was *not* going to give herself to Modi despite his pleas (and her own attraction to him), might have wanted to make sure that no other woman gave herself to him either. She was protecting Jeanne, and Zbo, too, seeing to it that Modi fulfilled his contract with Zbo by painting—only painting—as he was supposed to do.

Zbo's supervision and Lunia's policing him can only have increased Modi's exasperation. This could also explain some of the groundless quarrels Modi had with Zbo, the inexplicable absences, and his refusal at times to do any painting at all. Praise be to Jeanne that she never criticized or lectured Modi. Now Zborowski, only too aware of Modi's mental

and physical condition, roused himself to a supreme effort. By argument and persuasion, he seems to have persuaded Berthe Weill to hold a Modigliani exhibition in her gallery.

Berthe Weill knew Modi well, as she did all his contemporaries. But up until now she had not chosen to show or sell any of his work. She was a tiny woman who wore glasses and favored tailored suits. While she had always been polite to Modi and encouraged him when he visited her *boutique,* she would not take him on. She thought him a cultivated, sensitive man with a superbly handsome head, but she could not decide whether or not he was an alcoholic. Her shop on the Rue Victor-Massé was so small that she had to show her pictures by pinning them with clothespins on a wire strung across it. She had at different times displayed prints by Willette and Balluriau, watercolors by Dufy, and paintings by Othon Friesz, Marquet, Girieud, Vlaminck, Utrillo, Pascin, Picasso, Van Dongen, and Jacqueline Marval.

In time people began to buy from her, but, as Friesz told Michel Georges-Michel, it was always a fight for an artist to collect his money from Berthe. Friesz said that on one occasion Picasso entered her boutique and threw down his *navaja* (a long Spanish knife). The next day Berthe offered it to Friesz in payment for one of his landscapes:

> "I can't eat wood," I told her; "I'm not a sword-swallower, even of Spanish swords. I want money!"
> Without a word little Weill turned round, pulled up her skirt, took a note out of her stocking, and handed it to me.[24]

That Berthe agreed to hold the exhibition at all speaks as well for her good nature as for Zbo's salesmanship. The exhibition was to be held at her new location, Galerie B. Weill, 50 Rue Taitbout, Paris (9me). The cover of the program for the show reads, *"Exposition des Peintures et de Dessins de Modigliani, du 3 décembre au 30 décembre, 1917,"* daily except Sundays. The cover also shows a drawing of a Modigliani nude, a long-haired woman with her head tilted to her right, her arms curved pleasingly around her breasts, her pubic hair prominent.

As with so many projects in which Modi was involved and which were launched with such high hopes, the exhibition was an unqualified disaster. The story has been told many times, but perhaps best in Berthe Weill's *Pan! Dans L'Oeil* (Smack in the Eye), a book as peculiarly titled and written as Nina Hamnett's *Laughing Torso.* As she tells it, the paintings were hung on a Sunday and, on Monday, December 3, 1917, the *vernissage,* the private showing, was held. No sooner had it begun than one passer-by, seeing so many people gathered inside, stopped for a look. Then two passers-by, three, and finally a mob.

They all seemed transfixed by one painting, Modi's most striking nude, which, some accounts have it, Zbo had put in the window expressly to attract as much attention as possible. Across the way from Berthe's shop was the office of *le commissionnaire divisionaire*, the division police commissioner. Noticing the crowd gathered before Berthe's gallery, he sent a policeman over with orders that the nude be removed from the window immediately. But why? asked Berthe, as her guests milled around. For answer, the policeman raised his voice and repeated, *"Monsieur le Commissaire vous 'ordonne' d'enlever ce nu!"* (The Commissioner *orders* you to remove that nude!) Baffled, since the ruling had been brought on by only the one nude and there were more inside, Berthe complied and had the offending painting taken out of the window. Meanwhile, those in the gallery snickered without understanding what had happened. Berthe admits that she did not know either.

Outside, the mob, which had grown, now became hostile. Berthe sensed danger. In a little while the same policeman, still hostile, came back and informed her, "Monsieur le Commissaire wants to see you upstairs in his office!" Berthe, perhaps sensing what was coming, stalled: she had too much to do, hadn't time, all these people . . . The policeman repeated his order. Berthe crossed the street after him " . . . *sous les huées and quolibets de la foule"* (facing the hue and cry and dirty cracks on the crowd).

"You asked me to come up?" she asked the commissioner when she faced him.

*"Oui"* said the commissioner, whom Berthe identifies as Rousselot, *"et je vous ordonne de m'enlever toutes ces ordures!"* (Yes, and I order you to take all that filth out of the window!)

Aware now that the investigating policeman had told the commissioner that the pictures inside were as bad as the one in the window, Berthe tried another approach:

"Fortunately there are some connoisseurs who are not of that opinion. What's wrong with those nudes?"

"Those nudes!" Rousselot bellowed, his eyes widening. *"Ces nues . . . ils ont des p-p-poils"* (Those nudes . . . they have h-h-hair— meaning pubic hair.) And now, posing, putting on a big show for the crowd, which encouraged him with approving laughter, the commissioner issued his final command: *"Et si mes ordres ne sont pas executés de suite je fais saisir tout par un escouade d'agents."* (And if my orders are not executed immediately I'll have the whole lot confiscated by a squad of policemen.)

Berthe had little choice in the matter. She gave up. She closed the shop, shut the door, pulled the blinds and, presumably, the crowd gathered outside dispersed. Those caught inside by her sudden decision

helped take down the paintings from the walls. Berthe says that M. Henry Simon, Ministre des Colonies; Marcel Sembta, Madame Aguttes, and other well-known people had already left. As for Commissaire Rousselot, he ought to have taken poison. Once the paintings were down, the exhibit, which had never officially opened, was officially over. Berthe noted that two drawings were sold, however, and that she bought two paintings herself to compensate Zborowski for the debacle.[25]

∽ ∽ ∽ Chapter Twenty-eight

*"Mon vieux, they never made anything more beautiful than that!"*

M odigliani's reaction to the closing of Berthe Weill's exhibition by
the police is not known. It was probably a greater shock to Zbo-
rowski, but Modi could not have been too surprised, since he had
long been convinced that nothing ever turned out right for him. It was fate
conspiring against him as always; it reinforced his belief that he was
being persecuted.

In spite of Modigliani's convictions and ". . . of the talented painter
persistently cold-shouldered by dealers and the public, . . . Zborowski's
efforts had gradually borne fruit." A few knowing collectors had begun to
buy Modiglianis before the war and, although the war itself had killed
the art market and thus ". . . inevitably retarded . . . the growth of
Modigliani's reputation . . . , slowly and surely he was making a name
for himself." Although the one-man show arranged for Modi at Berthe
Weill's seemed an abject failure, in one sense it "was a real success, not
merely a *succès d'estime.*" [1]

In the promotional as well as the commercial sense, the Berthe Weill
show had its value: people were bound to hear what had happened, to be
curious about the sensational nudes banned by a stupid police commis-
sioner. They would talk about Modigliani. The whole business was in-
credible. Had the police ever banned the work of any other artist or
closed down an exhibit of Picasso, Matisse, Rouault, Braque, Derain?
No, not of one of them! Here was something else that set Modi apart.

Modi had always excelled in portraying the nude, even in the days
when he was a student of Guglielmo Micheli's in Leghorn. His nudes of
1916–1917 were exceptional in the rose-orange coloring of their flesh, the
exquisite line, their honest sensuality. They were personal tributes to the

beauty of the models' bodies. These attractive young women gazed from the canvas fearlessly, without shame, proud, provocative, desirable, knowing they were attractive. As to their *"p-p-poils,"* pubic hair, which so offended Commissioner Rousselot that he stuttered with excitement, Modi showed it because it belonged, because he found everything about the female body beautiful. His were not classic nymphs carelessly eluding lascivious satyrs, nor painted academically with rich draperies artfully covering them. Modi's were beautiful women, alive and bestowed on mankind for a purpose. Modi saw them as meant for love, and Modi loved them all—the waitress from Rosalie's, the shy, awkward peasant girl who suffered such torture removing her clothes, the laundresses, the beauties, all of them. Modigliani's "nudes are instinct with a sensuality for which it is not easy to find a parallel in art." One need only look at Modigliani's pictures "with an unprejudiced eye, disregarding all the dubious legends that have grown up around them"—and the artist, it might be added—to find not ". . . even the faintest trace of unwholesomeness, perversity or morbidity. . . . What Modigliani expresses is often a mood of brooding, tranquil melancholy, sometimes gentle sensuality, never anything perverse or morbid." [2]

Leopold Zborowski was too busy and too worried to theorize about Modigliani's art. Overwhelmed by debts and the problem of trying to keep Modi reasonably solvent, Zbo seems to have panicked momentarily after the fiasco at Berthe Weill's. Modi's health was failing. Zbo was anxious to get him away from Paris before it failed completely. He was so desperate for money that he turned up at Jacques Lipchitz's studio and tried to persuade him to buy some of the nudes that had been in the show. Although it contains obvious errors of fact, as compared with Berthe Weill's account, the following passage from the Lipchitz biography is of interest because it shows Zborowski's despair and panic:

> In 1917 Zborowski arranged a show for Modigliani at the Berthe Weill gallery in the Rue Laffitte. In the window he had placed four of Modigliani's nudes which seemed to have shocked some people. For suddenly the police appeared, insisted that Zborowski remove them from the window. Depressed, Zborowski came to see Lipchitz. He had hoped to attract attention by these nudes so that people would come into the gallery and perhaps buy some of Modigliani's work. Now his hopes were dashed and he asked Lipchitz whether he would buy the four nudes for five hundred francs. Lipchitz had the double portrait; besides his quarters were very small. So he said, "Where will I put those four nudes with all these triangles?" He refused. [3]

The four nudes, only one of which had been in Berthe Weill's window, were a bargain at the price and, in time, would be worth hundreds of

thousands of francs. As it was, Lipchitz was soon enough forced to sell the double portrait to Léonce Rosenburg after a disagreement with his dealer,[4] and his parents never did get to see it. Buying the nudes would have been good business, but artists rarely speculate in art. Lipchitz's prudent refusal of Modi's nudes was as bad an error of judgment as his hesitation over buying Utrillo's painting at the Flea Market.

What is perhaps most amazing of all is Modi's resilience. He went on as he always had. He drank and took hashish; he made scenes, got thrown out of the Rotonde. Jeanne had to fetch him from jail. He drew at the cafés; he painted when he felt like it at Zbo's; and all the time his health worsened. Although he had a chronic cough, he continued to smoke cigarettes heavily. Sometimes he coughed up blood. Modi still patronized Marie Wassilieff's artists' canteen which, by now, according to Foujita,[5] had acquired a certain snob interest. It had been self-starting at the outset, with Marie as sparkplug. She had induced artists and friends to furnish the place. They had brought ill-assorted chairs, stools, and tables, so the canteen was a cheerful hodgepodge. But it had an exotic, cosmopolitan air. The artists sang, danced with the women guests, and the idle curious enjoyed watching Bohemia at play. There was also impromptu entertainment. Skits were worked up and were often representative of the countries from which the artists came. Picasso, for example, liked to play toreador, using a tablecloth for a cloak. Volunteers to play the bull were called for. The hilarity grew when a pretty girl stepped forward, put her two index fingers to her head as horns, and charged the cloak to shouts of "Olé!" It was good fun, but as the horseplay continued and it seemed her canteen might be wrecked, Marie Wassilieff had to call off the bullfight.

Marie scolded Modi for selling his drawings to "Americans and other foreigners," and insisted that he do a portrait of her. Modi did her in oils. Marie forever bewailed the fact that "she foolishly sold it for a thousand francs" after Modi's death. The buyer resold it for thirteen thousand, and the second buyer at a still further profit. Marie says that Modi allowed himself to be made the butt of jokes by visitors to the canteen, ". . . and it made her heart bleed to see a man of such talent as Modi capering about, frightfully drunk, and making a pitiable fool of himself for their amusement." Marie specialized in fancy dolls, caricatures of well-known people. Modi infuriated her by painting over the face of one of her dolls, "and then when she tried to stop him, ran off with it." [6]

Marie was wary of Modi. She did not want him at the banquet she planned to give celebrating the return of Fernand Léger, who had taught at her art school, and of Georges Braque "back from the war." Wounded in 1915 at the front, Braque had undergone a long convalescence, and had only begun painting again in 1917 when the banquet presumably

took place. Marie Wassilieff's account is the only one to give details of the banquet and to record that there was a last, tempestuous meeting of Modigliani with his nemesis Beatrice Hastings. Marie had said that Miss Y, as she called her, ". . . was at first very beautiful, with curly hair. Later she was more haggard than Modigliani."

Marie decided on the banquet in her canteen because everyone was so glad to see Léger and Braque back in circulation. But owing to a lack of space, the guest list was limited to thirty-five. Marie explained that Picasso was on the banquet committee with Beatrice to decide who should attend. There must have been heated discussion over the guest list: Marie says that with Beatrice "it was a question of her bringing Pina." Picasso was dubious about him, but Marie said she could. Beatrice had the final say about the guests.

Marie lavished a great deal of thought on the decorations for the welcome-home party. She chose a black tablecloth and red napkins, both of paper, to contrast with the white plates. There were two crowns of laurel for Braque and his wife. To make sure that Modigliani wouldn't spoil things, she took the precaution of warning him to stay away from the banquet:

> For heaven's sake, don't come tomorrow. I haven't invited you. Do me this one favor and I'll give you three francs instead of your fifty centimes. . . . I don't want a scandal.[7]

Modi, it would appear, a favorite of Marie's, was given a handout every day, if Marie can be believed. The little bribe seemed a good idea. The banquet was a success, and all went well until "the end of the meal." Then, as if by plan,

> . . . the doors burst open, and there was the whole band of painters and models who hadn't been invited. Pina, when he saw Modigliani, drew a revolver, and pointed it at him. I seized the gun by main strength, forced him out the door, and he rolled down the stairs.[8]

Unfortunately, Marie gives no more details about the dramatic confrontation of Modi, Beatrice, and Pina. But the banquet seems to have gone right on after the room was partly cleared. The party was the kind Kisling approved of: "By six in the morning Braque and Derain were dancing with the bones of the lamb."

Beatrice still belonged to the exclusive inner group, part of Picasso's circle, and was still attached to Pina. Modigliani knew it but had certainly not been shattered when Beatrice left him. It was Pina who was afraid of Modigliani and it was Pina who went for Modi, not Modi for him. Modi did not think much of Pina. Neither did anyone else, except an adulatory

biographer [9] and Beatrice, who admired his manly physique. As a sculptor, he was a shadow of Rodin. Pina is remembered not as an artist nor as a man, but because he was Beatrice's lover after Modigliani and, if Marie Wassilieff is right, as the man who pulled a revolver on Modigliani at the banquet for Braque and Léger.

It may have been because of the publicity brought on by the Berthe Weill exhibit that in the early months of 1918 Zbo, for the first time, began to make some good sales of Modi's work. William Kundig, a collector who happened to be in Paris, bought a pink nude for three hundred francs which is today worth a fortune, Carco says, and at the same time Carco himself bought five nudes at ridiculously cheap prices. And Jacques Netter, another noted collector, convinced by the example of a friend who specialized in Impressionists, asked Zbo to put aside several Modiglianis for him.

The rush seemed to be on. Other collectors came to Zbo's apartment to see and buy, among them the policeman Zamaron, now *secrétaire général de la Préfecture de police* and one of the first to speculate in the works of the Montparnassians. Another was Louis Libaude, a wily fellow always anxious to cash in on a good thing, who had his portrait painted by Modigliani. Finally, a banker named Schenemayer rushed over to the Rue Joseph-Bara and, without bothering to look at the five or six portraits for which Zbo was asking four thousand francs, bought the lot after some haggling and took them along with him. These sales following one after the other must have intoxicated Modigliani with happiness. Money seemed to be pouring in at last. "We're saved!" he shouted.[10] And so it must have seemed after all those long, empty years.

The next ordeal the Boches had planned for Paris was a huge railway cannon capable of hurling heavy shells a range of 76 miles, describing a 15-mile-high trajectory, and able to ruin and terrify beautiful Paris, to kill and maim noncombatants. When *la grosse Berthe* first shot her deadly projectiles, everyone in Paris thought it was another air raid. As the warnings sounded, people ran for the Métro shelters as usual and waited for the All Clear.

But the bombardment continued for some time. Though searchlights combed the skies over the city, they could find neither planes nor zeppelins. Yet the sound of artillery in the distance, a regular and insistent pounding, continued. Big Bertha was finally recognized as responsible for this new, barbaric form of long-range murder. Paris was the target of three enormous guns shooting from Ham, Laon, and Fère-en-Tardenois, about 100 kilometers away. About 180 shells hit the city. It was a brutal and remorseless, systematic and efficient bombardment. Paris

quivered in shock. The terrified populace fed on rumors: the Germans had hundreds of Big Berthas. Soon they would begin firing all at once, and Paris would be wiped out!

Panic spread on the chill winds of March, 1918. The exodus began. Everyone who could—everyone who had money, a remote cousin, friend, or relative—fled to the safety of the country. Only true Parisians, the brave and the foolish, the duty-bound and the cynical, the very old and the very poor, remained. The art dealers left, and as many artists as could. The art market, which had been shaky and uncertain all during the war, plummeted. Derains, Vlamincks, Utrillos, and Valadons were offered at such low prices that no one wanted them. Collectors had agreed to buy only at high prices, and were frantic as the highs slipped and slipped again.

In a jam, pressed for money and badly wanting to take Modigliani and his own family away from Paris, Zborowski approached Netter again. He knocked down the price of twenty paintings to two thousand francs. Netter became a sort of partner of Zbo's and, if it is true that he knew how to drive a bargain, it is also true that he was not the kind to take advantage of the depressed and paralyzed art market. It was thanks to Netter that not only Modi was able to get by but Soutine, too.[11]

In March, 1918, Jeanne Hébuterne was pregnant and Modi's health was worse. It was decided, therefore, that Jeanne, Modi, Jeanne's mother, and the Zborowskis should go to Nice. This required endless persuasion, argument, and planning on Zbo's part. Blaise Cendrars said that Zbo was afraid of Big Bertha,[12] which was pure malice on his part. Zbo was no more afraid of staying in Paris than anyone else. Nor were his motives for leaving Paris for the Midi self-serving. He arranged the trip for the sake of Modigiani's health, for Jeanne, who could spend her pregnancy in a good climate far from Big Bertha; for his own family, and because the Parisian art market had completely collapsed. Zbo had the idea that Nice and its environs were filled with wealthy refugees, their pockets stuffed with the family cash and jewels. They would, he was convinced, be inclined to invest in Modiglianis, perhaps even in Soutines. Zbo, as always, had good intentions.

Apparently Jeanne's pregnancy brought about a reconciliation with her family. Jeanne Modigliani implies that the Hébuternes and the Zborowskis got together, after Modi's Jeanne had told her family that she was expecting a baby, and that they all agreed it was imperative Jeanne and Modi leave Paris for the South.

The Hébuternes realized they could never separate the pair. Besides, Modi had "openly declared that he intended to marry her." This was a useful lever, but the Hébuternes seemed to have held out to the last: Achille bitterly refused to give in, but his wife was more forgiving. This

is borne out by Goldring's statement that when the group did leave, ". . . with them travelled Madame Hébuterne, who, at the last moment, decided she could not let her daughter go alone." [13]

The details of Modigliani's trip to the South of France in April, 1918, remain in dispute. Knowing that Modigliani would miss Paris and his old friends of the Rotonde, realizing, too, that some diversion would be necessary to keep Modigliani and Madame Hébuterne from each other's throats, Zborowski invited Foujita and Soutine to make the trip. Soutine, ragged and penniless, needed a change and was presumably to have his expenses paid by Zbo. Foujita would not be a financial burden: he was under contract to Chéron and received a regular monthly allowance for his work. Foujita's wife, the lovely, spirited Fernande Barrey, also made the trip.[14] She was an energetic and capable woman, who had greatly helped her husband in promoting and selling his work. She was utterly frank and scrupulously honest about herself. As Foujita began to be well known, reporters interviewed him and Fernande. One of them graciously "suggested that she started life as a model. 'Model!' exclaimed Mme Foujita. 'I was a streetwalker!' " [15]

No one but Zborowski would have had the temerity to gather together such an ill-assorted group or imagine that they could have a peaceful and commercially successful trip to the Midi. Zbo knew the Nice-Cannes locale because he had once recovered there from an illness. From the point of view both of health and sales he could not have made a worse choice. In peace or war, the Riviera was not noted either for its art dealers or collectors. It was near the sea, and damp, a climate not suited to those suffering from tuberculosis. Besides, there were no sanitariums as there were in mountainous Vence or in Switzerland.

It is a wonder Zbo ever got his troupe on the road. The trip was made in two sections: Jeanne and her mother were sent on alone as an advance party, no doubt to avoid conflict with Modigliani, who traveled with the Zborowskis, the Foujitas, and Soutine. Cheated of making the trip with Jeanne, and disgusted because Madame Hébuterne was one of the party, Modi gave Zbo trouble until the last minute. When it came time for the train to leave, he did his usual disappearing trick, causing Foujita and Zbo to run up and down the platform and in the station, looking for him as the conductor yelled, *"En voiture!"*

Foujita found him at the station lunchroom. Afraid that wine would not be available on the train, Modi was trying to buy a couple of bottles to tide him over. He must have been surly, uncertain whether he wanted to leave Paris after all. He was reminded that Jeanne had gone ahead and was waiting for him; that Nice was close to his beloved Italy and Leghorn. Traveling was no novelty to Foujita, who had come to Paris

from Japan; but Soutine, immured in Paris since his arrival, gaped out the window, speechless, like the dazed peasant he was.

The comedy of errors continued as Zbo arranged for lodging at Cagnes-sur-Mer, near Nice. The Zborowskis, along with Jeanne and her mother, took rooms in Le Pavillon des Trois Sœurs, a villa owned by a crusty old eccentric known as Papa Curel. It was set high on a hill back of the village of Cagnes, two miles from the water, with a good view of the Mediterranean. For the moment Modi was housed in an adjoining villa, further up the hillside, with Foujita, Fernande, and Soutine. The eighty-year-old Curel claimed to have known many artists and supposedly understood their ways.

From bits and pieces of evidence we can assume that Modi was furious at being separated from Jeanne, and not even remotely tactful to Madame Hébuterne. The constant, bitter arguments must have tried Jeanne in the extreme. In such an atmosphere it does not seem possible that Modigliani could paint. Yet Madame Zborowska assured Douglas Goldring that he did, and well. "Indeed, he had always worked passionately. Nobody could reproach him on that score. He would complete in a few days a picture that would take most men weeks or months to accomplish." [16]

Zbo, very low on funds, and straining to make sales at the Nice hotels, ran his venture on a shoestring. When he wasn't away, he was helping his wife smooth over the quarrels between Madame Hébuterne and Modigliani, which was why Modi had been put in a separate villa. Papa Curel was another problem. A fanatic musician in his own way, he played the trumpet, and saw no reason why he couldn't tootle it whenever he chose. The noise so disturbed Soutine that Zbo had to move him to still another of Curel's villas.

Modi had been restricted to red wine. Because he missed Paris and the fun and intimacy of the Rotonde, he spent time looking for a bar in Cagnes when he should have been working. He found one, high up on the hill, owned by a harpy called Mademoiselle Rose. It was "a curious place that rather resembled a cave, for although giving directly on a little square, it had no windows whatever." It was also *the* local meeting place, and popular with "resident painters and writers." There were artists and peasant factions, arguments, brawls, and fist fights. Modi felt at home. Besides raising hell himself, he quickly went into debt for drink. Mademoiselle Rose was as charitable as Rosalie, to a point, but made the same error as the owner of the little Italian restaurant on the Rue Campagne-Première:

She was, however, contemptuous of the drawings of Belgian refugees that he gave in exchange for drinks, and tore up what she deemed to

be "ugly geese with long necks," thereby adding yet one more to the crowd who later tore their hair, figuratively, on learning how much they had lost.[17]

Modi kept away from Les Pavillon des Trois Sœurs while he was working. If he went to see Jeanne, he had to face Madame Hébuterne. That was followed by a domestic explosion that Hanka Zborowska was called on to stop by separating the combatants, leaving bruised egos and an uneasy armistice for her husband to deal with. As for Zbo, he had been so sure of making sales in the big hotels that he had treated himself to a new suit before leaving Paris, but the situation was as discouraging as in Paris. In fact, it was worse. Nice swarmed with refugees. The wealthy filled the hotels and overflowed onto the Boulevard des Anglais, but none was in a mood to buy art. They ate well, lived well, drank well, but they held on to their money and their jewels.

Chaim Soutine also longed for the success and the big money that sales would bring. He believed Zbo would find millionaires falling over themselves to buy paintings. Soutine had never had a vacation, nor did he understand what a vacation was. He had worked without let-up in Paris, night and day. Now the soft climate of the Riviera stunned him. He was overcome with lassitude, made sleepy by the sea. Foujita called him the Lizard because he spent most of his time snoozing in the sun, jumping to his feet whenever Zbo returned from a successful tour of the hotels.

Soutine was incredulous when Zbo reported no luck, but he was not discouraged. Foujita had taken over Modi's role and was teaching Soutine the niceties. (Soutine's reputation as the dirtiest artist in Montparnasse had not changed, nor would it ever.) Foujita began by making sure that Chaim had not brought any bedbugs from his Paris cave. He made Soutine strip, tossed his clothes into a tub of soapy water, and persuaded him to wash himself in another. Foujita made sure Soutine scrubbed, washed, and soaked and rinsed himself. He introduced Soutine to the art of brushing teeth, providing him with toothbrush and powder and demonstrating their use. Soutine was enchanted. In no time, he was brushing his teeth at all hours, marveling at the results in a mirror, calling excitedly to Foujita and Modi to admire his beautiful white teeth.

"Soutine had never before seen the sea—his excitement was boundless." [18] Perhaps Foujita taught him the rudiments of swimming, choosing an out-of-the-way stretch of beach where they couldn't be seen. Modi had gone swimming from time to time as a boy in Leghorn. Considering that he was weak, coughing, and constantly out of breath, he must have done little more than soak. As he spent more time with his friends and less in the dungeon-like Cagnes bar, he was oftener in or near the ocean.

Modi, it is said, greatly admired Ortiz de Zarate's big chest and solid

physique. But the fact that Foujita, who was slight, was so much stronger and so much more athletic, seems to have annoyed him. He had scuffled with Foujita before and had always been the loser. Eager to see him humbled, Modi went to the trouble of bringing over a boy of seventeen or eighteen, "a husky bad actor who had been in prison," to take on Foujita. "Let's see what you can really do with him," Modi challenged Foujita. It was no contest. Jujitsu prevailed. Foujita said, ". . . So I threw him a couple of times on the terrace, and Modigliani never took me on afterward."

Foujita watched Modi at work and always remembered his "orgasmic" behavior. Foujita says ". . . he went through all sorts of gesticulations . . . his shoulders heaved. He panted. He made grimaces and cried out. You couldn't come near." As a result Foujita was impressed that Modi's work was as delicate as it was. On the other hand, "Soutine . . . worked in a regular deluge of color, with newspapers on the floor under him and paint all over his arms." Modi was interested in the technique of other artists and how they got their effects. Foujita said:

> Once at Cagnes, I was drawing, doing a landscape. Modigliani crept up behind me and watched for an hour. Then he tapped my shoulder and said, "Now I understand." He loved Oriental things—he had a stylized art. Foujita stressed *stylisé* rather than *déformé.*" [19]

Eccentrics often seem to be eccentric about everything except money, about which they are like everybody else. Papa Curel demanded that the rent for his villas be paid on time, which Zborowski was unable to do. He had made no sales. He had not only to pay the rent, but, more important, feed his party. They would have starved without the advances forwarded to Foujita by Chéron and Zamaron. Fernande Barrey remembers a time when they hadn't seen Soutine for two days. She and Foujita went to the villa he occupied to see what had happened to him. They called his name. His head appeared from a skylight, and he said: "I can't come down. Zborowski isn't back yet. He's gone to Nice to sell a canvas. . . . I'm awfully hungry." [20]

Apparently Soutine's lunch depended on Zborowski's selling a painting. They told him to come down and took him to Père Curel's place, where they had rented a floor with the Zborowskis. Fernande gave Soutine two slices of *gigot*—only two because otherwise there would have been none left for them. The next day Soutine went over to Fernande. To express his thanks he brought her a painting and a little screech owl he had found. He told her to choose which she wanted. Fernande chose the screech owl. No sooner had she taken the little owl in her hand than it flew away. Soutine went off laughing.

Bad enough for Madame Hébuterne to be trapped in this mad crew of artists, but not to have enough to eat must have seemed insupportable. Modi did his best to see that the party did not starve, and proved to be quick and resourceful. ". . . Modi, when matters were very bad indeed —just before they had to bolt for Nice—used to commandeer fowl and bring a couple home in triumph, always refusing to say how he came by them for fear of arousing Zborowski's tender scruples. He was, it appears, an excellent hen-roost robber and thoroughly enjoyed the job." [21]

Apparently convinced that Modi would be better off living conveniently distant from the bistros of Nice and from Madame Hébuterne, Zbo took him to visit a painter friend who had a house in Cagnes bordering close on Renoir's property. He was Anders Osterlind whose father, Allan Osterlind, was also a painter. Zbo hoped that Modi might board there for a while. Osterlind's wife, Rachel, was a pretty, sympathetic woman. The Osterlinds had a young daughter, and Modi had always liked children. (See photograph, facing page 385.) It must have seemed to Zbo that Modi would be in congenial surroundings and well cared for. And Madame Osterlind would keep him on his best behavior.

The story of this visit, often distorted, seems most accurately told by Osterlind:

> Modigliani arrived one day in the garden of my Cagnes home. He had the beautiful features of an Italian prince, but he was tired and dirty, one might have said, as if from having unloaded cargoes in the port of Genoa. With him was his shadow, the poetic Zborowski, who, in brotherly friendship, wanted to keep him from the dangerous life of Nice.
>
> Happy to welcome him I gave Modigliani the best room, all white and clean, where he never did sleep very much. Coughing and thirsty, he spent the nights drinking by the jug and spitting on my walls as high as he could, looking on afterward at the course of the saliva. He painted some beautiful things in this room, a beautiful portrait of a woman, he did several drawings, too.
>
> Zborowski furnished colors and canvas, and the exact amount of necessary alcohol which was useful and indispensable to his mental state. He kept hoping that Modigliani would not go down the narrow street leading to the section where lay the bistros in which he admired the advertisement—Pernod fils—a bottle and two glasses on a black background—whose beauty he extolled.
>
> "Mon vieux," [he'd tell us] "they never made anything more beautiful than that!" [22]

Osterlind was as understanding as he was obliging. Apparently a man of regular family habits like Matisse, he could only be distressed by his house guest, sick, troubled, and in a perpetual state of frenzy. Jeanne

Modigliani, who believes that Modi stayed with the Osterlinds several months after the group left Cagnes, says that the lovely golden-eyed Rachel Osterlind was

> slowly dying of intestinal tuberculosis, the result of Spanish influenza. Modigliani painted her one day, seated in a rocking chair, her chin resting softly on her right hand. The portrait was later stolen from Osterlind and came to light again, slightly repainted, only a short time ago.[23]

The Osterlinds lived quietly and never drank anything stronger than tea. They often asked Modi to join them, but he begged off, perhaps on the excuse of buying cigarettes in town. He did buy smokes, but it was liquor he wanted and, occasionally, a little hashish to chase away the blues. But it was not available. So he drank "at a bar at the top of the Chemin des Collettes . . ." sitting

> at a rustic table, polished to a high luster by elbows of the peasants, which Modigliani thought looked like "a table by Cézanne." Here he drank *pastis* under a Pernod advertisement whose simplicity, enobled by a haze of pipe smoke, seemed to him to be a work of art superior to those shown at the official Salons.[24]

While Modi was staying with Osterlind, he went to see Renoir. The famous confrontation between the two painters is another story that has been distorted and exaggerated. Some accounts have Modi taking along a picture to show Renoir; others have Zborowski, Soutine, and Foujita present. Foujita claims to have had a much happier visit with Renoir than the one with Modi. He says he met Renoir, who talked at length about his interests as a young man and the interests of other Impressionists in Japanese engravings and the influence they had on their work. Gently, Renoir told Foujita of his regret at no longer being able to enter exhibitions and of not knowing his own work. Foujita, it seems, recalls his visit with joy and considers it a high point in his life.[25]

It may well have happened. Foujita is the only witness. But old, weak, and crippled with arthritis, Renoir lived in complete isolation, and refused even to see dealers who had traveled to see him. It is unlikely that Foujita went to see Renoir on his own, though it is possible that he went after the visit with Modi. In any case, Modi's visit was arranged by Osterlind, a family friend and intimate. Here is Osterlind's account of it:

> Renoir's property was two hundred meters from my house, overrun by olive trees and rosebushes. This dwelling haunted Modigliani's imaginative spirit. He wanted to meet the master of Cagnes.
> Returning one day from the village, where he had at great length

admired his favorite poster of Pernod fils, he said to me, "Take me to Renoir."

That very evening Renoir received us in his dining room where he was brought after his work. It was a big bourgeois room. On the walls were some of his canvases. Also a delicate, gray landscape of Corot which he liked.

The master lay crumpled in an armchair, shrivelled up, a little shawl over his shoulders, wearing a cap, his whole face covered with a mosquito net, two piercing eyes behind the veil.

It was a delicate thing putting these two face to face: Renoir with his past, the other with his youth and confidence; on the one side joy, light, pleasure, and a work without peer, on the other Modigliani and all his suffering.

After Renoir had had some of his canvases taken down from the wall [so they could be examined more closely], a grim, somber Modigliani listened to him speak.

"So you're a painter too then, eh, young man?" he said to Modigliani, who was looking at the paintings.

"_____"

"Paint with joy, with the same joy with which you make love."

"_____"

"Do you caress your canvases a long time?"

"_____"

"I stroke the buttocks for days and days before finishing a painting."

It seemed to me that Modigliani was suffering and that a catastrophe was imminent. It happened. Modigliani got up brusquely and, his hand on the doorknob, said brutally, "I don't like buttocks, monsieur!" [26]

Other versions of the story have it that Modi had just come from the bars of Cagnes and was feeling his liquor. But a "grim, somber" Modi makes one feel that if he had been drunk, he had sobered quickly in Renoir's presence. At any rate, Renoir and Modigliani were at cross-purposes from the beginning. The old master was a benign seventy-seven now. While his art had brought him comparative wealth and enduring fame, neither was particularly important to him. Renoir had always been a happy family man with a sunny, outgoing nature. He was ingenuous, not an intellectual: he didn't "think" painting; he simply painted.

Renoir was in miserable health and suffered acute pain. He had turned to sculpture, but the actual work had to be done by assistants who carried out his directions. His arthritis was so severe he could scarcely hold a brush. He was cared for by his housekeeper and a maid, and since his wife's death, Les Collettes had become run-down, overgrown, almost sinister. Considering the state of his health, it is a wonder that he went on

painting, even more that he consented to receive visitors at all. But miserable as he was he still had some of his flashing, youthful spirit, a zest Modigliani would have admired if he had given himself the chance. Jean Renoir, his son, tells about a reporter who visited Les Collettes, and, astonished at Renoir's crippled hands, crudely asked how he could paint. " 'With my prick,' replied Renoir, really vulgar for once." But no one laughed. And Jean Renoir feels that this was a striking expression of the truth: "one of those rare testimonies, so seldom expressed in the history of the world, to the miracle of the transformation of matter into spirit." 27

Jean Renoir speaks of his father discovering and rediscovering the world every instant of his existence. He stresses the fact that Renoir did not think of a nursing mother when he saw a beautiful breast nor of childbearing when he saw a well-rounded belly. Jean Renoir tells of the time when his father, his Uncle Edmond, and Émile Zola were visiting the lovely Hortense Schneider, "reigning queen of the *Variétés*." As they sat in her dressing room, Zola and Uncle Edmond discussed "the theme in painting." Renoir was bored. Even Hortense yawned.

Suddenly Renoir turned to her. "That's all very fascinating," he said, interrupting, "but let's talk of more serious things. How is your bosom these days?" Hortense smiled and said, "What a question!" Then she "opened her bodice and gave him proof of her bodily charms." Renoir and his brother burst out laughing, but Zola turned "red as a peony," mumbled something no one could understand, and rushed out of the actress's dressing room. Renoir felt that the writer was "a regular provincial." "And then," said Renoir, of Zola, "What a queer idea, to believe that working people are always saying *merde!*" 28

As painters, Renoir and Modigliani had some similarities; temperamentally, they had none. Renoir's strength lay in his innocence, his lack of sophistication; Modi's, perhaps, in his experience and sophistication. Renoir was a happy, uncomplicated man who painted happy, uncomplicated pictures of beautiful women and flowers. What he liked he was sentimental about. He often gushed about painting and beauty as he saw them. Emotional suffering, mental torment, were alien to his nature. He could not understand why Paul Gauguin had bothered to go to Tahiti when there was so much to paint in France and it was so easy to manage.

Renoir's remark about stroking buttocks for days and days before finishing a painting was the remark that had upset Modigliani. He was disgusted, he regretted having come. Better to remember when he had visited the Right Bank galleries with Gabriel Fournier, marveled before the Renoirs and said that no one could paint women, especially the women of Paris, like Renoir. A genius who could paint sublimely should not give way to sickeningly rapturous outpourings about buttocks. Modi

appreciated shapely buttocks, but Renoir seemed to have no feelings be-
yond the physical for what he saw. For a true artist the parts were in-
separable from the whole: a nude was one, complete or it was nothing.

Renoir, who had only a little more than a year to live, and Modigliani,
who was less than half Renoir's age and was to die only a scant month
after the old master, never really met. Osterlind's account makes it clear
that only Renoir talked and then perhaps as much for his own ears as for
his visitors'. Or perhaps Modi had been too shocked to speak in the face
of Renoir's accomplishments. Perhaps he felt more strongly than ever
that he had failed; so, in fear and defense, he had been rude, and fled.

∾∾∾ Chapter Twenty-nine

*"With one eye you look outside, with the other you look inside."*

I t was not only in Paris that displays of Modigliani's paintings caused riots: at the very time he was in Nice, one of his nudes in the window of an art gallery in Toulouse was the target of stones. Mme. Marcellin Castaing, today the proprietor of a fine antique shop on the corner of the Rue Jacob and the Rue Bonaparte in Paris, tells about it.

She and her husband were staying with Mr. Castaing's parents in Toulouse to escape Big Bertha's shells in Paris. One day, while walking around the city, they saw a crowd of students carrying on a *monôme,* a student riot of sorts, in front of the Chappe-Lautier Gallery. As they went closer they could see that the students were throwing stones at the window where a Modigliani nude was displayed. The Castaings looked at the painting, went inside, and stayed an hour. They were so interested that they asked if the dealer had anything else by Modigliani. Among a number of paintings stacked in a corner against the wall, the dealer found a Modigliani portrait of a servant girl. The Castaings bargained for it and for the nude and got both for five hundred francs.

When the paintings were delivered, Mr. Castaing's parents absolutely refused to have them in their home and insisted that they be immediately returned to the gallery. The young Castaings reluctantly complied. But the spell had worked on them. When they went back to Paris, they bought about forty of Modigliani's drawings at ten francs apiece. Later, they gave many of them as gifts to friends. Mme. Castaing feels that Modigliani was, above all, a great draftsman. After his death the Castaings were able to buy another Modigliani nude in a gallery in the Rue de la Boétie. This time it cost them six thousand francs.[1]

While at the Osterlinds, besides his sensitive portrait of the ailing

Rachel Osterlind, Modigliani may well have painted one of his most memorable studies of children, *The Little Girl in Blue*. His style now, except in his portraits of Jeanne, often seemed to incorporate the simplicity and clarity that he so admired in the Pernod poster. His composition was fresh and appealing, as evocative as the bottle and two glasses in the advertisement. If he was worried and irritable, as he must have been, it did not show in the paintings.

He is said to have been furious with the little girl in blue because he had sent her out for a bottle of wine and she had come back with lemonade. But the painting of her is enchanting. She wears a thin purple ribbon tied in a bow above her black hair, which is chopped off in the back, drooping and loose in front. There is a part of sorts down the middle, but a wing of hair falls over her left temple and three strands stick up above the part. Her worn blue dress is only a shade less pale than her extraordinary eyes. Hanging from her neck to well below her shoulders, the dress has a ruffled white-lace hood. Her head is tilted a little forward and to the left. She grasps her left hand with her right held in front of her as if for moral support. The little girl holds her pose, transfixed by Modi's intensity.

*The Little Girl in Blue* has been acknowledged one of Modi's best, most touching, and perhaps his most popular portrait of a child.

Leopold Zborowski had hoped by showing Renoir some of Modi's paintings to obtain his backing. But Modi's outrageous behavior at Les Collettes had killed that hope. It was foolish and regrettable, but certainly typical. Modi apparently *had* to kick the props out from under those who took pains for him. He never seemed to make allowances for anyone except himself.

But Zbo was not beaten. He was never beaten. Another man would have admitted long since that the trip was a commercial failure. Foujita said that Zbo's ". . . method was to sit reading a paper on the esplanade, or to go into hotels, presumably with a rendezvous with a duke, or some important person, but nothing came of all this." [2] When the rich residents of Nice didn't have him thrown out as a tiresome sponger, they gave him ridiculous sums for his paintings out of charity.[3] Zbo was intelligent enough not to go on giving away valuable paintings for next to nothing. It was time, anyway, for a judicious retreat from Les Pavillon des Trois Sœurs and the other villas his party occupied.

Papa Curel had had enough. He wanted his rent money and he wanted it *now*. It was July. Since Zbo could not put up what was owed, the whole party was ordered to get out. According to Foujita, he and his wife and Soutine decided to return to Paris. Since the choice was between paying

Curel's rent or buying train tickets, they bought train tickets. Curel retaliated by seizing the baggage and belongings of the Zborowskis and Foujitas. Having no idea of the value of paintings, Curel took the trunks, which were held together with twine, and ignored the paintings. Even today Foujita gets great pleasure recalling Curel's stupidity. If he had taken the paintings, in five years, Curel, the trumpet player, would have been a millionaire. He would have owned several fine Modiglianis, Soutines, and Foujitas. "Papa Curel died strangled with regrets," Foujita recalls.[4]

Domestic life at the villa was hell, especially for poor Madame Hébuterne, who was completely out of her milieu. Jeanne "flatly refused to give up her Modi, the mother had made an heroic effort out of her love for her girl, and had insisted upon coming with her to Cagnes which, in itself, was a sacrifice, as it must have been a considerable strain on her slender resources." The good woman did "her utmost to stifle her continuously outraged feelings . . . despite Madame Zborowska's attempts to appease her and quiet Modi." Money was a big problem. "There had been all along perpetual rows and recriminations on both sides," at the villa, "family life had been anything but cordial . . . ," and ". . . Madame Hébuterne, the mother-in-law-to-be . . . particularly restive and angry."

Just before the move from Les Pavillon des Trois Sœurs, Modi turned up drunk one evening. Madame Hébuterne, exasperated beyond enduring, swore "that she would never have anything to do with him again, and cursing art and everything having to do with it for having robbed her of both her children, rushed to her room." [5] But if Jeanne refused to give up Modi, Madame Hébuterne was just as loath to surrender her daughter. After Zborowski took his party to Nice, he apparently put Foujita, Fernande, and Soutine on the first train back to Paris. Madame Hébuterne did not accompany them.

In Nice, Zbo managed to find the cheapest available accommodations. He looked respectable, he was persuasive, and Hanka's commanding, aristocratic good looks helped get them quarters. Zbo found a room for Modigliani at the Hotel Tarelli, 4 Rue de France. The Zborowskis had rooms not too far away; Jeanne and her mother were quartered in the Rue Masséna.

Nice itself had a frantic, unsettled air. It was crowded with people who had escaped from terrorized Paris and its daily bombardment by *la grosse Berthe,* and with assorted refugees comfortably sitting out the war. They were a tough, hard-living, demoralized lot. While they enjoyed themselves in the luxury hotels, talked, drank, and danced on the terraces of the restaurants and cafés they lived from day to day, guiltily trying to

put the war out of their minds. Most of them were people of culture; some were titled. In any case, they gave the deceptive impression of being free spenders and knowledgeable patrons of the arts.

But for Zbo the pinch was as severe in Nice as it had been in Cagnes. Modi painted in his room. Blaise Cendrars and Léopold Survage, friends of the Zborowskis, were living in Nice. So Modi did not lack for friends. He saw them often and also called on the Russian sculptor Alexander Archipenko, in his villa.

Modi was full of complaints when he visited the Archipenkos. He sounded like a henpecked husband. Archipenko and his wife listened patiently to his outbursts, letting him drink and talk himself out. When it came time to go, Archipenko gave Modi a bag and let him help himself to the vegetables and fruit in his garden.[6] The vegetables undoubtedly went into the community pot, with the fruit as dessert. Modi arrived like a man who had escaped from the clutches of rapacious women, and left like an escaped convict voluntarily returning to prison.

Modi carried on as he had in Paris, making drawings in his blue sketchbook of men and women in the bars, restaurants, and hotels along the Promenade des Anglais where the idle rich sauntered as they did on the Champs-Elysées. When a mild epidemic of wartime influenza struck Nice, Modigliani became seriously ill. Because Jeanne was so far along in her pregnancy, it was probably Hanka Zborowska who looked after him. Zbo, harried and badly in need of money, felt he was wasting his time in Nice. He had hoped that Lunia Czechowska, who had been holding the fort at the Rue Joseph-Bara while he was away, might manage some sales. But she had not, "so that now he found himself unable to stop at Nice and unable to get back to Paris." [7]

His illness gave Modi a bad scare. He knew that his friend Cardoso had died of flu in Portugal, and with Jeanne expecting in a few months, Modi, when he finally did get out of bed, gave up both alcohol and cigarettes. But his pledge—as might be expected—did not last. As soon as he was convalescent, he resumed drinking and smoking as before. Blaise Cendrars may have had something to do with it.

Cendrars said that some American friends gave Jeanne a *robe-de-style* for her pregnancy and that she carried her child high, "in her teeth," as they say in France. Cendrars, who was in Nice writing a scenario for a movie being filmed there late in 1918, thought that "Modigliani was in bad shape—you saw it at a glance." If this is true, then Cendrars gave Modigliani some very bad advice:

> Cendrars told him, "You should drink again." He took Modigliani to his hotel, put a 1,000-franc note on the night table, and told the porter to let Modigliani in at any time. Every day, when Cendrars

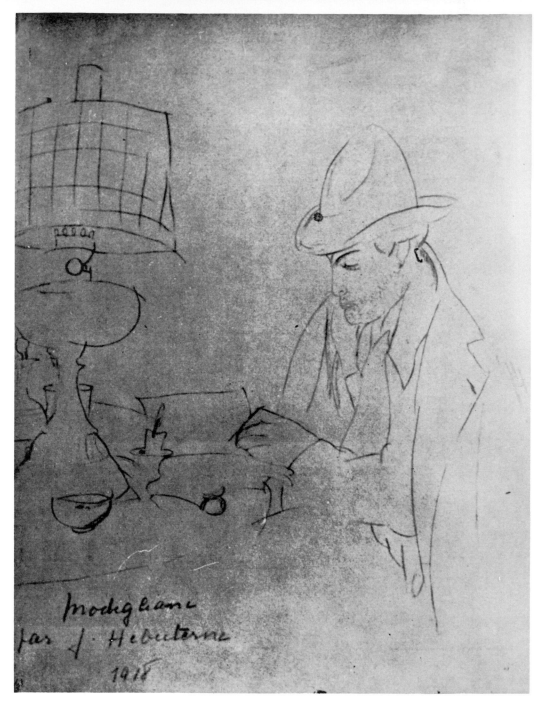

Modigliani reading by lamplight in Nice, 1918 or 1919, by Jeanne Hébuterne. Jeanne, who also did an oil painting of their courtyard in Nice, had marked artistic ability, as this drawing shows. The notation, bottom left, is by Paulette Jourdain, who at one time lived with the Zborowskis. *(Courtesy Vallecchi Editore)*

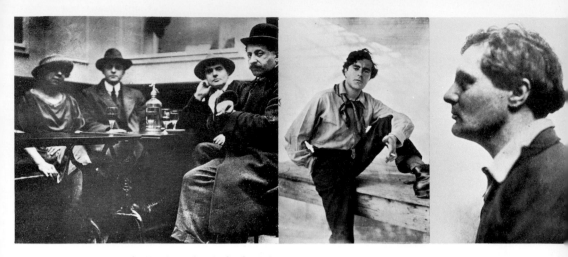

LEFT. Modigliani at the Café du Dôme, probably in 1919, in the company of an unknown woman, Adolphe Basler (wearing derby), and of a man usually identified as Abdul Wahab Gelani, a Tunisian known as the Arab. Too immaculate to be the legendary Abdul, the man has also been identified as Gottlieb, possibly the same painter Gottlieb with whom Moïse Kisling fought a duel in July, 1917. *(Marc Vaux)* CENTER. One of the most familiar photographs of Modigliani. From the look of his shoes, they could well be the sturdy new ones that he asked Zborowski to bring back from London after the Sitwell exhibition there in July, 1919. *(H. Roger Viollet)* RIGHT. Another familiar photograph of Modigliani. This classic profile shot was probably taken during his last years. *(H. Roger Viollet)*

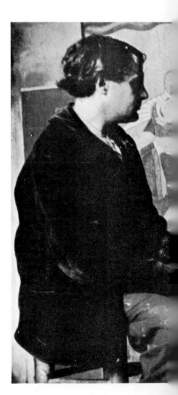

Supposedly the last photograph taken of Modigliani, this informal picture was probably snapped late in 1919. *(Courtesy Vallecchi Editore)*

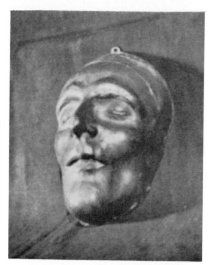

Front view of Modigliani's death mask begun by Moïse Kisling and Conrad Moricand, then put together and completed by Jacques Lipchitz from the broken pieces of the original plaster mold. Twelve casts were made of the death mask. *(Courtesy Pierre Cailler Editeur)*

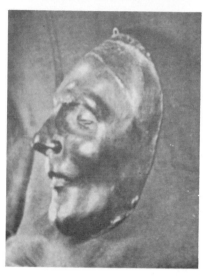

Profile view of the mask. The sunken lips show that Modigliani had apparently lost all his teeth during his last years, and wore dentures. *(Courtesy Pierre Cailler Editeur)*

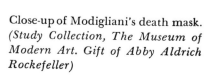

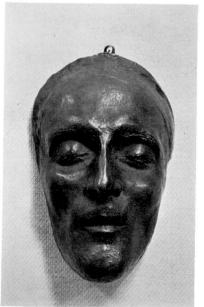

Close-up of Modigliani's death mask. *(Study Collection, The Museum of Modern Art. Gift of Abby Aldrich Rockefeller)*

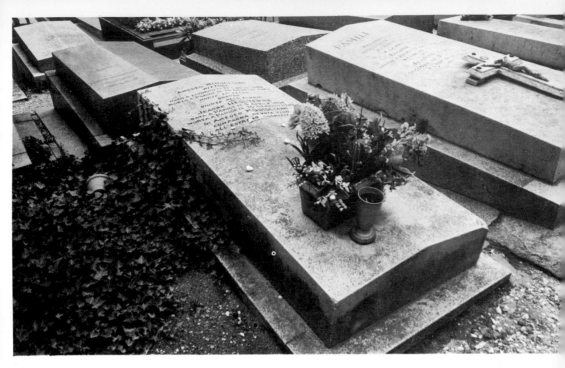

Common grave of Amedeo Modigliani and Jeanne Hébuterne in Père-Lachaise Cemetery, Paris. *(Eddy Van Der Veen)*

Jeanne Modigliani (Mme. Nechtschein), daughter of Amedeo Modigliani and Jeanne Hébuterne, at her exhibition of abstract paintings at the Obelisque Gallery, Rome, May, 1964. *(Black Star)*

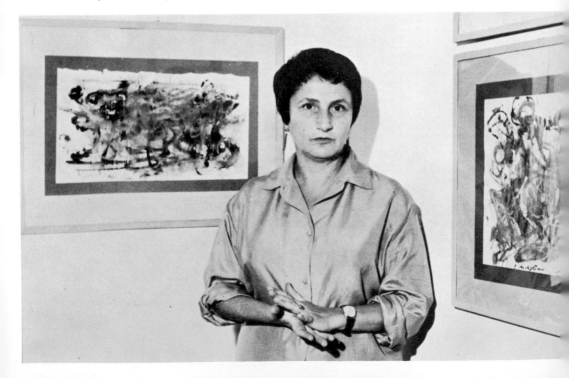

came in, he looked to see if Modigliani had taken the note. It was always there—until one day it was gone. Cendrars thought, *good,* and he went through every bistro in Nice looking for Modigliani. He did not find him until he was coming in at six in the morning when he saw a man lying asleep in the middle of the Place Iéna. It was, of course, Modigliani. From then on Modigliani lived as he had in Paris, and he got better.[8]

Cendrars's recollections have been described as "colorful and boldly inaccurate." [9] Nevertheless, Modi was often with Cendrars, and something of the sort may have happened. At about this time Modi painted a distinctive portrait of Cendrars showing him with a fringed crew cut, a broad forehead, jug ears, no eyebrows, black, pupil-less eyes very close together, a huge, long nose, a tiny pursed mouth, and a lantern jaw, and chin.

Cendrars, although he no doubt commissioned the portrait to help Modigliani, thought as highly of it as he did of the artist. But he, too, was often in the sticky position of needing money badly and he was forced to sell his portrait. Cendrars's picture by Modigliani was exhibited at Silberman Galleries in New York under the title *Portrait of 88 Dresses.* The title has a story to explain it. It seems that one day Cendrars's girl wanted to see the Russian ballet in Paris. Cendrars managed to get tickets, but the girl then complained that she had no dress to wear befitting so magnificent an occasion. Cendrars gave her the portrait to sell for a gown. The girl told him she didn't know how to go about it. Cendrars advised her to go see Paul Poiret, who would probably give her a beautiful dress in exchange for the portrait. She did. Poiret admired the portrait and, in exchange, gave her eighty-eight dresses.[10] This was the kind of story Modigliani would have enjoyed.

Modi also did a portrait of Gaston Modot, supposedly once a painter but then an actor who had a part in the picture Cendrars was working on. Modi may well have been an old friend of Modot's who, along with Harry Baur, another actor, had been among the coterie who visited Picasso in the old days and listened to the stimulating talk at the Bateau-Lavoir. Gino Severini said that Modigliani and Modot, the future daredevil star and stunt man of 150 silent films, had once shared an abandoned shack, called "La Maison du Curé," which was situated on top of the Butte.[11]

Modi painted Modot in a black beret, an open-necked white shirt rolled up to the elbows, and slacks. He gave Modot a heavy jaw and a thick, bull neck, as swollen and broadened as the nose in his portrait of Cendrars. Amusingly enough, he caught Modot perfectly in the picture. Modot, who first signed for film work in 1910, quoted in a magazine article what the producers had said to him at the time.[12] "You're big, you've

got just the mug (*gueule*) for it, you're hired." In his portrait, it was Modot's *gueule* (jaw, chops, mug, snout) that Modi had emphasized.

In Nice, Modi sat in the sun, walked with a heavy step, and chose the benches farthest away from the tumultuous Promenade des Anglais. Perhaps this was immediately after he had had influenza and felt his weakest. While everyone else dressed in the light clothes suited to the climate, Modigliani dressed in black.

Modi was one of the few Jews among his friends to proclaim his origin, his religion and its rites, and to speak lovingly of his home and family. Roch Grey, also known as the Baroness Oettingen, characterizes his crazy, piercing laughter as a spasm caused by a stomach convulsed with cold and hunger.[13] These are sound-enough observations, but the Baroness is 'way off when she calls Modigliani "vicious with vice." She says: "At his first view, even a partial one, of a well-formed female, he trembled with ardor, proving that love was the only real support on which his senses were ever entirely fixed." This is the kind of rank exaggeration that legend grows fat on. Modi was always attracted to women, as they were always attracted to him. He even made a play for Lunia Czechowska when he was living with Jeanne. But this hardly makes him a sex fiend. It may be that Modi's bravado and childish exhibitionism fooled even those who knew him.

Modi sober and afraid to drink or smoke could not have been a happy man. Cendrars is, therefore, probably right in saying that when Modi resumed his old habits he got better. Léopold Survage, the Cubist painter who saw a great deal of Modi in Nice, recalls that Modi used to live in small hotels. He was regularly told to leave them after a few days because he would reach them late at night, singing, making a lot of noise, and rousing the other guests. Modi, more often than not, fought with the guests and the management, which was another trial for Zbo, who did the smoothing and placating.[14]

In his Rue de France quarters, prostitutes lived in the rooms around him. The girls took turns posing for him. One day, the story goes, a man who was keeping one of the girls found her posing for Modi. He was furious and in the impassioned argument that followed, demanded that Modigliani pay *him* for using her as a model.[15]

Modi's knack for getting himself caught in unlikely situations, often through no fault of his own, was matched by Zbo's for extricating him from them.

Deeply in debt, Zborowski was frantic: no sales in Nice and no news from Paris. He had to get money quickly to keep Modigliani painting, to pay for food, materials, and the coming baby. It was imperative that he also raise enough to return to Paris and resume the search for buyers.

Desperation forced his hand. He did what he hadn't had the nerve to do before because of the fateful interview with Modigliani: he wrote to Renoir, though he did not expect a reply. Meanwhile, he kept trying to sell Modi's paintings in Nice. Zbo had supposedly come across only one potential buyer in all Nice—a gross, wealthy man, a meatpacker who had made a fortune during the war and had very special ideas about art. He owned a mansion and wanted a nude for his bedroom. It had to be painted to order, sharp and clear as a photograph. A voluptuous model was to lie on her stomach, and the emphasis was to be on her plump buttocks. The meatpacker admired rumps. He would pay well for a big, daring nude that appealed to him.[16]

Since Modi had been so explicit on the subject of buttocks with Renoir, Zbo apparently decided not to mention the offer to him. An interesting footnote to this story is that later another admirer of nudes, whose taste was like that of the rich butcher, forced Emanuele Modigliani to seek exile in Paris. That was in the thirties when a Modigliani nude fetched 350,000 francs. "The purchaser was a compatriot by the name of Benito Mussolini." [17]

Zbo took stock of his situation: he had a good supply of Modiglianis but no buyers. Renoir seemed to be the only hope. And Hanka Zborowska had her hands full; she cooked for the party, kept an eye on Modi, acted as go-between for him to Madame Hébuterne, saw that Jeanne was properly cared for, and kept house for her husband. Zbo's job was to bring in money—just that. Somehow he persevered with Modi's paintings.

Then, very suddenly, Zborowski's luck changed. It happened in so dramatic a manner—two pieces of luck—that it would seem that God really does reward the honest, the humble, and the good. Zbo apparently managed to make a sale for one hundred francs. Who the buyer was and how the sale came about is not known. It wasn't much. One hundred francs wouldn't pay their bills or help Modi carry on for long, but it was a help. Zbo decided to use a little of it to go to Marseille, where it seemed to him he might find more buyers. But before leaving on this eleventh-hour trip he received a reply to his letter to Renoir. It seems that Renoir had read the article Zborowski had written about him for one of the many small Parisian journals. Renoir had been "greatly pleased" by what Zbo had written and received him "as a privileged visitor."

Zborowski "confided his ideals to Renoir" and told him of his unrewarded efforts in establishing and selling the work of young, talented, and unrecognized artists, the kind whose paintings seemed to irritate the critics and the public as the Impressionists had at one time. The day of the privileged visit was apparently one of Renoir's better days. He approved of what Zbo was doing and now:

Greatly daring, Zborowski showed Modi's stuff, fearing to see the frown of displeasure at the mere mention of the artist's name. But no, Renoir had a big heart and overlooked Modi's behaviour when presented by Osterlind, or maybe secretly liked him for it.[18]

Whether he actually liked Modigliani's work cannot be said, but what mattered was that Renoir understood that Zborowski was trying to back brilliant unknowns like Modigliani and Soutine. In token of this he offered two of his own paintings to Zborowski, which could easily be sold ". . . in Paris, where they were certain to find buyers, at big prices, the commission on which would assist them both." Greatly heartened, Zborowski left immediately for Marseille, taking the two Renoir paintings and ten Modiglianis.

But Marseille, a seaport and commercial center, was apparently no more of an art market than Nice. Zbo ran into Kisling, who was on furlough from the front lines after going back into service. Kisling remembered him ". . . rushing about trying to interest dealers . . . most of [whom] . . . laughed at him for his pains." [19] Somehow or other, Zbo got hold of Jacques Netter. Netter appears to have bought all ten of the Modiglianis for the price of 500 francs, which was very little, but the gold francs of 1917 were worth far more than they are today—500 were worth about 2,500 francs.

The paintings Netter bought included *The Little Girl in Blue* for which, many years later, according to Madame Zborowska, Zbo was offered 400,000 francs. (Today, as with all Modiglianis, that painting is worth even more.) Goldring adds that some time after Modi's death Zbo ". . . bought back one of these same pictures, which he had sold for fifty francs, for 30,000 francs to resell to a client." Back in business again and with enough of a bankroll to do them all some good, Zbo kept only enough for his ticket to Paris, and sent the rest to his wife for Modigliani.

Home again in the Rue Joseph-Bara, Zbo had no trouble disposing of the Renoirs, and sales of Modiglianis continued. It was still a slow, wearing business, but Zbo was able to send enough money to keep Modi alive. Most significantly:

It may be remarked that from this moment onward Modi never knew again the terrible destitution of his vagabond days, though he was not destined to enjoy his comparative prosperity for long. But as the months went by and fairly good news always came from Paris, he was no doubt cheered by the hope that the success for which he had struggled and suffered was now really within sight.[20]

Left behind to be guardian in Nice, when she would certainly rather have been in Paris with her husband, Hanka Zborowska was all-

important to Jeanne, to Modi, and to Madame Hébuterne. She was very conscious of right and wrong. She felt for Modi and Jeanne but she also sympathized with Madame Hébuterne. Modigliani, however, always came first with her husband, so he came first with Hanka, too. Her duty was to give him the means and the peace of mind to paint. She was to smooth out differences with Madame Hébuterne and to manage Jeanne's as well as Modi's affairs. Modi was spending more time drinking with his friends, but he was also painting diligently, not letting a day pass without visiting Jeanne.

Armistice Day came at last! November 11, 1918, was as great an occasion for demonstrations, fireworks, and unrestrained celebration in sleepy Nice as in the rest of the world. Zbo had been writing from Paris that he was selling paintings. Now, with the Armistice, which Modi celebrated with his friend Survage, it is certain that the public optimism about the future also infected him. Now that peace had come everything would be different; everything had changed for the better. For a start he and Jeanne could be together.

> . . . Shortly after the Armistice, evidently to Modi's joy, expressed or secret, Madame Hébuterne suddenly quarrelled more violently than ever with her daughter, and leaving her to fend for herself with her lover, took a room in the Californie quarter.[21]

While they had only a short week or so together, it must have been blissful after their months of enforced separation. Jeanne's time was close. When it came about an hour after they reached the Saint-Roch Hospital, Jeanne gave birth to a baby girl. In a small anteroom Modi walked up and down, the traditional expectant father, blowing clouds of cigarette smoke and wringing his hands. The date was November 29, 1918.

Modi probably walked away from the hospital like a man in his sleep. He was proud. But he needed a drink badly. He would drink a toast or two and then go on to the *mairie* to register the birth. But he never got there:

> Unfortunately, his celebrations of the happy event were so protracted that he finished by arriving there too late to do so. Afterwards he forgot this trivial matter, a fact which, later, was destined to cause tiresome complications.[22]

Although Modi wanted to return to Paris, he and Jeanne stayed on in Nice. Hanka and Zbo, who had returned for a short stay in Nice, would leave for Paris shortly. Madame Hébuterne would follow in a few weeks

as soon as Jeanne gathered her strength and could care for her baby. Having reluctantly abandoned the idea of returning to Paris, Modi would now paint and paint—Zbo could count on it. Modi meant it, but the baby was a problem from the beginning. Perhaps it was not so much that Jeanne was unable to nurse her baby as it was a problem of fitting the baby into her complicated and demanding life with Modigliani. One of the first things was to find a suitable wet nurse. In a letter dated February 6, 1923, to Eugenia Garsin, Félicie Cendrars, the poet's first wife, wrote of seeing the little family in Nice. She said that Modi had been a close friend of her husband's and had often visited her home in Paris in 1915–1917. In Nice in 1918:

> . . . Jeanne wore her plaits around her head like a coronet. I saw her for the last time around Christmas, after the birth of the child. We were all going to look for a wet nurse because neither she nor her mother could manage the child. Modigliani offered me a tangerine and also one to his wife (we were in front of a fruit store)—and that is my last memory of them.[23]

They found a wet nurse so there was no reason for Madame Hébuterne to stay on, nor is it likely that she wanted to. She had fought for her daughter, and lost, although it was plain to her—as it had always been —that the monstrous Italian would never marry Jeanne and had never intended to. He would break his word and Jeanne's heart as he had her parents'.

While Jeanne apparently stayed home with her baby, Modi spent New Year's Eve with Léopold Survage at a restaurant called the Coq d'Or. It was not the sort of occasion Modi could miss. The two friends enjoyed as gay an evening as they could afford. Although they drank only red wine, Modi deliberately exaggerated in the postcard he sent Zbo, which he headed "On the stroke of midnight."

MY DEAR FRIEND,

I embrace you as I would have liked to do on the day you left us.

I'm having a high old time with Survage here at the Coq d'Or. I've sold all my pictures.

Send me some money right away. The champagne is flowing like water. We send you and your dear wife best wishes for the New Year.

Resurrectio Vitae.

Ic incipit vita nova.

Il novo Anno!

The card was signed "Modigliani" and, next to this signature, Survage had scribbled Happy New Year in Russian, his own name, and under

this *"Vive* Nice, *vive* the first night of the New Year." [24] Zborowski had a literal mind and seems to have taken Modigliani at his word. No copy of his reply exists, but judging from Modi's next letter, Zbo must have remonstrated in some way:

MY DEAR FRIEND,

You're a fathead [*ballot*] who doesn't understand a joke. I haven't sold a single thing. Tomorrow or the next day I'll forward what I have on hand.

Now for something *true* and very serious which has just happened to me. My wallet with the 600 francs it contained has just been stolen. This seems to be a specialty of Nice, I'm told. You can just imagine how annoyed I am.

Naturally I'm broke. Or almost anyway. As you can see, it's an idiotic situation. However since it's neither in your interest nor mine that I stay hard up and unable to work, here is what I propose: Wire 500 francs in care of Sturvage [the painter's real name], if you can. And I'll reimburse you 100 francs a month—that is for the next five months you can deduct 100 francs from my monthly allowance. In every way I can I'll keep track of the debt. Apart from the money I lost, the question of papers is an even greater worry.

That was about all I needed just when I had a little peace. In spite of all this nothing can interrupt me, I hope. Please believe, my dear friend, in my loyalty and friendship, the good wishes I send your wife, and the cordial hand I extend to you.

MODIGLIANI.[25]

The loss of his passport and certain identification papers meant that he could not leave Nice, much less apply for the documents he would need to marry Jeanne, as he had promised. He had to borrow a hundred francs from Survage to tide him over. But Modi's friends would have been astonished at his having six hundred francs in his pocket, a fortune for him, and probably more money that he had ever had in his possession at one time. But if Survage's memory is accurate, Modigliani never had the money. It was Survage's wallet that was stolen, not Modi's.

Survage, an old man of about eighty-five in 1964, was amiable and willing to talk. He said he had met Modigliani at the Rotonde around 1910 or 1911, and had run into him again in Nice in 1918 or 1919. Modi had drunk a lot in his life, but being a poor man he drank red wine because it had the double advantage of acting as a fortifier and of being comparatively cheap.

Survage used to see Modigliani every day in Nice. During the day they worked in Survage's two-room apartment. Survage lived in one room, and

left the other one empty. It was here that Modi painted a portrait of a soldier. Often models did not show up as promised, and Modi was in despair. Survage felt that people in Nice not only did not like to sit; they had no time, and felt a certain embarrassment in posing, so Modi tried two landscapes, though he wasn't particularly interested in them.

Survage and Modi spent their evenings together, and Survage confesses that he drank nearly as much as Modi. They were in the habit of taking walks along the Avenue de la Gare. It was here they met some soldiers on leave, a few of them Arabs, and got into conversation. It was some time after they had left the soldiers that Survage realized his wallet was gone. They hurried back to where they had been, but the soldiers had left. Survage was very upset by the theft, especially at the loss of his papers, since he was not a naturalized French citizen.

The next day he and Modi took their usual walk on the Rue de la Gare. As they were passing a café a soldier called out to them. It turned out to be the soldier who had taken Survage's wallet. To Survage's great joy the soldier gave him back the wallet with the precious papers, mumbling only "money gone," *argent parti*. Survage insists that it was *he* who lost his wallet, *not* Modigliani. It is an apparent contradiction. Modigliani wrote to Zborowski about it more than once and mentioned speaking to Paul Guillaume, then visiting Nice, about the loss of his papers. The only conclusion is that both artists had their pockets picked.

Survage says that Modi often sang as he worked, always Hebraic or Jewish songs, never anything else. Survage also recalls that one day Modi showed Survage a portrait of his mother done when he went to Leghorn. Survage said she was *"une très belle matrone"* (a very beautiful matron). If Modi did paint a portrait of his mother, it was probably done on his last trip home in 1913. Unless it was very small, it is hard to conceive of his bringing it to Nice in his baggage. It is, however, another evidence of how much he loved Mamma and how proud he was of her. If the portrait did exist, it disappeared, since it is not included in any catalogue of Modigliani's work.

Modi did paint a portrait of Survage. While it has none of Modigliani's distortions, barring a slight lengthening of Survage's nose and a slight lengthening and thickening of his neck, Survage feels it is a curious picture because the right eye is all of one color with no pupil, while the other is perfectly normal. When Survage asked him why he had done this, Modigliani answered, "With one eye you look outside, with the other you look inside."

Survage says that he never saw Modigliani take drugs or act under their influence. But he does report that Modigliani was particularly fond of an Italian red wine called Barbera. Survage became concerned about

Modi's drinking. One day, hoping to make him ease up, Survage accused Modi of being an alcoholic. Modi was furious at the accusation, and probably to prove it false, drank nothing for three days. On the fourth day he arrived at Survage's staggering, dead drunk. Later, in an effort to make him stop drinking, Survage decided to walk with him over the Col de Villefranche, a mountain pass, to Villefranche, a little town next to Nice. They went on foot, ate a *"friture,"* a dish of little fish, fried crisp, in a restaurant in the port, drank moderately, and spent a pleasant evening together.[26]

While Modi wrote to his mother only at intervals, it is certain that he continued to hear from her regularly. The letters must have been solicitous, with frequent references to his health and the repeated declaration that he was always welcome at home. He apparently no longer received money from home.

Emanuele was now a Socialist deputy, clearly acknowledged as head of the family. News of Dedo had reached Leghorn periodically, and while the Modiglianis felt a close bond with their youngest and believed in his right to do as he pleased, it was now tacitly admitted that he would never amount to much as a painter. It was particularly painful, from what the family had heard and seen of Gino Romiti, Oscar Ghiglia, and other pupils of Micheli's who had had the intelligence to remain in Italy, that Modi's work could not compare with theirs. He had been the most talented boy in the class, but Paris had destroyed his art and, judging from his last visit to Leghorn, from news that reached them from Paris, and from what Emanuele had seen for himself, he was also destroying himself. As always he would listen to no one. But a good mother could not help reminding him to take care of himself.

Two of Modi's communications to Leghorn written at this time still exist. One is an undated letter which reads:

DEAREST MOTHER,

A thousand thanks for your affectionate letter. The baby is fine and so am I. It doesn't astonish me that having been so much a mother that you now feel like a grandmother even without "legal sanction."
I am sending you a photograph.
I have a new address: write 13 Rue de France, Nice.
I kiss you warmly,

DEDO.[27]

The other is a postcard with a few hastily written lines, dated April 13, 1919:

DEAREST MOTHER,

I am here right near Nice. Very happy. As soon as am settled, I'll send you my permanent address. I kiss you warmly,

DEDO.[28]

It is apparent that Modi had written of his attachment to Jeanne Hébuterne and that she was the mother of his daughter.

He seems never to have told his mother that the Zborowskis had befriended him. Modi put first things first and told his mother about Jeanne Hébuterne, but a dealer was of secondary importance. Despite all Zborowski had done for him, Modi's attitude was still guarded. He had hailed Paul Guillaume as his "new pilot" and had inscribed this notice on one of his first portraits of the natty little dealer. But the good things the association with Guillaume had promised never materialized. His feelings about Zborowski were, therefore, more restrained, less exuberant and optimistic. It would be time enough to tell his family about Leopold Zborowski when he was established and selling.

Yet he had a grateful regard for Zbo. This is evident from his letters, the most extensive recorded correspondence he ever had. He wrote nine letters to Zbo, all of them requesting money or thanking Zbo for money forwarded to him. The letters are worried and sensitive. They show maturity and a new sense of responsibility. They express warm friendship for Zbo, tacit acknowledgment of Modi's awareness that he was "a financial burden" and utterly dependent on Zbo for encouragement and every material need.

Modi pledged himself to make good on his debts. Jeanne Modigliani finds the letters moving, particularly because Modi ". . . in order not to seem a parasite . . . forced himself to paint a given number of pictures each month, just at the time when he most needed to stop for breath, accustom himself to the new light, and to the change of background." [29] In his anxiety to fulfill his obligations to Zborowski, to Jeanne and the baby, Modi was doing something he had never done before: he was painting under pressure. He was a worker eager to make good on his contract.

## ᔯ ᔯ ᔯ Chapter Thirty

*"The only thing I can do now is to shout good and loud with you: 'Ça ira' for men and for people, believing that man is a world worth many times the world . . ."*

M odigliani reached a point where he felt the pinch of poverty so keenly that it became impossible for him to concentrate on his work. A worried Modi put matters with unusual bluntness, willingly accepting whatever blame was due, in his next letter:

DEAR ZBO,

Here is the question: or: that is the question [*sic*]. (See Hamlet) That is

*To be or not to be.* I am the sinner or the horse's ass [*con*, a vulgarism], that's for sure: I recognize that I am to blame (if there is any blame) and my debt (if there is to be a debt) but now the question is this: If things haven't broken down completely, then I'm really foundering. You understand. You sent 200 francs, 100 of which went to Survage to whose assistance I owe the fact that I'm not completely down and out . . . but now . . .

If you free me, I'll recognize my debt and keep going.

If not I'll remain immobilized where I am, tied hand and foot . . . : and in whose interest will that be.

I have actually 4 canvases on hand. I've seen Guillaume. I hope he will help me with my papers. He gave me some good news. Everything would be going well if it weren't for that damned business: why can't you make up for it and quickly so I can keep right on going as I am?

I've said enough for now. Do what you want to do—or can do—but answer me . . . it's really urgent and time presses.

Affectionately.

Say hello to Madame Zborowsky [*sic*],

MODIGLIANI.[1]

Following Modi's hurry call for money, Zbo had apparently been able to scrape up only two hundred francs, clearly not enough. Modi promptly paid the money he owed Survage, leaving himself only one hundred francs for board, meals, the wet nurse, and the drinks he needed. Where before he had never worried about being penniless, Modi was now very conscious of being a family man. He needed peace of mind to paint; the hundred francs wouldn't last long; and he was appealing to Zbo to help him make up the loss of the stolen six hundred francs quickly, so that he could keep on painting.

Perhaps Survage really needed the money, or else Modi hated to be in debt to him. We know that Léonce Rosenburg represented Survage but did not give him a monthly allowance. For many years Léonce Rosenburg had been interested in modern art, and by 1908 had established himself as mentor and supporter of the growing school of Cubism, sharing the position with Daniel Kahnweiler. But since Kahnweiler was a German he could not operate as a dealer during the war years. He had been interned in Switzerland, and, in his place, Rosenburg represented Braque, Gris, Léger, Lipchitz, Metzinger, Picasso, and Survage. He united his artists in a movement called Groupement de l'Effort Moderne and, as of November 22, 1918, ". . . issued Lloyd's Bank a standing order for credit." Every three months the artists were paid the following: Braque, 3,500 francs; Léger, 4,500; Herbin, 3,000; Severini, 3,000; Laurens, 3,000; Gris, 3,000; Hayden, 2,500; Metzinger, 3,000; and Lipchitz, 3,000. Picasso and Survage do not seem to have been on the credit list.[2]

Survage may at this time have been courting the young Germaine Meyer, whom he later married. Madame Meyer had gone to Nice with her two daughters during the war. A Pierre Bertin visited her place one day as Modigliani dropped in. As the two friends talked, Germaine Meyer crossed the room and was introduced by Bertin to Modi, who immediately expressed a wish to paint her. Germaine agreed. Modi returned two days later with canvas and paints and told Germaine to sit at the piano. She began to play Ravel's Ma Mère l'Oye as Modi studied her. Suddenly he asked her to stop. He did a sketch of her, then began the portrait. He finished it the next day and gave it to Germaine as a gift. He began a second portrait, but because Germaine came down with influenza it was never finished. But he did do another portrait of her later on.[3]

Then Paul Guillaume arrived in Nice. He came to do business with Renoir, but Renoir, never too fond of dealers, apparently refused to see him. Survage says that it was Apollinaire who had talked Guillaume into becoming a picture dealer and had also introduced him to Giorgio de Chirico. According to Survage, Guillaume had brought along a collection

of engravings, intending to present them to Renoir as a gift in the hope
that the master would give him some paintings to sell on commission.
(Either business was slow or Guillaume had heard of Zborowski's little
coup.) Survage says that Renoir would give Guillaume no paintings and
that Guillaume looked Modigliani up in Nice.

Two photographs (facing page 385) exist of Modigliani strolling along
the Promenade des Anglais with Guillaume. In one, Madame Archipenko,
the sculptor's wife, is walking between the two men. Modi is smiling. In
the second, Modi and Guillaume are alone, looking rather somber and
strained. In both shots Guillaume is nattily dressed, overcoat slung over
his arm, carrying a cane, while Modi looks like a tramp with his overcoat
draped over his shoulder like a cloak, wearing a battered wide-brimmed
black felt hat. They are the prince and the pauper.

Survage says that Modi left his rooms for a meeting with Guillaume
and they went for a walk on the Promenade des Anglais. They were pho-
tographed by one of the ubiquitous photographers who snap pictures of
tourists, strollers, lovers, anybody who will buy. When Guillaume and
Modi met again the next day, Guillaume asked Modigliani to pay him
for the photograph. This apparently enraged Modi. Survage reports that
the two men knew each other from Paris but, owing to Guillaume's tight-
fistedness, they did not get on very well. The cheap business of the well-
dressed, affluent dealer insisting that Modi pay him back for a snapshot
taken by a sidewalk photographer speaks volumes for the cause of the un-
easy relationship that existed between Modi and Guillaume.

Guillaume was exactly the opposite of the generous Zborowski. What
good news he could have brought Modi it is hard to say. Perhaps the
paintings Guillaume had bought from Modi had been sold or were sell-
ing. It is also highly unlikely that Guillaume helped Modi secure new
papers. He was not a man to run errands for anyone. Gestures and glow-
ing phrases were more his style, but he did write memorably of his one-
time client: "He passed like a meteor—all grace, all anger, all scorn, and
his aristocrat's soul will linger among us for a long time in the iridescence
of his beautiful, versicolored rags." [4]

In any case, Zbo, as always, responded to Modi's plea for money. Modi
thanked him in his next letter:

DEAR ZBOROWSKY [sic],

Received your 500 and thanks.

I am going back to my interrupted work.

So far as explaining myself goes (since one can never explain oneself
completely in a letter), there has been "a vacuum" [un trou].

Received a charming letter from your wife.

I don't want you to cancel any debts . . . on the contrary. Rather

set up or let us set up, if you wish, credit which can take care of those vacuums—at least those *which can be filled*—brought on by unforeseen circumstances. Hope to see you soon in Nice and to hear from you before then.

All good wishes,

MODIGLIANI.[5]

In his next brief letter, on which he noted "Friday night" at the bottom of the page, Modi again expressed his thanks to Zbo:

DEAR ZBO,

Thanks for the money. Tomorrow morning I will send you some canvases.

I am undertaking some landscapes. The first ones will probably be on the amateurish side.

My best wishes to Madame Zborowsky. [*sic*] Affectionately,

MODIGLIANI.

Try to get Guillaume to send me the recommendation he promised so that I can have new papers made.[6]

The first landscape Modi did showed a country road opening toward the sea between a low white building on the left and a higher, walled, tower on the right. The tower had a brown tiled roof, a long narrow slit of a window in its middle, and an odd, lopped-off, fuzzy-topped tree in front of it. It was an uncluttered picture, tranquil, austere, even perhaps a little somber. Modi softened the angles and the color, particularly the white-blue of the sky, giving the entire composition a hazy look. The other landscape was a corner view of a shuttered apartment building, two tall poplars rearing up in the foreground like long-necked, plumed ostriches. Again the scene was soft, tranquil, dreamy. Modi did only these two landscapes, pleasing works, skillfully executed, but he had no illusions about them.

It was not that the landscapes were amateurish, as he had predicted to Zbo they would be, but that they were not his forte. He did not *feel* them. For him, landscape was artificial: it could not be hurt, so it did not exist.

In another painting, apparently done at about the time he did the two 1919 landscapes, Modi sat a figure outdoors and called her *La jolie épicière*. She was a pretty grocer's wife or assistant. She sits in a chair in a courtyard, a large tree to her left in the foreground; two more trees rise back of the wall behind her. The doorway of her store is also in the background. The young, stolid-faced girl has her hands crossed in her lap. She

wears a black dress with a round white collar and a large white apron. The portrait, fresh and appealing, seems to be the only one Modi ever did of a model outdoors. He probably undertook it to study the effect of light on the human face in the open. The figure so dominates the picture that a second glance is necessary to see that the subject is out of doors.

Others to the contrary, Survage feels that Modigliani did not do much painting while he was in Nice. Mostly he wasted his time. Modi was to send Zborowski four pictures a month, but even that was too much for him. He managed to send only three. Yet it took Modigliani about two or three hours to do a portrait. He was apparently unable to work for longer periods, and seldom worked twice on the same picture. Modi would take a bottle of *marc* (a kind of wine made from the residue of pressed grapes or apples) to painting sessions. As he began to work he did not drink at all. But, after a while, he would get thirsty and reach for the bottle. Modi worked with spirit, continues Survage, even in a kind of rage, expending so much energy that by the time he finished a portrait he was usually tight.

Survage believes that Modigliani lived only for his painting, that he had no other attachment. He goes so far as to say that even "the Hébuterne episode" was secondary. He does add that the child was so important to him that Modi went to great lengths to find someone to take care of her properly, finally locating a Calabrian *nourrice,* or wet nurse, in Nice.

Survage is wrong in calling "the Hébuterne episode" secondary to his painting. That love affair was neither an episode nor secondary. Despite Modi's complaints to Archipenko and his behavior in front of Survage, Jeanne and her doings were of great consequence to him. What seemed to Survage a casual attitude toward Jeanne and the baby was a sham. Having dependents made Modi feel just like the bourgeois he had always despised, yet his ambivalence is understandable. He was proud of his striking young wife and her absolute devotion to him, prouder still perhaps of the beautiful baby girl he had fathered, but they worried him. They were his entire responsibility. He was painting for them now, to ensure their bed, board, and future.

Fame and success were secondary to cash on the line. If he was frightened at the bourgeois responsibilities life had thrust on him so ironically, he still had the problem of turning out so many pictures a month without regard to how he felt, the difficult light, the problem of finding suitable models, and the hundred other irritations plaguing him. Modi seems to have found his models on the street. He painted children, peasant men and women, nursemaids (including little Jeanne's wet nurse), gypsy women, and people who had interesting faces like the old bearded notary

in Nice with his visored cap, his big sagging nose, his long-stemmed pipe. He excelled at children's portraits. He did a fine one of the concierge's son, a skinny little boy, short-haired, with troubled eyes, yet eager as only boys can be.

His composition was simpler than ever, gentle, rounded, sweet, with soft colors. His portraits had a dignity, serenity, and an affection for the models he had not shown before. Jeanne was his favorite: he never tired of painting her. She was a new person every time he looked at her. He painted her in many ways, hair unbound, hair in plaits or, in the early portraits, wearing the unusual hat she liked. She assumed endless poses, holding them for hours as he painted. Never had he had a more ideal or more beautiful subject. She was the best. She demanded his best, and Modi was absorbed in expressing his love for her on canvas. He gave her an appearance, an expression transcending what was there. It came from his own inner vision, what he would have called reflections of Jeanne's soul.

Modigliani knew that people's faces were not what they showed the world. To what he saw he added what he felt and what lay behind the unfathomable vision of his darling. They were his creations, these love portraits, Modi's way of saying "I love you," untiringly, adoringly. Jeanne's love for him was also evident in the portraits. If he elongated her neck here, distorted her figure there, or transformed her features to the extent that the portraits no longer resembled Jeanne—or perhaps any women who ever lived—it was immaterial, except to silly purists and realists. These portraits were eloquent tributes to his beautiful beloved.

Some measure of the depth of his feeling for Jeanne is evident in the fact that unlike the many other lovely women he had loved and lived with, Modigliani never seems to have sketched or painted her in the nude. It was not whether Jeanne was right for such a study. She was too precious, too beloved, too much his to share with anyone. If he wanted her home and out of the way, he also wanted no one else to see her body. Jeanne understood. Modi needed her in his own image. It was for this she had forsaken everything else in her young life. She adored him.

Modigliani would be pleased to know that his portraits of Jeanne are often considered his finest work. In portraying her he summoned up his greatest art in its many surpassing variations:

Manifestations of passion are always *disproportionate* to the object that arouses them. And nowhere in Modigliani's œuvre is this substitution of emotive for anatomical proportion so clearly demonstrated as in the twenty portraits celebrating the beauty of Jeanne Hébuterne.

. . . Scanning these love letters—for such they are—writ large on canvas, we realize how arbitrary is any attempt to appraise a work of

art in terms of its moral qualities and to assign psychological values to the painter's choice of colors and their arrangement on the picture surface. For in the softness of the colors, the fragile delicacy of the tones and the exquisite discretion with which relationships between the picture elements are stated, we cannot fail to sense the expression of a love no less discreet than ecstatic. Modigliani is speaking here almost in a whisper; he *murmurs* his painting as a lover murmurs endearments in the ear of his beloved. And the light bathing this picture is the light of adoration.[7]

He spent his days with Survage and other friends, but he always went home to Jeanne. As a talented artist, she may at one time have dreamed of being a great painter. First-rank women painters were a rarity, but there had been Mary Cassatt, Berthe Morisot, Suzanne Valadon, the mother of Modigliani's good friend Maurice Utrillo, and Marie Laurencin, the mistress of Guillaume Apollinaire. Jeanne may have had the ambition, but she knew that Modigliani was a master compared to her. Not only did Modi need her; he demanded everything of Jeanne, all of her. If she ever thought he would change, she quickly learned better: he would remain Modigliani in life as on canvas.

During the long hours when she was left alone in her room, Jeanne sketched and painted. She did an oil from their window, showing the steps and doorway of the building adjoining the building adjoining theirs, a big bare tree in the foreground. Jeanne Modigliani says of this painting, later given to her as a gift by Paulette Jourdain, that the ". . . view of a courtyard seen from above, is sober in its warm tonalities of dark red, brown and rose and composed with a quiet boldness surprising in so young a woman." [8] Psychologically, its composition, inside looking out, is like that of a prisoner putting down what can be seen from his cell window. One can only wonder what Modigliani thought of it.

But he must have admired the fine pencil sketch Jeanne did of him reading by the light of a kerosene lamp and a candle. (Facing page 416.) It was presumably drawn in their room. Modi is reading a book at a table. The night air is cool. He is wearing his broad-brimmed, punched-in, black felt hat, with the sides turned up. He has his overcoat around his shoulders, but he is intent on his book, his mouth firmly set. Jeanne's line is delicate and strong; the drawing so forceful and finished that it bears out the claims that Jeanne had great talent. The scene is intimate and domestic, peaceful and serene. It explains why Modi wrote to his mother at the time that he was very happy.

Considering the amounts of money Zbo sent to him, Zbo was doing better than ever since his return to Paris. But if Modi now had more ready cash than in the past, he still was no better at handling it. He seems to have kept it all himself. If Jeanne had wanted to budget some or

save a little, she never saw any of it. Survage says that Zborowski sent him quite a lot of money, about six hundred francs a month which, in those days, was more than ample for his needs. But, as always, when Modi was in the money he declared himself a sort of holiday and went off to celebrate.

As soon as Zbo's letters arrived, according to Survage, he and Modi went to the bars along the Avenue de la Gare. When Modi drank, a madness seized him. He would throw his money to the soldiers, many of whom were spending their furloughs in the cafés of Nice. After a few days, Modi was naturally broke and went to eat with Survage, who was a little more careful with his own money. Survage saw little of Jeanne in Nice and goes so far as to say that Modigliani rarely saw her himself. Survage remembers that Modi took coffee with Jeanne and then put her on the tramway so she could go back to her mother (Madame Hébuterne), whom he never saw at all. Survage recalls Jeanne as a very gentle, kind woman who used to draw tiny still lifes on sheets of letter-sized paper. She gave one to Survage, which he was to give to Jeanne Modigliani much later on.

Survage's recollection that Modi painted very little on the Riviera is as erroneous as his assertion that Modi rarely saw Jeanne. There is adequate proof that Modigliani painted a great deal in Nice and Cagnes: Madame Zborowska's testimony, Modi's own letters, and the record of his listed works, though the list is somewhat inaccurate. As for his seeing Jeanne, most of the twenty or more portraits of her seem to have been done in this period.

According to the catalogue list of Modigliani's works compiled by Arthur Pfannstiel,[9] Modi painted 309 portraits from the beginning of 1914 to his death in January, 1920. (Pfannstiel has it 80 paintings for 1918 and 11 in 1919.) This does not include his early work, those paintings owned by Dr. Paul Alexandre, those lost or destroyed by the artist himself. Some critics have estimated Modi's output for 1914–1919 to be as high as 450 canvases. Putting Modigliani's undated pictures in any sort of chronological order is a tricky business at best. Many portraits assigned a date in fact belong to a different year because Modi painted in certain ways at certain times, going from one style to another in any period, not from one to another chronologically as, for example, Picasso did.

The work of Modi's early years in Paris is easier to account for because it was done in a markedly different experimental style and within a limited span of time from his later work. The drawings and sketchbooks that Dr. Alexandre owns have never been classified, analyzed, or reproduced in full. Only a few writers and critics have had a chance to look at them —and they have had just that—a look. The Alexandre portraits are much better known and, although often reproduced, have rarely been

exhibited. Dr. Alexandre's collection remained intact until recently when he began to dispose of some of the paintings. A very old man now, tired, seeing only members of his immediate family, Dr. Alexandre is not available for interviews, although Jeanne Modigliani says he looks much as he did in his portraits.

Dating a portrait, whether by wild or educated guess, remains vital to the art market. The paintings of his vintage years, when he supposedly found himself and painted his most characteristic Modiglianis, bring more money. The prices have equaled or exceeded the best Picassos, going from a previous high of approximately $67,600, when Modi's *Garçon Rouge* was sold for 24,000 pounds at an auction held by Sotheby and Company of London in April, 1963, to $272,000, which was what the Hammer Galleries of New York paid for *La Fille du Peuple* in December, 1965. Except for a number of paintings ascribed to his last years, which might well have been done earlier, since his elongated swan's-neck style did not emerge full blown, the fact remains that Modigliani's output increased after meeting Beatrice Hastings and increased further when he found his real Beatrice, Jeanne Hébuterne. After their "marriage" and the birth of their child, he began his longest, sustained period of production, sometimes sending as many as five or six paintings a month, or more, to Zbo in Paris. So much for Survage!

Modi's next letter to Zbo, sent in January or February, 1919, was probably written at a terrace table, with Jeanne or Survage sitting near him as he sipped an apéritif. It is on Café de Paris stationery:

DEAR ZBO,

Thanks for the cash. I am waiting till a little head I painted of my wife is dry before sending you, along with those you know about, four canvases.

I am slaving like a Negro and going right on.

I don't think I can send you more than 4 or 5 canvases at a time because of the cold.

My little girl is in blooming health. Write if all this isn't too much trouble.

My best wishes to Madame Zborowski and my warmest affection to you.

MODIGLIANI

Send me some canvas *immediately*. Don't forget that Place Ravignan business. Write to me.[10]

The last reminder may have had something to do with Modi's request that Zborowski rescue some of Modi's work from one of his old studios, but it is hard to be certain of it.[11] Nevertheless, speculation is permissi-

ble and may even be fruitful. It is possible, now that the war was over, that Modi had heard a rumor that Elvira had been shot "as a spy" [12] and was reminded of the portraits of her his landlord in Place Ravignan had confiscated after La Quique had left him. He may have asked Zborowski to retrieve them. This would explain why the portraits of La Quique are dated 1919.

Modigliani's next letter to Zborowski was dated February 27, 1919. Again he speaks of sending on some paintings:

DEAR FRIEND,

Thanks for the 500 and especially for being so prompt. It's only today that I shipped you the canvases (4).

I'm going to begin to work at 13 Rue de France.

The way things are going, the changes of pace, especially the change of season, makes me fear a change in the weather and my rhythm.

Let's give things a chance to grow and develop.

I've been taking it easy the last few days: fruitful laziness; that's real work.

Now for the Survage story in two words: little pig. But enough of that. Are you coming down in April? Thanks to my brother all that to-do over my papers has been taken care of. As things stand now, I can leave when I please.

I am still tempted to stay on, going back only in July.

Write if you have time and give my best to Madame Zborowski. Sincerely,

MODIGLIANI

The baby is fine.[13]

Old letters invariably contain personal references understood only by the correspondents *at the time*. Today Survage says that the sentence referring to him pertained to a young woman Modigliani was courting but whom Survage won in the end. But that is Survage's explanation. It is also possible that Modi, who was not courting anyone in Nice, may have come to regard Survage as a "little pig," perhaps over money.

The art market in Paris had opened up since the Armistice. There was a great interest in contemporary art. All dealers were doing better. More and more inquiries were being made at the Rue Joseph-Bara about the extraordinary work of Amedeo Modigliani. One young aristocrat of distinguished English parentage, Sacheverell Sitwell, had crossed the Channel lately, examined the new art in postwar Paris, and had been particularly impressed by the audacity and style of contemporary French painting. Of all the works he saw, twenty-two-year-old Sacheverell

Sitwell seems to have been most taken by the paintings of Picasso and Modigliani, whose work he may have seen in Paul Guillaume's or, possibly, Chéron's gallery. In time, he found Zborowski. But Zbo did not speak English. Nevertheless Sacheverell's French was apparently enough to convey warm appreciation of Modigliani's art and a proposal.

Sacheverell Sitwell also represented his brother Osbert, then editor of the quarterly *Arts and Letters*. They hoped to sponsor an exhibition of modern French art in London that summer, possibly in July.[14] Since Zborowski represented Modigliani, Zbo was evidently proposed as the man to take charge of the exhibit. He would help choose and process the canvases, supervise their shipping to London, then cross the Channel and assist in displaying and selling the paintings.

Presumably he was told to make whatever arrangements were necessary with other dealers and artists, work out the project, and keep the Sitwell brothers advised of developments. Once Zbo understood what he was being asked to do, he must have been overjoyed at the idea of showing Modi abroad. Picasso, Matisse, Braque, and many other artists had been exhibited outside France, but not Modigliani. Zbo had forgotten the ghastly failure of Berthe Weill's exhibit, but the world had changed since the war, and in London, surely other Englishmen would be as enthusiastic as Sitwell. Sitwell told Zbo he was short of funds for the moment, or he would have bought a painting to take back to show his brother. He did buy a drawing for an undisclosed sum.

Sir Osbert Sitwell wrote of this in a book of reminiscences, *Laughter in the Next Room.* He said that Sacheverell had joined him in Biarritz, bringing along a fine Modigliani drawing ". . . together with the remains of a very exquisite silverpoint drawing of Modigliani and Jeanne Hébuterne in the nude by [Auguste] Herbin." [15] This drawing has never been authenticated as a drawing of Modi and Jeanne.

Zborowski set about getting in touch with other dealers to set up the proposed Sitwell exhibition. He planned to take advantage of his position to include the works of other artists he represented besides Modigliani, as well as good friends—Soutine, Kisling, Ortiz de Zarate, Utrillo, Suzanne Valadon, and Survage. Judging from Modigliani's next letter to Zbo, documented histories of the artists to be represented were necessary for the catalogue of the exhibition and for newspaper publicity. Most artists hardly cared what was said about them so long as their names were spelled correctly and their paintings well placed in the exhibit, but Modigliani did—very much.

We can infer from Modi's answer that Zbo wrote enthusiastically about the forthcoming exhibition. He would have told how Sacheverell Sitwell had found Modi's paintings and Picasso's the most interesting of all contemporary French artists; how he had gone to the trouble of looking up

Zborowski, had asked all about Modigliani, and then fairly stunned Zbo with his suggestion for an exhibition in London in which, as Zbo understood it, Modi would be "starred." It was Modi's great opportunity, the one Zbo had been hoping and praying for. It would spread his work and his name far beyond Paris, and could be the making of his career. Modi deserved it after so many years of hard work, bad luck, and suffering. Modi wrote:

MY DEAR FRIEND,

Sincerely moved by your good letter. I am the one who must thank you.

So far as the publicity is concerned, I naturally leave it all up to you . . . if it is indispensable. . . . Your affairs are ours, and if I don't believe in it, above all on principle, or because I am not mature enough for publication, neither do I despise "vile money." But since we are in agreement let's go on to other things.

Here is my date and place of birth: Amedeo Modigliani born July 12, 1884, at Leghorn. As it is I wrote to my brother two or three days ago and I'm waiting for his reply.

In addition my "real" identity card (I had only the receipt for it) is in the commissioner's office on the Rue Camp. Première in Paris. It shouldn't be too difficult to take care of this matter.

Another thing: you speak of coming here toward the end of April: I think I can easily wait for you here until then. Meantime, as I go right ahead, you should look into the possibility of settling in Paris as there is a great "hic" [difficulty or "rub"]. (Are you ever going to look into that Montmartre business?)

My daughter is getting astonishingly bigger. I find great comfort in her and a thrill that can only increase in the future.

Thanks for the toys. It's a little too soon for them maybe. . . .

The only thing I can do now is to shout good and loud with you: 'Ça ira' for men and for people, believing that man is a world worth many times the world and that the most ardent ambitions are those which have the pride of Anonymity.

Non omnibus sed mihi et tibi . . .

MODIGLIANI [16]

Not since his youthfully grandiose letters to Oscar Ghiglia had he expressed such noble sentiments. Minus the old romantic trappings, the over- and under-tones of Nietzsche and D'Annunzio, he was Amedeo Modigliani speaking simply, sincerely, humbly, humanly. He wrote soberly and optimistically, with a knowledge of his true worth. These telling phrases both rebuke and refute those who see Modigliani's art as little more than the product of a morbidly warped, decadent brain, the

languorous result of drink and drugs, the pictorial evidence of a depraved personality obsessed by "a certain sickness of life."

Modigliani's paintings may be considered as brooding X rays touched with sadness and melancholy, but never disenchantment with life and people. He shouts good and loud with Zborowski the refrain from a popular song of the French Revolution: *Ça ira*—things will work out, we will win, we will triumph. Although he qualifies his thoughts by writing in Latin, "not for everyone but for you and me," he belongs and he is involved. He takes pains to reaffirm his belief, his love, his faith in humanity. Jeanne Hébuterne had washed away the pain and the bitterness, expunged for the moment the cankers eating his spirit. He loved and was loved; he believed and he was believed in; he loved life and he embraced it.

## ⌣⌣⌣ Chapter Thirty-one

*"If you have two thousand francs a month and spend nineteen hundred on alcohol, you must expect to live in misery. Modi never knew when to stop."*

In the late spring of 1919 Modi painted his infant daughter and her nurse in a picture called *Femme assise avec Enfant*. It was probably the only picture he painted of little Jeanne, whose round, blooming face shows her to have been a healthy baby. The calm, slit-eyed nurse has a noncommittal air about her. One can somehow tell that while the child has been entrusted to her care, it is not hers. She also seems to be on guard, watchful, as she peers from the canvas.

Although Modi painted swiftly, finishing his canvases in one or two sittings—with the one exception of the dual Lipchitz portrait—he seems to have spent considerably more time on this picture. John Russell guesses that it ". . . cost him as many as forty sittings. Possibly his delight in the birth of his own child caused him to linger over the subject; possibly he wanted to see how far he could go in the way of 'finish' and painstaking construction." [1] Russell does not say where he got his information; but it does not seem likely: it simply was not Modi's method.

Apparently occupied with organizing the London exhibition, Zborowski does not seem to have gone to Nice as he had said he might. By this time, excited by the good news, Modi had had enough of Nice and was impatient to join his friends in the Paris he loved. According to a safe-conduct issued by the Cagnes police, Modi left by train on May 31, 1919.[2] He went alone, apparently with the understanding that Jeanne would join him as soon as a suitable nurse for the baby could be found in Paris.

To be back home again, *really* home in Paris was what he wanted. Modi was weary of placid Nice and its bright sunlight, weary of having to paint on schedule. He wanted a breathing spell, a chance to drink and talk with his old friends at the Rotonde, the freedom to roam Paris. Certainly he was eager to see what Zbo was up to and whether Zbo's opti-

mism was warranted. Modi's letters to Zbo reveal his frustration, the helplessness he felt in Nice, where he was in the position of a poor relation unable to look after himself. Now he was back in the nerve center where things were happening.

Paris and its people had changed since the Armistice. There was a new mood, a new spirit in the air. Modi himself looked fairly well, certainly a great deal better than he had in April of the year before when they had gone to Cagnes.

Zbo apparently asked Lunia Czechowska again to serve as chaperone and guard to Modi. Lunia says only that at the beginning of the summer Modi left Jeanne in the Midi and returned to Paris, where he worked without stopping "in a veritable frenzy." It was then that he made a number of drawings and oil portraits of Lunia. She says that he liked being looked after and always finished by doing everything she asked him, even to the extent of giving up his drinking, seriously taking care of himself so he could get well and live for his daughter's sake.

Lunia has sweet memories of her long conversations during sittings. As she posed, Modi confided all that was closest to his heart—his mother, Leghorn, and especially his beloved daughter. His dreams were simple and touching: he wanted to live near his mother in Italy and there regain his health. To be completely happy, Modi needed only to have his daughter near him, a house with a dining room, in fact, to live like everyone else. Lunia says: "With his Latin exuberance, these were dreams without end." [8] They were also, apparently, dreams without Jeanne, and the omission is possibly Lunia Czechowska's. But the absence of Jeanne Hébuterne in this idyll is as conspicuously uncharacteristic as is his odd desire to live in bourgeois conformity à la Matisse.

Modi remained alone in Paris during most of June of 1919, presumably living at his apartment on the Rue de la Grande-Chaumière. After his day's stint there or at the Zborowskis', he and Lunia went to the Closerie des Lilas in the late afternoon, sat with friends on the terrace, and then went to Rosalie's for supper. Rosalie had her protégés and, "among them her God was Modigliani." It seems that Rosalie often prepared Italian dishes well laced with garlic for him. They were so good, says Lunia, that Modi used to say, "When I eat garlic, it's as if I kissed the mouth of the woman I love." Rosalie always scolded Modi for drinking too much, telling him that he was a disgrace to Italy. They spoke Italian together and, as Rosalie's scolding became more shrill, Modi knew how to put an end to it. He resorted to speaking French, which Rosalie spoke too poorly to continue the argument.

After dinner we used to walk in the petit Luxembourg [the park there]; it was very hot that summer. Sometimes we went to the movies,

other nights we strolled around Paris. One day he took me to a street fair to show me *la Goulue,* Toulouse-Lautrec's favorite model, who appeared in a cage with some wild animals. It reminded him of other times, and he recalled that era at length, the painters and figures which have since become famous. We walked and walked, often stopping by the little wall along the Luxembourg Gardens. He had so many things to talk about that we were never able to say good night. He spoke of Italy, which he was never to see again, and of the baby he was never to see grow up, and he never breathed a word about art the whole time.[4]

Jeanne returned to Paris in the last week in June, having been separated from her "husband" about a month. She wired on June 24, 1919, to Modigliani in care of Zborowski, Rue Joseph-Bara:

> Need money for trip. Wire one hundred seventy francs plus thirty for nurse. Letter follows. Arriving Saturday at eight o'clock by express. Let nurse know.[5]

Jeanne Hébuterne was not unable to take care of the baby in Paris, but she needed a nurse for the child. She had had several lonely weeks to ponder her situation. She was well aware that she had two helpless babies on her hands—one of them young, lusty, and vigorous; the other, weak and ailing. Little Jeanne would do as well, if not better, in the hands of an experienced nurse; Modigliani needed all her time and care to stay alive. Besides, who would stay with the baby while Jeanne tramped the streets looking for Modi, tried to drag him home when he was dead drunk, or had to fetch him from the police station at three o'clock in the morning?

Jeanne had other troubles, but it is doubtful whether she confided them to her lover at this point. It did not show yet, so she didn't have to say anything and, besides, she wasn't sure. But she had felt this way before. The symptoms were unmistakable without having to consult an obstetrician. She was pregnant again. The child she was now carrying must have been conceived in May, possibly on the night before Modigliani had left for Paris alone. Modi was heedless. He never thought of taking precautions. When he wanted her, he wanted her, and Jeanne gave herself wholly and willingly.

Meanwhile, care of the baby was left to Lunia. There is no explanation why, but Lunia says that Modi was drinking. This apparently happened only after Jeanne's return, since Lunia asserts that Modi never touched a drop, was a model of good behavior on their long, chummy strolls through Paris at night. Not only was Modi back on the bottle but Jeanne, one month or so pregnant, was perhaps too ill to look after her baby.

What Modi's reaction was when Jeanne told him she was expecting another baby we do not know. But we do know that he was already depressed because, though Paris and Montparnasse had changed, nothing was any better for him. His friends, especially artists, were doing better than ever, making money and reputations. Zborowski, as usual, had exaggerated. He had still to dole money out to Modi. His paintings were selling at a snail's pace; neither the public nor the critics knew of his work, nor were they the least interested. It was infuriating to keep talking of patience and fortitude. As for the promised exhibit in London in July, if it ever did come off, it would surely be a repetition of Berthe Weill's. Everything was just as before, only worse.

If Modi's friend, the painter Gabriel Fournier, can be believed—and it is hard to see why he should make up such a story—Jeanne did care for the baby at least for a few days on her return to Paris before turning it over to Lunia Czechowska. Fournier saw Modi come to the Rotonde with a baby in his arms. It was so unusual a sight in itself that Fournier came over and asked Modi whose baby it was.

Modi said it was his daughter. Fournier congratulated him and patted the baby's cheek. Then Modi asked if he didn't notice anything about her. Fournier said no, what? *"Tu ne trouves pas qu'elle a l'air c . . . ?"* Modi asked. Fournier was shocked! How could Modi say a thing like that about a baby! Fournier thought it was, "Perhaps to conceal his emotion and not to fall into the naive pride of fathers. A painful scene in any case." No one else saw Modi with his baby in public. Perhaps he wanted to hold and walk with his daughter before he and Jeanne gave her up. Or he may deliberately have assumed a crude pose for Fournier's benefit.[6] Modi loved his little Nannoli, whatever he may have said when he was drunk in the Rotonde.

After the baby was confided to the care of Lunia Czechowska in the Zborowskis' apartment, Lunia and the Zborowskis had to make up excuses to keep Modi from seeing his daughter when he was drinking. He would come with his friend Utrillo. They could hear them singing drunkenly blocks away on the Rue Notre-Dame-des-Champs. *La mère* Salomon, the concierge, who was in on the strategy, would refuse to let them in, saying the baby was sleeping and it was no place for boozers:

> Both of them then sat on the sidewalk facing the building, and Modigliani called up to me [Lunia] for news of the baby. He stayed there for hours and my heart was torn to see him so unhappy. We didn't turn on the lights so he would think we had all gone to bed. Then he'd go off sadly with his friend. If I'd been alone, I certainly would have let him come up. Sometimes they gave in to my pleas; then he'd come up and sit next to his child, looking at her with such intensity that he

ended up falling asleep himself; and I watched over both of them. Poor dear friend, those were the only moments that he had his little daughter all to himself.[7]

In her memoirs Lunia says that after endless inquiries they finally found a *pouponnière*, public nursery or infants' home, for the baby in Chaville, a suburb of Paris near Versailles. Jeanne Modigliani speaks of the nurse at Moncey being a capable girl from Loiret, and adds that the correspondence with her "represents an accurate draft of the Modigliani-Hébuterne menage: telegrams, gifts, and baby bonnets alternating with long silences." [8] It would appear that little Jeanne was in the care of a young woman employed by a combination day nursery—children's home in Chaville or Moncey.

With the baby out of the way and in good hands, Modi was painting steadily again except for the usual outbursts and lapses. He seems to have been working against time as he labored for Jeanne, the beautiful Nannoli of whom he was so proud, and the child-to-come that he hoped would be a son. He had easily adjusted again to the light of Paris after Nice and was painting among people who loved and admired him. During these summer months, says Lunia, he painted his loveliest nudes and finest portraits, among them a portrait of Madame Zborowska in a black dress, along with others of Lunia and of Jeanne. He did several of Lunia in various sizes, including two of her in a yellow dress, in one of which she is holding a fan. These were bought by Jacques Netter at 150 francs apiece.[9] He also did a ravishing profile portrait in dark blue-green for which she posed on the terrace adjoining the main room of the Zborowskis' apartment. This is one of Modigliani's best-known portraits. A handsome woman with delicate bone structure and an exquisite profile, Lunia made an outstanding model. Both she and Hanka Zborowska had the chiseled, aristocratic, Madonna-like beauty peculiar to some Polish women. Modi's portraits of Lunia have a warm, wistful loveliness, but none is so striking as the one of Lunia in the yellow dress holding a fan, hand to her cheek as she poses in sumptuous profile, her thick brown hair piled elegantly on her regal head. Lunia also mentions another portrait of herself of the same period in which she wears a black velvet dress, a little turban, sitting on an Empire chair before a chest of drawers. She says that the background of the canvas is a dark garnet red, as in all Modi's paintings of that time.

Lunia Czechowska's other memories of Modigliani during this last warm summer are touching and amusing. Modi was fastidious. Max Jacob had remarked that no matter how down and out he was, Modi always managed to be shaved and well groomed, and to have his clothes laundered. Whatever he wore, Modi imparted to it style and distinc-

tion.[10] Lunia says that he was in the habit of washing himself from head to foot after he had finished painting for the day in Zbo's apartment. He used a basin and, on this particular afternoon in midsummer, "heavy with heat and annoyances," she had heard the splashing as Modi sang. Then, all of a sudden, there was a terrible noise. A cascade of water was followed by the clatter of the washbasin crashing on the pavement.

It seems that Modi had set the basin on the window ledge. It was unsteady, and had fallen to the street. Immediately, *la mère* Salomon began screaming in fury. She and Modi argued "in varied and florid terms." This was hardly the sort of thing to calm him down, says Lunia, and she did not know what to do, since he had apparently decided to send the irascible concierge out of her mind. Lunia does not say whether Modi was naked and whether the concierge was on the street yelling up at Modi, but they must have been. Finally, as she recalls it, Modi squatted on the window ledge and, balanced dangerously, began to sing.

Lunia trembled with fear that he might fall. She must have remonstrated with him, but Modi refused to leave. He wanted to wait until Zbo came back. This went on until dark when Lunia lighted a candle and suggested that he stay for dinner. She explains that he delighted in eating at the Zborowskis and that the invitation succeeded in calming him down.

Lunia went off to prepare supper, a shivering Modi climbed from his precarious ledge still singing, and got dressed. But, as might be expected with Modi, farce-comedy turned off as quickly as it came on. While Lunia was preparing the meal, Modi came in, asked her to raise her head for a few moments, and, by the light of the candle, did a lovely sketch of her. On it he wrote one of his most meaningful aphorisms in Italian: *"La Vita e un Dono: dei pochi ai molti: di Coloro che Sanno e che hanno a Coloro che non Sanno e che non hanno."* (Life is a Gift: from the few to the many; from Those who Know and have to Those who do not Know and have not.) [11]

Two of Modigliani's oldest Italian friends have left their recollections of Modi as he was that hot, troubled summer of 1919. Umberto Brunelleschi returned to Paris at the end of the war, after having been away for four years. The first person he ran into was Modigliani, looking "ravaged and unkempt." Despite his appearance, Modi was at work, making a drawing of a beggar sleeping on a bench. Surprised at seeing Brunelleschi, Modi hugged him, became quite emotional over his Italian officer's uniform, and bombarded him with questions.

They agreed to have dinner at Rosalie's. Brunelleschi changed into civilian clothes and arrived punctually. Modi, as might be expected, did not. Brunelleschi sat at one of the four marble-topped tables and looked around. He describes the little restaurant as narrow and smoky. It reeked

of boiled cabbage, and the dim lighting "made one think of a funeral wake in a peasant's cottage." Although it was Italian-owned and operated, Brunelleschi obviously did not like Rosalie's. He looked at the art on the stained, yellow walls: a few drawings and four or five paintings by the likes of Modigliani, Picasso, Utrillo, Kisling, and others, which, he concluded, were "probably left in payment of some not too good meal."

Rosalie and her son did not know him, and treated him indifferently. Brunelleschi ate his meal in thoroughly bad humor. Modigliani never did show up. Brunelleschi "found him a few hours later at the Closerie des Lilas, the café where Paul Fort, Prince of Poets, held his court. Modigliani was roaring drunk and didn't remember a thing." Brunelleschi was to return to Rosalie's again in 1932, just before her little restaurant closed forever and Rosalie retired to the country "to end her days among chickens, hens, and memories." This time, eager to talk with the *"bonne hôtesse"* about Modigliani, her most important customer, his reception was much different. Rosalie and Luigi greeted Brunelleschi like an old friend.[12]

And Anselmo Bucci, after the war, went to see Modi one night in his apartment, undoubtedly on the Rue de la Grande-Chaumière, which was in "a gloomy tenement house which rented studios to painters." Bucci knocked at the door. It was opened by "a tiny, transparent waif of a woman with a waxen-white face." This was Jeanne, whose jade-green, haunted eyes reminded Bucci of three small canvases by Modigliani he had seen in the window of Laura Wylda's Art Gallery in the Rue des Saints-Pères on a winter evening in 1906.

"Modigliani is not home," the tiny woman told Bucci. "I am Mrs. Modigliani." It was apparently common practice for a woman to assume her lover's name. Modi considered her his wife, in any case, and so, evidently, Jeanne thought of herself. Bucci knew where to find Modi. He was at the Rotonde and, says Bucci, "after such a long, stormy time, he was quite natural—and almost wholesomely human as I hadn't seen him in fifteen years." As old friends they had much to talk about. One subject was the war "with which he [Modi] disagreed although he said half-seriously:

" 'I wanted to go on foot all the way up to the front, but when I reached the end of the Boulevard I was dissuaded. What about you though? Gone and been a hero with the Futurists?' "

They turned to art "where," says Bucci, "he [Modi] was getting his first recognition."

"I've had some good results at the last *Salon d'Automne,*" said Modi. "My canvases had some success. But I chose them you know, chose them with the greatest care."

It is hard to know from Modi's remark in this account exactly what he meant by "the last *Salon d'Automne.*" The catalogues of the Salon

d'Automne show that Modi entered only three of these exhibitions: the first in 1907 when he showed seven paintings and drawings; the second in 1912 in which he entered as a group the seven sculptures that Jacques Lipchitz saw ranged outside like organ pipes; and the third in 1919, from November 1 through December 12 at the Grand Palais, in which Modi showed four paintings. Neither the Salon des Indépendants nor the Salon d'Automne was held during the war years. Modi was obviously not referring to the 1912 Salon d'Automne in which he exhibited only sculpture.

For all that he has been reported as looking emaciated and spent, coughing and spitting blood in December of 1919, he still had his good days, his appearance could be deceptive. He might have seemed perfectly natural and in good shape to Bucci, but that statement remains as puzzling and unsatisfactory as the rest of Anselmo Bucci's account. Modi told Bucci he had just made a contract and was quite happy about it. But he did complain, even protest vigorously, about the reputation his friends were giving him by saying that he was going about starving. Then all of a sudden he said to Bucci:

"I'm a Jew, you know."

"I've never given it a thought!" Bucci assured him.

"It's true. There's no 'Jewish question' in Italy. I'm a Jew and you know about the family spirit we have. *I can say that I've never known misery.* My family has always helped. Maybe at times with a money order for five francs [the gold francs of those days], but they never abandoned me."

Bucci says he was surprised at Modi's tone and his confident mood, which was so unusual in him. He was also pleased "at the confidence he finally showed in me." Bucci now mounts the rostrum to declare unequivocally:

. . . And I am glad to be able to offer my public testimony to Modigliani's family. Someone has accused them of letting him die of starvation in the streets of Paris. His father, his brother have been accused. I am glad to be able to quote Modigliani's own words, which I have already put down in an article in the *Ambrosiano*, a Milan newspaper, twenty years ago.

Let us once and for all debunk this romantic legend which seems to please biographers and which the public seems to like. Modigliani never went hungry. Someone who has can tell you that.

Modigliani drank. He drank all the time from 11 A.M. to 3 A.M., and drinking was expensive even then. One could have a perfectly complete and decent meal (soup, a main course, fruit or cheese, a quart of wine, and all the bread one could eat) at the Bouillon Chartier, and elsewhere for one franc twenty-five centimes; and the apéritif then in fash-

ion, absinthe, the famous "green," used to cost half the price of a meal. We have all wondered at Modigliani's alcoholic prowess in the various cafés. To destroy himself by drinking as he did, he had to have plenty of money.

Bucci and Modi went to a bar on that particular evening, then on to Rosalie's for a bite, where they found the owner "with her dripping nose in her pans and behind her an international restaurant four meters square." Here Jeanne—Bucci calls her Modigliani's "wife"—met them. Modi, "like all alcoholics, ate very little. He was "most affectionate" toward Jeanne, "almost ostentatious in petting her, talking to her, asking questions."

Afterward they went out and "of course headed for the Rotonde." But on the way, they stopped at an intersection and Modi sent away "his wife, hugging and kissing her with a great show of affection and waving at her from far." Bucci was "a little surprised" at this; Modi explained:

"We are going to the café, just the two of us. My wife—she goes home in the Italian way. Are you surprised?"

"It was an evening of revelations," Bucci tells his readers.

"Italy." Modigliani sighed, opening his arms wide and looking up at the pink sky. "I'll go back to Italy. I want to go back to Leghorn. I want to live in Italy."

"I never saw him again," Bucci writes. His direct account of meeting Modigliani seems authentic, but his general comments, as recorded in 1951,[13] are rather strained. Obviously Bucci has added his bit to the legend that grew up around Modigliani after his death. On this occasion, Modi was sober, well behaved, articulate, polite, and loving, if a little uxorious toward Jeanne. Modi's blurting out that he was a Jew and that there was no Jewish problem in Italy was natural enough, but the rest of what Bucci puts into his mouth is not. It sounds like the propaganda that was meant to prove it was France which ruined Modigliani, not glorious Italy, Motherland of Art.

Bucci insists too much. Modi gladly took the responsibility for his own life: he never blamed his family or Italy. As for the development of his genius, the credit goes, not to Italy nor to France, nor to his family, but to Amedeo Modigliani, with a powerful assist from Leopold Zborowski.

Modigliani left different impressions on different people. In her reminiscences, the Russian painter Marevna Vorobëv also tells of meeting Modigliani in Montparnasse a short time before his death. She says that he had just come back from Cagnes and ". . . told me that he was then getting from Zborowski a monthly allowance of three thousand francs." Miss Vorobëv grants that this was good money "for those times, but one must not forget that he was married and already had a child dependent

on him." (Many other people besides Miss Vorobëv have mistakenly believed that Jeanne and Modi were married. Since they did give this impression, it is plain that their relationship was regarded as close and permanent.) Miss Vorobëv remembers Modi saying:

"I'm getting fat and becoming a respectable citizen at Cagnes-sur-mer. I'm going to have two kids; it's unbelievable. It's sickening!"

Although she took him seriously, it seems evident that Modi was doing a little boasting. He mocked himself as being a fat, respectable bourgeois, the proud father of two children. But this was no less false than his claim that Zbo was paying him three thousand francs a month. Miss Vorobëv says that he looked well when she saw him this last time, adding, "it was after he had gone back to living in Paris, and had begun taking drugs and drinking again, that he fell seriously ill." [14]

Marevna Vorobëv writes that, just for a single glass of wine, Modi "would make you a present of a remarkable drawing, done anywhere and at any time of the day or night, which was always interesting and sometimes amazing—for a mere glass of wine." Many people who received drawings in this way preserved them "like veritable treasures." And so they were. He did several of Marevna and of Diego Rivera, which she gave away to friends. Later, when she was living in Cagnes, Miss Vorobëv was given a chance to buy back one of the drawings for thirty thousand francs.

One has to believe that Modi knew his drawings would pay back kindness; that a piece of paper with one of his sketches would someday turn into gold. But only Modi knew it, and therein lay the cream of the jest: the drawings were tickets for his long passage to immortality. He might have been saying, with Shakespeare:

> Time hath, my Lord, a wallet at his back,
> Wherein he puts alms for oblivion.

One of the riddles left behind by Modigliani consists of a single statement in his distinctive handwriting on a sheet of lined gray paper. This "strange document," now owned by Jeanne Modigliani, reads:

I pledge myself today July 7, $^{1919}$ to marry Mademoiselle Jane [sic] Hebuterne as soon as the papers arrive.[15]

It is signed by Amedeo Modigliani, Leopold Zborowski, Jeanne Hébuterne, and Lunia Czechowska in that order and, at the bottom right, "Paris, July 7, 1919." The pledge seems to have been written hastily, impulsively, judging from the writing and the insertion of the year above the line. From the way he misspelled Jeanne's name, it is possible

to make a guess at the circumstances under which the idea came to Modi.

Omitting the acute accent in Hébuterne is an oversight, but writing Jeanne as the English *Jane* may be because of all the talk of England and the forthcoming London exhibition. Why Hanka Zborowska was not present to sign the document, which Modi tried to make as official as possible by putting in the date—for the second time—at the bottom, cannot be explained. But the chances are that Modi did not write it at the Zborowskis' apartment, more likely at a café table. Zbo was probably about to leave for London to supervise the Sitwell exhibition and this gathering was in the nature of a celebration. Toasts were undoubtedly drunk to Zbo's success and to Modi's, and to Jeanne, who was expecting another baby.

Quickly Modi scrawled his pledge on the paper, signed, and turned it over to Zborowski. Zbo read what was written, nodded, noted that Modi had omitted the year in the first line, and signed. Jeanne came next. Modi then corrected his omission and passed the paper on. It is impossible to imagine what Lunia Czechowska thought as she put down her name last, her signature neat, rounded, connected. Jeanne's was scratchy, jumpy, disconnected, tending as sharply to the left of the page as Lunia's did to the right.

Since it was not legally sworn to before a lawyer or notary, the document had no legal validity, but it was a gesture on Modigliani's part that meant he wanted the world to know his intentions. Modi had given his word and his hand. For Jeanne this was enough.

Zborowski must have worried about the London exhibition. Many artists were to be represented, but Modigliani was the one that counted for him. It had to be the big success Zbo had always hoped for.

As nearly as can be determined, Modi's contract allowed him something like three hundred francs a month, his paints, brushes, and canvases all being supplied by Zbo, who also paid his rent. Modi's salary was deducted from whatever paintings were sold during a particular period, and these sales may often have provided an extra cushion to augment what he was paid by the week.

But whatever Modi received, it was never enough. More often than not he had spent his week's salary and was back at Zbo's to ask for an advance on next week's. Modi spent his own money—all of it. And Jeanne, much as she may have wanted to, was never able to save a cent, although she certainly must have tried. Very little money ever passed through her hands, though on one occasion she seems to have managed to get hold of one hundred and fifty francs which she put for safekeeping between the pages of a book. She was never able to use it. Nina Hamnett found the money when she went back to Paris in 1920 and lived with Zawado in Modigliani's old apartment.

During his last years, 1918 and 1919, Modigliani was never penniless or destitute, except sporadically, and through his own fault, Kisling told Goldring. Kisling felt that during this period Modi received more than enough to lead a comfortable, satisfactory life if he had had any sort of control. "If you have two thousand francs a month and spend nineteen hundred on alcohol, you must expect to live in misery. Modi never knew when to stop." [16]

If Modi could not stop, what was it that drove him to destruction, especially now when his talent was being recognized, when he was living with a woman who adored him, had a lovely infant daughter, a good dealer who was also a friend, a man who admired, supported and fought for him, besides many other devoted friends? The answer is by no means simple. It lies partly in the habits of a lifetime that could not be so easily abandoned, certainly not without a kind of discipline outside his work, which Modi did not have. The habits were also the result of poor health and the constant and still gnawing sense of his failure. By now they made a vicious circle that he with his temperament was unable to break.

What he had wanted when he had come to Paris as a twenty-two-year-old was the kind of success he could take back to Mamma in Leghorn, something tangible to repay her for all her sacrifices, to show her he was as worthy as his brothers and to silence his embittered sister and his doubting friends from Micheli's old art class.

Now, thirteen years later, he had nothing to show for the years, the work, the pain and misery he had suffered. On July 4, Modi turned thirty-five. He was tired. On one plane, success no longer mattered to him; but on another, he was counting on the London exhibit: he needed a sensational coup to revive his spirits, bring him back from the dead. A dramatic recognition and quick fame were too much for any realistic man to expect from the London exhibit, and Modi, with his history of failures, knew better. Yet he was a drowning man with a wife, a daughter, and a son on the way. . . . This time it had to happen.

## ❦❦❦ Chapter Thirty-two

*"It is the only crime I have ever committed."*

From the names of those who appeared in the London exhibition,[1] Zborowski appears to have done a good job of collecting works by most of the outstanding French artists of the time. There were sculptures by Zadkine and Archipenko, and canvases by Picasso, Matisse, Derain, Vlaminck, Marcoussis, Lhote, Léger, Friesz, Alice Halicka, Fournier, Dufy, Survage, Valadon, Utrillo, Modigliani, Kisling, Soutine, and Ortiz de Zarate. It must have been an exhausting business satisfying everybody, but Zbo was a patient, amenable man anxious to do everything to advance Modigliani's career. The dealers no doubt pressed him hard, but Zbo would eat dirt to put on this exhibit.

Zborowski arrived in London with his crates of paintings some time toward the end of July, 1919. He had left the wolves of the Paris art world behind to face a pack of foreign predators. His young associates, Osbert and Sacheverell Sitwell, were aristocrats, intellectuals, art lovers, men-about-town, social leaders. Like Nina Hamnett they had wit, charm, and the knack of knowing everybody important, but unlike Nina they had position and were able to use it for the benefit of art. To them Leopold Zborowski was an odd one. Osbert described him as having

> . . . flat, Slavonic features, brown almond-shaped eyes, and a beard which might have been shaped out of beaver's fur; ostensibly he was a kind, soft businessman and a poet as well. He had an air of melancholy to which the fact that he spoke no English, and could not find his way about London (to which city this was his first visit) added.[2]

Osbert said "ostensibly." Zbo appeared to be a kindly, easygoing poet; but he was a dealer, his job was to sell pictures, and Osbert wasn't going to be fooled. Picture dealers were not philanthropists, and this Zborowski

452 ❧

fellow was not giving anything away. The exhibition was to be held at the Mansard Gallery at Heal's in a large room that Nina Hamnett said had once been used as a dancing school. She wrote that Kremegne and Zawado were also among the artists represented.[3] The exhibition was advertised as a display of Modern French Art. The Sitwells were gentlemen of taste and gave considerable thought to the proper hanging and mounting of the pictures. Presumably Zbo stood around and watched, though making sure that Modigliani was prominently featured but surely feeling shy and out of place among these "swells." Roger Fry, the distinguished art critic, gave the Sitwells a hand, and Goldring says that another art critic and poet, ". . . the late Gabriel Atkin" also ". . . looked after the arranging and hanging of the pictures."[4] It was a gay, frantic time, but poor, bewildered Leopold Zborowski, who unfortunately left no impressions of the Sitwells, must have wondered what he had got himself into.

The Sitwells had an extraordinary reputation in London. They were the nucleus of London's "in" group, leaders of the *avant-garde* in art, literature, in all that was new and sophisticated. Nothing like these paintings had been shown in London in years. No one admitted as much but, on the basis of the sensation caused by past exhibitions of modern art, this one would provoke greater controversy, set the critics and the public back on their collective heels. One gathers that the Sitwells rather liked the idea.

The "in" group appreciated good modern art as they did good modern everything else. "Picasso had long been the favorite of the cognoscenti of modern art," Osbert wrote, although they knew Matisse and were familiar with the names of some of the other artists in the exhibit. Picasso had been in London that same summer with Sergei Diaghilev's Ballets Russes, and had scored a big hit with his scenery and costumes for *The Three-Cornered Hat*, a ballet with music by Manuel de Falla and choreography by Leonide Massine. It was well known that on opening night, July 22, 1919, at the Alhambra Theater, Picasso had applied finishing touches right up to curtain time, even to the point of decorating the costumes of the principals as they waited to go onstage.[5] Derain was also known because of his curtain, scenery, and costumes for another of Diaghilev's ballets, *La Boutique Fantasque*, which had also been presented in London in 1919.

The Sitwells were sincere in their praise of Modigliani's work and proud to be the first to introduce him to the British public. Osbert was particularly taken with Modi's nudes, and believed the reclining figures derived from Titian and Giorgione. The brothers were anxious to buy a Modigliani before the exhibition opened, but Zborowski made them understand that this was impossible because most of them were owned by Parisian dealers.[6] This remark is mystifying unless it means that the Mo-

digliani the Sitwells wanted to buy was a canvas owned by Paul Guillaume or Chéron. Much more likely, since this was a pooled exhibit under Zborowski's direction, Zbo had to make rules and therefore refused to sell a single item till he got instructions from Paris. Zbo must have relayed the Sitwells' request, for Sacheverell and Osbert were permitted to choose a single picture for themselves at what it had cost the dealer. This again is confusing, but, at any rate, the brothers chose their favorite, *Peasant Girl*, paying a more than reasonable four pounds (about twenty dollars) when the average gallery price for a Modigliani had been set at between thirty and forty.[7]

Every art exhibition of any pretense has to have a catalogue. The Sitwells had shrewdly asked Arnold Bennett to write the preface for theirs. Bennett was not only an old family friend but an art lover, and perhaps the outstanding British novelist of the day. To increase their chances of success, the Sitwells capitalized on his name, hoping, as Osbert put it, that Bennett's reputation would save them from vilification, abuse, and the vulgar display of bad temper that always greeted modern art in London. But this literary coup was in vain. The exhibit opened on August 1, 1919. Osbert noted that while most of the critics were impressed, or at their lowest level, civil, the general public was true to itself. It did not matter to ordinary people that Clive Bell applauded the painters in *The Nation* and that Roger Fry and other such noted critics as Thomas W. Earp and Gabriel Atkin praised the exhibition and the extraordinary work of Amedeo Modigliani.

To the Sitwells it was most satisfying that it was the newcomers, Modigliani and Utrillo, who were the sensation of the show rather than the great names and established masters. In spite of the adverse public reaction, "a good many of the pictures" were sold on opening day. Osbert said that Arnold Bennett paid fifty pounds for what was apparently a portrait of Lunia Czechowska. Another good friend of the Sitwells paid seventy pounds for a Modigliani and an Utrillo. Osbert added that five years later the friend sold both paintings for twenty-six hundred pounds, a sizable though not unusual markup.

It must have been an exciting day for Zbo. As soon as he could, he dispatched a telegram to his wife reading, according to Lunia, "Lunia sold for 1,000 francs; bought by Arnold Bennett." [8]

One can imagine the Sitwells introducing Zbo to Arnold Bennett, Zbo proud and tongue-tied, and Bennett praising Modigliani in his squeaky, stammering French. Lunia says that when Zbo got back he told them that Bennett already knew Modigliani's work and greatly admired it. Bennett said that he was particularly fond of Modi's portraits because they conjured up the heroines of his novels. Modi's women could not have looked

less like Bennett's heroines, but Zbo must have been bursting with pride, and such an embellishment is understandable. Lunia says that Modi had the greatest success of the exhibition and that his paintings sold for the highest prices. The first statement may well be true, partly owing to the enthusiasm of the Sitwells and Arnold Bennett, but not the second. Surely the works of Picasso, Matisse, Derain, Vlaminck, Thote, Léger, and some of the others, if they were sold, outpriced the paintings of the unknown Modigliani. We do know from their later actions that as soon as Zborowski informed the dealers in Paris that Modigliani was the hit of the show and in demand, the word came back swiftly that Zbo was to raise the prices on all Modi's paintings.

When Modi was advised of his London success, he asked Zbo for only a modest gift, a pair of shoes. Zbo, who had plenty of time during his lonely evenings to turn his hand to poetry about London, must have written his own reports of the exhibition to his wife and to Modi and sent along press clippings. Jeanne Modigliani writes that ". . . as usual, Modigliani sent the favorable clippings to his mother," [9] but the "as usual" is something of an exaggeration since, up to 1919, no one had written at all about Modigliani. Except for the one mention of his name in the reviews of the 1910 Salon des Indépendants by his friends André Salmon and Guillaume Apollinaire and for his obituary notices, Modigliani's name *never once* appeared in the Parisian press in his nearly fourteen years in that city.

Modi must have been pleased at his London success and reviews, but he seems very cool writing to his mother about it and about the article Francis Carco had just written on him in a Swiss magazine. Here is his card, written even as the London exhibition was being held, dated August 17, 1919:

DEAR MOTHER,

Thanks for your good card. I'm having sent to you *L'Eventail,* a magazine containing an article about me. I'm having an exhibit with some others in London. I asked to have the newspaper clippings sent to you. Sandro [the brother of his childhood friend Uberto Mondolfi], who is now in Paris, will be going back through Paris before returning to Italy. My little girl, who we had to bring back from Nice and who I have sent to the country near here, is in wonderful health. I'm sorry not to have any photographs. All my love,

DEDO.[10]

Modigliani's card is so matter-of-fact that it almost seems as though he hardly cared any more. Either that, or it is a case of once burned, twice

shy: he had too often written of a success that never materialized. His message was informative and to the point, but such welcome good news called for enthusiasm.

Carco's laudatory article about Modi appeared in *L'Eventail, Revue de Littérature et d'Art,* published in Geneva, in the July 15, 1919, issue. The August 15 issue carried a number of reproductions of Modi's drawings. In itself Carco's effort to publicize Modigliani was a marked change from the neglect that had been his lot. Yet the card to his mother is restrained. After so many years of bitter failure, perhaps he preferred to let the clippings and the article speak for him.

Osbert Sitwell and his brother were at the exhibition every day, selling catalogues, answering inquiries, and "quieting or trying to quiet protests about the pictures." They were stationed at a table in the middle of the room on which there was, at one side, "an enormous wicker basket full of sheaves of Modigliani's drawings for a shilling." [11] Certainly they were the great bargain of the show. Goldring says the drawings were five shillings each, and "At the end of the show this basket was almost full, which does not say much for the perspicacity of London art lovers." [12]

People protested loudly about the show. Their reactions at the show and outside the Mansard Gallery spilled over into the newspapers. Following Clive Bell's laudatory review, *The Nation* published letter after letter attacking the paintings on a moral plane. One of them castigated the entire collection as "glorying in prostitution." The photographs of Modigliani's pictures published in the newspapers every day exacerbated the public. Modi's swans' necks "maddened and enraged" people, arousing them to "passionate and venomous derision." Osbert had a theory that the thicker the neck of the letter writer, the more vitriolic his criticism.[13]

As usual in the art world, what was viewed as an outrage, as an unspeakable offense to good taste created a furor of publicity. It had done so with the debut of the Fauves, the Cubists, and the Futurists. The reaction of the Parisian dealers to the news of Modi's amazing London success accounts for their instructions to Zbo. While the exhibition was on, according to Osbert Sitwell, Zborowski received a telegram from his Paris colleagues telling of Modigliani's "grave relapse"; the message "ended with a suggestion to hold up all sales until the outcome of the painter's illness was known." It seems that Sacheverell, who saw the telegram, was inexpressibly shocked at this example of the callousness of businessmen and that Zborowski personally asked the Sitwells to refuse to sell if a purchaser wanted to buy. Osbert adds that Modigliani "did not comply to the program drawn up for him." He regained his strength, and died the next year.[14]

Before condemning Zbo it is well to remember that he spoke no English, and the Sitwells, who had the limited, English aristocrat's knowledge of French, perhaps jumped to nasty, if justified, conclusions. Zbo was under obligation to the Paris dealers, and the truth revolved on the ugly fact, as well known to artists as to dealers, that the works of a promising artist rose astronomically in value after his death.

Modi had certainly not suffered a "grave relapse" of any kind when Zbo received the telegram. The dealers may have heard rumors; someone may have seen or heard that Modi was coughing and spitting blood and leaped to the conclusion that he was dying. This is at least a charitable explanation. Zbo himself had lamented the ironic fact that an artist's work rose in value after his death. But he would have learned the truth about Modi's health from home: a letter or a telegram was all that was necessary.

Considering the kind of man he was, this strategy of his colleagues must have troubled Zbo. It is even possible that the rumor had been agreed upon before he left Paris. The dealers knew that as soon as sales of Modiglianis were stopped, there would be questions, and once the rumors of his relapse got around there would be a scramble to get in line to buy his paintings once they were on the market again. Zbo might not like the method, but his job was to get the best prices he could for Modi's paintings. Besides, Modi's stuff had been going cut-rate for years. All was fair when it came to prying money from the hard-nosed, tightfisted English.

Even if Zbo was using an accepted art dealer's gambit—and the Sitwells thought he was—Osbert did not hold it against Zborowski. He did not think Zborowski, kind and nice as he was, was the philanthropist-poet Douglas Goldring made him out to be in *Artist Quarter*. Osbert feels that Zbo had a flair for selling, that he would want to be remembered for that, and that the job of a picture dealer was not to be a philanthropist.[15] That is Osbert Sitwell's belief. But the facts of the relationship between Zbo and Modi do not bear him out, and his conclusions reveal that he did a superficial reading of Goldring and had no understanding of the unusual relationship between Zbo and Modi.

The London exhibit continued through August and seems to have been an unqualified success. The idea persists that not so many of Modi's paintings were sold as Zbo had hoped, given the excitement his work had generated. But compared to the Berthe Weill fiasco of two years before, it was a roaring triumph. Despite the fact that the wicker basket of Modi's drawings was still almost full after the show, "All the same, he must have made some money out of the exhibition, which also made his name more widely known." [16]

There is further proof that not too many paintings were sold in Osbert

Sitwell's complaint that the public did not respond to the exhibition as it should have, thus losing a good chance to make a profit.[17] For all his admiration of art, Osbert seems to have been very aware of the investment value of the paintings.

Nina Hamnett ". . . found this exhibition very inspiring and exciting and longed for Paris." She says the Modiglianis were not at all expensive and that the one of "the boy," probably *Peasant Boy,* now in the Tate Gallery, had cost forty pounds. Nina then mixes up the chronology of her story when she writes: "The art dealer returned to Paris as news came that he [Modigliani] was dying in the Hôpital de la Charité, where Alfred Jarry and so many other celebrated people have died. He died a few days later and telegrams were sent to London to put up the prices of his pictures." [18] This is entirely false.

According to Osbert's account, the Sitwell brothers continued negotiations with Zborowski after the show. In the fall of 1919, when Modi's health was really failing, they worked hard to swing a deal by contracting with Zbo to buy a hundred or more Modiglianis for a purchase price of between 700 and 1,000 pounds. At roughly $5 the pound, 100 paintings for 1,000 pounds would be $5,000, or approximately $50 each. This would have been an incredible bargain and, had the deal been consummated, it would have made the Sitwell brothers millionaires many times over. They would have had a corner on the Modigliani market.

Although Osbert does not say so, the London success had not made Modi's fortune. Some of his pictures had been sold. He had made a great splash and received his first substantial, laudatory reviews, but the public and the dealers in Paris felt as they always had. If the Sitwells were trying to arrange a deal for "one hundred or more Modiglianis," it would mean that Zbo was prepared to dispose of his entire stock of Modi's paintings. It could only have been a desperation move. Still, $5,000 for the lot was a large sum at the time, and would certainly have impressed the Parisian dealers. The deal, which could not have been to Zbo's liking, would, however, have put a large sum of money in Modi's hands, permitted him to take his long-desired trip to Leghorn, and perhaps—certainly Zbo counted on this—induced him to take care of his health or put himself in his mother's care and thus prolonged his life.

Osbert and Sacheverell lacked the capital necessary to swing the deal. To raise it or to make some sort of down payment, they tried to get their father, Sir George R. Sitwell, to advance them the cash or buy the paintings himself as an investment. It would have been one of the best investments ever made, and the Sitwells seem to have done their best to sell their father on it. The matter hinged on an interview with the father. Osbert described how Sir George came to Osbert's rooms to inspect the *Peasant Girl,* the Modigliani portrait he and Sacheverell had been

allowed to buy for four pounds. Along with Sir George came a jittery old family friend—a Mr. MacTotter, known to the brothers as the Silver Bore.

Sir George, an outspoken eccentric of arbitrary opinions, was to pass judgment on the painting and the proposed transaction with Zborowski. There sat the *Peasant Girl*, "monumental, posed forever in her misty blue world." And now everything depended on the result of "an interesting duel" between Papa, MacTotter, and the girl. She lost. What decided Sir George was that, for the indignant Silver Bore, the painting had "no movement or expression." Osbert was greatly disappointed. He could not move his father. He sold the portrait to a friend for eighty pounds five or six years later, adding that a week afterward the *Peasant Girl* was in the window of a famous French dealer to whom the friend had sold her for four thousand pounds.[19]

Arnold Bennett always prized his Modigliani and considered the artist "certainly one of the great painters of this century." He recalls in the same *Journal* entry for August, 1929, that he paid only fifty pounds for it eight years before (actually ten), and that he had been invited to a current private showing of Modiglianis in a West End gallery. There were no fifty-pound Modiglianis this time. Bennett stopped in front of the portrait that pleased him most and asked the price. The manager of the gallery said that a Parisian dealer had offered him six thousand pounds but he had refused to sell it. According to Osbert Sitwell, Bennett, shortly before his death in 1931 when he was deep in a writing and financial slump, sold his Modigliani "at a huge profit." (Here again was the irony to be repeated so often: Modi, unable to save himself, came again and again to the rescue of others.)

When Osbert and Sacheverell visited Paris shortly after Modigliani's death, they were startled by the change in Zborowski. Osbert remarks on the richness of his fur coat and the enormous sweep of its collar. He says that Zbo "showed his good nature and childish and evident pleasure at the style in which he was now able to live." [20] This was true, but it was written many years after the meeting, when a single Modigliani was worth thousands upon thousands of pounds, and one can detect in it a slight taste of sour grapes: think in what style the Sitwells would have lived had the deal with Zborowski gone through.

But who, knowing Zbo, could blame him? It may have seemed like childish pleasure to the Sitwells, but it can have been part of the strategy of a successful dealer to look successful. It can more likely have been a gesture of vindication for his faith in Modi, for his willingness to go hungry and ill-clothed for that faith when no other dealer would give Modi anything but passing notice.

Zbo had quite literally given up everything for Modi: his family had

suffered. Zbo had been scorned, called a fool for backing the tempera-
mental, impossible Modi. If the aristocratic Sitwells took Zborowski for
no more than a hardheaded dealer gone *nouveau riche,* Modigliani him-
self would have understood, even applauded Zbo's long-awaited, well-
earned reward.

Nor should it have surprised the Sitwells that Zbo, like most people,
like Modi himself, had always looked forward to the day when he and his
family could live well.

Back in Paris after the praise, the acclaim, and the rarefied atmosphere
of London, Zbo knew it had been a good trip. He brought good news,
gifts for his family, including the fine English shoes Modi had asked for
and a handsome woolen scarf as a present. Everything considered, Zbo
had done well and had reason to be pleased with his work. But after ex-
penses and the percentage due other dealers had been deducted from the
sales, Zbo—and Modi—would end up with only a modest profit. There
was the big deal with the Sitwells in the offing, and he must have told
Modi about it.

What counted as much as immediate sales was the extraordinary re-
views, with Modi hailed as the sensation of the show. What must have
been hardest for Zbo to get across to Modi, who demanded Success, Fame,
and Money *now,* not tomorrow or the next day, was the indisputable
truth that his career was, at last, launched.

Carco's article in *L'Eventail* "attracted to Zborowski two or three Swiss
collectors, who, profiting by the exchange rates, bought some of Modi-
gliani's nudes for next to nothing." [21] The last three words told the
story, and Modi could throw them back in Zbo's face. A sensation in
London, written up in Geneva, exhibited at the Cabaret Voltaire in
Zurich—and in Paris what? Montparnasse had changed as had all Paris:
money, new people, tourists, and rich Americans were rolling in and tak-
ing over. Everybody was selling, getting good prices with little effort, ex-
cept Modi. Goldring cites chapter and verse of one text:

> Zborowski was now rather more successful with Modigliani's work;
> but in real income the increase did not amount to much. The dealers
> did not yet understand him [showing that Modi's London success must
> have been regarded as a fluke]. Zborowski told a story of a rich man
> whom he tried to convince of the value of Modigliani's pictures and
> also to touch by reason of the artist's poverty and ill health.
> "Pah," answered Croesus, "what does it matter if an artist is poor?
> He does not need to live well, and besides, if he's sick, he can go into a
> hospital, can't he?" [22]

While Modi's August 17 postcard to his mother seems the hurried message of a dutiful son, as reassuring as his serene paintings, Modi himself was becoming unmanageably difficult the more his health failed. His senses were dulled, his nerves frayed raw. To Zbo's enthusiasm he could only respond with a *"Merde!* So what?" The dealers, the collectors, the buyers, the general body of critics and the public still did not care for his work.

Nothing had changed for him, and Modi knew that it never would in his lifetime. He painted in spurts, working intensely when he did work, which drained his waning strength. Exhausted, he had to take long periods off to recover. The Rotonde was unrecognizable these days, and the time came when Modi was no longer welcome at it. Libion had sold out; the new owner wanted the big money. There was no more credit for anyone. Artists were to keep away if they couldn't pay cash.

Modi didn't like it and he said what he thought of the place. Before long he was at the familiar police station around the corner. But he still went to the Rotonde, to drink and draw. People thought him picturesque.

He continued to paint, and in the last months of his life paid tribute to the two modern painters he most admired. His friend Charles-Albert Cingria, the poet, tells how Modi wanted to see Matisse and paint him. Matisse did not know who Modigliani was, but he was agreeable enough, as Cingria recorded it.

"I'm perfectly willing, but I can only give you five minutes," said Matisse.

"That's enough. I plan to do three portraits; the others I can do from memory." [23]

Cingria wrote that when Matisse saw the result, he posed a full hour for Modi, a long session for so busy a man. Cingria does not date this incident, nor have any of Modi's drawings or paintings of Matisse ever been shown, although they could very well exist. There is no reason to doubt Cingria's word.

Cingria also says that Modi was very fond of him and his brother. Some people had told Modi that Cingria and his brother were Danish. Modi corrected them as Cingria says he himself had.

"No," said Modi, "they come from the Raguse [another name for Dubrovnik in Yugoslavia]. And I know the people from Raguse: they're from Raguse."

But, says Cingria, people kept insisting on his Danish origin to maintain the indictment that he had a "Nordic" background. In Paris, people had a mania for classifying those who don't look like others: they must be either American or Swedish. To all of which nonsense Modi replied:

"The question is meaningless to me. They're from Raguse, that is to say, they're Levantine-Italians. . . . And so *merde* . . ." [24]

Another painting of Modi's last months seems to have been a portrait commissioned by Roger Dutilleul, "a rich and inspired collector" who ". . . had heard of Modigliani, of his portraits and of his work: perhaps from Paul Guillaume or from the unfortunate exhibition Zborowski had tried putting on at Berthe Weill's gallery." It seems Dutilleul, interested in young painters, arranged to have Modigliani visit him and paint his portrait. The old collector knew the charges were "65 francs plus the canvas, the frame, the paint, and several bottles." Once in Dutilleul's apartment, Modi looked around with interest:

Everywhere hung paintings by modern artists, which Dutilleul showed with enormous enjoyment to his guest; many by Picasso among them. And Modigliani stopped before a still-life by Picasso, enthusiastic and admiring. "How great he is," he said. "He's always ten years ahead of the rest of us." And he asked Dutilleul if he could keep it beside him while he painted, as an example and an inspiration. Thus the splendid portrait of Dutilleul renders homage to a still-life by Picasso; it is not too rash to suppose it was painted in 1909–10 since its tender greens and grays are still Cézannesque.

In this anecdote Modigliani's intelligence, his modesty and his greatness all appear. [25]

In his portrait, Roger Dutilleul is a kindly, pleasant-faced older man with short-clipped hair and a handlebar mustache. He is wearing a wing collar, an elegant black frock coat, and shows himself to be a pipe smoker. The composition is rich, warm, and simple. In the opinion of the English critic John Russell, it is "one of the finest of Modigliani's late male portraits," and shows ". . . the monumental calm of the great seated portraits of Modigliani's last years: *'le grand style,'* as he himself called it." [26] The Dutilleul portrait is almost a companion piece to Modi's *The Notary from Nice*, also known as *The Man with the Pipe*, and *Le Niçois*.

Like the Notary, Dutilleul is seated in a chair, but his pipe is poised in his right hand, his left hand tucked on his hip under his right elbow, his head cocked a little to the left, his eyes curiously blank. A few subtle distortions can be noticed, but no swan's neck. Dutilleul is relaxed, benign, at peace, a man who admires art and artists, a man pleased to be sitting for a painter who finds his incentive in the work of Picasso, whom he acknowledges as a master ten years ahead of his contemporaries. As in *The Notary*, the colors are muted, delicate, but daringly applied, and the figure has "that *eleganza tutta toscana* of which Modigliani's friend Severini once spoke." [27]

Modi had raged bitterly against Picasso as a dirty bourgeois who had made a commercial success of Cubism; and no doubt he was envious of Picasso's success and the apparent ease with which he achieved it. He had also spoken of Picasso's contrivances as something to be avoided by a serious artist.[28] Yet Modi recognized Picasso's genius. He had already paid homage to him when he inscribed the word "Savoir" on his 1915 portrait of Picasso.

Picasso, always in command of himself, had made deprecating remarks about Modi's choosing to get drunk always in the most public places.[29] But Picasso had also praised Modi as the only man in Paris who knew how to dress. Yet there seems to have been some coolness between them, despite the fact that "During the war, relations between the two were such as to admit of this [1915] portrait and of at least two drawings of Picasso by Modigliani." [30] And on one occasion, Picasso is said to have painted over a picture he had got from Modigliani because he was short of canvas.[31]

This was done impulsively. Again, it may be part of the Picasso legend. Many collectors have X-rayed their Picassos, but the Modigliani has never been found. Yet it must have happened, for Picasso told the story to David Douglas Duncan and ended it by saying, "It is the only crime I have ever committed." And Duncan remarks, "Just so there can be no misunderstanding—you should have seen those Spanish eyes when Picasso told me about it." [32]

Judging from the testimony of Françoise Gilot, who spent many long hours with Picasso as model and companion from the early 1940's into the 1950's, it is plain that Picasso has not forgotten Modigliani. When she visited his studio at 7 Rue des Grand-Augustins for the first time, in May, 1943, she spotted a painting of Modi's among the clutter, along with others by Matisse, the Douanier Rousseau, and Vuillard. Not long afterward, while taking her to see his old studio in the Bateau-Lavoir— where it all began, as he put it—Picasso took the trouble to point out where Modigliani had lived. It was above the Bateau-Lavoir on the Butte, a small, squat structure like a shed, set back from the street on a knoll.[33]

Mlle. Gilot does not give the exact location, but it seems to be the old carpenter's shop at 7 Jean-Baptiste-Clément. This was the place André Utter had helped Modi find after Modi had been ordered out of his room in the Hotel Bouscarat. It was there that the ceiling had fallen in on him.

Carco has written that the always sober Picasso was annoyed with both Modigliani and Utrillo because ". . . they took advantage of their drunkenness [as well as their appalling misadventures] to escape his control." In so doing, they ". . . never gave any importance to Cubism . . ." as they continued to paint in their own styles, thus remaining

free.[34] And in this connection, Epstein's comment to Arnold L. Haskell is particularly revealing:

> Of all the artists influenced by him [Picasso], Modigliani alone was sufficiently strong to retain his individuality. He is Picasso's equal as a painter, but not as a technician, and he has not attempted to ape Picasso technically. Picasso is an extremely sophisticated artist.[35]

Surely Picasso was conscious of Modigliani's artistic strength and independence, as surely he must have appreciated these same qualities in Modi as a friend. Picasso to this day owns a Modigliani portrait of a man.

∾∾∾Chapter Thirty-three

"C'est magnifique."

Modigliani continued to be productive on into the fall of 1919. One of his portrait subjects was the American painter Morgan Russell, who was the same age as he. This portrait has also been arbitrarily dated 1918, but was almost certainly done in 1919. Russell had studied with Robert Henri in the United States. He began as a realist, then abandoned realism for something he chose to call "Synchromies." Along with Stanton Macdonald-Wright, a fellow American artist, Russell had exhibited his paintings at the Bernheim-Jeune Gallery in 1913. Together they had launched "Synchromism," a movement in which form was secondary, color all-important.

Russell had something sad and confused about him; he communicated a lost, a tragic spirit, and Modi painted the troubled portrait of a troubled artist. Thomas Craven found special meaning in Modi's portrait of Russell. Although he saw little merit in modern art and damned most modern artists as fakers, Craven was interested in Modigliani's "psychological insight into character, . . . not the formal side of his art," and the portrait of Morgan Russell was a good example:

In this pallid face, Modigliani, fifteen years ago [*Modern Art* appeared in 1934], divined the ignominious destination of a promising American who remained in Paris. And through all his characters he revealed the disintegration of his own personality. . . .[1]

Modigliani did not know that he was painting a man whose art and spirit were in turmoil. He painted, as he always did, what he saw in the face of his subject, what he felt there, the mysterious communication be-

tween artist and subject. Craven, who read so much into the portrait, exemplified what Malraux calls the "crude determinism" with which paintings are often judged today: the approach which traces a direct connection between the artist's talent and the secrets of his private live. Craven ticks off Russell's "ignominious destination," about which he was wrong, *and* Modigliani's own personality disintegration in the same picture. This is too much—and inaccurate.

Outside of some commissioned portraits, Modi tended more and more to paint close friends and Jeanne. There was Jeanne in a turtle-neck sweater; Jeanne pensive in a white slip, showing unmistakable signs of pregnancy; Jeanne before a red door in red bodice, dark skirt, looking like a madonna; and a similar portrait of her in which ". . . he reproduces the movements of the Virgin's hands in Simone Martini's *Annunciation,* in the Uffiizi. . . ." Here he uses "a sinuous movement whose rhythm he merely reverses, making his sitter's left hand toy with the collar of her sweater just as the Virgin's right hand lightly clasps the border of her hood." [2]

He painted artist friends: exiled Polish friends of the Zborowskis—Baranowski, Wielhorski, and Dilewski; Hanka, severely beautiful; Zbo, gentle, staunch; and Lunia, always soft and wistfully lovely. And although his health was ruined and he was emotionally torn, gnawed ragged with despair, the pictures themselves make it ". . . self-evident . . . that the last years of the painter's life were marked by a serenity, a harmony, and a pensive, aristocratic detachment which affiliates these works to those of the more contemplative early Italian masters. . . ." [3]

André Malraux has an explanation for this. He thinks that when artists have felt death approaching they have been moved to make pictures which are like testaments. He gives as examples the last Renoirs (which the painter had been working on when Modigliani met him at Cagnes), the Crows of Van Gogh, the last Titians, Delacroix's last works —and he might well have included Modigliani's of 1918–1919.

The early works of an artist are only his starting point: he does not use them to perfect them but to confirm his personal system of relations, synthesizing the facts of visual experience that his genius substitutes for life itself. Genius is not perfected, it is deepened; it does not so much interpret the world as fertilize itself with it.

The artist's ambition is "to recapture and perpetuate a language whose beginnings were lost in the mists of time . . .":

In its service the artist took poverty for his bedfellow, and the usual tale of sacrifice went on, from Baudelaire to Verlaine, from Daumier to Modigliani, and how many others! Rarely can so many great artists have made so many sacrifices to an unknown god—unknown because

those who served him, though vividly conscious of his presence, could describe it only in their own language: painting. Even the artist most disdainful of the bourgeois (i.e. the unbeliever), when painting his most ambitious picture, felt qualms about employing the vocabulary which would have conveyed to others his ambition.

Yet it is the artist's faith that stakes a claim on eternity.

The outcast artist had taken his place in history; haunted henceforth by visions of his own absolute, while confronted by a culture growing ever less sure of itself, the modern painter came to find in his very ostracism the source of an amazing fertility. Thus, after having traced on the map of Paris, like wavering blood-trails, so many sad migrations from tenement to tenement, the inspiration issuing from these humble studios where Van Gogh and Gaugin met—flooded the world with a glory equaling Leonardo's.[4]

Every great painter knows that he is great. Cézanne and Van Gogh both did. And Modigliani never lost the conviction that his painting would be immortal.

Malraux knew Modigliani in the last year of his life when the artist was almost through leaving wavering blood-trails on the map of Paris. He recalls an occasion when the difficulty of pleasing a sitter was being discussed:

I remember hearing one of our great modern painters remark ironically to Modigliani: "You can paint a still life just as the fancy takes you, and your customer will be delighted; a landscape, and he'll be all over you; a nude—maybe he'll look a bit worried; his wife, you know . . . it's a toss-up how she'll take it. But when you paint his portrait, if you dare to tamper with his sacred phiz—well, he'll be jumping mad." Even among those who genuinely appreciate painting there are many who fail, until confronted with their own faces, to understand the curious alchemy of the painter, which makes their loss his gain. Every artist who acted thus was a modern in some sense: Rembrandt was the first great master whose sitters sometimes dreaded seeing their portraits. The only face to which a painter sometimes truckles is his own—and how queerly suggestive these self-portraits often are! [5]

Malraux, now French Minister for Cultural Affairs, says that the "great modern painter" talking to Modigliani was Georges Braque.[6] Malraux also says that his opinion of Modigliani's work at the time is of no interest whatsoever because he was too young. But he makes it clear that because Modigliani was a drunkard he does not admire him any the less. His opinion now is that Modigliani was the successor of Neroccio, one of

the important painters of Siena in the Quattrocento. Malraux's appraisal of Modigliani is as original as it is just.

Since the date 1919 has been affixed to the portraits of La Quique and are in *"le grand style"* of Modi's last years, it would seem that the "Place Ravignan business," about which he had written Zborowski from Nice, was settled at last. Presumably Zbo retrieved them from wherever they had been stored. They may well have suffered in their dark, damp exile, the canvases covered with grime and mold, their stretchers warped. Back in his own studio or at Zbo's apartment, Modi can have studied the pictures, remembered painting the big nude of Elvira sitting on a chair, her dress on her lap, her beautiful solid body, her calm repose, her lovely enigmatic face. He had to make her live again. It was not easy. La Quique had retreated deep into the spoiled and faded portraits painted in a style of six years earlier. Perhaps, under hashish, he summoned her back from the shadows, laughing, mocking, screaming obscenities. Elvira cooking Marseille bouillabaisse, Elvira drinking, taking dope, raging, pleading, making love. La Quique the enigma. When one portrait was redone, perhaps the others followed more easily. In any case, his nude of Elvira is one of Modigliani's most popular, most reproduced paintings.

Modi also wandered, returning again to Montmartre, perhaps to look up Maurice and to chat with Max Jacob. His old friends Suzanne Valadon and André Utter had bad news. Maurice, who had always painted as effortlessly as he breathed, had suddenly lost his touch. He had been painting Montmartre scenes from old postcards, as was his habit, but now he simply turned out larger postcards, lacking all his old brilliant inspiration. Suzanne was very worried that Maurice was losing the only thing he had in life. Painting had become so baffling and exhausting for him that she had talked him into committing himself voluntarily at Picpus.

Surely Modi was saddened by this news. He himself had changed. He was tired, pale, and coughing; he didn't look well, but there was no use advising him to take care of himself. Like Maurice, he seemed listless and without spirit, baffled and exhausted, too, but with life rather, not with painting as Maurice was.

With Max, except for brief flashes of his old charm, Modi was bitter and angry with everyone and everything. People were out to get him. They were conspiring to keep him unknown, to separate him from Jeanne and prevent his marrying her, the woman he loved. Max, shrewdly tactful and amiable, heard him out quietly.

Sometimes Modi looked more or less as always. It was only when he took the ever-present cigarette from his mouth or put down his glass to break into a fit of coughing, that Max suddenly noticed how ravaged he was. There was a disturbing listlessness about him, a slackening of inter-

est, a frightening sense of his letting go. Modi ought to take better care of himself, Max thought. Things were no longer the same as they had been. It was a better, more hopeful, more understanding world. Their art was being accepted and understood. Not his art! Modi snapped. *Merde!* People still wanted *their* paintings, not those the artist chose to give them. As for his health, he was all right.

Max Jacob loved Modigliani. Modi particularly endeared himself to Max ". . . by his exceptional understanding of (and memory for) French poetry." Max wrote of him afterward: "Your life of simple grandeur was lived by an aristocrat, and we loved you." [7]

During this period Modigliani visited Derain, who was always a friend and whose work he admired. Actually Modi had said as many nasty things about Derain as he had about Picasso. André Derain had painted in every style, followed every movement, but never slavishly, always in an original way. Nevertheless Modi, out of jealousy and spite, had sneered at him as "a manufacturer of masterpieces," a *"faiseur de beauté"* because his work seemed cerebral and contrived. "Derain did a drawing of him from which Modi later painted a full-sized portrait—a 'portrait of the artist,' after Derain. . . . This drawing of Derain's seems to be the only souvenir of Modi the family [Modigliani's] have in their possession." [8]

Modi, like most artists, did a number of self-portraits. It has already been noted that he did one of himself as Pierrot in 1915, when costume parties were popular, but apart from several sketch portraits, the self-portrait from Derain's drawing seems to be the only other one in oil in existence. This mirror-reversed self-portrait shows Modi sitting in a chair in his apartment, his paint-splattered easel in his right hand, his left resting on his knees, apparently holding a brush. He wears a full blue scarf knotted thickly at his neck and trailing down his back—possibly the one Zbo had brought back from London. He is also wearing his famous rust-colored corduroy coat and dark trousers. Behind him are the angle of the walls and a blank canvas. Modi is looking calmly and tranquilly to his right. The eyes are hooded, pupil-less, and dark.

Although some critics have professed to see in this picture the kind of horror, fateful self-destruction, and decay evident in the last stages of Oscar Wilde's *Dorian Gray*, the true impression is of peace and serenity:

Illness has consumed Modigliani's handsome face, and dimmed the melancholy of his burning gaze. This is not the face marred by drunkenness, but one that rested serenely in the peace Modigliani had found at last in Zborowski's friendship, in Jeanne Hébuterne's love. Modigliani is here one of the most moving figures in the *"comédie humaine"* created by his own vision.[9]

Modigliani's wanderings about Paris in these final months of his life, as nearly as they can be traced, seem like a pilgrimage to the past, way stops in a farewell tour of Paris and his life in it. Modi must often have had second thoughts about sculpture, bitterly regretting that he had been forced to abandon it. Perhaps, on his rare good days now, he thought of trying it again, toyed with the idea of getting the feel of hammer and chisel on stone. It may have been this that moved him to walk over to see his old friend Constantin Brancusi, who was older and shaggier, but otherwise unchanged. He certainly was not successful, nor did he seem to care. He did the kind of mannered sculpture that he wanted to do, had to do. He was cheerful, confident, working with all his old contemplative dedication. Modi did a drawing of a friend of Brancusi's, a young writer and fellow Rumanian named Konrad Bercovici, who had long black hair, a flowing mustache, and wore a wide-brimmed hat. The two men had presence, an aura of strength, the sense of being able to force their personalities on any world no matter how unwilling. Presumably, Modi gave the sketch to Bercovici. Recently exhibited in Boston and Los Angeles, the sketch has written on the back of its frame, "That is me, Konrad Bercovici, as seen by Modigliani in Brancusi's studio in 1919."

Jeanne and Modi's apartment was under the Ortiz de Zarates', but Ortiz's wife and Jeanne apparently saw each other rarely. The De Zarates had two children, Laure, now seven, and Julien, two, and had moved back to Paris in 1916 after a stay at Natigues, near Marseille. The family was hard up. Hedwige de Zarate had received a little money from home during 1915, but, as we know, Ortiz had lost his government grant from Chile after buying a Gauguin in Pont-Aven, Brittany. Ortiz had also tried to enlist. He was refused because of an "athletic heart," but was for a while put to work as a docker in Port-de-Bouc, near Marseille.

They lived very simply. Ortiz painted and Hedwige earned a little money doing decorative designs. Modi was not received in Ortiz's apartment, according to Laure de Zarate Lourie.[10] Mme. de Zarate was wary of Modi. She regarded him as a very handsome man, but sick and eccentric. But Modi did often stop in to visit at Ortiz's studio in the same building. Modi watched him paint, and often helped himself to some fruit from Ortiz's still lifes. Ortiz saw most of his café friends *au café* by preference. His wife knew the Zborowskis and spoke Polish with them. Mme. Zborowski was extraordinarily good-looking, and all her portraits look like her. The same was true of Germaine Survage, who for years looked as she did in her portraits. But then, says Laure, most of Modigliani's portraits have the same likeness to caricature that makes them profound studies of character.

Mrs. Lourie says that Ortiz's relations with his children were of the

kind you find in Spanish, French, and Italian families. The father does not confide in the children; he does not chat *avec les enfants,* so she knows little of what he may have said about Modi. Still, Mrs. Lourie does remember that Ortiz first admired Modi as a great sculptor and was sorry when he became mostly a painter. "But look at his drawings," he said once. "They are purely and primarily a sculptor's annotation."

Laure Lourie says De Zarate had a low opinion of Zborowski, with whom he had a contract. Ortiz felt that while Zbo did his best for his painters, it was hard to get money from him even when he made a "killing."

Zbo kept no books. He was, as we know, rather an inept businessman, given to taking crazy risks out of generosity, but he was a diligent salesman and dedicated to his brood. The charges that he lived extravagantly after becoming established are part of a myth that grew up around him, too. Zbo seemed to live high only by comparison with the days when he sold his shirt and scratched about Paris to keep Modi alive:

> To illustrate how a rumour, in danger of becoming a legend, can permeate everywhere, even Ortiz de Zarate, says Sandahl, had got hold of it. When on one occasion, Ortiz complained of the absence of buyers, Sandahl advised him to go and offer canvases to Zborowski.
>
> "Oh no," said Ortiz, "he won't buy my work. I'm not sick." [11]

Ortiz may have been somewhat resentful of Zbo's special efforts in behalf of the always ailing Modi and the "sick" Soutine. His daughter does feel that Modi drank too much, but, she points out, few people realize that well-to-do Europeans who guzzled fine wines at dinner actually consumed much more than the bohemians who sat around in the cafés.

Mme. de Zarate thought Modi rather a bad influence on Ortiz. Ortiz liked his company, however, and did take hashish with him. But Mrs. Lourie says that Ortiz felt it was not quite true that Modi was an unsuccessful painter. It seems that a friend of Ortiz's wife came to Paris especially to have her portrait painted by Modigliani. Ortiz arranged the sitting, and this elegant lady, the Baroness Van Muyden, stayed across the street in the little Hotel Liberia in order to have her portrait done in as short a time as possible.

Laure Lourie remembers her joy when, on the days there were no sittings, this beautiful Swiss woman took her in an open hack to the Tuileries Gardens where, up to that time, she had never so much as sailed a toy boat. She feels that Madame Van Muyden's husband (Georges) probably paid a fair price for the portrait since she was an intelligent and generous woman. The picture, *Portrait of Madame G. Van Muyden,* is dated 1917:

This is one of the most "Modiglianian" portraits in the sense that there is a hint of mannerism about it, of yielding to the exigencies of style. Claude Roy has excellently defined this type of more generic and less individualized portrait: "This model is usually sitting on a chair, in an attitude of vacant, melancholy grace, into which one is free to read either a *morbidezza* that is 100% Italian, or a vegetative indifference that is 100% modern, or a subdued and pensive sensuality." [12]

One gets the idea that, in this instance, Modi pleased the lady to please his friend rather than himself. Ortiz was always generous, shared everything with his friends, and helped Modi again and again. When he couldn't help him, he went out and begged others to, as he had with his barber who had bought Modi's paintings that Zborowski hadn't been able to sell. Very soon, Ortiz would again be helping Modi—and Jeanne —for the last time.

Maurice Utrillo was in a sanitarium. Chaim Soutine was alone and painting in Céret with the same methodical frenzy as in Paris. Some art historians say that Zborowski became Soutine's dealer only *after* Modigliani's death. This is not as documented, and leaves unexplained the fact that Zborowski had taken Soutine along on the expedition to Cagnes in 1918 and paid for his way, as well as for Soutine's trip to Céret. Until then he had represented Soutine in perhaps a halfhearted manner compared to his dauntless enthusiasm for Modigliani, but only because Hanka couldn't stand him. Now, although painting steadily, adding at least ten paintings a week to the unsold pile in Zbo's apartment, Chaim was lost, unhappy, and disenchanted with Paris. He was discouraged. He wanted Zbo to return all his paintings, intending to destroy them and start over.

Perhaps Modi and Zbo recalled how Soutine had liked Cagnes, the bright light and the good air. Céret, the little village in the eastern Pyrenees where Picasso had often spent his vacations before the war with Braque, Gris, Derain, and others, seemed a likely place. Financing Soutine was no problem. All he needed was painting material. He had none of Modi's mania for alcohol and women. Or so it might have been arranged. Monroe Wheeler, a biographer of Soutine writes: "In this year [1919] Zborowski, now developing a serious interest in him, proposed his going to a small town in the Pyrenees called Céret, where he stayed the greater part of the next three years." [13]

Modigliani's health was now in a decline, steadily deteriorating day by day. During the summer he seemed very tired, and coughed all the time, Lunia Czechowska writes. "I could do nothing for him since he had a wife. Zborowski saw things differently. My principles, not just bourgeois,

but of simple moral honesty regarding another woman held me back. I knew that Jeanne Hébuterne loved him and for me that was sacred." [14] These sentences contain far more meaning than the words express. It implies that Jeanne was not doing enough for Modi—at least not as much as Lunia could have done and would have if he hadn't had a "wife." The fact that Zborowski didn't share her views—that he felt she ought to do everything she could for Modi, irrespective of Jeanne—shows the lengths he was prepared to go to help his friend. Zbo seems to have urged Lunia to do whatever Modi wished: to give herself to him, to run off with him, *anything* that would force him to take care of his health. Lunia goes on to say that Modi also loved Jeanne, ". . . but, since I wouldn't be his, he couldn't stand my belonging to another man." When Modi became aware that she was going out with another man (who does not seem to have been her husband), he thought she was in love, says Lunia. He then criticized her so much that she began to feel guilty toward him. "I was to remain the spiritual friend," she continued, "such was my destiny. I was young and probably romantic. I had to abstract my feelings since another person needed me. I had no experience of life and acted by pure intuition. I forced myself not to fall in love with the man I had met. . . .[15]

The fall of 1919 was very sad because of Modi's condition and her own bad health, Lunia explains. Shortly after helping Modi move into his new studio, she had to leave Paris and recuperate in the Midi. Her friends—probably the Zborowskis and perhaps others—insisted that Modigliani go away with her and, Lunia adds, Modi himself wanted to:

> But Jeanne Hébuterne was expecting her second child and the idea of leaving Paris depressed her. She had sad memories of the time when Giovanna [little Jeanne] was born; and the idea of Modigliani going without her distressed her just as much.[16]

It is doubtful that Modi wanted to go off to the Midi with Lunia. He hadn't particularly liked being in Nice and had missed Paris all the time he was there. Besides, he had for some time been talking of going back to Italy. He also knew that his pursuit of Lunia was hopeless—if there had ever been anything more to it than male pride of conquest—and he must have been as certain that he would not regain his health in the Midi, in Leghorn, or anywhere else. As for Jeanne, leaving Paris was the last thing she wanted to do: her little daughter was boarding just outside Paris; she herself was heavy and awkward in the late months of pregnancy; she had managed a reconciliation of sorts with her parents, and there was Modi. Jeanne knew Lunia and she knew Modi. She and Modi were to stay in Paris.

Lunia says she left alone, promising Modi that she would see him again

soon. Her troubles seem to have been more emotional than physical. She went off to the Midi to recuperate, ultimately to Bourbon l'Archambault, a rural spa in the Allier region renowned for its curative waters. She was away from Paris ten months, and never saw Modi, her spiritual friend, again.

Time was catching up with Modi, not in years but in the abuses to which he had subjected his weakened and diseased body. He drank and drugged, and nothing stopped him. He loved his devoted Jeanne, adored his daughter, was grateful to good, loyal Zbo and to his wife, but they could not curb his habits. He was ". . . more emaciated, and feverish, and the consciousness of his failing strength exasperated him to further excess." [17]

As he roamed the streets at night, Jeanne went out looking for him and would argue, persuade, and struggle to get him home. Not that it wasn't an old and familiar story. One day Chana Orloff met Jeanne sitting on a bench on the Boulevard Raspail. Jeanne was pregnant and told Chana that she had to go to the police station every night, wait for Modi's release, and then urge him to go home with her.[18]

Goldring tells another story about Modi, who was sitting on the terrace of the Rotonde as Libion, the former owner of the café, happened along. Libion greeted Modi, joined him at his table, and ordered an apéritif for both of them. He asked Modi how things were going.

"Oh, I know I'm done!" said Modi, pounding his chest.

"Don't say that, my lad. Your year in the Midi must have done you some good."

"Oh, it's no use fooling oneself." Then Modi turned cheerful. "As soon as they wake up and know who I am, I'll go back to Italy with my kiddie and get cured. Only Mother knows what's good for me."

Zbo, as he continued to try to sell Modi's paintings, urged him "to go into a sanitarium, and even found a doctor to undertake to look after him in exchange for a picture or so. Modi would not listen." He only got angry and replied:

"Oh, leave me alone! I'm all right." [19]

Modigliani was selling, and his career took a promising turn just as he was becoming very ill in November, 1919. It was increasingly hard for him to work. Because of his condition, he got drunk more and more on less and less alcohol. Zborowski repeatedly advised him to rest in the Midi or to go to a sanitarium. But Modi wanted to walk the streets, thinking this would cure him. When Zbo remonstrated with him, he told Zbo to leave him alone.

Modi still went to the Zborowskis', attempting to work there as well as at home, but not often succeeding. Zbo could not help advising him to

see a doctor and, when he persisted, Modi "would go off in a temper and drink instead of working." [20]

The thought of returning to Leghorn must have preyed on his mind on into the winter of 1919. He even wrote to his mother about it:

DEAR *Maman,*

I am sending you a photograph. I regret not having any of my daughter. She is in the country with a nurse.

I'm thinking things over: maybe in the spring I'll take a trip to Italy. I'd like to go through a "period" there. But, all the same, I'm not sure.

I hope to see Sandro again.

It seems that Uberto [Mondolfi, who was to be mayor of Leghorn from 1920 to 1922] is taking the leap into politics. . . . I hope he goes right ahead. All my love.

DEDO [21]

It is plain from this that Modi was in such a troubled state that indecision plagued him. Perhaps to cheer him up, as well as to keep his name before the public, Zborowski entered some of Modi's paintings in the 1919 Salon d'Automne that was held in the Grand Palais from November 1 through December 12. Modi had little to do with entering his pictures; his address is given as 3 Rue Joseph-Bara. Zborowski's. There were four Modigliani oil portraits in the Salon, Nos. 1368 through 1371 and, respectively, *La Fille du Peuple, Portrait d'homme, Nue,* and *Portrait d'une jeune fille.* His work seems to have attracted as little attention as always, and, so far as can be learned, was not mentioned by any critic.

And Modi, only too well aware of his lack of recognition, was still terribly grateful for the least acknowledgment. Léon Indenbaum saw him at the Rotonde only a few months before Modi's death. When Modi spotted his old friend, he put his hand in his pocket and brought out "an English Jewish paper." He told Indenbaum to read it. Indenbaum says it was an article full of praise for Modigliani. *"C'est magnifique,"* he said to Indenbaum. Modi was so moved that he kissed the paper before putting it back in his pocket. [22]

Indenbaum felt the incident showed how badly Modi needed and wanted some encouragement, some comprehension. By contrast with this neglect, Indenbaum remembers Modigliani's funeral with its crowd of more than a thousand people . . . how onlookers, watching the long procession pass, wondered aloud who on earth they could be burying . . . and then the soaring prices after his death.

He recalled how he had heard a collector or dealer saying of

Kremegne, *"Il s'attarde,"* that he was sticking around a bit too long, that it was time he died; and another saying of artists that they should work like hell and die (*"crever"*). Indenbaum believes that Modi felt deeply what vultures the dealers were. In his slacking off, in his refusal to take care of himself, in his conviction that walking the streets would cure him, Modi gave every sign of being conscious that the dealers were saying of him, *"Il s'attarde."* If he was sticking around too long, then he would hasten his exit, since there was nothing else to be done. He had done what all good artists should do, worked like hell, and if dying had to come, then that was it.

*"Au fond Modigliani s'est suicidé,"* said Indenbaum. And if, when you came down to it, Modi *had* committed suicide, he knew perfectly well what he was worth. All along he was quite conscious of his own value. His suicide was probably deliberate, not unconscious. True, said Indenbaum, everyone was his friend, but his art was not recognized—the artist and not the art. Because of this, Indenbaum explains, there was a *"refoulement,"* a driving back, a pressure, an inhibition. The world did not want Modigliani. And Modigliani was too much for the world of his time.

# $\backsim\backsim\backsim$ Chapter Thirty-four

## Ave et Vale

Modigliani and Zborowski were both poets, though Zbo was the professional, but their love of poetry may have been their strongest bond as friends. Fritz Sandahl tells two stories about them as poets. Zbo went to visit Sandahl in what seemed "a particularly uplifted and poetic mood, as expressed in his eyes and manner." Sandahl, who was not a friend of Zbo's at the time, thought that business matters were worrying Zbo, who now "took a chair and absent-mindedly lighted a cigarette." Zbo gave Sandahl a queer look, took a notebook from his pocket, "and in a melodious voice recited with much enthusiasm a fairly long poem—or so it appeared to the victim." When Zbo finished, he looked up eagerly and asked Sandahl how he liked it. Sandahl told him he had no doubt it was very good, except that he didn't understand a word of Polish.

The other story put Modi in Zbo's position. It was late one night after the Rotonde had closed. Modi was outside the café with another man, ". . . a little Polish or Russian Jew, a poor, ill-clad devil who never spoke to anybody, yet whom everybody knew by sight, for he used to sit for hours, almost motionless, over a café-crème." With his big blue sketchbook in one hand and gesturing wildly with the other, Modi had jammed the little man against the railing of the Métro entrance, "while he declaimed, or rather howled, a poem he had written in Italian, to the unwilling auditor who, of course, did not understand a word." Sandahl observed it all as Modi yelled, "Livorno, cara Livorno" with enthusiasm.[1]

Five of Modigliani's poems have survived, the one in Italian and four in French. They were apparently found among Modi's papers after his

$\backsim$ 477

death and were experiments never intended for publication. But they have appeared in various magazines [2] since his death and are of great interest for the light they throw on other sides of Modigliani's personality.

The first is a nostalgic hymn in praise of Leghorn with a touch all his own:

> *rida e strida di rondini*
> *sul mediterraneo*
> *o livorno!*
> *questa corona di grida questa corona di strida*
> *io t'offro*
> *o poeta alla testa de capra*

> titter and chitter of swallows
> over the Mediterranean
> O Leghorn!
> this crown of cries this crown of shrieks
> I offer thee,
> poet of the goat-head

This poem could date back to Modi's last trip home in 1913. He had often watched the swallows, tittering and chittering as they swooped over the harbor. Perhaps he wrote it after he had thrown his unwanted statues into the canal. He was the poet of the goat-head, the cries and shrieks over the sacrifice of his statues, the goat-head's crown.

> *du haut de la montagne noire, le roi*
> *Celui qu'il élut pour régner, pour commander*
> *pleure les larmes de ceux qui n'ont pu rejoindre les étoiles*
> *et de la sombre couronne de nuages*
> *tombes des gouttes et des perles*
> *sur la chaleur excessive de la nuit.*

> from up on the black mountain, the king,
> the chosen to rule, to command
> weeps the tears of a man who could not reach the stars
> and from the dark crown of clouds
> fall drops, pearls
> on the extravagant night heat.

Into this somewhat mystical poem all sorts of psychological meanings may be read. Modi had often conceived of himself as a god or king, and here the king on top of the black mountain weeps the tears of a man unable to reach the stars. And from the dark crown of clouds there fell a benediction on the world of stress and strain, the world where this man

had struggled and failed. The same imagery and meaning are in the next poem:

| | |
|---|---|
| *évoque . . . vacarme* | Evoke . . . hubbub |
| *grand vacarme silencieux* | great silent hubbub |
| *dans le minuit de l'âme* | in the soul's midnight |
| *o cris silencieux!* | o silent cries! |
| *abois, appels, melodies* | bayings, calls, melodies |
| *très haut vers le soleil* | high, high toward the sun |

The silent hubbub is taking place in Modi's own soul's midnight. There is a yearning here as he hears cries coming from above, a sensual rhythm that tears him apart.

| | |
|---|---|
| *la déesse* | the goddess |
| *appels aux nomades* | calling all nomads |
| *a tous les nomades lointain* | calling all far-off nomads |
| *les clairons du silence* | bugles of silence |
| *barque de quiétude* | ship of tranquillity |
| *endors-moi* | lull me to sleep |
| *berce-moi* | rock me to sleep |
| *jusqu'à la nouvelle aurore* | until the new day breaks |

Modi was always a nomad in Paris. Now he calls out to all the nomads in an appeal for a state of grace, an end to the tumult, a yearning for serenity and peace in a new place in a new time. His last poem expresses the same feeling with more of a sense of mystical leave-taking, of a journey to the stars:

| | |
|---|---|
| *ave et vale* | hail and farewell |
| *reconnaissance* | recognition |

| | |
|---|---|
| *sourds drames nocturnes* | muffled nocturnal dramas |
| *et féeries nocturnes escarboucles* | and nocturnal ruby fairylands |
| | |
| *jusqu'à ce que jaillissent* | until there gush from |
| *en les féeriques palais érigés* | alert fairy palaces |
| | |
| *les avalanches de lumière* | avalanches of light |
| *en les féeriques palais érigés* | in alert fairy palaces |
| | |
| *sur des colonnes de lumière* | on pillars of light |

While the poem had special meaning for Modi, the title *hail and fare-well* and the symbols of darkness and light are life and death. They show a man who, if not wanting death, is prepared to meet it, perhaps even looking forward to the "nocturnal ruby fairylands" and the "avalanches of light" beyond. As a poet Modi was an amateur. His poems show no real literary talent, but there is sensitivity and they are moving with a tragic kind of beauty.

Modi "was a great poet only in his painting," but his poems, besides having "a certain psychological interest," reveal "something of the spiritual climate of his brief existence," according to Claude Roy. He points out that Modi belonged to those Italian intellectuals for whom "living was no simple matter." He had come to bright Paris from the twilight-land of pessimistic Italy, from a country

> Bathed in the light not so much of the Mediterranean sun as of the black sun of melancholy, and knowing by heart hundreds of lines of the greatest and most forlorn of Italian poets, Leopardi, Modigliani entered a world where, as in Italy, life was not taken lightly.[3]

But, as expressed in the heart of his poems, Roy makes clear that Modi sought a state of grace "not by way of drugs or the thrills of 'scarlet nights,' but in solitude and silence, in tranquil contemplation of a canvas or block of stone." For Modi the painter, just as for Baudelaire the poet, "only the creative act could lead the way to that total self-realization whose artificial surrogates they sought in drunkenness, in nocturnal adventure, in hashish, and excesses of all sorts." Modi reached beyond for the "true life," which Rimbaud referred to. Until then he asked for "bugles of silence, ships of tranquillity" to lull and rock him to sleep "until the new day breaks."

Two fragments of poems also exist. Both are short, to the point, autobiographical. Perhaps, because they tell the whole story, they should be regarded as finished:

| | |
|---|---|
| *Ma plus belle maîtresse* | My fairest mistress |
| *C'est la paresse . . .* | Is laziness . . . |

| | |
|---|---|
| *Il y a dans le corridor* | In the hallway |
| *Un homme qui m'en veut a mort . . .* | There's a man bearing me |
| | a deadly grudge . . . |

These fragments are not obscure compared to Modi's other poems. Modi had written Zborowski in one of his letters from Nice, "I've been taking it easy the last few days: fruitful laziness, that's real work." It was a theory he believed in, and now, hardly able to bring himself to paint, he liked to think about it.

With the "man" biding his time in the hallway, Modigliani seems to have seized on the idea that death could somehow be avoided out on the streets. Modi refused to stay home; he roamed and he roamed restlessly, relentlessly, desperately. Schaub-Koch writes of his walking the streets of Montmartre all night with a painter named Chigo, endlessly talking about the urgency of demolishing the Sacré-Cœur, whose architecture Modi abominated, as well as certain buildings on the Rue de l'Abreuvoir. Schaub-Koch feels that Modigliani hardly knew what he was saying, his imagination was boiling so.[4] But quite apart from his feverish excitement and his steadily weakening condition, it is possible to sense his terrible frustration and his fear: Jeanne and little Jeanne to care for; another baby expected soon; all the promises he had made to his mother; his artistic future still dark with a few glimmers of brightness on the horizon, and sure to brighten further, if Zborowski could be believed, if only he took care of himself and hung on. So Modi convinced himself that if he kept moving, kept talking, then "the man in the hallway" would vanish. . . . He would get well, go on painting, be recognized, successful *if* . . . Perhaps Modi really believed it.

Yet Modi knew that Death had been out there in the hallway waiting for a long time.

It cannot be said authoritatively, but some time after her return to Paris in late June of 1919, Jeanne seems to have tried for another reconciliation with her parents. She no doubt would have liked to have her mother near her again when her baby was born in late January or early February. Besides, she had something important to show the Hébuternes, something that might make for a change of heart. This was the witnessed statement written by Modi, pledging his intention to marry her as soon as he had the necessary documents. To the Hébuternes the situation was scandalous, an affront to all decent standards and to the church. But, since it was an accomplished fact and Jeanne would not be separated from this disgraceful Jewish artist by whom she had had one illegitimate child and was expecting another, marriage would smooth matters over a little. It would remedy nothing, nor would it condone their actions, but

it would at least honor their union in the eyes of the church and the law. It might also save a little face.

When Jeanne came back from Nice with the baby, Gabriel Fournier says there was a reconciliation with the Hébuternes—a reconciliation, he adds, which proved ephemeral.[5] The Hébuternes may have been unconvinced by the marriage pledge at the same time they badly wanted to believe in it. Nothing would ever change their opinion of Modigliani, but the document was at least a token of good intentions.

Perhaps Leopold and Hanka Zborowski used their good offices to influence the Hébuternes, or Jeanne's parish priest intervened. If this is what happened, and something of the sort did happen, then the jealous and suspicious Modi, fearful that the Hébuternes would try to break them up, must have agreed to the visits reluctantly.

And if seeing their daughter was an ordeal for the Hébuternes, how much more of an ordeal must it have been for Modigliani to let her go to them. The hinges of his life were his love for Jeanne and his work. But it was increasingly difficult for him to show his love; abuse and drinking came more easily. Jeanne could only endure as his temper worsened with his health until, sick with worry as he lost weight, coughed, and spat blood, she tried to take some kind of remedial steps only to face more vicious abuse. Now she kept her own counsel as she had all along. No suggestions that he see a doctor, no pleas, no appeals—Modi couldn't stomach them. How painful it was to see him deteriorating visibly, and do nothing. Besides worrying about Modi, she fretted about little Jeanne, the baby she was carrying and, most of all, she dreaded the future.

Seeing her parents, on top of all this, must have put an almost unbearable strain on so young a woman. All the time she was with the Hébuternes in the old apartment, she knew that Modi was waiting for her, choking on the bile of his wrath at the world, his twisted jealousy, and the disease that was slowly killing him. As she left her parents, sick and exhausted from the effort of being reasonable with unreasonable people, she had then to deal with Modi. André Salmon has written a presumably eyewitness account of a scene between them after one of these visits. He says, first, that Jeanne had a calming influence on Modi, that he drank less, took hashish rarely, and was in control of himself now. No more scenes in public, "and even his outbursts were beginning to be forgotten." [6]

Jeanne was almost always able to pacify Modi, "but only by sacrificing her own personality and merging it with his could she subdue him completely." Jeanne "innocently imagined that she had to take him or leave him, and that if she could not cherish and admire him as he was, she ran the risk of harming him . . . that if Modigliani were cured of his bad habits and his passions it would thwart his genius." Salmon adds that

Modi did his best "to control the worst elements of his nature in a sincere desire to please her, and to savor the undreamed-of-happiness which the gentle Jeanne had brought him." [7]

This casts the relationship between Jeanne and Modi in a rather romantic, soap-opera-ish light. It also makes Jeanne appear spineless and compliant. Jeanne certainly knew what she was doing when she committed herself to Modi. He was a god, father, brother, sweetheart, as Indenbaum put it. She was prepared to submit to his whims and accept his ways. Jeanne knew she had to in order for them to live together. Her idea was not to reform him, as many of Modi's friends had hoped Jeanne would do. She simply wished to share his life, make and keep him happy if she could, do whatever she had to do. As for harming him by changing him, thwarting Modi's genius by curing his bad habits and passions—this is on a level with Salmon's theory that Modi's taking hashish was responsible for his genius. It was not.

The artist Simon Mondzain (the subject of a sketch at the Restaurant Baty that Modi inscribed *"à ce cochon de Mondzain"* [8]) often saw Jeanne and Modi walking across Paris, according to Salmon, "truly romantic lovers, arm in arm and pressed close together." He used to come on them at nightfall as they roamed from "the Lion de Belfort in Montparnasse to the Observatory" or the Place de l'Observatoire. Along here they would sit "at the foot of the Admiral Courbet monument" to talk intimately as lovers do. Then they would hold hands and indulge in a farewell kiss before Jeanne left to visit her parents.

Salmon tells how he came on them one evening as he was going home. What attracted his attention was hearing "a snarl suggesting a demon in torment in front of me." It came from Modi. He and Jeanne "were walking slowly along by the high iron railing that encloses the Luxembourg Gardens." Salmon surmises that Jeanne had just returned from seeing her parents, joining Modi in "the café in the Latin Quarter exactly on time, just as she had promised." (How Salmon should know this is hard to say.) But Modi was in a vile and bitter mood partly because of alcohol, and "The scene that followed was appalling."

After hearing the infuriated, snarling voice, he saw the drunken Modi attack Jeanne, an unresisting Jeanne, silent as a figure in the "muffled nocturnal dramas" of Modi's *ave et vale*. Shaking and spluttering with rage, Modi cursed and struck Jeanne, snatched her thin wrist, yanked her by the arm, ". . . dragged her along by the hair, letting go only to fling her against the iron railing of the Gardens." Salmon did not know what to do, did not think it his place to interfere, to save the couple from each other. Not coming close enough to be recognized, he cried out:

"Modigliani! That's enough!"

Salmon says that Modi let go of Jeanne, but did not turn toward him.

Modi looked straight in front of him before breaking into a run to over-take Jeanne, who had suddenly broken away from him. She was not flee-ing from Modi, but from pure fear. "She was frightened by the hordes of rats which at that hour of the night emerged from the sewers and ran about under the feet of pedestrians going along that part of the Boule-vard Saint-Michel." Salmon thinks that Jeanne got over her fear by the time Modi overtook her and grabbed her pigtails again, "the plaited tresses of a Christian martyr or a princess of dreams." Then "The couple vanished into the night, just as Modigliani had so often vanished into the night when alone." [9]

What they said when they were together was their own affair, says Claude Roy, "but Jeanne still looks out at us from those portraits whose tranquil air" is so startling when one remembers how seriously ill Modi was, how he drank and flew into black rages. But, says Roy, he was "never in a rage when he stood before his canvas and gave the portraits of his 'very gentle lady' all the loving, clear-eyed attention of which he was capable." And Jeanne surely loved Modi "because . . . Modi with all his faults was lovable." He concludes:

> Nothing matters today but those immortal portraits: that gentle drooping head and flowerlike face whose outline Jeanne's lover traced ever and again, unfaltering, with loving care.[10]

Jeanne Modigliani resents the inaccuracy of the "legend [that] has turned Jeanne Hébuterne into a sweet, humble, submissive creature." [11] She had talent, and her friends considered her to be serious and intelli-gent and to have a strong personality, not the weak one Salmon at-tributes to her. Jeanne was human and had the spirit of any young woman her age. While she probably took more than her share of abuse —because Modi was the man he was and there was only one way to live with him—she also fought hard for a rapprochement with her family and her church affiliation. Both mattered to Jeanne. And with some conces-sions, she apparently won on both counts. She and Modi argued as mar-ried couples do, Jeanne usually giving in because she loved Modi. Proof that Jeanne could more than hold her own with Modi very likely exists in some wry verses that Modi scribbled on a drawing of his friend Fabiano de Castro. It is attributed to 1918 as it appears in Raffaello Franchi's book,[12] but it could just as well have been done in 1919. The verse reads:

| | |
|---|---|
| *un chat se gratte la tête* | a cat scratches his head |
| *comme un poète* | like a poet |

| | |
|---|---|
| *qui cherche une rime* | searching for a rime |
| *ma femme* | my wife |
| *pour un prêtre* | for a priest |
| *me jette un verre à la tête* | throws a glass at my head |

As of November and December, Modi "was obviously in a bad way" frequently breaking into coughing fits that developed into hemorrhages from the mouth. He grew weaker, but furiously denied that anything was wrong with him, even when the little painting he did exhausted him and "he had to rest for days on end." Again and again Zbo, Hanka, and others pleaded with him to leave Paris, go to a sanitarium, or at least see a doctor for treatment. "All their fond arguments were in vain." Modi consistently refused; he was irritated and exasperated by their suggestions.

"Let me alone!" he lashed out. "I'm all right." [13]

Jeanne's inability to persuade or force her husband to go to a doctor must have been incomprehensible to the Zborowskis and to Modi's friends. And it must have been intolerable to Zbo to stand by helpless. Modigliani *was* being recognized. Success had been 'way out of sight before; now it was on the horizon, quiet but growing tangible. If only Modi could be patient and reasonable, as Jeanne cared for him and Zbo furthered his career. But Zbo, good man that he was, had yet to learn to accept the impossible as impossible. One went along, did nothing, submitted to the agony of submitting as Jesus did on the Cross.

Renoir died on December 17 at seventy-eight, painting to the very end. The newspapers carried long, laudatory obituaries about him. Modi remembered meeting Renoir at his house in Cagnes, perhaps with shame. Zbo had greatly admired Renoir and his work, nor could he forget how the old man had indirectly helped Modi by letting Zbo sell some of his paintings. Helpless and crippled as he was, Renoir was painting a still life of anemones on the last day of his life. And his last words, according to two members of his household, concerned painting, to which he had devoted a lifetime. "I think I am beginning to understand something about it," Grand'Louise the cook thought she heard him say. His nurse thought it was, "Today I learned something." [14]

Although he felt life slipping from him, or, more properly, himself slipping from life, Modi had moments when he rallied and seemed to convince himself that he would be all right. Chantal Quenneville, a friend of Jeanne's, remembered meeting him during the Christmas holidays, and was startled to see him help himself twice to sandwiches at a little all-night café on the Boulevard de Vaugirard near Marie Wassilieff's studio. "Overeating—that's the only thing that can save me," he

told her. Chantal had posed for him at the Closerie des Lilas, but this was the first time Modi had spoken to her of his health. She says that Modi accompanied her to the dark steps by Marie Wassilieff's door, gave her a bunch of violets, and left. To this, Jeanne Modigliani adds that since Modi never liked to speak of his tuberculosis, this has created that part of the legend which tells of his romantic death from "starvation, alcohol and God knows what metaphysical torment." [15] The fact remains that, although not the actual cause of death, they were vital accessories to it.

Fritz Sandahl last saw Modi toward the end of December, 1919. He had changed greatly from the Modi that Sandahl had first met at the Closerie des Lilas in 1911 when Sandahl and a friend came to hear Paul Fort, the Prince of Poets, recite. "Sandahl was struck by the vigour of his [Modi's] speech, his air of mocking confidence, and the fact that he was very handsome, sprightly, and carefully dressed."

Now Modi "looked melancholy and worn out," although he was perfectly sober—which Sandahl found most unusual. Modi was staring up at an advertising poster with a big bright colored drawing.

"Yes, that's not bad, is it? They're beginning to get the idea."

It was a typical Modigliani conceit, but Sandahl thought him right. The drawing on the advertisement was reminiscent of Modi's work "in the elongation of the neck and the treatment of the face." Sandahl didn't know whether it was conscious imitation or chance on the part of the commercial artist. Then Modi said:

"Paris is so gray and sad and I'm so fed up with everything. Ah! I hope soon to get back to dear Italy and the sunshine." [16]

Shortly after Christmas Day Modi received his last communication from his mother, a postcard dated December 27:

I hope my very dear Dedo that this arrives just on the first morning of the year, as if it were a sweet kiss from your old mother, bringing with it every blessing and every possible good wish. If there is such a thing as telepathy, you will feel me near you and yours.

a thousand kisses,

MAMAN [17]

Perhaps Modi showed the card to Jeanne and spoke warmly of going to Italy in the spring after the baby was born and he felt better. And Jeanne, who must have gone to church Christmas Day and prayed, may well have nodded in agreement and prayed silently again. In a sense Modi did have every blessing and every possible good wish from those who loved him. And the year to come could have been the most rewarding of his career, as Zbo kept telling him it would be. But Modi was immune to hope: because he was so close to not feeling anything.

Another letter must have reached him about the same time. It was dated December 31 and is now owned by Jeanne Modigliani, who finds it "touching in its disinterested humility":

DEAREST FRIEND

My tenderest thoughts turn to you on the occasion of this new year, which I so much hope will be one of moral reconciliation for us. I put aside all sentimentality and ask for only one thing, which you will not refuse me since you are intelligent and not a coward: that is a reconciliation which will permit me to see you from time to time. I swear to you on the head of my son, who for me is *everything*, that no evil thought crosses my mind. No—but I loved you too much and suffer so much that I ask this as a final plea.

I will be very strong. You know my present situation: materially I lack for nothing, mostly earning my own living.

My health is very bad, the pulmonary tuberculosis is sadly doing its work . . . Some good moments—some bad—

But I can't go on any longer—I would just like a little less hatred from you. I beg you to think well of me. Console me a little, I am too unhappy, and I ask for a little bit of affection that would do me so much good.

I swear to you that I have no ulterior motives.

I have for you all the tenderness that I must have for you.[18]

It was written in a stylishly neat and flowing hand and signed *Simone Thiroux.*

It was this letter of Simone's that to Dr. and Mrs. Dyre Diriks was the strong and moving piece of evidence that proved Modigliani *was* the child's father—that and the little boy's *"tête de cherubin,"* or angel-face. At the time of her letter, Simone's son was about two years and seven months old. The child had probably been christened Serge Gérard. Marguerite Diriks was his godmother, and another friend of Simone's, André Delhay, a parliamentary journalist, was his godfather. The christening party was given by Mrs. Diriks in a room on the first floor of the Closerie des Lilas, on the same day that Jeanne Hèbuterne's little Jeanne was born at the Saint-Roch Hospital in Nice.[19]

Mrs. Diriks had very little to do with Simone's child, saw him several times, and recalls him as a charming and beautiful little boy. Simone was a poor mother: Mrs. Diriks had to remind her to wash the baby and change his diaper in the early days. After Mrs. Diriks it was Camilla Sandahl who had taken over from the helpless Simone and arranged for the baby to be sent to a wet nurse in the country. Fernande Barrey, Foujita's wife at the time, also befriended Simone and looked after her energetically. By 1962, however, Fernande had forgotten Simone's name; she

thought it was Germaine, that she had died in 1919, and that the baby was called Zaza.[20]

It was through Fernande that Simone met Taya, the sculptress, who was then married to the Vicomte Lascano Tegui. Simone, a good musician, used to go to their place on the Rue Boissonade to play the piano, "finding in music, as she said, some compensation for life's cruelty." Simone, as time went on, could no longer pay the cost of the wet nurse and had to bring the little boy back to Paris. She brought him to Taya's studio, where the sculptress and her mother gladly looked after him "until Simone could decide what was to be done." Taya so liked the child that she took him along to Rosay-par-Septeuil for a long visit. She would have liked to adopt Serge Gérard, but family and financial reasons prevented it. He was an unusual little boy, extraordinarily musical for his age. Taya long remembered his strong little voice as he sang familiar nursery rhymes like *Frère Jacques*.[21]

Serge Gérard was not to be adopted and find a permanent home until after his mother's death. Up to this time, abandoned by her family, turned out by her aunt in Paris, Simone struggled to support herself and the boy as an assistant nurse or aide in the Cochin Hospital. She lived at 207 Boulevard Raspail in the same building as the Diriks, and neglected her health as Modigliani did. Like him she would neither listen to advice nor take care of herself.

Modigliani, failing rapidly as he was, somehow was still capable of extraordinary gestures that must have put a tremendous strain on his remaining strength. Paulette Jourdain vividly recalled how, on New Year's day, 1920, Modi came into the Zborowskis' apartment at seven o'clock in the morning. He had apparently been out partying all night, then remembered his good friends because he was carrying "a huge bunch of flowers." Modi was also "so drunk that he could hardly stand up, and had to be piloted to a divan to sleep it off." It was Modi at his foolish worst and endearing best. The wonder was that he could get about at all. ". . . It was astonishing how he kept up physically, in appearance, considering the amount he drank and drugged," Paulette said.[22]

Nevertheless he had become so sick and weak that he seemed barely able to move about. "He was ordered to stop in bed and rest . . . ," Goldring says, but does not say who did the ordering. It was not a doctor, since he refused to see one, and it was not Jeanne. Perhaps it was Ortiz de Zarate, who lived upstairs. But Modi would not stay in his studio nor at the Zborowskis'. He wandered the streets interminably, as Schaub-Koch said, as if he could walk off his illness. ". . . Visiting all the bistros, drinking more desperately than ever . . . he seemed like a haunted

beast, endeavoring to avoid a fate that he was persuaded he could not escape." [23]

And Jeanne went looking for him as always. Mrs. Diriks saw her trying to make him leave the Closerie des Lilas, dragging at his coat collar. Jeanne pleaded with him. Blind drunk, Modi tore himself free brutally, "muttering his eternal: 'Oh, leave me alone! I'm all right!'" Zbo continued to protest and to insist that he see a doctor, but Modi refused. He shook Zbo with a sneering laugh, "Oh, leave me alone! In the spring we'll go to Italy and Mama will look after us, and then I'll get all right and paint again. You'll see."

He did not look up his old friend Dr. Alexandre, nor Dr. Devraigne, either of whom might have helped him. Jeanne's time was not far off; it is conceivable that she had consulted Dr. Devraigne. But Modi was beyond help. There was no escaping the man in the hallway.

He went on one last binge with Maurice Utrillo. This must have been when he was confined to his room. Modi was furious to find himself jailed. He had been forbidden to drink, and there wasn't a full bottle in the room. He shook the doorknob, pounded on the wall, shouted and cursed. Moving angrily to the window, he suddenly smiled as he caught sight of the rope ladder fire escape. He flung it out the window, swung himself over the sill, and descended to the street.

After a few drinks at the nearest bar, he went on to another, where he let out a whoop of joy. There was Maurice!

John Storm reconstructed the incident: it seems that Utrillo, who had voluntarily committed himself to the institution at Picpus, had just escaped from it. Very shrewdly, "instead of going back to the Butte, where he knew the authorities would be sure to find him, he made for Montparnasse." Perhaps he had hoped to run into Modi, which was just what had happened. Now they drank, talked, and then went over to Rosalie's, where they bummed a meal. Without any money for drinks, they knew what to do. Modi took Maurice back to his own studio where by that time Jeanne was probably so glad to see him that she said nothing.

Borrowing materials from Modi, Maurice proceeded to paint "a couple of Montmartre street scenes from memory." Leaving Maurice with Jeanne, Modi took the wet canvases over to Zborowski's. Zbo, generous and gullible and anxious to please Modi, bought the canvases, innocently thinking that the money was to help Maurice. Now Modi and Maurice toured the bars of Montparnasse as they had those of Montmartre in the old days. ". . . A wild binge," says Storm, and "What money they did not drink up was folded into paper airplanes and sent gliding into the trees along the Boulevard Raspail." In time they staggered back to the apartment on the Rue de la Grande-Chaumiére to collapse in sleep.

Maurice, who like Modi was a man of incredible resourcefulness, was not one to let go of a good thing. He was not in the apartment when Modi awoke the next day—nor were Modi's clothes. Jeanne, nine months pregnant, saddled with two drunks, knowing her husband was dying and deliberately hastening his death by drinking bouts, apparently said little. The door of the apartment banged open and in came Maurice smiling drunk with bottles of wine in his arm. He had pawned Modi's clothes to manage it. "Now their drinking could go on!"

Chaim Soutine happened to drop by Modi's apartment "at the tail end of the ensuing drinking bout," Storm says. The wine was gone, but there was a way to get more. Turnabout! that was the answer. Modi asked Utrillo to take off *his* clothes, told Soutine to hurry over to the pawnshop, hock them, and come back with more wine. Storm has it that "Soutine informed Zborowski of what was going on." [24] He probably did, but not before Jeanne had caught him at the door and whispered that he must go to Zbo right away and tell him everything.

Zborowski, knowing he had been tricked, was very familiar with the shop where Maurice had pawned his clothes, went to it, reclaimed them, and ran to Modi's apartment. Modi was talked into going back to bed; Maurice was taken away to a hotel. This was the last time the two friends saw each other, Modi dying ". . . a few weeks later."

Some stories say that the sympathetic Zbo kept Maurice hidden from the asylum authorities in an obscure hotel. Supplied with food, canvas, and paints, Maurice is supposed to have remained under Zbo's care for several months. But finally he got drunk and abusive in public, and was arrested and sent back to Picpus.

Louis Latourettes, who had seen Modi at many stages of his career in Paris, made comments on it that sound like those of a Greek chorus on the fall of a tragic character. Modi had seemed sad to Latourettes the last time he had seen him in Montparnasse—at the Rotonde, Rosalie's, and a local bookstore. He had asked bitingly for news of his old friends and had complained of the builders who were encroaching on the Rue de l'Abreuvoir and certain corners of the Rue Lamarck that he held dear. Latourettes thought he looked haggard.

"Salute on my part the cherry tree on top of the Rue Lepic," he had said. "Say that I could never get to eat its fruit. The kids of the Rue Norvins always beat me to it before the cherries ripened."

Latourettes met him again at the Closerie des Lilas in early January (1920) looking feverish, pale, and emaciated. He had been drinking heavily, "a pile of saucers registering the numerous drinks he had already consumed." Latourettes, who was a financial reporter, apparently asked him how things were going, having heard that Zborowski was selling his work.

"Oh, yes, I've made some money! But, look, since you're in finance and we've had bankers in the family, you should consider me a colleague and give me tips to make more."

Latourettes thought he looked "like a corpse," and was horrified.

"You're not looking well, old man," he said.

"Oh, I'm all right. Maybe I ought to try an altitude cure—on the Butte! And I'd like to see some of the old places again. Say 'good-bye' to the cherry tree. You remember it? We'll dine at Labille's one of these days and I'll settle a long-standing debt." [25]

Latourettes tried to cheer him up, but Modi persisted in wallowing in the macabre, which was hardly surprising, for Modi was beyond cheering up.

Marie Wassilieff met Modi on the street not long before his death. "I couldn't believe the change in him. He had lost his teeth; his hair was flat, straight, he had lost all his beauty. 'I'm for it, Marie,' he said." [26]

Modi went back to the Butte just once more, according to André Utter. It was late one night. Suzanne Valadon, Utter, and some friends were having dinner at Guerin's, a restaurant nearby their place, as Modi joined them. He wasn't drunk, but he had been drinking. He had to sit next to Suzanne Valadon, insisted on it,

> making another guest give up his place to please him. He greeted her more affectionately than usual, and informed the whole restaurant that Valadon was the only woman who understood him, because she had had such a lot of trouble with Utrillo. "Only she can pardon such as I," he cried, which raised some uncertain laughs, for everybody felt uncomfortable.[27]

Then Modi subsided, saying not a word, which was unusual for him, "letting others talk and staring drearily at nothing, still huddling close to Valadon like a child who was afraid of the dark." He had a few drinks, then began to sing a mournful Jewish dirge, which Goldring calls the "Lamento" and Jeanne Modigliani says was "probably the Kaddish, the prayer for the dead, which was the only one known to the unbelieving Modigliani." [28] The *Kaddish* goes "Yis-gad-dal v'yis-kad-dash sh'neh rab-bo . . ." or "Extolled and hallowed be the name of God throughout the world which He has created . . ." Modi had probably chanted it with the congregation in Leghorn. It had remained imprinted in his mind. The others found it painful to listen to as Modi "finished the lament sobbing on Valadon's shoulder."

They "tried to buck him up and make him laugh." This was a party. Everybody must be gay. They joked, sang the songs he liked best. Modi would not be comforted, nor would he explain what was depressing him:

He pleaded for more to drink, sang more dismal chants, and cried. Valadon wanted him to sleep in the adjacent studio in the Rue Cortot, but he wouldn't listen. Others offered to take him back to Montparnasse in a car. No, nothing would console him. Finally he left them and stumbled off into the night, singing and weeping.[29]

∽∽∽ Chapter Thirty-five

*"Poor Amedeo, he would go and die like a dog!"*

Some of his friends thought Modi had prophetic powers. The fact that Modigliani sought out Suzanne Valadon in Montmartre, chanted the prayer for the dead, sobbed and acted so strangely seemed a premonition of his death. Chana Orloff, the sculptress, wondered if "he had foreknowledge that his life was to be brief." Modi had written the number 12 on a drawing of her husband and "her husband died on the 12th." [1]

Modi had often scribbled on his drawing the prophecies of Nostradamus, the astrologer, whom he greatly admired. Toward the end of his life, he felt persecuted and seemed to be convinced that a plot was responsible for his failures, his lack of success. Life and people had conspired against him, he maintained. He also felt that he could predict the future as Nostradamus had. During the war years, Modi had assured his Russian friend Ilya Ehrenburg that Nostradamus's prophecies had predicted the French Revolution, the rise and fall of Napoleon, the end of papal rule in Italy, as well as Italy's unification. Modi quoted some of Nostradamus's as yet unfulfilled prophecies, one of which could be taken as foretelling the rise of Hitler, the Nazi dictatorship, and the massacre of the Jews. [2]

Although Modi seemed to be telling Latourettes, Marie Wassilieff, and others that he was dying, many of his friends did not seem to understand. Modi, more than once, had been seriously ill, coughed blood and collapsed, only to recover again. In 1913, before going home sick, he had sat in the Rotonde, coughed, pounded his chest, and exclaimed, "Oh, I know I'm done!" They believed it, and they didn't believe it. They had been

through it all before, and Modi had survived, gone on painting, drinking, drugging, wenching.

Ossip Zadkine was discharged from service in December, 1917. He saw Modi at the Rotonde, "thin and wasted away, unable to drink much, becoming drunk on one glass of wine, but always sitting at a table with friends, always drawing. Sometimes in a hoarse voice, breathing with difficulty, he sang. He sang incomprehensible words in which there was no music. But that didn't matter to him, he continued the song which made him gasp brokenly inside." [3]

Modi's friends had "taken care of" Modigliani at this time, and Zadkine thought Modi saw through their many ruses to help him "but he said nothing." For then he loved Jeanne Hébuterne, "his friend who was then his only friend. A real person for she was good and had a beautiful soul." But the company of a beautiful soul cannot keep a man from dying.

Three weeks before his death, Modi had a "sudden desire to go see the child where she was at nurse in the country." Goldring believes he knew his end was approaching. "Up till then he had been satisfied with the reports of Jeanne, who visited her baby every week." [4] It took strength of character for Jeanne to visit her daughter alone. It took stamina as well as strength of character to call on her parents by herself. Moving about was awkward in the ninth month of her pregnancy. Seeing little Jeanne at the nursing home could only have made Jeanne more aware than ever how unable she was to look after her child and to wonder how she could possibly manage when the second arrived. Nothing would change. Certainly not her beloved Modi. And each time she saw her parents, she realized the hopelessness of a true reconciliation. They would not change, either.

We know that Modigliani did visit his child alone from a few lines in a letter Zborowski wrote Emanuele after Modi's death. "Three weeks before his death, is if he saw the end coming, Modigliani got up at seven o'clock in the morning—something very unusual for him—and went to see his daughter. He came back very happy." [5] One wonders what he did when he saw his daughter.

"Only a month ago," Zborowski wrote to Emanuele, "Amédée was very anxious to leave for Italy with his wife and child. He waited only that his wife give birth to the baby, which he planned to leave in France with the nurse who is now looking after his little daughter Giovanna." Modi's health, which was always bad, Zbo explained, had come to be a cause of great worry. Zbo had repeatedly advised him to go to a sanitarium in Switzerland, but to no avail. If Zbo said, "Your health is bad, go take care of it," Modi looked on him as an enemy. His reply was al-

ways, "Don't lecture me." Poor Zbo. Modi's enemy was not life, death, fate, or people, but himself.

Léon Indenbaum remembers having seen Modigliani two days before his death, but this is not possible because—according to the account Zbo sent to Emanuele—Modi was unconscious at the time. Perhaps it was two weeks or ten days, certainly after he had gone to see his daughter in the country. It was winter, and Indenbaum, who was working with the sculptor Emile-Antoine Bourdelle, was on his way to the academy at eight o'clock in the morning. He heard someone behind him with a terrible cough and recognized Modi, who, again, was up extraordinarily early for him or had perhaps been tramping the streets all night.

Seeing Indenbaum, Modi flung his arms wide and opened his mouth in an expression of surprised pleasure, as he always did when he met someone he knew. Then he shook hands warmly and exchanged *"Bonjours."* Modi, Indenbaum recalls, was very pale, very *"défait,"* emaciated, and *"méconnaissable,"* unrecognizable. He had lost his voice and spoke strangely.

*"Je pars en Italie,"* he said. *"Il me faut du soleil; il fait trop gris ici."* [6]

He had said much the same thing to Fritz Sandahl. He was leaving for Italy. He needed sunlight. Everything was too gray here.[7] Indenbaum feels that Modigliani died in complete *"déchéance,"* destitution. Nobody took care of him any more. *"Zborowski n'était plus là . . ."* But Indenbaum did not say what he meant by Zborowski's "no longer being around." It may have seemed that Zbo had abandoned Modi, but that was not so: Zbo could do nothing for him; no one could. Indenbaum thought Modi was in great *"dénuement,"* utter poverty. He said that people who now call themselves his great friends turned away when they saw him. True, Indenbaum admits, it took a strong character to be able to be a friend of Modi because he was difficult, and yet . . . In any case, he vividly remembers Modi's terrible appearance.

The last outing soon followed. It was bitter cold in Paris that January of 1920, the coldest winter in many years, bone-chilling and windy. Most people were sensible enough to stay home if they could. Not Modigliani. He was looking for something, something he thought he could find outdoors on the streets. Jeanne had probably pleaded with him to stay in the drafty, poorly heated studio, which at least was bearable compared to the chill outside. But he would not listen. He was all right. He wanted to be left alone. Jeanne didn't argue. She was tired, her feet swollen, and she didn't feel well. The baby was kicking inside her.

Shaken by a racking cough, Modi hesitated in the Rue de la Grande-Chaumière as the icy wind clawed at him and an icier rain beat into his face. Modi carried his overcoat, which Jeanne must have forced on him,

and his corduroys soaked up water like a sponge as he fought his was to Rosalie's, then rolled on from one bar to the next. He stopped at the Rotonde last, "very drunk, his eyes . . . wild, and . . . in one of his worst cantankerous moods, quarrelsome, abusive, and terribly emaciated." [8] Now some artists, the Vicomte de Lascano Tegui among them, were leaving on an errand across town. It was dark, late, the frigid wind blowing a tempest, driving the rain before it. The artists were going to see a man named Benito, a draughtsman, whose place was on the Rue de la Tombe-Issoire near the Rue d'Alésia, a long way from the Rotonde.

It was plain to the artists, all of whom knew Modi, that he was in such a state that he had to be taken home. They argued with him, offered to accompany him, but Modi refused. They went outside; Modi followed them. Another argument. No! He would not go back to Jeanne and he would not accompany them. The rain had drenched him, was still drenching him, but he would not put on his overcoat, which was "trailing behind him like the skin of a slain animal." The artists shrugged and started off, Modi following some distance behind.

He muttered and shouted to himself, "attracting the attentions of passersby, as it was already late, to another drunken, mad artist." It was hard to tell whether he was wild and hallucinated with drink, drugs, or fever or all three. Certainly he was a very sick man. When he reached the huge, thirty-six-foot-high Lion of Belfort monument of Frédéric-Auguste Bartholdi, Modi evidently imagined it ". . . some dreadful monster, for he yelled insults and challenges at it." Now and then Lascano, or one of the others, dropped back ". . . and tried to reason with Modi, but only met with abuse." In his fever and delirium, it is doubtful that he even recognized them.

After some time they reached Benito's door, waited for Modi to catch up, and tried again to talk sense to him. More arguments and abuse. Now they collared him. He must either come inside out of the cold with them or be good, put on his coat and go home. Modi fought his captors with all his strength, biting, kicking, scratching. There was nothing to be done, so they left him outside on the sidewalk. Their session with Benito lasted until after midnight. Modi was still there when they came out, but a policeman, suspicious of his wild antics, was on the point of arresting him. Lascano and his friends pleaded with the officer, who finally relented. "Modi consented at last to accompany them." The trip back was even more agonizing than the trip to Benito's had been.

Modi acted up the whole time: he shouted, cursed, swore, vilified. The foam on his mouth made Lascano think he was having delirium tremens:

> He wanted to "get" everybody. He had no friends; never had had any; they were all traitors, mountebanks, and far worse. He wanted

them all to sit in the cold and wet on a seat on the boulevard, raving that it was the quay of some imaginary, miraculous sea. Nothing would shift him.[9]

Struggling and shouting, he then insisted on sitting on a bench near the gates of L'Eglise de Montrouge, the church on the Rue d'Alésia ". . . where, before his feverish eyes, passed wild figures of Soutine, sombre streets of Utrillo, fantastic policemen in white gloves and blue capes coming to arrest him." Presumably the others went on, but Lascano stayed close, afraid to leave Modi, yet not knowing what to do next. As he waited, a woman came out of the darkness and sat next to Modi on the bench—a prostitute, looking like a Félicien Rops (1833–1898) etching of *Mors Syphilitica,* with two sunflowers on her temples, and clothes by Toulouse-Lautrec.

Modi began "babbling to her about a phantom boat." This and the reference to Modi's raving that his cold wet seat on the boulevard "was the quay of some imaginary miraculous sea" leads one to think that he was having a vision of the harbor of Leghorn, where he had been longing to go. And just before he collapsed he saw himself in a boat going there. A taxi, presumably summoned by his friends, took him back to Jeanne Hébuterne.[10]

After this episode, in which he may have caught pneumonia, "Modi did consent to stop in bed and be nursed by the harassed young Jeanne, but he still violently opposed anybody who wanted to bring medical aid or to persuade him to go to a clinic." [11] It was not hatred of doctors that made him refuse to see them, but childish fears. He had been sick for the first seventeen or eighteen years of his life; doctors had attended him constantly. He had languished home in bed and in hospitals for weeks on end. He knew what the doctors would say and he did not want to hear it. The dreary warnings, the lectures, all the rest.

He was very sick, burning with fever. In his delirium he still "talked a lot about his mother and the springtime, when both he and Jeanne would go to Italy and he would begin painting again. Friends who heard of his pitiable state came to see him, but he shouted at them to go away, as if he hated to be seen in his weakness." Which he undoubtedly did. Even on his deathbed he was proud—and difficult. He would not eat; it took infinite patience to get him to swallow a little soup.

In the days that followed, Jeanne was alone with Modi. Zborowski was undoubtedly busy selling pictures, and concluded that Modi was either disinclined or not well enough to paint. Few people had telephones. If Modi had any money, it was very little. In any case, Jeanne was too occupied with her patient to go to market. Laure Lourie says that her father, Ortiz de Zarate, took food cooked by her mother to them, sharing the

Spartan minimum needed by the De Zarate family. Mrs. Lourie, who was seven years old at the time, remembers the crises created in the household by her father's requests.[12]

But Modi would not eat, took little soup, and "Fruit, which someone brought him, he threw up." He wanted drink, alcohol. He demanded it, screamed for it. "Maybe Jeanne, out of sheer pity and inexperience [just as Lunia Czechowska had smuggled wine to Utrillo in the asylum], gave him some, for she loved him desperately and could not bear to see him suffer. . . . In that miserable studio, sparsely furnished, with no modern convenience, even a trained nurse would have refused to take care of him." [13] In her very advanced pregnancy, with Modi out of his head, thrashing, knocking away a bowl of soup, roaring for wine, it must have been hell for Jeanne.

He did not improve. Apparently two days later, he was still so sick and his fever so high from the feel of him, that Jeanne rushed over to the Zborowskis. Zbo hurried back with her, looked at Modi, talked to him. It may have been at this meeting that Modi supposedly mumbled the two statements that are so firmly a part of the legend. Zbo tried to make cheerful conversation, only to be cut off.

"No matter what happens," said Modi, "you have nothing to worry about. In Soutine I'm leaving you a great artist."

Again Zbo protested. Modi must not talk that way. Everything would be all right if he would only—

"I'm leaving the mud behind. Now I know all there is to know and soon I'll be no more than a handful of dust."

Zbo was so thoroughly alarmed at Modi's condition that he immediately sent for a doctor. This ". . . of course should have been done long before, despite all the invalid's protests. Modi, with his mulish obstinacy, really frightened of the verdict by which he had for so long been obsessed, always refused. This time he had to put up with it; but it was too late." [14] In his letter to Emanuele, Zborowski went over the sad details step by step. Even then he couldn't believe them:

. . . He was a child of the stars for whom reality did not exist. All the same nothing led us to believe the catastrophe was so near. He had appetite; he took walks and he was in good spirits. He never complained of anything bothering him. Ten days before his death [this could well be after his night in the biting cold with Lascano Tegui and the others], he had to go to bed and all of a sudden began to have great pain in his kidneys. The doctor who came said it was nephritis (before that he had never wanted to see a doctor). He used to suffer from kidney pains, always saying they quickly passed. The doctor came every day. The sixth day of his illness I fell sick myself, and my wife went to see him in the morning. When she came back, I learned that

he was spitting blood. We ran to find the doctor, who said that he had to be taken to the hospital as soon as the bleeding stopped. Two days later he was taken to the hospital unconscious. . . .[15]

These crucial two days are difficult to account for. They have to be reconstructed from several sources to get some understanding of what actually happened. In the light of modern medical procedures, the decision of the doctor, as Zbo reports it, seems incredible. Modigliani was a very sick man. It was necessary for him to go to the hospital but not, the doctor ordered, until the bleeding stopped. Certainly moving him might aggravate the hemorrhaging of the lungs, but that risk would be better taken than to have left him to get worse in the dirty, littered, poorly heated studio with only Jeanne to care for him.

During Modi's last forty-eight hours in the Rue de la Grande-Chaumière, it appears that Zbo was unable to visit him because he was sick in bed himself. And Hanka, probably worried about her husband, had to put off seeing Modi for a time. The doctor had seen Modi, Hanka had been informed of his decision, and there was nothing further she could do.

Ortiz de Zarate, from his own account, was away from Paris for a few days, and returned to find Modi desperately sick:

> He was very ill. . . . Each week I arranged for coal to be delivered to him, but then I had to be away for eight days. When I came back, I went to see him. He was in a bad way. Lying with his wife on a repulsively-dirty pallet-bed . . . I worried about him. "Are you eating at least?" I asked him. . . . Just then someone brought him a tin of sardines and I noticed that the two mattresses, the floor as well, were covered with greasy oily markings . . . with more empty tins and lids all about. . . . Modigliani, already at the point of death, had been eating sardines for eight days!
>
> I had the concierge bring up some boiled beef and broth (*pot-au-feu*), and I sent for a doctor in whom I had the most confidence. "The hospital immediately," he advised. And as we brought Modigliani to the Charité Hospital, he said to me in a weak husky voice: "I have only a little bit of brain left . . . I know well this is the end." And he added: "I have kissed my wife, and we have agreed on eternal happiness."
>
> I understood what he meant—later on.
>
> Alas, all care was in vain. I went to see our unfortunate friend, accompanied by his wife and Mme. Zborowska. Alone, I went for news.
>
> Fifteen days earlier, and perhaps he might have been saved . . . He suffered terribly. An injection put him to sleep forever. . . . As I stood silently by his wife, she said to me: "Oh! I know that he's dead. But I also know that he'll soon be living for me." [16]

Written ten years after the fact, Ortiz's account contradicts what Zborowski wrote to Emanuele Modigliani in his letter dated January 31, 1920. Ortiz tells of appalling neglect, of Modi and Jeanne subsisting on a diet of sardines for eight days while he was absent, of no one going to see the dying Modigliani in all that time, except the "someone" who brought Modi still another tin of sardines on the day Ortiz came back and went up to see his friend. There is another discrepancy: Ortiz says that Modi was conscious as he was being taken to the hospital; Zborowski wrote that he was unconscious.

Goldring has the doctor coming over to examine Modi. Then:

> Outside, in the passage leading from the miserable studio, the doctor made the discreet grimace that medical men usually make on such dismal occasions. An ambulance was telephoned for immediately. Modigliani, trembling and already delirious, was carried off to the Hôpital de la Charité. On the way he was heard to murmur: "Italia, cara, cara Italia." Then he sank into a coma and never recovered consciousness. The doctors spoke grimly of the alcoholic poisoning, plus drugs on top of pulmonary meningitis. Next day, the 24th of January 1920, Modigliani died.[17]

Ortiz de Zarate and Kisling found Modi and Jeanne in their freezing apartment, empty bottles and sardine cans all around them, Jeanne Modigliani says. She recounts what people who saw the dying Modigliani report that he said—recommending Soutine to Zborowski; asking Jeanne to follow him to the grave "so he could have his favorite model in Paradise and enjoy eternal happiness with her"; telling Ortiz that all he had left was "a little bit of brain," and finally, murmuring *"Cara, cara, Italia"* (dear, dear Italy), in the ambulance on the way to the hospital. Miss Modigliani rightly feels that these are two many "last words" for one man.[18]

So they are. Modi more than likely said nothing, since he was delirious or unconscious at the time, but the legend insists that he did.

Picking the hard facts from the purported ones gives us this chronology: Modi fell seriously ill ten days before his death, as reported by Zborowski, probably the morning after he had been out all night with Lascano Tegui and his artist friends. Modi had not been well before this, had taken to his bed off and on, and Ortiz, who now left for eight days, had helped look after him. In any case the doctor came. If he did diagnose nephritis, as fatal today as it was then, he should certainly have packed Modi off to the hospital immediately.

Zborowski says the doctor looked in on Modi every day; so, probably, did Zbo. On the sixth day, Zbo was sick and his wife went to visit Modi in his place. Then came the news that Modi was spitting blood and the doctor was sent for quickly. Perhaps it was up to Jeanne to let the doctor

or the Zborowskis know when the bleeding had stopped. Since the De
Zarates were away, she had no one close at hand to turn to. Modi may
have continued to spit blood and Jeanne may have wanted to fetch help.
But Modi was in pain, raving and hysterical, and he may not have
wanted her to leave him.

So Jeanne stayed, lying on the bed next to him, sick, worried, and her-
self exhausted. The coal stove went out; the cold crept into the apart-
ment. Modi lost consciousness and, holding him in her arms, Jeanne lay
in near-unconscious sleep until Ortiz returned, found them, and sum-
moned Moïse Kisling and Zbo.

Ortiz sent the concierge down to his own apartment for some beef
broth and to telephone the doctor. When the ambulance came, the un-
conscious Modigliani was carried downstairs on a stretcher and taken to
the Hôpital de la Charité on the Rue Jacob. Run by Sisters of Charity,
the hospital was for the poor, the down-and-out, the homeless.

As for what happened in the hospital, Zborowski wrote to Emanuele:

> Everything possible was done for him, his friends and I calling in
> several doctors to attend him, but tubercular meningitis had set in. It
> had been weakening him for a long time, and the doctor hadn't recog-
> nized the symptoms. Modigliani was lost.[19]

Blaise Cendrars told Frederick Wight that he had a friend whose
brother was an excellent doctor and they had obtained a room for Modi
at the Hôtel Dieu (charity hospital). "Modigliani was to have been
trepanned for an abscess in the brain. It was a question of finding
money." [20] This seems to be just another of Cendrars's "colorful and
boldly inaccurate" recollections. There does not seem to have been any
question of operating on Modigliani.

It was Thursday, January 22, when Modi was taken to the hospital un-
conscious. Kisling, who called in other doctors to consult on Modi's con-
dition, also sent *pneumatiques*, special-delivery letters to Modi's friends.
The grave news spread quickly through Montparnasse. It was all up with
Modigliani, they said. Jeanne, soon to go to the hospital herself for the
delivery of her child, apparently stayed on at the apartment in the Rue
de la Grande-Chaumière, waiting for news of Modi. Perhaps someone
stayed with her or perhaps Hanka Zborowska, Paulette, and Hedwige de
Zarate took turns.

Meanwhile, Zbo, Ortiz, Kisling, and possibly Salmon, visited the hospi-
tal. There was nothing Jeanne could do. All day Thursday and on into
Friday there was no change.

The next day, Saturday, Modi was still alive, though deep in a coma.
Knowing his death was inevitable, the doctors nevertheless went through

the motions of treating him. He did not rally. Modi, whose amazing constitution had survived shocks and abuses which would have killed even a healthier man years earlier, had sunk too low. Tubercular meningitis was the verdict given Zborowski. Modi died at ten minutes to nine on the night of January 24, 1920, "without suffering and without regaining consciousness," according to what Zbo wrote Emanuele. He was thirty-five and a half years old.

Tearfully recalling the tragic circumstances of his death, years later as she stood in her little restaurant where Modi had eaten, argued, and made scenes so many times—and had finally made famous—Rosalie summed it all up in one sentence:

"Poor Amedeo, he would go and die like a dog!" [21]

It was probably Zborowski who had to tell Jeanne the sad news. He was so overcome with grief that Kisling had to take over the arrangements for Modi's funeral. But the sensitive Zbo was enough in control of himself not to want Jeanne to stay on alone at her apartment. Paulette Jourdain, although then only fourteen, told Jeanne Modigliani that she remembers taking Jeanne to a little hotel on the Rue de Seine, no doubt at Zbo's suggestion:

> Her time was so close that she already waddled like a duck. . . . She seemed calm, but the next morning the chambermaid found a knife under her pillow.[22]

The next day, Sunday morning, Jeanne was taken to the hospital for a last look at Modigliani. Kisling, who had taken upon himself the job of making a death mask of his friend (and botched the job), was there.

He said he would never forget Jeanne's terrible cry at the sight of her dead lover, "the most piercing cry that ever a woman uttered when confronted by the corpse of her man." Kisling had been at war, seen men die in the trenches, "but never had death seemed to him so frightful." The long kiss Jeanne bestowed on Modi so upset Kisling that he had to leave. Jeanne then asked to be alone with Modi. "When she rejoined her friends, they were astonished to notice that her face was so calm." [23]

In contrast Jeanne Modigliani says that Jeanne went to the hospital accompanied by her father Achille Hébuterne, who must have been informed of Modi's illness and death. According to a doctor named Barrieu and André Delhay, M. Hébuterne, loyal to his daughter, although quiet and reproachful, stayed at the entrance to the room while Jeanne went over to the corpse. Miss Modigliani writes that Stanislas Fumet, a childhood friend of Jeanne's who was accompanied by his wife Aniouta, said that Jeanne did not kiss the body:

She looked at it for a long time as if her eyes were living over her tragedy. She moved away, walking backward to the door. When we reached her, she was still holding on to the memory of the dead man's face and forcing herself not to see anything else.[24]

Jacques Lipchitz, who had to take over the making of the death mask Kisling had ruined, was apparently also at the hospital. Jeanne was like a Gothic Madonna, he said, and made of tougher fiber than she appeared. Lipchitz has said that Jeanne went to the morgue (probably the hospital morgue) to see Modigliani's body. As she entered, she passed Simone Thiroux, who was crying at the door, without seeming to notice her. Jeanne went to the corpse, fell on it, and started to kiss it on the mouth. As she again passed Simone on the way out, she said nothing, then stopped and suddenly gave Simone two slaps in the face.[25]

One has to conclude that some vital information has been omitted, that both versions have some truth, including what Lipchitz observed, and that Jeanne very possibly saw the body on two separate occasions. The first time may have been in his room on the Saturday night Modi died; the second may very likely have been on Sunday morning in the hospital morgue.

After leaving the hospital on Sunday morning, Jeanne went back to the Zborowskis' apartment on the Rue Joseph-Bara. Once there, according to Jeanne Modigliani, Jeanne took the hand of little Paulette and said, "Don't leave me." But then, it seems, when M. Hébuterne asked his daughter to go with him—Paulette felt the two were very close even though they were so quiet and reserved with each other—Jeanne accompanied him back to the Rue Amyot. Goldring says that both Mme. Zborowska and a woman he identifies only as Madame L. pleaded with Jeanne.

. . . to let them take her to the Tarnier clinic, where her room was reserved, as her time was near. Only a few days before, proud and chaste Jeanne Hébuterne had taken a friend's hand and placed it lightly on her belly, murmuring: "Feel how it lives!"
Poor blue-eyed Jeanne, so little given to speech and who so rarely laughed—perhaps she had an early premonition of her tragic end—was nearly insane with grief. As she was in no state to be left to sleep in the studio in the Rue de la Grande-Chaumière and would not go to the clinic, she was taken to the house of her parents. . . . They were implored to look after her tenderly.[26]

It is hard to believe that Achille Hébuterne went to the hospital where Modigliani lay dead with his daughter and later asked her to go home

with him. In spite of their uneasy reconciliation, it is inconsistent with his actions at the time Jeanne turned her back on her family and went off with her "degenerate Jewish artist." It is also inconsistent with the behavior of Jeanne's parents when her crushed body was found on the street outside their apartment building on the Rue Amyot. All the same, in justice to M. Hébuterne, inconsistent behavior is very possible, and he may very well have responded to Zborowski's pleas after being told of Modigliani's death. He can have been shamed into going to his daughter's side: Jeanne had no place to go, no one to turn to; and, after all, he was her father.

One thing is known: Jeanne did return to her parents' home some time on the morning of Sunday, January 25.

The circumstances leading up to Jeanne's suicide less than twenty-four hours after she reached home are shrouded in mystery, in the reports of controversy, and in envenomed contradictions. Goldring wrote that "Of what actually passed between them and their unfortunate daughter only they [the Hébuternes] could render an account." Father and mother never saw fit to give their side of the story. André, Jeanne's brother, who is still living, has adamantly refused to shed any light on what happened.

To reconstruct the events of those twenty-four hours is the only course left. To start with, it was probably Mme. Hébuterne who persuaded her husband to go to Jeanne and bring her home. Mme. Hébuterne was a little more sympathetic to Jeanne than her husband. In spite of all she had had to put up with, she had insisted on going to Cagnes with Jeanne and had stayed on with her in Nice until after her baby was born. It is possible that she had wanted to go to Jeanne after being told of Modigliani's death, but no respectable woman could do this on her own. Her husband had to go in her place.

Now, with Jeanne secluded in her old bedroom, numb with grief, mother, father, and son in the next room discussed what was to be done with Jeanne. Modigliani was dead. They, and even Jeanne, were well rid of him. He had left his pregnant wife and child without a franc, with nothing at all but his worthless paintings, which Zborowski couldn't even give away. It would be their job to support Jeanne and her two children, which was a family's duty in normal circumstances, but these were not and had never been normal circumstances. On the contrary, the whole affair was scandalous, disgraceful, disgusting.

Jeanne and her two illegitimate children could hardly live with the Hébuternes. Achille was an important man with an important job. How could he hold up his head before his superiors, his friends, and his neighbors with Jeanne in the house? He would help her, support her, always do what he could, but she could not, must not live with them. She could

stay on for a few days, seeing no one, not moving from the house until the baby was due, but after leaving the hospital Jeanne and her two children must go away.

Mme. Hébuterne must have been hard put to rebut her husband's arguments. She loved her daughter, was overcome by her tragedy, and perhaps pleaded to the point of hysteria. Whether André simply listened to his mother and father or took a stand, there is no way to know. But there must have been angry words, shouting argument, tears, accusations, and counteraccusations all through Sunday and well into the night to the point of exhaustion. As for Jeanne, lying stunned and dazed on her bed, trying to comprehend the extent of her loss, who can say whether she heard her parents or, if she did, whether it made any impression or mattered in the least?

It was not a question of where she was going to live, but how. Modigliani had been her whole life. Now that he was gone she had no life, nothing at all left to her. Jeanne had made a total commitment to Modigliani. The Hébuternes had no conception of the love she had borne him because they had never understood how their daughter, so well brought up, could love such a man in the first place. Nor could they have had any true comprehension of the depth of Jeanne's desolation now that Modigliani was dead. The Hébuternes regarded Modi as a monster who had seduced and debauched their daughter. They could, therefore, never understand, as Léon Indenbaum said, how Modi could be everything to her—father, brother, husband, fiancé, even a kind of god.

For this reason, Indenbaum was not surprised at Jeanne's suicide.[27] She knew Modi was dying because *"On le voyait finir,"* you could see him going. And she knew what she had to do. Her decision was taken over a long period of time. *"Ce n'était pas un coup de tête,* Indenbaum explained. It was not a sudden, rash impulse when she killed herself. Jeanne had thought it out long before; made up her mind that it had to be. *"Sa pensée était arretée depuis longtemps."* This remark of Indenbaum's tells much about Jeanne. For a long while she had stopped thinking. She knew what was going to happen, had known it all along. In her acceptance Jeanne achieves the nobility, the stature of a character in a Greek tragedy: she knew and played her role from beginning to certain end.

That she was planning suicide is evident in Paulette's statement that the chambermaid found a knife under Jeanne's pillow in the little hotel on the Rue de Seine. Whether Paulette, young and impressionable as she was, saw fit to mention the fact to the Zborowskis, who could have passed in on to the Hébuternes, is not known. But in any case the Hébuternes were too preoccupied with their own problems to think about Jeanne's. Another piece of evidence to prove what Jeanne had in mind comes

from the artist Waclaw Zawadowski.[28] Zawado, as he was known, says that Jeanne, in the hours before she jumped out the window, passed the time doing drawings of herself committing suicide: killing herself with a knife (as she had contemplated), jumping out of the window (as she was shortly to do), and in other ways as well.

These drawings were found in the Rue de la Grande-Chaumière studio, not in the Hébuterne apartment. Whether André spent the night with his sister, as reported, Zawado did not know, but in the light of what happened, he knew that André had not spent the whole night with her. In the English version of her book, Jeanne Modigliani says that Jeanne threw herself from the fifth-floor window of her parents' apartment at dawn on Monday. She adds that Mrs. Roger Wild, Jeanne's friend, who was born Jeanne or Germaine Labaye, says:

> . . . Several times during the night André Hébuterne, who adored his sister, had stopped her from committing suicide, but at dawn had dozed off, and by the time he heard the noise of a window opening, it was too late. To spare his mother the sight of the mutilated body, he told her that Jeanne was only hurt and asked them to take her away.[29]

In the French edition of Jeanne Modigliani's book, published in 1961 (the Italian and American editions came out in 1958), Miss Modigliani repeats the report about Jeanne jumping out of the fifth-floor window at dawn, but omits all mention of André Hébuterne. (In his letter to Emanuele, Zborowski said she died at four in the morning.[30]) She does include, however, a most revealing, hitherto unpublished statement by Chantal Quenneville inscribed "To the daughter of Jeannette Hébuterne." The statement clarifies a great deal and, while it cannot explain everything, relieves Jeanne Modigliani of the bitter, if unsubstantiated, charge that, as Laure de Zarate Lourie put it, she preferred "to cover up for her maternal grandparents." [31]

Wanting the truth about her father, Jeanne Modigliani sought to write a biography without any of the legend in it. It was not easy. In many cases those who had known Modigliani were of no particular help to her. They felt Modi belonged to them—to those who had known him —not to his daughter, who would always be an outsider. Chantal Quenneville's account casts the Hébuternes in the same harsh, unforgiving, heartless light as other books and biographies about Modi, as the testimony of friends of Jeanne and Modi, and as the legend itself:

> Jeannette Hébuterne had sought refuge with her parents, Catholics offended by her union with the Jewish Modigliani, and did not say a word.
> Two or three days had slipped by when I asked André Delhay:

What about Jeannette? He gave me a black look. She had thrown her-self out the fifth-floor window of her parents' home. The broken body had been picked up in the courtyard by a workman, who had carried it to the fifth-floor landing, where the horrified parents slammed the door in his face. The same workman had then brought the body over to the Grande-Chaumière studio in a cart. Here the janitor refused to accept it, saying "it was not that of a tenant." Finally this workman, who re-mained unknown and merited being decorated, went to the police sta-tion where he was told to bring it back to the Rue de la Grande-Chaumière on orders of the police. There the body stayed, neglected the whole morning long.

Jeannette Léger was with me. We went to the studio right away; the sight of the body of this young woman, so gifted, so devoted in her love for Modigliani, gave us great pain. She had been my friend at the *Ecole des Art Décoratifs* and the *Académie Colarossi.* Jeanne Léger went to look for a hospital attendant to dress the body. I stayed alone at the harrowing scene. The head, white and sprinkled with spots of green, still bore traces of that life which she had renounced of her own heroic free choice. She had a child by Modigliani and was expecting another. Her belly jutted out under the coarse blanket. One leg seemed to have been broken in the fall. . . .

I put things in order a little, swept up the studio which was full of empty boxes of preserves [presumably sardine tins] and coal. In the other room, just about everywhere, there were bottles of wine, also empty. On the easel there was a fine portrait of a man, which was not finished. I saw drawings by Jeanne in which she had portrayed herself, just as she looked with her long braids, in the act of stabbing herself in the breast with a long knife. Had she foreseen her own end?

Modigliani's funeral services were impressive. All Paris came to Père Lachaise. There were so many flowers! The war was over; we didn't want to look sad, and we were used to death.

Jeanne's burial was far different from that of the man she had so humbly adored. Her parents didn't want to see anybody. They planned to put her into the ground at eight o'clock in the morning. Somebody managed to learn the details. Who was there to represent us at this unlikely hour? Zborowski, Kisling, André Salmon, and their wives were in one taxi. In another were the parents, the brother, [Chana] Orloff, and I. The pitiful hearse and the two taxis made the interminable trip out to one of those dismal cemeteries in the distant suburbs under cold, gray skies.[32]

~~~ Chapter Thirty-six

"Cover him with Flowers."

Moïse Kisling had the idea of making a death mask as a memento of Modigliani for his family and friends. He was apparently given little time to make it. The hospital authorities were anxious to move the corpse from the room to the hospital morgue. The mask had evidently to be done hastily in the hospital amphitheatre by Kisling with the assistance of Conrad Moricand, a Swiss friend of Modigliani's.

Neither man had had any experience as a sculptor or knew how to make a death mask, which takes a sure, delicate hand. It is understandable that they botched the job. The plaster mold did not set solidly, so it came off in pieces. Frantic, they hurried to Jacques Lipchitz with the pieces and begged him to take over. Lipchitz has said that the death mask brought to him was easily in a hundred pieces. Not only were parts missing, but hair, facial tissue, and exudations adhered to the plaster, greatly complicating the job of putting the pieces together.[1]

Lipchitz had to manage what amounted to a complete reconstruction before he could shape a suitable mold from which twelve copies were cast. Modigliani had false teeth, and according to Marie Wassilieff, his good looks had vanished. But in his death mask, Modi's face looks neither ravaged nor emaciated. (See photographs, following page 416.) Tranquil, the eyes shut as in so many of his paintings and sculptures, his features have a tragic nobility, a classic beauty.

Besides trying to make a death mask of his dear friend, choosing a coffin and arranging Modi's funeral, the rest of the usual sad chores were also Kisling's responsibility. They fell on him because, as Zborowski wrote to Emanuele, Zbo was so upset he hadn't the head for it. Zbo, in his letter, also says that Kisling made a drawing of Modi on his deathbed

and that he would send the snapshot and the drawing on to Emanuele. There is no explanation of the snapshot.

Zborowski does seem to have been able to send a telegram to Emanuele Modigliani in Rome telling him of Amedeo's untimely death. One story has the telegram arriving before Jeanne's death, and the reaction of the Modigliani family as generous and prompt. They had never abandoned Modi, their erring artist. According to this version of the story they wired back that Jeanne and her daughter should come to Leghorn and live with them. Margherita's little biography said only that:

> . . . His affection for his family never slackened even though he re-mained at a distance. . . . He understood the sacrifices his family had made for him, and he returned the last remittance they sent him.
>
> He began to talk of the sweet loving companion who gave him a daughter in 1918. His letters were full of tenderness and joy, and he planned to return to Italy in 1920 as soon as his second child was born, to show his family to his relatives.[2]

The interesting point here is that Modi, apparently heartened by the London exhibition, Carco's article in the Swiss magazine, and Zbo's reassuring promises, actually believed success to be close enough that he returned his allowance. He apparently felt he no longer needed help from home, but he learned differently soon enough. He had no money when he died, nor had Zborowski, who seems not to have sold enough paintings to pay for a cheap funeral. Emanuele, now a prominent politician and a member of the Chamber of Deputies, seems to have been unable to get to Paris for the funeral. Italy was in a state of postwar upheaval; the red tape was thick; and passports were difficult to clear, even for a Socialist deputy.

It was almost a month before he could reach Paris.[3] The fact that Zbo's letter to Emanuele is dated January 31 bears this out. But Emanuele did telegraph instructions to Paris: "Cover him with flowers, Modigliani,"[4] while others have the message, befitting the legend, as "Bury him like a prince." No source mentions whether Emanuele also wired funds to cover the splendid, princely funeral he envisioned for his brother. The fact that Kisling went to great lengths to raise money to cover the costs makes it seem that only instructions came from Italy.

In his letter to Emanuele, Zbo said he would be pleased if Emanuele wrote his thanks to André Salmon, 6 Rue Joseph-Bara, and to Kisling, 3 Rue Joseph-Bara, both of whom had done so much for Modi before and after his death. Zbo says that Kisling organized the funeral. He also speaks of the child, the lovely little fourteen-month-old daughter of Jeanne and Modi:

. . . Now I am taking care of her. But you are the only one who can take the place of her parents. My wife and I would willingly take her as our own daughter—but Amédée always expressed the wish that she be brought up in Italy among her family.

Don't worry yourself for a minute about the child. In a few days I'll go see her with my wife. In any case she is in good health and beginning to walk.

If you have anything to suggest concerning Modigliani's child— write to me and I'll do as you say.[5]

Zbo did not know Modi's brother, nor did he know how the family would feel about adopting the illegitimate child, which was why he asked whether Emanuele had any suggestions concerning little Jeanne. Zbo also told Emanuele:

To do homage to Modigliani, we have organized a little committee to collect the work of different painters and sell them for the benefit of his daughter. The sale will probably bring 25 to 30,000 francs, which you can accept in her name. For it is an homage of the artists to her father.[6]

Zbo went on to say that at some future date he planned to organize a big show of Modigliani's work and would let Emanuele know in advance when it was to be. One might wonder, perhaps, why Zborowski did not sell his Modiglianis to pay for the funeral and to help little Jeanne. The prices of the paintings had doubled and trebled in value by the hour after Modi's death. Zbo could have raised cash quickly, but he would also have lost a great deal of money. He was sick with grief and certainly in no mood to sell to the same dealers and collectors who had laughed at the idea of buying Modiglianis not long before. Besides, the work contributed by other living artists—unfortunately not named—was a gesture of friendship and admiration on the part of Modi's colleagues and was not undergoing the inflation in price of Modi's work.

On the heels of Modi's death, the news of Jeanne's suicide sent more shock waves through Montparnasse and across to the Butte. "Genuine grief for poor Modi and his love was mixed with rage against, and disgust at, the parents, whose behaviour seemed incomprehensible, inhuman." Kisling and his committee hurried about, raising money to bury Modi like a prince.

Everybody—painters, writers, models, women of the Quarter, even picture dealers, bistro owners and waiters who had frequently had to throw him out, contributed willingly in honour of one who was indeed the last Bohemian of a generation.[7]

It seems that Modi's friends proposed to bury Jeanne with him. "But no! The monstrous parents refused their permission to allow the couple to sleep their last sleep together." Just who proposed this is not known. But Jeanne was hidden away, buried out of sight.

According to the bill [8] made out to Kisling by Charles Daude, 59 Rue Bonaparte, near the Rue de Vieux Colombier, Paris, 6e, the cost of Modigliani's funeral on Tuesday, January 27 was 1,340 francs. This included the coffin and wreaths. Lipchitz helped Kisling pick out Modigliani's coffin.[9] He still remembers the unctuous undertaker congratulating them on their choice and their plans. *"Vous serez content,"* he told them. *"Vous serez satisfait."* Just how anyone could be pleased and satisfied under the circumstances is hard to say.

Chantal Quenneville wrote that Modi had an imposing funeral; all Paris followed the cortege to Père-Lachaise Cemetery, and there were many, many flowers. Léon Indenbaum speaks of a great funeral procession and a crowd of more than a thousand people being present. Laure Lourie, on the other hand, feels that the reports of the funeral were exaggerated. Perhaps a lot of people came, but no more than would fill a big café. In her opinion, the report of a great funeral, as transmitted to Leghorn, was done solely to impress and console Modigliani's mother and the rest of the family. Showing how her father, Ortiz de Zarate, felt about Modigliani, Mrs. Lourie adds, "He is supposed to have given his suit to bury Modigliani in. And it is true." [10] Pincus Kremegne remarked that he inherited Modi's last pair of shoes after his death—brand-new shoes Modi had worn only once or twice and which led Kremegne right to a bar the first time he put them on.[11]

Modigliani's funeral was held on Tuesday, January 27, and the obituary notices announced that those attending were asked to gather at Charity Hospital on the Rue Jacob at two thirty in the afternoon. Burial was to be at Père-Lachaise. In France it is customary—or has been—for funeral processions to wind through the streets, friends and relatives walking on foot behind the horse-drawn hearse, policemen halting traffic, passers-by taking off their hats in respect, on to the cemetery slowly, solemnly, respectfully. Dying penniless in a pauper's hospital, Modi was nonetheless covered with flowers and buried like a prince.

Most of Modi's long-time friends—"Some of them now much thicker in the waist and jowl, some already celebrated, others well on the road to success," [12]—were in the line of march. Max Jacob, Moïse Kisling, André Salmon, Chaim Soutine, Constantin Brancusi, Ortiz de Zarate, Léon Indenbaum, Gino Severini, Leopold Survage, André Derain, Jacques Lipchitz, Pablo Picasso, Francis Carco, Fernand Léger, André Utter, Suzanne Valadon, Maurice Vlaminck, Kees Van Dongen, Leopold Zborowski, Foujita, Zawado, and many, many more—artists, writers, poets,

women, even young people who had seen Modigliani on the streets, heard about him, or already absorbed the legend. "Almost unnoticed in the crowd, there was a tall, pallid girl with ash-blonde hair, sad and silent—Simone, la Canadienne." [13]

Carco had walked along back of the hearse next to Picasso. Later Carco wrote that it was Picasso, as usual, who aptly summed up the meaning of the scene. Turning to Carco, he pointed to the funeral coach draped with flowers and to the police standing smartly at attention along the way— the same *agents* who had so often subdued and arrested Modi at the Rotonde and elsewhere in Montparnasse.

"D'you see?" said Picasso, quietly. "Now he is avenged." [14]

In his letter to Emanuele, obviously begun on the day of the funeral and then put away for a week, Zborowski began:

> Today Amédée, my dearest friend, rests in Père-Lachaise Cemetery covered with flowers according to your wish and ours. All the world of young artists made this a moving and triumphant funeral for our dear friend and the most gifted artist of our time. . . .[15]

And Luigi Cesana, a family friend, wrote about the funeral to Emanuele on the day he attended it. Emanuele seems to have asked Cesana to get in touch with Kisling's funeral committee, to speak for the family, and perhaps to give funds.

> I hope the letter I sent you yesterday arrived before this one. Today we accompanied Dedo to his final rest. . . . In your sorrow it may comfort you to know the display of affection that your dear one received.
>
> This morning several newspapers of the left announced his death (and I enclose a clipping from the *Lanterne*). At the hospital there was a mob of friends, among them many women. Artists of every country and every race: French, Russian, Italian, Chinese, etc. A large quantity of fresh flowers; two wreaths with the respective inscriptions: *To our son*, *To our brother*. Everybody followed the hearse to Père-Lachaise, which is about seven or eight kilometers from the Charité. A rabbi recited prayers at the cemetery. I don't know, as I wrote you yesterday, whether you or your poor brother wanted it, but his friends thought that they were doing the right thing in having a rabbi attend and that it would please your father. I might add that the rabbi wanted to know the first name of the deceased's father and I believe that no one else beside myself could have answered this question. I don't know why this was. . . .[16]

The dealers had expressed their sympathy at the death of Modi and immediately tried to capitalize on it. While Modi's paintings had

brought only between 100 and 150 francs before his death, now the deal-
ers hounded Zborowski, even during the funeral procession itself, offering
him as much as 40,000 francs for fifty pictures, or 800 francs apiece.[17]
Overwhelmed as he was with grief, one can imagine what Zbo thought of
these vultures. Carco, too, was approached in the funeral cortège:

> They talked about it quite naturally as we followed the coffin, as if it
> were a scheme which was none of the deceased's business. *"Huit milles,*
> *dix milles, Sapristi. Vous êtes dure!"* [Eight thousand, ten thousand.
> Damn it. You're a tough one!] they complained as the wheels of the
> hearse groaned over the pavement of Père-Lachaise. *"Allons onze*
> *beaux billets! des grands."* [Come on, eleven beautiful bills! big ones.] [18]

When Zbo had tried to sell them some of Modigliani's paintings a year
before, these same dealers had almost thrown him out of their offices.
"Today" (1940), Carco adds, "they act like protectors of art." Berthe
Weill wrote that Louis Libaude had heard two days before Modi's death
that Modi's case was hopeless. Then like a hyena worrying a carcass,
Libaude pounded the pavements of Paris and bought up all the Modi-
glianis he could find. Until then he hadn't bought a single one. And fol-
lowing Modi's death he ran about like a fool, saying, *"J'en ai de la*
chance! Jusqu'à la veille de sa mort, j'ai encore trouvé des Modiglianis
pour rien! Il était temps. . . !" (Have I had luck! Right up to his death
watch, I still picked up some Modiglianis for nothing. It was about
time. . . !).[19]

Recalling the funeral, Foujita said that all Modi's friends were there
and that never had such a funeral been seen from the Charity Hospi-
tal. He remembers the day as being cold and sad, and that "The day
before there were thirty dealers who came to his studio to try to get
paintings, but there were only two at the funeral. All the models were
there, all weeping." [20]

In his letter to Emanuele, Luigi Cesana wrote of the many women
gathered at the hospital before the funeral procession. Modi was a legend
even among the models who hadn't posed for him; they, too, ate inexpen-
sively at Rosalie's, and were well aware of the dark, glowering prince who
was *la patronne's* favorite.

Charles Beadle heard of Modi's death from a Swiss painter friend
named Fornerod, who earned his living in an art gallery. He told Beadle
that the day after Modi's death buyers had appeared at the gallery asking
for his pictures. The gallery had some, although none were presently on
display "because they had despaired of finding a buyer." The one Forne-
rod brought out of the back room to show his customer was marked 300
francs in a cipher on the back of the canvas. Fornerod now asked 3,000.

The men bought it "and others, each at ten times the price marked—and sold them afterwards with another rise of ten times."

Commenting on the ugly fact that Modi's death was "required to permit him to enter the kingdom of fame so long denied," Goldring thought a suitable epitaph might have read:

> Here lies one who lived, worked, and suffered—that dealers might live in comfort.[21]

Of the many newspapers published in Paris in 1920, besides the *Lanterne* mentioned by Luigi Cesana, only six, including *L'Evénement, L'Avenir, Bonsoir, L'Intransigeant, Excelsior,* and *L'Humanité* carried obituaries of Modigliani. The last two were apparently liberal, Socialist-oriented newspapers (thus explaining Cesana's reference to the "left") and speak of Modi as "the brother of our comrade Modigliani, Socialist deputy from Leghorn, the popular and courageous orator."

The obituaries pay tribute to Modigliani's talent and the great loss suffered by the world of art. Some of them bring in the tragedy of Jeanne. With the exception of *L'Evénement,* they are all short, routine pieces. Francis Carco, as art critic for *L'Evenement,* old and good friend of Modi's, an early and great admirer of his work, outdid himself. His notice appeared on the second page under the announcement of the opening of the Salon des Indépendants:

> Let those artists who, the day before the opening of the Salon des Indépendants, escorted the remains of the painter Modigliani bear witness to the immense loss to young painting caused by his death. And it is with emotion that I join with Modigliani's name that of Hébuterne, his companion. This young woman, who killed herself before the realization of what a sure talent promised, refused to survive the man whom she loved and who guided her in her art. This double and tragic loss, at the moment when success seemed bound to reward the research of a particularly gifted painter, cannot but sadden, as much as in France, the daily increasing number of Modigliani's admirers abroad. Much nonsense was said of him; he was ignored and all too often unjustly treated. Today we know that nothing can keep his memory unscathed from the worst slander. . . . No doubt because of excesses so often repeated that they have given birth to a legend. Modigliani outraged the feelings of certain collectors, thus giving rise to a scandalized outcry. These eccentricities concerned only the man; it is not up to us to judge them. His work remains for us. What power it has over us! Remember Modigliani's nudes and portraits. A painter of character, of attitudes, of graceful rhythms; I know of few who, as detached as he was from any influence, have imposed a style more sober and more directly involved in its subject matter. He sacrificed everything to the re-

quirements of this style, pushing his research so far that the distortions he used no longer could shock the human affection we have for our own likeness. And in so doing he managed to achieve his greatest ambition.

Renoir, whom he met in the Midi, was generous in encouraging him . . . and so was the public. This could be seen in the recent exhibition in London, as it was in the last Salon d'Automne, and also, unhappily, at the opening of a one-man show of some twenty of his paintings which, by an odd coincidence, took place on Tuesday in the Devambez Gallery at the same time as his burial.[22]

Whether Renoir encouraged Modigliani beyond the gift to Zbo of some of his own paintings is debatable. It is also true that Renoir had refused to see Paul Guillaume and other dealers anxious to capitalize on his fame and that he was impressed by the work Zbo showed him by Modi. The London exhibition had been more sensation than success. The public had been cool, critical, and scornful of modern art. The four paintings in the 1919 Salon d'Automne evidently did attract more favorable attention than in the past, yet no reviews have been found that cover Modi's entries in it.

Carco's reference to a one-man show of twenty-odd paintings opening at the Devambez Gallery on the day of Modigliani's death points up one fruit of Zborowski's struggle to bring Modi's art to the attention of the public. That they should be exhibited in this particular gallery is curious. Devambez,[23] whose gallery on the Place Saint-Augustin was supposed to be one of the most important in Paris, was the the father-in-law of Chéron, who had so exploited Modi in the basement of his own high-pressure, buy-'em-cheap-sell-'em-dear gallery in the Rue de la Boètie. That Modi's work was shown in this gallery could in all probability only be the result of some bargaining on Zbo's part.

There are stories about how Chéron tried to force Modi to fulfill his contract which Modi broke when he had apparently fled his jailer. It may be that after Zbo became Modi's exclusive dealer, Chéron brought the matter of the broken contract to Zbo's attention. Chéron had claims on Modi and expected Modi to make them good. Perhaps Modi did; perhaps Zbo had to let Modi work out the rest of the contract. Chéron would certainly have insisted on it because he had buyers for Modi's paintings. In any case, Zbo may have agreed to the arrangement—with strings. Chéron could have Modi's services as agreed, but *only* if Chéron prevailed on his father-in-law, Devambez, to exhibit Modi's paintings at some later time. When Modi lay on his deathbed, the one-man show opened at the Devambez Gallery. It was not a coincidence: think of having an exhibition of the work of the Prince of the Bohemians on the very day he died!

To reconstruct the circumstances surrounding Jeanne Hébuterne's death is to pick one's way through mysteries and conflicting testimony. Chantal Quenneville's account would seem to be definitive in all respects; nevertheless her explanation of the Hébuternes' actions—acceptable and truthful as it seems to be—remained undocumented. It was at this point that the legend took over, as it did with every event in Modigliani's life, until it seems impossible to discover the truth at this late date. Even Umberto Brunelleschi claims to have seen and heard things that he not only could not have seen but that did not happen as he described them:

> I have seen him on his deathbed in the lugubrious hospital of the "Charité," staring glassy-eyed and muttering: "Italy—my Italy!" I have seen his little Jeanne—the sickly young woman who loved him blindly, passionately—giving all she had to give. I have seen with a shudder of horror her frail body covered with a white sheet, stiff on the cobbles of that yard where she threw herself in the gray dawn of a morning.
> Amedeo is dead. He'll be happy up there, but he'll need me, he'll need my care, my love, my body to paint. And blindly as she had followed him on earth she followed him to Heaven.[24]

In his biography Lipchitz is made to labor under the same sort of misinformation. Kisling runs to him with the news that Modigliani has been rushed to the hospital and is dying. Lipchitz visualizes ". . . Modigliani's rail of a body fighting death, racked by paroxysms of coughing, murmuring with his strangling breath 'Italia! cara Italia!' as the ambulance was careening to the hospital. How unhappy he must have been away from his native land." Worried about the grieving, pregnant Jeanne, Lipchitz paces the floor, unable to work, reliving memories, hoping that it is not too late and that ". . . perhaps they will find a way to save her."

Although Modigliani died on January 24, Jeanne jumped to her death early on the morning of January 25, and Modigliani's funeral was held at two-thirty on the afternoon of January 27, the Lipchitz biography says:

> In the midst of the largest funeral Montparnasse had ever known, with many friends and flowers, sidewalks lined with people bowed in grief and homage, word came to them that she had opened her fifth-floor window and flung herself to the pavement.[25]

The fact is that all those at the funeral were aware of Jeanne's death: there had been talk of a double funeral, even of a joint burial in Père-Lachaise. Lipchitz can be excused for not being able to remember the chain of events after a lapse of forty-one years; but lapses are what legend

thrives on. Lipchitz's biographer has him wondering "at the tumultuous passions flaming in that shy and introverted girl." Lipchitz thinks of the dead Modigliani and asks, "Did he ever dream that he would be the cause of her death? He who was so gentle and so reverent of women. Why had destiny given him the power to make those whom he loved suffer?" Why indeed? Some questions have no answers, even though "Over the years he [Lipchitz] had expected just such a dénouement as this . . ."

The Hébuternes must have been asleep when Jeanne fell to her death. If André had dozed off as he kept watch over his sister and was awakened by the sound of a window being opened, he saw Jeanne jump and was the only one in the household aware of what had happened. Numb with shock and horror, he may have hesitated for a few seconds; then, stopping only to shout the terrible news at his parents' door, he may have rushed down to the street as the workman came on Jeanne's shattered body.

One must assume that it was the frightened, shaken André who identified his sister and instructed the workman to take her body back upstairs. We are told that the horrified parents slammed the door in the workman's face. That may have seemed to have happened, but shock and hysteria could account for the slamming of the door. Mme. Hébuterne must have been in such a state that one can well believe that "To spare his mother the sight of the mutilated body, he [André] told her that Jeanne was only hurt and asked them to take her away." Mme. Hébuterne could certainly not have believed that after jumping five stories to the street, her daughter "was only hurt." It would be natural for André and his father to spare her the sight of the mutilated body, especially since she was probably hysterical with grief. The whole building must have been aroused by now, but believing that the horror of the suicide and the broken body could be swept out of sight like dirt under the rug, they decided not to bring the corpse into the apartment.

Instead the workman was instructed to take the body to the Rue de la Grande-Chaumière in a cart, according to Chantal Quenneville. André may have told him where the studio was. Taking Jeanne's body there was only a stopgap measure. The Hébuternes no doubt hoped to get the body out of their own apartment building for now, then figure out what to do with it later when they had time to think rationally. Apparently they never did have time. The news of Jeanne's suicide exploded like a bomb, and public opinion immediately turned against the Hébuternes. That was followed by the request for a joint funeral. If the Hébuternes would not permit that, then at least they would allow Jeanne and Modi a common grave in Père-Lachaise. The Hébuternes refused both requests. They would continue to try to hide the scandal. If they had failed to keep Jeanne and her lover apart in life, they would not fail now.

Horror and shame paralyzed the Hébuternes, who shut themselves off from the world. Meanwhile Jeanne's unclaimed body remained in the studio she had shared with Modigliani. The kindly workman did indeed deserve a medal for his noble persistence. Turned down by her parents, Jeanne was now refused admittance to the Rue de la Grande-Chaumière tenement on the grounds that she was not a tenant! This must have occasioned more heated argument. The lone workman must at some point have enlisted or picked up assistants, for "they" next hit on going to the nearest police station and then, after more excited consultation, returned to the apartment with official orders that the body *must* be accepted. The police apparently joined the workman in his poor opinion of the callous Hébuternes. And so the family's heartless role was forever fixed in the tragedy. They, no doubt, felt themselves badly used.

Modigliani's friends now did what they would to care for the girl Modi had loved. Foujita, who liked to say that Jeanne fell in her nightdress and came down like an angel, went to the apartment. Since there was no one to care for Jeanne's body, he and Ortiz de Zarate "offered to clean her up and wash off the blood, but then some people came from the hospital." [26] Marie Wassilieff contributed some magnificent Russian sheets that she owned ". . . So at least she [Jeanne] had that when she was laid out on her bed. The people who came to see her lying there felt the sheets and were impressed—they were that sort of people." [27] Mme. Zborowska, who always despised the Hébuternes for their actions, felt that Jeanne ". . . laid out on the ramshackle divan . . . appeared as if asleep, at peace, and more beautiful than she had ever been in life." [28]

Two friends of Modigliani were supposed to have kept guard over the body all night to keep away the rats. Zawado says that he and a friend, Abdul Wahab Gelani, a Tunisian (and no doubt the wild Arab some considered such a bad influence on Modi), kept watch over Jeanne's body in the studio.[29]

Zawado also claims that he was the first to enter the studio on the Rue de la Grande-Chaumière after Modi's death. Drawings were littered everywhere and there was a painting on Modi's easel—his last painting and a very bad one, Zawado remembers—the work of someone who knew that it was all over. According to Zawado, and much to the general public's delight when it got into the legend, the studio was thick with bottles—empty ones, full ones, half-full ones.

Chana Orloff heard one day that Modigliani was seriously ill, the next day that he had died. She immediately went in search of Jeanette (*sic*), ". . . and I found her as calm as a statue. Too calm." Chana was frightened of this look of Jeanne's. She adds that Jeanne was pregnant with her second child, "and had just come from a visit to the maternity hospital. They told her it was too soon, and they sent her away." [30]

Jeanne was probably too stunned to tell the doctors her circumstances. If Chana Orloff's story is true and if the doctors at the clinic had seen fit to accept Jeanne in her advanced state of pregnancy, she might not have taken the final step—at least not so soon. One can imagine from this account of Chana Orloff's that Jeanne might have wanted or even decided to wait until the child was born. She had thought of suicide, played seriously with the idea as the drawings show, but one must conclude that what happened in the Hébuterne apartment drove her to the decision not to wait to kill herself until after the birth of her child.

Mme. Orloff's story leads one to believe that Jeanne had already made up her mind to take her own life, but her frightening calm could just as well have been due to extreme shock. The Hébuternes suspected nothing. Chana Orloff said they took her in, Jeanne ". . . pretended great weariness and went to her room." Mme. Orloff could not know this unless she had been present or the family had told her about it afterward. Next Mme. Orloff says, "Nothing led them to believe she was going to commit suicide." (This is contrary to Mme. Roger Wild's testimony, in the American edition of Jeanne Modigliani's book, that "several times in the night André Hébuterne, who adored his sister, had stopped her from committing suicide, but at dawn he had dozed off, and by the time he heard the noise of a window opening, it was too late." [31] Mme. Orloff then reported that, the next morning, workmen found Jeanne's body in the street.

She does confirm the fact that the Hébuternes refused to receive Jeanne's body in their apartment. "Her father said it would upset her mother too much." Mme. Orloff recalled that the body was brought to the studio after first being taken to the police station. She herself was overwhelmed by the sight of Jeanne's body, "almost that of a child," in her coffin. Besides the coffin, the studio, said Chana, "contained only a table, bottles of medicine along the window shelf, and a painting of her." Nothing of Modigliani's. After Chana and her unnamed companion left the rooms, the concierge locked the door behind them, and the body was again alone.

> Her father and mother came to ask us not to come to the funeral: "There had been enough scandal." Despite the cold, the early hour, and her relations forbidding us, her friends were there: F. Léger, A. Salmon, Kisling, and the rest. The coffin was put on a *camionette* [small truck], which drove off as fast as possible, but we pursued it in taxis. But we could only stay at the entry of the cemetery; we were forbidden to enter. [32]

Laure Lourie, although a child at the time, remembers hearing talk of the Hébuternes' cruelty to Jeanne. Even though they had allowed her to

come home after Modigliani's death, they rejected her, and there were dreadful scenes that drove her to suicide. Mrs. Lourie says that Jeanne had been told that she had to leave the next day.[33] This may well have been the Hébuternes' decision. It may also be that her parents did not want Jeanne buried in Père-Lachaise, not so much to separate her from Modigliani as to keep the burial as quiet as possible. It is ironic that they chose distant Bagneux where Oscar Wilde was first buried in haste and shame, later to be exhumed and reinterred in Père-Lachaise under Jacob Epstein's memorial. Almost the same thing was to happen to Jeanne.

The Hébuternes did not want flowers. Jeanne's friends brought only a huge wreath made up from the flowers ". . . that were left over from the magnificent funeral of Modigliani," [34] though they could hardly have put the wreath on the grave if they were forbidden to enter the cemetery. Chana Orloff speaks of the taxis pursuing the truck that bore Jeanne's body to the cemetery. A suicide could only have burial, not a respectable funeral. Jeanne's coffin was carried on a small truck, rather than in a standard hearse, to help disguise the fact of a funeral. On the other hand, Chantal Quenneville speaks of the "pitiful hearse" being followed by two taxis, one containing the Zborowskis, the Kislings, and the Salmons, and the other "the parents, the brother," Chana Orloff, and herself. (Chana Orloff's account adds Fernand Léger to the group. It is possible that Léger and his wife, an old friend of Jeanne's also, went along. There may have been a third taxi.)

If Miss Quenneville's story is accurate—and it is the most straightforward account we have—then it would seem that the Hébuternes made a human gesture by permitting two of their daughter's old school friends to accompany them to the grave in the same taxi. Chantal Quenneville's account is also the only one that mentions Mme. Hébuterne's going to her daughter's burial.

The circumstances of Jeanne's suicide and the attitude of her family could be made clear by André Hébuterne, but he has remained silent despite the publication of conflicting and sometimes highly imaginative accounts. He has pursued his own modest career as a painter without capitalizing on his connection with Modigliani, and lives a secluded life. Although he is said to object to much that has been written of his sister Jeanne, he has done nothing to refute it. In 1954, Chana Orloff, who has expressed her disapproval of most of what has been written about Modigliani except his daughter's book, said:

Jeanne . . . was from a petit bourgeois family, and she often came with her brother to my place. Her brother's admiration for his sister was very great; nevertheless he later condemned her without pity. . . .[35]

But in 1964 she declined to comment on Modigliani without the approval of André Hébuterne, which she knew would not be forthcoming.[36] Perhaps she and André Hébuterne are both sick of purveyors of legend, sensation-mongers, and those who have made a profession of writing their reminiscences.

That André has exercised a power of censorship over some of what has been written is suggested in a letter from André Salmon [37] in which Salmon asserts that he has said all that he was "permitted to say" on Jeanne Hébuterne's death in *La Vie Passionnée de Modigliani* (published in the United States in an abridged version as *Modigliani, a Memoir*.[38] Beyond that, Salmon, who has written highly colored and unverifiable accounts of Modigliani and Jeanne, declined to comment further.

Two efforts have been made to obtain accurate information from André Hébuterne.[39] An interviewer spoke twice with André's wife, Georgette, who declined to reveal her husband's whereabouts and agreed only to forward a letter to him. From her remarks it appeared that what she knew of the story she learned from the late Mme. Hébuterne rather than from André, her husband, who refused to speak of Jeanne and Modigliani. Mme. Hébuterne was less rigid, more sympathic to artists than her husband Achille, a bourgeois businessman. In the beginning they both refused to recognize that Jeanne had become Modigliani's mistress, and after Jeanne's suicide they did everything possible to keep the affair quiet. Georgette's attitude, if it is a reflection of André's, indicates that her husband is bitterly opposed to all discussion of the tragedy; that the picture dealers (Zborowski excepted) were a pack of vultures; that everything that has been written of the affair is false. No reply has ever been received by this writer from André Hébuterne.

If he believes that he and his family have been maligned, he has had ample opportunity to set the record straight. Since he has not done so, one can only believe that he has no case; that there is no mystery about Modigliani, Jeanne, or her family; that everything happened very much as Chantal Quenneville, Chana Orloff, Jeanne Modigliani, Douglas Goldring, and others have reported it.

The testimony of André Salmon, who has written most voluminously and irresponsibly about the fate of Modigliani and Jeanne, has been discredited by its contradictions. Although the French edition of his book on Modigliani is called a novel and he has availed himself of the novelist's license to invent scenes, he declines to justify his myths. Jeanne Modigliani [40] questions his veracity; so does Mrs. Lourie,[41] because he wrote a totally untrue account of Ortiz de Zarate's death though he had the facts as Mrs. Lourie set them down.

The whole story has never been told in detail, nor—as so often hap-

pens in such painful situations—will it probably ever be. And, one might add, it does not really matter.

Enough is known from the circumstances, from the testimony of relatively unprejudiced witnesses (even granting errors and discrepancies), and from the known facts to give us the essentials: Jeanne Hébuterne seems to have been rejected by her parents in death as in life, was buried in ignominy, shame, and haste, and there is still bitterness in the family, though Modi and his beloved Jeanne now share a peaceful grave in Père-Lachaise Cemetery and Modigliani grows in stature every year.

◇ ◇ ◇ Chapter Thirty-seven

"Like the vine that produces the grape he asked nothing more."

Simone Thiroux had been right when she had written to Modigliani that her health was bad and tuberculosis was sadly doing its work. Simone lived as recklessly as Modigliani. Her son, Serge Gérard, was everything in her life, as she had claimed. But Simone was no more constituted to look after him than she was to look after herself. Her repudiation by Modi had drained her spirit, sapped her vitality. There seems little doubt of her genuine love for Modi. She went to see him on his deathbed (as reported by Lipchitz) and walked in his funeral procession ". . . almost unnoticed in the crowd . . . a tall, pallid girl . . . sad and silent."

Living in the same building as Dr. and Mme. Diriks, at 207 Boulevard Raspail, Simone continued to support herself as a nurse or assistant nurse at the Cochin Hospital, though she had neither the strength nor the temperament for the job. Simone worried about her son (being cared for by a nurse in the country), particularly his illegitimate status, but she seems never to have given marriage a thought. For her there had been only Modigliani, the abortive hope of a "moral reconciliation" between them, and the recognition of her son by the man she insisted was his father.

Simone never held Modi's ill treatment of her against him. Her friends took sides—many of them were furious at his callousness—but Simone seems never to have excoriated Modi or otherwise expressed any resentment of his actions. This might lead one to suspect that, although Simone might be sure the child was his, she recognized that Modi's having caught her in an incriminating situation with another man gave both men

the benefit of the doubt and a plausible out. Now her health grew worse and, as was her nature, Simone did nothing about it.

This was not stupidity or even indifference. Simone was a good-hearted, easygoing girl incapable of taking anything that happened to her with the seriousness it demanded. Just as Modigliani had roamed Montparnasse with a racking cough and spat blood, so Simone persisted in going out, sitting on café terraces, proudly displaying her blood-stained handkerchief. Simone never denied that she was sick; she laughed it off and tried to be gay.

Simone continued to neglect her health to the day of her death, which seems to have been about a year after Modigliani's. One day Simone insisted on bringing a flower up to Mme. Diriks in her seventh-floor apartment, although there was no elevator. The concierge told Simone that she was much too weak for such a climb and would gladly take the flower up for her. Simone refused; Marguerite Diriks had always been so kind to her that Simone wanted to give it to her friend herself. This gesture also expresses very well the foolishly lovable side of Simone's character.

She arrived at the Diriks' red-faced and panting. Mme. Diriks was furious, although she did appreciate Simone's thoughtfulness. She made Simone promise to go down to her room and get to bed immediately. Mme. Diriks had to go out in the afternoon. She stopped in at Simone's on the way. No one was there. Later, Mme. Diriks passed the Rotonde. It was near the apéritif hour. There, on the terrace, sat Simone.

I was so angry that I pretended I hadn't seen her, but she ran after me, making all sorts of excuses and saying that she had only come out to get some air for half an hour.

"You must be crazy sitting out there in mid-winter. And I told you you were not to get up, let alone go out. Now will you obey me, or will you not? If you won't, I shall never have anything to do with you again. Never even speak to you!"

But Simone could not take anything seriously. As Mme. Diriks told it, she

. . . laughed gaily and coughed. I noticed with horror that the handkerchief that she put to her mouth was blood-stained. Again she failed to keep her word. Instead of going to bed, she went after dinner to dance at the Café Versailles. Later in the evening she had a severe hemorrhage and was rushed to the Hôpital Cochin. There, shortly afterwards, she died.[1]

The parallel with Modigliani—the recklessness, the negligence, the short but intense life, the premonition of death, and the repeated refusal

to take precautions—are striking and not accidental. One could say of Simone as Léon Indenbaum said of Modigliani, *"Au fond elle s'est suicidée."* It is a little consolation that, as Mme. Diriks said, her death was quick. Nothing is known about her funeral or her burial, but her good, understanding friends Dr. and Mme. Diriks and Mr. and Mme. Fritz Sandahl must have taken care of them.

Finally, there was the question of what should be done with Simone's handsome little son, Serge Gérard. Mme. Camilla Sandahl took the train to the country, presumably Normandy, to fetch the little boy. On the return trip to Paris, Mme. Sandahl and Serge Gérard shared a train compartment with a pleasant, elderly couple. The man was a retired army officer.[2]

Serge Gérard was a charmer—a toddler apparently as *joli comme un cœur* as his father before him. "The small boy crowed and laughed and sang and seemed such a gay little person that he won the hearts of the couple." Mme. Sandahl found them so interested that she couldn't resist telling them ". . . the whole story, which excited their sympathy." Having lost a child of their own, the couple were immediately eager to adopt the little boy. Mme. Sandahl answered their "intimate inquiries" truthfully, ". . . seeking to hide nothing of the faults of the father, nor, naturally, his reputation as an artist now that he was dead." Simone's background was acceptable, but "The couple seemed mostly scared by the artist side of the parentage." [3] Nevertheless they still wanted Serge Gérard as their own, but stated several conditions.

They stipulated that the boy was to be examined by three specialists to make certain that he was not tainted by tuberculosis, which he could have from both his mother's and his father's side. Their absolute condition for adoption would require that all rights to the child be given up by all friends and relatives and, most important, that no research ever be undertaken, if they did adopt him, to discover his whereabouts. Until after the physical examination Serge Gérard lived with the Sandahls in Paris. He was "a chubby, attractive little fellow" of three and a half, with "a way of screwing up his mouth, when displeased, exactly like the contemptuous, haughty expression of his father." And "he had learned parrotwise from his country nurse" two lines of a song that couldn't help reminding Fritz Sandahl of Modi:

> *Camarades des vignerons*
> *Je te dis courage.*[4]

Considering Modi's fondness for wine, Gérard's piping to the comrades of the vine growers that they take courage had its own rueful appeal. The adoptive couple suffered as they waited the decision of the doctors. The

retired officer insisted that Gérard looked just like the son he had lost, and ". . . wept with anxiety lest the boy be condemned. . . ." Afraid that this might happen, the wife refused to visit Gérard during the tense waiting period. Fortunately, Serge Gèrard passed all medical tests, showing not a trace of the tuberculosis that had stricken both his parents. Now, "furnished with a medical certificate certifying the boy as sound," the delighted couple took him away with them.

It had been a condition of the adoption that the identity of the adoptive parents be kept secret. Mme. Sandahl was one person who knew their name, but she is dead and probably never disclosed it. Mme. Diriks may have known their name but would not reveal it, having given her word. Nothing further was heard or known of the boy until some seven years later when Mme Sandahl received a photograph in the mail, ". . . without a word or any address, portraying a handsome boy . . . , who strikingly resembled Modigliani." [5]

Mme. Sandahl showed it to Mme. Diriks. The boy would then have been about ten; the resemblance to Modigliani was unmistakable. It is understood that Jeanne Modigliani recently tried to trace this alleged half-brother, but without success. At the time they were interviewed in March, 1963, the Diriks mentioned rumors that had this "lost" son of Modigliani (who would then have been forty-five) a picture dealer somewhere. In any case, Dr. and Mme. Diriks thought it a wild story, completely untrue. It is typical of the Modigliani legend. For Modi to have an art dealer for a son would be too great an irony.

Although several portraits are attributed to 1920, it is doubtful that Modigliani did any painting at all between Christmas, 1919, and his death on January 24. His last painting—and, according to some, found on his easel in the Rue de la Grande-Chaumière studio after his death— was the *Portrait of Mario*, "the Greek composer Mario Varvogli." [6] Varvogli was shown in a black felt hat and black overcoat and seated in a chair. His head was tilted to the right, his right elbow propped on the back of the chair, right hand dangling, left hand on his lap, his left leg crossed over his right.

The colors were deep, muted blacks and reds. There was no swan's neck for Mario, and the distortions were subtle. The sitter was posed before a door, a favorite background of Modigliani's and one in which it is possible to read too much symbolism. As with his portrait of Baranowski, Modi used

his late, serpentine, compositional formula. But whereas Baranowski is set before us in a space that is hardly defined, Monsieur Mario is given not merely the classic Modigliani door, by way of rearground, but also

the slanting floorline with which Modigliani had begun to experiment in 1918: cf. the *Gypsy Woman* and *Mme. Amédée* in the Chester Dale collection.[7]

Modi made sketches and studies for this portrait as he did for all his portraits. Russell says that a preliminary drawing of Mario's head and shoulders is in the Museum of Modern Art. Mario, in this portrait, is gazing intently at the painter, his eyes black oval slits, his mouth pursed, a shadowy stubble around it. This is a fine, finished painting with all the psychological insight that even a Paul Guillaume might have wished for. What is outstanding, considering Modi's physical condition at the time, is that no deterioration is evident in the work. The portrait is hard and firm, clean and precise, well organized and composed—as good as any Modigliani.

In spite of Zawado's claim that he took over the studio and stories that the studio was ransacked by dealers, nothing seems to have been touched until the arrival of Emanuele Modigliani. Jeanne Modigliani says that after Emanuele received Zborowski's telegram informing him of Modi's death, he had to wait almost a month to get the necessary passport to go to Paris [8] even though he was a deputy and first-rank political figure. A lawyer himself, and only too familiar with the habits of his brother, Emanuele could not have been too surprised to find Amedeo's affairs in a dreadful legal mess.[9]

The family had apparently come to a decision regarding little Jeanne: Margherita wanted to adopt her. One can only reflect on what Modi would have said at the prospect of his spinster sister, with whom he was always out of sympathy, taking charge of his daughter's life. The great complication was the fact that she was born in Nice and ". . . Modi had neglected to register her birth, so that legally she did not yet exist." The Hébuternes also had a valid claim to the child. Emanuele apparently discussed the matter with them. They were more than willing to surrender their rights: they had never meant to exercise them. The Hébuternes wanted no reminder—certainly not a living one—of the scandal, the guilt, and shame that oppressed them and would continue to.

After corresponding with Emanuele, it must have been Zborowski who met him at the station, accompanied him to Modi's studio, and then to the Hébuternes in the Rue Amyot. Emanuele's impression of them is rather more charitable than one would expect. But then, it was easier for him to be objective. He described Achille Hébuterne as

. . . an inoffensive little man in a frock coat, with a goatee beard; the typical Frenchman of 1900, evidently with ideas to match. . . . The Hébuternes had acted more from stupidity and utter lack of compre-

hension than out of malice; they were hopelessly narrow in their views, and not sufficiently large-hearted and tolerant to forgive their child's lack of reverence for their own little gods.[10]

Emanuele's judgment, while it does not excuse the Hébuternes' behavior, at least explains it. Not only is it fair and honest, but one is inclined to think that even Modi would have agreed with it. The "stupidity and utter lack of comprehension," narrow-mindedness, smallness of heart, and intolerance were the very qualities that had epitomized bourgeois morality to Modi. ". . . Their faces will need bashing for another three hundred years," he had once said to Ilya Ehrenburg.[11] Emanuele also went through his brother's "effects" in the forlorn, miserable studio. He gathered together drawings, male figure studies, and, presumably, Modi's poems, which were later to be published in Italy. Among other papers he found a horoscope of little Jeanne and a post-office order for the nurse who lived near Orléans. Emanuele also came on ". . . the quaint contract of marriage made by Modi, which he had believed to be in order." [12] It showed Modi's intention of marrying Jeanne when the proper papers came through, but it had no validity whatsoever. Emanuele could only have smiled at his brother's naïveté and "his ignorance of legal matters" that had caused Modi to bungle everything. "The non-registration of the birth at the Mairie in Nice caused interminable trouble to set right."

One wonders how it came about, since there is no record of Zborowski's having known him, but Emanuele managed to meet Dr. Paul Alexandre, Modi's good friend and patron from the fall of 1907 through the outbreak of the war in 1914. One also wonders why Dr. Alexandre, so far as is known, never took the trouble to look Modi up after returning to civilian life from his years in service. Emanuele saw the paintings that Alexandre had bought, the many drawings, and ". . . the school copybooks, filled with studies of anatomy, which showed that even in his early days Modi had evidently been attempting to work out a new form."

There seem to have been no paintings in Modi's studio. What was there, besides the last *Portrait of Mario,* must have been taken by Zborowski as his contractual right, not by dealers who invaded the studio. At the time he was in Paris settling Modi's affairs and the matter of adoption of little Jeanne, Emanuele ". . . inquired about his late brother's works and was informed that there was none now unsold." Modi had already been dead over a month, and this was well after "the onslaught of the dealers who would not recognize his talent while he was living." [13] Emanuele could have seen dozens of Modi's paintings at Zborowski's apartment in the Rue Joseph-Bara, but there is no further mention of

Zbo. It may be that Zbo was afraid that he might have to surrender all Modi's paintings to the family, thus losing an investment that represented all his capital. Apparently startled to hear that everything of Modi's had been sold, Emanuele smiled and said, "However, after I assured the interested parties that I did not intend to claim them, but wished merely to see my brother's latest works, quite a number were unearthed." [14] Emanuele frankly admitted that he "did not understand Modi's pictures, personally preferring the Academic style." Since this put him with the majority, Modi would not have been in the least surprised.

Although little Jeanne was with a nurse just outside Paris, Emanuele ". . . in company with an uncle, . . . went down to Orléans in search of the child." Since neither André Hébuterne nor Umberto were legally her uncles, the loose wording must refer to an uncle of Emanuele's, probably a Garsin from Marseille. Then, in what sounds like a rags-to-riches theme in keeping with the legend:

> From a peasant's cottage little Jeanne was immediately transferred to a sumptuous villa in the Midi, owned by mutual friends, while awaiting the completion of the formalities—a long process—for her legal adoption by her aunt.[15]

Simone Thiroux was still alive in Paris, but she did not bring the problem of little Serge Gérard to Emanuele's attention as she could have. If the boy was Modigliani's son, as the evidence seems to indicate, he had as valid a claim as little Jeanne on the family. Their obligation to Simone and her son was as strong as hers. Zborowski could have brought the matter to Emanuele's attention, but he realized how complicated and uncertain the situation was. There were no doubts about little Jeanne; there were grave doubts about the paternity of Serge Gérard. Ironically, if Emanuele and his family had known of Serge Gérard's existence, it would have been far easier to adopt him than it proved to be to adopt the little girl. Legally, Serge Gérard was a better candidate for adoption than Jeanne except that Modi had heatedly denied his paternity.

Although Modi bungled matters by failing to register his daughter's birth in Nice, his devotion to her did help in the end. Léopold Survage says that Modi went to a great deal of trouble to find the proper person to look after his baby girl while in Nice, finally settling on an Italian *nourrice,* and that corroboratory letters were found that assisted in the child's legitimization.[16] But it was little Jeanne's maternal "grandparents" who really cleared the way.

In her book Jeanne Modigliani reproduces part of a document, dated March 28, 1923, showing that the Hébuternes appeared before a Paris notary, called Maître Maxime Aubron, and made a sworn declaration

MODIGLIANI

intended to clarify judicial matters, both in France and Italy, pertaining to the birth of the child. It began:

> From our marriage there was born on April 6, 1898, a daughter, Jeanne Hébuterne who, from her birth until the age of which we will speak, lived with us in Paris. In the month of July, 1917, our daughter met an Italian painter, Amédée Modigliani of Leghorn, who lived in Paris. They fell in love with each . . .[17]

Jeanne's parents appear to have relented still further about 1930. Perhaps they had mellowed; time had softened them and put a new light on their tragedy. Or perhaps they sought to salvage their guilt by yielding to public opinion. To be more generous, perhaps they had a change of heart. The Socialists in Italy had been finished since 1924 when their leader, Giacomo Matteoti, was brutally murdered by Fascist thugs. Mussolini was in power. Il Duce's dictatorship was so firmly established that Emanuele, as well as other Socialists, had been forced to flee to Paris as exiles. Friends of Modi and Jeanne had always wanted it; now, with their help and time, the eloquent Emanuele "persuaded the Hébuterne family to allow him to have the remains of their daughter exhumed" from the Bagneux cemetery and reinterred next to Modigliani. (See photograph, facing page 417.) ". . . The inscription on the flat granite gravestone in the Jewish section of the cemetery of Père-Lachaise," reads:

AMEDEO MODIGLIANI

Pittore

Nato a Livorno il 12 Juglio 1884
Morte lo colse il 24 Gennaio 1920

Quando

Giunse alla gloria

JEANNE HÉBUTERNE

Nata a Parigi il 6 Aprile 1898
Morta a Parigi il 25 Gennaio 1920
Di Amedeo Modigliani compagna
Devota Fina all' estremo
Sacrifizio [18]

So they were together again, Modi, the painter who had died just as he had attained his greatest glory, and Jeanne, his devoted companion to the last sacrifice.

When Lunia Czechowska returned to Paris and the Rue Joseph-Bara in September, 1920, she did not know that Modigliani was dead. From time to time she sent him flowers—surely a strange gift from a woman to a man. When she asked the Zborowskis for news of Modigliani, they told her he was in Leghorn, his health at present so poor that he was unable to paint. Undoubtedly alerted by the Zborowskis, other friends told Lunia the same story. She did notice that they avoided mentioning Modi. Lunia thought it strange, and accused them of having forgotten him.

The first night she stayed with the Zborowskis, Lunia had a strange dream about Modi that disturbed her so much that, although it was very early, she hurried into Hanka's room to tell her about it. Lunia asked her when the Zborowskis had last heard from Modi. Hanka reassured her so convincingly that Lunia did not insist. But that afternoon, Lunia went to see a Swedish friend who knew of her bond with Modigliani but nothing of the conspiracy of silence adopted by the Zborowskis. It was this friend who told her the news of Modi's death and Jeanne's suicide. Lunia was shocked, but she could not hold it against Zbo and Hanka that they had neglected to tell her the truth immediately and then lacked the courage to tell her later.[19]

Nina Hamnett also came back to her adored Paris in March, 1920. She had heard of the double tragedy of Jeanne and Modi and had her own opinions. The Hébuternes "were *sale bourgeoisie*." That told the whole story. She repeated the story of two friends of Modi's, whom she did not name, watching over Jeanne's body "in case mice or rats were about the place." Possibly explaining why Zawado found so many bottles in the apartment, ". . . they brought some wine and spent the night there." Nina also added a new touch. "On the day that Modigliani died his cat jumped out of the studio window and was killed." [20]

She goes on, embroidering gaily, to claim that Jeanne "had always said that she would like to be buried in the same cemetery he was." The family had refused, taken her to the Cimetière de Bagneux, but the mourners got even. "The friends of Modigliani and she went very early in the morning to the funeral and when the moment came when the funeral guests shake hands with the relations, they stood with their hands behind their backs as a protest." [21] Nina continued with her art, met everybody, lived by her wits, and stayed on in Paris, courtesy of a Belgian passport that she had obtained easily in London.

Inevitably she ran into Beatrice Hastings, who, said Nina, "had been sensible enough to stay in Paris during the war." One night, while they were together at the Rotonde, Nina spotted a badly dressed "young man with long fair hair." Nina acknowledged that "It was a repetition of Edgar," for now Beatrice said he was a very talented artist and asked if

Nina wanted to meet him. Nina rashly said yes. They all went off to somebody's studio in the Rue de la Grande-Chaumière, the fair-haired young man being then very drunk. Nina "had an awful presentiment that at any minute I should fall in love with him." She did. She asked him to her studio later, and they enjoyed each other's company. "I was delighted with him and we sang to his guitar and drank white wine all afternoon." 22

Broke again, Nina, who never lacked friends, wrote to London for help and had thirty pounds sent to her. She continued to cling to her fair-haired young man, but she was too trusting: she gave him all her money, and he promptly ran off with a woman friend of hers. Penniless, she went to see Marie Wassilieff and wept on her shoulder. She called on Zborowski. Generous as ever, Zbo gallantly loaned Nina a hundred francs. Lovesick and abandoned by E., as she referred to him, she continued to pine. Marie let her stay in her studio. Nina lingered here, crying for a whole week. Then Marie got very bored, threw her out, and Nina returned to her dreary, dirty hotel.

During all this time the "nice Arab" (Abdul Wahab Gelani) and "the other Pole" (Zawado) were very kind to her. Now Zawado "who lived in Modigliani's studio said I could come and work there if I liked." Zawado wanted to marry her, but she told him of her initial mistake with Edgar. Nevertheless they went south with Foujita and his wife, and they all had a gay, mad time.

Nina found Modigliani's studio very uncomfortable, but she didn't mind as she was quite used to discomfort. Zawado sold pictures to Zborowski, who even loaned them "a spare copy of Modigliani's death mask." Sitting on either side of Modi's old scarred table, Nina and Zawado read French classics in the evening by the light of a kerosene lamp. The death mask gave them the creeps. "It was rather horrible as his mouth had not been bound up and his jaw had dropped. It looked terrifying through the door of the first workshop in the shadow. We felt that we had to keep it with us, because if we did put it out or give it away it would be a breach of friendship." 23 Very often Abdul Wahab Gelani spent the evenings with them.

Paris continued to be full of memories of Modi. At her little restaurant in the Rue Campagne-Première, "Rosalie . . . wept when Modigliani's name was mentioned, although, when he was alive, she threw him out several times a week." Times were hard for the young artists. They sketched and they painted and they had no money among them. They had a cat, too. Nina wrote of a time when they were very broke, she, Zawado, and Abdul. For three days they couldn't turn up so much as a penny, but took a broad view: ". . . We did not mind much about our-

selves, but we were sorry for our cat, who had to starve also." Then, un-expectedly, they were saved:

> We had a lot of Modigliani's books and in despair the Pole took one on philosophy and read it to us. As he turned the pages he suddenly came on a HUNDRED FRANC NOTE. Modigliani's wife used to hide money away from him and this was one of his notes. We were so delighted that we rushed to the nearest workman's restaurant, taking the cat with us, and drank to Modigliani's health all evening.[24]

Jeanne Hébuterne may have tried to save money by hiding it, but she had the opportunity about as rarely as she had the money. If she did slip the hundred-franc note into the philosophy book, she must have forgotten about it. In those last trying weeks she and Modi could have used a hundred francs. Or perhaps Jeanne had put it aside for that long-talked-about, long-hoped-for trip to Italy, which was never to be. This piece of good fortune and haunting memories were all Nina Hamnett was to have of Modi. She had long since given away those drawings of his that she had bought for five francs each.

Although Nina seems to have lived with Zawado for several years in Modigliani's old studio in the Rue de la Grande-Chaumière, Zawado did not mention her when interviewed, and much of his information about Modi is based on legend, not fact.

Zawado told of an American, possibly attracted by the legend, who dropped in unannounced at the studio. He looked around, and noticed a palette Zawado had hung on the wall. It was, in fact, Modi's palette. After asking the price and bargaining, the American bought it for 150 francs. Zawado thought this a very good price at the time, and promptly spent it, celebrating the occasion with friends (in the same spirit as related by Nina earlier). Sometime later, another customer turned up and saw a palette hanging in the same place. Assuming it must be Modigliani's, he also wanted to buy it. Zawado made the sale at the same 150-franc price. Selling palettes became quite a profitable trade: Zawado kept hanging up new palettes, making sure they had a well-used look.[25]

The death of Modigliani, although it could not have been unexpected, shocked and stunned his friends and fellow artists into taking stock of their own lives. His death was sudden, unreal, and terribly final. Life no longer seemed quite so gay. Modi's end was a warning. They carried on as usual and looked the same, but they were not the same. Chaim Soutine perhaps felt the blow most deeply:

The calamitous extinguishment of this artist of greater facility and more fortunate background must have caused all of his friends to doubt the feasibility of their wild, artistic life, and it is possible that the emotions precipitated in this event expressed themselves in certain tumultuous and obscure canvases which Soutine did at the time.[26]

After the funeral Soutine returned to Céret and painted a large number of sinister canvases in which, said Mme. Marcellin Castaing, *"il jetait sa gourme,"* he got rid of his black feelings.[27] Kisling, who was one of the gayest and most convivial men in Montparnasse, also felt Modi's loss deeply. Although he was to have a highly successful career, Gino Severini says that after Modi's death Kisling painted decidedly less good pictures.[28] The slickness began to show a little, the striving for commercial success.

The Modigliani boom continued. Zborowski did not then or later reap quick profits. The first Modigliani exhibition seems to have taken place at the Galerie l'Evêque in Paris in 1921. This may well have been the posthumous show Zbo had mentioned to Emanuele in his letter. In February, 1922, thirty-nine of Modigliani's paintings were shown at the Galerie Bernheim-Jeune, also in Paris. And that same year Modigliani's work was first exhibited in Italy when twelve of his paintings were hung at the Thirteenth International Art Exhibition in Venice.

Further exhibitions followed at the Galerie des Champs-Elysées and the Galerie Bing, both in Paris, in 1924 and 1925; in 1926 thirteen of his paintings were shown on the occasion of the Thirtieth Anniversary of the Salon des Indépendants. Six of these were listed as the property of Paul Alexandre. These included *The Jewess; Portrait with a Crucifix* (which is hard to identify from its title); *The Cellist; Nude—Jeanne Seated* (this was the young prostitute who was a patient of Dr. Alexandre and of whom Modi painted several nudes); *The Beggar Woman,* and *Portrait of Paul Alexandre Before a Windowpane.* Paul Guillaume showed a portrait of himself and one of Jean Cocteau. Felix Fénéon had his *Sleeping Woman with Hands Back of the Nape;* the police official Zamaron lent two untitled portraits; Jacques Netter showed another, and there was a *Portrait of a Young Woman* owned by Marcel Bernheim.

Zborowski's name is conspicuously absent from the list of those who lent their paintings to the show, probably because he no longer owned any Modiglianis.

Modigliani was not shown in an American gallery until 1929 when De Hauke & Co., Inc., in New York displayed thirty-seven of his paintings; in 1931 the Demotte Galleries, also in New York, hung twenty-nine. Since then hardly a year has gone by without a Modigliani Exhibit in Boston, Los Angeles, New York, Paris, London, and in galleries and mu-

seums all over the world. Modigliani was exhibited as a part of a collection, which included Soutine, Picasso, Matisse, Derain, Pascin, De Segonzac, Kisling, Utrillo, Laurencin, De Chirico, Alexis Gritchenko, Hélène Perdriat, Kars, and Lotiron, owned by Dr. Albert C. Barnes and shown by him at the Pennsylvania Academy, Philadelphia, in April, 1923.[29]

Although ten years had passed since the scandalous Armory Show, modern art was still far from being accepted. Matisse, Picasso, Utrillo, Pascin, Derain, Kisling, and Perdriat drew some grudging praise from local critics. Soutine was anathema. "Morbid, emotional and unliteral . . . diseased and degenerate," said one critic. Further, "a group of doctors, psychologists, and alienists headed by Dr. Francis X. Dercum" had their say. Dr. Dercum and his henchmen unanimously agreed that

> the artists who painted such things were either crazy or moral degenerates. . . . The works represent . . . ghastly lesions of the mind and of the body. . . . The work of insane persons who lean toward art . . . are far superior to the alleged works of art I saw at the exhibition. . . .[30]

Dr. Barnes, hurt and infuriated, took "drastic revenge" on the American public and on critics. When his Foundation finally opened, it was open only at his whim. He screened visitors, slammed the door on some —including very well-known people—and opened halfway to others. So the Foundation was to remain for years; and even today, more than fourteen years after the doctor's death, entering the Foundation is a formal, legal ritual.

Although he was more interested in Soutine, and seems to have bought Modigliani only as an afterthought, it was Barnes's investment that made Modi's paintings soar in price. In the first two years after Modi's death, the prices increased each time his paintings were bought and sold, but they probably could have been bought anywhere for from $100 to $400 apiece.

When Dr. Barnes turned up unexpectedly at Jacques Lipchitz's studio in December, 1922, with Paul Guillaume, Lipchitz was doing badly and had no prospects. The sight of his enemy Guillaume, with whom he had quarreled bitterly "over a matter of theory and principle," further angered him. He had no way of knowing that Barnes, who had just bought a great deal of African sculpture from Guillaume, had agreed to the dealer's suggestion that they visit young Lipchitz, one of the most advanced of the modern sculptors.

Seeing Guillaume and a stranger at the door, Lipchitz did not want to let them in, ". . . but Berthe [his wife] insisted, reasoning that after all Guillaume was a dealer and Lipchitz badly needed a patron." Barnes

bought eight pieces of his sculpture. It all came to "ten per cent less than he had asked for," but Lipchitz was saved. Barnes also gave Lipchitz a contract for some sculpture to fill five special niches in his projected art museum in Merion. Lipchitz and Barnes also became good friends. Lipchitz accompanied him around Paris with two other artists, Moïse Kisling and Jules Pascin, whose work Barnes had also bought. Barnes, who considered Guillaume's gallery a shrine, just at this time had been very taken with a painting of Soutine's, *The Pastry Cook,* which was in his window. There is no way of proving it, but it was undoubtedly Zborowski who urged Guillaume to feature this portrait, also known as *Le Petit Patissier,* in his gallery. And Guillaume, remembering Modigliani, decided to take a chance on this single picture of Soutine's.

Barnes was apparently unable to buy *The Pastry Cook,* in time to become one of Soutine's most famous works, and, it has recently been revealed, a masterpiece that might well never have survived had it not been for the frantic efforts of Zborowski. A story in *The New York Times,* dated April 26, 1966, told of a lawsuit being brought against the mighty Louvre by Santiago Commeno, an Argentine painter specializing in restoring damaged art, for the museum's failure to identify Soutine's *The Pastry Cook* as an original copy by Commeno.

Once a showpiece of the Domenica Walter Collection of nineteenth and twentieth century art, *Le Petit Patissier* was given to the Louvre in 1965. Commeno explained that Soutine had "damaged his own painting beyond repair in 1924 during a fit of alcoholic anger," and that "Leopold Zborowski, a friend of the painter, had asked Mr. Commeno to copy it."

The Argentine art restorer stated that, unless the Ministry of Cultural Affairs agreed to label the Louvre's *Pastry Cook* as a copy of Commeno "after Soutine," he would demand $4,000 damages.

That Zborowski should have done such a thing to preserve his friend's masterwork shows the lengths the dealer was prepared to go to save Soutine from himself. Zbo had done the same, many times over, for Modigliani."

Soutine was still an unknown, his thick, hot colors, his twisted, dancing composition appreciated by only a very few. According to Lipchitz, "Barnes seems to have recognized his unique talents," insisted on seeing more and, with the sculptor, Kisling, and Pascin, went over to see Zborowski at 3 Rue Joseph-Bara.[31]

The three years Soutine spent mostly in Céret were the most prolific in his life; between 1919 and 1922, Soutine painted over two hundred canvases. "His accelerated production has been attributed to his alarm at the death of his friend Modigliani." [32] Now his work was piled up around the walls of Zbo's apartment, and Lipchitz says ". . . he had just returned from Céret . . . with some of his newest landscapes of the

Pyrenees with their exuberant colors." Whenever people came to the apartment, Zbo took out Soutine's work and praised it as enthusiastically as he had Modi's. He gave *Dead Rooster with Tomatoes* to Francis Carco, but with Barnes the situation was different. Here was a man prepared, on an impulse, to buy all the Soutines he could get hold of. What a break for Soutine, who had been so depressed since Modi's death that Zbo had had to dissuade him from burning *all* his work!

Barnes, on this January day in 1923, after having done most of the Paris museums with Lipchitz, cleaned out the city's art galleries for a reported three million francs' worth of paintings, and bought some Pascins and Kislings, now put in a bid for all of Zbo's Soutines. He offered 60,000 francs, $3,000, or $50 apiece for the sixty paintings. Zbo accepted the offer although the price was dirt cheap. He was probably so thankful, so astonished that it did not occur to him to haggle. Perhaps another dealer, certainly Paul Guillaume, would have pegged the prices higher once it was clear to him that Barnes was "hooked." Lipchitz himself had been smart enough to set good fat prices on his sculpture as soon as he realized that Barnes was going to buy. But Zbo, through no fault of his own, was not that kind. William Schack, Barnes's biographer, writes:

> Leopold Zborowski was not a shrewd dealer—he was neither shrewd nor a dealer by choice, but a poet who shared his meager income with his friends Soutine and Modigliani, and had their pictures on his hands. He was willing to sell cheap because he had yet to sell a single Soutine; and the artist was willing to sell cheap for the same reason and because he needed a sign of recognition as much as he needed money.[33]

The statement is true but not altogether true. Zbo was a salesman. He believed in Modi and Soutine and handled their paintings because no other dealer would. He sold cheap because, otherwise, neither painter would have sold anything. Neither Modi nor Soutine told him how much to sell for, leaving prices up to Zbo. It is doubtful, therefore, that Zbo consulted Soutine about Barnes's offer. This bonanza, according to Lipchitz, sent Soutine into a joyous delirium. Pocketing his money from Zbo, he ran out into the street, hailed a cab and, holding up the wad of money, ordered the driver to take him to the Riviera—to Nice. And as success opened up to him, he continued to be a twisted, whipped-dog type of man, but he lived very differently. He stayed at the Crillon Hotel, thoroughly enjoying his money.

Who could blame him? It had been an agonizingly long haul. His wild extravagances are understandable. What is not so understandable was Barnes's boast to the American collector R. Sturgis Ingersoll: "I found

Soutine when he was sick, cold and broke. I took the contents of his studio for a song." Delighted with himself, Barnes laughed as he said it; Ingersoll found the "words sickening. . . ."[34] Lipchitz had a rare understanding of Soutine: as an artist he had gone through the same torture, personal sorrow, confusion, to find himself:

> Soutine's aspirations were of the highest order, and out of the darkness to which he was rushing came the brightest glow. The death of his dearest friend, Modigliani, was a spur to his emotion and he was immersed in fears, trials, driven to hysteria by what he thought was the inadequacy of his paintings which he tried to set on fire. Yet he was able to seize the creativity in him and knead it to his purpose, and in that period emerged his unique and vibrant style.[35]

Great artists, Modi included, all seem to have gone through some hell to produce their best work—the work they had always wanted to do, dreamed of doing, and which had, until then, always escaped them.

At the time Barnes bought Soutine's paintings, he also gave Modigliani a boost by buying all the canvases Zbo had on hand. The price he paid is not known, but it must have been greater than the amount he paid for the Soutines. Despite claims to the contrary, Barnes does not seem to have been as fond of Modigliani's work as he was of Soutine's. Modiglianis were then in demand in Paris, and Barnes must have been aware that he was investing in a good thing. To see how a legend can get started—and Barnes was the type to start plenty—consider this statement by his biographer:

> Zborowski had also not sold any of his Modiglianis up to this time. Not even the artist's sensational life and his death at thirty-six from tuberculosis brought on by dissipation, nor the suicide of his mistress when she learned of it, had aroused interest in his painting. . . . His . . . work, poles apart from that of Soutine, also appealed to Barnes, and he became one of the discoverers—some say *the* discoverer—of Modigliani, the first buyer of his paintings.[36]

The number of Modiglianis owned by Barnes remained a mystery until the Barnes Foundation was finally opened to the public in March, 1961. The collection, headlined as a "$400 Million Treasure 'Hidden' 38 Years," was estimated to exceed a thousand items, most of them masters of the twentieth century. It included Titian, Rubens, Bosch, Goya, El Greco; many pieces of primitive African sculpture; modern sculpture by Lipchitz, Zadkine, and others; two hundred Renoirs, one hundred Cézannes, seventy Matisse oils, and almost thirty Picassos. But according to Emily Genauer of the New York *Herald Tribune:*

The surprise of the collection is the exceptional quality of its many works by Modigliani and Soutine. These, along with the brilliance of the really great canvases by others, alone make a visit to the Barnes collection a memorable experience. . . .[37]

Modigliani and Soutine (who died in 1943 of a perforated ulcer during the German occupation of France) were joined like heavenly twins of art, the stars of a great American collection, their paintings worth thousands and thousands of dollars, their reputations great, secure, and international. Unbelievable! Yet neither artist would have been particularly surprised, for that had always been their destiny. Leopold Zborowski had always been sure of their position. He had never had a moment's doubt after he befriended them. If he ever took time to reflect, he must have considered his life worthwhile merely for having established this unlikely pair where they belonged among the giants of art.

It cannot be denied that without Zbo's faith and heroic efforts on their behalf, Modigliani and Soutine might still be unknown today—or, at best, worth a bare footnote apiece in a history of art. In spite of his work, his optimism, his continual search for young, original talent, Zbo never found another artist to touch either of them. He made enough money to open his own art gallery, to live comfortably, to have a car and a luxurious, fur-collared coat to impress the impressionable, but he was never a successful businessman. He was too generous, too trusting, too warmhearted.

The young artists he subsequently unearthed, promoted, and subsidized—Ebiche, Richard, Fourrier, Farrey, and Béron—proved to have neither the talent nor the promise Zbo had seen in them. As he had with Modi, Zbo deprived himself to help his parasitic protégés who, Kisling told Goldring, "would lie in wait for him at the Café du Dôme." This was always after the news had spread that Zbo had sold some paintings. Zbo would treat the gang to drinks, then dispense "each worker his due." Then, Kisling said, the "hard luck" boys surrounded him, and Zbo "would think nothing of giving a thousand francs to one, five hundred to another, and so on. . . ."

Kisling felt that Zbo remained a poet with his head in the clouds, that it was "his idealistic, anarchist principles" that prevented him, "not so much from making money, as keeping it." He took "insane risks." In the days of his gallery on the Rue de Seine, he once had a 100,000-franc Gauguin on exhibition. A "wily German" convinced him that he had "a sure buyer" in Berlin. The gullible Zbo turned the painting over to him without even a receipt or a down payment. "He never saw the German nor the canvas again" and was unable to take any legal action. To pay back the debt, he did sell a number of Modiglianis, Soutines, and Kis-

lings at a profit, but he had yet to learn his lesson. The next time "a suave but impecunious member of the French nobility" talked Zbo into letting him show his Utrillo collection, for which the dealer had paid 200,000 francs, to another interested "nobleman." The result was the same.

While Zborowski did make money on his Modiglianis after Modi's death, Kisling said, ". . . He did not make nearly as much . . . as people imagined and he would have done if he had hung on to them and had the foresight not to sell too early."

In 1931 Zborowski became chronically ill and had to give up his business. His funds were so low, said Kisling, that "friends had to aid the ménage and arrange for a chemist to supply medicine on credit, and for tradesmen to supply food for his wife and for Paulette and the child." Deeply in debt, Zbo died of pneumonia and heart complications on March 24, 1932, a tired, worn-out forty-three. Never a moneymaker or a professional dealer, Zbo proudly listed himself as *homme de lettres* on his identity card, not a *commerçant*. And one must agree with Goldring that there was something rather beautiful, even unnatural, in the way Leopold Zborowski sacrificed himself and his literary ambitions for his *poulains*. His name will remain forever linked with those of Modigliani and Soutine.

After her husband's death Hanka Zborowska had many obligations to meet. She would have found it exceedingly difficult to discharge them had it not been for André Derain, a good friend of both Modi and Zbo, who gave her some of his paintings. By selling them, she was able to settle most of her debts. From the thousands and thousands of francs, dollars, pounds, pesos, and yen realized from the sale of paintings by his most famous *poulains*, Leopold Zborowski received at most only a token sum. But that was all right: Modigliani and Soutine were established, recognized, appreciated, esteemed. That was really all Zbo had wanted.[38]

In a small testimonial volume entitled *Omaggio a Modigliani* (1884–1920), edited by Giovanni Scheiwiller and published in Milan on January 25, 1930, on the tenth anniversary of the artist's death, many of his friends joined in paying him homage. After introductory pages with three poems by Modigliani, there are perfunctory eulogies by many modern artists, critics, and writers, some of whom had known Modi. Only a few are worth noting. Soutine said: "It is Modigliani who gave me confidence in myself." Vlaminck said unequivocally: "He was a great artist. His work is the strongest proof of this. His paintings have great distinction—vulgarity, banality, and coarseness are not present."

Leopold Zborowski, recalling his good friend, was the most moving, the most poetic, the most profound, "Like the vine that produces the grape he asked nothing more."

∽∽∽ Chapter Thirty-eight

Portrait by Modigliani

Gazing upon this flat unseeing face
Disquietingly calm in pale distortion
Is to confront the formal paraphrase
Of inexpressible and secret vision.

I have seen such a face before
When I have come to you from dreams so clear
That flesh and dreams distorted by their fusion
Press within the eyes' encircling frame
In that unfocused instant before time
Provided that third dimension.
I dared not speak of this but as illusion—
Though my heart knew it held a moment's grace—
Yet I believed the lovely imitation
Which gave to fleeting truth a form and place.

BARBARA D. HOLENDER [1]

Though distance distorts, time and memory deceive and exaggerate; though nostalgia and dreams of lost youth tend to transpose facts, those who knew Modigliani seem to recall him with startling clarity. Modi had vivid qualities about him—a radiant purity, as Max Jacob called it, that remained in the memories even of those who only brushed his life in an accidental way. But as Charles Beadle, Douglas Goldring, and others who have sought information from Modi's contemporaries have discovered, many of the people who remember Modi so vividly did not really like him. He was, in the main, impossible. It took a divinely patient sort like Zborowski to put up with him.

While it is astonishing that so chaotic a man turned out serene canvases, it confounds doctrinaire art critics and historians that without being a part of any of the important movements of his time, his reputation nonetheless is so powerful, so solid, so enduring. Modi studied, borrowed, adapted, interpreted in his own way: he was not a team player. He deliberately disassociated himself from all the "isms" that so transformed modern art. He insisted that he had no style. He was Modigliani. As Cingria put it:

> In spite of everything, Modigliani is immensely appreciated, his paintings in great demand. Why is this? The era and its influences meant nothing to him. He could have done anything at all—that was his security—he would have been himself. The others will all disappear because they were only of their time.[2]

The Modiglianis of art are disturbing because their work springs from a tortured soul, which the public, suckled on the legend, prefers to believe is demented, amoral, debauched, and sordid. What a relief, they say, to turn to Renoir, a sanely happy and contented man with the intelligence to see that "a painting must be lovable, cheerful, pretty," because there are enough sad, ugly things in the world without creating more of them. These nay-sayers and the critics who consider that Modi produced a morbid, mannered, limited, superficially elegant art, confuse legend with art, a man's life with the products of his genius. Besides, it is easier and more comfortable to accept the legend.

Painters may well feel and see more deeply, suffer more from life than most of us. But they remain men, human beings with the same wants and urges, exits and entrances, lusts and agonies and ecstasies, hopes, desires, despairs as the rest of us. They do have one great advantage: they reverse Shakespeare's "The evil that men do lives after them,/The good is oft interred with their bones." Their "evil," if evil it ever was, was involuntary, unconscious, part of life's travail, and soon forgotten; their "good" lives on in museums, galleries, and collections, on walls and in reproductions all over the world.

Malraux makes an astute observation on the artists who "gamble on the miracle":

> . . . At the end of an epoch during which art was perpetually harassed by determinism under many guises, we are learning to hear the challenge of the man who is master of his art to those who gamble on the miracle. Indeed this mastery is a common measure of all great works of art, however extravagant they may appear.[3]

Long before Modi died, he had become master of his art. His art, as Malraux stipulates, came first, inseparable from his will, and his ques-

tioning served him as a source of growth as it serves great poets. "Shake-speare's interrogation of the meaning of life is the source of his noblest poetry." With Modi, too, it was the source of his noblest portraits. Mal-raux speaks of Man being obsessed with Eternity rather than with inexorable subjection of which death is a constant, tedious reminder. And the brief survival of his works, "which does not last long enough to see the light die out from stars already dead," is pitifully feeble indeed. To Malraux, survival is not measurable by duration, nor is death assured of its victory:

> Survival is the form taken by the victory of a creator over Destiny and this form, when the man himself is dead, starts out on its unpre-dictable life. Great statues, more human than mankind which aspired to body forth an ultimate, timeless truth, are still murmurous with the myriad secret voices which generations yet unborn will elicit from them. The most glorious bodies are not those lying in graves.

Malraux feels that man becomes truly Man only when in quest of what is most exalted in him. He finds beauty in the thought that this animal who knows that he must die can wrest from the disdainful splendor of the nebulae the music of the spheres and broadcast it across the years:

> In that house of shadows where Rembrandt still plies his brush, all the illustrious shades, from the artists of the caverns onwards, follow each movement of the trembling hand that is drafting for them a new lease of survival—or sleep.
> And that hand whose waverings in the gloom are watched by the ages immemorial is vibrant with one of the loftiest of the secret yet compelling testimonies of the power and the glory of being man.

André Malraux understands art and artists far better than most men. He is also more conscious of the debt mankind owes its great artists, more ready to recognize their achievements, and honor them in life and in death. As Minister of State in Charge of Cultural Affairs, Malraux offici-ated at the memorial funeral services for the late Georges Braque in the Colonnade de Louvre where, on September 3, 1963, he delivered a brief, eloquent speech paying homage to the artist on behalf of France:

> . . . Never in a modern country has one of its dead painters been given an homage of this nature. The history of painting, which recog-nizes a masterly achievement in the work of Braque, has been a long story of contempt, misery, and despair. Just by his death Braque seems to assure revenge on Modigliani's miserable burial services and the sin-ister interment of Van Gogh. And since everyone in France knows that

there is part of the glory of France that is called Victor Hugo, it is good to tell them there is part of the glory of France called Braque—because the glory of a country also consists of what it gives the world.[4]

Malraux's tribute from the government to a great artist would certainly have amazed Modigliani. His recognition of Modigliani would have stunned Modi.

The influences on Modigliani's art have been the subject of much speculation. Modi was aware of them and used them only as they served his purpose. An Italian steeped in a classical tradition, according to Schaub-Koch, he could hardly avoid being a classicist to some degree. Yet he was self-taught in art, guided by instinct. He was drawn to the primitive, but he had roamed the museums and knew the masters. He praised Uccello, Giorgione, the Mary Magdalen of Titian, El Greco, and the French Jean Clouet and Demoustier.

His curiosity was aroused by Egyptian statues, by Assyrian and Chaldean art in the Louvre, and he used them in his own esthetic research. Schaub-Koch, who saw his early drawings in Paris, watched his evolution.

Schaub-Koch describes the first drawings as only rough sketches from which emerge synthetic and harmonious forms. The eyes, the hair, the nose, and the mouth always capture his original, spirited aim. Later on came his incessant research into stylization—the harmonious curving of the legs, the arms, the hips, the breasts, and the long stretch of the neck, which is perhaps a distant memory of Egypt or Assyria.

To Schaub-Koch, a drawing of Modigliani's is always a work of the spirit. Modi drew from and on the treasures he had accumulated in his mind. He was a well-bred Jew who inherited a literary background which was steeped in the Old Testament, Dante, Petrarch, and Don Quixote, and to which he added the modern poet. He himself was a poet and, like Picasso and Vlaminck—and even Maurice Utrillo—he wrote poetry as an extension of his art.[5]

Jeanne Modigliani believes that of all the Italian artists mentioned as having a relation to her father's work, Tino di Camaino (1285–1337), a Sienese sculptor who may have been the pupil of Giovanni Pisano, is the one who is most important. In support of this, she cites the Italian critic Enzo Carli who was "struck by the surprising quality that links Modigliani's sculpture to that of the Sienese," and felt that Modigliani could have seen and admired the tomb of Bishop Orso or the *Charity* in the Bardini Museum. Tino also worked in Pisa, which was close to Leghorn, and Modigliani may have seen his sculptures for the tomb of Emperor Henry VII in the Pisa Cathedral.

But Miss Modigliani thinks that it was in Naples, at the time of his visit with his mother, that he was "struck by Tino's originality." In the churches of Santa Chiara, San Lorenzo, and Santa Maria Donna Regina, young Dedo might have seen and appreciated in Tino's sculptures "the monumental and successful solution of those plastic problems with which he would be dealing all through his short artistic career." Tino's "oblique placing of the heads on cylindrical necks, the synthesis of decorative mannerism with such sculptural density and above all, the use of line not only as a graphic afterthought, but as a means of composing his volume and holding his masses together in a way that even seems to accentuate their heaviness,"—these elements seem to confirm Tino's influence on Modi. Miss Modigliani concluded that from then on the critics of Modigliani's work saw it as a swinging back and forth "between the demands of his clean rhythmic line and his love for full, solid and round volume." [6]

On the other hand Alfred Werner, who has written a definitive book on Modigliani's sculpture, doubts that Modigliani was attracted to the work of Tino di Camaino in his formative years. Werner says that Tino was not well known in Modigliani's day and did not begin to be really appreciated before the twentieth century. He argues that, "If there are affinities between Tino's oblique placing of elongated heads on cylindrical necks and the manner of Modigliani, these can be due to conceptual similarities in styles tending toward the formal and abstract rather than to any precocious wisdom on the part of a very young man to whom we must not ascribe unusual powers of discernment." [7] Dedo was probably impressed by all the sculpture he saw in Naples, Rome, Florence, and Venice. He was most likely not drawn to the work of any one man; his sculpture did not acquire a style of its own until he came under the influence of primitive art and the work of Brancusi in Paris.

André Malraux, author of *The Voices of Silence,* one of the greatest art books ever written, has said that Modigliani was the successor to Neroccio.[8] Neroccio De'Landi was, along with Matteo di Giovanni, the greatest painter of Renaissance Siena, according to Bernard Berenson, who saw in him a resemblance to Simone Martini:

> . . . Why he was Simone come to life again. Simone's singing line, Simone's endlessly refined feeling for beauty, Simone's charm and grace—you lose but little of them in Neroccio's panels and you get what to most of us counts more, ideals and emotion more akin to our own, with a quicker suggestion of freshness and joy.[9]

Modigliani knew Simone's work—he had described his painting while he was delirious with typhoid fever, seen them in the Uffizi, and tacked reproductions of them to the walls of his Paris studio. If Neroccio had

Simone's qualities, so did Modigliani—the winging line, the endlessly re-
fined feeling for beauty, the charm and grace, the ideals and emotions,
the freshness and joy.

Neroccio, according to Gertrude Coor's book on him, was a meticulous
craftsman who applied his paint thinly and with great delicacy. His com-
position was nearly shadowless; his models were achieved with marvelous
translucent pink-and-white flesh tones. The beauty of Neroccio's images
was too personal to be perpetuated by others, Miss Coor says; his ex-
quisite art died with him.[10] The experts were to say the same of Modi-
gliani.

Like Simone Martini, Neroccio was interested in melodious line and in
painting graceful, original figures, *and* he remained a romantic idealist
all his life. Describing Neroccio's *Portrait of a Lady,* Miss Coor speaks of
its simple, clean execution, the model's oval face with its wistful spirit
and dreamy beauty. Neroccio's most important contribution to the
Sienese school were his rendering of flesh as if it were diaphanous, filled
with light, and his emphasis on flexible, assertive lines. Here again the
aptness of Malraux's comparison is striking. And again like Modigliani,
Neroccio had a highly developed aesthetic sense. He, too, was a superb
craftsman who skillfully adapted various Tuscan compositional, icono-
graphic, and stylistic innovations and assimilated other outside influences
to his own needs. In nearly every major respect Miss Coor's description of
Neroccio's qualities bears out the validity of Malraux's view.

The French critic Claude Roy, who has written an excellent study of
Modigliani and his work, also mentions Simone Martini in connection
with Modigliani. He says that in the series of magnificent portraits he
painted of his great and last love toward the end of his short life, Modi-
gliani "seems often to associate with the direct homage he pays to her
delicate beauty another, subtler homage to the country of his choice." He
points out that in one of his finest paintings of Jeanne Hébuterne, Modi-
gliani "reproduces the movement of the Virgin's hands in Simone Mar-
tini's *Annunciation,* in the Uffizi; a sinuous movement whose rhythm he
merely reverses, making his sitter's left hand toy with the collar of her
sweater just as the Virgin's right hand lightly clasps the border of her
hood." [11] This, again, is a cogent and valid comparison. Looking at
reproductions of the two portraits side by side, it stands up far better
than comparisons of Tino di Camaino's sculpture with Modigliani's.

Critics tend to make definitive statements out of what are suppositions
and opinions about the influence of one artist on another. Besides, simi-
larities in style may not be due to direct or conscious influences. Never-
theless, given that warning, it is extraordinarily acute on the part of
André Malraux to pair Modigliani with the Sienese master. It is an opin-
ion and it is carefully labeled just that, yet it is a telling example of the

insight, the stunning clairvoyance that distinguish *The Voices of Silence*. And it throws new light on the sources of Modigliani's art.

Few art critics seem to be able to consider the artist apart from the man. They describe Modigliani's paintings as having the same "sad, neurotic charm of the Italian's personality." Others speak of an ". . . impression of delicate and precocious distinction, rare and somewhat unhealthy, of a *morbidezza* that would not have been disowned by Botticelli." His art is seen as "limited" and "mannered." He is classified as belonging to the *Ecole de Paris,* a school confined to ". . . foreigners . . ." whose "works betray a certain sickness of life." Or he has "an irremedial pessimism . . . ," ". . . an anxious tense intellectualism, which he shared with numerous Jewish artists of his day" and which give "his work a disillusioned tone." Their writing is tidy, scholarly, and sincere, but even when they guarantee Modigliani a lasting place among the great, they tend to be condescending, as James Thrall Soby was in his 1951 monograph:

> If Modigliani had lived? He would be sixty-six now, younger than the men—Matisse, Rouault, Brancusi, Picasso, Braque—who continue to be the most persuasive figures in contemporary European art. He could not have held their pace, not only because his fever was integral with his gifts, as already suggested, but because the creative span of modern Italian painters is especially brief, as though the rich old age of Titian and others had been borrowed in a sense from their living descendants.[12]

Carco, who knew Modigliani, felt that his excesses concerned the man, not his art. It is not possible to say what Modigliani's painting would have been if he had lived, any more than it is sound to generalize on the creative span of Italian painters.

C. J. Bulliet wrote that Modigliani's nudes ". . . may be ranked ultimately with the great ones of all times—with Giorgione's *Sleeping Venus,* Titian's *Venus Awake,* Goya's *Maja* (nude and even more impudently clothed), with Manet's sensational wanton in the Louvre." Bulliet felt that universal judgment was scarcely ready yet for Modi's "distorted" females with their greatly elongated torsos, monster eyes, and lengthened faces—"yet, withal, possessing a fascinating loveliness, that is a reminder of Botticelli." Yet he could also speak of ". . . the hot Orientalism resident in the mixture of Hebrew blood that flowed through his Italian veins" to produce "morbidly entrancing . . . creations of feverish sensuousness."[13]

Adolphe Basler and Charles Kunstler called Modigliani "a species of

Negro Botticelli." [14] Thomas Craven was seduced by the legend into calling Modi "a gifted wastrel . . . a specimen of the effects of Bohemianism on the artist . . . a real artist, but not a great one. He had talent and charm, but he was incapable of self-discipline." [15] Arthur Pfannstiel put the matter simply:

The art of Modigliani is not accessible immediately to all. To approach it one must enter it deeply, enter it even with effort. Then this work glows with a purity that comes from laws the most secret and eternal of the art of all the ages.[16]

The late Maud Dale, one of the first to appreciate and collect Modigliani in the United States, felt that while Picasso's art was a vision, Modigliani's portraits were passages that described his subject's terror, misery, and morbid sensibility. She thought one of his most beautiful pictures was ". . . of Rosalie's little servant clasping her scant cotton chemise about her, honored with the invitation to sit for a portrait, but disturbed by her lack of clothes." Mrs. Dale said that the charm of the sitter and the situation (in *Nude with Chemise*) would last as long as canvas lasts.[17]

Eric Newton wrote of Modigliani's "finely wrought Botticelli contour, dependence on beauty of shape, the avoidance of all emphasis on shadows, and the consequent sacrifice of volume and weight." He found Modi the least ambitious of painters. The artist painted a single figure isolated on canvas, dependent for meaning on innate stylistic beauty, assurance of outline, extraordinary reticence of modeling, and an oriental economy of color tending to pale pink, cool greenish gray, and variegated warm brown. Newton said that Modigliani's mannerism sprang from purity.[18] Edgar Levy denies that Modi was a mannerist. It is his constraint that leads to his judgment, says Levy, but Modigliani was neither a mannered artist, nor mannered, nor a Mannerist. "Mannerism is devious, Modigliani is forthright. . . . It is not hard to understand that Modigliani is often mistaken for a Mannerist, but to see him as mannered is not to see him at all." Levy takes pains to cite "the central element of Modigliani's genius, so obscure during his life and so immediately apparent on his death. . . ." It was just that Modigliani

. . . stamped and, in greater measure than most men, gave identity to the years in which he worked. Because that identity is still palpable, because it extends into our days and will spread in time for generations, we say, ingenuously, that he was ahead of his time. What we imply is that ordinary men around him, ticking off fractions of seconds, were dwarfed by a giant who could mold and cast half a century.

Levy notes that so many of Modi's contemporaries in writing about him ". . . with a curious unanimity, almost as if by some arranged consensus, . . . remembered and made a point of his aristocracy." Levy calls it a justifiable conceit to attribute this to his artistic inheritance. In mentioning all the artists and movements that influenced Modigliani, Levy is aware of his adopting Cubist techniques for the moment, but not following them into Cubism's mannered phase. He finds it a

> . . . sign of Modigliani's pure style that at the time many of his friends were adulterating their Cubism, and his mentor Brancusi was producing the most mannered sculpture of the century, he turned his attention more sharply than ever to the enduring realities of his sitters.

Levy sees "an absence of privacy in a distorted portrait by Picasso," and "an open invitation in one by Matisse, that conduces to the freest intercourse." But, for him, "even with a multitude of observers, a Modigliani speaks separately, quietly, to each one." It is this special quality that Levy thinks links the artist with his great predecessors to a marked degree not exhibited in any other modern artist:

> Into this restrained and isolated community of pictures, he condensed a deeper and more woeful humanity than dozens of painters who fling figures and shapes around with uninhibited frenzy.
> It is a world of unremitting pain and desperate anxiety, but a world we cherish nevertheless for its balms of tenderness, of courage, and of beauty, for the lovely bodies of women and for its solid substance. In all this he is the painter of our passion: our Giotto.[19]

William S. Lieberman declared that no one since Titian had done more voluptuous nudes, and noted that never in his drawings, paintings, or sculptures did Modi depict the feet of the human figure.[20] Evarts Erickson called Modigliani's theme the mystery of the human face, adding that, although Modi's analysis of the sitter was occasionally merciless, his portraits usually reflected a deep compassion, a love of humanity. His paintings were intensely moving affirmations of human dignity; his immortalization of Jeanne Hébuterne in twenty canvases made one of the crests of modern art.[21]

Ilya Ehrenburg remembered Modi sitting in the evenings at a restaurant where other artists gathered. Modi sat on the stairs "sometimes declaiming Dante, sometimes talking of the slaughterhouse, of the end of civilization, or poetry, of anything but painting." Ehrenburg felt that Modi created in his work a multitude of people who moved those who saw them with their sadness, their frozen immobility, their haunted tenderness, their air of doom. To Ehrenburg, it was only the zealots of

realism who objected to Modi's swans' necks, distortions, and elongations. Paintings were not anatomical drawings; proportions were altered by thoughts, emotions, passions.

Besides, Modi was no remote observer, contemplating people from a distance. He lived with them. "These were portraits of people who loved, longed, and suffered." And Modi's dates, Ehrenburg felt, "were not only milestones marking his progress as an artist," but also "milestones of an epoch: 1919–1920." Modi knew perfectly well how many vertebrae there were in a neck; after all he had studied anatomy in Leghorn, Florence, and Venice:

> But he knew something else as well: for instance, how many years there are to a single twelvemonths such as 1914. And if apparently age-old conceptions of human values were changing, how can an artist fail to see his model's face changed?
> . . . His fate was closely bound up with the fates of others; and if anyone wants to understand the drama of Modigliani, let him remember, not hashish but the gas chamber; let him think of Europe lost and frozen, of the devious paths of the century, of the fate of any of Modigliani's models round whom the iron ring was already closing.[22]

Claude Roy quotes the aphorism Modi had written for Lunia Czechowska "under one of his loveliest pencil sketches, *"Life is a Gift; from the few to the many; from Those who Know and have to Those who do not Know and have not,"* and says:

> Modigliani knew, Modigliani had everything, and throughout his life bestowed it lavishly on all. Let us try, then, to appraise, to understand and to esteem his work at the highest level, that of the Masters.

Modi had the divine knowledge, the spark, the radiance. He did more than fight the good fight: he won it without ever knowing it. Modi had saved his dream, and died a success because he had done what is permitted few men: he had accomplished what he set out to do, fulfilled his art and, in so doing, himself. Modigliani's career as an artist was "one long meditation on the mystery of the human face." Roy finds Modigliani

> one of the supremely gifted few who seems to say everything with next to nothing; in whose works a simple line, a brief illusion, a faintly indicated gesture suffice to bring before us all the infinite, incredible profusion of human life.

If Modi, only a few months before his death, was so moved by an article in an English Jewish paper praising him that he kissed it, and ex-

claimed, *"C'est magnifique,"* how moved he would have been at such praise and understanding at this:

> His masterpieces inspire the same respect and awe that we feel when, gazing at the vault of the Torcello basilica, we see the Virgin and the Child floating in a sea of golden light; or when we contemplate the Virgins in the paintings of the Sienese masters. Modigliani transposed the celestial vision of the great painters he revered and loved to the mundane plane of the easel picture, and erected a private Byzantium in the heart of a cosmopolitan Babel. He was an uncrowned Basilius of the private life of the world beyond the world, a Fra Amedeo of the fallen angels.[23]

The phrase "the private life of the world beyond the world" echoes in the mind because it is similar to what Modi wrote to Zbo from Nice: "The only thing to do now is to let out a great shout with you: *'Ça ira,'* for men and for people, thinking that man is a world worth twice the world and that the most ardent ambitions are those which have had the pride of Anonymity." It is only fitting that an Amedeo Modigliani, who thought so highly of his fellow men, should in due time be hailed, appreciated, and applauded by them in return.

In his letters to Oscar Ghiglia, Modi had spoken of beauty as "a fruit of the noblest strivings of the soul." He held on to this belief all his brief, intense life and, as Roy points out, these "noble strivings" are present in all his paintings. His work proves that "Modigliani was a master; and all aesthetic mastery calls for self-mastery on the artist's part." Alone, hungry, frozen with cold, unsteady with drink, dazed with hashish, depressed, desperate, and despairing, "his hand never shook upon the white expanse of paper or canvas he was working on." There are no botched Modiglianis.

Modi's art is the vindication of his life. He believed in himself and his art, and, truly, nothing else ever mattered. If he managed triumph only after his death, because he was his own worst enemy, it does not matter. How he lived his life does not matter: he *did* triumph—and so very few of us do. And in the tragic and peculiar fashion in which he achieved this posthumous triumph, Claude Roy compares him "with one of those exiled princes disguised as beggars whom we read of in fairy tales, and who at the story's end, casting off their rags, triumphantly ascend the throne." Perhaps that very throne Modi wrote of in his poem: up atop the black mountain on which sits the king, "the chosen-to-rule, to command," who "weeps the tears of a man who could not reach the stars . . ."

Modigliani is gone. His work remains. The man and his legend no longer matter. In one sense his life could be summed up with the same brilliant cynicism displayed by Somerset Maugham in describing the death of

his leading character in his short story *Mayhew*. "And yet to me his life was a success. The pattern is good and complete. He did what he wanted, and he died when his goal was in sight and never knew the bitterness of an end achieved." True, yet not so true. In any case Douglas Goldring, who was probably the first man to write of Modigliani with understanding and intelligence, is entitled to the last word.

For the distillation of Modigliani's quality as a man, when all is said, is found in the masterpieces he left behind him. They are more really *himself* than anything that has been recorded about the personality that produced them. Perhaps I have now got to the root of the matter. An artist should be judged not by his extravagances, intoxications, quarrels, vehement and silly letters, inability to be a bourgeois husband, lapses from being a "perfect gentleman," and so forth, but solely by the extent of his achievement. By these standards Modigliani is among the immortals and requires no justification.[24]

✂✂✂ A Modigliani Chronology

Except for the dates that can be substantiated by his mother's diary and family history, as well as other verifiable landmarks in his life, it is hard to set down exact dates concerning Amedeo Modigliani. His friends and fellow artists have given both contradictory and conflicting places and times in their various accounts; Modigliani himself never had the habit of dating his letters and postcards, and the dates of many of his paintings have often been arbitrarily assigned by art dealers, knowing that those supposedly painted in his last "great" years bring the highest prices.

The chronology is thus based on cross-checking, deduction, elimination, and educated guesswork. Nevertheless, under the circumstances, it is believed to be as accurate as humanly possible.

1793 Maternal great-grandfather, Giuseppe Garsin, born in Leghorn, February 6, son of Solomon and Regina Spinoza Garsin.

1819 Isaac Garsin, maternal grandfather, born.

1835 Giuseppe Garsin moves famliy to Marseille.

1840 His father, Flaminio Modigliani, born in Rome.

1849 Isaac Garsin marries a cousin, another Regina, in Algeria. His paternal grandfather Modigliani moves from Rome to Leghorn.

1855 His mother, Eugenia Garsin, born in Marseille.

1870 Flaminio Modigliani meets Eugenia Garsin in Marseille.

1872 Flaminio Modigliani marries Eugenia Garsin in Leghorn. First child, Emanuele Giuseppe Garsin, born October 21.

1874 Margherita Olimpia Modigliani born.

1878 Umberto Isacco Modigliani born.

1879(?) Emily Alice Beatrice Haigh (later Hastings) born in Port Elizabeth, South Africa.

1884 Amedeo Clemente Modigliani born July 12.

1894 Isaac Garsin dies. Amedeo at grammar school.

1895 Emanuele graduates from law school, University of Pisa; elected a councilman of Leghorn, joins Socialist Party. Amedeo seriously ill with pleurisy.

1897 Amedeo passes grammar school examinations, takes bar mitzvah.

1898 Emanuele is arrested for subversive activities on May 4, fined and sentenced to jail before military tribunal in Florence on July 14. Amedeo begins art lessons under Guglielmo Micheli in August, then has typhoid fever with pulmonary complications. Jeanne Hébuterne born in Paris, April 6.

1899 Amedeo abandons high school work to study art full time. Emanuele freed in March, after serving eight months, as government grants amnesty to political prisoners.

1900 Amedeo very ill in September with double and acute pleurisy. Lesion on lung leads to tuberculosis.

1901 Amedeo spends the winter with his mother in Naples, Capri, Amalfi, then goes on to Rome, Florence, and Venice. Leaves Leghorn on his own to visit Florence.

1902 Spends winter in Rome, enrolls in Scuola di Nudo in Florence on May 7. Experiments with sculpture at Pietrasanta near Carrara in late summer.

1903 Moves to Venice and enrolls in Institute of Fine Arts on May 19.

1904 Living, studying, and painting in Venice.

1905 Late in the year Amedeo's mother visits him in Venice and gives him money to go to Paris.

1906 Goes to Paris by train, via Geneva, arriving in January. Lives in hotel near Madeleine, attends Académie Colarossi, rents shack in *maquis*. Three of his paintings exhibited in window of Laura Wylda's The Art Gallery in the Rue Saint-Pères.

1907 First look at primitive art. Fascinated by Toulouse-Lautrec and Gauguin. Lives briefly at the Hôtel du Poirier, Hôtel du Tertre, the Bateau-Lavoir, and the Hôtel Bouscarat. While living at 7 Place Jean-Baptiste-Clément, exhibits two oils and five watercolors at the Salon d'Automne. First great interest in Cézanne.

1908 Works at artists' colony 7 Rue du Delta. Has five entries in the Salon des Indépendants.

1909 Refuses to sign Futurist Manifesto. Moves to Montparnasse, where he lives briefly in La Ruche. Brancusi sparks his interest in sculpture. Returns to Leghorn in late June or early July. Emanuele obtains sculpturing job in Carrara for Amedeo. He returns to Paris in September. Lives at 14 Cité Falguière.

1910 Six of Modigliani's paintings hang at the twenty-sixth Salon des Indépendants, March 18 through May 1. Moves between La Ruche, Cité Falguière, and Couvent des Oiseaux, Rue Douai.

1911 Living at 39 Passage de l'Elysée-des-Beaux-Arts. Joins his Aunt Laura Garsin for a few days' holiday at Yport. Exhibits sculpture at Cardoso's studio, Rue du Colonel-Combes.

1912　Doing more sculpture than painting. Exhibits seven heads *en bloc* at the Salon d'Automne.

1913　Spends terrible winter at 216 Boulevard Raspail. Poor and starving, Amedeo has physical breakdown. Returns to Leghorn in bad shape. Works on sculpture, throws it into a canal on the advice of his friends. Employed briefly as artist-in-residence by the dealer Chéron. Another dealer, Paul Guillaume, becomes interested in his work. Emanuele is elected to the Chamber of Deputies from Budrio.

1914　Paints a few portraits for Guillaume. Lives briefly with Diego Rivera, then at 16 Rue du Saint-Gothard. Meets Beatrice Hastings in July. Emanuele visits Paris, tries to persuade his brother to come home.

1915　Modigliani painting steadily and involved with Guillaume. Tries to enlist in French Army. Quarrels with Beatrice.

1916　Modigliani breaks with Beatrice in July or August. Another physical breakdown. Now living at 13 Place Emile-Goudeau XVIII. His work is exhibited in *"la salle Huyghens"*—a studio at 6 Rue Huyghens—where it is seen by Leopold Zborowski. Late in year has contract with Zborowski. Simone Thiroux now his mistress.

1917　Breaks with Simone, who is now pregnant with his child. Modigliani denies he is the father. Meets Jeanne Hébuterne in March. Simone's son, Serge Gérard, born in May. Zborowski rents two rooms for Jeanne and Modigliani at 8 Rue de la Grande-Chaumière. Modigliani's paintings hung in Dada Gallery, Zurich. Disastrous exhibition at Berthe Weill's gallery, 50 Rue Taitbout, December 3.

1918　Modigliani and Jeanne go to Cagnes with the Zborowskis. On November 29 Jeanne gives birth to a girl at the Nice Hospital.

1919　Modigliani paints on a schedule and writes urgent letters to Zborowski in Paris for money. Paints his only landscapes near Nice. Returns to Paris, May 31. In July, Osbert and Sacheverell Sitwell sponsor a modern art exhibit in London featuring Modigliani's work. First written publicity as Francis Carco praises his work in an article for *L'Eventail*, a Swiss magazine. Four of Modigliani's paintings entered in the Salon d'Automne.

1920　Taken to Charity Hospital unconscious in an ambulance, Thursday, January 22. Dies without regaining consciousness on Saturday, January 24. At four in the morning Sunday, January 25, Jeanne Hébuterne jumps to her death from her family's apartment. Modigliani buried "like a prince" on Tuesday, January 27, in Père-Lachaise Cemetery. Jeanne then secretly buried in Bagneux Cemetery outside Paris.

1921　Simone Thiroux dies of tuberculosis. Her son Serge Gérard adopted by a couple whose identity is kept secret. Posthumous exhibition arranged by Zborowski at Galerie l'Evêque, Paris.

1922　Thirty-nine paintings shown at Galerie Bernheim-Jeune, Paris. Modigliani's first exhibition in his native Italy at the Thirteenth International Art Exhibition, Venice. Grenoble Museum buys a Modigliani, first one to do so.

1923　Modigliani first exhibited in the United States at the Pennsylvania Academy, Philadelphia, as part of Dr. Albert C. Barnes's collection of modern French paintings.

1924　Exhibition at the Galerie Bing, Paris.

1925　Exhibition at the Galerie Bing, Paris.

1926 Thirteen Modigliani paintings hung on the occasion of the Thirtieth Anniversary of the Salon des Indépendants.

1929 First official American exhibition—thirty-nine paintings at the galleries of Hauke & Co., Inc., New York.

1930(?) The Hébuternes finally agree to the reinterment of their daughter in Modigliani's grave at Père-Lachaise Cemetery.

1931 Twenty-nine paintings exhibited at the Demotte Galleries, New York.

∽∽∽ Personal Acknowledgments

Although I consulted all the available reference material pertaining to Modigliani in the New York Public Library and the New York Museum of Modern Art Library, as well as other available sources, I am particularly indebted to the works of two authors. One is Jeanne Modigliani, daughter of the artist, whose biography of her father in the American edition (*Modigliani: Man and Myth*) and the French edition (*Modigliani sans légende*) provided invaluable letters, documents, diary excerpts, dates, and other intimate facts about the painter and his family. The other is the late Douglas Goldring who published *Artist Quarter* under the pseudonym Charles Douglas in London in 1941. I want to express my thanks both to Miss Modigliani and to Mrs. Malin Goldring.

Written by one man, a biography is the sum total of the work of many people who have gone before him, as well as that of the others who have assisted him in his task. I wish to express my sincere thanks for research material furnished by John Olliver of Paris; Mrs. Sara Nickerson of London; Mrs. Malin Goldring of Deal, Kent, England; Mrs. Laure De Zarate Lourie of Los Angeles; André Malraux of Paris; Alfred Werner of New York; Ardengo Soffici and Mrs. Elsa Sellers of Florence; Gorham Munson of New York, and David Douglas Duncan of Mouans-Sartoux, A.-M., France.

Grateful thanks are also due the following, who were either interviewed or written to by the author or, in his behalf, by John Olliver: the late Alexander Archipenko of New York; Jacques Lipchitz of Hastings-on-Hudson; the late Gino Severini, Ossip Zadkine, Léopold Survage, André Salmon, Dr. and Mme. Dyre Diriks, Léon Indenbaum, Mme. Chana Or-

loff, Mme. André Hébuterne, Zawado (Waclaw Zawadowski), Mme. Lunia Czechowska, and Mme. Marcellin Castaing, all of Paris.

Others to whom I am indebted for editorial assistance, translations, permissions, information, art work, and photographs are: the late Donald Elder of New York; Richard Schmid of Gaylordsville, Conn.; Dudley Fitts of Andover, Mass.; Antony Alpers of Wellington, New Zealand; Eric Rosenthal of Cape Town, South Africa; Mme. Jeanne Modigliani Nechtschein of Paris; John Beevers of London; Mr. and Mrs. J. W. Alsdorf of Winnetka, Ill.; Luis Vargas Rosas, Director of the Museo Nacional de Belles Artes, Santiago, Chile; Thomas Craven of Martha's Vineyard, Mass.; Stanton Macdonald-Wright of Pacific Palisades, Calif.; R. H. Wilenski of Marlow-on-Thames, England; Mrs. Chester Dale and the late Mr. Dale of New York; Monroe Wheeler of New York; Miss Iris Sichel of Pretoria, South Africa; Mrs. Floyd Mueller of Ojai, Calif.; George Boswell of Paris; Eddy Van Der Veen of Paris; Israel Shenker of Rome; Aldo Durazzi of Rome; Bernhard Auer and Jeanne Kerr of Time Inc., New York; Livio Senni of New Milford, Conn.; Roland Penrose of London; Horace Gregory of Palisades, N.Y.; Matthew Josephson, Barry Roberts, Mrs. Robert L. Seligmann, Mrs. Clara Merz, and Henry B. Anderson of Sherman, Conn.; Mrs. Sally Aerts of Staten Island, N.Y., and to staff members of the New York Public Library, the New York Museum of Modern Art Library, the Yale University Library, and the Sherman Library.

A special vote of thanks goes to my wife, Edna Dolan Sichel, to my agent, Theron Raines of New York, and to my editor, James Ellison of Dutton, for their advice, encouragement, and assistance during this long project.

PIERRE SICHEL

∾ ∾ ∾ Notes and References

After their first mention, the following abbreviations are used for publications most often cited in the text:

| | |
|---|---|
| MMM | *Modigliani: Man and Myth*, New York, 1958 |
| MSL | *Modigliani sans légende*, Paris, 1961 |
| AQ | *Artist Quarter*, London, 1941 |
| ROM | "Recollections of Modigliani by Those Who Knew Him," Los Angeles, 1958 |
| MJR | "Introduction to Catalogue," *Modigliani Exhibition,* John Russell, London, 1963 |
| MDV | "Modigliani dal vero," *Panorama Dell'Arte*, Turin, 1951 |
| TVOS | *The Voices of Silence*, New York, 1953 |
| FDM | *Fils de Montmartre*, Paris, 1955 |
| MCR | *Modigliani*, Claude Roy, New York, 1958 |
| MSK | *Modigliani*, Emile Schaub-Koch, Paris, 1933 |
| MMV | *Montmartre Vivant*, Paris, 1964 |
| RLDM | "Rosalie, l'ostessa di Modigliani," *Illustrazione Italiana*, 1932 |
| LDP | *L'Ami des Peintres*, Paris, 1953 |
| LT | *Laughing Torso*, New York, 1932 |
| MPV | *Montparnasse Vivant*, Paris, 1962 |
| ELJL | *Encounters: The Life of Jacques Lipchitz*, New York, 1961 |
| CAM | *Amedeo Modigliani*, Ambrogio Ceroni, Milan, 1958 |

Notes to Chapter One

1. Herman J. Wechsler, *Lives of Famous French Painters* (New York: Washington Square Press, 1963), p. 186.

2. Jeanne Modigliani, *Modigliani: Man and Myth* (New York: Orion Press, 1958), p. 11; *Modigliani sans légende* (Paris: Librairie Gründ, 1961), p. 21.

3. Alfred Werner, "The Life and Art of Amedeo Modigliani," *Commentary* (New York, May, 1953), LXXXV, 475–483.

4. Modigliani, *op. cit.*, American edition, p. 4; French edition, p. 14.

5. Werner, *op. cit.*, pp. 475–483.
6. Modigliani, *op. cit.*, A., pp. 7–8; F., pp. 17–18.
7. Werner, *op. cit.*, pp. 475–483.
8. Modigliani, *op. cit.*, A., p. 13; F., p. 23.
9. Modigliani, *op. cit.*, A., p. 12; F., p. 22.
10. Douglas Goldring, *Artist Quarter* (London: Faber and Faber, 1941), p. 68. (Book originally published under pseudonym of Charles Douglas.)
11. Montgomery Carmichael, "Leghorn," *Pall Mall* (London, 1898), VIII, No. 16, 391–401.

Notes to Chapter Two

1. MMM, p. 17; MSL, p. 27.
2. MMM, p. 15; MSL, p. 25.
3. All the facts about the arrest, imprisonment, and sentencing of Emanuele Modigliani from documents and newspaper files researched in the Florence library by an Italian associate.
4. Frederick S. Wight, "Recollections of Modigliani by *Those Who Knew Him*," *Italian Quarterly* (Los Angeles: University of California), Spring, 1958, II, No. 1, 36.
5. From Bergen Evans' introduction to *I Promessi Sposi* by Alessandro Manzoni, a Premier Book published by Fawcett Publications Inc., copyright © 1962. P. V.
6. John Russell, Introduction to Catalogue, Modigliani Exhibition (London: The Arts Council of Great Britain, 1963), The Tate Gallery, September 28–November 5, 1963, p. 9.
7. Wight, *op. cit.*, p. 38.
8. MMM, p. 19; MSL, p. 29.
9. MSL, pp. 30–31.
10. Ilya Ehrenburg, *People and Life, 1891–1921*. Translated from the Russian by Anna Bostock and Yvonne Kapp. (New York: Alfred A. Knopf, Inc., 1962), pp. 151–158.
11. AQ, pp. 68–69.

Notes to Chapter Three

1. MMM, pp. 24–25; MSL, p. 34.
2. *Ibid.*, MMM, pp. 24–25; MSL, p. 34.
3. ROM, p. 38.
4. Alfred Werner, *Modigliani the Sculptor* (New York: Arts, Inc., 1962), p. xi.
5. ROM, p. 39.
6. *Ibid.*, p. 39.
7. P. D'Ancona, "Cinque lettre giovanili di Amedeo Modigliani," *L'Arte*, fasc. III (Turin, May, 1930), pp. 257–264, as reproduced in *Amedeo Modigliani* by Ambrogio Ceroni (Milan: Edizioni del Milione, 1958), pp. 10–18.
8. Letter to author from Mrs. Laure de Zarate Lourie, February 14, 1963.
9. Jean-Paul Crespelle, *Montparnasse Vivant* (Paris: Librairie Hachette, 1962), p. 23.
10. AQ, p. 72.
11. *Ibid.*, p. 71.

Notes to Chapter Four

1. MMM, pp. 32 and 107; MSL, pp. 41 and 113.
2. Giovanni Papini, *Laborers in the Vineyard* (New York: Longmans Green and Company, 1930; copyright David McKay Company, Inc.), pp. 41–48.

3. *Ibid.*, pp. 28–39.
4. Ugo Ojetti, "Amedeo Modigliani," *Corriere della Sera* (Milan), January 28, 1930.
5. Ardengo Soffici, "Ricordi di Modigliani," *Ricordi di Vita Artistica E Litteraria* (Florence: Vallecchi Editore, 1942), pp. 217–220.
6. André Salmon, *La Vie Passionée de Modigliani* (Paris: Editions Gérard & Cie., 1957), pp. 26–39; *Modigliani: A Memoir,* translated by Randolph and Dorothy Weaver (New York: G. P. Putnam's Sons, 1961), pp. 26–36.
7. Letter to author from Ardengo Soffici, February 17, 1964.
8. MJR, p. 5.
9. MMM, p. 34; MSL, p. 44.
10. MMM, p. 35; MSL, p. 45.
11. AQ, p. 72.

Notes to Chapter Five

1. AQ, p. 72.
2. Ludwig Meidner, "The Young Modigliani—Some Memories," *Burlington Magazine* (London, April, 1943), LXXXII, 87–91.
3. AQ, pp. 74–75.
4. AQ, pp. 75–76.
5. Umberto Brunelleschi, "Rosalie, l'ostessa di Modigliani," *L'Illustrazione Italiana* (Milan, September 11, 1932), pp. 344–345.
6. André Warnod, *Fils de Montmartre* (Paris: Librairie Arthème Fayard, 1955), pp. 29–31.

Notes to Chapter Six

1. Jean Renoir, *Renoir, My Father* (Boston: Little, Brown and Company, 1962), p. 290.
2. Special Number of *Paris-Montparnasse*, No. 13, February, 1930, p. 19.
3. AQ, p. 76.
4. Emile Schaub-Koch, *Modigliani* (Paris: Mercure Universel, 1933), p. 12.
5. Louis Latourettes in Preface to Arthur Pfannstiel's *Modigliani* (Paris: Editions Seheur, 1929), pp. ii–iii; quoted in AQ, pp. 83–85.
6. Renoir, *op. cit.,* p. 370.
7. AQ, p. 88.
8. AQ, pp. 47–48.
9. John Malcolm Brinnin, *The Third Rose, Gertrude Stein and Her World* (Boston: Atlantic-Little, Brown and Company, 1959), p. 89.
10. Anthony Blunt and Phoebe Pool, *Picasso, The Formative Years* (Greenwich, Conn.: New York Graphic Society Publishers, Ltd., 1962), p. 5.
11. Schaub-Koch, *op. cit.,* pp. 16–17.
12. Claude Roy, *Modigliani,* translated by James Emmons and Stuart Gilbert (Paris: Edition D'Art Albert Skira, 1958; Skira International Corporation), p. 18.

Notes to Chapter Seven

1. Fernande Olivier, *Picasso et Ses Amis* (Paris: Editions Stock, 1933), pp. 56–61.
2. FDM, p. 79.
3. AQ, p. 53.
4. AQ, p. 55.

5. Alice B. Toklas, *What Is Remembered* (New York: Holt, Rinehart, and Winston, 1963), p. 132.

6. Anthony Blunt and Phoebe Pool, *Picasso, The Formative Years* (Greenwich, Conn.: New York Graphic Society Publishers, Ltd., 1962), p. 17.

7. AQ, pp. 84–85.

8. AQ, pp. 23–38.

9. R. H. Wilenski, *Modern French Painters, 1863–1903* (New York: Vintage Books, 1960), p. 50.

10. Bernard S. Myers, *The German Expressionists* (New York: Frederick A. Praeger, 1956), pp. 71–72.

Notes to Chapter Eight

1. AQ, pp. 88–89.

2. Gino Severini in an interview with associate, February, 1964.

3. Letter to author from Mrs. Laure de Zarate Lourie, February 14, 1963.

4. Anselmo Bucci, "Modigliani dal vero," in *Panorama Dell'Arte Italiana* by Marco Vallsecchi and Umbro Apollonio (Turin: Editori Lattes, 1951), pp. 348–352.

5. Maurice de Vlaminck, *Tournant Dangereux* (Paris: Editions Stock, 1929), p. 187.

6. Pierre Courthion, *Montmartre* (Paris: Editions D'Art Albert Skira, 1956; Skira International Corporation), pp. 96–98.

7. AQ, pp. 57–59.

8. André Malraux, *The Voices of Silence* (New York: Doubleday and Company, 1953), pp. 418–447.

9. Francis Carco, *The Last Bohemia, from Montmartre to the Latin Quarter*, translated by Madeleine Boyd (New York: Henry Holt and Co., 1928), p. 32.

Notes to Chapter Nine

1. John Storm, *The Valadon Drama, The Life of Suzanne Valadon* (New York: E. P. Dutton Company, 1959), p. 97.

2. Francis Carco, *The Last Bohemia, from Montmartre to the Latin Quarter*, translated by Madeleine Boyd (New York: Henry Holt and Co., 1928), pp. 11–13.

3. Raymond Cogniat, Jacques Lassaigne, and Marcel Zahar, *Panorama des Arts 1947* (Paris: Aimery Somogy Editeur, 1948), pp. 241–242.

4. AQ, pp. 82–90.

5. R. H. Wilenski, *Modern French Painters, 1863–1903* (New York: Vintage Books, 1960), p. 309.

6. John Canaday, *Mainstreams of Modern Art* (New York: Simon and Schuster, 1959), pp. 322–324.

7. *Ibid.*, p. 405.

8. Bernard S. Myers, *The German Expressionists* (New York: Frederick A. Praeger, 1956), pp. 71–72.

9. Gotthard Jedlicka, *Modigliani* (Zurich: Eugen Reutsch Verlag, 1953), as quoted by Alfred Werner in "The Inward Life of Modigliani," *Arts* (New York, January, 1961), XXXV, No. 4, 36; also in Werner's *Modigliani the Sculpture* (New York: Arts, Inc., 1962), p. xvi.

10. FDM, p. 74.

11. AQ, p. 102.

12. Gertrude Stein, *Picasso* (Boston: Beacon Press, 1959), p. 9.

13. Roland Penrose, *Picasso: His Life and Work* (New York: Schocken Books, 1962), pp. 121–148.

14. Frank Elgar and Robert Maillard, *Picasso* (New York: Frederick A. Praeger, 1956), p. 56.

15. Stein, *op. cit.*, p. 9.
16. Jean-Paul Crespelle, *Montmartre Vivant* (Paris: Librairie Hachette, 1964), pp. 66–68.
17. Penrose, *op. cit.*, p. 133.
18. Robert S. de Ropp, *Drugs and the Mind* (New York: Grove Press, 1960), p. 101.
19. Gino Severini in an interview with associate, February, 1964.
20. MMM, p. 41; MSL, p. 51.
21. MDV, pp. 349–352.

Notes to Chapter Ten

1. AQ, p. 91.
2. AQ, pp. 93–99.
3. TVOS, p. 418.
4. AQ, p. 102.
5. Pierre Courthion, *Montmartre* (Paris: Edition D'Art Albert Skira, 1956), p. 99.
6. Arthur Pfannstiel, *Dessins de Modigliani* (Lausanne: H. L. Mermod, 1958), p. 84.
7. FDM, pp. 107–108.
8. MMM, p. 41; MSL, p. 51.
9. AQ, p. 120.
10. MCR, p. 117.
11. MJR, p. 6.
12. MSK, p. 15.
13. MMM, p. 41; MSL, p. 51.
14. MMM, p. 44; MSL, p. 54.
15. Katherine Kuh, "Italy's 'New' Renaissance: An Inquiry," *Saturday Review* (New York, February 11, 1961), XLIV, No. 6, 32.
16. TVOS, pp. 508–509.
17. André Gide *The Journals of André Gide*, Volume I, 1889–1913 (New York: Alfred A. Knopf, Inc., 1947), pp. 129 and 196.
18. Interview with Gino Severini by associate, February, 1964.

Notes to Chapter Eleven

1. AQ, p. 120.
2. Alfred Werner, *Modigliani the Sculptor* (New York: Arts, Inc., 1962), pp. xxx and 40.
3. TVOS, pp. 343–344.
4. Interview with Alexander Archipenko by author, June 8, 1962.
5. FDM, p. 75.
6. MMM, p. 42; MSL, p. 52.
7. MMV, p. 182.
8. Gustave Fuss-Amoré and Maurice des Ombiaux, *Montparnasse* (Paris: Albin Michel, 1925), p. 117.
9. Carola Giedion-Welcker, *Constantin Brancusi* (New York: George Braziller, 1959), p. 219, as quoted from *Hommage à Rodin*. Quatrième Salon de la Jeune Sculpture, Paris, 1952, III, cat. p. 22.
10. *Ibid.*, p. 219.
11. Jacob Epstein, *An Autobiography* (London: Hulton Press, 1955), p. 223.
12. Nina Hamnett, *Laughing Torso* (New York: Ray Long and Richard Smith, Inc., 1932), pp. 123–124.
13. MCR, p. 120.
14. Giedion-Welcker, *op. cit.*, pp. 219–220.

15. MJR, p. 7.
16. MCR, p. 33.

Notes to Chapter Twelve

1. MMM, p. 47; MSL, pp. 56–57.
2. MSL, p. 57.
3. MSL, p. 58.
4. MMM, p. 27; MSL, p. 37.
5. AQ, p. 125.
6. MMM, p. 48; MSL, p. 58.
7. MCR, p. 24.
8. Alfred Werner, *Modigliani the Sculpture* (New York: Arts, Inc., 1962), pp. xxxi and 26.
9. Curt Stoermer, "Erinnerungen an Modigliani," *Der Querschnitt* (Berlin, June, 1931) as quoted by Alfred Werner in *Modigliani the Sculptor*, p. xxi.
10. Werner, *op. cit.*, pp. xxxi and 1.
11. André Gide, *The Journals of André Gide*, Volume I, 1889–1913 (New York: Alfred A. Knopf, Inc., 1947), pp. 236–237.
12. Adolphe Basler, *La Sculpture Moderne* (Paris: 1928) as quoted by Alfred Werner in *Modigliani the Sculptor*, p. xxii.
13. Charles-Albert Cingria, "Pages Sur Modigliani" in Arthur Pfannstiel's *Dessins de Modigliani* (Lausanne: H. L. Mermod, 1958), p. xii.
14. MCR, p. 40.
15. AQ, p. 121.
16. AQ, pp. 30–31.
17. MMM, p. 49; MSL, p. 60.
18. AQ, p. 121.
19. "What a thrill I gave 'em!" appears in AQ, p. 122. The phrase *"Quel 'swing' je leur ai appliqué!"* appears in Louis Latourettes' Preface to Arthur Pfannstiel's *Modigliani* (Paris: Editions Seheur, 1929), p. xii.
20. Maurice de Vlaminck, *Tournant Dangereux* (Paris: Editions Stock, 1929), pp. 216–217.
21. Francis Carco, *L'Ami des Peintres* (Paris: Librairie Gallimard, 1953), pp. 34–35.

Notes to Chapter Thirteen

1. MMM, pp. 57–58; MSL, pp. 67–68.
2. AQ, pp. 111–112.
3. MSK, pp. 45–47.
4. AQ, p. 104.
5. AQ, pp. 112–113.
6. AQ, p. 197.
7. AQ, pp. 59–64.
8. MMM, p. 50; MSL, pp. 60–61.
9. Letter to author from Mrs. Laure de Zarate Lourie, February 14, 1963.
10. RLDM, pp. 344–345.

Notes to Chapter Fourteen

1. AQ, pp. 115–118.

2. LDP, pp. 33–34.

3. Roland Penrose, *Picasso: His Life and Work* (New York: Schocken Books, 1962), p. 204.

4. MDV, pp. 349–352.

5. Jacob Epstein, *An Autobiography* (London: Hulton Press, 1955), p. 216.

6. *Ibid.*, p. 46.

7. *Ibid.*, p. 195.

8. *Ibid.*, p. 195.

9. *Ibid.*, pp. 46–49.

10. *Ibid.*, pp. 46–49.

11. AQ, p. 204 as taken from *Montparnasse* by Gustave Fuss-Amoré and Maurice des Ombiaux (Paris: Albin Michel, 1925), pp. 92–93.

12. Epstein, *op. cit.*, pp. 46–49.

13. AQ, p. 229.

14. AQ, p. 93.

15. AQ, p. 96.

16. AQ, p. 97.

17. TVOS, pp. 343–344.

18. Epstein, *op. cit.*, pp. 46–49.

19. Adolphe Basler, special issue of *Paris-Montparnasse*, No. 13, February, 1930, p. 8.

20. R. H. Wilenski, *Modern French Painters*, Volume I, 1863–1903 (New York: Vintage Books, 1960), p. 42.

21. André Gide, *The Journals of André Gide*, Volume I, 1889–1913 (New York: Alfred A. Knopf, Inc., 1947), pp. 156 and 158.

22. AQ, p. 292.

Notes to Chapter Fifteen

1. Fernand Hazan, *Dictionary of Modern Painting*, published under his direction (New York: Tudor Publishing Company, n.d.), p. 59.

2. R. H. Wilenski, *Modern French Painters*, Volume II, 1904–1938 (New York: Vintage Books, 1960), p. 65.

3. *Ibid.*, p. 63.

4. LDP, p. 205.

5. LDP, p. 196.

6. LDP, p. 17.

7. AQ, p. 63.

8. LDP, pp. 194–195.

9. AQ, p. 63; also LDP, p. 215.

10. RLDM, pp. 344–345.

11. Arnold Haskell, *The Sculptor Speaks* (London: Heinemann, Ltd., 1931), p. 132.

12. Jacob Epstein, *An Autobiography* (London: Hulton Press, 1955), pp. 46–49.

13. Alfred Werner, *Modigliani the Sculptor* (New York: Arts, Inc., 1962), p. xxvii.

14. AQ, pp. 249–250.

15. Jacques Lipchitz in an interview with author, December 14, 1963.

16. Jacques Lipchitz, *Modigliani* (New York: Harry Abrams, Inc., in association with Pocket Books, Inc., 1954), unpaged.

17. Charles-Albert Cingria, "Pages Sur Modigliani" in Arthur Pfannstiel's *Dessins de Modigliani* (Lausanne: H. L. Mermod, 1958), p. xiv.

18. Irene Patai, *Encounters, The Life of Jacques Lipchitz*, (New York: Funk & Wagnalls Co., 1961), p. 115.

19. Lipchitz in *Modigliani, op. cit.*, unpaged.

20. *Ibid.*, unpaged.

21. MMM, p. 56; MSL, p. 66.

22. Roch Grey, "Modigliani," *Action* (Paris, December 6, 1920), No. 6, pp. 49–53.

23. AQ, p. 124.

24. Ambrogio Ceroni, *Amedeo Modigliani, Dessins et Sculptures,* (Milan: Edizione Del Milione, 1965), p. 11.

25. Augustus John, *Chiaroscuro: Fragments in Autobiography* (London: Jonathan Cape, 1952), pp. 130–131.

26. LT, p. 27.

27. Hazan, *op. cit.,* p. 132.

28. LT, p. 59.

29. AQ, p. 124.

30. MJR, p. 6.

31. MMM, p. 62; MSL, p. 72.

32. Gastone Razzaguta, "Amedeo Modigliani," *Virtu degli Artisti Labronici* (Leghorn, 1943), p. 175 as quoted by Jeanne Modigliani in MMM, p. 62; MSL, p. 72.

33. Filippelli Silvano, "Testimonanze livornesi Modigliani," *Revista di Livorno* (Leghorn, July–August, 1956), pp. 224–239, as quoted by Jeanne Modigliani in MMM, p. 63; MSL, 73. Jeanne Modigliani feels that these photographs were snapshots of the heads that Modigliani had exhibited at Amedeo Cardoso's studio in 1911.

34. *Ibid.* Silvano, pp. 224–239 as quoted by Jeanne Modigliani in MMM, p. 63; MSL, p. 73.

35. MCR, p. 42.

Notes to Chapter Sixteen

1. AQ, pp. 192–193.

2. AQ, p. 194.

3. Ossip Zadkine in Special Number of *Paris-Montparnasse*, No. 13, February, 1930, pp. 12–14.

4. MPV, p. 68.

5. ROM, pp. 40–41.

6. MCR, quoting Zadkine, p. 18.

7. Zadkine, *op. cit.,* pp. 12–14.

8. AQ, pp. 208–209.

9. AQ, pp. 194–196.

10. MPV, p. 16.

11. Gustave Fuss-Amoré and Maurice des Ombiaux, *Montparnasse* (Paris: Albin Michel, 1925), pp. 111–112.

12. Ambrogio Ceroni, *Amedeo Modigliani, Dessins et Sculptures* (Milan: Edizione Del Milione, 1965), p. 11.

13. Letter to author from Mrs. Laure de Zarate Lourie, February 14, 1963.

14. MPV, pp. 23–24.

15. MPV, p. 78.

16. R. H. Wilenski, *Modern French Painters, 1904–1938* (New York: Vintage Books, 1960), p. 91.

17. ROM, p. 49.

18. Background on Chaim Soutine from Monroe Wheeler, *Soutine* (New York: The Museum of Modern Art, 1950), pp. 32–33 and MPV, pp. 42–43.

19. ELJL, p. 191.

20. Maurice Raynal, *Modern Painting* (Paris: Editions D'Art Albert Skira, 1960. Skira International Corporation), p. 221.

21. Wheeler, *op. cit.,* p. 31.

22. *Ibid.,* p. 42.

23. ELJL, p. 192.

24. AQ, pp. 163–167.

25. Aicha (Goblet), *Paris-Montparnasse*, No. 13, February, 1930, p. 16.

3. ROM, p. 40.

4. Ilya Ehrenburg, *People and Life, 1891–1921* (New York: Alfred A. Knopf, Inc., 1962), p. 149.

5. World War I background based on material from Barbara W. Tuchman's *The Guns of August* (New York: Macmillan, 1962).

6. Ossip Zadkine, Special Number of *Paris-Montparnasse*, No. 13, February, 1930, pp. 12–14.

7. Léon Indenbaum in an interview with associate, May, 1964.

8. ROM, p. 41.

9. ROM, p. 50.

10. ROM, p. 47.

11. ROM, p. 42.

12. Marevna Vorobëv, *Life in Two Worlds* (New York: Abelard-Schuman, 1962), p. 158.

13. MPV, pp. 160–161.

14. ROM, p. 42.

15. Beatrice Hastings, *The Old "New Age," Orage—and Others* (London: Blue Moon Press, 1936), p. 28.

Notes to Chapter Twenty-One

1. MJR, p. 14.

2. Arthur Pfannstiel, *Dessins de Modigliani* (Lausanne: H. L. Mermod, 1958), pp. 26 and 79.

3. Lamberto Vitali, *Quarantacinque desegni di Modigliani* (Turin: Guilio Enaudi Editore, 1959), Plate No. 10.

4. *Action*, No. 7, May, 1921, table of contents, cover.

5. MMM, p. 71; MSL, p. 81.

6. MCR, p. 78.

7. MCR, p. 78.

8. Berthe Weill, "Utrillo, Modigliani sont venus me voir," *Pan! dans l'Oeil!* . . . (Paris: Librairie Lipschutz, 1933), pp. 204–205.

9. Fernande Olivier, *Picasso et Ses Amis* (Paris: Editions Stock, 1933), pp. 17–21.

10. Patrick Waldberg, "Frank Haviland," *Mains et Merveilles* (Paris: Mercure de France, 1961), pp. 17–21.

11. Léon Indenbaum in an interview with associate, May, 1964.

12. MPV, pp. 123–124.

13. MPV, pp. 123–124.

14. Fernand Hazan, *Dictionary of Modern Painting*. Published under his direction (New York: Tudor Publishing Company, n.d.) p. 31.

15. Letter from Mrs. Malin Goldring, December 17, 1962.

16. MPV, p. 67.

17. Florent Fels, *L'Art Vivant de 1900 a Nos Jours* (Geneva: Pierre Cailler, 1956), pp. 115–116.

18. AQ, pp. 224–236.

19. Max Jacob, "Connaissez-vous Maître Eckart?" *Derniers Poèmes* (Paris: Editions Gallimard).

Notes to Chapter Twenty-Two

1. Adolphe Basler, Special Edition of *Paris-Montparnasse*, No. 13, February, 1930, pp. 8–9.

2. Ilya Ehrenburg, *People and Life, 1891–1921* (New York: Alfred A. Knopf, Inc., 1962), pp. 151–158.
3. MPV, p. 69.
4. Jacques Lipchitz in an interview with author, December 14, 1963.
5. Marevna Vorobëv, *Life in Two Worlds* (New York: Abelard-Schuman, pp. 159–160.
6. *Ibid.,* p. 289.
7. AQ, pp. 244–245.
8. Beatrice Hastings, *The Old "New Age," Orage—and Others* (London: Blue Moon Press, 1936), p. 29.
9. Letter from Antony Alpers to author, August 16, 1961.
10. AQ, p. 268.
11. James Storm, *The Valadon Drama: The Life of Suzanne Valadon* (New York: E. P. Dutton & Co., Inc., 1959), p. 185.
12. ELJL, p. 151.
13. Maurice Raynal, *Modern Painting* (Paris: Editions D'Art Albert Skira, 1960. Skira International Corporation), p. 221.
14. MPV, pp. 39–64.
15. MPV, p. 70.
16. ELJL, pp. 147–150.
17. Vorobëv, *op. cit.,* pp. 170–173.
18. Interview with Léon Indenbaum with associate, May 1964.
19. MPV, pp. 87–118.
20. MPV, pp. 87–118.

Notes to Chapter Twenty-Three

1. AQ, p. 233.
2. MMM, 79, MSL, p. 89.
3. MMM, pp. 107–108; MSL, pp. 113–114.
4. MMM, p. 80; MSL, p. 90.
5. AQ, p. 253.
6. AQ, p. 252.
7. ELJL, pp. 190–191.
8. Harold Ettlinger, *Fair Fantastic Paris* (New York: Bobbs-Merrill Company, Inc., 1944), pp. 86–90.
9. LT, pp. 76–79.
10. Franco Russoli, *Modigliani* (New York: Harry N. Abrams, Inc., 1959), unpaged, opposite Plate 16.
11. *Ibid.,* opposite Plate 7.
12. MSK, p. 20.
13. TVOS, pp. 447 and 458.
14. MSK, pp. 25–26.
15. Ambrogio Ceroni, *Amedeo Modigliani,* including "Les Souvenirs de Lunia Czechowska" (Milan: Edizione del Milione, 1958), p. 20.
16. MPV, p. 134.
17. Ossip Zadkine, Special Number of *Paris-Montparnasse,* No. 13, February, 1930, pp. 11–14.
18. *Ibid.,* pp. 11–14.
19. Ceroni, *op. cit.,* pp. 20–21.
20. *Ibid.,* p. 21.
21. *Ibid.,* p. 25.

Notes to Chapter Seventeen

1. MSK, p. 27.
2. Henri Perruchot, *Cézanne* (New York: The World Publishing Company, 1961), p. 203.
3. AQ, p. 199.
4. John Storm, *The Valadon Drama: The Life of Suzanne Valadon* (New York: E. P. Dutton & Co., Inc,. 1959), p. 168.
5. *Ibid.*, p. 169.
6. AQ, p. 206.
7. Fernande Olivier, *Picasso et Ses Amis* (Paris: Editions Stock, 1933, as quoted in MPV, p. 52.
8. MPV, p. 50.
9. MPV, p. 51.
10. MPV, p. 54.
11. AQ, p. 198.
12. MSK, pp. 13–14.
13. Jacob Epstein, *An Autobiography* (London: Hulton Press, 1955), pp. 46–49.
14. MPV, p. 154.
15. MPV, p. 154.
16. Florent Fels, *L'Art Vivant de 1900 a Nos Jours* (Geneva: Pierre Cailler, 1956), p. 109.
17. Léon Indenbaum in an interview with associate, May, 1964.
18. AQ, pp. 199–200.
19. MMM, p. 71; MSL, p. 81.
20. LDP, p. 22.
21. AQ, pp. 103–109.
22. MMM, p. 68; MSL, p. 78.

Notes to Chapter Eighteen

1. RLDM, pp. 344–345.
2. Ossip Zadkine, Special Number of *Paris-Montparnasse*, No. 13, February, 1930, pp. 12–14.
3. Anthony Hartley (ed.), *The Penguin Book of French Verse, The Nineteenth Century* (Middlesex: Penguin Books, 1958), pp. 149–150.
4. Ilya Ehrenburg, *People and Life, 1891–1921* (New York: Alfred A. Knopf, Inc., 1962), pp. 151–158.
5. ELJL, p. 119.
6. ELJL, p. 119.
7. ELJL, p. 119.
8. MCR, pp. 83–84.
9. Bertram D. Wolfe, *The Fabulous Life of Diego Rivera* (New York: Stein and Day, 1963), p. 74.
10. MCR, p. 86.
11. Léon Indenbaum in an interview with associate, May, 1964.
12. LT, p. 48.
13. LT, pp. 48–49.
14. LT, pp. 1–41.
15. AQ, p. 213.
16. Ardengo Soffici, "Ricordi di Modigliani," *Ricordi Di Vita Artistica E. Litteraria* (Florence: Vallecchi Editore, 1942), pp. 217–220.

17. MSK, p. 13.
18. MSK, p. 16.

Notes to Chapter Nineteen

1. LT, p. 58.
2. ROM, pp. 41–43.
3. MPV, pp. 182–184.
4. MPV, pp. 183–184.
5. LT, p. 53.
6. LT, p. 54.
7. MJR, p. 9.
8. LT, p. 54.
9. MPV, p. 132.
10. AQ, pp. 216–217.
11. AQ, pp. 207–208.
12. MPV, pp. 67 and 68.
13. LT, pp. 70–71.
14. Letters of Beatrice Hastings to Douglas Goldring courtesy of Mrs. Malin Goldring.
15. AQ, p. 225.
16. "Anecdote . . ." *Paris-Montparnasse*, No. 13, February, 1930, p. 19.
17. Beatrice Hastings' remarks, source and date unknown, reproduced as printed in end pages of *Modigliani* by Jacques Lipchitz (New York: Harry Abrams, Inc., in association with Pocket Books, Inc., 1954), unpaged.
18. The mystery of Beatrice's identity was solved by Eric Rosenthal when he came across a book of hers in the Cape Town Public Library. On the title page there was written the words, "Written by Beatrice Hastings at Leith Hall, Surrey, October 1910." Pasted on the front cover was a card reading, "Presented to the Public Library, Cape Town, by the author Beatrice Hastings, daughter of John Walter Haigh of Port Elizabeth. June 13, 1934." No author's name appears on the book, which is a romantic novel about South Africa called *The Maid's Comedy, A Chivalric Romance in 13 Chapters*. It was evidently privately printed in London by Stephen Swift, 10 John Street, Adelphi, in 1911, and is probably the only novel by Beatrice Hastings still in existence.
19. Beatrice Hastings, *The Old "New Age," Orage—and Others* (London: Blue Moon Press, 1936), n. p. 13.
20. *Ibid.*, p. 8.
21. Letter to author from Gorham Munson, December 21, 1963.
22. Philip A. Mairet, *A. R. Orage, A Memoir* (London: J. M. Dent & Sons Ltd., 1936), pp. 46–47.
23. *Ibid.*, pp. 51–52.
24. Antony Alpers, *Katherine Mansfield* (New York: Alfred A. Knopf, Inc., 1953), pp. 130–134.
25. *Ibid.*, pp. 128–129.
26. *Ibid.*, p. 141.
27. Letter to author from Gorham Munson, November 29, 1963.

Notes to Chapter Twenty

1. LT, p. 71.
2. Frank Elgar and Robert Maillard, *Picasso* (New York: Frederick A. Praeger, Inc., 1960), p. 83.

Notes to Chapter Twenty-Four

1. CAM, pp. 21–22.
2. CAM, p. 22.
3. Marevna Vorobëv, *Life in Two Worlds* (New York: Abelard-Schuman, 1962), pp. 160–161.
4. AQ, pp. 340–341.
5. AQ, pp. 251–263 and 309–321.
6. Michel Georges-Michel, *From Renoir to Picasso* (Boston: Houghton-Mifflin Company, 1957), p. 147.
7. *Ibid.*, p. 147.
8. CAM, p. 19.
9. AQ, p. 309.
10. AQ, pp. 254–255.
11. LDP, pp. 33–37.
12. LDP, p. 36.
13. Interview with Dr. and Mme. Dyre Diriks, March, 1963, and Léon Indenbaum interviewed by associate, May, 1964.
14. AQ, p. 247.
15. AQ, p. 246.
16. AQ, p. 247.
17. MPV, pp. 161–162.
18. AQ, p. 248.
19. ELJL, pp. 214–216.
20. Jacques Lipchitz, "I Remember Modigliani," as told to Dorothy Seckler, *Art News* (New York, February, 1951), XLIX, No. 10, 26–29 and 64–65.
21. Jacques Lipchitz, *Amedeo Modigliani* (New York: Harry N. Abrams Company in association with Pocket Books, Inc., 1954), unpaged; also ELJL, p. 167.
22. Maurice de Vlaminck, *Tournant Dangereux* (Paris: Editions Stock, 1929), p. 216.
23. MCR, pp. 94–95.
24. Vlaminck, *op. cit.*, p. 216.
25. MCR, p. 101.
26. AQ, p. 208.
27. Vlaminck, *op. cit.*, p. 217.
28. AQ, pp. 234–236.
29. Léon Indenbaum in an interview with associate, May, 1964.
30. AQ, p. 314.
31. Léon Indenbaum in an interview with associate, May, 1964.
32. Francis Carco, *The Last Bohemia, from Montmartre to the Latin Quarter,* translated by Madeleine Boyd (New York: Henry Holt and Company, 1928), p. 29.
33. Interview with Jacques Lipchitz by author, December 14, 1963.
34. Interview with Dr. Diriks, March, 1963.
35. Ilya Ehrenburg, *People and Life, 1891–1921* (New York: Alfred A. Knopf, Inc., 1962), p. 185.
36. *Ibid.*, pp. 198–199.
37. AQ, p. 249.
38. Jacques Lipchitz in an interview with author, December 14, 1963.

Notes to Chapter Twenty-Five

1. MMM, pp. 87–88; MSL, pp. 97–98.
2. MPV, pp. 14–16.

3. ROM, pp. 43–46.
4. MSL, p. 110.
5. ROM, pp. 49–51.
6. CAM, p. 28.
7. AQ, p. 264.
8. MPV, p. 124.
9. Gino Severini in an interview with associate, February, 1964.
10. Léon Indenbaum, in an interview with associate, May, 1964.
11. AQ, p. 270.
12. Dr. and Mme. Dyre Diriks in an interview with associate, March, 1963.
13. AQ, pp. 326–327.
14. AQ, pp. 326–327.
15. MMM, p. 88; MSL, p. 98.
16. LT, pp. 133–134.
17. AQ, pp. 285–286.
18. CAM, p. 28.
19. AQ, p. 258.
20. AQ, pp. 311–312.
21. AQ, pp. 313–314.
22. MMM, p. 78; MSL, p. 88.
23. CAM, pp. 24–25.
24. LDP, p. 39.
25. LDP, p. 40; AQ, p. 286; MMM, pp. 77–78; MSL, pp. 87–88; door picture reproduced Plates 20 and 21 in Pierre Descargues' *Amedeo Modigliani* (Paris: Les Editions Braun et Cie., 1954).
26. ELJL, pp. 157–158; also author's interview with Jacques Lipchitz, December 14, 1963.
27. James Storm, *The Valadon Drama: The Life of Suzanne Valadon* (New York: E. P. Dutton & Co., Inc., 1959), p. 169.
28. CAM, pp. 24–25.
29. AQ, 317–319.
30. LDP, p. 41.
31. MJR, pp. 7–8.
32. TVOS, pp. 334–335.

Notes to Chapter Twenty-Six

1. AQ, pp. 267–268.
2. Ramón Gómez de la Serna, Special Number of *Paris-Montparnasse*, No. 13, February 1930, p. 6; also quoted by Bertram D. Wolfe in *The Fabulous Life of Diego Rivera* (New York: Stein and Day, 1963), pp. 73–74, from Ramón Gómez de la Serna, *Ismos* (Madrid: 1937), pp. 329–350.
3. AQ, pp. 268–269.
4. AQ, p. 269.
5. MMM, p. 82; MSL, p. 92.
6. AQ, p. 267.
7. AQ, 259–261.
8. LDP, p. 69.
9. Francis Carco, *Bohème D'Artiste* (Paris: Albin Michel, 1940), pp. 212–215.
10. CAM, p. 33.
11. LDP, p. 38.
12. AQ, pp. 322–323.
13. AQ, p. 258.

14. AQ, p. 261, as quoted from *Montparnasse* by Gustave Fuss-Amoré and Maurice des Ombiaux (Paris: Albin Michel, 1925), pp. 200–201.

15. AQ, p. 262, from Fuss-Amoré and Des Ombiaux, *op. cit.*, p. 201.

16. Jacques Lipchitz in an interview with author, December 14, 1963.

17. Fernand Hazen, *Dictionary of Modern Painting*, published under his direction (New York: Tudor Publishing Company, n.d.), pp. 43 and 67.

18. AQ, p. 265.

19. LDP, p. 68.

20. AQ, pp. 266–267.

21. AQ, p. 265.

22. AQ, p. 265.

23. MCR, pp. 71 and 74.

24. Franco Russoli, *Modigliani* (New York: Harry N. Abrams Company, 1959), un-paged, opposite Plate 15.

25. *Ibid.*, pp. 9–10.

26. Jean Cocteau, *Modigliani* (Paris: Fernand Hazan, 1950, from the Bibliothèque Aldine des Arts), unpaged.

27. AQ, p. 265.

28. Erickson, Evarts, "Amedeo Modigliani, Son of the Stars," *School Arts* (Worcester, April, 1959), LVIII, No. 8, 38.

29. MMM, p. 82; MSL, p. 92.

Notes to Chapter Twenty-Seven

1. Michel Georges-Michel, *From Renoir to Picasso* (Boston: Houghton Mifflin Company, 1957), p. 114.

2. CAM, Plate 91.

3. Georges-Michel, *op. cit.*, p. 142.

4. Georges-Michel, *op. cit.*, p. 143.

5. Alfred Werner, *Modigliani the Sculptor* (New York: Arts, Inc., 1962), pp. xiv–xv.

6. ELJL, p. 175.

7. MPV, p. 127.

8. Georges-Michel, *op. cit.*, p. 161.

9. MPV, p. 131.

10. ROM, pp. 44–45.

11. ROM, p. 45.

12. Georges-Michel, *op. cit.*, p. 84.

13. ELJL, pp. 175–176.

14. Gertrude Stein, *Picasso* (Boston: Beacon Press, 1959), p. 11.

15. Georges-Michel, *op. cit.*, p. 84.

16. AQ, p. 266.

17. Ernest Hemingway, *A Moveable Feast* (New York: Charles Scribner's Sons, 1964), pp. 81–82.

18. Blaise Cendrars, "Cendrars devant ces images nous a raconté trois histoires," *Arts* (Paris, March 14–20, 1956), No. 555:9.

19. AQ, pp. 270–271.

20. Georges-Michel, *op. cit.*, p. 254.

21. MSK, p. 15.

22. CAM, pp. 25–26.

23. MSK, pp. 43–44.

24. Georges-Michel, *op. cit.*, pp. 49–50.

25. Berthe Weill, "Exposition Modigliani," *Pan! dans l'Oeil!* . . . (Paris: Librairie Lipschutz, 1933), pp. 226–229.

Notes to Chapter Twenty-Eight

1. MCR, p. 97.
2. MCR, pp. 64–68.
3. ELJL, p. 166.
4. ELJL, p. 196.
5. ROM, p. 49.
6. AQ, pp. 220–221.
7. ROM, p. 42.
8. ROM, pp. 42–43.
9. Gaston Adam de Pawlowski, *Alfredo Pina* (Paris: Jean Allard, 1929).
10. LDP, p. 38.
11. LDP, p. 39.
12. ROM, p. 48.
13. AQ, p. 272.
14. MPV, pp. 157–158.
15. AQ, p. 257.
16. AQ, p. 274.
17. AQ, p. 274.
18. ROM, p. 50.
19. ROM, pp. 50–51.
20. MPV, p. 158.
21. AQ, p. 334.
22. Ernest Brummer, "Modigliani chez Renoir," *Paris-Montparnasse,* Special Issue, No. 13, February, 1930, pp. 15–16.
23. MMM, p. 93; MSL, p. 103.
24. MMM, p. 93; MSL, p. 103.
25. MPV, p. 157.
26. Ernest Brummer, "Modigliani chez Renoir," *Paris-Montparnasse,* Special Issue, No. 13, February, 1930, pp. 15–16.
27. Jean Renoir, *Renoir, My Father* (Boston: Atlantic-Little, Brown Company, 1962), pp. 449–459.
28. *Ibid.,* p. 191.

Notes to Chapter Twenty-Nine

1. Mme. Marcellin Castaing in interview with associate, March, 1964.
2. ROM, p. 50.
3. MPV, pp. 56 and 81.
4. MPV, p. 158.
5. AQ, pp. 276–277.
6. Alexander Archipenko in an interview with author, June 8, 1962.
7. AQ, p. 278.
8. ROM, p. 48.
9. ROM, p. 47.
10. *New York Post,* March 18, 1954.
11. MPV, p. 182.
12. "Gaston Modot," *L'Ecran Français,* June 27, 1949, No. 209, p. 16.
13. Roch Grey on "Modigliani," *L'Action* (Paris, December 6, 1920), No. 6, pp. 49–53.
14. Leopold Survage in interview with associate, February, 1964.
15. Francis Carco, *The Last Bohemia, from Montmartre to the Latin Quarter,*

translated by Madeleine Boyd (New York: Henry Holt and Company, 1928), p. 30.

16. André Salmon, *La Vie Passionnée de Modigliani* (Paris: Editions Gérard and Cie., 1957), pp. 320–331; *Modigliani: A Memoir,* translated by Randolph and Dorothy Weaver (New York: G. P. Putnam's Sons, 1961), pp. 194–195.

17. Frank Arnau, *Three Thousand Years of Deception in Art* (London: Jonathan Cape Limited, 1961), p. 32.

18. AQ, pp. 278–279 and 333–335.

19. AQ, p. 324.

20. AQ, p. 279.

21. AQ, pp. 279–280.

22. AQ, p. 280.

23. MMM, p. 89; MSL, p. 99.

24. MMM, p. 89; MSL, p. 99.

25. MMM, p. 90; MSL, p. 100.

26. Leopold Survage in interview with associate, February, 1964.

27. MMM, p. 91; MSL, p. 102.

28. MMM, pp. 91–92; MSL, p. 102.

29. MMM, pp. 90–91; MSL, pp. 100–101.

Notes to Chapter Thirty

1. MMM, p. 109; MSL, pp. 115–116.

2. Maurice Rheims, *The Strange Life of Objects* (New York: Atheneum, 1961), pp. 191–192.

3. MMM, pp. 93–94; MSL, p. 104.

4. MJR, p. 8.

5. MMM, pp. 109–110; MSL, p. 116.

6. MMM, p. 110; MSL, p. 116.

7. MCR, pp. 112–113.

8. MMM, p. 88; MSL, p. 98.

9. Arthur Pfannstiel, *Modigliani et Son Oeuvre* (Paris: Bibliothèque Des Arts, 1956), as quoted by Jeanne Modigliani in MMM, p. 66; MSL, p. 76.

10. MMM, pp. 110–111; MSL, p. 117.

11. MMM, p. 92; MSL, p. 102.

12. AQ, p. 109.

13. MMM, p. 111; MSL, pp. 117–118.

14. Osbert Sitwell, *Laughter in the Next Room* (Boston: Atlantic-Little, Brown and Company, 1948), pp. 58–59.

15. *Ibid.,* p. 59.

16. MMM, pp. 111–112; MSL, pp. 118–119.

Notes to Chapter Thirty-One

1. MJR, p. 8.

2. MSL, p. 105.

3. CAM, p. 28.

4. CAM, pp. 28–29.

5. MMM, p. 95; MSL, p. 105.

6. MPV, p. 124.

7. CAM, p. 29.

8. MMM, p. 95; MSL, p. 105.

9. CAM, p. 29.

10. MSK, p. 13.

11. CAM, p. 32.
12. RLDM, pp. 344–345.
13. MDV, pp. 348–352.
14. Marevna Vorobëv. *Life in Two Worlds* (New York: Abelard-Schuman, 1962), pp. 162–163.
15. MMM, p. 95; MSL, p. 105.
16. AQ, p. 324.

Notes to Chapter Thirty-Two

1. Osbert Sitwell, *Laughter in the Next Room* (Boston: Atlantic-Little, Brown Company, 1948), p. 165.
2. *Ibid.*, pp. 164–165.
3. LT, p. 116.
4. AQ, p. 289.
5. Roland Penrose, *Picasso: His Life and Work* (New York: Schocken Books Inc., pp. 104–106.
6. Sitwell, *op. cit.*, p. 166.
7. Sitwell, *op. cit.*, p. 167.
8. CAM, p. 30.
9. MMM, p. 96; MSL, p. 106.
10. MMM, p. 96; MSL, p. 106–107.
11. Sitwell, *op. cit.*, pp. 171–172.
12. AQ, p. 289.
13. Sitwell, *op. cit.*, p. 174.
14. Sitwell, *op. cit.*, p. 177.
15. Sitwell, *op. cit.*, p. 177.
16. AQ, p. 289.
17. Osbert Sitwell, *Noble Essences* (Boston: Atlantic-Little, Brown Company, 1950), pp. 332–333.
18. LT, p. 116.
19. Sitwell, *Laughter in the Next Room, op. cit.*, pp. 178–183.
20. *Ibid.*, p. 177.
21. LDP, p. 260.
22. AQ, p. 287.
23. Charles-Albert Cingria, "Pages sur Modigliani" in Arthur Pfannstiel's *Dessins de Modigliani* (Lausanne: H. L. Mermod, 1958), p. xiv.
24. *Ibid.*, p. xiv.
25. Franco Russoli, *Modigliani* (New York: Harry N. Abrams Company, 1959), p. 28.
26. MJR, pp. 14 and 19.
27. MJR, p. 13.
28. MJR, p. 16.
29. LDP, p. 33.
30. MJR, p. 16.
31. Roland Penrose, *Picasso: His Life and Work* (New York: Schocken Books Inc., 1962), p. 204.
32. Letters from David Douglas Duncan to author May 4 and 29, 1964.
33. Françoise Gilot and Carlton Lake, *Life with Picasso* (New York: McGraw-Hill Book Company, 1964), pp. 17 and 79.
34. LDP, pp. 33–34.
35. Arnold L. Haskell, *The Sculptor Speaks, Jacob Epstein to Arnold L. Haskell* (London: Heinemann, Ltd., 1931), p. 106.

Notes to Chapter Thirty-Three

1. Thomas Craven, *Modern Art* (New York: Simon and Schuster, 1934), p. 201.
2. MCR, p. 13.

3. MCR, p. 13.
4. TVOS, p. 458.
5. TVOS, p. 119.
6. Letter to author from M. Marcel Brandin, secretary to André Malraux, Minister of Cultural Affairs, January 6, 1964.
7. MJR, p. 17.
8. AQ, p. 287.
9. Franco Russoli, *Modigliani* (New York: Harry N. Abrams Company, 1959), opposite Plate 36.
10. Letter to author from Mrs. Laure de Zarate Lourie, February 14, 1963.
11. AQ, p. 336.
12. Russoli, *op. cit.,* opposite Plate 22.
13. Monroe Wheeler, *Soutine* (New York: The Museum of Modern Art, 1950), p. 50.
14. CAM, p. 32.
15. CAM, p. 32.
16. CAM, p. 33.
17. AQ, p. 288.
18. ROM, pp. 45–46.
19. AQ, pp. 288–289.
20. Francis Carco, *The Last Bohemia, from Montmartre to the Latin Quarter,* translated by Madeleine Boyd (New York: Henry Holt and Company, 1928), pp. 30–31.
21. MMM, p. 97; MSL, pp. 107–108.
22. Interview with Léon Indenbaum by associate, May, 1964.

Notes to Chapter Thirty-Four

1. AQ, pp. 330–331.
2. Amedeo Modigliani, three poems in *Omaggio a Modigliani (1884–1920)*, edited by Giovanni Schweiller, Milan, January 25, 1930; "Ave et Vale" in *Notes and Memoirs, Amedeo Modigliani*, Genoa, 1945; poems in *Europe Almanach*, 1925, p. 140; Three poems in *Les Arts à Paris*, No. 1, October, 1925.
3. MCR, pp. 23 and 26.
4. MSK, p. 45.
5. MPV, p. 124.
6. André Salmon, *La Vie Passionnée de Modigliani* (Paris: Editions Gérard & Cie., 1957), pp. 332–337; *Modigliani: A Memoir,* translated by Randolph and Dorothy Weaver (New York: G. P. Putnam's Sons, 1961), p. 200.
7. *Ibid.*, p. 327; p. 200.
8. Arthur Pfannstiel, *Dessins de Modigliani* (Lausanne: H. L. Mermod, 1958), pp. 30 and 80.
9. Salmon, *op. cit.,* French edition, pp. 332–334; American edition, pp. 203–204.
10. MCR, p. 105.
11. MMM, p. 88; MSL, p. 98.
12. Raffaello Franchi, *Modigliani* (Florence: Arnaud Editore, 1947), p. 25.
13. AQ, p. 290.
14. Jean Renoir, *Renoir, My Father* (Boston: Atlantic-Little, Brown Company, 1962), p. 458.
15. MMM, pp. 96–97; MSL, p. 107.
16. AQ, pp. 328–329.
17. MMM, p. 110; MSL, p. 117.
18. MMM, pp. 115–116; MSL, pp. 111 and 118–119.
19. AQ, p. 280; also Dr. and Mme. Dyre Diriks in an interview with associate, March, 1963.
20. MPV, p. 161.
21. AQ, pp. 281–282.
22. AQ, pp. 314–315.
23. AQ, pp. 291.

24. John Storm, *The Valadon Drama: The Life of Suzanne Valadon* (New York: E. P. Dutton & Co., Inc., 1959), pp. 200–201.

25. Louis Latourettes in his Preface to *Modigliani* by Arthur Pfannstiel (Paris: Editions Seheur, 1929), pp. xv–xvi; AQ, pp. 291–292.

26. ROM, pp. 43.

27. AQ, pp. 292–293.

28. MMM, p. 97; MSL, p. 107.

29. AQ, p. 293.

Notes to Chapter Thirty-Five

1. ROM, p. 44.

2. Ilya Ehrenburg, *People and Life, 1891–1921* (New York: Alfred A. Knopf, Inc., 1962), pp. 151–158.

3. Ossip Zadkine in Special Issue of *Paris-Montparnasse*, No. 13, February, 1930, pp. 12–14.

4. AQ, p. 290.

5. MMM, p. 115; MSL, p. 121.

6. Léon Indenbaum in an interview with associate, May, 1964.

7. AQ, p. 329.

8. Lascano Tegui in Special Issue of *Paris-Montparnasse*, No. 13, February, 1930, pp. 5–6; AQ, pp. 293–295.

9. *Ibid.*, Tegui, p. 5; AQ, pp. 294–295.

10. *Ibid.*, Tegui, p. 6; AQ, p. 295.

11. AQ, p. 296.

12. Letter to author from Mrs. Laure de Zarate Lourie, February 14, 1963.

13. AQ, p. 296.

14. AQ, p. 297.

15. MMM, p. 114; MSL, p. 121.

16. Ortiz de Zarate in Special Issue of *Paris-Montparnasse*, No. 13, February, 1930, pp. 15–16.

17. AQ, p. 297.

18. MMM, p. 97; MSL, p. 108.

19. MMM, p. 114; MSL, p. 121.

20. ROM, p. 48.

21. RLDM, pp. 344–345.

22. MMM, p. 98; MSL, pp. 108–109.

23. AQ, p. 299.

24. MMM, p. 98; MSL, p. 99.

25. Jacques Lipchitz in an interview with author, December 14, 1963.

26. AQ, p. 299.

27. Léon Indenbaum in an interview with associate, May, 1964.

28. Zawado (Waclaw Zawadowski) in an interview with associate, March, 1964.

29. MMM, p. 99.

30. MMM, p. 115; MSL, p. 121.

31. Letter from Mrs. Laure de Zarate Lourie to author, February 14, 1963.

32. MSL, pp. 109–110.

Notes to Chapter Thirty-Six

1. Jacques Lipchitz in an interview with author, December 14, 1963.

2. ROM, p. 40.

3. MMM, p. 60; MSL, p. 71.
4. AQ, p. 300.
5. MSL, pp. 121–122.
6. MSL, p. 122.
7. AQ, p. 300.
8. MPV, p. 125.
9. Jacques Lipchitz in an interview with author, December 14, 1963.
10. Letter from Mrs. Laure de Zarate Lourie, February 14, 1963.
11. MPV, p. 46.
12. Francis Carco, *The Last Bohemia, from Montmartre to the Latin Quarter,* translated by Madeleine Boyd (New York: Henry Holt and Company, 1928), pp. 288–297; also AQ, p. 301.
13. AQ, p. 301.
14. Carco, *op. cit.,* p. 297.
15. MMM, p. 114; MSL, p. 120.
16. MSL, pp. 119–120.
17. AQ, p. 301.
18. Francis Carco, *Bohème D'Artiste* (Paris: Albin Michel, 1940), pp. 74–75.
19. Berthe Weill, *Pan! dans l'Oeil!* . . . (Paris: Librairie Lipschutz, 1933), pp. 229–230.
20. ROM, p. 51.
21. AQ, p. 302.
22. *L'Evénement,* January 29, 1920.
23. MPV, p. 50.
24. RLDM, p. 344–345.
25. ELJL, pp. 188–190.
26. ROM, p. 51.
27. ROM, p. 43.
28. AQ, p. 300.
29. Zawado (Waclaw Zawadowski) in an interview with associate, March, 1964.
30. ROM, pp. 45–46.
31. MMM, p. 99.
32. ROM, p. 46.
33. Letter from Mrs. Laure De Zarate Lourie, February 14, 1963.
34. AQ, p. 303.
35. ROM, p. 45.
36. Mme. Chana Orloff in an interview with associate, March, 1964.
37. Letter to associate from André Salmon, April 25, 1964, reading: Dear Sir, I regret being unable to satisfy you in this matter. Surviving them all, I am aware of having done much for the survival of my friends who have vanished. At the advanced age I have achieved, how could I be better occupied than in the reflection and examination of my life's work?
Furthermore, I could not answer the questions you put to me. I have more or less shared the life of the friends of my youth. I never thought of controlling their lives to give evidence at a later date. Sincerely, André Salmon.
He adds two postscripts: "My regrets are sincere. I rather deplore my decision not to assist the work of a foreign colleague. I have done it so many times! To the point that I ought to have a doctor's degree from numerous universities.
"I have said all that I was permitted to say about the death of Jeanne Hébuterne in my book, which you seem not to have heard of: *Vie passionnée de Modigliani,* Edition Pierre Seghers, 228 Boulevard Raspail, Paris. It has been published in English in an adaptation, not a translation, which is too abridged to recommend to a researcher A.S."
38. André Salmon, *La Vie Passionnee de Modigliani* (Paris: Editions Gérard & Cie., 1957), pp. 341–345; *Modigliani: A Memoir,* translated by Randolph and Dorothy Weaver (New York: G. P. Putnam's Sons, 1961), pp. 210–213.
39. Mme. André Hébuterne in an interview with associate, April, 1964.

40. MSL, p. 13, note 2.
41. Letter from Mrs. Laure de Zarate Lourie, February 14, 1963.

Notes to Chapter Thirty-Seven

1. AQ, pp. 303–304.
2. Dr. and Mme. Dyre Diriks in an interview with associate, March, 1963.
3. AQ, pp. 304–305.
4. AQ, pp. 328–329.
5. AQ, p. 305.
6. MJR, p. 21.
7. MJR, p. 21.
8. MMM, p. 61; MSL, p. 71.
9. AQ, pp. 305–308.
10. AQ, p. 306.
11. Ilya Ehrenburg, *People and Life, 1891–1921* (New York: Alfred A. Knopf, Inc., 1962), pp. 151–158.
12. AQ, p. 306.
13. AQ, p. 307.
14. AQ, pp. 307–308.
15. AQ, p. 307.
16. Leopold Survage in an interview with associate, February, 1964.
17. MMM, p. 116; MSL, pp. 123–124.
18. AQ, pp. 307–308.
19. CAM, pp. 33–34.
20. LT, p. 116.
21. LT, p. 117.
22. LT, p. 125.
23. LT, p. 154.
24. LT, p. 155.
25. Zawado (Waclaw Zawadowski) in an interview with associate, March, 1964.
26. Monroe Wheeler, *Soutine* (New York: The Museum of Modern Art, 1950), p. 50.
27. Mme. Marcellin Castaing in an interview with associate, March, 1964.
28. Gino Severini in an interview with associate, February, 1964.
29. William Schack, *Art and Argyrol, the Life and Career of Dr. Albert C. Barnes* (New York: A. S. Barnes and Co., 1963), pp. 124–133.
30. *Ibid.*, p. 130.
31. ELJL, pp. 203–216.
32. Wheeler, *op. cit.*, p. 50.
33. Schack, *op. cit.*, pp. 121–122.
34. ELJL, p. 213.
35. ELJL, p. 194.
36. Schack, *op. cit.*, pp. 122–123.
37. *New York Herald Tribune*, March 19, 1961.
38. AQ, pp. 320–321 and 322–325.

Notes to Chapter Thirty-Eight

1. Barbara D. Holender, "Portrait by Modigliani," *The New York Times*, October 19, 1960.
2. Charles-Albert Cingria in his "Pages sur Modigliani," in Arthur Pfannstiel's *Dessins de Modigliani* (Lausanne: H. L. Mermod, 1958), p. xviii.
3. TVOS, pp. 582–612.

4. Courtesy of M. Marcel Brandin, secretary to Minister of Cultural Affairs André Malraux.

5. MSK, p. 18.

6. MMM, pp. 31–32; MSL, pp. 40–41.

7. Alfred Werner, *Modigliani the Sculptor* (New York: Arts, Inc., 1962), p. xx.

8. Letter to author from M. Marcel Brandin, secretary to Minister of Cultural Affairs André Malraux, January 6, 1964.

9. Gertrude Coor, *Neroccio De'Landi, 1447–1500* (Princeton: Princeton University Press, 1961), p. vii, quoting Bernard Berenson, *The Central Italian Painters of the Renaissance* (New York and London, 1897), pp. 55 ff.

10. Coor, *op. cit.*, pp. 11–12, 15, 114.

11. MCR, p. 13.

12. James Thrall Soby, *Modigliani* (New York: The Museum of Modern Art, 1951), p. 11.

13. C. J. Bulliet, *Apples and Madonnas* (New York: Covici-Friede, 1933), pp. 157–158. From *Apples and Madonnas* by C. J. Bulliet.

14. Adolphe Basler and Charles Kunstler, *The Modernists: From Matisse to De Segonzac* (New York: William Farquhar Payson, 1931), p. 72.

15. Thomas Craven, *Modern Art* (New York: Simon and Schuster, 1934), Introduction, p. xx.

16. Arthur Pfannstiel, *Modigliani* (Paris: Editions Seheur, 1929), p. 126.

17. Maud Dale, *Modigliani* (New York: Alfred A. Knopf, Inc., 1929), p. 11.

18. Eric Newton, *The Arts of Man* (Greenwich, Conn.: New York Graphic Society Publishers, 1960), p. 249.

19. Edgar Levy, "Modigliani and the Art of Painting," *The American Scholar*, Summer, 1964, pp. 400–407.

20. William S. Lieberman, Foreword to Catalogue *Modigliani Exhibition*, Los Angeles and Boston (Los Angeles: University of California, 1961), pp. 9–11.

21. Erickson, Evarts, "Amedeo Modigliani, Son of the Stars," *School Arts*, Worcester, April, 1959, vol. 58, no. 8, p. 39.

22. Ilya Ehrenburg, *People and Life, 1891–1921* (New York, Alfred A. Knopf, Inc., 1962), pp. 151–158.

23. MCR, pp. 118–120.

24. AQ, pp. 341–343.

⌇⌇⌇ Bibliography

General

Alpers, Antony. *Katherine Mansfield.* New York: Alfred A. Knopf, Inc., 1953.

Arland, Marcel. *Chronique de la Peinture Moderne.* Paris: Edition Corrêa, 1949.

Arnau, Frank. *Three Thousand Years of Deception in Art.* London: Jonathan Cape, 1961.

Barnes, Albert C., and De Mazia, Violette. *The Art of Henri Matisse.* New York: Charles Scribner's Sons, 1933.

Basler, Adolphe, and Kunstler, Charles. *The Post-Impressionists: From Monet to Bonnard* (trans.). New York: Willian Farquhar Payson, 1931.

————. *The Modernists: Matisse to De Segonzac.* New York: William Farquhar Payson, 1931.

Berger, René. *Discovery of Painting.* New York: The Viking Press, 1963.

Blunt, Anthony, and Pool, Phoebe. *Picasso, The Formative Years.* Greenwich: The New York Graphic Society, 1962.

Brinnin, John Malcolm. *Dylan Thomas in America.* Boston: Atlantic-Little, Brown and Co., 1955.

————. *The Third Rose, Gertrude Stein and Her World.* Atlantic-Little, Brown and Co., 1959.

Bulliet, C. J. *Apples and Madonnas.* New York: Covici-Friede, 1933. Copyright Crown Publishers, New York, 1958.

Canaday, John. *Mainstreams of Modern Art.* New York: Simon and Schuster, 1959.

Carco, Francis. *Les Veillées du "Lapin Agile."* Paris: L'Edition Française Illustrée, 1919.

————. *The Last Bohemia, from Montmartre to the Latin Quarter.* Translated by Madeleine Boyd. New York: Henry Holt and Co., 1928.

————. *Montmartre à Vingt Ans.* Paris: Albin Michel, 1938.

————. *Bohème d'Artiste.* Paris: Albin Michel, 1940.

————. *Ombres Vivantes.* Paris: J. Ferenczi et Fils, 1947.

————. *L'Ami des Péintres.* Paris: Librairie Gallimard, 1953.

Cavanne, Pierre. *The Great Collections.* New York: Farrar, Straus and Co., Inc., 1963.

Ceroni, Ambrogio. *Amedeo Modigliani* (including *Les Souvenirs de Lunia Czechowska*). Milan: Edizione Del Milione, 1958; *Amedeo Modigliani, Dessins et Sculptures*. Milan: Edizione Del Milione, 1965.

Cocteau, Jean. *Modigliani*. Paris: Fernand Hazan Editeur, 1958.

Coor, Gertrude. *Neroccio De'Landi, 1447–1500*. Princeton: Princeton University Press, 1961.

Coquiot, Gustave. *Les Indépendants*. Paris: Librairie Ollendorf, 1920.

Coughlan, Robert. *The Wine of Genius: A Life of Maurice Utrillo*. New York: Harper and Bros., 1951.

Courthion, Pierre. *Montmartre*. Translated by Stuart Gilbert. Paris: Editions D'Art Albert Skira, 1956.

———. *Paris in Our Time*. Translated by Stuart Gilbert. Paris: Editions D'Art Albert Skira, 1957.

Cowles, Fleur. *The Case of Salvador Dali*. Boston: Little, Brown and Co., 1959.

Craven, Thomas. *Modern Art*. New York: Simon and Schuster, 1934.

Crespelle, Jean-Paul. *Montparnasse Vivant*. Paris: Librairie Hachette, 1962.

———. *Montmartre Vivant*. Paris: Librairie Hachette, 1964.

Dale, Maud. *Modigliani*. New York: Alfred A. Knopf, Inc., 1929.

Davidson, Jo. *Between Sittings, An Informal Biography*. New York: Dial Press, 1951.

De Ropp, Robert S. *Drugs and the Mind*. New York: Grove Press, 1960.

Descargues, Pierre. *Amedeo Modigliani*. Paris: Les Editions Braun et Cie., 1934.

Dorgelès, Roland. *Quand J'étais Montmartrois*. Paris: Albin Michel, 1936.

Douglas, Charles. *See* Goldring, Douglas.

Duncan, David Douglas. *The Private World of Pablo Picasso*. New York: Ridge Press, 1958.

Ehrenburg, Ilya. *People and Life, 1891–1921*. New York: Alfred A. Knopf, Inc., 1962.

Elgar, Frank, and Maillard, Robert. *Picasso*. New York: Frederick A. Praeger and Company, 1956.

Epstein, Jacob. *An Autobiography*. London: Hulton Press, 1955.

Ettlinger, Harold. *Fair Fantastic Paris*. New York: The Bobbs-Merrill Company, 1944.

Faure, Elie. *History of Art—Modern Art*. Translated by Walter Pach. Garden City: Garden City Publishing Company, 1937.

Fels, Florent. *L'Art Vivant de 1900 a Nos Jours*. Geneva: Pierre Cailler, 1956.

Franchi, Raffaello. *Modigliani*. Florence: Arnaud Editore, 1947.

Fuss-Amoré, Gustave, and Des Ombiaux, Maurice. *Montparnasse*. Paris: Albin Michel, 1925.

Gardener, Helen. *Art Through the Ages*. Fourth Edition. New York: Harcourt, Brace and Co., 1959.

Georges-Michel, Michel. *From Renoir to Picasso*. Boston: Houghton Mifflin Company, 1957.

Gide, André. *The Journals of André Gide*. Volume One, 1889–1913. New York: Alfred A. Knopf, Inc., 1947.

Giedion-Welcker, Carola. *Constantin Brancusi*. New York: George Braziller, Inc., 1959.

Goldring, Douglas. *Artist Quarter*. (Originally published under pseudonym of Charles Douglas.) London: Faber and Faber, 1944.

Hamnett, Nina. *Laughing Torso*. New York: Ray Long and Richard R. Smith, Inc., 1932.

———. *Is She a Lady? A Problem in Autobiography*. London: A. Wingate, 1955.

Hartlaub, G. F. *Impressionists in France.* Milan: The Uffici Press, n.d.

Haskell, Arnold L. *The Sculptor Speaks, Jacob Epstein to Arnold L. Haskell.* London: Heineman, Ltd., 1931.

Hazan, Fernand. *Dictionary of Modern Painting.* Published under his direction. New York: Tudor Publishing Company, n.d.

Hemingway, Ernest. *A Moveable Feast.* New York: Charles Scribner's Sons, 1964.

Jedlicka, Gotthard. *Modigliani.* Zurich: Eugen Reutsch Verlag, 1953.

Jianou, Ionel. *Brancusi.* New York: Tudor Publishing Co., 1963.

John, Augustus. *Chiaroscuro: Fragments in Autobiography.* New York: Pellegrini and Cudahy, 1952.

Kiki. *The Education of a French Model.* New York: Belmont Books, 1962.

Lassaigne, Jacques, Cogniat, Raymond, and Zahar, Marcel. *Panorama des Arts 1947.* Paris: Aimery Somogy, 1948.

Liebling, A. J. *Normandy Revisited.* New York: Simon and Schuster, 1958.

Lipchitz, Jacques. *Amedeo Modigliani.* New York: Harry N. Abrams Company in association with Pocket Books, Inc., 1954.

Malraux, André. *The Voices of Silence.* New York: Doubleday and Company, 1953.

Mairet, Philip. *A. R. Orage, A Memoir.* London: J. M. Dent and Sons, 1936.

Mansfield, Katherine. *The Letters of Katherine Mansfield to John Middleton Murry, 1913–1922.* London: Constable and Co., 1951.

————. *Journal.* Edited by John Middleton Murry. Definitive edition. London: Constable and Co., 1954.

Meyer, Franz. *Marc Chagall.* New York: Harry N. Abrams, Inc., 1963.

Modigliani, Jeanne. *Modigliani: Man and Myth.* New York: The Orion Press, 1958.

————. *Modigliani sans Légende.* Paris: Librairie Grund, 1961.

Murray, Peter and Linda. *A Dictionary of Art and Artists.* Middlesex: Penguin Books, 1959.

Myers, Bernard S. *The German Expressionists.* New York: Frederick A. Praeger and Co., 1956.

Nacenta, Raymond. *School of Paris.* Greenwich, Conn.: New York Graphic Society, 1960.

Newmeyer, Sarah. *Enjoying Modern Art.* New York: New American Library, 1957.

Newton, Eric. *The Arts of Man.* Greenwich, Conn.: New York Graphic Society, 1960.

Norman, Jane, and Norman, Theodore. *Traveler's Guide to Europe's Art.* Great Neck, N.Y.: Channel Press, 1959.

Olivier, Fernande. *Picasso et Ses Amis.* Paris: Editions Stock, 1933.

Papini, Giovanni. *Laborers in the Vineyard.* New York: Longmans Green and Co., 1930.

Patai, Irene. *Encounters: The Life of Jacques Lipchitz.* New York: Funk and Wagnalls, 1961.

Pawlowski, Adam de. *Alfredo Pina.* Paris: Jean Allard, 1929.

Pelaudi, Luigi, and Servolini, Luigi. *Dizanario illustrato dei pittori, desegnatori, e incisori Italiani moderni e contemporanei.* Three volumes. Milan: A. M. Commanducci, 1962.

Penrose, Roland. *Portrait of Picasso.* New York: The Museum of Modern Art, 1957.

————. *Picasso, His Life and Work.* New York: Schocken Books, 1962.

Perruchot, Henri. *Cézanne.* New York: World Publishing Co., 1961.

Pfannstiel, Arthur. *Modigliani*. Preface by Louis Latourettes. Paris: Editions Seheur, 1929.

———. *Modigliani et Son Oeuvre, Critique et Catalogue Raisonné*. Paris: Bibliothèque des Arts, 1956.

———. *Dessins de Modigliani*. Preface by Charles-Albert Cingria. Lausanne: H. L. Mermod, 1958.

Raynal, Maurice. *Modern Painting*. Paris: Editions D'Art Albert Skira, 1960.

Read, Herbert. *A Concise History of Modern Painting*. New York: Frederick A. Praeger, Inc., Publishers, 1959.

Renoir, Jean. *Renoir, My Father*. Boston: Atlantic-Little, Brown Company, 1962.

Rheims, Maurice. *The Strange Life of Objects*. New York: Atheneum Publishers, 1962.

Rodman, Selden. *Conversations with Artists*. New York: Capricorn Books, 1961.

Roy, Claude. *Modigliani*. Translated by James Emmons and Stuart Gilbert. Paris: Editions D'Art Albert Skira, 1958.

Russoli, Franco. *Modigliani*. New York: Harry N. Abrams Company, 1959.

Salmon, André. *Modigliani: A Memoir*. Translated by Randolph and Dorothy Weaver. New York: G. P. Putnam's Sons, 1961.

Schack, William. *Art and Argyrol, the Life and Career of Dr. Albert C. Barnes*. New York: A. S. Barnes and Co., 1963.

Schaub-Koch, Emile. *Modigliani*. Paris: Mercure Universel, 1933.

Schweiller, Giovanni. *Modigliani*. Paris: Editions Chronique du Jour, 1928.

Selvers, Paul. *Orage and the New Age Circle*. London: Allen and Unwin Ltd., 1959.

Selz, Jean. *Modern Sculpture, Origins and Evolution*. New York: George Braziller, Inc., 1963.

Sima, Michel. *Faces of Modern Art*. New York: Tudor Publishing Company, 1959.

Sitwell, Osbert. *Left Hand, Right Hand*. Boston: Atlantic-Little, Brown Co., 1944.

———. *Great Morning!* Boston: Atlantic-Little, Brown Co., 1947.

———. *Laughter in the Next Room*. Boston: Atlantic-Little, Brown Co., 1948.

———. *Noble Essences*. Boston: Atlantic-Little, Brown Co., 1950.

Soffici, Ardengo. *Ricordi De Vita Artistica E Litteraria*. Florence: Vallecchi Editore, 1942.

Sonabel, Y. *Modigliani Nudes*. Paris: Fernand Hazen, 1958.

Sprigge, Elizabeth. *Gertrude Stein, Her Life and Work*. New York: Harper Bros., 1957.

Steegmuller, Francis. *Apollinaire, Poet Among Painters*. New York: Farrar Straus, 1963.

Stein, Gertrude. *The Autobiography of Alice B. Toklas*. New York: Harcourt, Brace Company, 1933.

———. *Picasso*. Boston: Beacon Press, 1959.

Storm, John. *The Valadon Drama: The Life of Suzanne Valadon*. New York: E. P. Dutton & Co., Inc., 1959.

Taylor, Joshua C. *Futurism*. New York: The Museum of Modern Art, 1961.

Toklas, Alice B. *What Is Remembered*. New York: Holt, Rinehart and Winston, 1963.

Tuchman, Barbara W. *The Guns of August*. New York: Macmillan Co., 1962.

Valsecchi, Marco, and Apollonio, Umbro. *Panorama Dell'Arte*. Turin: Editori Lattes, 1951.

Vlaminck, Maurice de. *Tournant Dangereux*. Paris: Editions Stock, 1929.

Vorobëv, Marevna. *Life in Two Worlds*. New York: Abelard-Schuman, 1962.

Waldberg, Patrick. *Mains et Merveilles*. Paris: Mercure de France, 1961.

Warnod, André. *Le Berceau de la Jeune Peinture*. Paris: Albin Michel, 1926.

———. *Ceux de la Butte*. Paris: René Juillard, 1947.

———. *Fils de Montmartre*. Paris: Librairie Arthème Fayard, 1955.

Wechsler, Herman J. *Lives of Famous French Painters*. New York: Washington Square Press, 1962.

Weill, Seymour S. *Francis Carco, the Career of a Literary Bohemian*. New York: Columbia University Press, 1952.

Werner, Alfred. *Modigliani the Sculptor*. New York: Arts, Inc., 1962.

Wheeler, Monroe. *Soutine*. New York: The Museum of Modern Art, 1950.

Wilenski, R. H. *Modern French Painters, 1863–1903*. New York: Vintage Books, 1960.

———. *Modern French Painters, 1904–1938*. New York: Vintage Books, 1960.

Wolfe, Bertram. *Diego Rivera, His Life and Times*. New York: Alfred A. Knopf, Inc., 1939.

———. *The Fabulous Life of Diego Rivera*. New York: Stein and Day, 1963.

Poetry

Hartley, Anthony (ed.). *The Penguin Book of French Verse, The Nineteenth Century*. Middlesex: Penguin Books, 1958.

———. *The Penguin Book of French Verse, The Twentieth Century*. Middlesex: Penguin Books, 1959.

Holender, Barbara. "Portrait by Modigliani." *The New York Times* (New York), October 19, 1960.

Kay, George (ed.). *The Penguin Book of Italian Verse*. Middlesex: Penguin Books, 1958.

Modigliani, Amedeo. Three poems in *Omaggio a Modigliani (1884–1920)*. Edited by Giovanni Schweiller. Milan: January 25, 1930.

———. "Ave et Vale" in *Notes and Memoirs, Amedeo Modigliani*. Genoa: 1945.

———. Poems in *Europe Almanach*, 1925, p. 140.

———. Three poems in *Les Arts à Paris*, No. 1, October, 1925.

Fiction

Carco, Francis. *Les Innocents*. Paris: Albin Michel, 1952.

Longstreet, Stephen, and Longstreet, Ethel. *Man of Montmartre*. London: Weidenfield and Nicolson, n.d.

Mansfield, Katherine. "Je Ne Parle Pas Francais," *The Short Stories of Katherine Mansfield*. New York: Alfred A. Knopf, Inc., 1941.

Manzoni, Alessandro. *I Promessi Sposi (The Betrothed)*. Introduction by Bergen Evans. New York: Fawcett World Library, 1962.

Salmon, André. *La Vie Passionnée de Modigliani*. Paris: Editions Gérard & Cie., 1957.

Wight, Frederick S. *Verge of Glory*. New York: Harcourt, Brace and Company, 1957.

Wittlin, Thaddeus. *Modigliani, Prince of Montparnasse*. New York: The Bobbs-Merrill Company, 1964.

Catalogues, Magazines, Monographs, and Newspapers

D'Ancona, P. "Cinque lettre giovanili di Amedeo Modigliani." *L'Arte* (Turin: May, 1930) as reproduced in *Amedeo Modigliani* by Ambrogio Ceroni (Milan: Edizioni del Milione, 1958).

Ball, Hugo (ed.). *Cabaret Voltaire* (Zurich), May 15, 1916.

Brunelleschi, Umberto. "Rosalie, l'ostessa di Modigliani." *L'Illustrazione Italiana* (Milan), September 11, 1932.

Carco, Francis. "Modigliani," *L'Eventail* (Geneva), July 15, 1919.

Carmichael, Montgomery. "Leghorn," *Pall Mall* (London), 1898.

Catalogue. *Les Synchromistes.* Morgan Russell and S. Macdonald-Wright. October 27–November 8, 1913. Bernheim Jenne et Cie., Paris.

Catalogue. *An Exhibition of One Hundred Paintings from the São Paulo Museum of Art.* The Museum of Fine Arts, Toledo, Ohio, October 8–November 17, 1957.

Catalogue. *Modigliani Paintings and Drawings.* Foreword, William S. Lieberman; introduction, Frederick S. Wight. The Museum of Fine Arts, Boston, and the Los Angeles County Museum. Published by the Committee on Fine Arts Productions, University of California, 1961.

Catalogue. *Modigliani Exhibition.* Introduction by John Russell. The Arts Council of Great Britain. The Tate Gallery, London, September 28–November 5, 1963.

Catalogue. *Amedeo Modigliani 1884–1920.* Perls Galleries, New York, October 29–December 7, 1963.

Cendrars, Blaise. "Modigliani," *Vient de Paraître* (Paris), September–October, 1927.

———. "Cendrars devant ces images nous a raconté trois histoires," *Arts* (Paris), March 14–20, 1956.

———. "Portrait of 88 Dresses," *New York Post,* March 18, 1954.

Erhenburg, Ilya. "Modigliani: How Many Vertebrae to a Neck?" *Show* (New York), July, 1962.

Erickson, Evarts. "Amedeo Modigliani, Son of the Stars," *School Arts* (Worcester), April, 1959.

Grey, Roch (pseudonym of Baroness Helène Oettingen). "Modigliani," *Action* (Paris), December 6, 1920.

Guillaume, Paul (ed.). *Les Arts à Paris.* (Paris), October, 1923.

Hastings, Beatrice. *The Old "New Age," Orage—and Others.* London: Blue Moon Press, 1936.

———. *Defence of Madame Blavatsky.* Worthing: Hastings Press, n.d.

———. *New Universe "Try,"* a review devoted to the defense of Madame Blavatsky. Worthing: B. Hastings, 1937–1939.

Ibanez, Felix Marti. "Psychiatry Looks at Modigliani," *Gentry,* Fall, 1953.

Kuh, Katherine. "Italy's 'New' Renaissance: An Inquiry," *Saturday Review* (New York), February 11, 1961.

Levy, Edgar. "Modigliani and the Art of Painting," *The American Scholar* (Washington), Summer, 1964.

Meidner, Ludwig. "The Young Modigliani—Some Memories," *Burlington Magazine* (London), May, 1943.

Modigliani, Jeanne. "Modigliani," *Arts* (Paris), January 31–February 6, 1962.

Modot, Gaston. Interviewed. *L'Écran Français.* (Paris), June 27, 1949.

Ojetti, Ugo. "Amedeo Modigliani," *Corriere della Sera* (Milan), January 28, 1930.

Orage, Alfred Richard (ed.). Files of *The New Age* (London), 1907–1920.

Paris-Montparnasse. Special number devoted to Modigliani (Paris), February, 1930.

Schweiller, Giovanni (ed.). *Omaggio a Modigliani (1884–1920).* Printed in Milan on the tenth anniversary of Modigliani's death. Three poems by Modigliani. Introduction by Sergio Solmi. Statements by Baraud, Bernasconi, Braque, Carco, Carra, Casorati, Cendrars, De Chirico, Cocteau, Courthion, Derain, Fels, Friesz, George, Guillaume, Jacob, Jerrans, Kisling, Lipchitz, Marinus, Michel, Montale, Oppi, Piceni, Pisis, Pound, Prampolini, Raimondi, Salmon, Savinio, Segonzac, Severini, Soutine, Vlaminck, Zborowski.

Soby, James Thrall. *Modigliani.* New York: The Museum of Modern Art, 1951.

"A Van Dongen Portrait," *Vogue* (New York), January 1, 1961.

Vitali, Lamberto. *Quarantacinque desegni di Modigliani.* Turin: Giulio Enaudi Editore, 1959.

Werner, Alfred. "The Life and Art of Amedeo Modigliani," *Commentary* (New York), May, 1953.

———. "The Inward Life of Modigliani," *Arts* (New York), January, 1961.

———. "Modigliani Master Draughtsman," *American Artist* (New York), February, 1964.

Wight, Frederick S. "Recollections of Modigliani by Those Who Knew Him," *Italian Quarterly* (Los Angeles: University of California), Spring, 1958.

✧ ✧ ✧ Index